20TH CENTURY CULTURE

A

DICTIONARY

OF THE ARTS

AND LITERATURE

OF OUR TIME

DAVID BROWNSTONE

AND

IRENE FRANCK

Prentice Hall

New York London Toronto Sydney Tokyo Singapore

First edition

 Prentice Hall

Simon & Schuster, Inc.
15 Columbus Circle
New York, NY 10023

Published by Prentice Hall

Manufactured in the United States of America

Prentice Hall and colophons are registered trademarks of
Simon & Schuster, Inc.

1 2 3 4 5 6 7 8 9 10

Library of Congress Cataloging-in-Publication Data

Brownstone, David M.
 20th century culture : a dictionary of the arts and literature of
our time / David Brownstone, Irene Franck. — 1st ed.
 p. cm.
 Includes index.
 ISBN 0-13-210519-5 : $24.95
 1. Arts, Modern—20th century—Dictionaries. I. Franck, Irene M.
II. Title. III. Title: Twentieth century culture.
NX456.B76 1991
700′.9′04—dc20 91-1994
 CIP

All photographs were supplied courtesy of the Bettman Archive.

Preface

What an extraordinary century this has been! When it began, most of the main forms and themes that were to dominate world culture in our time did not yet exist. None of the films that millions of us now routinely watch had been made. Radio and television had not yet been invented; for that matter, neither had jazz, rock, cubism, surrealism, or the stream of consciousness. We began the century with a set of quite separate cultures in the world; as it closes, we find ourselves drawn together more and more, in a single world culture, increasingly unified by the screen and broadcast forms, by the world-wide information and communications network that is developing, by the faces, works, and ideas that are seen by all of us, throughout the world. Indeed, there is also danger in this: National and ethnic cultures can be submerged by a kind of worldwide homogenization if we are not careful to nurture them.

We have set out here to write a book that reflects the extraordinary pace of cultural change in our time, by fully recognizing the emergence of new forms, techniques, and ideas, and by making very little distinction between "high" culture and "popular" culture. Our aim here has been to create rather a new kind of work, one that ties together all the highlights of 20th-century culture—the key people, works, ideas, and movements in the arts and literature of the century, in such diverse areas as painting, film, fiction, classical and popular music, poetry, theater, sculpture, photography, dance, opera, variety, and architecture, in an easily accessible A-to-Z format and in concise, straightforward language.

In these pages, then, you will find a very wide range of information, with The Beatles, Bogart, bop, and *Born on the Fourth of July* very happily coexisting with Böll, the Bolshoi, Borges, Brancusi, and Braque. Similarly, we have made every effort to present creative people and their works in unified fashion; to see Aldous Huxley well, you must see the filmscripts as well as the novels, and to properly follow *The Grapes of Wrath* you must start with the classic novel and watch it develop into the equally classic film and much later the play.

This is the second of our *20th Century* dictionaries; the first was the *Dictionary of 20th Century History*, the first edition of which was published by Prentice Hall Press in 1990. That work covered the central events, people, movements, ideas, and discoveries of the century, focusing on political, military, economic, religious, scientific, and medical matters. It carried a few culturally related entries, as well, for their general historical relevance, which will be found treated here in much expanded form. We have written each book to stand either alone or as companion to the other.

Please note that where small capitals have been used within entries, they indicate the presence of another entry with further directly related information. In the *Casablanca* entry, for example, you will in this way find references to entries on Humphrey BOGART, Ingrid BERGMAN, Paul HENREID, Claude RAINS, Conrad VEIDT, Sydney GREENSTREET, Peter LORRE, Michael CURTIZ, and the song AS TIME GOES BY. Similarly, the entry on Picasso will yield references to LES DEMOISELLES D'AVIGNON, Georges BRAQUE, CUBISM, SURREALISM, GUERNICA, and the ballets THE THREE-CORNERED HAT and Leonid MASSINE'S PARADE.

Our thanks go to our editor, Kate Kelly, to assistant editor Susan Lauzau, and to production editor Lisa Wolff, who have so effectively worked with us every step of the way, and to their publishing colleagues. As always, we also thank the staff of the Chappaqua Library, and their counterparts throughout the northeastern library network, whose continuing help is greatly appreciated.

David Brownstone
Irene Franck
Chappaqua, New York

A

Aalto, Alvar (Hugo Alvar Henrick Alto, 1898–1976), Finnish architect and furniture designer; he emerged as a world figure in the mid-1930s, most notably with his Viipuri Municipal Library (1935), which began to intertwine the necessary fulfillment of functions with earthtones, landforms, northern light, and the use of wood—all themes that were to run through much of his further work. His later work includes such structures as the Finnish Pavilion at the 1939–40 New York World's Fair; Baker House (1948) at the Massachusetts Institute of Technology; and the celebrated town hall group (1952) at Säynatsälo, Finland.

Abbey Theatre, The Dublin theater and theater company; the theater opened on December 27, 1904, with its chief initiators being William Butler YEATS, Lady Gregory, and John Millington SYNGE. It became the main vehicle for the development of the Irish national theater, introducing such major plays as Synge's THE PLAYBOY OF THE WESTERN WORLD (1907) and Sean O'CASEY's THE PLOUGH AND THE STARS (1926).

Abbott and Costello (William B. "Bud" Abbott, 1895–1974, and Louis Francis "Lou" Cristello, 1906–57), U.S. comedy team, together 1931–57, starting in variety, moving into radio and musical theater in the late 1930s, and into film in 1940. They starred in the Broadway musical *Streets of Paris* (1939), and became film stars with *Buck Privates* (1940), then making a series of popular film comedies.

Abbott, Berenice (1898–), U.S. photographer; she studied with Man RAY in Paris 1923–25 and worked in Paris until 1929, in the late 1920s doing photographic portraits of many of the cultural notables of the time. In that period Ray and Abbott "discovered" the work of Eugène ATGET, and Abbott helped support Atget during the last few years of his life while at the same time preserving thousands of his pictures; she later played a major role in bringing forward his work. She returned to the United States in 1929 and for the next two decades documented the character and growth of New York City, focusing from the late 1950s on the photographic portrayal of physical shapes and forms.

Abbott, George (1887–), U.S. actor, director, producer, and writer, on stage from 1913, who turned fully toward playwriting and production on the modest Broadway success of *The Fall Guy* (1925), written with James Gleason. Major success came with *Broadway* (1926) and *Coquette* (1927). His later works included *Three Men on a Horse* (1935), *Where's Charley?* (1948), THE PAJAMA GAME (1954), DAMN YANKEES (1955), and *Fiorello* (1959); he co-produced and co-directed the screen versions of *Pajama Game* and *Damn Yankees*. A phenomenon in the modern American theater, Abbott continued to produce and direct past the age of 100, often collaborating with others on the writing of his plays but in full control of those he directed and produced, whether written by himself or others.

Abe, Kobo (1924–), Japanese writer, a novelist, playwright, and screenwriter, who adapted his own novel *The Woman in the Dunes* (1962) into the highly allegorical film of that name (1964). His work also includes such novels as *The Road Sign at the End of the Road* (1949) and *The Box Man* (1973).

Abe Lincoln in Illinois (1938), the Robert SHERWOOD play, about the Illinois years of

Abraham Lincoln; it ends as he boards the train for Washington after his election to the presidency. Raymond MASSEY was Lincoln, a role he re-created in the 1940 John CROMWELL film, strongly supported by Gene Lockhart and Ruth Gordon.

Abramovitz, Max (1908–), U.S. architect, partnered with Wallace K. HARRISON in Harrison and Abramovitz 1945–76; a few of his many notable works are the three interfaith chapels at Brandeis University (1955), the Corning Glass Building (New York, 1959), Philharmonic Hall at the Lincoln Center for the Performing Arts (New York, 1962), and the Columbia University Law School and Library (1962).

Abstract Expressionism, an approach developed by many visual artists during the first decade of the 20th century, probably first applied as a descriptive term, from about 1910, to the paintings of Wassily KANDINSKY, for their use of color and nonrepresentational forms to express their creator's emotions and thoughts. The main use of the term has been to describe the highly individual, extremely varied body of styles used by a number of American artists, centered in New York City, from approximately 1945 to 1955, who have since become known as the NEW YORK SCHOOL. Most of these, though not all, worked in some form dictated by the "automatic painting" theories of the surrealists (see SURREALISM) and in wholly nonrepresentational forms. The most notable of the several styles involved was that of Jackson POLLOCK, who pioneered in the "drip and splash" automatic painting technique. Because the act of painting then becomes central, and the painting itself merely a partial recording of the process, the technique came to be called ACTION PAINTING, a term sometimes rather loosely used as a synonym for abstract expressionism. Some of the other styles associated with the school were the near-calligraphy of Willem DE KOONING; the quite independent neosurrealist images of Arshile GORKY; the strongly defined, emotive brushwork of Franz KLINE; and the color-field painting of such artists as Mark ROTHKO and Barnett NEWMAN, which

from the late 1950s emerged as a successor movement to abstract expressionism.

absurd, theater of the, a trend in the mid-20th-century theater that sees life as meaningless and the world as wholly inimical, as people are unable to communicate, to take action, or indeed ultimately to survive in that world. The absurdist view was scarcely original: It had strong affinities with such earlier movements as SURREALISM and with much in contemporary philosophical and literary work. Samuel BECKETT'S WAITING FOR GODOT (1953) and several short plays by Eugéne IONESCO powerfully introduced this view in the theater during the early 1950s; they were soon joined by Harold PINTER, Edward ALBEE, and others. The term *theater of the absurd* is related to the existential *absurd* posited by Albert CAMUS and others. However, it is essentially a critics' invention, rather than a descriptor used by the playwrights involved, who manage to communicate their views very effectively, as have so many other figures in all the arts who have been disoriented by the massive dislocations dominating the life of the 20th century.

Academy Awards, from 1927, the annual film awards of the U.S. Academy of Motion Picture Arts and Sciences, which are the most prestigious of the many world film awards. The highly prized awards, gold-plated statues called OSCARS, are voted on by the several thousand Academy members in many artistic and technical categories, the most important of which are best picture, best director, best actor, and best actress.

Achebe, Chinua (1930–), Nigerian writer, whose first novel, *Things Fall Apart* (1958), established him as a major African novelist and analyst of the impact of colonialism upon Africa. His further work also includes such novels as *Arrow of God* (1964), and *A Man of the People* (1966), as well as poetry, children's books, and essays.

action painting, a painting style widely used by the dominant group among the American Abstract Expressionists in the period 1945–55; the style considerably depended on the "automatic painting" theories of SURREALISM, as developed by Jackson POLLOCK and others

into the "drip and splash" and other automatic painting techniques. The term has often been used as a synonym for ABSTRACT EXPRESSIONISM, although the latter describes a much wider variety of styles and theoretical approaches.

Actors Studio, a STANISLAVSKY-oriented actors' workshop organized in New York City by Cheryl CRAWFORD, Robert Lewis, and Elia KAZAN in 1947 and directed from 1948 by Lee STRASBERG. The Actors Studio strongly influenced the acting approaches and techniques of many leading American actors, including Marlon BRANDO, James DEAN, Paul NEWMAN, Al PACINO, and Joanne WOODWARD, with its stress upon The METHOD, an approach that focused on the finding of the emotional wellsprings from which the actor might create each role.

Acuff, Roy Claxton (1903–), U.S. musician, a very popular singer and a leading figure in country music from the late 1930s, as a singer with GRAND OLE OPRY and a recording star, with such songs as "Great Speckled Bird" and "Wabash Cannonball." He was also a fiddler and bandleader, appeared in the film *Grand Ole Opry* (1940), and was in the early 1940s host of the show as well. He appeared in several other films and also wrote many songs.

Adams, Ansel Easton (1902–84), U.S. photographer, a pianist who became the foremost landscape and nature photographer of the modern American West and whose work was informed by his lifelong commitment to the cause of conservation. Adams became a member of the Sierra Club in 1917 and a director in 1936; his first published portfolio was the soft-focus *Parmelian Prints of the High Sierras* (1928), published by the Sierra Club. His further photographs were the sharp, clear work for which he was celebrated; some it was published in such landmark collections as TAOS PUEBLO (1930), *Sierra Nevada: The John Muir Trail* (1936), *Death Valley* (1954), *Yosemite Valley* (1959), and THIS IS THE AMERICAN EARTH (1960). In 1944 he did the eloquent BORN FREE AND EQUAL, a photographic essay on interned Japanese-Americans at the Manzanar detention camp during World War II. Adams was also a founder of the trailblaz-

ing Museum of Modern Art photo collection in 1940; in that year he also directed the landmark Pageant of Photography Exhibition at the Golden Gate International Exposition. In 1946 he founded the first college photography department, at the California School of Fine Arts in San Francisco. He also wrote several texts in the field, including *Making a Photograph* (1935) and the five-volume *Basic Photo Series* (1957–69).

Adams, Maude (1872–1953), U.S. actress, on stage at the age of five and a leading player in the American theater during the 1890s. In 1905 she created the PETER PAN role in the J. M. BARRIE play, by far her best-known role.

Addams, Charles (1912–88), U.S. cartoonist, best known as creator of the collection of grotesques featured in "The Addams Family" (1964–66), the television series developed on the basis of his cartoons, which from 1935 had appeared in *The New Yorker*. His work was published in such collections as *Drawn and Quartered* (1942), *Monster Rally* (1950), and *Night Crawlers* (1957).

Adderly, Cannonball (Julian Edwin Adderly, 1928–75), U.S. musician and composer, a notable jazz saxophonist from the mid-1950s, who played and recorded with such other notables as John COLTRANE, Miles DAVIS, George SHEARING, and his brother Nat Adderly; he led his own group from the late 1950s through 1975.

Adler, Jacob (1855–1926), Russian-American actor, a leading figure in the American Yiddish-language theater, whose most notable leads included *The Yiddish King Lear* (1892) and Shylock in *The Merchant of Venice* (1901).

Adler, Larry (Lawrence Cecil Adler, 1914–), U.S. harmonica virtuoso and composer, the first to use the harmonica, which he feels is best described as a "mouth organ," as a full-scale concert instrument. On stage as a variety performer from the late 1920s and on film from 1931, most notably in *St. Martin's Lane* (1938), Adler made his first records in 1934 and made the first of many appearances as a soloist with a symphony orchestra in Sydney, Australia, in 1939. Many composers, including Ralph VAUGHAN WILLIAMS and Darius

MILHAUD, composed works for him to play. He toured widely, with dancer Paul Draper, 1941–49; both were accused of Communist affiliation during the McCarthy period and were blacklisted in the United States. Adler then relocated to Britain, going forward with his career. He composed several film scores, including *Genevieve* (1953), KING AND COUNTRY (1963), and *High Wind in Jamaica* (1964).

Advise and Consent (1959), the Allen DRURY novel, about high-level Washington intrigue, centered around the nomination of a secretary of state accused of having been a Communist; it appeared during a time of national revulsion against McCarthyism, winning a Pulitzer Prize. It was adapted into the 1960 play, and into the 1962 Otto PREMINGER film by Wendell Mayes, with Henry FONDA as the center of controversy, leading a cast that included Walter PIDGEON, Charles LAUGHTON, Don Murray, Burgess MEREDITH, Franchot TONE as the President, and Lew AYRES.

African Queen, The (1935), the novel by C.S. Forester, about a missionary and a riverboat captain who ultimately blow up a German warship in East Africa during the early days of World War I. It was adapted by James AGEE into the 1951 John HUSTON film, with Humphrey BOGART in the Oscar-winning Charlie Allnut role and Katharine HEPBURN as Rose Sayer, in a cast that included Robert Morley and Theodore Bikel.

Afternoon of the Faun, The (*L'après-midi d'un faune*), the ballet choreographed by Vaslav NIJINSKY, set to the orchestral work by Claude DEBUSSY; it was first produced in Paris, in May 1912, by the BALLET RUSSES company of Sergei DIAGHILEV, with Nijinsky in the leading role.

Agee, James (1909–55), U.S. writer, whose first notable work was his essay on the life of southern tenant farmers during the Great Depression, which was joined with the photographs of Walker EVANS in LET US NOW PRAISE FAMOUS MEN (1941). His posthumously published novel A DEATH IN THE FAMILY (1957) won a PULITZER PRIZE; it was also adapted into Tad Mosel's prize-winning play ALL THE WAY HOME (1960), itself

adapted into the 1963 film. Agee wrote for films and television as well, most notably including the screenplay for THE AFRICAN QUEEN (1952). He was also a major film critic from 1939–48, his work later being collected in *Agee on Film* (1958).

Agnes of God (1980), the John Pielmeier play, about Agnes, a young nun who is accused of murdering her newborn baby, and the psychiatrist and mother superior charged with questioning her in an attempt to determine the facts of the matter. Amanda Plummer created Agnes, opposite Elizabeth Ashley as Dr. Martha Livingstone and Geraldine PAGE as Mother Miriam Ruth. Pielmeier adapted his play into the 1985 Norman JEWISON film, with Meg Tilly as Agnes, Jane FONDA as the doctor, and Anne BANCROFT as the mother superior.

Agnon, Shmuel Yoseph (Samuel Yosef Czackzkes, 1888–1970), Galician-Israeli writer, working in Hebrew, whose novels and short stories examined Jewish, and especially Hasidic, life in prewar Eastern Europe, and whose later work included a heightened strain of mysticism. He was a co-winner of the 1966 NOBEL PRIZE for literature. His best-known works include *A Bridal Canopy* (1931), *A Guest for the Night* (1938), and *The Day Before Yesterday* (1945).

Agon, a ballet choreographed by George BALANCHINE, with music by Igor Stravinsky; a short, atonal, highly abstracted work first produced at New York in November 1957 by the New York City Ballet.

Aherne, Brian (1902–86), British actor, on stage from 1910 and on screen from 1924, who came to the United States in 1931 to play opposite Katharine CORNELL in THE BARRETTS OF WIMPOLE STREET. He played leads in such films as *Song of Songs* (1933), opposite Marlene DIETRICH; *Beloved Enemy* (1936); *The Great Garrick* (1937); *Captain Fury* (1939); and *My Son, My Son* (1940).

Ah, Wilderness! (1933), the Eugene O'NEILL play, a comedy set in the Connecticut of O'Neill's childhood. Elisha COOK, Jr., created the role of the teenage boy; George M. COHAN and Marjorie Marquis played his parents. The

play became the 1935 Clarence BROWN film, with Mickey ROONEY in the boy's role. It was also adapted into the 1959 stage musical, *Take Me Along*.

Ailey, Alvin (1931–89), U.S. dancer, choreographer, and director, on stage as a dancer with the Lester Horton company from 1950 and as a choreographer with that company from 1953. In 1958 he formed the Alvin Ailey American Dance Theater, a primarily Black company, which presented such works as Ailey's *Blues Suite* (1958); the classic REVELATIONS (1960), which became its best-known work; and *Cry* (1971). He also choreographed such works as Samuel BARBER's *Antony and Cleopatra* (1960), and appeared in such films as *Carmen Jones* (1954), while performing in and in several instances directing off-Broadway plays. His company was part of the City Center of Music and Drama from 1952.

Akhmatova, Anna (Anna Andreyevna Gorenko, 1889–1966), Soviet poet, who was recognized as a leading lyrical poet with publication of the early works collected in *Evening* (1912) and *The Rosary* (1913). She continued to publish only until 1923, falling out of favor with the government, and was able to publish again only decades later, after the end of the Stalin period. Her *Poem Without a Hero* (1962) became one of the key works of the modern Soviet period. Her *Requiem* (1964) honored the dead of the Stalin period.

Albee, Edward Franklin (1928–), U.S. writer, who emerged as one of the leading playwrights of the modern period with such early short works as *The Zoo Story* (1959), *The Sandbox* (1960), *The Death of Bessie Smith* (1960), and *The American Dream* (1961), followed by such plays as the TONY-winning WHO'S AFRAID OF VIRGINIA WOOLF? (1962), *Tiny Alice* (1964), and the PULITZER PRIZE-winning *A Delicate Balance* (1966), and also by such adaptations of novels into plays as *The Ballad of the Sad Café* (1963) and LOLITA (1979). His earlier works often were seen as part of the THEATER OF THE ABSURD, with its focus on contemporary alienation. Film adaptations of *Who's Afraid of Virginia Woolf?* (1966) and *A Delicate Balance* (1973) reflected the central importance of the bitter relation-

ships revealed and were essentially filmed plays.

Albéniz, Isaac (1860–1909), Spanish composer and pianist, much of whose work reflects the influence of Spanish folk music; his major work was the *Iberian Suite* (1906–9), a group of 12 piano pieces.

Albers, Josef (1888–1976), German painter, designer, and teacher, resident in the United States from 1933 and an American citizen from 1939; he was a student and then a teacher at the BAUHAUS, 1920–33, in that period working mainly with glass pictures and at the same time developing what became his lifelong dedication to nonrepresentational work and the exploration of color, most fully expressed in his *Homage to the Square* series of paintings, begun in 1950. Albers taught at Black Mountain College from 1933 to 1949 and was the chairman of the Yale Architecture and Design Department from 1950 to 1958.

Alda, Alan (1936–), U.S. actor, best known by far for his lead as the battlefield surgeon Hawkeye in the long-running television comedy-drama series M*A*S*H (1972–83). He has also appeared in many films, most notably *California Suite* (1978); *Same Time Next Year* (1978); *The Seduction of Joe Tynan* (1979); and *Crimes and Misdemeanors* (1989); and he wrote, directed, and starred in *A New Life* (1988). He has also written several other screenplays and television scripts.

Aldrich, Henry, the fictional American teenager created in Clifford Goldsmith's 1938 play *What a Life*. Ezra Stone was the first Henry, re-creating the role in the popular radio show that followed. Jackie COOPER was Henry in the 1939 film, which generated a series of 1940s films starring Jimmy Lydon as Henry.

Aldrich, Robert (1918–83), U.S. director and producer, whose strongly realistic, often quite violent work included such films as *The Big Knife* (1955), *Hush . . . Hush, Sweet Charlotte* (1965), *The Dirty Dozen* (1967), *The Longest Yard* (1974), and *Twilight's Last Gleaming* (1977).

Aleichem, Sholem (Solomon Rabinovich, 1859–1916), Jewish-Russian writer and the most popular of all Yiddish-language writers,

whose best-known works were the series of short pieces on *Tevye the Dairyman* (1894–99), set in a fictional East European Jewish village. Many of his works were adapted for the stage, most notably by the Yiddish Art Theatre. They were the basis of the Joseph Stein–Sheldon Harnick Broadway musical FIDDLER ON THE ROOF (1964), in which Zero Mostel created the Tevye role. In the 1971 Norman JEWISON film, the role was played by Topol. Aleichem's series of short works *Mottel, the Cantor's Son* (1907–16) were also widely read.

Alexander, Jane (Jane Quigley, 1939–), U.S. actress, who in her first starring theater role created the role of Ellie, Black prizefighter Jack Johnson's white lover in *The Great White Hope* (1968). She re-created the role on film in 1970 and went on to play Eleanor Roosevelt in television's ELEANOR AND FRANKLIN (1976), and to a succession of strong roles in such films as ALL THE PRESIDENT'S MEN (1976) and KRAMER VS. KRAMER (1979). In 1990, she starred on Broadway in *Shadowlands*.

Alexander Nevsky (1938), the Sergei EISENSTEIN film, with score by Sergei PROKOFIEV and with Nikolai CHERKASSOV in the title role, about the successful 13th-century defense of Russia against an invasion by the Teutonic Knights. The film, featuring the central Battle on the Ice, was a patriotic set piece, to some extent aimed at preparing the Soviet people for the coming Nazi invasion of the Soviet Union.

"Alexander's Ragtime Band" (1911), the Irving BERLIN song, a landmark work signaling the infusion of JAZZ into American popular music, with words and music by Berlin. It was also the title of the 1938 Henry KING film, starring Tyrone POWER opposite Alice FAYE.

Alexandria Quartet, The, four complexly interrelated novels written by Lawrence DURRELL, consisting of *Justine* (1957), *Balthazar* (1958), *Mountolive* (1958), and *Clea* (1960), all set in Alexandria, in which the same people and situations are explored from many different points of view, in a highly regarded, often purposefully obscure set of works.

Alfie (1966), the Lewis Gilbert film, adapted by Bill Naughton from his play, about the love life and stumbling steps toward maturity of a young Londoner; Michael CAINE created the Alfie role, leading a cast that included Shelley Winters, Vivien Merchant, Millicent Martin, and Julia Foster. Burt BACHARACH and Hal David wrote the film's song "Alfie," which became a popular hit. Alan Price played Alfie in the 1975 sequel, *Alfie Darling*, directed by Ken Hughes.

Algren, Nelson (1909–81), U.S. writer, a Chicago-based realist whose work focused on the underside of American life and who emerged as a major novelist in the 1940s with *Never Come Morning* (1942). His THE MAN WITH THE GOLDEN ARM (1949) was adapted into the 1955 film, with Frank SINATRA in the central role of the junkie. Algren's *A Walk on the Wild Side* (1956) was the basis of a 1962 film, which used the name of his work but otherwise had little to do with it.

Alice Doesn't Live Here Anymore (1975), the Martin SCORSESE film, starring Ellen BURSTYN in an OSCAR-winning role as a woman on her own with a small child, leading a cast that included Kris KRISTOFFERSON, Jodie FOSTER, Alfred Lutter, Diane Ladd, Billy Greenbush, Harvey Keitel, and Vic Tayback. Robert Getchell wrote the screenplay. The film was the basis of the long-running television series "Alice," with Linda Lavin in the title role.

Alice's Restaurant (1969), the Arthur PENN film, which took off from the popular Arlo GUTHRIE song and album of that name. Guthrie, James Broderick, and Pat Quinn as Alice played key roles.

All About Eve (1950), the Joseph L. MANKIEWICZ film, for which he also wrote the screenplay, sardonically portraying the rise of a young actress in the New York theater. Bette DAVIS played Margot Channing, the threatened older actress, with Anne BAXTER as the young actress, Eve, and George SANDERS as critic Addison De Witt, in a cast that included Celeste HOLM, Gary Merrill, Hugh Marlowe, and Thelma Ritter. Marilyn MONROE had a small comic role, as the kind of sex symbol she soon became. Mankiewicz won OSCARS for his direction and screenplay, as did the film, Sanders as best supporting actor, and costumes. The film was the basis of the Broad-

way musical *Applause*, in which Lauren BACALL won a TONY as Margot.

"All Animals Are Equal, but Some Animals Are More Equal Than Others," George Orwell's slogan from the satire ANIMAL FARM (1945).

Allen, Fred (John Florence Sullivan, 1894–1956), deadpan U.S. comedian, in vaudeville as a juggler and in musical theater before becoming one of the most popular American radio performers of the 1930s and 1940s. His weekly programs "Town Hall Tonight" (1934–40) and "Texaco Star Theater" (1940–49) were faithfully followed by millions of listeners. His wife and radio partner was Portland Hoffa. He was also a popular variety-show host and guest star in early television.

Allen, Woody (Allen Stewart Konigsberg, 1935–), U.S. director, actor, and writer, who began as a radio and television comedy writer in 1952, moved into cabaret performance of his own material in 1961, and turned to films as screenwriter and actor in *What's New, Pussycat?* (1965), the first of a series of well-received comedies that included his OSCAR-winning ANNIE HALL (1977), for which he won best director and best screenwriter OSCARS. He adapted his 1966 play *Don't Drink the Water* for film in 1969 and in 1969–70 appeared on Broadway in his play *Play It Again, Sam*, adapting it for film in 1972. He wrote, directed, and appeared in such later films as MANHATTAN (1979), *Stardust Memories* (1980), *Broadway Danny Rose* (1984), HANNAH AND HER SISTERS (1986), and *Crimes and Misdemeanors* (1989), while writing and directing such films as *Interiors* (1978) and *Radio Days* (1987).

All God's Chillun Got Wings (1924), the Eugene O'NEILL play, his straightforward attack on American bigotry, a story of love and miscegenation that was sharply attacked by the bigots of the time. Paul ROBESON played the Black lawyer who married his White childhood sweetheart, who ultimately went mad when she could not come to terms with her own prejudice.

Allgood, Sara (1883–1950), Irish actress, from 1904 to 1914 a leading member of the ABBEY THEATRE company. Back at the Abbey in the 1920s, she played the role of Juno Boyle in Sean O'CASEY's JUNO AND THE PAYCOCK (1926), creating the role on screen in the 1930 British film directed by Alfred HITCHCOCK. She also played Bessie Burgess in THE PLOUGH AND THE STARS. She later played scores of character roles in such Hollywood films as HOW GREEN WAS MY VALLEY (1941) and JANE EYRE (1944).

"All in the Family" (1971–83), the very popular U.S. television comedy series, which introduced Archie BUNKER, played by Carroll O'Connor, as a prototypical, entirely outspoken bluecollar bigot, surrounded by his unimpressed family, including his wife, played by Jean Stapleton, and a considerable number of the objects of his bigotry, including the Jeffersons, a Black family next door. Bunker is a caricature; the serious object of the exercise seemed to have been an attempt to combat bigotry by ventilating it and exposing its stupidity. The series was developed by Norman Lear and based on the British series "Till Death Do Us Part."

Allman Brothers, U.S. southern-based ROCK band, formed in March 1969 by Duane Allman, Gregg Allman, Butch Trucks, Dicky Betts, Berry Oakley, and Jai Johanny Johanson. It was a widely popular group, firmly based in the American blues heritage. The band lasted until the mid-1970s, although Duane Allman was killed in a motorcycle accident in October 1971 and Berry Oakley died in another motorcycle accident in November 1972. It broke up in 1976, amid drug-related legal problems.

All My Sons (1947), the Arthur MILLER play, set in World War II, about family ties, guilt, and generational conflicts, set in a story line revolving around the war profiteering of the family's father. On stage, Ed Begley created the central Joe Keller role, with Arthur Kennedy as his surviving son; in the 1948 Irving Reis film, the cast included Edward G. ROBINSON, Burt LANCASTER, Howard Duff, Mady Christians, Arlene Francis, Lloyd Gough, and Louisa Horton.

All Quiet on the Western Front (1929), the antiwar novel by German author Erich Maria REMARQUE, in which he saw the futility and pain of the trench warfare of World War I through the eyes of a front-line German soldier. It was Remarque's first novel and very much reflected his own experiences as a soldier at the front. The book was an international bestseller and in 1930 was adapted by Maxwell ANDERSON, George ABBOTT, and Del Andres into Lewis MILESTONE's classic early American talking film, winning best picture and best director OSCARS. Its star, Lew AYRES, was a pacifist who became a World War II conscientious objector. Delbert MANN remade the film in 1979, with Richard Thomas in the central role. Remarque pursued similar postwar themes in his two sequels, *The Road Back* (1931) and *Three Comrades* (1937), the latter made into Frank BORZAGE's 1938 film.

All That Jazz (1979), the Bob FOSSE film, a largely autobiographical backstage musical, with Roy SCHEIDER leading a cast that included Jessica LANGE, Ann Reinking, Ben Vereen, Leland Palmer, and Erzsebet Foldi. Editing, art, set, costume design, and music all won OSCARS.

All the King's Men (1946), the PULITZER PRIZE-winning novel by Robert Penn WARREN, based on the career of corrupt Louisiana politician Huey Long. Robert ROSSEN adapted the novel into the 1949 film, which he also directed, with Broderick CRAWFORD in the central role in a cast that included Mercedes McCambridge, John Ireland, Joanne Dru, and Shepperd Strudwick. The film, Crawford as best actor, and McCambridge as best supporting actress all won OSCARS.

All the President's Men (1974), the book by *Washington Post* reporters Robert Woodward and Carl Bernstein, detailing their key role in the exposure of the Watergate scandal, which eventually forced the resignation of U.S. President Richard M. Nixon. William Goldman adapted the book into the 1976 Alan J. PAKULA film, with Robert REDFORD as Woodward, Dustin HOFFMAN as Bernstein, Jason ROBARDS as Ben Bradlee, and Hal Holbrook as Deep Throat, in a cast that included

Jane ALEXANDER, Martin Balsam, Jack Warden, Meredith Baxter, and Ned Beatty. Goldman won an OSCAR for his screenplay, and Robards a best supporting actor Oscar.

All the Way Home (1960), the Tad Mosel play, adapted from James AGEE's largely autobiographical novel *A Death in the Family* (1957), which examined the tangle of emotions and relationships following the accidental death of the family's father. Pat Hingle and Colleen DEWHURST starred in the play; Philip Reisman, Jr. adapted the play into the 1963 Alex Segal film, starring Robert PRESTON and Jean SIMMONS, in a cast that included Pat Hingle, Aline MacMahon, John Cullum, and Michael Kearney.

"All You Need Is Love" (1967), the BEATLES song, in its time emblematic of the loving, dissenting young flower-people of the mid-1960s; the work became an enduring standard. Words and music by John LENNON and Paul MCCARTNEY.

Alonso, Alicia (Alicia Ernestina Martinez Hoyo, 1921–), Cuban dancer and ballet director, on stage as a dancer in musicals from the late 1930s, with New York's Ballet Theatre from 1941, and as a leading ballerina from 1943, in such roles as her very notable *Giselle* and in Alberto Alonso's *Carmen Suite*. She founded her own company in 1948, rejoined the now-American Ballet Theatre in 1951, and in 1959, after the Cuban Revolution, became director and prima ballerina of the National Ballet of Cuba.

Alpert, Herb, (1935–), U.S. musician, head of the TIJUANA BRASS group, who in 1962 invented the "Ameriachi" style. Their first popular hit was "Lonely Bull" (1962), a Mexican-style version of "Twinkle Star," which was followed by a series of enormously popular albums and concerts for the balance of the 1960s. Their album *A Taste of Honey* won the 1965 record of the year GRAMMY. Alpert took a long rest, from 1969 to 1974, then returning with a new Tijuana Brass group, but now stressing a much wider set of popular JAZZ styles.

Altman, Robert (1922–), U.S. film director, best known for his first commercial suc-

cess, M★A★S★H (1970), and his highly textured NASHVILLE (1975); both received Best Picture ACADEMY AWARD nominations, and Altman won best director nominations for both pictures. He also directed such films as McCABE AND MRS. MILLER (1971), *Streamers* (1983), *3 Women* (1977), *Popeye,* (1980), and *Vincent and Theo* (1990), as well as extensively directing for television.

"Always on My Mind" (1971), a song identified with Willie NELSON; the title song of his 1982 album, with words and music by Johnny Christopher, Mark James, and Wayne Thompson.

Amadeus (1980), the TONY-winning Peter SHAFFER play, about the bitter envy of composer Antonio Salieri, directed at the young Wolfgang Amadeus Mozart; Ian McKellan won a Tony for his portrayal of Salieri in the Broadway production. Shaffer wrote an OSCAR-winning adaptation of his play, which became the 1984 Milos FORMAN film, with F. Murray Abraham as Salieri and Tom Hulce as Mozart, in a cast that included Roy Dotrice and Elizabeth Berridge. Forman, the film, Shaffer, and Abraham as best actor all won Oscars.

Amado, Jorge (1912–), Brazilian novelist, a key figure in his country's modern cultural history. His early work, beginning with *Carnival Land* (1930), was largely concerned with matters of social justice, especially for the poor in his home area, Brazil's impoverished Northeast. He later became a major international figure, as his later work developed a very wide appeal; it included such well-known works as *Gabriela, Clove and Cinnamon* (1958), which became a television series and the 1963 film, *Gabriela; Doña Flor and Her Two Husbands* (1966), which became the 1978 film; and *Tent of Miracles* (1969).

Amahl and the Night Visitors (1951), the opera by Gian Carlo MENOTTI; it was a trailblazing work in that it was an opera written directly for television. The opera, a Christmas story, became a perennial children's favorite.

Amarcord (1973), the Federico FELLINI film, a semiautobiographical work set in fascist Italy during the 1930s, with Puppela Maggio, Armando Brancia, Ciccio Ingrassia, and Giuseppe Lanigro in key roles; the work won a best foreign film OSCAR.

"Amazing Grace," the 18th-century hymn; it became a popular song during the folk song revival of the post-World War II period, most notably as sung by Judy COLLINS in her 1970 album *Whales and Nightingales.*

Ambler, Eric (1909–), British writer, who wrote several notable thrillers from the late 1930s, including such novels as *Epitaph for a Spy* (1938), *The Mask of Dimitrios* (1939), *Journey into Fear* (1940), *The Schirmer Inheritance* (1953), and *The Levanter* (1972). *Journey into Fear* was adapted into the 1940 film directed by Orson WELLES, who also appeared in the film, which starred Joseph COTTEN, while *The Mask of Dimitrios* became the 1944 Peter LORRE–Sydney GREENSTREET film. Ambler also wrote many screenplays, including those for THE CRUEL SEA (1953), *A Night to Remember* (1958), and *The Wreck of the Mary Deare* (1959).

Ameche, Don (Dominic Felix Amici, 1908–), U.S. actor, who became a star in radio's *The First Nighter Program* (1930–36), then moved to Hollywood to star in such films as *Ramona* (1936), *The Story of Alexander Graham Bell* (1939), *Midnight* (1939), and *Heaven Can Wait* (1943). His career sagged somewhat after the mid-1940s, although he continued to play supporting roles in films and to work in theater and television. In his seventies he emerged in films once again, winning a best supporting actor OSCAR for his role in *Cocoon* (1985), and then playing substantial roles in several more films, including the 1988 sequel, *Cocoon: The Return.*

America, America, the Elia KAZAN film, about the escape of a young Greek boy from Turkey and his turn-of-the-century emigration to the United States. Kazan also wrote the screenplay, basing it at least in part on some family experiences. The cast included Stathis Giallelis, Harry Davis, Frank Wolff, and Elena Karam.

American Gothic (1930), the Grant WOOD painting, portraying a midwestern farm couple; the bitterly realistic work, with its implied

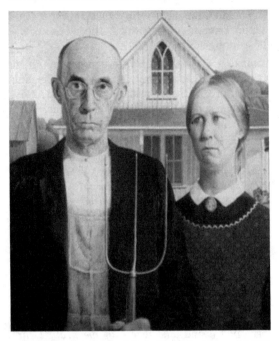

The grim, strained faces of Grant Wood's quintessential Midwestern farm couple in *American Gothic* (1930)

social criticism, became one of the most popular of Depression-era artworks.

American Graffiti (1973), the George LUCAS film, a period re-creation with Richard DREYFUSS, Ron Howard, Paul Le Mat, and Charlie Martin Smith as the four young men on the loose in a small California town on a single night in 1962, just after their high-school graduation; the cast included Candy Clark, Cindy Williams, and MacKenzie Phillips. Lucas, Glira Katz, and Willard Huyck wrote the screenplay. A sequel, *More American Graffiti*, was made in 1979.

American in Paris, An (1951), the Vincente MINNELLI film musical, with Gene KELLY and Leslie CARON in the leads, strongly supported by Oscar Levant, Nina Foch, and Georges Guetary; Alan Jay LERNER wrote the story, screenplay, and lyrics, while Johnny Green and Saul Chaplin wrote the score. The film, Lerner, Green, and Chaplin all won OSCARs, as did Alfred Gilks and John Alton for their cinematography.

Americanization of Emily, The (1964), the Arthur Hiller film, a mildly absurdist antiwar

film starring James GARNER, as the cowardly American lieutenant who almost becomes the first dead man on Omaha Beach, opposite Julie ANDREWS as his entirely sane English rose, with Melvyn DOUGLAS, James COBURN, and Joyce Grenfell in key supporting roles. Paddy CHAYEVSKY wrote the screenplay, basing it on the William Bradford Huie novel.

American Scene Painting, a body of largely naturalistic American work, including graphics, that focused on American regional, folk, and social-protest themes from the early 1930s through the mid-1940s; much of it was greatly influenced by the realities of the Depression-era United States. The movement's forerunners were the realistic artists of the ASHCAN SCHOOL; some, like John SLOAN, president of the Art Students League from 1931, deeply and directly influenced the new movement. Such key artists of the American Scene as Grant WOOD and Thomas Hart BENTON were also called regionalists; Wood's AMERICAN GOTHIC was one of the earliest and most notable signature works of the movement. The SOCIAL REALISTS of the period, such as Ben SHAHN and Philip EVERGOOD, were also American Scene artists.

American Tragedy, An, the 1925 Theodore DREISER novel, based on the Gillette-Brown murder case; it is a powerful recounting of the case and of the society Dreiser blamed for creating it. The novel was adapted into the 1931 Josef von STERNBERG film, with Sylvia SIDNEY in a pivotal role. It also became the 1951 George STEVENS film A PLACE IN THE SUN, with Montgomery CLIFT, Shelley Winters, and Elizabeth TAYLOR in key roles.

America's Sweetheart, Mary PICKFORD, the most popular screen star of the silent era.

Amis, Kingsley (1922–), British writer, a satirist whose early novels, such as *Lucky Jim* (1954) and *I Like It Here* (1958), firmly established him as one of the prototypical "angry young men" of the period. His later work chose a wider set of targets in an overlapping set of establishments, losing none of its edge in the process. His novel *The Old Devils* won a 1986 Booker Prize.

"Amos 'n' Andy" (1929–54), a radio show starring Freeman J. Gosden and Charles J. Correll,

White performers who developed and played stereotypical Black roles in dialect in this long-running series, which also generated the 1951–53 television series, with Black actors Alvin Childress and Spencer Williams, Jr. in the roles. Civil rights groups had long protested the stereotypes presented; as protests grew in the changed atmosphere of the 1950s, both the radio and television versions were canceled.

Anastasia (1956), the Anatole LITVAK film, starring Ingrid BERGMAN in an OSCAR-winning role as the young woman who may or may not be the last survivor of the family of Czar Nicholas II, leading a cast that included Yul BRYNNER, Helen HAYES, Felix Aylmer, Martita Hunt, and Akim Tamiroff. The Arthur Laurents screenplay was based on a Marcelle Maurette play.

Anatomy of a Murder (1959), the Otto PREM-INGER film, based on the Robert Turner novel, a drama starring James STEWART as a lawyer defending a sensational, difficult case, heading a cast that included Lee REMICK, Arthur O'Connell, Ben Gazzara, George C. SCOTT, and Eve Arden. Joseph Welch, the lawyer who had defeated and destroyed Senator Joseph McCarthy at the Army–McCarthy hearings, was the judge.

Andalusian Dog, An (*Un Chien Andalou*, 1928), the short surrealist film by Luis BUÑUEL and Salvador DALI; extraordinarily innovative, it became a landmark in the history of the experimental film and continues to be a staple in film courses all over the world.

Anderson, Judith (Frances Margaret Anderson, 1898–), Australian actress, on stage from 1915, who first starred on Broadway in *Cobra* (1924) and went on to become one of the leading players of her time, in such roles as that of Olivia Manion in the Eugene O'NEILL play MOURN-ING BECOMES ELECTRA (1932), Gertrude to John GIELGUD's *Hamlet* (1936), Lady Macbeth to Laurence OLIVIER's *Macbeth* (1937), and the title role in *Medea* (1947), for which she won a best actress TONY. She was on screen in many character roles from 1933 and is there best known for her Mrs. Danvers in REBECCA (1940), also playing strong supporting roles in such films as CAT ON A HOT TIN ROOF (1958) and *A Man Called Horse* (1970). Late in her

career, at 86, she successfully undertook a major role in the television series "Santa Barbara."

Anderson, Lindsay Gordon (1923–), British theater and film director and critic, long associated with the Royal Court Theatre, and from 1969 the director of several plays by David STO-REY, including *In Celebration* (1969; and the film, 1974), HOME (1970), and *The Changing Room* (1973), also directing a wide range of modern and classic plays on both sides of the Atlantic through the 1980s. In film he is best known for *This Sporting Life* (1963) and *O Lucky Man!* (1973).

Anderson, Marian (1902–), U.S. singer, a celebrated contralto; TOSCANINI called hers "the voice that comes once in a hundred years." She was on stage in concert from 1925, and after 30 years of singing to appreciative worldwide concert audiences became in 1955 the first Black artist to sing at the Metropolitan Opera. In 1939 she was because of her race denied the use of Constitution Hall in Washington, D.C., by the Daughters of the American Revolution. Eleanor Roosevelt then

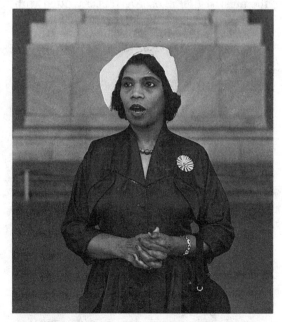

Marian Anderson singing at the Lincoln Memorial in 1952, 13 years after the concert sponsored by Eleanor Roosevelt.

resigned from the DAR and sponsored Anderson's Easter Sunday 1939 concert at the Lincoln Memorial; 75,000 to 100,000 came to hear Anderson sing.

Anderson, Maxwell (1888–1959), U.S. writer, often on social themes, whose work was on stage from 1923 and whose war play WHAT PRICE GLORY? (1924), written with Lawrence Stallings, established him as a major playwright. It was done as a film twice, in 1926 and 1952. Some of Anderson's other well-known works are his first blank-verse play, *Elizabeth the Queen* (1930); *Both Your Houses* (1933), which won a PULITZER PRIZE; WINTERSET (1935), with its echoes of the Sacco–Vanzetti case; the musical *Knickerbocker Holiday* (1938), written with Kurt WEILL, and which starred Walter HUSTON on Broadway; and KEY LARGO (1939), which starred Paul MUNI on Broadway and in 1948 became the classic John HUSTON film, with Humphrey BOGART in the lead. He also wrote the history plays *Joan of Lorraine* (1946), which starred Ingrid BERGMAN on Broadway, and *Anne of the Thousand Days* (1948), which in 1969 starred Richard BURTON and Genevieve BUJOLD on screen; the musical *Lost in the Stars*, also written with Kurt Weill, which was an adaptation of Alan PATON's South African novel *Cry, the Beloved Country*; and *The Bad Seed* (1955), which became the 1956 film.

Anderson, Sherwood (1876–1941), U.S. writer, whose collection of related Midwestern short stories, *Winesburg, Ohio* (1919), established him as one of the leading writers of the period. It was followed by several other short story collections and novels, most notably the novel *Dark Laughter* (1925).

Andersson, Bibi (1935–), Swedish actress, on stage and screen from 1956, who became a major film player in a succession of classic Ingmar BERGMAN films, including SMILES OF A SUMMER NIGHT (1955), THE SEVENTH SEAL (1956), WILD STRAWBERRIES (1957), *Brink of Life* (1958), and THE MAGICIAN (1958), later going to a wide variety of leading and strong supporting roles in American and European films, including SCENES FROM A MARRIAGE (1974).

Andre, Carl (1935–), U.S. sculptor, early in his career strongly influenced by the work of BRANCUSI; in the mid-1960s he moved into the creation of minimalist work, consisting of the assembly of unjoined stacks of such available materials as identical bricks or blocks, later also moving into the creation of works formed in earth, called variously LAND ART, EARTHWORKS, and CONCEPTUAL ART. The 1972 sale of a collection of his bricks to London's Tate Gallery created a considerable controversy.

Andrews, Dana (Carver Dana Andrews, 1909–), U.S. actor, on screen from 1940, who played leads and substantial supporting roles in several major 1940s films, including *The Ox-Bow Incident* (1943), *Laura* (1944), *A Walk in the Sun* (1946), THE BEST YEARS OF OUR LIVES (1946), and *Boomerang* (1947), and later in his career moved into a long series of supporting roles in films and television.

Andrews, Harry Fleetwood (1911–89), British actor, on stage from 1933, mainly in classical roles, who became a leading actor in the Old Vic company after World War II and in Shakespearean roles at Stratford-upon-Avon from 1949. He became best known to an international audience for his very strong film and television character roles, as in MOBY DICK (1956), *55 Days in Peking* (1962), and *Nicholas and Alexandra* (1971), while continuing to work in the theater.

Andrews, Julie (Julia Elizabeth Welles, 1935–), British actress, on stage as a singer from age 12, who became a musical-theater star with her creation of the Eliza DOOLITTLE role in MY FAIR LADY (1960). She won a best actress OSCAR for her first film, MARY POPPINS (1964), and then starred in the worldwide hit THE SOUND OF MUSIC (1965). Other notable films include THE AMERICANIZATION OF EMILY (1964), *Thoroughly Modern Millie* (1967), *Star!* (1968), VICTOR/VICTORIA (1982), and *Duet for One* (1986).

Andrews Sisters (Laverne, 1915–67; Maxine, 1918– , and Patti, 1920–), U.S. recording, radio, and film singing group of the 1930s and 1940s, which was extremely popular on radio from the late 1930s and in a succession of such films as *Buck Privates* (1941) and

Hollywood Canteen (1944) before and during World War II. They were best known for their rendition of BEI MIR BIST DU SCHOEN, one of the greatest hits of the late 1930s.

Andreyev, Leonid Nikolayevich (1871–1919), Russian writer, a protégé of Maxim GORKY; his bitterly realistic work focused on the splintering of Czarist society. He emerged as a major literary figure with his first collection of short stories, which was followed by such short works as *In the Fog* (1902), the novel *The Red Laugh* (1904), and his very popular play *King Hunger* (1907). He also wrote several other plays, the most notable of them *He Who Gets Slapped* (1914). Andreyev was a revolutionary who became a member of the Kerensky government and then fled to Finland after the Bolshevik Revolution.

Andric, Ivo (1892–1975), Yugoslav writer, best known by far for his Bosnian trilogy, three novels written during World War II and all published in 1945: *The Bridge on the Drina*, *Bosnian Chronicle*, and *The Woman from Sarajevo*. Andric emerged as a substantial national poet with his first collection of poetry, *Ex Ponto* (1918), published several collections of short stories during the interwar period, and continued to write short fictive works after his novels had moved him onto the world stage. He was awarded the NOBEL PRIZE for literature in 1961.

Andrzejewski, Jerzy (1909–83), Polish writer, whose ASHES AND DIAMONDS (1948), about the Polish resistance movement during the latter stages of World War II, brought him into the front rank of postwar Eastern European novelists. It was adapted into the classic 1958 Andrzej WAJDA film. Andrzejewski later joined the Communist Party and served in Parliament but in the mid-1950s became a leading dissenter, writing such works as *The Inquisitors* (1960), in which he used the Spanish Inquisition much as Arthur MILLER used the Salem witch trials in THE CRUCIBLE. Later still, Andrzejewski became one of the founders of Solidarity.

Angelou, Maya (1928–), U.S. writer, whose several autobiographical works powerfully illuminate the experience of developing as a Black woman and an artist from the l930s; these included her first and best-known work, *I Know Why the Caged Bird Sings* (1970); *Gather Together in My Name* (1974); *Singin' and Swingin' and Gettin' Merry Like Christmas* (1976); *The Heart of a Woman* (1981); and *All God's Children Need Traveling Shoes* (1987). Her published works also include several poetry collections.

Angel Street (1939), the earliest film version of GASLIGHT, made by Thorold Dickinson, with Anton Walbrook and Diana Wynyard in the leads; it was retitled *Angel Street* for American release.

"Animal Crackers in My Soup" (1935), the Shirley TEMPLE song; she sang it to what became a worldwide audience in the film *Curly Top*. Music by Ray Henderson; words were by Irving Caesar and Ted Koehler.

Animal Farm (1945), the satirical George ORWELL novel, which attacked Stalinism as a betrayal of the Russian Revolution, within the setting of a revolt of farm animals in which the worst pigs triumph, their ultimate slogan becoming ALL ANIMALS ARE EQUAL, BUT SOME ANIMALS ARE MORE EQUAL THAN OTHERS. An animated film version of the novel was made in 1955 by John Halas and Joy Batchelor.

Anna and the King of Siam (1946), the John CROMWELL film, a costume drama about the adventures of English governess Anna Owens in the court of the king of Siam in the 1860s. Irene DUNNE was Anna, opposite Rex HARRISON as the king, leading a cast that included Gale Sondergaard, Linda Darnell, Lee J. COBB, Mickey Roth, and Tito Renaldo. Arthur Miller won a cinematography OSCAR; Art Wheeler and William Darling won Oscars for art and Thomas Little and Frank E. Hughes for interiors. The film, adapted by Talbot Jennings and Sally Benson from the Margaret Landon biography, was the basis for the Richard RODGERS–Oscar HAMMERSTEIN II musical THE KING AND I.

Anna Christie (1921), the Eugene O'NEILL play, the story of a former prostitute, set in a waterfront milieu; Pauline Lord created the title role. It was adapted for film in 1923, with

Blanche Sweet as Anna, and most notably in 1930, as Greta GARBO's first talking movie. In 1957 it became the musical *New Girl in Town*, with Gwen Verdon as Anna. The play was originally written as CHRIS CHRISTOPHERSON (1920), the name of the male lead, with Lynn FONTANNE as Anna, but that version never reached Broadway.

Annie (1977), the long-running Broadway musical; the Thomas Meehan book was based on the Harold GRAY comic strip LITTLE ORPHAN ANNIE, with lyrics by Martin Charnin and music by Charles Strouse. Andrea McArdle created the title role on stage, in a cast that included Dorothy Loudon and Reid Shelton. In the 1982 John HUSTON film version Annie was played by Aileen Quinn, in a cast that included Albert FINNEY, Carol BURNETT, Bernadette Peters, Edward Herrman, and Geoffrey Holder.

Annie Get Your Gun (1946), the long-running musical, starring Ethel MERMAN as Annie Oakley on Broadway, while Mary MARTIN played the role on tour; Irving BERLIN wrote the words and music to such songs as THERE'S NO BUSINESS LIKE SHOW BUSINESS, "Doin' What Comes Naturally," and "Anything You Can Do I Can Do Better," and Herbert and Dorothy Fields wrote the book. Sidney Sheldon adapted the play into the 1950 George Sidney film, with Betty Hutton as Annie Oakley, in a cast that included Howard Keel, Edward ARNOLD, and Louis Calhern.

Annie Hall (1977), the very popular Woody ALLEN romantic comedy, in which he and Diane KEATON starred, and which completed the process of developing Allen into a mainstream world film figure. The film won an OSCAR for best picture. Allen won best director and best screenwriter Oscars and a best actor nomination; Keaton was best actress.

Anouilh, Jean (1910–), French writer, who took as his main theme the question of personal integrity in a society inimical to its maintenance. His first play was *The Ermine* (1931); some of his most notable plays are *Antigone* (1942), *Ring Around the Moon* (1948), *Waltz of the Toreadors* (1952), which became the 1962 John Guillermin film, *Médée* (1953), *The Lark*

(1953), and the TONY-winning BECKET (1959), which became the memorable 1964 Peter Glenville film, with Richard BURTON as Becket and Peter O'TOOLE as Henry II.

Antonioni, Michelangelo (1912–), Italian film director and writer, who worked as a screenwriter with Roberto ROSSELLINI and Federico FELLINI before becoming an international figure with the success of his first major film, *L'Avventura* (1950). It was followed by such films as *La Notte* (1960), *The Red Desert* (1964), *Blow-up* (1967), and *The Passenger* (1974), all of them attracting great attention for their cinematic style, purposeful ambiguity, and their fully conveyed sense of hopelessness carried to *anomie*.

Antony and Cleopatra, the 1966 opera by Samuel BARBER, libretto and original production by Franco ZEFFERELLI, based on the Shakespeare play; the work opened the new Metropolitan Opera House at New York's Lincoln Center. Gian Carlo MENOTTI rewrote the libretto for the 1975 restaging of the opera at the Juilliard School.

"Anything Goes" (1934), title song of the Broadway musical of the same name, sung by Ethel MERMAN in the Reno Sweeney role, which she re-created in the 1936 film; words and music by Cole PORTER.

Aparajito (1956), the Satyajit RAY film, also called *The Unvanquished*, the second in the APU TRILOGY, with a cast that included Pinaki Sen Gupta, Karuna Bannerjee, Kanu Bannerjee, and Smaran Ghosal. Ray wrote and directed the film, based on the Bibhuti Bhusan Bandapaddhay Banerji novel; the music was by Ravi SHANKAR.

Apartment, The (1960), the Billy WILDER film; Jack LEMMON starred as the young corporation man who advances himself by loaning his apartment to his bosses as a place of assignation, leading a cast that included Shirley MACLAINE, Fred MACMURRAY, Edie Adams, Ray Walston, and Jack Kruschen. The film and Wilder won Oscars, as did I.A.L. Diamond and Wilder for the screenplay, Daniel Mandell for editing, Alexander Trauner for art, and Edward G. Boyle for set decoration. The film was the basis for the long-running

1968 Neil SIMON Broadway musical *Promises, Promises*.

Apocalypse Now (1979), the Francis Ford COPPOLA Vietnam War epic, a heavily presented antiwar film focusing as much on the inimical cultural and natural environment as on the war; John Milius and Coppola wrote the screenplay, based very loosely on Joseph CONRAD's novel *Heart of Darkness*. The very large cast included Marlon BRANDO, Martin Sheen, and Robert DUVALL. Vittorio Storaro won a cinematography OSCAR.

Apollinaire, Guillaume (Wilhelm Albert Kostrowitzky, 1880–1918), French writer and critic, a leader of the artistic avante garde of his time, who is said to have originated the term SURREALISM. His influential first collection of poems, *Alcohols* (1913), was followed by the collection *Calligrammes* (1918).

Apollo (1928), the ballet by Igor STRAVINSKY, on classical themes; although first produced in April 1928 in the United States, its landmark production was the BALLET RUSSES version, choreographed by George BALANCHINE and presented in Paris in June 1928, with Serge LIFAR in the title role.

Appalachian Spring (1944), the Aaron COPLAND ballet, on American folk themes; it was originally choreographed by Martha GRAHAM, with sets by Isamu NOGUCHI, and produced at the Library of Congress.

Appleby, John, the fictional Scotland Yard inspector created by J.I.M. STEWART, writing as Michael INNES.

Après-midi d'un faune, L', original French name for THE AFTERNOON OF THE FAUN.

"April Showers" (1921), a song introduced by Al JOLSON in the Broadway musical *Bombo* (1921), with music by Louis Silvers and words by Buddy DeSylva.

Apu trilogy (1955–59), three films by Indian director Satyajit RAY, about the life of a poor Bengali family. The first, PATHER PANCHALI (1955), introduced modern Indian film to a very appreciative world audience; it was followed by APARAJITO (1956) and THE WORLD OF APU (1959).

Aragon, Louis (1897–1982), French writer, in the 1920s a leading surrealist; he became a

Communist in 1931 and thereafter was a major literary figure on the Communist left. He was a prolific writer whose best-known works include the four-novel sequence *The Real World* (1943–44), the five-volume *The Communists* (1949–51), and *Holy Week* (1958). Several of his many volumes of poetry are centered on his wife, Elsa Triolet. Aragon was a Resistance leader during World War II.

Arbuckle, Fatty (Roscoe Conkling Arbuckle, 1887–1933), U.S. film actor, writer, and director, in variety before entering films in 1908. He became one of Mack SENNETT's KEYSTONE KOPS in 1913, a star in film comedy, and a major film-industry figure, starting his own company in 1917. In 1921, actress Virginia Rappe died at a San Francisco party hosted by Arbuckle; he was charged with manslaughter as the result of an alleged rape, and although ultimately acquitted after three trials, was ruined and forced out of the film industry by the attendant scandal. Afterward, he directed over a score of films, using the pseudonym William Goodrich.

Arbus, Diane (1923–71), U.S. photographer, for the major part of her career a fashion photographer; from the late 1950s she took an entirely different turning, perceiving and photographing American grotesques and far outsiders as within the "normal" range and thereby moving to redefine normality.

Archipenko, Alexander (1887–1964), Russian sculptor, who worked in France and Germany from 1908 to 1923, then emigrated to the United States and became an American citizen in 1928. From early in the second decade of the century his work was associated with CUBISM. He was a leading innovator in the development of internal space within sculpture, boring holes in what earlier would have been solid figures, as in his notable *Walking* (1912), and also soon joined in the introduction of new materials and polychromal work into modern sculpture, often in the form of collages that included such materials as wood, bronze, and glass, as in his *The Bathers* (1915).

Arch of Triumph (1946), the Erich Maria REMARQUE novel, about anti-Nazi refugees in Paris in the late 1930s; the book became the

basis of the 1948 Lewis MILESTONE film, with Charles BOYER and Ingrid BERGMAN leading a cast that included Charles LAUGHTON and Louis Calhern.

Argentina, La (Antonia Mercé, 1890–1936), Spanish dancer, classically trained by her balletmaster father and on stage from the age six, who became one of the most celebrated Spanish dancers of the century, developing her work largely from Spanish folk-dance themes and touring the world from the end of World War I through the mid-1930s.

Arlen, Harold (Hyman Arluck, 1905–86), U.S. songwriter and composer, who is best known for having written the music to such songs as OVER THE RAINBOW, for which he won an ACADEMY AWARD; BLUES IN THE NIGHT; STORMY WEATHER; THAT OLD BLACK MAGIC, and dozens of other well-known popular songs. He wrote the music for several Broadway musicals, including *Earl Carroll's Vanities* (1930), *St. Louis Woman* (1946), and *Bloomer Girl* (1948), and for over a score of films, including THE WIZARD OF OZ (1939), *Blues in the Night* (1941), and *The Sky's the Limit* (1943).

Arliss, George (George Augustus Andrews, 1868–1946), British actor, also on the American stage from 1901, whose work included creation of the title roles in *The Devil* (1908; on film, 1921) and *Disraeli* (1911; on film, 1921, 1929), as well as the rajah role in *The Green Goddess* (1921; on film, 1923). He won an ACADEMY AWARD as best actor for the 1929 sound-film version of *Disraeli* and is also remembered for his *The House of Rothschild* (1934).

Armendariz, Pedro (1912–63), Mexican actor, on screen in Mexico from 1935 and the star of many Mexican films, including MARIA CANDELARIA (1943) and *The Pearl* (1945), though in Hollywood largely limited to strong supporting roles in such films as *Three Godfathers* (1949), *The Wonderful Country* (1959), and *From Russia with Love* (1963). He committed suicide after learning that he had terminal cancer, probably contracted or enhanced by his three-month-long radiation exposure near the Nevada Test Site in 1954 while filming THE CONQUEROR.

Armory Show, The International Exhibition of Modern Art, held at New York's 69th Regiment Armory from February 17 to March 15, 1913; the show subsequently traveled to Chicago and Boston. In this first major American 20th-century international art exhibition, 400 of the 1,600 works shown were modern European works, a large number of them shocking to contemporary American tastes and extraordinarily illuminating to many American artists, museums, and collectors of the time. An estimated 300,000 came to see the paintings; for the overwhelming majority, Marcel DUCHAMP's cubist NUDE DESCENDING A STAIRCASE was a monstrous perversion of art; for some who would later be tastemakers, it was a new classic work and American art had taken a whole new turn. The latter view ultimately prevailed, but hardly because of the Armory Show. Until the end of World War II—two world wars and an interwar period away—American art was dominated by the realists, who had moved toward ascendancy with the 1908 exhibition of THE EIGHT.

Armstrong, Lil (Lillian Hardin, 1898–1971), classically trained U.S. JAZZ pianist, singer, and bandleader, from the early 1920s a notable figure in American jazz. She was a pianist with King OLIVER's band from 1920 to 1924 and then led her own band in Chicago, recording with her husband, Louis ARMSTRONG, Kid ORY, Johnny DODDS, and Johnny St. Cyr in THE HOT FIVE and The Hot Seven. Chicago-based, she led bands throughout the 1920s and 1930s, later became largely a piano soloist in cabarets, and worked throughout North America and Europe. She and Armstrong parted in 1931, although she continued to work as Lil Armstrong.

Armstrong, Louis ("Satchmo," 1901–71), U.S. musician, a trumpeter, cornetist, singer, and bandleader, who was one of the leading JAZZ and popular music figures of the century. He was a cornetist and trumpeter in New Orleans from 1913 and emerged as a major figure after joining King OLIVER's Chicago band in 1922, making his first records from 1923 with Oliver. His recordings with Oliver, Sidney

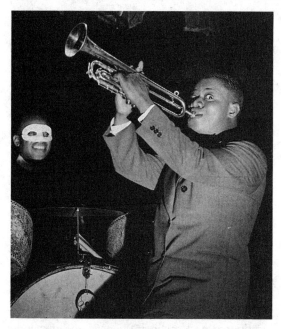

The inimitable Louis Armstrong doing the skeleton number from the film *Pennies from Heaven* (1936).

BECHET, and such groups as The Red Onion Jazz Babies are classics of New Orleans jazz, many of them with such central figures as Bessie SMITH and Ma RAINEY. In 1924 he married Oliver's pianist, Lillian Hardin (see Lil ARMSTRONG). He left Oliver for Fletcher HENDERSON in 1924, then played with his wife's band from 1925, still in Chicago. In this period he, Lillian, Kid ORY, Johnny DODDS, and Johnny St. Cyr recorded as THE HOT FIVE, making a long series of what were to become classic jazz records, in which Armstrong emerged as the first leading jazz soloist, beginning a new phase in jazz history. He developed his own group in the mid-1920s, went to New York in the late 1920s, played at London's Palladium in the first of many concert appearances abroad in 1932, and began his long film career with *Pennies from Heaven* (1936). He later appeared in such films as *The Birth of the Blues* (1941), CABIN IN THE SKY (1943), *Satchmo the Great* (1957), *Paris Blues* (1961), and HELLO, DOLLY! (1969). Armstrong's main, extraordinarily innovative, and influential work was early, in the 1920s, and in

such works as "Big Butter and Egg Man," "Wild Man Blues," and WEST END BLUES; yet for the next four decades he was a worldwide figure in popular music. From the mid-1930s he was a very popular singer, of such songs as his signature song, WHEN IT'S SLEEPY TIME DOWN SOUTH; STARDUST, "Blueberry Hill," "Mack the Knife," and "Hello, Dolly!," and in his very notable series of recordings with Ella FITZGERALD.

Arness, James (James Aurness, 1923–), U.S. actor, who played in several films before settling down to create the U.S. marshal Matt Dillon role in the long-running television series GUNSMOKE (1955–75). He is the brother of actor Peter GRAVES.

Arno, Peter (Curtis Arnoux Peters, 1904–68), U.S. cartoonist, whose generally satirical work, focusing on targets drawn from New York café society, was published in *The New Yorker* from 1925 and by several other magazines as well; he also published several collections of his work.

Arnold, Eddy (1918–), U.S. singer and composer, in radio from 1936, who emerged as a major country-music singer and recording artist in the post-World War II period, soon becoming a leading popular-music figure as well. He appeared on GRAND OLE OPRY from the early 1940s and on television in *The Eddy Arnold Show* (1952–56).

Arnold, Edward (Gunther Edward Arnold Schneider, 1890–1956), U.S. actor, on stage from 1907 and on screen in silent films from 1915. He was in the New York theater during the 1920s, most notably creating the Andrew Mayo role in Eugene O'NEILL's BEYOND THE HORIZON (1920), and in 1932 moved back to Hollywood. He starred in such films as *Diamond Jim* (1935), *Meet Nero Wolfe* (1936), and *Come and Get It* (1936), played major character roles in such classics as YOU CAN'T TAKE IT WITH YOU (1938) and MR. SMITH GOES TO WASHINGTON (1939), and was one of the most powerful and durable character actors of the 1930s and 1940s.

Around the World in 80 Days (1956), the OSCAR-winning Mike Todd film directed by Michael Anderson; writers James Poe, John

Farrow, and S.J. PERELMAN won Oscars for their adaptation of the classic Jules Verne novel, as did cinematographer Lionel Linden and Victor Young for his music. The huge cast was led by David NIVEN and included Cantinflas, Robert Newton, Charles BOYER, and Shirley MACLAINE, as well as many other leading players in cameos, including Noël COWARD, Ronald COLMAN, John GIELGUD, Marlene DIETRICH, Trevor HOWARD, and Buster KEATON.

Arp, Jean (Hans Arp, 1877–1966), German painter and sculptor, whose main work was done in France and Switzerland; from about 1912 he was associated with many of the art movements of the time, including EXPRESSIONISM, CONSTRUCTIVISM, DADA, AND SURREALISM, creating and exhibiting abstract paintings in Switzerland during World War I and torn-paper picture-collages and relief sculptures during the interwar period, while beginning to produce full-scale three-dimensional sculpture in the early 1930s. He also wrote several volumes of poetry and essays.

Arrabal, Fernando (1932–), Spanish writer, in France from 1955; he is a highly experimental, often SURREAL playwright whose works are often described as ABSURDIST, although they seek to communicate, through several shock-producing devices. A few of his best-known plays are *Picnic on the Battlefield* (1952), *Guernica* (1959), *The Architect and the Emperor of Assyria* (1967), and *And They Put Handcuffs on the Flowers* (1969).

Arrau, Claudio (1903–), Chilean pianist, a child prodigy who made his debut in Chile at age five and in Europe at 11; he studied in Germany from 1912 and lived and taught there until 1940, though touring throughout the world during the interwar period. Arrau preferred and was a notable interpreter of several of the romantics, but was most recognized for his performance of Beethoven. He was based in the United States after 1941, while continuing to tour widely.

Arrowsmith (1925), the Sinclair LEWIS novel, about a young doctor-scientist torn between his desire to serve humanity and the attractions of the moneyed life; Lewis was awarded a PUL-

ITZER PRIZE for the work, which he refused. The book was adapted by Sidney HOWARD into the 1931 John FORD film, with Ronald COLMAN as Arrowsmith, leading a cast that included Helen HAYES, Myrna LOY, and Richard Bennett.

Arsenic and Old Lace (1941), the long-running Joseph Kesselring comedy. On Broadway it starred Josephine Hull and Jean Adair as the homicidally inclined sisters who bury callers in their basement, with a cast that included Boris KARLOFF, John Alexander, and Allyn Joslyn. Hull, Adair, and Alexander re-created their roles in the 1944 Frank CAPRA film; Cary GRANT led a cast that also included Raymond MASSEY, Priscilla Lane, Peter LORRE, Jack Carson, and Edward Everett Horton.

Artaud, Antonin (1896–1948), French writer, actor, and producer, who developed the concept of the "theater of cruelty," which prefigured and much influenced the development of the THEATER OF THE ABSURD and of such playwrights as Jean GENET, Samuel BECKETT, and Eugène IONESCO.

Art Deco, a major style in the European and American decorative arts, introduced at the Paris Exposition of 1925 (Exposition Internationale des Arts Décoratifs et Industriels Modernes); it became the main decorative arts movement of the 1930s. The Art Deco style, a commercial version of which was called Art Moderne, attempted to adapt modern industrial forms and materials, capable of being mass-produced, to the decorative arts, and so stressed such forms as streamlining, symmetrical shapes, and rectangles, and added to the decorative arts such man-made materials as plastics and reinforced concrete. Its perceived sources of inspiration were rather eclectic, from CUBIST and BAUHAUS to Native American forms to some BALLET RUSSES set designs, while the objects themselves ran heavily toward human and animal figures, plant forms, and natural phenomena. From the late 1920s, the American form of Art Deco increasingly stressed the decorative impact of entire interior spaces, while continuing to create individual Art Deco objects.

Arthur, Jean (Gladys Georgianna Greene, 1905–), U.S. actress, on screen in silent films from 1923, who became a star in the mid-1930s, beginning with her role opposite Edward G. ROBINSON in *The Whole Town's Talking*. She went on to play leading roles in several of the films of Hollywood's Golden Age, many of them light, socially conscious comedies, including MR. DEEDS GOES TO TOWN (1936), YOU CAN'T TAKE IT WITH YOU (1938), MR. SMITH GOES TO WASHINGTON (1939), and *The Talk of the Town* (1942). She also starred in two classic Westerns, *The Plainsman* (1937) and SHANE (1953). On stage she starred on Broadway in PETER PAN (1950), and she did a short-lived sitcom on television, "The Jean Arthur Show" (1956).

art nouveau, a late-19th-century style and movement in European and American decorative arts and architecture, that lasted through the first decade of the 20th century; it used a long, sinuous, rhythmic, often branching or undulating line as the center of the work or object. The movement began in Britain, as in the work of Aubrey Beardsley and the architect Charles Rennie Mackintosh; some other very notable art-nouveau stylists were Antonio GAUDÍ, who extended the style and made it into a total, quite personal architectural approach; Louis Comfort TIFFANY, who applied the style to his glass objects before the turn of the century and to several other kinds of artifacts thereafter; French designer René Lalique; and architect Louis SULLIVAN, whose art-nouveau decorative approach was an integral part of much of his work.

Asch, Sholem (1887–1957), Jewish-American writer, born in Poland, whose main work was in Yiddish and who was one of the major Jewish cultural figures of the 20th century. His early play *The God of Vengeance* was first produced in German by Max REINHARDT in 1907, considerably enhancing international acceptance and further development of contemporary Yiddish drama. He wrote several other plays as well, most notably *Mottke the Vagabond* (1917) and *Mottke the Thief* (1935). Some of his best-known novels are the trilogy *Three Cities* (1933); *East River* (1946); his trilogy on biblical themes, *The Nazarene* (1939),

The Apostle (1943), and *Mary* (1949); and *The Prophet* (1955).

Ashbery, John Lawrence (1927–), U.S. writer, whose highly allusive, intensely personal poetic work became very highly regarded in the 1970s; his collection *Self-Portrait in a Convex Mirror* (1970) won a PULITZER PRIZE and several other awards and was followed by such collections as *Houseboat Days* (1977) and *Shadow Train* (1981). He has also published several plays and one novel.

Ashby, Hal (1936–88), U.S. director and film editor; he won an editing OSCAR for IN THE HEAT OF THE NIGHT (1967) and also edited such films as *The Cincinnati Kid* (1975) and *The Russians Are Coming! The Russians Are Coming!* (1976). He directed such films as *Shampoo* (1975), BOUND FOR GLORY (1976), COMING HOME (1978), and BEING THERE (1979).

Ashcan School, a term that started as a derogatory description of the work of the eight American artists who exhibited together in New York in 1908, since known as THE EIGHT, who were the progenitors of 20th-century American realism. Ultimately these artists led in the development of the national movement in American art during the first 45 years of the century.

Ashcroft, Peggy (Edith Margaret Emily Ashcroft, 1907–), British actress, on stage from 1926 and for six decades a leading player in the English-speaking theater, establishing herself through such roles as that of Naomi in *Jew Süss* (1929), Desdemona to Paul ROBESON's *Othello* (1930), and Juliet to both John GIELGUD and Laurence OLIVIER, who alternated as Mercutio and Romeo in Gielgud's 1935 production of *Romeo and Juliet*. Her first New York appearance was in *High Tor* (1937). She played in many of the great classical and modern roles, including a notable lead in *Hedda Gabler* (1954). Ashcroft appeared in a few films early in her career, including THE 39 STEPS (1935) and *Rhodes of Africa* (1936), later appearing in such films as SUNDAY, BLOODY SUNDAY (1971), in an OSCAR-winning role in A PASSAGE TO INDIA (1984), in *She's Been*

Away (1990), and on television in a major role in THE JEWEL IN THE CROWN (1984).

Ashes and Diamonds (1948), the Jerzy ANDRZEJEWSKI novel, about the Polish resistance movement during the latter stages of World War II, which established him as a major postwar novelist. It was adapted into the classic 1958 Andrzej WAJDA film, with Zbigniew Cybulski in the lead.

Ashkenazy, Vladimir (1937–), Soviet pianist, who made his debut in 1945; he is a notable interpreter of such Russians as RACHMANINOFF, PROKOFIEV, and SCRIABIN and of the full classical repertory as well. He left the Soviet Union in 1963 and was based in Britain until moving to Iceland in 1968, while throughout his career continuing to tour throughout the world.

Ashton, Frederick William (1904–88), British dancer, choreographer, and ballet director, a major figure in British and world ballet from the mid-1930s. His first work was *A Tragedy of Fashion* (1926); during the course of the next five decades such works as FAÇADE (1931), *Apparitions* (1936), *Le Baiser de la Fée* (1935), *Dante Sonata* (1940), DAPHNIS AND CHLOÉ (1951), and *Ondine* (1958) strongly influenced the development of British ballet and simultaneously the career of prima ballerina Margot FONTEYN. Ashton became the chief choreographer of the Vic-Wells Ballet in 1935; the company later became the Sadler-Wells and then the ROYAL BALLET. He was associate director from 1952 to 1963, and director from 1963 to 1970.

Asimov, Isaac (1920–), U.S. writer, whose *Foundation* trilogy (1951–53) established him as a leading science-fiction author and whose later work was prolific and diverse; he has written hundreds of books in a wide range of fiction and nonfiction forms and subject areas, though most of his work has been in science fiction and popular science.

Asner, Edward (1929–), U.S. actor, in films and television in supporting roles from 1965; he is best known for his long-running LOU GRANT role in television's THE MARY TYLER MOORE SHOW (1970–77), a role he transferred to his own dramatic series, The LOU GRANT SHOW (1977–82), through which he took up many of the major social issues of the time.

Asphalt Jungle, The (1950), the John HUSTON film, a prototypical robbery film from planning through execution, made notable by its direction and the performances of Sterling HAYDEN, Sam JAFFE, James Whitmore, Marc Lawrence, and Marilyn MONROE (in an early small role). It has since been remade several times.

Asquith, Anthony (1902–68), British director, whose work was on screen from 1928. By far his most notable film was the classic PYGMALION (1938), codirected with Leslie HOWARD; he also directed such films as *The Winslow Boy* (1948), THE BROWNING VERSION (1951), *The Importance of Being Earnest* (1952), and *The Millionairess* (1960).

Assault, The (1986), the Fons Rademakers film, a best foreign film OSCAR-winner set in Holland during and after World War II, with a cast that included Derek de Lint, Monique van de Van, Elly Weller, and Marc van Uchelen. The Harry Mulisch novel was adapted for film by Gerard Soeteman.

Astaire, Fred (Frederick Austerlitz, 1899–1987), U.S. dancer and actor, on stage in vaudeville from the age of seven with his sister Adele; they danced together for 25 years, until 1931, becoming Broadway stars in the early 1920s in such shows as *Lady, Be Good* (1924), *Funny Face* (1927), and *The Bandwagon* (1931). Adele Astaire retired in 1931; Fred Astaire moved into films, in 1933 beginning the movie career that established him as the foremost dancer in film history and whose work greatly influenced the development of the film musical. His films, many of them made during Hollywood's Golden Age, include the 10 classic film musicals made with Ginger ROGERS—*Flying Down to Rio* (1933), *The Gay Divorcée* (1934), ROBERTA (1935), TOP HAT (1935), *Follow the Fleet* (1937), *Swing Time* (1937), *Shall We Dance* (1937), *Carefree* (1938), *The Story of Vernon and Irene Castle* (1939), and *The Barkleys of Broadway* (1949)—as well as the classic EASTER PARADE (1948) and the drama ON THE BEACH (1959), in

which he did not dance but instead displayed his very considerable acting talents.

"As Time Goes By" (1931), the signature song played by Dooley Wilson as Sam ("Play it, Sam") in CASABLANCA (1942); words and music were by Herman Hupfield.

Astor, Mary (Lucille Vasconcellos Langhanke, 1906–87), U.S. actress, on screen from 1921 and a silent-film star after her appearance with John BARRYMORE in *Beau Brummel* (1924). She is best known for her memorable roles as Edith Cortwright opposite Walter HUSTON in DODSWORTH (1936) and as Brigid O'Shaughnessy opposite Humphrey BOGART in THE MALTESE FALCON (1941). She won a best supporting actress OSCAR for *The Great Lie* (1941).

Asturias, Miguel Angel (1899–1974), Guatemalan writer, whose novels, poems, and short stories reflect his affinity for Mayan culture and Guatemalan history, coupled with his commitment to Central American democracy. He was a Guatemalan legislator and diplomat before being forced into exile after the CIA-sponsored coup that toppled the Arbenz government in 1954. His best-known works are the satirical fantasy *Mr. President* (1946); the short-story collection *Weekend in Guatemala* (1956), focusing on the 1954 right-wing coup; and the trilogy consisting of *Strong Wind* (1950), *The Green Pope* (1954), and *The Eyes of the Interred* (1960), strongly attacking the behavior of U.S. business interests in his country. He was awarded the 1967 NOBEL PRIZE for literature.

Atget, Eugène (Jean Eugène August Atget, 1856–1927), French photographer, one of the leading documentarians of the 20th century; he began as an actor, turned to photography in 1898, and from then until the mid-1920s documented Paris and its life, in thousands of telling photos that were to inform the work of generations of further photographers. Man RAY and Berenice ABBOTT discovered his work in the mid-1920s; Abbott helped support Atget in his final, impoverished years, preserved much of his work, and brought it forward, building worldwide recognition for the work that flowered in the 1950s.

Atkinson, Brooks (1894–1984), U.S. journalist, who was chief drama critic for the *New York Times* (1925–60), from that position considerably influencing the development of the American theater, and in thoroughly benign fashion.

Atlantic City (1980), the Louis MALLE film, written by John GUARE, about an aging small-time Atlantic City gangster and some young hustlers who take him in over his head; Burt LANCASTER played the central role, in a cast that included Susan Sarandon, Robert Joy, Kate Reid, and Robert Piccoli.

Attenborough, Richard (1923–), British actor, producer, and director, on stage from 1941 and on screen as an actor from 1942, in such films as IN WHICH WE SERVE (1942), *Brighton Rock* (1947), *The Magic Box* (1951), *Private's Progress* (1955), *The Great Escape* (1963), and *Séance on a Wet Afternoon* (1964). He directed such films as OH! WHAT A LOVELY WAR (1969), *Young Winston* (1972), *Conduct Unbecoming* (1975), *And Then There Were None* (1975), *A Bridge Too Far* (1977), A CHORUS LINE (1985), and CRY FREEDOM (1987). The massive epic GANDHI (1982), which he directed and produced, won eight Oscars in all, including best picture and best director.

Atwood, Margaret (1939–), Canadian writer and editor, who became a leading figure in Canadian literature from the 1960s with the appearance of her collection *The Circle Game* (1966) and her novel *The Edible Woman* (1969). Her later work includes several further volumes of poetry, two short-story collections, and such novels as *Murder in the Dark* (1983), *The Handmaid's Tale* (1986), and *Cat's Eye* (1989).

Auchincloss, Louis Stanton (1917–), U.S. writer and lawyer, whose chosen settings lay in the upper reaches of New York society and in the institutions serving that elite; his best-known novels include *Venus in Sparta* (1958), *Portrait in Brownstone* (1962), *The Rector of Justin* (1964), *The Dark Lady* (1977), *Watchfires* (1982), *The Book Class* (1984), and *Diary of a Yuppie* (1986). He also wrote several

volumes of short stories and several biographical works.

Auden, W.H. (Wystan Hugh Auden, 1907–73), British-American writer, one of the leading poets of the 20th century. He was an extraordinarily influential poet and dramatist on the left during the 1930s, from the appearance of such early works as *Poems* (1930) and *The Orators* (1932), and in association with such close friends as Christopher ISHERWOOD and Stephen SPENDER. His drama *The Dance of Death* (1933) was followed by several collaborations with Isherwood, including the plays *The Dog Beneath the Skin* (1936) and *The Ascent of F-6* (1936) and the prose-and-poetry *Journey to a War* (1939), written after he and Isherwood had traveled to China in 1938. Auden was a stretcher-bearer in the Republican Army during the Spanish Civil War, an experience reflected in his poetry of the period. He emigrated to the United States in 1939, to some extent summing up his sad view of the 1930s, looking back from New York in his celebrated poem "September 1, 1939." During the 1940s he rejected his earlier Marxism and embraced Christianity; such later works as *The Age of Anxiety* (1948) and *Homage to Clio* (1960) to a considerable extent reflecting his changed views.

Aumont, Jean-Pierre (Jean-Pierre Salomons, 1909–), French actor, on stage from 1930 and on screen from 1931; he became a film star in France in such 1930s films as *Maria Chapdeleine* (1934) and *Hotel du Nord* (1938), went abroad to fight with the Free French during World War II, and emerged as an international star in such films as *The Cross of Lorraine* (1942) and *Assignment in Brittany* (1943). His later films included LILI (1953) and DAY FOR NIGHT (1973).

Auntie Mame (1956), the play by Jerome Lawrence and Robert E. Lee, based on the Patrick Dennis novel; in the original stage play, the eccentric, sophisticated central character of Mame was created by Rosalind RUSSELL, who re-created the role in the 1958 Morton DaCosta film, leading a cast that included Forrest Tucker and Coral Browne. Angela LANSBURY was Mame in the long-running 1966 musical version, with songs by Jerry Herman

and book by Lawrence and Lee. The 1974 film musical *Mame* was directed by Gene Saks, with Lucille BALL in the title role.

auteur theory, the theory that the director of a film is its prime creator, or author (*auteur* in French), put forward formally first by François TRUFFAUT in 1954, in CAHIERS DU CINÉMA, and then taken up as a major theoretical construct and debated for decades by many film theorists, although Truffaut himself later tired of the argument.

"Autobiography of Miss Jane Pittman, The," a fictional television biography of Jane Pittman, a southern Black woman who began her life as a slave and lived a full century, seeing enormous and continuing civil-rights changes in her lifetime. Cicely TYSON played the title role in a cast that included ODETTA, Josephine Premice, Richard Dysart, and Ted Airhart. Tracy Keenan Wynn adapted the Ernest J. Gaines novel; John Korty directed.

Autry, Gene (Orvon Autry, 1907–), U.S. singer, composer, and actor, on radio as a country music singer from 1928; he became a leading singing cowboy star from his first appearance in *In Old Sante Fe* (1934) through scores of films and the long-running early television series "The Gene Autry Show" (1950–56).

"Avalon" (1920), the Al JOLSON song, which he introduced in the Broadway musical *Sinbad* (1920), with words and music by Jolson and Vincent Rose.

Avedon, Richard (1923–), U.S. photographer, a leading portraitist and fashion photographer, long associated with *Harper's Bazaar* (1945–65) and *Vogue* (1966–). His portraits were collected in several volumes, most notably in *Observations* (1959), with text by Truman CAPOTE. The film *Funny Face* (1957) was based on his life story to date.

Ayckbourn, Alan (1939–), British writer and director, from 1971 the artistic director of the Stephen Joseph Theatre in the Round at Scarborough, where he developed much of his work, then often taking it on to London and New York. His best-known works include *Absurd Person Singular* (1972), *The Norman Conquests* (1973), *Bedroom Farce* (1975), *Joking*

Apart (1978), *A Chorus of Disapproval* (1984), *A Small Family Business* (1986), and *Man of the Moment* (1988).

Ayres, Lew (Lewis Ayer, 1908–), U.S. actor, a musician before entering the movies in 1928. After playing opposite Greta GARBO in *The Kiss* (1929), he starred in Lewis MILE-STONE's classic ALL QUIET ON THE WESTERN FRONT (1930), by far his greatest role. During the 1930s he appeared in such films as *State Fair* (1933), HOLIDAY (1937), and *Last Train from Madrid* (1938), and late in the decade he began the very popular DR. KIL-DARE film series, beginning with *Young Dr. Kildare* (1938). His career was seriously damaged by his pacifist stance during World War

II, although he served as a noncombatant medic. His later career included starring roles in *The Dark Mirror* (1946) and *Johnny Belinda* (1948) and strong supporting roles in such films as ADVISE AND CONSENT (1962) and *The Carpetbaggers* (1964), as well as many television roles.

Aznavour, Charles (Shahnour Aznavouian, 1924–), French actor and musician, on stage in variety from the mid-1930s, who emerged as a leading French cabaret singer in the mid-1950s, often in performances of his own songs. He has appeared in such films as *Shoot the Piano Player* (1960), *And Then There Were None* (1974), and *The Tin Drum* (1979).

B

Babel, Isaak Emanuilovich (1894–1941), Soviet writer, whose first two short stories were published in 1916, in Maxim GORKY's magazine *Annals*. In his short-story collection *Odessa Tales* (1924) he wrote of Jewish life in his home city, also writing two plays on similar themes. Babel fought with the Red Army during the Russian Revolution, and many of his powerful, often bitter war stories were collected in *Red Cavalry* (1926), the volume that established him as a leading Soviet literary figure. But his unswerving honesty was scarcely appreciated in the Stalinist Soviet Union that then emerged: he was arrested in 1939 and died in prison. In the mid-1950s, after the death of Stalin, he was posthumously rehabilitated and his works were reissued.

Babette's Feast (1987), the Gabriel Axel film, a best foreign film OSCAR-winner set in Denmark, with a cast that includes Stephane Audran, Gudmar Wivesson, Bibi ANDERSSON, Jarl Kulle, Birgitte Federspiel, and Jean-Philippe Lafont. Axel's screenplay was based on the Isak DINESEN short story.

"Babi Yar" (1961), the poem by Yevgeny YEV-TUSHENKO, which caused an enormous furor in the Soviet Union, for in it he publicly opened the question of Stalinist anti-Semitism; until then the Soviet government had not even marked the site of the German massacres of tens of thousands of Soviet Jews near Kiev. Dmitri SHOSTAKOVICH quoted part of the poem in his *Thirteenth Symphony* (1962), known as the *Babi Yar Symphony*.

Baby Snooks, the little-girl role created on radio by Fanny BRICE in 1936, in *The Ziegfeld Follies of the Air*; she played it until her death, in 1951.

Bacall, Lauren (Betty Joan Perske, 1924–), U.S. actress, who became a star overnight with her first film, the classic TO HAVE AND HAVE NOT (1944), in which she played opposite Humphrey BOGART, whom she married in 1945. She and Bogart also starred in three other major films, THE BIG SLEEP (1946), *Dark Passage* (1947), and KEY LARGO (1948); she also played opposite Charles BOYER in *Confidential Agent* (1945). Later in her career she played leads on Broadway in such plays as *Cactus Flower* (1965), *Applause* (1970), and *Woman of the Year* (1981), winning TONY AWARDS for the latter two roles, while continuing to play strong character roles in such films as MURDER ON THE ORIENT EXPRESS (1974) and *Mr. North* (1988).

Bacharach, Burt (1929–), U.S. composer and pianist; he and lyricist Hal David began their long partnership in 1958 and became leading popular songwriters, with such songs as "The Story of My Life" (1957), "Magic Moments" (1968), and scores of other popular hits. Most notably they worked with Dionne WARWICK from 1962, creating almost 40 songs for her, such as "Don't Make Me Over" (1963) and "Walk on By" (1964). They also wrote the scores for the play *Promises, Promises* (1968) and for several films, including *What's New, Pussycat?* (1965) and BUTCH CASSIDY AND THE SUNDANCE KID (1969), winning an Oscar for the song "Raindrops Keep Falling on My Head" from the latter film. Bacharach's later career included a new writing partnership, with his wife, Carole Bayer Sager; one result was the very notable AIDS-benefit song "That's What Friends

Are For" (1988), recorded by Dionne Warwick, Elton JOHN, Gladys KNIGHT, and Stevie WONDER.

Back Street (1931), the Fanny Hurst novel, a melodrama about a woman who spends decades as the faithful mistress of a man who is married to another. It was filmed three times, most notably in Robert Stevenson's 1941 version, with Margaret SULLAVAN and Charles BOYER in the leads. The 1932 version, greatly popular in its day, starred Irene DUNNE and John Boles and was directed by John M. Stahl. The 1961 version, directed by David Miller, starred Susan HAYWARD and John Gavin.

Bacon, Francis (1909–), British artist, largely self-taught, who began painting in the late 1920s. With his celebrated triptych *Three Studies for Figures at the Base of a Crucifixion* (1944), exhibited in April 1945, he emerged as a major modern painter who focused on depicting what he saw as the most loathsome qualities of humanity and of the human experience; he continued to do so in a considerable body of other triptychs and single paintings, which are now in the world's major museums and private collections.

Bacon, Henry (1866–1924), U.S. architect; a designer of many public buildings and monuments, he is best known for the Lincoln Memorial (1922), the setting for Daniel Chester FRENCH's statue.

Bad Seed, The (1954), the Maxwell ANDERSON play, adapted from the William March novel. On Broadway Patty McCormack played the pathological child, in a cast that included Nancy Kelly, John O'Hare, Evelyn Varden, Henry Jones, Lloyd Gough, and Eileen Heckart. In the 1956 Mervyn LEROY film McCormack, Kelly, Jones, and Heckart re-created their stage roles.

Baez, Joan (1941–), U.S. folk singer and guitarist, noted for the unusual purity and quality of her voice; on stage from 1959, her appearance at the Newport Folk Festival of 1960 brought quick recognition, and her early albums established her as a leading figure in the folk-song revival then under way, part of the emerging countercultural movement that

would flower later in the 1960s. She was a civil rights and anti-Vietnam War activist, whose rendition of the emblematic WE SHALL OVERCOME was a very notable feature of both movements.

Bailey, Pearl (1918–90), U.S. singer, dancer, and actress, on stage in variety from age 15 and on Broadway from 1946 in such plays as *St. Louis Woman* (1946) and the all-Black production of HELLO, DOLLY! (1967), for which she won a TONY AWARD. She also played in such films as *Carmen Jones* (1954), *St. Louis Blues* (1957), and PORGY AND BESS (1959).

Baker, Josephine (1906–75), U.S.-French singer, dancer, and actress, on stage in variety from the age of eight, who became a major star in European variety, musical theater, and films after her extraordinary reception by Paris audiences in *La Revue Nègre* (1925). She was a major cabaret star of the interwar period, at the Folies Bergère and the Casino de Paris, and also starred in such films as *Zou Zou* (1934) and *Moulin Rouge* (1935).

Bakst, Léon (1866–1924), Russian stage designer and painter; he was a stage designer in St. Petersburg from 1900, there beginning to work with Sergei DIAGHILEV. He worked with Diaghilev's BALLET RUSSES company in Paris from 1909, designing the sets for such ballets as *Cleopatra* (1909), SCHEHERAZADE (1910), THE AFTERNOON OF THE FAUN (1912), DAPHNIS AND CHLOE (1912), and *The Sleeping Princess* (1921).

Balanchine, George (Georgi Melitonovich Balanchivadze, 1904–83), Russian-American dancer, choreographer, and ballet director, who staged his first work in the Soviet Union in 1922 and did not return from a 1924 tour of Western Europe, instead joining DIAGHILEV and in 1925 becoming chief choreographer of the Paris-based BALLET RUSSES. There he created such ballets as *Jack-in-the-Box* (1926), *The Cat* (1927), and APOLLO (1928). He formed his own company in 1933, went to the United States in 1934, and in 1935 formed the American Ballet, which in 1948 ultimately became the The

NEW YORK CITY BALLET. Balanchine created or re-created scores of ballets, many of them staples of the modern repertory. His long collaboration with Igor STRAVINSKY is especially notable, producing such works as *Apollo*, ORPHEUS (1948), FIREBIRD (1949), and AGON (1957). He also choreographed over a dozen Broadway musicals, including *On Your Toes* (1936), with its trailblazing ballet SLAUGHTER ON TENTH AVENUE, the ballet for the first time becoming an integral part of the show. He also choreographed for films and television and produced several operas.

Balcon, Michael (1896–1977), British producer, a central figure in the British film industry from the early 1930s, as head of production for Gaumont-British and MGM-British, director and production head for Ealing, and later head of Bryanston and British Lion. As a producer he was directly responsible for such films as MAN OF ARAN (1933), THE 39 STEPS (1935), TIGHT LITTLE ISLAND (1949), THE LAVENDER HILL MOB (1952), and THE CRUEL SEA (1953).

Baldwin, James Arthur (1924–87), U.S. writer, who emerged as a leading Black novelist with his largely autobiographical Harlem-based first novel, GO TELL IT ON THE MOUNTAIN (1953). He spent much of the rest of his life as an expatriate, continuing to produce such novels as *Giovanni's Room* (1956), *Another Country* (1962), and *If Beale Street Could Talk* (1974). His plays include *Blues for Mr. Charlie* and *The Amen Corner*, both produced in 1964. He also very powerfully and directly attacked American racism in such nonfiction works as *Nobody Knows My Name* (1961) and *The Fire Next Time* (1963).

Balenciaga, Cristóbal (1895–1972), Spanish fashion designer; he was Spain's leading dressmaker until 1937, then moved to Paris because of the Spanish Civil War, and was for the next three decades one of the world's leading clothes designers, in the 1950s becoming notable for his leaning toward a loose, free-form look.

Ball, Lucille ("Lucy," 1911–89), U.S. actress, who went from bit parts on the New York stage in the late 1920s to bit parts in films from 1933, then gradually building a career as a strong supporting player in comedy, as in STAGE DOOR (1937), and later moving into comedy leads in such films as *Dubarry Was a Lady* (1943) and *Fancy Pants* (1950). In 1951, she and her husband, Desi Arnaz, began the first and most successful situation-comedy series in television history, "I Love Lucy" (1951–57), and she became one of the world's most popular comedians, also doing television's "The Lucy Show" (1962–68), "Here's Lucy" (1968–73), and "Life with Lucy" (1986), as well as several more movies.

Balla, Giacomo (1871–1958), Italian painter, who moved through several styles in the early 1900s, settling in 1910 on FUTURISM and becoming a signatory of the *Technical Manifesto of the Futurist Painters* (1910). Much of his work focused on an abstracted representation of movement, as in *Dynamism of a Dog on a Leash* (1910), *Speeding Automobile* (1912), and *Swifts: Paths of Movement* (1913). His interest in futurism survived the short-lived movement, although he turned from it to more representational work in the mid-1920s.

Ballet Russes (1909–29), the ballet company created by Sergei DIAGHILEV, whose Russian troupe made its debut in Paris on May 18, 1909, marking the beginning of the modern ballet theater. It was by far the most important ballet company of the 20th century, for Diaghilev worked with many of the leading dancers and composers of his time to create much of what became the modern ballet repertoire and with many of the leading artists of the time to create the settings in which they were presented. His chief choreographers were FOKINE, NIJINSKY, MASSINE, NIJINSKA, and BALANCHINE; the composers included STRAVINSKY, DEBUSSY, and RAVEL, among others. Here Fokine created such works as SCHEHERAZADE, FIREBIRD, and PETRUSHKA, Nijinsky created and danced in THE AFTERNOON OF THE FAUN, and Massine created THE THREE-CORNERED HAT, while Balanchine and Stravinsky created the classic version of APOLLO. The company disbanded after the

Dancer-choreographer Vaslav Nijinsky in the Ballet Russes's then-shocking *The Afternoon of the Faun* (1912).

death of Diaghilev; its members and works were central to the ballet world during much of the rest of the century.

Bancroft, Anne (Anna Maria Louisa Italiano, 1931–), U.S. actress, in minor stage and screen roles during the 1950s, who emerged as a star with her TONY-winning starring Broadway roles in *Two for the Seesaw* (1958) and THE MIRACLE WORKER (1959). In 1962 she re-created the latter role on film, winning a best actress OSCAR, and went on to play leads in such films as *The Pumpkin Eater* (1964), THE GRADUATE (1968), *The Turning Point* (1977), AGNES OF GOD (1985), and *84 Charing Cross Road* (1987), the latter directed by her husband, Mel BROOKS.

Band, The, North American musical group, consisting of Canadians Jaime Robbie Robertson, Rick Danko, Richard Manuel, and Garth Hudson, and American Levon Helm. After years of working together from time to time, in 1967 they formed what became one of the most highly regarded ROCK bands of their time, creating the albums *Music from Big Pink* (1968), *The Band* (1969), *Stage Fright* (1970), *Cahoots* (1971), *Rock of Ages* (1972), *Moondog Matinee* (1973), *Northern Light-Southern Cross* (1975), and *Islands* (1977). Their farewell concert, in San Francisco on Thanksgiving Day 1976, was filmed by Martin SCORSESE as *The Last Waltz* (1978) and included appearances by Bob DYLAN, Joni MITCHELL, and many of the other leading musicians of the day.

Banerji, Bibhuti Bhusan (1894–1950), Indian writer, whose work includes novels, shorter fiction, and essays; by far his best-known works are the novels *Pather Panchali* (1928) and *Aparajito* (1932), which were adapted into the Satyajit RAY "APU" TRILOGY: PATHER PANCHALI (1955), APARAJITO (1956), and THE WORLD OF APU (1959).

Bang the Drum Slowly (1956), the Mark Harris novel, about two major-league baseball players, one of them dying of Hodgkin's disease; and about baseball, the team, a pennant, dignity, death, and a piece of the American experience. Paul NEWMAN starred in the 1956 television adaptation. Harris

adapted his novel into the 1973 John Hancock film; Robert DE NIRO and Michael Moriarty headed a cast that included Vincent Gardenia, Heather MacRae, Danny Aiello, and Phil Foster.

Bank Dick, The (1940), the classic film comedy; W.C. FIELDS starred as Egbert Sousé, a misanthropic layabout who becomes a bank detective by improbable means and ultimately foils a holdup, becomes rich, and walks off triumphant, still hating everything and everybody in sight. The film was directed by Edward Cline; Fields wrote the screenplay. The supporting cast included Cora Witherspoon, Una Merkel, Franklin Pangborn, Jessie Ralph, and Evelyn Del Rio.

Bankhead, Tallulah Brockman (1902–68), U.S. actress, on stage in leading roles in London and New York during the 1920s and 1930s. She is best known for her creation of the Regina Giddens role in THE LITTLE FOXES (1939) and of Sabina in THE SKIN OF OUR TEETH, and for her film role in LIFEBOAT (1943).

Banky, Vilma (Vilma Lonchit, 1898–), Hungarian star of American silent films, briefly a great star in the late 1920s in such films as *The Son of the Sheik* (1926), *The Night of Love* (1927), and *This Is Heaven* (1928). She retired from the screen with the advent of sound.

Bara, Theda (Theodosia Goodman, 1890–1955), U.S. silent film actress, a star after the appearance of her first film, *A Fool There Was* (1915). Studio publicity made her "The Vamp," a flamboyant, overtheatrical, overpublicized figure who starred in dozens of films during the next four years, including *Carmen* (1916), *Cleopatra* (1917), and *Salome* (1918), and then quickly faded into obscurity.

Baraka, Imamu Amiri (LeRoi Jones, 1934–), U.S. writer, a leading Black nationalist from the early 1960s, whose early work included the three one-act plays *The Dutchman, The Slave*, and *The Toilet* (1964) and whose later work included plays, poetry, short stories, and essays.

Barber, Samuel (1910–81), U.S. composer; his romantic early work included such works as *Dover Beach* (1931), composed for his own voice, and the very popular *Adagio for Strings* (1936), part of his String Quartet and used as a theme in the 1986 film PLATOON. Other notable works were the ballet *Medea* (1947); the vocal work *Knoxville: Summer of 1915* (1948); the PULITZER PRIZE-winning opera *Vanessa* (1958); the *Piano Concerto* (1962), which won a second Pulitzer, and the opera ANTONY AND CLEOPATRA (1966).

Barbusse, Henri (1873–1935), French writer, a journalist, novelist, and poet, whose experiences as a soldier during the early years of World War I were the basis of by far his best-known work, the antiwar *Under Fire* (1916). His earlier work includes the novel *The Inferno* (1908). Barbusse's later work was considerably influenced by his affiliation with the Communist Party following the Russian Revolution and included such works as *Light* (1919), *Chains* (1925), and *Stalin* (1935).

Bardot, Brigitte (Camille Javal, 1933–), French film actress, the "sex kitten" of the 1950s whose starring role in *And God Created Woman* (1956), the first film directed by Roger VADIM, then her husband, brought her worldwide celebrity.

Barlach, Ernst (1870–1938), German sculptor and writer; he was one of the leading European sculptors of the 20th century, much of whose powerful, deeply emotional freestanding work was informed by his great affinity for German Gothic woodcarving forms. In turn, his use of those forms, in wood and metal alike, stirred a revival of German sculptural woodcarving. He was a dramatist as well; in such plays as *The Dead Day* (1912), *The Poor Cousin* (1919), and *The Blue Bulb* (1929), he pursued the same search for belief that permeated his sculptures. During the Nazi period his works were banned as "degenerate"; hundreds were removed from public places, churches, and museums throughout Germany, including his celebrated Güstrow Cathedral flying angel, which was destroyed, and the equally celebrated war memorial at Magdeburg.

A typical Ernst Barlach bronze statue in wood-carving style: *The Avenger* (1914).

Barnes, Albert Coombs (1872–1951), U.S. scientist and art collector; his collection, very strong in 19th- and 20th-century French work, ultimately became the Barnes Museum, near Philadelphia.

Barr, Roseanne (1952–), U.S. actress and comedian, on stage in cabaret from the late 1970s and on screen in television from 1986, who emerged as a television star and celebrity in her "Roseanne" series (1988–). She also appeared in the film *She-Devil* (1989).

Barrault, Jean-Louis (1910–), French actor, director, and manager, on stage as an actor from 1931 and as a director from 1935. His first work was a partially mimed adaptation of William FAULKNER's *As I Lay Dying*. A major figure in the French theater, he was with the Comédie-Française from 1939 to 1956 as actor and director, leaving it with his wife, actress Madeleine REYNAUD, to form the Reynaud-Barrault repertory company at the Théâtre Marigny from 1946 to 1956. He subsequently managed several other companies, including the Théâtre de France. Barrault is best known internationally for his

creation on film of the mimed role Deburau in CHILDREN OF PARADISE (1945).

Barretts of Wimpole Street, The (1931), the Rudolf Besier play, which became a celebrated Katharine CORNELL vehicle. The play was directed by her husband, Guthrie McCLINTIC, and produced on Broadway by Cornell; she played Elizabeth Barrett Browning opposite Brian AHERNE as Robert Browning and Charles Waldron as her father. Sidney Franklin directed two film versions; in 1934 Norma SHEARER, Fredric MARCH, and Charles LAUGHTON were in the leads; in 1957 Jennifer JONES, Bill Travers, and John GIELGUD played the roles.

Barrie, James Matthew (1860–1937), Scottish writer, a playwright and novelist who is best known for such plays as *Quality Street* (1902), *The Admirable Crichton* (1902), *Dear Brutus* (1917), and *Mary Rose* (1920). His children's play, PETER PAN (1904) was based on his own 1902 novel *The Little White Bird*. In 1905 *Peter Pan* opened in New York, there becoming identified with Maude ADAMS; in later years Peter Pan became a classic starring role on the

English-speaking stage. The play became a celebrated American musical in 1954, with Mary MARTIN in the starring role.

Barry, Philip (1896–1949), U.S. writer, whose major work was in the theater. He is best known for such plays as HOLIDAY (1928), which was done on film twice, in 1930 and 1938, latterly in the George CUKOR version starring Katharine HEPBURN and Cary GRANT; *Hotel Universe* (1930); *The Animal Kingdom* (1932); and THE PHILADELPHIA STORY (1939), which starred Katharine Hepburn, who re-created the role in the 1940 film.

Barrymore, Ethel (Edith Blythe, 1879–1959), U.S. actress, daughter of Georgianna Drew Barrymore and Maurice Barrymore and sister of John and Lionel BARRYMORE. Her first major stage success was in *Captain Jinks of the Horse Marines* (1901), and she subsequently played many leads on the New York stage, including Nora in *A Doll's House* (1905); Juliet, Ophelia, and Portia in the early 1920s; and Miss Moffat in THE CORN IS GREEN (1940). Offstage she played a major role in the successful Actors Equity strike of 1919. From 1914 she was also seen in films and during the 1940s and 1950s played many strong character roles, winning a best supporting actress OSCAR for *None But the Lonely Heart* (1944), and appearing in such films as *Moss Rose* (1947), *The Farmer's Daughter* (1947), and *Kind Lady* (1951).

Barrymore, John (John Sidney Blythe, 1882–1942), U.S. actor, son of Georgianna Drew Barrymore and Maurice Barrymore, brother of Ethel and Lionel BARRYMORE, and widely recognized as one of the leading dramatic actors of the century. Nicknamed "The Profile" for his classic features, he early established himself in comedy, then moved into serious drama with his role as Falder in John GALSWORTHY's *Justice* (1916) and in the title role in *Peter Ibbetson* (1917). His New York *Hamlet* (1922) established him as a major Shakespearean actor; his London *Hamlet* (1925) was equally well received. He appeared in films from 1913, becoming a popular star in the 1920s, in the title roles in DR. JEKYLL AND MR. HYDE

(1920), Sherlock HOLMES (1922), *Beau Brummell* (1924), and *Don Juan* (1926); as Ahab in *The Sea Beast* (1926) and again as Ahab in MOBY DICK (1930); as François Villon in *The Beloved Rogue* (1927); and in such talkies as GRAND HOTEL (1932), *A Bill of Divorcement* (1932), *Counsellor-at-Law* (1933), DINNER AT EIGHT (1933), and *Twentieth Century* (1934). But alcoholism ultimately destroyed his career; after the mid-1920s he found theater roles difficult to sustain, and his film roles ultimately became self-caricatures, as in *Midnight* (1939) and *The Great Profile* (1940).

Barrymore, Lionel (Lionel Blythe, 1878–1954), U.S. actor, artist, and composer, son of Georgianna Drew Barrymore and Maurice Barrymore, brother of Ethel and John BARRYMORE. Although he played in the New York theater early in the century, sometimes with his brother John, as in *Peter Ibbetson* (1917) and *The Jest* (1919), his main work was in film, where from 1909 to 1953 he played in over 200 movies, in the early years playing leads and later playing strong character roles, although forced to play from a wheelchair from 1938. He is best known for such later roles as Dr. Gillespie in the DR. KILDARE films and for such films as YOU CAN'T TAKE IT WITH YOU (1938), IT'S A WONDERFUL LIFE (1946), and KEY LARGO (1948).

Barth, John (1930–), U.S. writer, best known for such long, complex, highly allegorical, and often comedic novels as THE SOT-WEED FACTOR (1960) and *Giles Goat-Boy* (1966); his 1972 shorter fiction collection, *Chimera* (1972), won a National Book Award.

Barthelme, Donald (1931–89), U.S. writer, whose hundreds of short stories present his absurdist view of a late-20th-century American society from which he was substantially alienated; his stories, many of them first written for *The New Yorker*, are collected in such volumes as *Come Back, Dr. Caligari* (1964), *Unspeakable Practices, Unnatural Acts* (1968), *Sixty Stories* (1981), and *Forty Stories* (1987). He also wrote such novels as *Snow White* (1967) and *The Dead Father* (1975).

Bartók, Béla (1881–1945), Hungarian composer, ethnomusicologist, pianist, and teacher, in concert from age 11. His research in Hungarian and other East-Central European folk music began in the early years of the century, was reflected in much of his musical work, and also generated many written works, some of them published in the 1960s, decades after his death. Bartók's most notable work began with the symphonic poem *Kossuth* (1903), on Hungarian national themes. It included the six quartets (1908–39); the opera *Bluebeard's Castle* (1911); two ballets, *The Wooden Prince* (1917) and *The Miraculous Mandarin* (1926); a considerable body of folk music; the *Cantata Profundo* (1930); and the *Concerto for Orchestra* (1943), as well as a large body of other instrumental music. He taught at the Royal Hungarian Academy of Music (1907–34) and also was one of the leading pianists of his time. In 1940, with the onset of World War II, he emigrated to the United States.

Baryshnikov, Mikhail (1948–), Soviet dancer, a leading member of Leningrad's KIROV BALLET from 1969 until his flight to the West in 1974; thereafter he was a guest soloist with many companies, and artistic director of the American Ballet Theater (1980–90). He created leading roles in such ballets as *Vestris* (1969), *Hamlet* (1970), *Creation of the World* (1971), *Connotations* (1976), *Santa Fe Saga* (1978), and *Rhapsody* (1980); choreographed *The Nutcracker* (1976), *Don Quixote* (1978), and *Cinderella* (1984); and appeared in such films as *The Turning Point* (1977), *White Nights* (1985), and *The Dancers* (1987).

Basehart, Richard (1914–84), U.S. actor, on stage from 1938 and on screen from 1947; he was the Fool in LA STRADA (1954), Ishmael in MOBY DICK (1956), and appeared in such films as *He Walked by Night* (1948); *Fourteen Hours* (1951); *The Brothers Karamazov* (1958); *Hitler* (1963), in which he played the title role; and BEING THERE (1979). His television appearances included a starring role in the series "Voyage to the Bottom of the Sea" (1964–67).

Basie, Count (William Allen Basie, 1904–84), U.S. musician, a pianist in the Walter Page band from 1928 and the Benny Moten band from 1929. He led the latter after Moten's death, in 1935, and emerged as a leading "big-band" conductor in the late 1930s with the help of record producer John HAMMOND, who "discovered" the band in Kansas City, helped bring it to New York, and produced the recordings that brought the band—and especially its rhythm section—to large, very appreciative audiences. A few of the leading musicians who played in the Basie band during the nearly three decades that followed were Lester YOUNG, Buck Clayton, Benny Morgan, Herschel Evans, and Illinois Jacquet.

Baskin, Leonard (1922–), U.S. sculptor, whose large-scale human figures conveyed his antiheroic view of humanity spiritually and physically damaged and very nearly destroyed, perhaps by the experiences and continuing threats of Baskin's own lifetime. His work in graphics was similar in thrust, though somewhat differently conveyed, largely by figures represented as anatomical or medical drawings.

Bates, Alan Arthur (1934–), British actor, on stage from 1956 and in film from 1959, who became a leading player with his success on stage as Mick in THE CARETAKER (1960), a role he re-created on film in 1963. On stage he played leads in such major modern works as *In Celebration* (1969); BUTLEY (1972), for which he won a TONY; and *Otherwise Engaged* (1975), while also consistently playing in the classics. On screen some of his most memorable work was in *Far from the Madding Crowd* (1967), *The Fixer* (1968), WOMEN IN LOVE (1969), *A Day in the Death of Joe Egg* (1971), and television's *An Englishman Abroad* (1983).

Batman, the cartoon character created by Robert KANE in 1939, which later generated radio, television, and film versions. The television "Batman" series (1966–68) starred Adam West in the title role, with Burt Ward as Robin. The Tim Burton 1989 film version starred Michael Keaton as Batman and Jack NICHOLSON as the Joker.

Bauhaus, the leading German modern design school of the Weimar period; the term also came to signify a body of approaches to modern design that became a centrally important school of thought, considerably influencing architecture and several allied arts during the interwar period and following World War II. The Weimar Bauhaus was founded by Walter GROPIUS in 1919 as a reorganization and major redirection of the existing art schools at Weimar. He moved it to Dessau in 1925 and was replaced as director by Ludwig MIES VAN DER ROHE in 1928. Mies was forced by the Nazis to close the school in 1933. The Bauhaus was an attempt to join the arts and crafts around architecture, within a concept of modern design as industrial design; the result was the development in architecture, design, and the decorative arts of the consciously ahistorical, smooth, featureless, machine-oriented forms that were to dominate modern design and produce the INTERNATIONAL STYLE during the next several decades. In addition to Gropius and Mies, Bauhaus teachers included such leading artists, designers, and theoreticians as KANDINSKY, KLEE, MOHOLY-NAGY, BREUER, Lyonel FEININGER, and ALBERS, several of whom became world leaders in architecture and the allied arts in the post-World War II United States.

Baum, L. Frank (Lyman Frank Baum, 1856–1919), U.S. writer, best known by far for his story *The Wonderful Wizard of Oz* (1900), the first of a series of 14 Oz books. He dramatized the first Oz book in the 1903 Broadway musical. In 1939 the book was the basis of the classic film THE WIZARD OF OZ; since then, Judy GARLAND has been Dorothy to some generations of the world's children, accompanied by Toto, the Lion, the Tin Man, the Scarecrow, the witches, the Munchkins, and the rest.

Baur, Harry (1880–1943), French actor, who played largely in the theater from the turn of the century and in occasional films from 1910; with the advent of sound he became in the 1930s a leading player in French films, in such roles as the title role in *Rothschild*

(1934), as Jean Valjean in *Les Misérables* (1934), and in the title role in *Volpone* (1939), as well as in many other major films of the period.

Bax, Arnold (1882–1953), British composer, long resident in Ireland; he often wrote on Celtic themes, as in the symphonic poem *In the Faery Hills* (1909), *In the Garden of Fand* (1916), *Tintagel* (1917), and *November Woods* (1919), later turning to his seven symphonies (1922–39) and to a considerable body of other instrumental work, including four piano sonatas. As Dermot O'Byrne he wrote several works of fiction on Irish themes.

Baxter, Anne (1923–), U.S. actress, on stage from 1936 and on screen from 1940; she won a best supporting actress OSCAR for *The Razor's Edge* (1946) and played the scheming young actress in the title role of ALL ABOUT EVE (1950), also appearing in such films as THE MAGNIFICENT AMBERSONS (1942), *Five Graves to Cairo* (1943), *Summer of the Seventeenth Doll* (1959), and *A Walk on the Wild Side* (1962); she also appeared on television.

Baxter, Warner (1891–1951), U.S. actor, in silent films from 1918 and a star in such works as THE GREAT GATSBY (1926) and *Ramona* (1928). He made the transition to sound with great success, winning a best actor OSCAR for his first sound film role, as the Cisco Kid in *In Old Arizona* (1929), and played in such films as 42ND STREET (1933) and *Stand Up and Cheer* (1933); thereafter he appeared mainly in B films.

Bazin, André (1918–58), French film critic, author, and editor, a cofounder in 1951 and thereafter chief editor of CAHIERS DU CINÉMA, and a powerful influence in the development of AUTEUR theory, the NEW WAVE movement, and the modern French cinema.

Beach Boys, The, the popular California music group, originally consisting of Mike Love, Brian Wilson, Carl Wilson, Dennis Wilson, and Al Jardine. The group became moderately popular with its first record *Surfin'* (1961) and built from there to the great international popularity it enjoyed in the late 1960s, with "Pet

The Beatles early on, in 1964—from left, George Harrison, Paul McCartney, Ringo Starr, and John Lennon.

Sounds" (1966) and "Good Vibrations" (1967).

"Beale St. Blues" (1916), the classic BLUES SONG, with words and music by W.C. HANDY.

beat generation, an avant-garde U.S. 1950s movement in literature and the arts that declared itself alienated from the material culture of the period. In essence the movement introduced and adapted a version of European 1920s Bohemianism into the American post-World War II literary scene. In artistic terms the "beats" attempted to stand on the shoulders of a wide range of experimentally minded Europeans and American expatriates, from Ezra POUND and Bertolt BRECHT to Henry MILLER and Jean GENET. Beat writers developed considerable stylistic innovations, as expressed in the work of such beat leaders as Jack KEROUAC, Allen GINSBERG, and Lawrence FERLINGHETTI, also providing artistic and behavioral models for many leaders of the much larger and more diverse 1960s American countercultural movement. Those

enraged by the movement and its defiance of current social conventions coined the derogatory term *beatniks* to describe those in the "beat" movement. Later, many of the derided beatnik personal styles of the 1950s became norms in American culture.

Beatles, The, British musical group formed in 1959 by George HARRISON, John LENNON, and Paul MCCARTNEY, and joined in 1962 by Richard Starkey (Ringo STARR). The four young musicians from Liverpool developed a body of then-unconventional music, performances, and personal styles that revolutionized the popular music of their time and had a major impact on the social revolution then in its formative stages, later to be called the COUNTERCULTURE. The Beatles began their joint career in Liverpool in 1958 and burst into popular consciousness in the autumn of 1962, shortly after Starr replaced drummer Pete Best. They emerged as a phenomenon in mid-1963 as adoring young fans mobbed them at every appearance, while such records as SHE LOVES YOU (1963); I WANT TO HOLD

YOUR HAND (1963), which became their signature song; and YESTERDAY (1965) catapulted them into a dominant position on the world popular music scene. They enjoyed an extraordinary reception in the United States, beginning with their February 1964 American tour, subsequent television appearances, and enormous media coverage. In 1964 Richard Lester directed their first film, A HARD DAY'S NIGHT; the title song became one of their most popular songs. Lester also directed their second film, *Help!* (1965). Later films included *Magical Mystery Tour* (1967), most notable for "Strawberry Fields Forever," and the extraordinarily inventive George Dunning animated film THE YELLOW SUBMARINE (1968), which contained Beatles standards such as ALL YOU NEED IS LOVE and songs drawn from their highly influential GRAMMY-winning album *Sergeant Pepper's Lonely Hearts Club Band* (1967), including the title song, "Lucy in the Sky with Diamonds," and "When I'm 64." The group began to drift apart in the late 1960s and formally dissolved in April 1970.

Beaton, Cecil (1904–80), British photographer and designer, a leading celebrity portrait photographer whose work long appeared in *Vogue* magazine. He was also a leading designer in theater, opera, and ballet, beginning with his scenery and costume designs for the London musical *Follow the Sun* (1936) and including his costume design for MY FAIR LADY (1956). He was costume designer for several films and production designer for GIGI (1958) and MY FAIR LADY (1964), winning OSCARS for both films.

Beatty, Warren (Warren Beaty, 1937–), U.S. actor, director, and producer; he appeared in minor television and theater roles before starring opposite Natalie WOOD in his first major film, *Splendor in the Grass* (1961). He became a major international film figure with BONNIE AND CLYDE (1967), which he also produced. He starred in such films as MCCABE AND MRS. MILLER (1971); *The Parallax View* (1974); *Shampoo* (1975); and *Heaven Can Wait* (1978), which he produced, wrote, and co-

directed. He won a best director OSCAR for the epic REDS (1981), which he also produced and co-wrote, and in which he starred as John REED. Beatty starred in the ill-fated *Ishtar* (1987) and as DICK TRACY (1990). He is the brother of actress Shirley MACLAINE.

Beauvoir, Simone de (1908–86), French writer, philosopher, and leading 20th-century feminist; with her longtime companion, Jean-Paul SARTRE, and in association with Albert CAMUS, she was at the center of the EXISTENTIALIST movement. Her most notable works are a philosophic treatise, *The Second Sex* (1952), a centerpiece of the modern feminist movement; a novel, *The Mandarins* (1956), a lightly fictionalized treatment of the existential movement and its leaders; and her three-volume autobiography: *Memoirs of a Dutiful Daughter* (1958), *The Prime of Life* (1960), and *The Force of Circumstance* (1963). Her novels also include *She Came to Stay* (1943) and *The Blood of Others* (1945). She also wrote on a wide range of other matters, among them aging, Communist China, and her relationship with Sartre.

bebop, alternate term for BOP.

Bechet, Sidney (1897–1959), U.S. musician, a JAZZ saxophonist and clarinetist who began playing in his hometown of New Orleans at age six, and who had played with many bands throughout the South by the time he joined King OLIVER in 1916. He became one of the leading jazz figures of the interwar period, playing in his own and other bands in France and the United States and recording from the early 1920s, as in 1924 with Louis ARMSTRONG and the Red Onion Jazz Babies. From the late 1940s he lived in France, returning to the United States only occasionally.

Becket (1959), the TONY-winning Jean ANOUILH play, pitting the integrity of churchman Thomas à Becket against the will of his king, Henry II. Edward Anhalt won an OSCAR for his adaptation of the play into the memorable 1964 Peter Glenville film, with Richard BURTON as Becket, Peter O'TOOLE as Henry II, and a cast that included John GIELGUD,

Richard Burton (left) and Peter O'Toole in the 1964 film of Jean Anouilh's *Becket*.

Martita Hunt, Donald Wolfit, Pamela Brown, Sîan Philips, and David Weston.

Beckett, Samuel (1906–89), Irish writer, living in France from 1938 and working primarily in French, best known as one of the major playwrights of the century, who was also a poet, novelist, screen and radio writer, and essayist. His first play, *Waiting for Godot*, made an extraordinary impact, for it was also the first major work of what was later called the THEATER OF THE ABSURD. It was produced in France in 1953; Beckett translated the play into English for its 1955 London production, which was followed by its 1956 New York production. Such later plays as *Endgame* (1958), *Krapp's Last Tape* (1960), *Happy Days* (1961), and *Breath* (1969) further explored Beckett's views as to the impossibility of communication. In 1969 he won the NOBEL PRIZE for literature and published his *Collected Works*. Later works include further plays and poems.

Beckmann, Max (1884–1950), German artist, who emerged as a leading painter before World War I. He served in the medical corps from 1914, came out with a severe emotional break-

down in 1915, and during the next several years developed his bitterly alienated later style, as in his *The Descent from the Cross* (1917) and the celebrated *The Night* (1919), both full of the tortured grotesques that characterize much of his further work. His work was condemned as "degenerate" by the Nazis; he fled Germany in 1937 and spent the war in Holland, emigrating to the United States in 1947. During the years in exile, and after the war, he continued to paint; his last work was the triptych *The Argonauts* (1950).

Beecham, Thomas (1869–1971), British conductor, largely self-taught. After his 1905 debut he founded and financed the New Symphony Orchestra in 1906, and from 1910 to 1920 he mounted opera seasons, notably bringing to London SALOME and ELECTRA in 1910 and the BALLET RUSSES of Sergei DIAGHILEV in 1911 and founding the Beecham (later the National) Opera Company in 1915. He founded the London Philharmonic Orchestra in 1932 and was artistic director at Covent Garden from 1933 and general director from 1935 to 1939. He spent the war years in the United

States and in 1946 founded the Royal Philharmonic Orchestra.

Beerbohm, Max (1872–1956), British writer and caricaturist, the half-brother of Herbert TREE; he succeeded George Bernard SHAW as the drama critic of the *Saturday Review* (1898–1910), occasioning Shaw's introduction of Beerbohm as "the incomparable Max." A noted caricaturist, parodist, and essayist, he wrote the novel *Zuleika Dobson* (1911) and several plays and was in essence a celebrated "man about letters" in Edwardian London.

Beery, Wallace (1885–1949), U.S. actor, on stage from 1904 and on screen from 1913; he began his long movie career as a female impersonator and played a considerable range of character roles throughout the silent era. Some of his most notable sound films were *The Champ* (1931), for which he won a shared best actor OSCAR; GRAND HOTEL (1932); DINNER AT EIGHT (1933); *Viva Villa!* (1934), as Villa; and *Treasure Island* (1934), as Long John Silver.

Behan, Brendan (1923–64), Irish writer, an Irish Republican Army activist in his youth, who spent some of his early years in prison and used his political work and prison experience as much of the basis for such often tragicomic plays as *The Quare Fellow* (1954) and *The Hostage* (1957) and in his autobiographical *Borstal Boy* (1958). His career and life were cut very short by his alcoholism and flamboyant lifestyle.

Behrens, Peter (1868–1940), German architect and industrial designer. From 1907 to 1914 he was artistic adviser for the German electrical company AEG, in that position developing a considerable body of industrial designs and structures and employing several young architects and designers who would later become major figures, including Ludwig MIES VAN DER ROHE and Walter GROPIUS. He continued to influence German architecture and design considerably through the Weimar period; during the Nazi period he continued to work and teach in Germany.

Behrman, S.N. (Samuel Nathaniel Behrman, 1893–1973), U.S. writer, a leading Broadway playwright, mainly in light comedy, beginning

with his *The Second Man* (1927). His best-known plays include *Amphitryon 38* (1937); *No Time for Comedy* (1939); *Jacobowsky and the Colonel* (1944), co-written with Franz WERFEL, which he adapted into the film *Me and the Colonel* (1958); and FANNY (1954), co-written with Joshua LOGAN. He also wrote such screenplays as *Queen Christina* (1933) and *Anna Karenina* (1935). Late in his career he wrote biographies of *Duveen* (1952) and Max BEERBOHM, in *Portrait of Max* (1960).

"Bei Mir Bist Du Schoen" (1937), the signature song of the ANDREWS SISTERS, with music by Sholom Secunda and words by Secunda and Sammy CAHN.

Being There (1979), the Hal ASHBY film, adapted by Jerzy KOSINSKI from his 1971 novel. The film starred Peter SELLERS as the retarded gardener Chance, whose slow, seemingly careful comments are taken as brilliantly incisive parables and metaphors, dealing with the main questions confronting humanity, in a cast that included Shirley MACLAINE, Melvyn DOUGLAS, Jack Warden, Richard BASEHART, and Richard Dysart. Douglas won a best supporting actor OSCAR.

Béjart, Maurice (Maurice Jean Berger, 1927–), French dancer, choreographer, and ballet director, on stage from 1945, who cofounded his own ballet company in 1953. From this ultimately grew his highly experimental, very notable company The Ballet of the 20th Century, which moved in the mid-1960s to expand the scope of ballet to include the South and East Asian influences so strongly influencing the countercultural movements of the time, especially in popular music. He also choreographed several operas and wrote a play and a novel.

Belafonte, Harry (Harold George Belafonte, 1927–), U.S. singer and actor, who became a leading popular folk-music star in the 1950s with such songs as "Scarlet Ribbons" (1955), "Calypso" (1956), and "Jamaica Farewell" (1957). His films include *Carmen Jones* (1952), *Island in the Sun* (1957), *Buck and the Preacher* (1971), and *Uptown Saturday Night* (1974).

Belasco, David (1859–1931), U.S. writer, producer, and actor; his best-known plays include *The Girl I Left Behind Me* (1893), *The Heart of Maryland* (1895), MADAME BUTTERFLY (1900), and THE GIRL OF THE GOLDEN WEST (1905). Belasco was one of the leading producers of the American stage early in the 20th century; he built his own theater in 1906, naming it The Belasco in 1910.

Bel Geddes, Norman (1893–1958), U.S. stage and industrial designer; he designed several sets for the Metropolitan Opera in the early 1920s but is by far best known for his work in the theater, emerging as a major, innovative designer with the sets of *The Miracle* (1923), and going on to design and produce such plays as *Hamlet* (1931) and DEAD END (1935), among the over 150 plays, films, and operas he designed, produced, or directed. He also designed several theaters, including the Kharkov State Opera House and the General Motors Futurama building at the 1939–40 New York World's Fair, and from the late 1920s was a leading industrial designer. His daughter is the actress Barbara Bel Geddes.

Bell, Clive (1881–1964), British art critic, whose views as to the "aesthetic emotion" that proceeds from an appreciation of the "significant form" of an artwork played a key role in developing British acceptance of such painters as Paul Cézanne, Vincent Van Gogh, and Paul Gaugin, whom he described as Post-Impressionists. Bell's views were put forward in his very influential book *Art* (1914), which was followed by such works as *Since Cézanne* (1922) and *An Account of French Painting* (1931). He and his wife, the painter Vanessa BELL, were members of the small group of friends and acquaintances that became known as the BLOOMSBURY GROUP.

Bell, Vanessa (Vanessa Stephen, 1879–1961), British artist, a leading British colorist of the first half of the 20th century, most notably during the first quarter of the century, when she was associated with the Post-Impressionists being introduced into Britain by her husband, Clive BELL, and Roger FRY. She was the sister of the writer Virginia Stephen WOOLF.

Bellamy, Ralph (1904–), U.S. actor, on stage in stock in the 1920s and on screen in scores of supporting roles from 1931, as in *The Awful Truth* (1937), *Carefree* (1938), and *His Girl Friday* (1940), and as Ellery Queen in four films during 1940 and 1941. He returned to the theater in 1943, starring on Broadway in such plays as *Tomorrow the World* (1943), STATE OF THE UNION (1945), DETECTIVE STORY (1949), and as Franklin D. Roosevelt in SUNRISE AT CAMPOBELLO, for which he won a TONY, re-creating the role on screen in the 1960 film. He was later seen in strong supporting roles in films and on television.

Bellow, Saul (1915–), U.S. writer, often on Jewish life in America, who emerged as a major American novelist in midcentury with such novels as the National Book Award-winning *The Adventures of Augie March* (1953), *Henderson the Rain King* (1959), HERZOG (1964), *Mr. Sammler's Planet* (1968), and *Humboldt's Gift* (1975), a PULITZER PRIZE-winner. He has also written several plays. Bellow was awarded the 1976 NOBEL PRIZE for literature.

Bellows, George Wesley (1882–1925), U.S. painter; after studying with Robert HENRI, he emerged as a major realist and action painter, who is generally identified as a leading member of the ASHCAN SCHOOL, with such works as *Forty-two Kids* (1907) and *Stag at Sharkey's* (1907), the latter a notable example of the sports, and especially prizefighting, themes that are an enduring feature of his work. Bellows later focused on lithographs and portraiture.

Belmondo, Jean-Paul (1933–), French actor, on stage and in films from the early 1950s, who became a star with his leading role in BREATHLESS (1960), thereafter playing in scores of leading and major supporting roles, as in *That Man from Rio* (1963), *Is Paris Burning?* (1967), *Borsalino* (1970), *Stavisky* (1974), and *Holdup* (1985).

Bely, Andrei (1880–1934), Russian writer, long identified with the Symbolist movement, whose highly experimental poetry was collected in such volumes as *Gold in Ashes* (1903) and *Ashes* (1909). His major novel was *Petersburg* (1913). He also wrote a considerable body

of essays and three volumes of memoirs (1931–34).

Ben-Hur (1880), the novel by Lew Wallace, about the life of a Palestinian Jew, Judah Ben-Hur, in Roman times, climaxing in a stirring chariot race. Dramatized in 1899, it later became the massive Fred Niblo silent film (1926), starring Ramon Navarro as Ben-Hur and Francis X. Bushman as Messala. In 1959 it became the equally massive William WYLER film, with Charlton HESTON as Ben-Hur in a cast that included Hugh Griffith, Jack HAWKINS, Stephen Boyd as Messala, Haya Harareet, Martha Scott, Sam Jaffe, and Finlay CURRIE. The film, Wyler, Heston as best actor, Griffith as best supporting actor, Robert L. Surtees as cinematographer, and Miklos Rozsa for music all won OSCARS.

Bendix, William (1906–64), U.S. actor, on stage from 1939 and on screen from 1942; he is best remembered for his five-year tenure (1953–58) as Chester A. Riley in the long-running television series "The Life of Riley." He also appeared in such films as *Wake Island* (1942), *The Glass Key* (1942), LIFEBOAT (1943), *The Hairy Ape* (1944), *A Bell for Adano* (1945), *The Blue Dahlia* (1946), and *The Life of Riley* (1949).

Benét, Stephen Vincent (1898–1943), U.S. writer, who emerged as a major American poet with his epic JOHN BROWN'S BODY (1928), a PULITZER PRIZE winner. His further work included many short stories and poems, including his short story "The Devil and Daniel Webster" (1939), which became the basis for the 1941 film, with Walter HUSTON's Devil playing opposite Edward ARNOLD's Daniel Webster. His long poem *Western Star* (1943) also won a Pulitzer Prize.

Bennett, Arnold (Enoch Arnold Bennett, 1867–1931), British writer, an extremely prolific novelist, dramatist, and short-story writer who emerged as a major novelist with his THE OLD WIVES' TALE (1908). The story was set in his native Staffordshire, the pottery-making center that became the "Five Towns" locale of his best-known novels and short stories, most notably in *Anna of the Five Towns* and the "Clayhanger" trilogy: *Clayhanger* (1910),

Hilda Lessways (1911), and *These Twain* (1916). His best-known plays were *Milestones* (1912) and *The Great Adventure* (1913). He adapted the latter from his own 1908 novel *Buried Alive*; it was later done several times and with several different names on film, including *His Double Life* (1933) and *Holy Matrimony* (1944).

Bennett, Constance (1904–65), U.S. actress, on screen from 1916, who emerged as a leading player in the 1930s with such films as *Moulin Rouge* (1933), *Topper* (1937), *Escape to Glory* (1940), *Two-Faced Woman* (1941), and *The Unsuspected* (1947). She was the daughter of actor Richard BENNETT and the sister of actress Joan BENNETT.

Bennett, Joan (1910–), U.S. actress, on stage from 1938 and on screen from 1916, who emerged as a leading player in the 1930s with such films as *Bulldog Drummond* (1929), *Little Women* (1933), *The Housekeeper's Daughter* (1939), *Man Hunt* (1941), *The Woman in the Window* (1944), *Scarlet Street* (1945), *The Macomber Affair* (1947), and *Father of the Bride* (1950). She is the daughter of actor Richard BENNETT and the sister of actress Constance BENNETT.

Bennett, Richard (1873–1944), U.S. actor, on stage from 1891 and a leading actor of the early 1900s, who played leads in such works as *The Lion and the Mouse* (1905), *What Every Woman Knows* (1908), and *Stop, Thief* (1912). In 1920 he created the Robert Mayo role in Eugene O'NEILL's BEYOND THE HORIZON and went on to create memorable roles in *They Knew What They Wanted* (1924) and WINTERSET (1935). He also appeared in several films, including *If I Had a Million* (1932), *Nana* (1934), THE MAGNIFICENT AMBERSONS (1942), and *Journey into Fear* (1943). He was the father of actresses Constance and Joan BENNETT.

Bennett, Tony (Anthony Dominick Benedetto, 1926–), U.S. singer, from 1951 one of the most highly regarded of American popular singers. Early in his career he was identified with such songs as his earliest hit, "Because of You" and "Just in Time." From 1962 his sig-

nature song became "I Left My Heart in San Francisco."

Benny, Jack (Benjamin Kubelsky, 1894–1974), U.S. comedian, in vaudeville during the 1920s, whose radio show (1932–55) was one of the most popular and durable in radio. He began the transition to television in 1950 and continued as a leading television comedian until 1965. His long-term cast, in both media, included his wife, Mary Livingstone (Sadie Marks); Eddie Anderson, playing Rochester; singer Dennis Day; Mel Blanc; and announcer Don Wilson. From 1929 Benny also occasionally appeared in films, including *Charley's Aunt* (1941), *To Be or Not to Be* (1942), and *The Horn Blows at Midnight* (1945).

Benton, Robert (1932–), U.S. director and writer, who with David Newman wrote the screenplays for such films as BONNIE AND CLYDE (1967) and SUPERMAN (1978). As a director he won an OSCAR for KRAMER VS. KRAMER (1979) and also directed *The Late Show* (1977), *In the Still of the Night* (1982), and *Places of the Heart* (1984).

Benton, Thomas Hart (1889–1975), U.S. painter, who from the mid-1920s was a leading exponent of "regionalism," in his instance the realistic, sometimes naturalistic depiction of southern and western American life and history, while at the same time attacking the dominant modernistic trends in Western art as perverse and degenerate. His very popular paintings include such works as *Louisiana Rice Fields* (1928), *Homestead* (1934), and *Roasting Ears* (1939). From the early 1930s, he was also a leading muralist, with such works as the *City Scenes* at the New School for Social Research (1931), the *The Arts of the West* at the Whitney Museum, the murals at the Missouri state capitol at Jefferson (1956), and the murals at the Harry S Truman Library at Independence, Missouri (1961).

Berenson, Bernard (Bernhard Berenson, 1865–1969), U.S. art critic, historian, and authenticator, a leading authority on the Italian artists of the Renaissance, from the appearance of *Venetian Painters of the Ren-*

aissance (1894), which was followed by several other major works, including *The Italian Painters of the Renaissance* (1930) and *Aesthetics and History* (1948). He spent most of his life in Italy, from 1900 at his home and workplace, I TATTI, near Florence, there making his living primarily as a leading authenticator for dealers and purchasers of Italian Renaissance art, most notably the dealer Joseph DUVEEN and such collectors as J. Pierpont MORGAN and Isabella Stewart Gardner, for whom he purchased the core of the collection that was to become her Boston museum.

Berg, Alban (1885–1935), Austrian composer, a student of Arnold SCHOENBERG; his work reflects the development of atonal and serial patterns that were to powerfully influence 20th-century music, while at the same time considerably including older classical forms. Story lines for the two operas at the heart of his work were adapted from earlier plays. His best-known work was the socially critical opera WOZZECK (1925); his second opera, LULU (1935), was based on two Frank Wedekind plays, *Earth Spirit* (1902) and *Pandora's Box* (1905). Berg also wrote considerable bodies of orchestral music and songs.

Bergen, Candice (1946–), U.S. actress, on screen from 1966 in such films as *The Group* (1966), *The Magus* (1968), CARNAL KNOWLEDGE (1971), *The Wind and the Lion* (1976), *Starting Over* (1979), RICH AND FAMOUS (1981), GANDHI (1982), and *Au Revoir, les Infants* (1987). Her photojournalistic work has appeared in several magazines. She is daughter of Edgar BERGEN. From 1989 she has had considerable success starring in television's "Murphy Brown."

Bergen, Edgar John (1903–1978), U.S. ventriloquist and actor, father of actress Candice BERGEN. He created his famous puppet Charlie MCCARTHY while still in high school, went into vaudeville with Charlie in 1926 and into films in 1933, became a star in radio after his guest appearance on the Rudy VALLEE show in 1936, and starred in his own radio show from 1937. During the next decade he became one of the most popular

The mesmerizing Max von Sydow (right center) and the young Bengt Ekirot in Ingmar Bergman's *The Magician* (1958).

of American performing artists. He created a second dummy character, Mortimer Snerd, in the late 1930s.

Bergman, Ingmar (1918–), Swedish director and writer, who from the early 1940s worked concurrently in film and theater and in the mid-1950s emerged as a major figure in the development of the art of film. Working with a group of gifted Swedish players who included Max von SYDOW; Bibi ANDERSSON; and Liv ULLMANN, his common-law wife for many years, and with cinematographer Sven NYKVIST, Bergman created such films as SMILES OF A SUMMER NIGHT (1955); WILD STRAWBERRIES (1957); THE MAGICIAN (1958); the OSCAR-winning THE VIRGIN SPRING (1960); the Oscar-winning THROUGH A GLASS DARKLY (1961); *Persona* (1966); *Cries and Whispers* (1972); SCENES FROM A MARRIAGE (1974); *Autumn Sonata* (1978); the Oscar-winning FANNY AND ALEXANDER (1982); and *After the Rehearsal* (1984), the latter three all first written for television. Bergman has for

decades also been a leading figure in the Swedish theater.

Bergman, Ingrid (1915–82), Swedish actress, in films from 1934, who re-created her 1936 Swedish role in *Intermezzo* in the 1939 English-language version, then stayed in Hollywood to become a major international film star, in such films as CASABLANCA (1943); FOR WHOM THE BELL TOLLS (1943); GASLIGHT (1944), for which she won a best actress OSCAR, and ARCH OF TRIUMPH (1948). Her career was seriously damaged in 1949 when she found herself effectively blacklisted in the United States after she left her husband and daughter for film director Roberto ROSSELLINI during the resurgent xenophobia of the McCarthy period in the United States. But her career revived considerably after the best actress Oscar was awarded for her performance in ANASTASIA (1956), which was made in Britain. She later won a best supporting actress Oscar for her work in MURDER ON THE ORIENT EXPRESS (1974). Bergman also appeared on stage and

won a best actress TONY for *Joan of Lorraine* (1946).

Bergner, Elisabeth (1900–86), Austrian actress, on stage from 1919, who became a leading player in Germany after her 1924 success in George Bernard SHAW's ST. JOAN, directed by Max REINHARDT. On screen from 1923, often in films directed by her husband, Paul Czinner, she became a star in such films as *Queen Louisa* (1928) and *Ariane* (1931). She and Czinner fled from Nazi Germany to Great Britain in 1933; there she starred in such films as *Catherine the Great* (1934), *Escape Me Never* (1935), and *As You Like It* (1936).

Berkeley, Busby (William Berkeley Enos, 1895–1976), U.S. choreographer and director, the child of a theatrical family, on stage from the age of five. He became a leading New York dance director in the 1920s and was in Hollywood from 1930. There, while the world was at the depths of the Great Depression, he developed the huge, extravagant, extraordinarily popular escapist musical production numbers that were his

Irving Berlin singing his own "Oh, How I Hate to Get Up in the Morning," from his World War I play *Yip Yip Yaphank* (1918).

hallmark, using innovative camera techniques that made a lasting impact on the development of the art of film. He choreographed such films as *Whoopee* (1930), 42ND STREET (1933), GOLD DIGGERS OF 1933 (and 1937), and *Ziegfeld Girl* (1941), also directing such films as GOLD DIGGERS OF 1935 and *Strike Up the Band* (1940).

Berle, Milton (Milton Berlinger, 1908–), U.S. comedian and actor, in films, vaudeville, and on stage as a child actor and then in variety as a stand-up comedian. He scored a major success in early television and dominated the comedy-variety side of the medium so completely that he was generally known as "Mr. Television" during the ascendancy of his "Texaco Star Theater" (1948–53). He continued to be an extremely popular figure in American television thereafter, late in his career also appearing in several strong supporting dramatic roles in films and television.

Berlin Alexanderplatz (1929), the novel by Alfred DÖBLIN; it was adapted for film in 1931 and again into Rainer Werner FASSBINDER's television miniseries, which became the 1980 film, with Gunther Lamprecht and Hanna Schygulla in the leads.

Berlin, Irving (Isadore Baline, 1888–1989), U.S. songwriter, who wrote many of the most popular American songs of the century; he wrote approximately 1,000 songs in all and the scores of many very popular theater and film musicals. His prodigious output began with the song "Marie from Sunny Italy" (1907), composed while working as a singing waiter on New York's East Side. It was ultimately to include such songs as ALEXANDER'S RAGTIME BAND; OH, HOW I HATE TO GET UP IN THE MORNING, from his World War I play *Yip Yip Yaphank* (1918), which he also featured in *This Is the Army* (1942); "A Pretty Girl Is Like a Melody," from the *Ziegfeld Follies of 1919*; BLUE SKIES, from the first talking film, THE JAZZ SINGER (1927); EASTER PARADE, from the play *As Thousands Cheer* (1933); WHITE CHRISTMAS, from the film *Holiday Inn* (1942); THERE'S NO BUSINESS LIKE SHOW BUSINESS, from the play ANNIE GET

Composer-conductor Leonard Bernstein rehearsing for the premiere of his *Songfest* (1977).

YOUR GUN (1946); and GOD BLESS AMERICA, written in 1918 for one war and introduced in 1938, in time for another. While many of his theater musicals were adapted for film, he also wrote the scores of many film musicals, including such Fred ASTAIRE–Ginger ROGERS vehicles as TOP HAT (1935), *Follow the Fleet* (1936), and *Carefree* (1938).

Bernanos, Georges (1888–1948), French writer, who took as his theme the conflict he perceived between Christianity and modern decadence. He explored that conflict in his first major novel, *Under the Sun of Satan* (1926), followed by *A Crime* (1935); THE DIARY OF A COUNTRY PRIEST (1936), by far his best-known work; and *Mouchette* (1937). He was a monarchist and was also associated with the fascist Action Française but with the Spanish Civil War and the rise of fascism in Europe reversed his position, parting with fascism in his influential *A Diary of My Times* (1938).

Bernstein, Leonard (1918–90), U.S. composer, conductor, and pianist, whose work covers a wide range of classical and popular forms. He

conducted several major symphony orchestras from 1943 and was musical director of the New York Philharmonic from 1958 to 1969. His early compositions include such works as his first symphony, the *Jeremiah* (1943); the ballet FANCY FREE (1944); and the Broadway musical ON THE TOWN (1944). He continued to write in classical and popular forms in such works as *Symphony No. 2, The Age of Anxiety* (1949), WONDERFUL TOWN (1953), WEST SIDE STORY (1957), the *Kaddish* symphony (1963), and the opera *A Quiet Place* (1983).

Berry, Chuck (1926–), U.S. singer and guitarist, an early ROCK-AND-ROLL figure who was popular in the late 1950s with such songs as "Roll Over Beethoven" (1956), "School Days" (1957), and "Rock-and-Roll Music" (1957). His career was severely damaged by a criminal conviction and jail sentence in the early 1960s.

Berryman, John (1914–72), U.S. writer, who emerged as a leading mid-20th-century American poet with his *Homage to Mistress Bradstreet* (1956). *77 Dream Songs* (1964) won a PULITZER PRIZE; it and *His Toy, His Dream, His Rest* (1968) were published as *Dream Songs* in 1969,

the combined works becoming by far his single most important work. His last substantial work was the largely autobiographical *Love and Fame* (1970). Berryman committed suicide in 1972.

Bertolucci, Bernardo (1940–), Italian film director, who gained critical attention for his *Before the Revolution* (1964) and *The Conformist* (1970) and worldwide popular attention for his LAST TANGO IN PARIS (1972), starring Marlon BRANDO, which was judged pornographic and banned in Italy and was generally perceived as a daringly sexual film in its time. He also directed the epic *1900* (1976); THE LAST EMPEROR (1987), for which he won a best director OSCAR, one of the nine Academy Awards won by the film; and *The Sheltering Sky* (1990).

"Bess, You Is My Woman Now" (1935), the classic song introduced by Todd Duncan as Porgy in the opera PORGY AND BESS (1935), with music by George GERSHWIN and words by Du Bose Heyward.

Best Man, The (1960), the Gore VIDAL play, produced shortly after the McCarthy period, about two candidates jockeying for their party's presidential nomination, one a conservative careerist who tries to win the nomination by smearing his opponent, the other a liberal who refuses to respond in kind, although evidence of his opponent's homosexual past is in hand. In the play, the protagonists were Melvyn DOUGLAS who won the TONY and Frank Lovejoy, with Lee Tracy as the outgoing President. Vidal adapted the play into Franklin J. SCHAFFNER's 1964 film, with Henry FONDA and Cliff ROBERTSON leading a cast that included Margaret Leighton, Edie Adams, and Lee Tracy again as the President.

Best Years of Our Lives, The (1946), the classic William WYLER film, a powerful treatment of the return home of three war veterans after World War II, and one of the most notable American films of the postwar period. Robert SHERWOOD wrote the screenplay, based on the 1945 McKinlay KANTOR novel. The leading roles were played by Fredric MARCH, Myrna LOY, Dana ANDREWS, and Teresa Wright, in a cast that included Virginia Mayo; Cathy O'Donnell; Hoagy CARMICHAEL; and Harold

Russell, a handless World War II veteran. The film, Wyler, Sherwood, March as best actor, and William Friedhofer for music all won OSCARS; Russell won a special Academy Award for the film.

Beyond the Horizon (1920), Eugene O'NEILL's first full-scale play, the story of two brothers and the woman they love, set on a New England farm. Edward ARNOLD, Richard BENNETT, and Helen MacKellar created the leads. The strong, original work broke new ground in the American theatre, established O'Neill as a leading playwright, and won a PULITZER PRIZE.

Bialik, Hayim Nachman (1873–1934), Russian-Jewish writer, editor, and translator, a leading 20th-century Hebrew poet; his early poem "City of Slaughter" (1903), dealt with the Kishinev massacres of that year and helped develop Jewish fighting resistance to further pogroms. His work also includes short stories, children's poems, religious texts, and a wide range of essays.

Bicycle Thief, The (1949), a classic film of the post-World War II Italian NEO-REALIST cinema; directed by Vittorio de SICA and written by Cesare ZAVATTINI, and with Lamberto Maggiorani in the leading role. It is the story of a poor working man who finally finds a job but whose vitally needed bicycle is stolen, and of his ultimately failed search for it with his young son. The film's powerfully developed themes of poverty, loneliness, and despair found a lasting worldwide audience.

Biederbecke, Bix (Leon Bismarck Biederbecke, 1903–31), U.S. musician, a JAZZ cornetist, pianist, and composer. In Chicago in the mid-1920s, he was one of the earliest significant White jazz musicians and was informally associated with Louis ARMSTRONG and other Black jazz artists, prefiguring the worldwide racial integration that would be characteristic of jazz in later times. He was with Paul WHITEMAN's orchestra from 1928 to 1930.

"Big Brother is watching you," the totalitarian slogan from George ORWELL's *1984*, his 1949 novel warning of the dangers posed by the development of the authoritarian state.

Big Chill, The (1983), the Lawrence Kasdan film, written by Kasdan and Barbara Benedek, about the reunion of a group of eight 1960s college classmates who have come together after the death of one of their former circle. The cast included Tom Berenger, Glenn CLOSE, Jeff Goldblum, William HURT, Kevin KLINE, Mary Kay Place, Meg Tilly, and JoBeth Williams.

Biggs, E. Power (Edward George Power Biggs, 1906–77), British-American organist and recording artist, whose 1942–58 weekly radio recitals on the Harvard University "classic" organ did much to popularize the instrument and its music, as did his many recordings.

Big Sleep, The (1939), the first novel of mystery writer Raymond CHANDLER, which was adapted by William FAULKNER, Leigh Brackett, and Jules Furthman into the classic 1946 Howard HAWKS film, with Humphrey BOGART in the Philip MARLOWE role, playing opposite Lauren BACALL in this fast-paced classic of the FILM NOIR style. Martha Vickers, John Ridgeley, Regis Toomey, Dorothy Malone, and Elisha COOK, Jr. played key supporting roles. Robert MITCHUM was Marlowe in the 1977 Michael Winner remake.

"**Bill**" (1927), Helen MORGAN's signature song; she introduced it on Broadway in SHOW BOAT (1927), and it then became identified with her. She also sang it in two film versions, in 1929 and in the classic 1936 remake. Music was by Jerome KERN, with words by Oscar HAMMERSTEIN II.

Billy Budd (1951), the opera by Benjamin BRITTEN, with libretto by E.M. FORSTER and Eric Crozier, adapted from Herman Melville's short novel, which was completed just before his death, in 1891; it is the powerful story of a press-ganged young sailor who becomes a victim of the shipboard system in which he finds himself and is ultimately quite legally murdered by it. The novel was also the basis of the 1949 Lewis O. Coxe–Robert H. Chapman play *Uniform of Flesh*, which they adapted into the 1962 Peter USTINOV film *Billy Budd*, with a cast that includes Robert RYAN, Ustinov, Melvyn DOUGLAS, and Terence Stamp as Billy Budd.

Billy Jack (1971), the Tom Laughlin film; he co-wrote the screenplay with Delores Taylor and directed and starred in this very popular rebel-with-a-cause story of man on the fringe of society, who equally well protects the wild horses of the southwestern desert and the children of an alternative school from conventional people and institutions. There were two sequels: *The Trial of Billy Jack* (1974) and *Billy Jack Goes to Washington* (1977).

Billy Liar (1963), the John SCHLESINGER film, about the fantasy life and world of a seemingly conventional young man in a northern English town. Tom COURTENAY led a cast that included Julie CHRISTIE, Mona Washbourne, Wilfred Pickles, Finlay CURRIE, and Ethel Griffies. Keith Waterhouse and Willis Hall adapted the work from their 1960 play, which was based on the Waterhouse novel.

Billy the Kid, the ballet choreographed by Eugene Loring, with music by Aaron COPLAND; a retelling of the folk legend in dance and a trend-setting work on American themes. It was first produced at Chicago, in October 1938, by Ballet Caravan.

Bing, Rudolf (1902–), Austrian-British opera manager, who worked at Darmstadt and Berlin from 1928, left Germany in 1933, was general manager of the Glyndebourne Opera 1936–48; artistic director and a founder of the Edinburgh Festival 1947–49; and general manager of the Metropolitan Opera 1950–72, in that position becoming a major influence in the development of American opera.

Bip, the mime character created by Marcel MARCEAU.

Bird in Flight, the celebrated series of increasingly abstract sculptures by Constantin BRANCUSI, which began in 1912 with the *Maiastra*, a depiction of the mythical bird; 28 versions later, in 1940, the work had evolved into the highly abstracted *Bird in Flight*. One version, *Bird in Space*, generated an American court action when customs officials had to be forced to admit the bird as a work of art rather than as a taxable piece of metal.

One of the many increasingly abstracted versions of Constantin Brancusi's *Bird in Flight*.

Birdman of Alcatraz (1961), the John FRANKENHEIMER film, starring Burt LANCASTER as murderer and later ornithologist Robert Stroud, imprisoned at Alcatraz for life, leading a cast that included Karl MALDEN, Edmond O'Brien, Betty Field, Thelma Ritter, Neville Brand, and Telly SAVALAS. Guy Trosper adapted the screenplay from the Thomas E. Gaddis book.

Birth of a Nation, The (1915), the D.W. GRIFFITH film, based on the novels *The Clansman* (the film's original title) and *The Leopard's Spots*, by Thomas E. Dixon, Jr., who also collaborated on the screenplay with Griffith and Frank E. Woods. Griffith also edited the film, which was shot by Billy BITZER. The leading roles were played by Lillian GISH, Mae Marsh, Henry B. Walthall, Ralph Lewis, and Miriam Cooper. The film was a landmark in cinema history, largely for its extraordinarily innovative technical side, though for its economic success as well. It was also an extraordinarily racist film, which glorified the Ku Klux Klan, generated race riots in several American cities, and contributed to the growth of the Klan as a national phenomenon during the 1920s.

Birtwhistle, Harrison (1934–), British composer, best known for the operas *Punch and Judy* (1967), *The Mask of Orpheus* (1983), and *Yan Tan Tethera* (1986) and for the orchestral work *The Triumph of Time* (1970). From 1975 he was musical director of the National Theatre and wrote incidental music for several plays.

Bishop, Elizabeth (1911–79), U.S. writer, whose *North and South—A Cold Spring* (1955), which included her first book, *North and South* (1946), won a PULITZER PRIZE; her *Complete Poems* (1969) won a National Book Award. Her poetry includes the 10-poem cycle *Geography III* (1976). She also wrote several travel books, having traveled widely before settling in Brazil.

Bisset, Jacqueline (1944–), British actress, on screen from 1965 in such films as *The Grasshopper* (1970), DAY FOR NIGHT (1973), MURDER ON THE ORIENT EXPRESS (1974), RICH AND FAMOUS (1981), UNDER THE VOLCANO (1983), *High Season* (1988), and *Scenes from the Class Struggle in Beverly Hills* (1989).

She has also appeared in such television films as *Choices* (1986) and *Forbidden* (1986).

Bitter Sweet (1929), the Noël COWARD musical; a story of young love set in late-19th-century Vienna, with a score that includes "I'LL SEE YOU AGAIN." It became the very popular 1933 Herbert Wilcox film, with Anna NEAGLE in the lead opposite Fernand Gravet, in a cast that included Ivy St. Helier, Esmé Percy, Kay Hammond, and Miles Mander. In 1940 it became the William S. VAN DYKE film, a vehicle for Jeannette MACDONALD and Nelson EDDY.

Bitzer, Billy (George William Bitzer, 1872–1944), U.S. pioneer cinematographer, who worked with Biograph as its leading camera operator from the turn of the century and very closely with D.W. GRIFFITH, 1908–20, in that period shooting all of Griffith's major films, including THE BIRTH OF A NATION (1915) and INTOLERANCE (1916). Bitzer was a great technical innovator, who with Griffith made many basic contributions to the art of film.

Bjoerling, Jussi (Johan Jonatan Bjoerling, 1911–60), Swedish tenor, on stage from the age of five, with his father and brothers as a quartet from 1916 to 1926 and at the Royal Swedish Opera from 1930, soon moving into leading roles. He became one of the most celebrated operatic tenors of his time and a very popular recording artist. From 1939 to 1941 and after World War II he was based largely in the United States, often in leading roles at the Metropolitan Opera.

Black and White in Color (1977), the Jean-Jacques Annaud film satire, about a group of French colonials in Africa who stumble toward an attack on a neighboring German fortification at the start of World War I, with a cast that included Mat Camison, Jean Carnet, Pierre Bachelet, Jacques Dufilho, Jacques Spiesser, and Catherine Rouvel. The work won a best foreign film OSCAR.

Blackboard Jungle, The (1955), the Richard BROOKS film, based on the Evan Hunter novel. Glenn FORD played the prototypically much-abused New York City schoolteacher, leading a cast that included a young Sidney POITIER, Anne Francis, Louis Calhern, and Vic Morrow. As the crises explored in the film

developed further, many more films on these themes followed in the next several decades.

blacklisting, placing the names of alleged subversives and other "undesirables" on government-generated and private lists, which are then used to deny them employment and destroy their careers, usually without even an opportunity to defend themselves. The practice was widespread in the United States from the late 1940s through the end of the McCarthy period, in the mid-1950s, though remnants of the practice continued long afterward. Blacklisting was particularly widespread and damaging to those in the film and television industries, driving many creative people abroad to seek work, forcing those who could to work under pseudonyms, as in the instance of some of the HOLLYWOOD TEN, destroying the careers of thousands, and in some instances promoting suicides. Blacklisting and the witch-hunting era of which it was a part also brought fear, self-censorship, and the loss of major creative people and is widely thought to have contributed greatly to the end of the "Golden Age" of American films.

Black Narcissus (1939), the Rumer Godden novel, about a group of nuns in the process of establishing a mission in the Himalayas, in then-British India. Michael POWELL and Emeric PRESSBURGER adapted the novel into their 1947 film; Deborah KERR played Sister Clodagh, leading a cast that included Flora ROBSON, Jean SIMMONS, David Farrar, Kathleen Byron, Sabu, and Esmond Knight. Jack Cardiff won an OSCAR for cinematography, as did Alfred Junge for art and sets.

Black Orpheus (1958), the Marcel Camus film, a retelling of the story of Orpheus and Eurydice set in the poorest districts of Rio de Janeiro during Carnival time, with an all-Black cast led by Breno Mello, Marpesa Dawn, and Adhemar Da Sylva. The screenplay, by Camus, Jacques Viot, and Vinicius de Moraes, was an adaptation of the Moraes play. The film won a best foreign film OSCAR.

Blake, Eubie (James Hubert Blake, 1883–1983), U.S. composer and pianist, a leading figure in RAGTIME, who with his partner Noble SISSLE composed and produced the most notable Black theater musical of the 1920s, SHUFFLE ALONG (1921), with its hit songs, I'M JUST WILD ABOUT HARRY and "Love Will Find a Way,"

the former becoming Harry S. Truman's campaign song in 1948. Blake wrote many other songs and was an active performer until his retirement in the early 1950s, reemerging in his late eighties to become a leading figure in the ragtime revival of the 1970s.

Blake, Nicholas, the pseudonym used by Cecil DAY LEWIS for his popular detective stories.

Blasco Ibañez, Vicente (1867–1928), Spanish writer and democratic leader, whose work portrayed the life of the poor in his native Valencia and attacked the role of the Catholic Church in Spain in such novels as *The Mayflower* (1895), *The Cabin* (1898), *The Shadow of the Cathedral* (1903), and *The Mob* (1905). He also wrote many popular novels, most notably THE FOUR HORSEMEN OF THE APOCALYPSE (1916), which became the classic 1921 Rex Ingram epic, starring Rudolph VALENTINO, redone in 1961 by Vincente MINNELLI; and BLOOD AND SAND (1908), which in 1922 became another extraordinarily popular Valentino vehicle, redone by Rouben MAMOULIAN in 1941, with Tyrone POWER in the lead.

Blaue Reiter, Der (The Blue Rider), a group of artists, most of them EXPRESSIONISTS, who exhibited together in the years 1911–14. Although they directly shared no specific style or school, they did share a desire to work freely in experimental, largely avant-garde styles and to create work of rich emotional and spiritual content, as indicated in the essays jointly edited by Franz MARC and Wassily KANDINSKY in 1911 and called *Der Blaue Reiter,* after a Kandinsky painting. In addition to Kandinsky and Marc, such artists as Paul KLEE, August MACKE, Jean ARP, and Maurice de VLAMINCK exhibited with the group during its brief existence, which was ended by the outbreak of World War I.

Blazing Saddles (1974), the Mel BROOKS film, a broad satire of the Western film genre. Cleavon Little was the ex-convict Black sheriff of a town full of bigots, and Gene Wilder was the whiskey-soaked Omaha Kid, in a cast that included Madeline Kahn, Harvey Korman, Slim Pickens, David Huddleston, Brooks, and Alex Karras.

Blithe Spirit (1941), the Noël COWARD comedy, set around a séance during which the lovely, spirited ghost of Charles Condomine's first wife arrives. Coward adapted his classic play into the equally classic 1945 David LEAN film, with a cast that included Rex HARRISON as Charles opposite Kay Hammond as the spirit of Elvira, Margaret Rutherford as Madame Arcati, Constance Cummings as Ruth Condomine, and Jacqueline Clark as Edith. Thomas Howard won an OSCAR for his special effects.

Blitzstein, Marc (1905–64), U.S. composer, whose left political musical *The Cradle Will Rock* (1937) provided a cause célèbre when the WPA's FEDERAL THEATRE PROJECT refused to support it as a MERCURY THEATRE production. Orson WELLES and John HOUSEMAN then moved it to another theater, where Blitzstein played the score from the stage while the cast performed from seats in the theater. His best-known work includes the symphony *Airborne* (1946); *Regina* (1949), based on THE LITTLE FOXES; and his long-running adaptation of Bertolt BRECHT and Kurt WEILL'S THE THREEPENNY OPERA (1954).

Blok, Aleksandr (1880–1921), Russian writer, a leading 20th-century poet and a key figure in the symbolist movement, whose early lyrical poems were collected in *Songs of the Beautiful Lady* (1904). With a failed marriage, coupled with the impact of the 1905 revolution, his work became far more powerful, much of it deeply pessimistic. His best-known work is *The Twelve* (1918), celebrating the victory of the Bolshevik Revolution of 1917. Blok's considerable body of work includes such verse plays as *The Puppet Show* (1906) and *The Rose and the Cross* (1912).

Blondell, Joan (1909–79), U.S. actress, on stage as a child with her parents in vaudeville, on the New York stage in the 1920s, and on screen from 1930, then playing leads and strong supporting roles for five decades in such films as *Sinners' Holiday* (1930), GOLD DIGGERS OF 1933, *Gold Diggers of 1937*, A TREE GROWS IN BROOKLYN (1945), and DESK SET (1957).

"Blondie," the extraordinarily popular comic strip created by Chic YOUNG in 1930; ultimately Blondie; Dagwood; their dog, Daisy; Mr. Dithers; Baby Dumpling; Cookie; and Dagwood's huge sandwiches, which went into the language, were syndicated in over 1,500 of the world's newspapers, generated 28 films

from 1938 to 1950, and also generated two brief television series (1957, 1968–69).

Blood and Sand (1908), the Vicente BLASCO IBAÑEZ novel, about a bullfighter and his loves, which in 1922 became the extraordinarily popular Rudolph VALENTINO film, directed by Fred Niblo. It was redone by Rouben MAMOULIAN in 1941, with Tyrone POWER in the lead.

Blood, Sweat, and Tears, U.S. band, founded by Al Kooper in 1967; he soon left, but the band, led by Steve Katz, Al Colomby, and singer David Clayton-Thomas, went on to become the first ROCK group to combine rock and JAZZ successfully, with its very popular, GRAMMY-winning *Blood, Sweat, and Tears* album of 1969, which contained "Spinning Wheel," "And When I Die," and "You've Made Me So Happy." Two more popular albums followed; by the early 1970s, though, the group's popularity had diminished, although it continued to perform.

Bloom, Claire (1931–), British actress, on stage from 1946 and on screen from 1948. From 1950 she was a leading Shakespearean player in Britain and from the mid-1950s in the United States as well, also playing in many modern classics. In 1952 she played opposite Charlie CHAPLIN in LIMELIGHT, becoming a major screen figure whose films have included *The Brothers Karamazov* (1958), LOOK BACK IN ANGER (1959), THE SPY WHO CAME IN FROM THE COLD (1965), *A Doll's House* (1973), and television's BRIDESHEAD REVISITED (1981).

Bloom, Leopold, the fictive character at the center of James JOYCE's ULYSSES. It is through Bloom's "stream of consciousness," as he moves through Dublin, that the work unfolds, and so he becomes a seminal figure in the literature of the century.

Bloomsbury Group, the several talented friends and acquaintances who lived, created, and informally met together in and around the Bloomsbury area of London during most of the first four decades of the 20th century. They were in no sense a movement but did share and develop some of their thinking, influencing their own work and that of others. They included such major figures as E.M. FORSTER, Virginia WOOLF, John Maynard Keynes, and Lytton STRACHEY, as well as the critics Roger FRY and

Clive BELL, the painters Vanessa BELL and Duncan Grant, and Leonard Woolf.

Blue Angel, The (1930), the classic Josef von STERNBERG film, based on the novel *The Small-Town Tyrant* (1905) by Heinrich Mann, with Emil JANNINGS in the role of the tyrannical schoolmaster who is seduced and destroyed by the cabaret singer Lola, played by Marlene DIETRICH in what became her breakthrough role.

Bluebeard, Michel FOKINE's final ballet, with music by Jacques Offenbach; it premiered in Mexico City in October 1941, with Anton DOLIN in the title role, opposite Alicia MARKOVA.

"Blue Eyes Cryin' in the Rain," a song first made popular by Roy ACUFF and remade with enormous success by Willie NELSON in his 1975 album *Redheaded Stranger*; words and music were by Fred Rose.

Blue Rider, The, the English translation of DER BLAUE REITER, the group of artists, most of them EXPRESSIONISTS, who exhibited together from 1911 to 1914.

blues, a southern Black musical form originating in work songs and Black country music, with its own 12- or 13-bar form, three-line lyrical form, and "blue note"; from the early 20th century, the blues became a major popular musical form, as sung by such artists as Bessie SMITH, Ma RAINEY, Big Bill BROONZY, and Blind Lemon JEFFERSON. From the mid-1920s, as Black migration from the southern countryside to northern industrial cities accelerated, a kind of "urban blues" developed, in the 1940s providing much of the basis for the development of the "rhythm-and-blues" style that was the precursor of ROCK.

"Blues in the Night" (1941), the title song for the 1941 Anatole LITVAK film, with music by Harold ARLEN and words by Johnny Mercer.

"Blue Skies" (1927), the Irving BERLIN song, introduced by Belle Baker in the Broadway musical *Betsy* (1927); both words and music were by Berlin. The song became identified with Al JOLSON after he sang it in the film THE JAZZ SINGER (1927). *Blue Skies* was also the title of the 1946 Fred ASTAIRE–Bing CROSBY film musical, directed by Fred Heisler, with songs by Berlin.

Blue Velvet (1986), the David Lynch film; he wrote the screenplay and directed. Kyle Mac-Lachlan, as the young man who finds murder, drugs, and several varieties of sexual aberration below the seemingly placid surface of small-town life, led a cast that included Dennis Hopper, Isabella Rossellini, Laura Dern, Dean Stockwell, and Hope Lange.

Bob and Carol and Ted and Alice (1969), the Paul MAZURSKY film, a conversation piece in its time, about two couples who swap mates while staying together in what was in the 1960s a sophisticated sexual foursome. Natalie WOOD and Robert Culp were one couple, Dyan Cannon and Elliott GOULD the other. A television series inspired by the work ran for a few months in 1973.

Boccioni, Umberto (1882–1915), Italian painter and sculptor, a student of Giacomo BALLA who in 1909 moved from Pointillism to become a leader in FUTURISM, with such works as *Riot in the Gallery* (1909) and *The City Rises* (1911). He and others issued the *Technical Manifesto of the Futurist Painters* (1910), and he issued the *Manifesto of Futurist Sculpture* in 1912, both works stressing the swift, violently emotional expression thought to properly depict the machine age, within the context of a resurgent Italian nationalism. Boccioni died while in the Italian armed forces during World War I.

Bogan, Louise (1897–1970), U.S. writer and critic, whose work includes *Body of This Death* (1923), *Dark Summer* (1929), *The Sleeping Fury* (1937), *Poems and New Poems* (1941), *Collected Poems* (1954), *The Blue Estuaries* (1968), and *A Poet's Alphabet* (1970).

Bogarde, Dirk (Derek van den Bogaerde, 1920–), British actor, who became a film star in light comedy, in *Doctor in the House* (1954) and its sequels, and later played substantial dramatic roles, as in *The Servant* (1963), *King and Country* (1964), DARLING (1965), THE DAMNED (1969), and DEATH IN VENICE (1970). Late in his career he wrote several well-received popular novels.

Bogart, Humphrey DeForest (1899–1957), U.S. actor, on stage in minor roles from 1922 and on screen from 1930, in the early years in no better roles. In 1934 he created the Duke Mantee role in THE PETRIFIED FOREST on Broadway and in 1936 re-created the role for

Humphrey Bogart and Ingrid Bergman as Rick and Elsa during their idyllic time in Paris, before they came to *Casablanca* (1943).

the film. He found himself then typecast as a villain, in such films as DEAD END (1937) and *The Roaring Twenties* (1939), breaking out of the stereotype and into worldwide recognition as one of the foremost film actors of the century in the classic THE MALTESE FALCON (1941). It was followed by such films as the equally classic CASABLANCA (1943); THE BIG SLEEP (1946); THE TREASURE OF THE SIERRA MADRE (1948); KEY LARGO (1948); THE AFRICAN QUEEN (1952), for which he won a best actor OSCAR; and THE CAINE MUTINY (1954). He and Lauren BACALL married after their first film together, TO HAVE AND HAVE NOT (1944).

Bogdanovich, Peter (1939–), U.S. writer and director, best known for his first major film, THE LAST PICTURE SHOW (1971). His films also include *What's Up, Doc?* (1972); PAPER MOON (1973); *Nickelodeon* (1976); and *Texasville* (1990), which he wrote and directed.

Bolero (1928), the ballet by Maurice RAVEL, first choreographed by NIJINSKA for the Paris-based company of Ida Rubinstein.

Bolger, Ray (1904–87), U.S. dancer and actor, on stage from 1922 and on screen from 1936. He danced and sang in such musicals as *George White's Scandals of 1931, On Your Toes* (1936), and *Where's Charley?* (1948), for which he won a TONY, and re-created the role on screen in 1952. Bolger is best known by far as the Scarecrow in THE WIZARD OF OZ (1936).

Böll, Heinrich Theodor (1917–85), German writer, whose experiences as a World War II German soldier deeply influenced much of his work, which focuses on the twin horrors of war and the Nazi period and on what he perceived as the gross hypocrisy of much of postwar German life. His early work includes such powerful, highly critical novels as *The Train Was on Time* (1949) and *Acquainted with the Night* (1953). He continued his attack on postwar materialism and hypocrisy, largely from a Catholic moralist point of view, in such novels as *Billiards at Half-Past Nine* (1959), *The Clown* (1963), *Group Portrait with a Lady* (1973), and *Safety Net* (1979) and such short-story collections as *Traveler, if You Come to Spa* (1950) and *Absent Without Leave and Other*

Stories (1964). All of these and his entire body of work also continued to remind Germany of its Nazi past. Böll was awarded the 1972 NOBEL PRIZE for literature.

Bolshoi Ballet, the historic Russian and then Soviet Moscow ballet company, established in 1776. For much of the Soviet period it remained a bastion of conservatism and of the classics, largely notable for such dancers as Galina ULANOVA and Maya PLISETSKAYA, though such Soviet classics as *The Red Poppy* (1927) and *The Stone Flower* (1954) did premiere at the Bolshoi.

Bolt, Robert Oxton (1924–), British playwright, screenwriter, and director, whose work was on stage from 1957 and on screen from 1962. His best-known plays include *Flowering Cherry* (1957), A MAN FOR ALL SEASONS (1961), and *Vivat! Vivat Regina* (1970). His best-known screenplays are those for LAWRENCE OF ARABIA (1962); DOCTOR ZHIVAGO (1965), for which he won an OSCAR; and his own *A Man For All Seasons* (1966), for which he won a second Oscar, while the film won six Oscars, including best picture. He also directed *Lady Caroline Lamb* (1972), *The Bounty* (1984), and *The Mission* (1986).

"Bonanza" (1959–73), the long-running television Western, with Lorne GREENE as late-19th-century Nevada rancher Ben Cartwright and Michael Landon, Dan Blocker, and Pernell Roberts as his sons.

Bond, James, 007, the fictional British secret agent created by Ian FLEMING in his series of very popular Cold War espionage novels, many of them adapted into even more popular films, most notably with Sean CONNERY in the James Bond role, beginning with *Doctor No* (1962); later films starred others, including Roger Moore and Timothy Dalton, although Connery returned in the eighties to play the role again.

Bondarchuk, Sergei (1920–), Soviet film director and actor, on stage from the late 1930s and on screen from 1948, who established himself as a leading actor in such films as *Taras Shevchenko* (1951) and *Othello* (1956), in which he played the title roles. He went on to become a leading director in such films as *Destiny of a*

Man (1959) and the OSCAR-winning epic WAR AND PEACE (1970), also playing leading roles in both of the latter films.

Bonnard, Pierre (1867–1947), French painter, one of the most celebrated colorists of the 20th century, from his first one-man show in 1904 through the interwar period. His scenes of family and Parisian life, while sometimes using somewhat abstracted forms, are largely independent of the main modernist approaches of his time yet wholly in the mainstream of Western art. He was part of no 20th-century movement in art, although for some years, in the 1890s, he and a few friends were briefly known and exhibited together at the "Nabis," Hebrew for *Prophets*. Bonnard was also a gifted illustrator, poster artist, and set designer, whose work had considerable impact on the development of the French decorative arts.

Bonnie and Clyde (1967), the Arthur PENN film about Bonnie Parker and Clyde Barrow, mid-American murderers and armed robbers of the 1930s who became folk heroes. Warren BEATTY and Faye DUNAWAY played the leads, in a cast that included Estelle Parsons, Gene HACKMAN, Michael J. Pollard, Gene Wilder, and Dub Taylor. David Newman and Robert BENTON wrote the screenplay. Parsons won a best supporting actress OSCAR, as did Burnett Guffey for cinematography.

Booth, Shirley (Thelma Booth Ford, 1907–), U.S. actress, on stage from 1919 and a star on radio in "Duffy's Tavern" (1940–43). Her most notable stage role was that of Lola Delaney in COME BACK LITTLE SHEBA (1950), for which she won a best actress TONY. She won a best actress OSCAR as Lola in the 1952 film, later starring in *The Matchmaker* (1958) and in the television series "Hazel" (1961–65). Booth won a second best actress Tony for *Time of the Cuckoo* (1952).

bop, be-bop, or **re-bop,** a highly improvisational and complex JAZZ form developed in the 1940s and developed largely in New York City by such jazz musicians as Dizzy GILLESPIE, Charlie PARKER, Thelonius MONK, and Bud POWELL.

Borges, Jorge Luis (1899–1986), Argentinian writer, a leading Latin American prose fantasist and poet, whose first book was a collection of poems, *Fervor de Buenos Aires* (1923), and whose stories are collected in such volumes as *Fictions* (1935–44), *The Aleph* (1949), *Dream Tigers* (1960), and *The Book of Imaginary Beings* (1969). He also published a considerable body of essays.

Borglum, John Gutzon (1867–1941), U.S. sculptor, best known by far for his monumental American presidential sculptures on Mount Rushmore, South Dakota. The work was begun in 1927; Washington was finished in 1930; Franklin Delano Roosevelt dedicated the Jefferson sculpture in 1936; Lincoln was finished in 1937, and Theodore Roosevelt in 1939. Borglum's other works include the Lincoln head in the rotunda of the Capitol in Washington, D.C. and the Confederate memorial at Stone Mountain, Georgia, begun in 1916 and unfinished.

Born Free and Equal (1944), the Ansel ADAMS photographic essay on interned Japanese-Americans at the Manzanar detention camp during World War II; the work became a landmark call for social justice.

Born on the Fourth of July (1989), the Oliver STONE film, based on Ron Kovic's autobiographial book about a paralyzed, disillusioned Vietnam veteran who becomes an antiwar activist. The cast was led by Tom CRUISE as Kovic and included Kyra Sedgwick, Frank Whaley, Raymond J. Barry, Caroline Kava, Cordelia Gonzalez, Jerry Levine, and Willem Dafoe. Stone and Kovic wrote the screenplay. Stone won a best director OSCAR, and David Brenner won an Oscar for his editing.

Born Yesterday (1946), the long-running Garson KANIN comedy, with Judy HOLLIDAY as Billie Dawn, the quintessential far-from-dumb blonde, opposite Paul Douglas as junk profiteer Harry Brock and Gary Merrill as Paul Verrall, a young writer. Holliday won a best actress OSCAR in the 1950 George CUKOR film version, opposite Broderick CRAWFORD as Harry and William HOLDEN as Paul.

Borzage, Frank (1893–1962), U.S. director and actor, on screen as an actor from 1912 and

as a director from 1916, whose work includes several silent and sound-film classics, including SEVENTH HEAVEN (1927), for which he won a best director OSCAR; *Liliom* (1930); *Bad Girl* (1931), for which he won another OSCAR; A FAREWELL TO ARMS (1932); THREE COMRADES (1938); and THE MORTAL STORM (1940).

"Both Sides Now" (1967; alternately named "Clouds"), a Joni MITCHELL song, with words and music by Mitchell; it became most popular in the Judy COLLINS version, sung in her 1971 album of that name.

Boulanger, Nadia Juliette (1887–1979), French teacher and conductor, closely associated with Igor STRAVINSKY and a student of Gabriel FAURÉ at the Paris Conservatory. She became one of the most celebrated composition teachers of the century, from 1921 at the American Conservatory at Fontainebleau, with such students as Elliott CARTER, Aaron COPLAND, Philip GLASS, Walter PISTON, Roger SESSIONS, and Virgil THOMPSON.

Boulez, Pierre (1925–), French conductor and composer, from the mid-1940s a leader of the modern movement in classical music and concerned with the development of new forms and structures, as exemplified by the work of his colleague Karlheinz STOCKHAUSEN. Boulez was the conductor of the BBC Symphony Orchestra, 1971–74, and of the New York Philharmonic, 1971–78.

Boulle, Pierre François (1912–), French writer, who drew on his wartime experiences in Southeast Asia in creating his novel THE BRIDGE ON THE RIVER KWAI (1952), which became the classic 1957 David LEAN film. His science-fiction novel *Planet of the Apes* (1963) was adapted by Michael Wilson and Rod Serling into the 1968 Franklin J. SCHAFFNER film, with Charlton HESTON in the lead.

Boulting, John (1913–85) and **Roy** (1913–), British directors and producers, twin brothers, whose early works include such dramas as *Pastor Hall* (1939), *Thunder Rock* (1942), *Fame Is the Spur* (1946), and *Seven Days to Noon*; they later turned to light satire with such films as *I'm All Right, Jack* (1959) and *Rotten to the Core* (1965).

Bound for Glory (1976), the Hal ASHBY film biography of Woody GUTHRIE, focusing on Guthrie's life as a wandering folk and protest singer during the late 1930s; David Carradine was Guthrie, leading a cast that included Melinda Dillon, Ronny Cox, and Gail Strickland. The screenplay was written by Howard Getchell, based on Guthrie's 1943 autobiography of that name. Haskell Wexler won an OSCAR for cinematography and Leonard Rosenman for music; the powerful old songs were by Guthrie.

Bourke-White, Margaret (1906–71), U.S. photographer, one of the leading photojournalists of the 20th century. YOU HAVE SEEN THEIR FACES (1937), her stark photo-essay on the Depression-era American South, with text by her husband, Erskine CALDWELL, was one of the most powerful documents to emerge from that period. She was a staff photographer for *Fortune* magazine from 1929 to 1933 and traveled and photographed throughout the Soviet Union in the early 1930s, publishing such photo-essays as *Eyes on Russia* (1931). She did the first cover of *Life* magazine in 1936; covered World War II from 1939; was a front-line war photographer in Africa, Italy, and Germany; and in 1942 was the first woman war correspondent accredited by the U.S. Army. Bourke-White was present at the liberation of Buchenwald; her photographs caught the horror of the place, shocked the world, and became one of the centerpieces of 20th-century photojournalism. In the late 1940s she covered the fight for Indian independence and the emerging apartheid system in South Africa. Then she went to war again, in Korea, and caught it all on film, for a huge mass audience and for the historical record. She also did several other books, including *North of the Danube* (1939) and *Say! Is This the U.S.A.?* (1941), both with Caldwell, as well as *Shooting the Russian War* (1942) and *Purple Heart Valley* (1944).

Bow, Clara (1905–65), U.S. actress, in movie bit parts from 1922, graduating to leads in 1925, who became one of the most popular stars of the 1920s in *It* (1927), thereafter being successfully promoted as the quintessential "flapper," the IT GIRL. A rather taxing and

exhibitionist personal life, poor health, and the advent of sound brought her career to an end in the early 1930s.

Bowen, Elizabeth (1899–1973), Anglo-Irish writer, who emerged as a substantial novelist in the late 1920s with *The Hotel* (1927) and *The Last September* (1929). Some of her best-known novels are *The House in Paris* (1935), *The Death of the Heart* (1938), *The Heat of the Day* (1949), and *A World of Love* (1955). She also wrote several volumes of short stories and was a prolific essayist.

Bowie, David (David Robert Jones, 1947–), British musician and actor, who early in his career often presented himself in bizarre costumes but emerged as one of the most durable and flexible ROCK singers of his time, with such recordings as *Space Oddity* (1969), *The Man Who Sold the World* (1971), *The Rise and Fall of Ziggy Stardust and the Spiders from Mars* (1972), *Low*, *Heroes* (1977), and *Let's Dance* (1983). He also starred as the alien being in the Nicholas Roeg film *The Man Who Fell to Earth* (1976), played a major role in Nagisa OSHIMA's *Merry Christmas, Mr. Lawrence* (1983), and appeared in THE LAST TEMPTATION OF CHRIST (1988) and several other films. He appeared on Broadway in THE ELEPHANT MAN (1980) and on television in Bertolt BRECHT's *Baal* (1982).

Boyd, William (1952–), British writer. His first novel, *A Good Man in Africa* (1981), won a Whitbread Award and was followed by the novels *An Ice-Cream War* (1982) and *Stars and Bars* (1985) and the short stories collected in *On the Yankee Station and Other Stories* (1981). He adapted *Stars and Bars* into the 1988 Pat O'Connor film, starring Daniel DAY LEWIS, in a cast that included Harry Dean Stanton, Martha Plimpton, Joan Cusack, and Laurie Metcalf. He has also written several telefilm scripts.

Boyd, William (1898–1972), U.S. actor, on screen from 1920, who played many silent-film leads during the 1920s, made the transition to sound, and in 1935 originated the Hopalong Cassidy role, which he then played in 66 films, producing the last 12 himself. When television came he recut the old films into television epi-

sodes, creating the extremely popular "Hopalong Cassidy" show, and also produced 52 new episodes for the medium.

Boyer, Charles (1897–1978), French actor, on stage and in films in France during the 1920s and in leading roles in European and American films from the early 1930s. The roles that established him as one of the great romantic leads of Hollywood's Golden Age were in such films as *The Garden of Allah* (1936), *Algiers* (1937), BACK STREET (1941), GASLIGHT (1944), and ARCH OF TRIUMPH (1948); he also displayed his considerable talents as a dramatic actor in the antifascist *Confidential Agent* (1945). His later films include *The Happy Time* (1952) and FANNY (1961). He resumed his stage career in America, in the late 1940s, most notably in *Don Juan in Hell* (1951).

Boy George (George Alan O'Dowd, 1957–), British singer, who became a leading popular singer in the early 1980s, with his band, the Culture Club, in such albums as *Kissing to Be Clever* (1982) and *Colour by Numbers* (1983). He often cross-dressed in his public appearances, making a point of being androgynous.

Bradbury, Ray (1920–), U.S. writer, who became a leading science-fiction magazine writer in the early 1940s and a substantial novelist and short-story writer in the 1950s, with such short-story collections as *The Martian Chronicles* (1950) and *The Golden Apples of the Sun* (1953) and such novels as FAHRENHEIT 451 (1953), which became the 1967 François TRUFFAUT film, and *Dandelion Wine* (1957). His screenplays include MOBY DICK (1954).

Brain, Dennis (1921–57), British musician, one of the leading French-horn and German-double-horn players of his time. From 1938 he toured widely in chamber groups and during the postwar period was a leading soloist with the Royal Philharmonic and Philharmonia orchestras, as well as a prolific recording artist. He was the son of horn player Aubrey Brain, the nephew of horn player Alfred Brain, and the brother of oboist Leonard Brain.

Braine, John Gerard (1922–86), British writer, one of the "angry young men" of the late 1950s, who suddenly emerged as a major nov-

elist with his ROOM AT THE TOP (1957), which was adapted into the very notable 1958 film. His sequel, *Life at the Top* (1962), became a much less successful film. He also wrote such novels as *The Queen of a Distant Country* (1972) and *The Two of Us* (1984).

Branagh, Kenneth (1960–), British actor and director, who emerged as a major figure in the 1980s. His notable theater work began with *Another Country* in 1982 and included highly regarded versions of *Hamlet* and *Henry V*; in 1987 he founded the Renaissance Theatre Company. He also appeared in several television films, most notably in *The Fortunes of War* (1987). Branagh's films include *A Month in the Country* (1987) and HENRY V (1989); he starred in, adapted, and directed the latter.

Brancusi, Constantin (1876–1957), Rumanian sculptor, resident in France from 1904; one of the leading sculptors of the 20th century, he was engaged in a lifelong, continuous move from figurative work to more fully abstracted forms that better and better expressed the qualities or essences of his sculpted objects and deeply influenced the development of world sculpture. His early work was inspired by Auguste Rodin, but by 1907 the process of abstraction had begun, in *The Prayer*, a process most evident in several celebrated evolutionary works in which he moved in many versions from the figurative to the fully abstracted work. An example: his BIRD IN FLIGHT series began with a very recognizable mythical bird, the 1912 *Maiastra*; 28 versions later, in 1940, it was the highly abstracted *Bird in Flight*. Indeed, the bird had become so abstracted by 1926 that American customs officials had to be forced by court order to admit a *Bird in Space* version as a work of art for an American show of Brancusi's work, rather than taxing it as a piece of metal. His celebrated egg also became highly abstracted between 1910 and the creation of *The Beginning of the World* (1924), as did his *Endless Column*, *The Kiss*, and *Fish* series. He did many major single works as well, some of them reflecting the influence of highly abstracted Black African forms.

Brando, Marlon (1924–), U.S. actor, in I REMEMBER MAMA (1944) and several other Broadway plays before his major role as Stanley KOWALSKI in A STREETCAR NAMED DESIRE (1947). This established him as one of the most innovative actors of his time and powerfully and definitively introduced the STANISLAVSKY-based set of techniques taught at the ACTORS STUDIO and later known as THE METHOD to the American theater. Brando's film career began with *The Men* (1950). He re-created the Stanley Kowalski role in the 1951 film of *Streetcar* and then played in such films as *Viva Zapata!* (1952), *Julius Caesar* (1953), and ON THE WATERFRONT (1954), winning a best actor OSCAR for *On the Waterfront*, along with Oscar nominations for several other roles. Brando directed and starred in *One-Eyed Jacks* (1961), and during the balance of the 1960s he continued to play in leads, but without great success. In 1972 he created the Vito CORLEONE role in THE GODFATHER, winning another best actor Oscar, but one he refused, as a symbol of his identification with the Native American cause. In 1972 he also appeared in LAST TANGO IN PARIS, at the time considered a daring film for its explicitly sexual content. He later appeared infrequently, usually in strong character roles in such films as APOCALYPSE NOW (1979), and moved into comedy with his self-parody of the Vito Corleone role in *The Freshman* (1990).

Brandt, Bill (1905–83), British photographer, whose works portray British life during the 1930s, often in semisurreal, rather abstracted style. His 1930s collections are *The English at Home* (1936) and *London at Night* (1938). During World War II he worked for the British government, documenting London's wartime experience. Much of his later work developed abstracted experimental forms, as most notably expressed in his collection *Perspective of Nudes* (1961).

Braque, Georges (1882–1963), French painter, who was in the early 1900s briefly an Impressionist and then a FAUVIST; he met Pablo PICASSO in 1907 and became one of the founders of CUBISM, producing such trailblazing works as *Houses at L'Estaque* (1908), *Man with a Guitar* (1911), *The Portuguese* (1911), and the early collage *Fruit Dish and Glass* (1912) in that period with Picasso importing the collage into

modern painting. Braque continued to include elements of cubism in his work throughout his life, though by the late 1920s he had moved to the still lifes and portraits that constitute much of his mature work.

Brassaï (Gyula Halász, 1899–1984), French photographer, best known for his 1930s pictures of Paris at night and of the underside of Parisian life, most notably collected in *Paris by Night* (1933).

Brave New World (1932), the Aldous HUXLEY novel, in which he portrays a future "Utopia" in which an omnipresent bureaucratic state controls human development and social organization. The book was in particular an attack upon the eugenics theories of the time, and so an attack upon fascism. Simultaneously, it foreshadowed the very real genetic-engineering concerns that emerged later in the century.

Breakfast at Tiffany's (1958), the Truman CAPOTE novella, set in New York; George Axelrod adapted it into the 1961 Blake EDWARDS film, with Audrey HEPBURN in the Holly Golightly role, opposite George Peppard, in a cast that included Patricia NEAL, Martin Balsam, Mickey ROONEY, and Buddy Ebsen. Henry MANCINI and Johnny MERCER won an OSCAR for the song "Moon River."

Bream, Julian Alexander (1933–), British guitarist, lutenist, and musicologist, considerably responsible for the 20th-century revival of the Elizabethan lute song and interest in the lute; in 1959 he founded the Bream Consort.

Breathless (1959), Jean-Luc GODARD's trend-setting NEW WAVE film, with Jean-Paul BELMONDO as the murderous, doomed existential French gangster, opposite Jean Seberg as the American lover who ultimately betrays him, with a screenplay written by François TRUFFAUT. The film was remade by Jim McBride in 1983, with Richard GERE and Valerie Kaprisky in the leads.

Brecht, Bertolt (Eugen Berthold Friedrich Brecht, 1898–1956), German writer, one of the seminal playwrights of the 20th century, whose powerful, highly innovative, often greatly abstracted work strongly influenced the development of the world theater. His early work reflected his discontent with German society,

and he became the leading playwright of dissent of the Weimar period, with *Baal* (1918); *Drums in the Night* (1922), which brought wide recognition of his talents; *In the Swamp* (1923); *A Man's a Man* (1925); and *The Rise and Fall of the City of Mahagonny* (1927) and *The Three-penny Opera* (1928), both done in collaboration with Kurt WEILL. He became a Marxist in the late 1920s and fled Germany in 1933, writing several major works in Scandinavian exile (1933–41); these include *Mother Courage, The Good Woman of Setzuan*, and *Galileo*. He lived in the United States from 1941 to 1947, there writing *The Caucasian Chalk Circle* (1945) and the story for Fritz LANG's film *Hangmen Also Die* (1943). He returned to Europe immediately after testifying before the House Un-American Activities Committee in 1947. In 1949 he and his wife, actress Helene WIEGEL, founded the BERLINER ENSEMBLE. Brecht was also a prolific poet and essayist, his work in these areas antedating his playwriting; his theater essays are an important element of his impact on the theater.

Brel, Jacques (1929–78), French cabaret singer and recording artist, very popular in France from the late 1950s and popular in the United States from the mid-1960s; the New York cabaret show *Jacques Brel Is Alive and Well and Living in Paris* (1968) generated a widely distributed record.

Brent, George (George Brendan Nolan, 1904–79), Irish-American actor, on stage in Ireland briefly in the early 1920s, on stage in the United States from the mid-1920s, and on screen from 1931; he became a star during Hollywood's Golden Age, in such films as 42ND STREET (1933), *The Painted Veil* (1934), *Jezebel* (1938), DARK VICTORY (1939), *Till We Meet Again* (1940), *The Rains Came* (1939), *The Great Lie* (1941), and *The Spiral Staircase* (1945).

Bresson, Robert (1907–), French director, whose strongly original work and thinking had considerable impact on his chosen medium, although his output was relatively modest. His work includes such films as *Angels of the Streets* (1943), *Ladies of the Bois de Boulogne* (1945), DIARY OF A COUNTRY PRIEST (1951), *A Man Escaped* (1956), *Pickpocket* (1959), *The Trial of*

Joan of Arc (1962), *Balthazar* (1966), *Mouchette* (1966), *Lancelot of the Lake* (1974), and *L'Argent* (1983).

Breton, André (1896–1966), French writer and editor, a founder of SURREALISM and its chief exponent; he espoused DADA in 1916, co-founded the magazine *Littérature* in 1919, experimented with automatic writing in the early 1920s, and in 1924 published his centrally important *Manifesto of Surrealism*, which was followed by additional surrealist manifestos in 1930 and 1942. He also published several collections of poetry and the novel *Nadja* (1928).

Breuer, Marcel Lajos (1902–81), Hungarian architect and designer, a leading figure in the development of the INTERNATIONAL STYLE; he was a student and then teacher at the BAUHAUS at Weimar and then Dessau from 1920 to 1928, there in 1925 inventing the tubular steel chair. He then practiced in Berlin and London, also designing innovative plywood furniture, before emigrating to the United States in 1937. Breuer taught architecture at Harvard from 1937 to 1946, and during the postwar period became a major figure in American architecture, with such structures as the IBM Research Center at La Gaude, France (1961), St. John's Abbey at Benedictine College (Collegeville, Minnesota, 1961), and New York's Whitney Museum of American Art (1966). His later work includes massive, often virtually windowless concrete structures that were viewed by some as a starkly antihuman development of the International Style and by others as a powerful development of that style and his work.

Brice, Fanny (Fanny Borach, 1891–1951), U.S. singer and actress, on stage from 1909, who became a leading musical-theater performer in the *Ziegfeld Follies of 1910* and who maintained her popularity through a succession of *Follies* and other shows, into the middle 1930s. She introduced several of the best-remembered songs of the time, including "Rose of Washington Square"; SECONDHAND ROSE; and MY MAN, a torch song that became one of the great hits of the 1920s in Europe and America and was publicly associated with her failed marriage to gambler Nicky Arnstein. In

the mid-1930s she entered a new phase of her career, playing the role of BABY SNOOKS on radio. She appeared in several films, including *My Man* (1928) and *The Great Ziegfeld* (1936). The films *Rose of Washington Square* (1938), FUNNY GIRL (1968), and *Funny Lady* (1975) were based on her life.

Brideshead Revisited (1945), the Evelyn WAUGH novel, about a titled Anglo-Catholic family during the interwar period, as seen through the eyes of a young family friend. It was adapted by John MORTIMER into the 11-part 1982 television series, with Jeremy Irons, Anthony Andrews, Laurence OLIVIER, Claire BLOOM, and Diana Quick in leading roles.

Bridge, The, the English translation of DIE BRÜCKE; the group of artists, most of them German, whose association and work during the years 1905–13 helped shape German EXPRESSIONISM.

Bridge on the River Kwai, The (1952), the Pierre BOULLE novel, which was covertly adapted by Carl Foreman and Michael Wilson, both then blacklisted by the film industry, into the classic, OSCAR-winning 1957 David LEAN film, with Alec GUINNESS, William HOLDEN, Jack HAWKINS, and Sessue Hayakawa in key roles. Lean and Guinness, among others, won Oscars for the film. One of the others was Boulle, who was listed as the writer of the screenplay, though he spoke only French.

"Bridge Over Troubled Water," the Paul SIMON song, introduced by SIMON AND GARFUNKEL in 1970, and the title song of their 1970 album; the song became a new standard recorded by many singers, notably Willie NELSON in the late 1970s.

Bridges, Beau (Lloyd Vernet Bridges III, 1941–), U.S. actor, on screen as a child in small roles; he emerged as a leading player in such films as *Gaily Gaily* (1969), *The Landlord* (1970), *The Other Side of the Mountain* (1975), NORMA RAE (1979), *Heart Like a Wheel* (1983), *The Wild Pair* (1987), *The Fabulous Baker Boys* (1989), and *The Iron Triangle* (1989). He is the son of actor Lloyd BRIDGES and the brother of actor Jeff BRIDGES.

Bridges, Jeff (1949–), U.S. actor, on screen from 1970 in such films as THE LAST

Alec Guinness (right) and Sessue Hayakawa near the climax of *The Bridge on the River Kwai* (1957).

PICTURE SHOW (1971), *Hearts of the West* (1975), *Winter Kills* (1979), HEAVEN'S GATE (1980), *Starman* (1984), *The Morning After* (1986), TUCKER (1989), *The Fabulous Baker Boys* (1989), and *Texasville* (1990). He is the son of actor Lloyd BRIDGES and the brother of actor Beau BRIDGES.

Bridges, Lloyd (1913–), U.S. actor, on screen from 1941; a few of his more notable films are *Talk of the Town* (1942), *A Walk in the Sun* (1945), HOME OF THE BRAVE (1949), HIGH NOON (1952), and *The Goddess* (1958). His many television appearances included a starring role in the series "Sea Hunt" (1957–60). He is the father of actors Beau BRIDGES and Jeff BRIDGES.

Brief Encounter (1945), the David LEAN film, adapted by Noël COWARD from his one-act play *Still Life* (1936), in which Celia JOHNSON and Trevor HOWARD play strangers who meet at a train station, are quickly drawn into a passionate attachment, yet ultimately return to their marriages; it was written, directed, and played with extraordinarily effective understatement.

"Bringing Up Father," the long-running comic strip, featuring Maggie and Jiggs as a newly rich couple in a rather unfamiliar world; it was originated by George MCMANUS in 1913 and drawn by him until his death in 1954.

Britten, Edward Benjamin (1913–76), British composer; his notable early works include an homage to his teacher Frank Bridge in *Bridge Variations* (1937), as well as several collaborations with W.H. AUDEN, as in the vocal and orchestral work *Our Hunting Fathers* (1936). A pacifist, Britten and his longtime companion and colleague Peter PEARS went to America in 1939; there the collaboration with Auden continued, in Britten's first opera, *Paul Bunyan* (1941). His second opera was PETER GRIMES (1945), one of the several works that established him as one of the leading opera composers of the century. His later operas include *The Rape of Lucretia* (1946), *Albert Herring* (1947), BILLY BUDD (1951), *The Turn of the Screw* (1954), *A Midsummer Night's Dream* (1960), *Owen Wingate* (1970), and DEATH IN VENICE (1973). Many of his operas contained roles created with Peter Pears in mind, as did such

highly regarded song cycles as *Seven Sonnets of Michelangelo* (1940), written for Pears; *The Holy Sonnets of John Donne* (1945); and *Songs and Proverbs of William Blake* (1965). He also composed many orchestral and vocal works, including the *War Requiem* (1962), based in part on the World War I poems of Wilfrid OWEN. Britten founded the English Opera Group in 1946, and in 1948 he and Pears were among the founders of the Aldeburgh Festival.

Broderick, Matthew (1962–), U.S. actor, on stage from 1981 and on screen from 1983, who emerged as a leading player on Broadway in such plays as *Torch Song Trilogy* (1981); *Brighton Beach Memoirs* (1983), for which he won a TONY; *Biloxi Blues* (1985); and *The Widow Claire* (1986). Simultaneously he built a movie career in such adventure films as *Max Dugan Returns* (1983), *Wargames* (1983), and *Ladyhawke* (1985); the film version of *Biloxi Blues* (1988); very notably as Robert Gould Shaw in GLORY (1988); and opposite Marlon BRANDO in *The Freshman* (1990).

Brodsky, Joseph Alexandrovich (1940–), Soviet writer, who began writing poetry for publication in the underground Soviet press while still in his teens and soon become a leading voice of dissent. He was imprisoned in Siberia, 1964–65, and emigrated to the United States in 1972. His published works include *A Christmas Ballad* (1962), *Isaac and Abraham* (1963), *New Stanzas to Augusta* (1964), *Verses on the Death of T.S. Eliot* (1965), *Verses and Poems* (1965), *Elegy to John Donne and Other Poems* (1967), *Song Without Music* (1969), *A Stop in the Desert: Verse and Poems* (1970), *Selected Poems* (1973), and *A Part of Speech* (1979). He also has published a considerable number of essays. He was awarded the NOBEL PRIZE for literature in 1987.

Broken Blossoms (1919), a film produced, directed, and written by D.W. GRIFFITH, based on "The Chink and the Chinaman," a short story by Thomas Burke. In it a Chinese shopkeeper in London's Limehouse tries to protect a young girl from her abusive father, but the father ultimately kills her and is himself killed by the Chinese man, who then commits suicide. Lillian GISH was the girl; Richard

Barthelmess played the shopkeeper and Donald Crisp the father.

Bromfield, Louis (1896–1956), U.S. writer, a journalist who became a novelist; his first four novels were the tetralogy *Escape*, consisting of *The Green Bay Tree* (1924), which he adapted for the stage as *The House of Woman* (1927); *Possession* (1925); the PULITZER PRIZE-winning *Early Autumn* (1926); and *A Good Woman* (1927). His later works include *The Rains Came* (1937), which became the 1939 Clarence BROWN film, starring Myrna LOY and Tyrone POWER; and *Mrs. Parkington* (1942), which became the 1944 Tay Garnett film, with Greer GARSON in the title role.

Bronson, Charles (Charles Buchinsky, 1921–), U.S. actor, on screen from 1951, who played supporting roles and later leads in scores of minor Westerns, war, and gangster films until the late 1960s, when he quite suddenly became a major international star in precisely the same kinds of films after leaving Hollywood for Europe, where his hard, violent, but understated persona was far better appreciated. Returning to the United States in the early 1970s, he continued to star in the same kinds of films, the American public having in the interim become conditioned to them. He is probably best known for his DEATH WISH group of films.

Brook, Peter Stephen Paul (1925–), British director, whose main work was in the theater, but who also directed in opera and film. Beginning with his Birmingham Repertory *King John* (1945), he directed dozens of classics and modern classics, in 1962 becoming a codirector of the ROYAL SHAKESPEARE COMPANY and in that year directing Paul SCOFIELD in *King Lear*. In 1964 he directed MARAT/SADE in London, directing it on screen in 1967. His highly experimental *A Midsummer Night's Dream* (1970) was followed in that year by his establishment of the Paris-based International Centre of Theatrical Research. His epic MAHABHARATA (1985) was first performed in France, then toured the world; his film version opened in 1989.

Brooke, Rupert (1887–1915), British poet, whose first volume of *Poems* (1911) was the

only one published during his lifetime. He enlisted in 1914, wrote his celebrated war poems that year, and died of blood poisoning on the island of Skyros, in the Mediterranean, on April 23, 1915. His war poems were published posthumously, in 1915, as *1914 and Other Poems*.

Brookner, Anita (1938–), British writer, art historian, and teacher, whose early works include studies of Watteau, Greuze, and David. She later wrote several novels, beginning with *A Start in Life* (1981) and including *Providence* (1982), the Booker Prize-winning *Hotel du Lac* (1984), and *A Friend from England* (1987).

Brooks, Gwendolyn (1917–), U.S. writer, whose work focused on the Black American experience; her poetry collections include *A Street in Bronzeville* (1945), the PULITZER PRIZE-winning *Annie Allen* (1949), *The Bean Eaters* (1960), *In the Mecca* (1964), and *Family Pictures* (1970).

Brooks, Louise (1906–85), U.S. actress and dancer, on screen in silent films from 1925. She became notable in film history chiefly for two 1929 silent-film classics made in Germany with director G.W. PABST, PANDORA'S BOX and *Diary of a Lost Girl*, both of which were "rediscovered" in the 1950s.

Brooks, Mel (Melvin Kaminsky, 1926–), U.S. actor, writer, director, and producer; he was a leading television comedy writer in the 1950s, then turned to film directing. He directed and wrote *The Producers* (1968), winning an OSCAR for the screenplay, and went on to direct such comedies as *The Twelve Chairs* (1970), BLAZING SADDLES (1974), and *Silent Movie* (1976), in most instances collaborating on the screenplay and also appearing in the film. In addition, he directed the drama *84 Charing Cross Road* (1987), which starred his wife, Anne BANCROFT.

Brooks, Richard (1912–), U.S. writer, director, and producer, who directed such notable films as THE BLACKBOARD JUNGLE (1955), CAT ON A HOT TIN ROOF (1958), ELMER GANTRY (1960), SWEET BIRD OF YOUTH (1962), and IN COLD BLOOD (1967).

His screenplay for *Elmer Gantry* won an OSCAR.

Brooks, Van Wyck (1886–1963), U.S. literary historian and critic, by far best known for his five-volume American literary history, *Makers and Finders*, consisting of the PULITZER PRIZE-winning *The Flowering of New England* (1936), *New England: Indian Summer* (1940), *The World of Washington Irving* (1944), *The Times of Melville and Whitman* (1947), and *The Confident Years* (1952). A prolific writer, he also did studies of Mark Twain, Henry JAMES, John Sloan, Helen Keller, and William Dean Howells, a considerable quantity of other essays, and several autobiographical works.

Broonzy, Big Bill (William Lee Conley Broonzy, 1893–1958), U.S. BLUES singer and guitarist, who began recording in the mid-1920s and emerged as a leading male blues singer in the 1930s. John HAMMOND helped him to gain wide recognition by bringing him to sing at the Carnegie Hall *Spirituals to Swing* concerts in 1938 and 1939. His late work most notably included the album *Big Bill's Blues* (1956).

Brophy, Brigid (1929–), British writer and critic, best known for such novels as *Hackenfeller's Ape* (1953), *The King of a Rainy Country* (1956), *Flesh* (1962), *The Snow Ball* (1964), and *In Transit* (1969). She wrote short stories, a play, studies of Aubrey Beardsley and Ronald Firbank, and a considerable body of essays.

"Brother, Can You Spare a Dime?" (1932), the Yip HARBURG song; its lyrics became emblematic of the Great Depression, and it was one of the most popular songs of its day. Two of its many notable renditions were the Bing CROSBY and Rudy VALLEE hit records.

Brown, Christy (1932–81), Irish poet and novelist, born with cerebral palsy, whose sole resource was the use of his left foot, which he learned to use in an astonishing variety of ways, including to type and paint. His first book was the autobiographical MY LEFT FOOT (1954), followed by the novels *Down all the Days* (1970), *A Shadow on Summer* (1974), and *Wild Grow the Lilies* (1976) and three books of collected poems: *Come Softly to My*

Wake: The Poems of Christy Brown (1971), *Background Music* (1973), and *Of Snails and Skylarks* (1977). Daniel DAY LEWIS played Brown in *My Left Foot*, Jim Sheridan's 1989 film version of the autobiography.

Brown, Clarence (1890–), U.S. director, whose work was on screen from 1920 and who directed several major films of Hollywood's Golden Age. He directed Greta GARBO in several films, including *Flesh and the Devil* (1926) and ANNA CHRISTIE (1930); among his other films are AH, WILDERNESS (1935), *The Rains Came* (1939), *The Human Comedy* (1943), *The White Cliffs of Dover* (1944), *The Yearling* (1947), and INTRUDER IN THE DUST (1950).

Brown, James (1928–), U.S. singer, composer, and producer, a major figure in the development of Black popular music from the late 1950s. After the success of such early records as *Please, Please, Please* (1956) and *Try Me* (1958), he became "Soul Brother No. 1," touring widely, recording, and ultimately taking his music to very appreciative national and interracial audiences. He also became a considerable political figure in the late 1960s, speaking against racism and trying to help develop Black business initiatives. His career waned somewhat in the late 1970s, although he made something of a comeback in 1986 with his rendition of "Living in America."

Browning Version, The (1948), the Terence RATTIGAN play, a character study of a failed, repressed, ultimately despairing British teacher, created on the stage by Eric Portman. Rattigan adapted the one-acter into the 1951 Anthony ASQUITH film; it starred Michael REDGRAVE, in a cast that included Jean Kent, Nigel Patrick, Wilfrid Hyde-White, Bill Travers, and Ronald Howard.

Brubeck, Dave (David Warren Brubeck, 1920–), U.S. musician, a classically trained JAZZ pianist and composer who became a leading exponent of modern jazz. He formed several groups in the late 1940s, began recording in 1949, and in 1951 formed the Dave Brubeck Quartet, which became very popular, recording such works as *Jazz Goes to College* (1954) and *Time Out* (1960), and toured all over the world until the quartet dissolved in

1962. Brubeck continued to be a major force in jazz, developing it as a classical and popular form.

Brücke, Die (The Bridge), a group of artists who from 1905 to 1913 exhibited together, in the early years developing the highly emotional, strongly stated style that became identified as German EXPRESSIONISM, much of it in the form of woodcuts and lithographs, greatly influenced by late medieval Gothic woodcuts and "primitive" ethnographic carvings. In 1905 the group consisted of Fritz Bleyl, Eric Heckel, Ludwig Kirchner, and Karl Schmidt-Rottluff; they were later joined for varying lengths of time by Max Pechstein and Emil Nolde and informally by several other artists. By the time they broke up in 1913, their several styles had diverged, as had their views, which had never coalesced into a coherent school of thought.

Bruhn, Erik (Belton Evers, 1928–86), Danish dancer, who joined the Royal Danish Ballet in 1947; he was a soloist with that company from 1949, and later danced in leading roles with several other major companies, including the Ballet Theatre and the ROYAL BALLET, becoming one of the most celebrated dancers of the period. He was ballet director of the Royal Swedish Opera House from 1967 to 1972, then became a producer at the National Ballet of Canada, and was its director from 1983 to 1986.

Brynner, Yul (1915–85), Russian-American actor and director, on stage from the late 1930s; he appeared in the New York theater as an actor and on television as an actor and director in the 1940s. He became a Broadway star in the title role of the musical THE KING AND I (1949), opposite Gertrude LAWRENCE, and won a best actor OSCAR in the 1956 film, opposite Deborah KERR. His later films, which varied considerably in quality, included *The Buccaneer* (1958), THE MAGNIFICENT SEVEN (1960), *Taras Bulba* (1962), and *Westworld* (1973). He devoted much of his life to work on behalf of the United Nations, and very late in life to the campaign against smoking, quite notably in a series of television advertisements that appeared posthumously,

in which he attributed his death due to cancer to his chain-smoking habit.

Bubbles, John W., professional name of John William SUBLETT, partner in the BUCK AND BUBBLES variety team.

Buck and Bubbles, Ford Lee WASHINGTON (1903–55) and John William SUBLETT (1902–86), a leading Black variety team. Buck was a pianist and trumpeter, Bubbles was one of the most innovative and skilled tap dancers of his time, and both were singers and comedians. They began as teenagers in New York; worked in vaudeville and cabaret; made several records; and appeared in several films, most notably CABIN IN THE SKY (1943). Sublett, working as John W. Bubbles, created the role of Sportin' Life in PORGY AND BESS (1935) on stage.

Buck, Pearl Sydenstricker (1892–1973), U.S. author, child of American missionaries; she grew up in China, later taught there, and wrote many novels about the country, starting with *East Wind, West Wind* (1930). Her PULITZER PRIZE-winning THE GOOD EARTH (1931) established her as a major popular novelist; it became the tremendously popular 1937 Sidney Franklin film, for which Louise RAINIER won a best actress OSCAR. The novel was part of a trilogy that included *Sons* (1932) and *A House Divided* (1935). She won the 1938 NOBEL PRIZE for literature. Her novel *Dragon Seed* (1942) became the 1944 wartime Katharine HEPBURN–Walter HUSTON film. Her later works include such novels as *Pavilion of Women* (1946) and *Imperial Woman* (1956); several children's books; biographies of her father and mother; and her own autobiographies, *My Several Worlds* (1954) and *A Bridge for Passing* (1962).

Buddenbrooks (1901), Thomas MANN's first novel, in which he explores the decay and ultimate destruction of a bourgeois German family. The illness and death of the artistic child of the family was meant as a metaphor for the death of the artist in bourgeois society.

Bugs Bunny, a cartoon character created in 1936 at Warner Brothers, with voice supplied by Mel Blanc; the character became the basis of a long-running series of cartoons in movies and on television.

Bujold, Genevieve (1942–), French-Canadian actress; on screen from 1964, her first major role was opposite Yves MONTAND in LA GUERRE EST FINIE (1966) and her second was as Anne Boleyn in *Anne of the Thousand Days* (1969). Some of her other films are *King of Hearts* (1966), *Obsession* (1976), *Murder by Decree* (1978), *Choose Me* (1985), and *The Moderns* (1988).

Bulgakov, Mikhail Afanasyevich (1891–1940), Soviet writer, whose autobiographical novel *The White Guard* (1925) stemmed from his experiences as a doctor in the Ukraine during World War I and the Russian Revolution. The novel was widely read in the Soviet Union; his adaptation of the work was produced by Constantin STANISLAVSKY at the MOSCOW ART THEATRE in 1926, as *The Day of the Turbines*, but was sharply criticized by the Communist bureaucracy for being too sympathetic to its "White Guard" protagonists and was quickly suppressed. His satirical short science-fiction novel *The Heart of a Dog* (1925) was suppressed for decades and republished in 1968. Such later plays as *The Red Island* (1928) and *The Cabal of Saintly Hypocrites* (1936) were also briefly seen, criticized, and withdrawn, while *The Flight* (1928) was not staged at all when written; all were staged in later periods, in the Soviet Union and in the West. His novel *The Master and Margarita* (1940) has been widely praised as one of the major novels of the century and as Bulgakov's masterwork; it was published in full in West Germany in 1969, after a censored edition had been published in the Soviet Union, and in 1978 was adapted for the stage by Andrei Serban.

Bunin, Ivan Alekseyevich (1870–1953), Russian writer, highly regarded while still in Russia for such realistic works on social themes as his novels of country life, *The Village* (1910), and *Dry Valley* (1911). His best-known shorter work is "The Gentleman from San Francisco" (1916). He went into exile in 1919, then writing on more personal themes in such novels as *Mitya's Love* (1925) and *The Well of Days* (1930), while continuing to write a substantial

number of short stories. He was awarded the NOBEL PRIZE for literature in 1933.

Bunker, Archie, the prototypical bigot played by Carroll O'Connor in television's ALL IN THE FAMILY.

Bunshaft, Gordon (1909–90), U.S. architect, from 1937 associated with and from 1949 a partner in Skidmore, Owings, and Merrill. The glass-walled "minimalist" slab, set on an open plaza, that was his trailblazing LEVER HOUSE (New York, 1952), was a highly regarded monument to the work of Ludwig MIES VAN DER ROHE and a prototype for thousands of other such austere, essentially closed, energy-consuming environments all over the world. His later works include such major structures as Yale University's Beinecke Library (1963), the Lyndon Baines Johnson Library (Austin, Texas, 1971), and the Hirshhorn Museum (Washington, D.C., 1974).

Buñuel, Luis (1900–83), Spanish director and writer, whose classic first short film, the surrealist AN ANDALUSIAN DOG (1928), was written in collaboration with his friend Salvador DALI and whose second directed film was the surrealist classic *The Golden Age*, which vigorously attacked many of the icons of the time, an inclination Buñuel continued to favor all his life. After one more early film, *Land Without Bread* (1932), he did not direct another film until his move to Mexico in 1947, where he did successful commercial films before moving back toward his early critical stance, though not toward surreal forms. His later work, much of it done in Europe, drew international critical acclaim; it includes such films as *Nazarin* (1959), *Viridiana* (1961), DIARY OF A CHAMBERMAID (1964), *Belle de Jour* (1967), the OSCAR-winning THE DISCREET CHARM OF THE BOURGEOISIE (1972), and *That Obscure Object of Desire* (1977).

Burchfield, Charles Ephraim (1893–1967), U.S. painter, a leading colorist and realist, much of whose early work was surreal in form and psychological in focus. During the interwar period, and especially in the 1930s, his work was that of a realist, focused on accurate portrayal of the deeply damaged quality of American small-town and rural life. His late

work focused on the powerful depiction of storms and other dark-hued natural phenomena, and of humanity and its works in nature's grip.

Burgess, Anthony (John Anthony Burgess Wilson, 1917–), British writer, a prolific novelist and critic, who has also sometimes written as Joseph Kell. His bleakly prophetic and very notable satire A CLOCKWORK ORANGE (1962) became Stanley KUBRICK's equally notable 1971 film. Some of his other well-known works are his first three novels, written in the late 1950s while he was an education officer in Malaya and published in 1964 as *The Long Day Wanes; Earthly Powers* (1980); and the several "Enderby" books, beginning with *Inside Mr. Enderby* (1963). He has also written several television plays, radio plays, and musical compositions.

Burleigh, Harry Thacker (1866–1949), U.S. singer and composer, a pioneering Black artist who brought Negro spirituals to a worldwide concert audience and was among the first to put on paper and arrange many such works. He was long identified with such classic songs as "Deep River," "Go Down Moses," and "Swing Low, Sweet Chariot," later brought to even wider audiences by such singers as Paul ROBESON and Marian ANDERSON. Burleigh was a soloist at New York's St. George's Episcopal Church (1894–1946) and in the choir of New York's Temple Emanu-El (1900–25). He also composed and arranged hundreds of his own art songs.

Burnett, Carol (1936–), U.S. actress, singer, and variety entertainer, best known on television as star of the long-running "The Carol Burnett Show" (1967–79). She also appeared in such plays as *Plaza Suite* (1970), *I Do, I Do* (1973), and *Same Time Next Year* (1977); in such films as *Pete 'n' Tillie* (1972) and ANNIE (1982); and in several telefilms and has toured widely in variety. In the 1989–90 television season she once again emerged as the star of her own show.

Burnett, William Riley (1899–1982), U.S. writer, some of whose popular novels also have proven highly cinematic. They include LITTLE CAESAR (1929), *The Dark Command* (1938),

HIGH SIERRA (1940), THE ASPHALT JUNGLE (1949), and *Adobe Walls* (1953).

Burns and Allen, the comedy team of George Burns (Nathan Birnbaum, 1898–) and Gracie Allen (1905–64), both on stage as veteran vaudeville performers before joining forces in 1922. They married in 1926. They were leading radio performers from 1932 to 1950, then switched to television in "The George Burns and Gracie Allen Show" (1950–58), which ended with her retirement. Burns, who had appeared in several 1930s films, returned to the screen in the 1970s, winning a best supporting actor OSCAR in *The Sunshine Boys* (1975), and continued to appear on screen in his eighties, as in *18 Again* (1988).

Burr, Raymond (1917–), Canadian actor, best known by far as television's Perry MASON (1957–66), the fictional criminal lawyer created by Erle Stanley GARDNER. He also starred as the crippled Los Angeles chief detective of his second hit series, "Ironside" (1967–75). He played the first of his long series of Hollywood heavies in 1946; from the late 1950s his main work was in television.

Burroughs, Edgar Rice (1875–1950), U.S. writer, best known as the creator of TARZAN in *Tarzan of the Apes* (1914) and the writer of scores of subsequent Tarzan stories, which became the basis of a veritable Tarzan industry that lasted for decades.

Burroughs, William Seward (1914–), U.S. writer, whose first novel was *Junkie: The Confessions of an Unredeemed Drug Addict* (1953). He became a major early COUNTERCULTURE figure after publication of his second novel, *The Naked Lunch* (1959). He later wrote such works as *The Soft Machine* (1961), *The Wild Boys* (1971), *Cities of the Red Night* (1981), and *The Western Lands* (1988).

Burstyn, Ellen (Edna Rae Gillooly, 1932–), U.S. actress, who emerged as a star in the 1970s. On screen she played a strong supporting role in THE LAST PICTURE SHOW (1971) and won a best actress OSCAR for ALICE DOESN'T LIVE HERE ANYMORE (1975). In 1975 she starred on Broadway in *Same Time Next Year*, re-creating the role in the 1978 film.

Burton, Richard (Richard Walter Jenkins, 1925–84), Welsh-British actor, on stage from 1944 and on screen from 1948, who became a leading actor with his role in the London production of *The Lady's Not for Burning*, which he played on Broadway in 1950. In the theater he was highly regarded for his series of major Shakespearean roles at the Old Vic in 1953–54; his 1964 *Hamlet*; and the lead in *Equus* (1976), which he re-created on film in 1977, although personal matters, including a serious drinking problem, kept him from becoming the massive theater figure so many had thought he might become. He became a highly visible international film figure with his role in *Cleopatra* (1963), which was accompanied by the publicity surrounding his affair with his costar, Elizabeth TAYLOR, to whom he was subsequently twice married. Beyond the publicity, though, he was clearly recognizable as one of the finest screen actors of his time, in such films as BECKET (1964) and WHO'S AFRAID OF VIRGINIA WOOLF? (1967); other notable films include *Night of the Iguana* (1964) and THE SPY WHO CAME IN FROM THE COLD (1965).

Busoni, Ferruccio Benvenuto (1866–1924), Italian-German composer, pianist, and conductor; a child prodigy, he was on stage in piano recital from the age of eight and taught and conducted in Berlin from 1894 to 1914, a period in which he introduced several modern works and wrote the prophetic *Sketch of a New Aesthetic of Music* (1907). His considerable body of work included the *Piano Concerto* (1904); several works on American Indian themes, beginning with the *Indian Fantasy* (1913); several versions of the *Fantasia Contrappuntistica*, on an unfinished Bach fugue; and the opera *Doctor Faust* (1924), finished by his student Philipp Jarnach.

Bus Stop (1955), the William INGE play, set in a roadside restaurant at which a busload of passengers have been stranded in a blizzard. Kim Stanley was Cherie; Albert Salmi was Bo; and Elaine Stritch was Grace, the restaurant owner. George Axelrod adapted the play into the 1956 Joshua LOGAN film, with Marilyn MONROE as Cherie, heading a cast that included Don Murray, Hope Lange, Eileen Heckart, Arthur O'Connell, and Betty Field.

Butch Cassidy and the Sundance Kid (1969), the George Roy HILL Western, starring Paul NEWMAN and Robert REDFORD as legendary outlaws being relentlessly and sometimes comically pursued by the law and their ultimate demise in Bolivia. Katharine ROSS also starred, in a cast that included Strother Martin, Jeff Corey, and Cloris Leachman. William Goldman won an OSCAR for his screenplay, as did Conrad Hall for cinematography, Burt BACHARACH for the score, and Bacharach and Hal David for the song "Raindrops Keep Fallin' on My Head."

Butler, Rhett, the rakish, romantic Southerner created by Margaret MITCHELL in GONE WITH THE WIND (1936); he was played by Clark GABLE in the 1939 film.

Butley (1971), the Simon GRAY play, a bitter comedy about the fragmenting life of a British university teacher. Alan BATES created the title role, re-created it on Broadway in 1972, winning a TONY AWARD, and starred in the 1975 Harold PINTER film version, in a cast that included Jessica TANDY, Richard O'Callaghan, Michael Byrne, Susan Engel, and Georgina Hale.

Butterfield 8 (1935), the John O'HARA novel, about a prostitute involved in a murder on the seamy side of New York high life. Elizabeth TAYLOR won an OSCAR in the 1960 Daniel MANN film, in a cast that included Laurence HARVEY, Mildred Dunnock, Eddie FISHER, Dina Merrill, and Betty Field.

Bye-Bye Birdie (1960), a TONY-winning early ROCK musical. Dick Gautier was Birdie, in a cast that included Dick Van Dyke, Chita Rivera, Kay Medford, and Paul Lynde; the almost nonexistent book was a story of minor generational conflict. Charles Strouse wrote the music, Lee Adams the lyrics, and Michael Stewart the book. Irving Brecher adapted the play into the 1963 George Sidney film, with a cast that included Van Dyke, Janet LEIGH, Ann-Margret, Maureen Stapleton, Paul Lynde, and Bobby Rydell.

C

Caan, James (1939–), U.S. actor, on stage from 1960 and on screen from 1963, who emerged as a star with his creation of Sonny Corleone in THE GODFATHER (1972), then played major roles in such films as *Cinderella Liberty* (1975), *The Gambler* (1975), *Rollerball* (1975), *A Bridge Too Far* (1977), *Comes a Horseman* (1978), *Chapter Two* (1980), *Bolero* (1983), GARDENS OF STONE (1988), and *Misery* (1990). His most notable television appearance was in the TV "Brian's Song" (1972).

Cabaret (1966), the long-running, TONY-winning Fred Ebb–John Kander musical play, based on John VAN DRUTEN's play I AM A CAMERA (1951), which was itself based on Christopher ISHERWOOD's *Good-bye to Berlin* (1939). Jill Haworth played the Sally Bowles role on Broadway; Liza MINNELLI played the role in Bob FOSSE's 1972 film, winning a best actress OSCAR, one of eight Oscars won by the film. These include a best director Oscar for Fosse and a best supporting actor Oscar for Joel Grey, who played in both play and film.

Cabell, James Branch (1879–1958), U.S. writer, best known for his long series of historical novels set in the mythical country of Poictesme, around his central character, Dom Manuel, which began with *The Soul of Melicent* (1913). The second novel in the series was *Jurgen* (1919); attempts to ban the book for alleged obscenity instead established Cabell as a major American literary figure.

Cabinet of Dr. Caligari (1920), the ground-breaking German Expressionist film directed by Robert Wiene, from a screenplay by Carl Mayer and Hans Janowitz, with Werner Krauss as the hypnotist, Caligari, and Conrad VEIDT as Cesare, his creature, in a role that established Veidt as a major figure in cinema history.

Cabin in the Sky (1940), the musical written by Lynn Root, with lyrics by John La Touche, performed by an all-Black cast that included Ethel WATERS, Rex Ingram, Todd Duncan, Katherine DUNHAM, Dooley Wilson, and J. Rosamond Johnson. The 1943 film version was directed by Vincente MINNELLI, with a cast that included Ethel Waters, Lena HORNE, Louis ARMSTRONG, Rex Ingram, Eddie Anderson (Jack BENNY's Rochester), Cab CALLOWAY, and John W. Bubbles (of BUCK AND BUBBLES), with additional songs by Harold ARLEN and Yip HARBURG.

Cabiria (1914), a landmark and technically innovative Italian epic set in Roman times, which considerably influenced such film-makers as D.W. GRIFFITH and Cecil B. DeMILLE. It was produced, directed, and written by Giovanni Pastrone, with a cast led by Lidia Quaranta, Umberto Mozzato, and Bartolomeo Pagano.

Caesar, Sid (1922–), U.S. comedian and actor, a leading figure in early television as star of the "Admiral Broadway Review" (1949), "Your Show of Shows" (1950–54), and "Caesar's Hour" (1954–57). "Your Show of Shows," with Caesar, Imogene Coca, Carl Reiner, and Howard Morris working in comedy ensemble, was one of the most notable comedy-variety series in television history.

Caesar and Cleopatra (1899), the George Bernard SHAW play, which was adapted into the 1946 Gabriel Pascal film starring Claude RAINS and Vivien LEIGH, with Flora ROBSON and Stewart GRANGER in strong supporting roles.

Cage, John (1912–), U.S. composer, whose early work, in the mid–1930s, stressed

Early television comedy star Sid Caeser getting a too-tight tie from his long-time partner, Imogene Coca.

atonality. In the late 1930s he moved into highly experimental work, creating such vehicles as the "prepared piano," a grand piano with its strings weighted and blocked by other objects, in an attempt to create a one-man percussion orchestra. He also quite early experimented with electronic music. In the mid–1940s, partially due to a developing interest in Zen Buddhism, he moved into indeterminacy; randomness; and, with his *4′ 33″* (1952), very notably into silence as a preferred mode of musical composition. He has written several books developing his musical and aesthetic theories.

Cage Aux Folles, La (1978), the Edouard Molinaro film, adapted by Francis Veber from the Philip Poiret play; a farce involving a gay couple, played by Ugo Tognazzi and Michel Serrault, who do their best to behave as if they were straight when Tognazzi's straight son brings home his bride-to-be and her parents. The film generated sequels in 1980 and 1985 and the Broadway musical, starring Gene Barry.

Cagney, James (1899–1986), U.S. actor, on stage and in vaudeville as a dancer and actor from 1920 and on screen from 1930, whose breakthrough film role was as a gangster in *Public Enemy* (1930). During the 1930s he played leads in many action films and also played Bottom in *A Midsummer Night's Dream* (1935). After his portrayal of George M. COHAN in *Yankee Doodle Dandy* (1942), for which he won a best actor OSCAR, his work became far more varied, including such films as WHAT PRICE GLORY? (1952), MISTER ROBERTS (1955), and *Man of a Thousand Faces* (1957). He retired in 1961, returning to do RAGTIME in 1981.

"Cagney and Lacey" (1982–89), the long-running television police series that broke new ground by making both its protagonists women officers. Tyne Daly was Mary Beth Lacey; Sharon Gless was Chris Cagney, a role originally played by Meg Foster for a short time in 1982.

Cahiers du Cinéma, the French film magazine, founded by André BAZIN in 1951, succeeding his *La Revue du Cinéma*. It was the vehicle

through which Bazin and others developed the AUTEUR theory and drew together as writers many of those who became the key directors of the NEW WAVE movement, including François TRUFFAUT, Claude CHABROL, and Jean-Luc GODARD.

Cahn, Sammy (Samuel Cohen, 1913–), U.S. lyricist, who began writing popular songs in the mid–1930s and in the 1940s became a leading Hollywood songwriter. His best-known songs included BEI MIR BIST DU SCHOEN (1937), which became the signature song of the ANDREWS SISTERS; "Three Coins in the Fountain" (1954); "All the Way" (1957); "High Hopes" (1957); and "Call Me Irresponsible" (1963), the latter four all winning OSCARS. He often worked with composers Jule STYNE and James Van Heusen.

Cain, James Mallahan (1892–1977), U.S. writer, whose very popular and, as it turned out, very cinematic early novels about ordinary people who murder for money powerfully illuminated some aspects of the underside of life in Depression-era America. His first novel was THE POSTMAN ALWAYS RINGS TWICE (1934), a dark, hard story of a woman who uses a worker passing through to help her murder her husband. It was the basis of Luchino VISCONTI's first film, *Obsession* (1942), a seminal work in the development of Italian NEOREALISM. Then, under its own name, it became the memorable 1946 Tay Garnett film, with Lana TURNER and John GARFIELD in the leads, and was remade by Bob Rafelson in 1981, with Jack NICHOLSON and Jessica LANGE in the roles. Cain's DOUBLE INDEMNITY (1936) explored similar ground; it became the 1944 Billy WILDER film, with Barbara STANWYCK, Fred MACMURRAY, and Edward G. ROBINSON in the leads. MILDRED PIERCE (1941) became the 1945 Michael CURTIZ film, with Joan CRAWFORD winning an OSCAR in the title role. Cain's work also included such novels as *Serenade* (1937), *The Butterfly* (1947), and *Rainbow's End* (1975), as well as many short stories.

Caine, Michael (Maurice Joseph Micklewhite, 1933–), British actor, on screen from 1956, who emerged as a film star in the 1960s, most effectively in comedies and action films.

His first notable role was in *Zulu* (1964); it was followed by *The Ipcress File* (1965) and then by ALFIE, *The Wrong Box*, *Gambit*, and *Funeral in Berlin*, all in 1966. His later films include *Sleuth* (1973), *The Man Who Would Be King* (1975), *Educating Rita* (1982), and HANNAH AND HER SISTERS (1986).

Caine Mutiny, The (1951), the Herman WOUK novel, which he adapted into the play *The Caine Mutiny Court-martial* (1953) and which was also adapted into the 1954 Edward DMYTRYK film, with Humphrey BOGART in the role of Captain Queeg and with Van JOHNSON, Fred MACMURRAY, Robert Francis, and José FERRER in key roles.

Calder, Alexander (1898–1976), U.S. sculptor and painter; from the mid-1920s he created pioneering wire sculptures while also creating portraits and drawings. In 1931 he began to create both unpowered and motor-driven "mobiles," and from 1932 he focused on the unpowered abstract moving and stable sculptures that came to be called "mobiles" and "stabiles," some of them monumental works. He is best known by far for these, and they were taken by later kinetic artists to be forerunners of their own chosen forms.

Caldwell, Erskine Preston (1903–87), U.S. writer, who emerged as a major figure with his novel TOBACCO ROAD (1932). Its extraordinarily lively and compassionate portrait of a ravaged Depression-era Georgia farm family became his best-known work and was adapted into the long-running Jack Kirkland play in 1933 and the John FORD film in 1941. Caldwell followed up with the equally notable *God's Little Acre* (1933), which became the Anthony Mann film in 1958. In 1937 he and his second wife, photographer Margaret BOURKE-WHITE, collaborated on the classic documentary work on the lives of southern sharecroppers, YOU HAVE SEEN THEIR FACES. He also wrote scores of short stories, several later novels, several works based on his World War II experience as a correspondent in the Soviet Union, and several travel books.

"California, Here I Come" (1921), an Al JOLSON song, later picked up by a good many other singers, that became emblematic of the

state and of the huge American move west to the Pacific during much of the 20th century; words and music were by Jolson, Buddy DeSylva, and Joseph Meyer.

Callas, Maria (Maria Kalogeropolous, 1923–77), U.S. soprano, one of the leading operatic personalities of the 1950s. She was with the Athens Royal Opera from 1939 and made her Italian debut in 1947, in the 1950s excelling in a series of bel canto roles in early-19th-century Italian operas. Her highly dramatic professional and personal style made her a media favorite, especially as a series of much-publicized feuds developed between Callas and several opera managements, while her recordings developed a considerable popular audience. On screen she played the dramatic, nonsinging title role in the 1971 Pier Paolo PASOLINI film *Medea*.

Calloway, Cab (Cabell Calloway, 1907–), U.S. jazz musician, who emerged as a leading singer and bandleader of the big band era at the COTTON CLUB in the early 1930s; his "Hi De Ho!" was one of the features of the time. He was most strongly identified with the song "Minnie the Moocher," which he wrote with Irving Mills and Clarence Gaskill and recorded in 1931, and with "Blues in the Night," recorded in 1942. He made appearances in several films, including STORMY WEATHER (1943) and *The Blues Brothers* (1980), and played opposite Pearl BAILEY in the 1967 all-Black revival of HELLO, DOLLY!.

Camelot (1960), the long-running Broadway musical, starring Richard BURTON as King Arthur opposite Julie ANDREWS as Guinevere, with Robert Goulet as Lancelot. It was based on T.H. White's *The Once and Future King* (1958), with music by Frederick LOEWE and book and lyrics by Alan Jay LERNER. Lerner adapted the work into the 1967 Joshua LOGAN film, starring Richard Harris, Vanessa REDGRAVE, and Franco Nero. Art, costumes, and music direction won OSCARS.

Camille (1936), the George CUKOR film, featuring the celebrated Greta GARBO portrayal of the doomed courtesan Marguerite Gautier, opposite a very young Robert TAYLOR as Armand. This and several other theater and film versions were based on the 1852 Alexandre Dumas (the elder) novel and subsequent play *The Lady of the Camellias*, as was the opera *La Traviata*. The role had been played by, among others, Sarah BERNHARDT, Theda BARA, and Alla NAZIMOVA, but ultimately it became identified with Garbo, in Cukor's version.

Campbell, Glen Travis (1936–), U.S. musician, a guitarist and country singer who became one of the most popular singers of the late 1960s, with his 1967 recordings of "Gentle on My Mind" and "By the Time I Get to Phoenix," as well as such later hits as "Wichita Lineman" (1968) and "Galveston" (1969). His film appearances include substantial roles in *True Grit* (1969) and *Norwood* (1970). On television he hosted "The Glen Campbell Goodtime Hour" (1969–72).

Campbell, Mrs. Patrick (Beatrice Stella Tanner, 1865–1940), British actress, who became a major figure on the London stage with her creation of the title role in *The Second Mrs. Tanqueray* (1893). She played many leading roles thereafter, most notably creating the Eliza DOOLITTLE role in PYGMALION (1914), which SHAW wrote with her in mind, having been much taken with her at the time, as their long correspondence indicates. She also played a few small film roles in Hollywood during the 1930s.

Camus, Albert (1913–60), French writer, much of whose work is set in his native Algeria, who became a centrally important European cultural figure in midcentury. The search for individual validity in what he saw as an essentially meaningless world and human condition informed all his work and was most definitively expressed in his essay "The Myth of Sisyphus" (1942). He called the perceived contradiction "the Absurd," so supplying much of the theoretical underpinning of the THEATER OF THE ABSURD, while also then moving side by side with the leaders of EXISTENTIALISM. But he and Jean-Paul SARTRE split in the early 1950s on the question of the Soviet dictatorship, which Camus, a democratic socialist, saw as profoundly antidemocratic, as he pointed out in his essay "The Rebel" (1951). His most influential works include the novels *The Stranger* (1942), *The Plague* (1947), and *The Fall*

(1956) and the plays *Caligula* (1938), *The Misunderstanding* (1944), and *The Just Assassins* (1950). As editor of *Combat* he was a leading figure in the French Resistance during World War II. Camus was a prolific essayist; many of his key essays were published in the English-language *Resistance, Rebellion, and Death* (1961). He was awarded the NOBEL PRIZE for literature in 1957.

Canetti, Elias (1905–), German-language writer, born in Bulgaria and resident in Great Britain from 1939. His works include the novel *The Tower of Babel* (1935); three plays; a travel book, *The Voices of Marrakesh* (1967); *Crowds and Masses* (1960), his major work in social psychology; and several autobiographies. He was awarded the 1981 NOBEL PRIZE for literature.

Caniff, Milt (Milton Arthur Caniff, (1907–), U.S. cartoonist, who created such comic strips as "Terry and the Pirates" (1934) and "Steve Canyon" (1947).

Cannery Row (1945), the John STEINBECK novel, set in a Depression-era cannery district; the book and its sequel *Sweet Thursday* (1954) were the bases of the 1982 David S. Ward film, with Nick NOLTE as the marine biologist opposite Debra Winger's prostitute.

Cantor, Eddie (Edward Israel Iskowitz, 1892–1964), U.S. singer and comedian. On stage from the age of 14, he worked as a singing waiter and in vaudeville before becoming a star in three successive *Ziegfeld Follies* (1917–19). During the 1920s he starred in such Broadway shows as *Kid Boots* (1923) and *Whoopee* (1929), both of which he also did as movies, in 1926 and 1930. He also played leads in such 1930s movie musicals as *The Kid from Spain* (1932) and *Roman Scandals* (1933). His radio show (1931–39) was immensely popular, with its signature song, IDA, SWEET AS APPLE CIDER. He also introduced such other popular songs of the period as "If You Knew Susie" and "Makin' Whoopee." Late in his career he also hosted his own television variety show (1954–55).

Capa, Robert (Andrei Friedmann, 1913–54), U.S. photographer, whose war photos established him as one of the leading photojournalists of his time. His first war was the Spanish Civil War, which generated probably his best-known shot: DEATH OF A LOYALIST SOLDIER

(1936). He was a front-line photographer during World War II, again in Palestine in 1948, and was killed by a land mine in Indochina in 1954.

Capek, Karel (1890–1938), Czech writer, who emerged as a major European playwright with two early anti-authoritarian plays: the science-fiction satire R.U.R. (1921), which introduced the word *robot*; and *The Insect Play* (1922), co-authored with his brother Joseph. His plays also include *The Makrapoulos Affair* (1923); *Adam the Creator* (1927), a sequel to *R.U.R.* and also co-authored with Joseph; *The White Scourge* (1937); and *The Mother* (1938), both of the latter works strong attacks on the fascist threat that was soon to overwhelm his country. His novels include such science-fiction works as *An Atomic Fantasy* (1925); *The Absolute at Large* (1927); and the trilogy composed of *Hordubal* (1933), *The Meteor* (1934), and *An Ordinary Life* (1934). He also wrote many highly regarded shorter works of fiction, and a book on his friend Czech president Thomas Masaryk. His brother Joseph, a painter and writer, was imprisoned by the Germans in the Bergen-Belsen concentration camp during World War II and died there in 1945.

Capote, Truman (1924–1984), U.S. author, a prolific short-story writer and essayist who was early in his career best known for such novels as *Other Voices, Other Rooms* (1948) and *The Grass Harp* (1951), which he adapted into the 1952 play; and for the novella BREAKFAST AT TIFFANY'S (1958), in which he created Holly Golightly, played memorably by Audrey HEPBURN in the 1961 Blake EDWARDS film. He collaborated with Harold ARLEN on the musical play *House of Flowers* (1954). Capote sharply changed direction with his last major work, the "nonfiction novel" IN COLD BLOOD (1966), the story of Kansas multiple murders, adapted and directed by Richard BROOKS into the 1967 film.

Capp, Al (Alfred Gerald Caplin, 1909–79), U.S. cartoonist and satirist, who created the comic strip L'IL ABNER (1934).

Capra, Frank (1897–), U.S. director, who worked in the film industry as a rather unsuccessful writer and director from 1922. Then, in the 1930s, he emerged as one of the leading

directors of Hollywood's Golden Age, most of whose very notable populist comedy-dramas exalted the perceived common decency of the hard-pressed Depression-era American. His first classic was IT HAPPENED ONE NIGHT (1934); it won him a best director OSCAR, was best film, and Claudette COLBERT and Clark GABLE both won OSCARS in the leading roles. He won a second best director Oscar for MR. DEEDS GOES TO TOWN (1936), and a third for YOU CAN'T TAKE IT WITH YOU (1938), which also was best picture. Capra directed such other classics as LOST HORIZON (1937), MEET JOHN DOE (1941), IT'S A WONDERFUL LIFE (1947), and STATE OF THE UNION (1948).

Cardin, Pierre (1922–), French fashion designer. From the early 1950s he was influential in introducing new high-fashion styles for men as well as women and in developing the new materials and single-sex "look" that would in some periods become dominant.

Caretaker, The (1960), the play by Harold PINTER, which established him as a major playwright. In its time the play's exploration of the dominant "Pinteresque" themes of alienation and ambiguity was seen as a substantial contribution to the then-developing THEATER OF THE ABSURD. Pinter adapted the play into the 1964 Clive Donner film, with a cast that included Alan BATES, Robert Shaw, and Donald Pleasance.

Carmichael, Hoagy (Howard Hoagland Carmichael, 1899–1981), U.S. composer, actor, singer, pianist, and bandleader, best known for his early, extraordinarily popular STAR DUST (1931, lyrics by Mitchell Parish) and such songs as "Rockin' Chair" (1930), GEORGIA ON MY MIND (1931, lyrics by Stuart Gorrell, revised by Mitchell Parish), "Ole Buttermilk Sky" (1946), and the OSCAR-winning "In the Cool, Cool, Cool of the Evening" (1951, lyrics by Johnny MERCER). He appeared in several films, often essentially as himself, as in TO HAVE AND HAVE NOT (1944) and most memorably in THE BEST YEARS OF OUR LIVES (1946).

Carmichael, Ian (1920–), British actor, on stage from 1939, and on screen from 1948, usually in light comedy. He is best known for his Lord Peter WIMSEY role in several mid-1970s British television series based on the Dorothy SAYERS mystery novels, including *Clouds of Witness, Murder Must Advertise, The Unpleasantness at the Bellona Club*, and *The Nine Tailors*.

Carnal Knowledge (1971), the Mike NICHOLS film, screenplay by Jules FEIFFER. Jack NICHOLSON and Art Garfunkel (of SIMON AND GARFUNKEL) played college classmates followed from their postwar college years through unsatisfied, sexually disoriented middle age in the swinging sixties; Ann-Margret and Candice BERGEN were the key women in their lives.

Carné, Marcel (1909–), French director, who in the late 1930s became a major figure in French cinema with such films as *Bizarre Bizarre* (1937), *Port of Shadows* (1938), *Daybreak* (1939), and the classic CHILDREN OF PARADISE (1945). He often collaborated with screenwriter Jacques Prévert.

Carney, Art (Arthur William Carney, 1918–), U.S. actor and comedian, on stage in variety from the 1930s, who is best known for his Ed Norton role in Jackie GLEASON's long-running television series THE HONEYMOONERS (1951–71). On stage his best-known roles were in *The Rope Dancers* (1957), *Take Her, She's Mine* (1961), and *The Odd Couple* (1965). He won an OSCAR as best actor for HARRY AND TONTO (1974) and played in several other films.

Carnovsky, Morris (1897–), U.S. actor, on stage from 1919, and a leading member of the THEATRE GUILD in the 1920s, in many strong supporting roles and some leads, including the title role in the 1929 production of *Uncle Vanya*. He appeared in many GROUP THEATRE productions in the 1930s, such as *Awake and Sing!* (1935) and GOLDEN BOY (1937). He was on screen from 1937 in such films as *The Life of Emile Zola* (1937), *Edge of Darkness* (1943), and *Cyrano de Bergerac* (1950), but was blacklisted after appearing as an unfriendly witness before the House Un-American Activities Committee during the McCarthy period, then pursuing the balance of his long career in the theater. From 1956 he was identified with the American Shakespeare Theatre and especially with the *King Lear* role, which he played in 1963, 1965, and 1975.

Caro, Anthony (1924–), British sculptor, who in 1960 emerged as a pioneering welded-metal sculpturist; his early work placed his often brightly colored works on the ground instead of on the traditional pedestal, while his later work, featuring rusted steel and muted colors, was often set on pedestals.

Caron, Leslie (1931–), French actress and dancer. She became a star in her first film, opposite Gene KELLY in AN AMERICAN IN PARIS (1951), and went on to star in such films as LILI (1953), *Daddy Long Legs* (1956), GIGI (1958), FANNY (1961), and *The L-Shaped Room* (1962), then moving largely into supporting roles.

Carousel (1945), a classic Richard RODGERS and Oscar HAMMERSTEIN II musical, adapted from Ferenc MOLNAR's 1921 play *Liliom*, with a score that included such songs as "If I Loved You," "June Is Bustin' Out All Over," and YOU'LL NEVER WALK ALONE. John Raitt was Billy Bigelow; Jan Clayton was Julie Jordan. In Henry KING's 1956 film version, Gordon MacRae and Shirley JONES played the leads.

Carr, Emily (1871–1945), Canadian painter, who from 1905 painted western Canadian Native American scenes derived from field trips north from Vancouver on the British Columbia coast. Her early work was not well received, and she essentially stopped painting until a 1927 Ottawa exhibition brought it forward once again, then to great appreciation. In this later period she added landscapes to her work, until forced to stop by worsening health, and in the early 1940s turned to writing several autobiographical works.

Carradine, John (Richmond Reed Carradine, 1906–1988), U.S. actor, on stage from 1931; he was a Shakespearean by choice who toured widely in classical roles throughout his life but was best known from the mid-1930s as a leading Hollywood character actor. He played rogues and deep-dyed villains in scores of films, as in *The Bride of Frankenstein* (1936), *Drums Along the Mohawk* (1939), and *House of Dracula* (1945), but also played a classic character role in THE GRAPES OF WRATH (1940). His three sons, David, (1936–), Keith

(1950–), and Robert (1954–) Carradine, followed him into acting careers.

Carroll, Madeleine (Marie-Madeleine Bernadette O'Carroll, 1906–87), British actress, on stage from 1927 and on screen from 1928. She starred in two mid-1930s British films, both directed by Alfred HITCHCOCK: opposite Robert DONAT in THE 39 STEPS (1935) and opposite John GIELGUD in *The Secret Agent* (1936). She went to Hollywood in the late 1930s, there appearing in such films as *Lloyds of London* (1936), *My Son, My Son* (1940), and *Northwest Mounted Police* (1940).

Carson, Johnny (1925–), U.S. late-night television show host. His "Tonight Show Starring Johnny Carson" (1962–) became a national institution as it neared its third uninterrupted decade of broadcasting.

Carter, Elliott Cook (1908–), U.S. composer; he was musical director of Ballet Caravan in the late 1930s and composed the ballets *Pocahontas* (1939) and *The Minotaur* (1947), as well as *Symphony No. 1* and several other tonal pieces before moving toward his densely complex mature work, as expressed first in the *Piano Sonata* (1946) and later in such works as the first three *String Quartets* (1951, 1959, 1971) and the *Double Concerto* (1961). His work includes a considerable body of other instrumental and vocal music.

Carter Family (1927–1943), a group of country singers that from the mid-1920s powerfully influenced the development of American country music, taking their themes and style from southern Appalachian folk music and making what became classic recordings of such songs as "Wildwood Flower," "Wabash Cannonball," "Church in the Wildwood," "Keep on the Sunny Side," and "I'm Thinking Tonight of My Blue Eyes." The group was originally a trio, consisting of A.P. (Alvin Pleasant) Carter, Sara Dougherty Carter, and Maybelle Addington Carter. In later years many other members of the family became country-music singers; most notably, Maybelle and daughters June, Helen, and Anita sang together as a new version of the family after 1943, with some of the grandchildren later tak-

ing up country-music singing careers. June Carter is married to singer Johnny CASH.

Cartier-Bresson, Henri (1908–), French photographer, whose spontaneous technique and transcendental view of humanity deeply influenced following generations of photojournalists. He worked in films and still photography during the 1930s, producing a Spanish Civil War film, *Return to Life* (1937). His second film was *The Return* (1945), based in part on his own experiences as a Nazi prisoner of war during World War II. After the war he traveled and photographed all over the world, ultimately generating a large body of pictures, some of which were published in such collections as *The People of Moscow* (1955), *Cartier-Bresson's France* (1971), *Faces of Asia* (1972), and *Photoportraits* (1983).

Cartland, Barbara (1901–), British writer of considerable numbers of very popular romance novels.

Caruso, Enrico (1873–1921), Italian singer, the most celebrated operatic tenor of his time, and the first operatic recording star, whose scores of records brought his voice and personality to far larger audiences than had ever before been available. He emerged as an international star in *Fedora* (1898) and from 1902 to 1920 was a leading tenor at the Metropolitan Opera. He can still be heard, albeit with less than full fidelity, in *Pagliacci, Carmen, Aïda,* and much of the rest of the tenor repertoire.

Cary, Joyce (Arthur Joyce Lunel Cary, 1888–1957), British writer, whose work in the Nigerian foreign service from 1913 to 1920 formed the basis for his four early novels, all set in Africa, beginning with *Aissa Saved* (1932). He is best known for his two late trilogies: *Herself Surprised* (1941), *To Be a Pilgrim* (1942), and *The Horse's Mouth* (1944); and *Prisoner of Grace* (1952), *Except the Lord* (1953), and *Nor Honour More* (1955). *The Horse's Mouth* was the basis of the 1958 Ronald Neame film, starring Alec GUINNESS.

Casablanca (1942), the classic, OSCAR-winning Michael CURTIZ anti-Nazi film set in French North Africa during World War II, with Humphrey BOGART as Rick and Ingrid BERGMAN as Ilsa, strongly supported by Paul

HENREID as Victor Laszlo; Claude RAINS as the corrupt French policeman who ultimately turns against the Nazis; Conrad VEIDT as the archvillain Major Strasser; Sydney GREENSTREET; Peter LORRE; and Dooley Wilson as the pianist, Sam, whose AS TIME GOES BY became the signature song of the film, as did Bergman's plea: "Play it, Sam!" The film, based on the play *Everybody Comes to Rick's,* by Murray Burnett and Jean Allison, also generated Oscars for Curtiz and screenwriters Julius and Philip Epstein and Howard Koch.

Casals, Pablo (1876–1973), the celebrated Spanish cellist and conductor, who began his long career as a soloist in 1898, and became an especially strong J. S. Bach interpreter. Casals, violinist Jacques THIBAUD, and pianist Alfred CORTOT formed a trio in 1905. A Spanish Republican, Casals removed himself to Prades, France after the fascist victory in the Spanish Civil War, and in 1956 settled in Puerto Rico, in both locations founding music festivals where he continued to play long into his eighties.

Cash, Johnny (John R. Cash, 1932–), U.S. musician, who became a popular country-

A country-music classic—singer-songwriter-guitarist Johnny Cash in live performance.

music singer, songwriter, and guitarist in the mid-1950s with his own "Cry, Cry, Cry" and "Hey, Porter" in 1955 and with "Folsom Prison Blues" (1955) and "I Walk the Line" (1956). He went on to become one of the central figures in country music; a few of his most notable recordings were the album *Bitter Tears: Ballads of the American Indian* (1964), *Ballads of the True West* (1965), and *At Folsom Prison* (1968). He also has appeared in several films, including *The Gunfight* (1970). Cash often sang with his second wife, June Carter, of the CARTER FAMILY. His daughter by an earlier marriage, Rosanne Cash, is also a popular country-and-western singer.

Cassavetes, John (1929–89), U.S. director, actor, and screenwriter, who developed a substantial acting career in the 1950s in such films as *Edge of the City* (1957) and ROSEMARY'S BABY (1968). His television work included the 1959–60 series "Johnny Staccato." His main interest was in the creation of art films; he directed and in several instances also wrote such films as *Shadows* (1960), *Faces* (1968), *Minnie and Moskowitz* (1971), and *Gloria* (1980), often starring his wife, Gena Rowlands.

Cassidy, Hopalong, Western series star created by William BOYD; he played Cassidy in 66 films and in the television series.

Castle, Vernon and **Irene** (Vernon Castle Blythe, 1887–1918; Irene Foote, 1893–1969), British dancers, who, from their Paris debut in 1912 shortly after their marriage until his enlistment in the British Air Force in 1914, were the leading ballroom dancers of their day, introducing such dances as the Castle walk and popularizing such dances as the turkey trot and the bunny hug. He died in an aircraft accident in 1918; she then retired.

Cat Ballou (1965), an Elliot Silverstein Western, a comedy starring Jane FONDA in the title role opposite Lee MARVIN in his OSCAR-winning twin gunfighters dual role. Nat King COLE memorably wove the song "The Story of Cat Ballou" throughout the film.

Catcher in the Rye (1951), the J.D. SALINGER novel, about the life and times of Holden Caulfield as he tries to find himself. The work

greatly appealed to young people through several student generations.

Catch-22 (1961), the Joseph HELLER novel, his very popular satire of the U.S. Army and its bureaucracy, set on a Mediterranean island during World War II. The "damned-if-you-do, damned-if-you-don't" title was so apt that it was quickly absorbed into the language. Buck Henry adapted the novel into the 1970 Mike NICHOLS film, with a cast that included Alan Arkin, Richard Benjamin, Jack Gilford, Art Garfunkel (of SIMON AND GARFUNKEL), Martin Balsam, Bob NEWHART, Paula Prentiss, Anthony PERKINS, Orson WELLES, and Martin Sheen.

Cather, Willa (1873–1947), U.S. writer, who emerged as a major novelist with her second novel, *O Pioneers!* (1913), a story based on her youthful experiences on the Nebraska frontier. She went on to write such Nebraska-based novels as *My Antonia* (1918) and *A Lost Lady* (1923), while her *One of Ours* (1922) won a PULITZER PRIZE. Her later work includes such novels as *Death Comes for the Archbishop* (1927), set in New Mexico, and *Shadows on the Rock* (1931), set in Quebec, both exploring the themes of Catholic commitment; she later wrote *Lucy Gayheart* (1935) and *Sapphira and the Slave Girl* (1940).

Cat on a Hot Tin Roof (1955), the PULITZER PRIZE-winning Tennessee WILLIAMS play, about a troubled and divided Mississippi family. On stage, Barbara Bel Geddes, Ben Gazzara, and Burl IVES played the key roles; in the 1958 Richard BROOKS film version, adapted for film by Brooks and James Poe, Ives recreated his stage role, joined by Elizabeth TAYLOR and Paul NEWMAN. Kathleen TURNER starred in a 1990 Broadway revival.

Cats (1981), the Andrew LLOYD WEBBER–Trevor NUNN musical, based on the T.S. ELIOT poetry collection *Old Possum's Book of Practical Cats* (1939); the 1982 Broadway version of the London play won seven TONYs, including best musical. The virtually plotless work is more a theater revue than a musical play.

Cavafy, Constantine Peter (1863–1933), Greek writer, a celebrated 20th-century poet whose

modest output was not formally published during his lifetime, save for a small, privately published collection in 1910. Much of his work sets modern personal concerns in the classic settings provided by the Hellenistic world, resonating and intertwining the two worlds and times.

Cavalcade (1931), the Noël Coward play, a Depression-era patriotic work extolling the virtues of British upper-class life, as personified by the family it follows from the turn of the century through the early 1930s and by the servants who attend them. Reginald Berkeley adapted the play into the 1933 Frank LLOYD film, with a cast that includes Clive Brook, Diana Wynyard, Ursula Jeans, Herbert Mundin, Una O'Connor, Irene Browne, and Beryl Mercer. The film, Lloyd, and art director William Darling won OSCARS.

Cavalcanti, Alberto (1897–1982), Brazilian director, writer, and documentary filmmaker, whose work was on screen from 1926 in such fiction films as *Yvette* (1927) and *Sea Fever*. From 1934 he worked with John GRIERSON on British documentaries, and from 1942 he directed a considerable variety of feature films in several countries, including *Nicholas Nickleby* (1947) and *Herr Puntila und sein Knecht Matti* (1955), the latter an adaptation of the Bertolt BRECHT play, in collaboration with Brecht.

Cavalry Trilogy, The, three massive John FORD films, focusing on the late-19th-century Western American Indian wars from the U.S. point of view. The first, *Fort Apache* (1948), starred Henry FONDA as the wrongheaded officer who forces the slaughter of most of his command, in a cast that included John WAYNE, Shirley TEMPLE, Victor MCLAGLEN, Pedro ARMENDARIZ, John Agar, and Anna Lee. The second was *She Wore a Yellow Ribbon* (1949), with Wayne as the retiring cavalry officer who ultimately prevents a new Indian war, and with McLaglen, Agar, Joanne Dru, and Ben Johnson in the main supporting roles. The third was *Rio Grande* (1950), with Wayne as a cavalry commander, opposite Maureen O'Hara.

Centennial (1978–80), the massive, 24-part television miniseries based on the 1974 James MICHENER novel about two centuries of American Western development, set in the fictional town of Centennial, Colorado, with Robert Conrad, Richard CHAMBERLAIN, Gregory Harrison, Alex Karras, Timothy Dalton, Raymond BURR, Sally Kellerman, Lynn Redgrave, David Janssen, and Robert VAUGHN in key roles.

Chabrol, Claude (1930–), French director, producer, and writer, one of the group of young film critics who gathered around André BAZIN and the CAHIERS DU CINÉMA in the mid-1950s, developed the AUTEUR theory, and became the directors of the NEW WAVE movement in French cinema. He directed such films as *The Cousins* (1959), which he also produced and wrote; *Bluebeard* (1963), *The Champagne Murders* (1967); *The Girlfriends* (1968); and *The Butcher* (1970), and also directed for television.

Chagall, Marc (1887–1985), Russian-Jewish painter, much of whose fantasy-filled work and religious allusion reflect the Hasidic influences of his Vitebsk childhood. While he can be identified with no single school, his work was greatly informed by his early years in Paris (1910–14), at the center of the development of modern art, years in which he produced such works as *Homage to Apollinaire* (1912) and *Paris Through the Window* (1913). He spent the years 1914–22 in what became the Soviet Union, as Vitebsk cultural commissar, and in Moscow; a notable painting of this period was the *Double Portrait with a Glass of Wine* (1917). He lived in Paris during the interwar period, continuing to paint such works as *Over Vitebsk* (1923) and *The Circus* (1931), while extending his reach to become one of the century's leading book illustrators: In 1923, he began the long projects that were to eventuate in the celebrated illustrated editions of *Dead Souls* (1948), La Fontaine's *Fables* (1952), and *The Bible* (1956). He fled France for the United States in 1941, where he continued to paint and also designed two ballets. Chagall resettled in France in 1948; in his later career he stretched even farther, into such celebrated stained-glass works as those at the cathedral in

Metz (1958) and at the Hebrew University Medical Center in Jerusalem and into such murals as those on the ceiling of the Paris Opera (1964) and at the Metropolitan Opera (1966).

Chaliapin, Feodor Ivanovich (1873–1938), Russian bass, one of the most celebrated operatic basses of his time; in the late 1890s he played leading roles in Moscow, and in 1901 he made his international debut in Milan, then playing leads in such operas as *Boris Godunov*, *Mephistopheles*, and *Don Giovanni*, most often at the Metropolitan Opera until 1929. He supported the Bolshevik Revolution and was artistic director of the Maryinsky (later the KIROV) Theatre until 1921, but then left Russia permanently. On screen, he was *Ivan the Terrible* in 1915 and *Don Quixote* in the 1933 G.W. PABST film.

Chamberlain, Richard (George Richard Chamberlain, 1935–), U.S. actor; after his long run as Dr. KILDARE in the television series (1961–66), he moved into several substantial action film roles but is by far best known for his leads in the television miniseries SHOGUN (1980) and THE THORN BIRDS (1983).

Chan, Charlie, fictional Oriental screen detective, a stereotype played most notably by Warner Oland from 1931 to 1937 and by Sidney Toler through the mid-1940s.

Chandler, Raymond (1888–1959), U.S. writer, a mystery magazine short-story writer from the early 1930s, who from the late 1930s created a group of realistic mystery novels set in Southern California and featuring his fictional detective Philip MARLOWE. These included his first novel, THE BIG SLEEP (1939), which was adapted by William FAULKNER and others into the classic 1946 Howard HAWKS film, starring Humphrey BOGART and Lauren BACALL, and again into the 1978 Robert MITCHUM vehicle. His FAREWELL MY LOVELY (1940) became *The Falcon Takes Over* (1942), the classic MURDER MY SWEET (1945), with Dick POWELL in the Marlowe role, and the 1975 *Farewell My Lovely*, with Mitchum playing Marlowe. Such other novels as *The Lady in the Lake* (1943) and *The Long Goodbye* (1954) were also adapted into films.

In addition, Chandler wrote or collaborated in the writing of such screenplays as DOUBLE INDEMNITY (1944) and *Strangers on a Train* (1951).

Chanel, Coco (Gabrielle Chanel, 1883–1971), innovative French fashion designer; she opened her first shop in 1913 and for the next three decades was a dominant fashion-setter, moving women's high-fashion styles away from laced-in discomfort to the easier, more comfortable look that characterized much of the interwar period. She also introduced the best-known perfume of the time, Chanel No. 5. Chanel was a considerable international celebrity for much of her life; Katharine HEPBURN portrayed her in the 1969 Broadway musical *Coco*.

Chaney, Lon (Alonso Chaney, 1883–1930), U.S. actor, who became known as "The Man of a Thousand Faces," later the title of the 1957 film in which James CAGNEY played Chaney. He was the son of deaf-mute parents and used his early experience to help him become the most extraordinary pantomimist and makeup artist in film history, who from 1912 to 1930 played approximately 150 very diverse roles, including his celebrated portrayal of Quasimodo in THE HUNCHBACK OF NOTRE DAME (1923), and the title role in THE PHANTOM OF THE OPERA (1925). His son Lon Chaney, Jr. also pursued a career in film, mainly in action and horror-film character roles.

Chapayev (1934), the Sergei and Georgy Vasiliev film about the Red Army partisan leader during the Russian Civil War, with Boris Bobochkin in the title role. Although far from being a crude propaganda piece, it became part of the Soviet patriotic run-up to World War II.

Chaplin, Charlie (Charles Spencer Chaplin, 1889–1977), British actor, director, writer, composer, and producer. The child of a theatrical family, he was on stage from the age of eight and in variety as a comic in his teens. From 1913 and beginning at KEYSTONE, he developed into the most popular screen comic of the century, as the tramp who captivated audiences all over the world. By 1916 he had achieved artistic control of his work and in

1919 became a co-founder of United Artists, with Mary PICKFORD, Douglas FAIRBANKS, and D.W. GRIFFITH. Some of his major silent films were THE TRAMP (1915), THE KID (1921), THE GOLD RUSH (1925), CITY LIGHTS (1931), and MODERN TIMES (1936), the latter two appearing during the sound era and carrying a sound track, but only for music and sound effects. His later sound films included THE GREAT DICTATOR (1940), MONSIEUR VERDOUX 1947), and LIMELIGHT (1952). Chaplin was attacked for alleged immorality in 1942, in the course of a paternity suit, and for alleged Communist sympathies by conservative groups as the post-World War II McCarthy era unfolded. He left the United States in 1952, returning only in 1972 to accept a second special ACADEMY AWARD, the first special award having been presented in 1928. The last of his four wives was Oona O'Neill, daughter of Eugene O'NEILL; his third had been Paulette GODDARD, the female lead in *The Great Dictator*. He was the brother of British comedian Syd Chaplin (1885–1965) and the father of actress Geraldine Chaplin (1944–) and actor Sydney Chaplin (1926–).

Chariots of Fire (1981), the OSCAR-winning Hugh Hudson film, about several young British athletes in the 1924 Olympics; Ben CROSS and Ian CHARLESON play the leads, strongly supported by Ian HOLM, Nigel Havers, Alice Krige, and Cheryl Campbell. Colin Welland won an Oscar for his screenplay, as did Vangelis for the score and Milano Canonero for costume design.

Charles, Nick, the sophisticated 1930s private detective created by Dashiell HAMMETT in his novel THE THIN MAN (1932) and played six times on screen by William POWELL, beginning with the 1934 film. Peter Lawford played the role in the 1957–59 television series.

Charles, Ray (Ray Charles Robinson, 1930–), U.S. musician; blind from early childhood, he composed and arranged in Braille, became a leading soul singer, and was one of the first major popular artists to merge the Black gospel and BLUES heritages while simultaneously breaking the American color line repeatedly from the mid–1950s. He is best known for his tremendously popular 1960 recording of Hoagy CARMICHAEL's GEORGIA ON MY MIND, as sung by Charles in its own way emblematic of the embattled civil rights movement of the time; for his recordings of such songs as "The Things I Used to Do" (1953), "I've Got a Woman" (1955), and "I Can't Stop Loving You" (1962); and for such albums as *The Genius of Ray Charles* (1959) and *Modern Sounds in Country and Western Music* (1964).

Charleson, Ian (1949–90), British actor, on stage from the late 1960s; by far his best-known work was the Eric Liddell role in CHARIOTS OF FIRE. Much of his work was in the theater; he played Hamlet at Britain's National Theatre shortly before his extraordinarily promising career was cut short by AIDS.

Charlie Bubbles (1968), a film written by Shelagh DELANEY and directed by Albert FINNEY; he also starred, as a British writer returning home for a visit, and perhaps to recapture some of his lost and mourned northern working-class roots. The cast included Billie WHITELAW, Colin Blakeley, and Liza MINNELLI in her first film role.

Charly (1968), the Ralph Nelson film, starring Cliff ROBERTSON in an OSCAR-winning role as a retarded adult who through medical intervention becomes intelligent and fully mature but ultimately learns that it is all temporary, and then regresses to his original state. Claire BLOOM also starred, in a cast that included Lilia Skala, Leon Janney, and Dick Van Patten. Stirling Silliphant wrote the screenplay, based on the Daniel Keyes novel *Flowers For Algernon*.

Chatwin, Bruce (1940–89), British travel writer and novelist, whose chief works were the travel book *In Patagonia* (1977) and the novels *On the Black Hill* (1982), *The Songlines* (1987), and *Utz* (1988).

Chayefsky, Paddy (Sidney Chayefsky, 1923–81), U.S. writer, whose many 1950s television plays included MARTY (1953), which he adapted into the OSCAR-winning 1955 movie, for which he won a best screenplay Oscar. He also wrote the screenplays for such films as *The Catered Affair* (1956) and *The Bachelor Party*

(1957), both adapted from earlier teleplays; *Middle of the Night* (1959), adapted from his own 1958 Broadway play; THE AMERICANIZATION OF EMILY (1964); *The Hospital* (1971), for which he won a second Oscar; and NETWORK (1971), which won him a third. His works also include such plays as *The Tenth Man* (1959) and *The Passion of Josef D.* (1964) and the novel *Altered States* (1978).

Chávez, Carlos (1899–1978), Mexican composer and conductor, whose considerable body of classical work, including seven symphonies, was greatly influenced by Mexican Indian themes. He was one of the key Mexican cultural figures of the century, as founder and director of the Mexican Symphony Orchestra (1928–48) and director of the National Conservatory (1929–33).

Checker, Chubby (Ernest Evans, 1941–), U.S. singer, who became a very popular ROCK singer during the short-lived twist dance craze of the early 1960s, with his renditions of such songs as "The Twist" (1960) and several "Twist" sequels. He then became identified with several other dances, including the hucklebuck, pony, fly, and limbo, each with its own song.

"Cheek to Cheek" (1935), a song introduced by Fred ASTAIRE and Ginger ROGERS in the film TOP HAT (1935), with words and music by Irving BERLIN.

"Cheers" (1982–), the long-running television situation comedy, set in a Boston bar named Cheers. Leading players in the series have included Shelley Long, Ted Danson, Rhea Perlman, Nicholas Colasanto, George Wendt, John Ratzenburger, and Kirstie Alley. The series was created by Glen Charles, Les Charles, and James Burrows.

Cheever, John (1912–82), U.S. writer, a prolific short-story author from the early 1940s, whose work was often published in *The New Yorker*. His first short-story collection was *The Way Some People Live* (1943). He emerged as a major figure with his novel *The Wapshot Chronicle* (1957), a National Book Award winner, which was followed by *The Wapshot Scandal* (1964), *Bullet Park* (1969), and *Falconer* (1977), while his flood of short stories contin-

ued unabated. His *The Stories of John Cheever* (1978) won a PULITZER PRIZE. He was the father of writer Susan Cheever.

Chekhov, Anton Pavlovich (1860–1904), Russian writer, his country's greatest playwright, and a prolific short-story writer. The great bulk of his work belonged to the 19th century, but it was his four classic turn-of-the-century plays that established him as a world figure. These were *The Seagull* (1896), which failed on original production but in 1898 found new life as one of the earliest productions of Konstantin STANISLAVSKY at the MOSCOW ART THEATRE; *Uncle Vanya* (1897); THE THREE SISTERS (1901); and THE CHERRY ORCHARD (1903), the latter three plays also introduced at the Moscow Art Theatre. All four plays ultimately became part of the standard repertory of theater companies all over the world.

Cher (Cherilyn Lapierre Sarkisian, 1946–), U.S. actress and singer, who became a leading popular singer in the early 1960s, with Sonny Bono in Sonny and Cher, a partnership that ended with their 1975 divorce. She went on to become one of the leading recording artists and popular entertainers of the 1980s, simultaneously appearing in such films as *Silkwood* (1983); *Mask* (1985); *The Witches of Eastwick* (1987); *Moonstruck* (1987), for which she won a best actress OSCAR; and *Mermaids* (1990).

Cherkassov, Nicolai (1903–66), Soviet actor, on stage from 1926, and on screen from 1927, who early in his career played in comedy and in the mid-1930s moved into his long career as a leading tragedian, mainly in classical roles. Internationally he is best known for his leads in several epic Soviet films, including ALEXANDER NEVSKY (1938), IVAN THE TERRIBLE (Part 1, 1944; Part 2, 1946), and *Don Quixote* (1957).

Cherry Orchard, The (1903), the classic play by Anton CHEKHOV, introduced by Konstantin STANISLAVSKY at the MOSCOW ART THEATRE. Chekhov's portrayal of aristocracy in decay anticipated the troubled times that lay ahead in Russia, at the same time reaching deeper into personal questions that transcend nation and circumstance—so much so that the

play has become part of the standard repertory.

Chesterton, G.K. (Gilbert Keith Chesterton, 1874–1936), British writer, best known for his creation of the FATHER BROWN detective stories, beginning with *The Innocence of Father Brown* (1911). He was one of the most diverse and prolific of early-20th-century authors, writing novels, plays, short stories, poetry, literary criticism, and a miscellany of essays. In 1922 he became a Catholic, thereafter producing a series of religious works as well.

Chevalier, Maurice (1888–1972), French singer and actor, on stage from the age of 11, who became a star in musical theater in 1909, playing opposite MISTINGUETT, his lover in that period, at the Folies-Bergére. He was wounded and became a German prisoner of war during World War I, then returned to the musical theater as a leading player and worldwide celebrity throughout the interwar period. He was accused of collaborating with the Nazis during World War II but later was exonerated. He was also accused of being a Communist sympathizer and refused entry into the United States in 1951, during the McCarthy era. Chevalier was on screen from 1908, his main screen career beginning in 1929, with leads in such films as *The Love Parade* (1929), *Love Me Tonight* (1932), and *The Merry Widow* (1934). Later in his career he played strong character roles in such films as GIGI (1958) and FANNY (1961). Among the songs most associated with him are "Louise," "Mimi," and (from *Gigi*) "Thank Heaven for Little Girls" and "I Remember It Well" (in duet with Hermione Gingold).

Cheyenne Autumn (1964), John FORD's last Western, this one a wholly sympathetic portrayal of a Cheyenne band trying to make its way home after having been uprooted and transported elsewhere by the Americans after the Indian wars. The huge cast was led by Richard WIDMARK, Dolores DEL RIO, Ricardo Montalban, Gilbert Roland, Carroll Baker, and Karl MALDEN and included appearances by Edward G. ROBINSON and James STEWART.

Chicago, Judy (Judy Cohen, 1939–), U.S. artist, best known for such feminist works as *The Dinner Party* (1978), which sets forth a large body of accomplishments attributed to women, and *The Birth Project* (1985), which extols the leading role of women in the creation of life.

Chieftains, The, the Irish folk band; David Fallon, Martin Fay, Paddy Moloney, Sean Potts, and Michael Tubridy were later joined by Derek Bell and Pendar Mercier. They emerged as a major international group in the mid-1970s and made 10 *Chieftains* albums (1964–81), *Bonaparte's Retreat* (1976), and several other albums, as well as doing several film scores, most notably the music for THE GREY FOX (1983).

Chien Andalou, Un, the surrealist Luis BUÑUEL–Salvador DALI film; its English title is AN ANDALUSIAN DOG.

Children of a Lesser God (1980), the Mark Medoff play, about the interplay and developing personal relationship between a deaf student and her voice teacher. Phyllis Frelich, herself hearing-impaired, created the Sarah Norman role and John Rubinstein created the James Leeds role; both won TONYs, as did the play. Medoff and Herter Anderson adapted the play into the 1986 Randa Haines film; Marlee Matlin, also hearing-impaired, won a best actress OSCAR for her Sarah, opposite William HURT as James, in a cast that included Piper Laurie and Philip Bosco.

Children of Paradise (*Les Enfants du Paradis*, 1945), the classic Marcel Carné film, with a screenplay by Jacques Prévert, and with Arletty as Garance and Jean-Louis BARRAULT as the mime Deburau; a romance set largely in mid-19th-century Paris, about lovers who find each other briefly and are then forced apart, their love and loss a metaphor for the fate of the artist in the real world. At the close of the film Deburau, dressed as Pierrot, unsuccessfully searches for Garance, in a sequence notable in film history.

Children's Hour, The (1934), Lillian HELLMAN's first play, about two schoolteachers and the man one of them is engaged to marry, all of whose lives are destroyed by a

malevolent student's accusation of lesbianism. Hellman adapted it into THESE THREE, the 1936 Billy WILDER film, with Miriam HOPKINS, Merle Oberon, and Joel MCCREA in the leads and Bonita Granville as the student. The 1936 film quite effectively substituted heterosexual "immorality" for lesbianism, the latter being thought unacceptable to movie audiences and the censoring Hays Office of the time. William WYLER remade the film in 1962, with the original play intact; the cast was led by Audrey HEPBURN, Shirley MACLAINE, and James GARNER.

China Syndrome, The (1979), the James Bridges film, about a nearly disastrous accident at a U.S. nuclear installation, with Jane FONDA, Jack LEMMON, and Michael DOUGLAS in key roles. It was highly topical and thought by many to be prophetic as well: The nearly disastrous American Three-Mile Island nuclear accident occurred in March 1979, while the full-scale disaster of the Soviet Chernobyl nuclear meltdown occurred in April 1986.

Chinatown (1974), the Roman POLANSKI film, set in 1930s Los Angeles, revolving around the politics of water and the fact of incest, with Jack NICHOLSON and Faye DUNAWAY in the leads and John HUSTON in a centrally important supporting role. Robert Towne won an OSCAR for his screenplay. A sequel, *The Two Jakes*, starring and directed by Nicholson, appeared in 1990.

Chirico, Giorgio De (1888–1978), Italian painter; from 1909 he developed a painting style that sought to reveal what he perceived as the essential mystery in ordinary things, creating works in which people were replaced by tailors' dummies and other inanimate objects, town squares were emptied and depicted as filled with impossible shadows, and an atmosphere was conveyed consonant with his concepts, which during World War I he began to call "metaphysical art." His work considerably influenced the developing surrealist movement (see SURREALISM). During the 1920s his thinking and work began to turn toward more traditional matters and forms, ultimately resulting in 1930 in a complete break with modernism.

Cho-Cho-San, the Japanese geisha who is driven to suicide by the betrayal of her American lover in PUCCINI's opera MADAME BUTTERFLY.

Chodorov, Edward (1904–88), U.S. writer, director, and producer. Some of his best-known works are the films *The Hucksters* (1947) and *Road House* (1948) and the play *Oh, Men! Oh,Women!* (1953). He was blacklisted by the film industry in 1953, after having been named a communist before the House Un-American Activities Committee and after having himself refused to "name names."

Chorus Line, A (1975), the long-running TONY-winning Broadway musical, conceived, directed, and choreographed by Michael Bennett and set around the auditions for a Broadway musical. Robert LuPone and Donna McKechnie, also a Tony-winner, headed a large cast, playing and dancing very strongly in ensemble; the show ran for a record-breaking 15 years, closing in 1990. Arnold Schulman adapted the play into the 1985 Richard ATTENBOROUGH film; Michael DOUGLAS led a large cast that included Alyson Reed, Terence Mann, Vicki Frederick, Cameron English, and Janet Jones.

Chris Christopherson (1920), the Eugene O'NEILL play that was the original version of ANNA CHRISTIE, with Lynn FONTANNE playing Anna. The play failed before reaching Broadway.

Christie, Agatha Mary Clarissa Miller (1890–1976), British author of scores of mystery novels, romances, short stories, and plays, beginning with the novel *The Mysterious Affair at Styles* (1920), in which she created Belgian detective Hercule POIROT. Ten years later, in *Murder at the Vicarage* (1930), she introduced Jane MARPLE. Her play *The Mousetrap* (1952) ran in London for over 30 years and was the longest running play in theater history. She also wrote such plays as *Witness for the Prosecution* (1953), later adapted into the 1957 Billy WILDER film and the 1982 television play, and also dramatized such novels as *Ten Little Indians* (1944) and *Murder on the Nile* (1946), both of which later became films, as did MURDER ON THE ORIENT EXPRESS (1974). Many of her

other novels also became films, and several Jane Marple works became television series.

Christie, Julie Frances (1940–), British actress, on stage from 1957, and on screen from 1962, who played her first film lead in BILLY LIAR (1963) and in 1965 starred in DARLING, winning a best actress OSCAR; in the same year, she played LARA in the epic DOCTOR ZHIVAGO. Her later films include *Far from the Madding Crowd* (1967), MCCABE AND MRS. MILLER (1972), *Shampoo* (1974), HEAT AND DUST (1983), and *Fools of Fortune* (1990).

Christina's World (1948), the most celebrated of Andrew WYETH's many paintings, showing his crippled neighbor Anna Christina Olson in a field looking toward a house on the horizon.

Cimarron (1930), the Edna FERBER Oklahoma-based pioneer novel, which was adapted by Howard Estabrook into the OSCAR-winning Wesley Ruggles film, with Richard Dix and Irene DUNNE in leading roles; the film was remade by Anthony Mann in 1960, with Glenn FORD and Maria Schell in the leads.

Cimino, Michael (1943–), U.S. filmmaker, who wrote, directed, and produced the OSCAR-winning THE DEER HUNTER (1978) and won a best director Oscar for the film. He also wrote and directed *Thunderbolt and Lightfoot* (1974), HEAVEN'S GATE (1980), and *The Sicilian* (1987) and produced and directed *The Year of the Dragon* (1985).

Citadel, The (1937), the A.J. CRONIN novel, about a doctor choosing between money and ethics. It became the 1938 King VIDOR film, with Robert DONAT creating the memorable Dr. Andrew Manson role in a cast that included Rosalind RUSSELL, Ralph RICHARDSON, and Rex HARRISON. Ben CROSS was Manson in the 1983 television miniseries.

Citizen Kane (1941), the first Orson WELLES film, an extraordinarily powerful, innovative work based substantially on the life of publisher William Randolph Hearst, in the film Charles Foster Kane. Welles produced and directed the film, collaborated on the OSCAR-winning screenplay with Herman J. Mankiewicz, and played the title role, in a cast that included Joseph COTTEN, Dorothy Com-

ingore, Everett Sloane, George Coulouris, Agnes Moorehead, Paul Stewart, Ray Collins, Ruth Warrick, Erskine Sanford, and Henry Shannon. Welles's directorial technique, his technical achievements, and the sheer quality of the total film greatly influenced the development of world cinema.

City Lights (1931), the Charlie CHAPLIN film; he directed, wrote the screenplay, composed the score, and starred in the silent tragicomedy classic, with Virginia Cherill as the blind flower girl who is ultimately cured by Charlie's sacrifice and Harry Myers as the rich man.

City of Angels (1989), the TONY-winning Larry Gelbart musical, with music by Cy Coleman and lyrics by David Gippel; a comedy about a writer in 1940s Hollywood, with a cast led by James Naughton, Gregg Edelman, and Dee Hoty.

"City of New Orleans, The" (1973), the Steve Goodman song, about an aging train of that name and the people riding it across the country. It was long identified with Judy COLLINS, although it became part of the standard folk-rock repertory, sung notably by Arlo Guthrie and Willie NELSON. Words and music were by Goodman.

Civic Repertory Theatre, the pioneering U.S. repertory theatre founded by Eva LE GALLIENNE in 1926 to present the classics and noncommercial new plays in repertory at very low prices, a concept enthusiastically supported by many theater people of the time, who worked in the company, as she did, for very little money. The company lasted until 1933, surviving four years into the Great Depression.

Clair, René (1898–1981), French writer and director, who created a notable body of light satirical comedy. After acting in several early 1920s films, he turned to filmmaking, creating such works as *Entr'acte* (1924), *Le Million* (1931), *The Ghost Goes West* (1935), *And Then There Were None* (1945), and *Beauties of the Night* (1952).

Clapton, Eric (1945–), British ROCK guitarist and singer, who played with several groups during the 1960s, including The Yardbirds, Cream, and Blind Faith, and emerged as

a guitar soloist and singer in the early 1970s with such albums as *Eric Clapton* (1970), *Eric Clapton's Rainbow Concert* (1973), and *461 Ocean Boulevard* (1975). His later albums include *Another Ticket* (1980) and *Just One Night* (1985). Clapton has composed several songs, most notably "Layla" (1970).

Clarke, Arthur Charles (1917–), British writer, who emerged as a popular science-fiction author in the 1950s. He is best known for his novel 2001: A SPACE ODYSSEY and the screenplay for the resulting film, written with and directed by Stanley KUBRICK.

Claudel, Paul-Louis-Charles-Marie (1868–1955), French writer, whose Catholicism permeates his many plays and volumes of inward-reaching poetry. His best-known plays include *Break of Noon* (1906), based on his own experiences in China; *The Tidings Brought to Mary* (1912); a trilogy: *The Hostage* (1911), *Crusts* (1918), and *The Humiliation of the Father* (1920); and *The Satin Slipper* (1929), which received a very notable stage introduction by Jean-Louis BARRAULT in 1945.

Clavell, James (1924–), British-American writer, best known for three historical novels, all set in East Asia: *Tai-Pan* (1966), which became the 1986 Daryl Duke film; SHOGUN (1975), which became the five-part 1980 television miniseries starring Richard CHAMBERLAIN; and *Noble House* (1981). His first novel, *King Rat* (1962), based on his own experiences in a Japanese prison camp, became the 1965 Bryan Forbes film. He has also written such films as *The Fly* (1958) and *The Great Escape* (1963) and wrote, directed, and produced several films, including *To Sir, with Love* (1967).

Clayburgh, Jill (1944–), U.S. actress, on screen from 1969, and on stage from 1970; she is best known for such films as *Gable and Lombard* (1976), *Silver Streak* (1976), the highly regarded *An Unmarried Woman* (1978), *Starting Over* (1979), *I'm Dancing As Fast As I Can* (1982), and *Shy People* (1987). She is married to playwright David RABE.

Clement, René (1913–1981), French director, a documentarian in the 1930s, who moved into fiction features during the postwar period and whose body of work includes such films as *The*

Damned (1947), *Forbidden Games* (1952), *Knave of Hearts* (1954), *Is Paris Burning?* (1966), and *Rider in the Rain* (1970).

Clements, John Selby (1910–88), British actor-manager, on stage from 1930, who managed and acted in several London theaters from 1935, beginning with his own Intimate Theatre repertory company in 1935 and including the Chichester Festival Theater 1965–73. He played leads in a wide variety of modern and classic plays, from 1943 often opposite his wife, Kay Hammond. His film career included roles in such films as KNIGHT WITHOUT ARMOR (1936), THE FOUR FEATHERS (1939), and OH! WHAT A LOVELY WAR (1969).

Clift, Montgomery (Edward Montgomery Clift, 1920–66), U.S. actor, on stage from 1934, who played in several strong supporting roles on Broadway before moving into screen roles, beginning with *The Search* (1948) and RED RIVER (1948). He played major roles in such films as A PLACE IN THE SUN (1951), FROM HERE TO ETERNITY (1953), and *Raintree Country* (1957) before suffering serious facial scars in a 1957 automobile accident, and then continued on, despite his greatly altered appearance, in such films as *The Young Lions* (1958), *Suddenly, Last Summer* (1959), THE MISFITS (1961), JUDGMENT AT NUREMBERG (1961), and in the title role in *Freud* (1962).

Clockwork Orange, A (1962), the Anthony BURGESS novel, a bitter satire set in a violence-ridden near-future Britain; Stanley KUBRICK wrote and directed the 1971 film adaption, with Malcolm McDowell in the lead, in a cast that includes Patrick McGee, Warren Clarke, and Michael Bates.

Clooney, Rosemary (1928–), U.S. singer, who became a popular figure in 1951 with "Come On-a My House" and "If Teardrops Were Pennies." She also appeared in several films, including *White Christmas* (1954) and *Deep in My Heart* (1955).

Close, Glenn (1947–), U.S. actress, on stage from 1974 and on screen from 1982, in such films as THE WORLD ACCORDING TO GARP (1982), THE BIG CHILL (1983), *The Natural* (1984), *Jagged Edge* (1985), *Fatal Attraction* (1987), *Dangerous Liaisons* (1989), *Reversal*

of Fortune (1990), and *Hamlet* (1990). She won a best actress TONY for her role in Tom STOPPARD's *The Real Thing* (1984).

Close Encounters of the Third Kind (1977), the Steven SPIELBERG film; he directed and wrote the screenplay of this modern science-fiction classic about a peaceful first encounter between humanity and an alien, benign, space-traveling civilization, with Richard DREYFUSS, Melinda Dillon, François TRUFFAUT, and Cary Guffey in the key roles. The extraordinary special effects were the most notable single aspect of the film; their success greatly accelerated the trend toward spectacle in the American films of the period.

Closely Watched Trains (1965), the Jiri Menzel film, adapted by Bohumil Hrabo from his own novel; a bittersweet comedy set in occupied Czechoslovakia during World War II, with a cast that included Vaclav Neckar, Vladimir Valenta, Jitka Bendova, Josef Somr, Libuse Havelkova, Jitka Zelenohorska, and Jiri Menzel. The work won a best foreign film OSCAR.

Clurman, Harold Edgar (1901–80), U.S. director and theater critic, who worked with the THEATER GUILD from 1925 to 1931, leaving the Guild in 1931 to found the GROUP THEATRE with Cheryl CRAWFORD and Lee STRASBERG; he directed the Group's first play, Clifford ODETS's *Awake and Sing* (1935). He managed the theater from 1936 to 1940, when it disbanded, directing several of Odets's other plays, and later directed many other new plays, such as THE MEMBER OF THE WEDDING (1950), BUS STOP (1955), and *Incident at Vichy* (1964). He was drama critic for *The New Republic* from 1949 to 1953, then moved to *The Nation*, and also wrote several books on the theater.

Coal Miner's Daughter (1980), the Michael Apted film, starring Sissy SPACEK in an OSCAR-winning role as country singer Loretta LYNN, leading a cast that included Tommy Lee Jones as Mooney Lynn, Levon Helm, and Beverly D'Angelo. Tim Rickman's screenplay was based on Lynn's autobiography.

Cobb, Lee J. (Leo Jacoby, 1911–76), U.S. actor, on stage from 1931, who developed strong character roles in such GROUP THEATRE productions as *Waiting for Lefty* (1935) and GOLDEN BOY (1937); in 1939, he also appeared in the film version of *Golden Boy*. In 1949 he created the Willy LOMAN role in DEATH OF A SALESMAN on Broadway, and very late in his career he played the title role in *King Lear* (1968). On screen he played a long succession of character roles, in such films as ON THE WATERFRONT (1954) and 12 ANGRY MEN (1957).

Coburn, James (1928–), U.S. actor, on screen from 1959, who emerged as a leading satirist in the title roles of such Cold War-era spoofs as *Our Man Flint* (1966), *In Like Flint* (1967), and THE PRESIDENT'S ANALYST (1967). Among his other films are *The Magnificent Seven* (1960), THE AMERICANIZATION OF EMILY (1964), *Duffy* (1968), *Bite the Bullet* (1975), *Cross of Iron* (1977), and *Death of a Soldier* (1986). His television appearances include a role in "The Dain Curse" (1978).

Cocteau, Jean (1889–1963), French writer, filmmaker, and painter, who worked in a very wide variety of forms and media with many of the leading people in the arts of his time. One of his best-known works was perhaps his most straightforward: It was the autobiographical *Opium* (1930), describing his addiction to the drug and subsequent recovery. His best-known films include *The Blood of a Poet* (1930), an early experimental work; the classic fantasy *Beauty and the Beast* (1946); *The Strange Ones* (1950), adapted from his 1929 novel; *Intimate Relations* (1954), adapted from his 1938 play; and *Orpheus* (1950) and its sequel *The Testament of Orpheus* (1960). Among his many other plays are *The Human Voice* (1930), *The Infernal Machine* (1934), and *The Eagle Has Two Heads* (1946). He also wrote the scenarios for several ballets, most notably for PARADE (1917), and published several volumes of poetry.

Cohan, George Michael (1878–1942), U.S. actor-manager and writer, on stage as a child with his family in vaudeville's *The Four Cohans*. He was a prolific playwright and songwriter, his plays including such musicals as *Little Johnny Jones* (1904), FORTY-FIVE MINUTES FROM BROADWAY (1906), and *Little Nel-*

lie Kelly (1922) and such dramas as *Seven Keys to Baldpate* (1913). Many of the songs in these musicals were among the greatest hits of their time, such as GIVE MY REGARDS TO BROADWAY, MARY'S A GRAND OLD NAME, YOU'RE A GRAND OLD FLAG, and OVER THERE. Late in his career he played major roles in AH, WILDERNESS! (1933) and *I'd Rather Be Right* (1937), as Franklin D. Roosevelt. Cohan also wrote several screenplays, adapted some of his plays for the screen, acted in several films, and in 1940 produced *Little Nellie Kelly* on film. He was played by James CAGNEY in the screen biography *Yankee Doodle Dandy* (1943).

Colbert, Claudette (Claudette Lily Chauchoin, 1905–), U.S. actress, on stage from 1923, who went to Hollywood with the advent of sound and became one of the stars of the Golden Age, becoming a leading player in comedy with her best actress OSCAR for IT HAPPENED ONE NIGHT (1934), but also playing in a wide variety of other roles, in such films as *Cleopatra* (1934), *Tovarich* (1937), *Midnight* (1939), *Drums Along the Mohawk* (1939), *Skylark* (1941), and *The Egg and I* (1947). She later returned to the stage, in such plays as *The Marriage-Go-Round* (1958) and *The Kingfisher* (1978), and also played in television.

Cole, Nat "King" (Nathaniel Adams Coles, 1917–65), U.S. JAZZ musician, who emerged as a major singer in the 1940s after becoming a jazz pianist and bandleader in the 1930s. He recorded scores of hit songs, such as "Mona Lisa" (1951), "Pretend" (1953), and his classic version of STAR DUST (1957), and appeared in several films, most notably as W.C. HANDY in ST. LOUIS BLUES (1958). He sang the title song in CAT BALLOU (1965), also appearing in the film. His daughter Natalie Cole also became a popular singer.

Coleman, Ornette (1930–), U.S. musician, a versatile JAZZ instrumentalist (especially saxophonist) and composer whose highly experimental group improvisational work of the early 1960s had considerable impact on the development of ROCK AND ROLL, and on the merging of several trends in modern popular music. In the mid-1960s he moved toward a partial fusion of jazz and modern classical

approaches, most notably in the long work *Skies of America* (1972); he described his music of the period as "harmelody." Coleman organized the group Prime Time in 1977, recording with them throughout the 1980s.

Colette (Sidonie Gabrielle Claudine Colette, 1873–1954), French writer, whose early semi-autobiographical novels, the *Claudine* series, beginning with *Claudine at School* (1900), were signed "Willy," the pseudonym of her husband, writer Henry Gauthier-Villars. A prolific novelist and short-story writer, her best-known works also include the *Cheri* series, beginning with *Cheri* (1920), and *Gigi* (1944), which was adapted into the 1959 Vincente MINNELLI film musical.

Collier, Constance (Laura Constance Hardie, 1878–1955), British actress, on stage at the age of three, in musical theater in her youth, and in many roles in the company of Beerbohm TREE, 1901–08. She also played in *Peter Ibbetson* (1915), and as Gertrude in John BARRYMORE's *Hamlet* (1925). Her film career began with INTOLERANCE (1916) and included substantial character roles in American films through 1950.

Collins, Judy (1939–), U.S. folk singer; a classically trained pianist, she emerged as a major folk singer in the early 1960s with her first album, *A Maid of Constant Sorrow* (1961), which she followed with such albums as *Wildflowers* (1967), *Recollections* (1969), *Whales and Nightingales* (1970), *Both Sides Now* (1971), *Judith* (1975), *Bread and Roses* (1976), and *The Fires of Eden* (1990). Much of her work of the 1960s reflected her civil-rights and anti-Vietnam War views; her later work continued to reflect these and related social concerns. She is identified with such songs as AMAZING GRACE, BOTH SIDES NOW, CITY OF NEW ORLEANS, "Send in the Clowns," and "Farewell to Tarwathie."

Colman, Ronald (1891–1958), British actor, in minor film and stage roles in Great Britain and the United States from 1916, who became a star opposite Lillian GISH in *The White Sister* (1923) and a major star in *Beau Geste* (1925). He successfully made the transition to sound, then starring in such films as ARROWSMITH

(1931); A TALE OF TWO CITIES (1935); LOST HORIZON (1937); RANDOM HARVEST (1942); and *A Double Life* (1948), for which he won a best actor OSCAR.

Colonel Blimp, the archetypal British conservative created by cartoonist David LOW during the interwar period, his ongoing comment on those who slept while the threat of fascism grew. Low developed the character so effectively that it soon entered the language; quite notably he did so while drawing for arch-conservative Beaverbrook's *Evening Standard,* Beaverbrook honoring his prior agreement as to Low's editorial freedom. The unrelated film THE LIFE AND DEATH OF COLONEL BLIMP (1943) is also often referred to as "Colonel Blimp."

Coltrane, John William (1926–67), U.S. JAZZ musician, the most celebrated jazz saxophonist of his generation; from the late 1940s through the 1950s he played and recorded with several bands, including those of Earl Bostic, Miles DAVIS, and Thelonius MONK, most notably with Davis on the album *Kind of Blue* (1959). He formed his own quartet in 1960 and soon became one of the leading jazz musicians of the period, with such albums as *Coltrane Plays the Blues* (1960), *My Favorite Things* (1960), *Duke Ellington and John Coltrane* (1962), and *Ascension* (1965).

Comden and Green (Betty Comden, 1915– , and Adolph Green, 1915–), U.S. musical theater collaborators and performers, who wrote the words and music to such theater musicals as WONDERFUL TOWN (1953); BELLS ARE RINGING (1956), adapting the play into the 1956 film; and *Applause* (1970), based on ALL ABOUT EVE. For film, they also wrote such musicals as ON THE TOWN (1949) and SINGIN' IN THE RAIN (1952).

Come Back Little Sheba (1950), the William INGE play about an alcoholic and his damaged but not entirely defeated wife. Sidney Blackmer won a TONY for creating the Doc Delaney role on stage, opposite Shirley BOOTH as Lola Delaney. She re-created her role and won an OSCAR for it opposite Burt LANCASTER in the 1952 Daniel MANN film, adapted from the play by Ketti Frings.

Coming Home (1978), the Hal ASHBY film, a powerful, sad, and entirely realistic post-anywar story about a woman and two soldiers, one of them her husband and the other the paraplegic veteran with whom she falls in love. Jane FONDA played the woman, Jon VOIGHT the paralyzed veteran, and Bruce Dern the soldier come home. Their war was the Vietnam War, lost and still bitterly divisive, and the film was widely viewed as part of a national coming to terms with Vietnam, especially because Fonda and Voight were leading opponents of the war. Fonda and Voight won best actress and best actor OSCARS, as did writers Waldo Salt and Robert C. Jones for their screenplay, adapted from the Nancy Dowd story.

Como, Perry (Pierino Como, 1912–), U.S. singer, a former barber who emerged as one of the leading popular singers of the 1940s with his recording of "Long Ago and Far Away" (1944), which he followed with scores of other hits, such as "Till the End of Time" (1945), "Prisoner of Love" (1946), and "Don't Let the Stars Get in Your Eyes" (1952). He starred in his own television show from 1948 to 1963, and also appeared in several films.

conceptual art, a rather general term covering a diverse and in some instances quite unrelated group of contemporary forms. Most of these forms cannot be defined as painting or sculpture and seem to share the theory that the artwork involved is not the artifact created (if any) but rather the process being performed, which embodies the idea being communicated by the artist. In this way, when an artist has a hole dug in the ground and then filled, perhaps taking photographs of the process, conceptual art is said to have occurred; by the same token, taking photographs of an archaeological dig might be thought of as an art process. Such works as Walter de Maria's *Mile Long Drawing* of parallel lines painted on the desert floor also have been generally described as conceptual art, although they are also often described as LAND ART, EARTH ART, or earthworks.

Connelly, Marc (Marcus Cook Connelly, 1890–1980), U.S. writer and director, who in the early 1920s collaborated with fellow journalist George S. KAUFMAN on several light comedies, beginning with *Dulcy* (1921) and

including their classic satire on early Hollywood, *Merton of the Movies* (1922), based on Harry Wilson's short stories, which was filmed in 1924, 1932, and 1947. Connelly's best-known play was an epic work on Bible themes with an all-Black cast, the PULITZER PRIZE-winning THE GREEN PASTURES (1930), based on the Roark Bradford stories; he also adapted and co-directed the work for the 1936 film. He and Frank Elsner co-authored *The Farmer Takes a Wife* (1934), based on the Frank Edmonds novel *Rome Haul*; the play became the 1935 and 1953 films. Connelly also wrote several other screenplays, including *Captains Courageous* (1937); directed many plays; was sometimes an actor; and wrote many short stories, a good many of them for *The New Yorker*.

Connery, Sean (Thomas Connery, 1930–), British actor, on stage from 1951 and on screen from 1956, who became a major international star as James BOND in *Dr. No* (1962), and played in six more very popular James Bond films, including *From Russia with Love* (1963), *Goldfinger* (1964), *Thunderball* (1965), *You Only Live Twice* (1967), *Diamonds Are Forever* (1971), and *Never Say Never Again* (1983). He also played leads and strong character roles in such films as *The Molly Maguires* (1970), *The Wind and the Lion* (1975), *The Untouchables* (1987), *The Presidio* (1988), *Family Business* (1989), *The Hunt for Red October* (1990), and *The Russia House (1990)*.

Connolly, Cyril (1903–74), British literary critic, an influential figure in British letters for several decades, who founded the magazine *Horizon* in 1939 and edited it until 1950. His best-known work is *Enemies of Promise* (1938), the first of several collections of criticism and miscellaneous book-related pieces.

Conqueror, The (1956), a film directed by Dick POWELL, with John WAYNE as Genghis Khan in a cast that included Susan HAYWARD, Pedro ARMENDARIZ, Agnes Moorehead, and William Conrad. The film itself was far from notable; what was extraordinarily notable, however, was that it was filmed in 1954 near the Nevada Test Site and that the three-month-long radiation exposure suffered by the cast and crew probably contributed to the unusually high incidence of cancer among those who had been on location, as later exposed by the children of some of those who died. Armendariz committed suicide in 1963, after learning that he had terminal cancer; Powell died of cancer in 1963, as did Moorehead in 1974, Hayward in 1975, and Wayne in 1979. After Wayne's death, an anonymous U.S. atomic-energy official was quoted as saying, "Please, God, don't let us have killed John Wayne."

Conrad, Joseph (Jósef Teodor Konrad Korzeniowski, 1857–1924), Polish-British writer, who spent his early years as a seafarer, publishing his first novel, *Almayer's Folly*, in 1895. He became one of the most notable writers of the late 19th and early 20th centuries with such novels as AN OUTCAST OF THE ISLANDS (1896), *The Nigger of the Narcissus* (1897), LORD JIM (1900), and *Nostromo* (1904) and such shorter works as *Heart of Darkness* and *Typhoon* (1902), all of these probing and illuminating the emotional worlds of Europeans living and working in what were for them faraway, exotic, and extremely difficult cultural and physical environments. In this period he also collaborated with Ford Madox FORD on the novels *The Inheritors* (1901) and *Romance* (1903). His later works include such novels as *The Secret Agent* (1907), *Under Western Eyes* (1911), *Chance* (1913), *The Shadow-Line* (1917), and *The Rover* (1923).

constructivism, a modernist movement in Russian and then Soviet art and architecture, influenced by and proceeding side by side with CUBISM and FUTURISM from the years immediately preceding World War I. Although never stated as a single coherent body of theory, it was an attempt to build a body of new, nonobjective objects, artworks, and structures on modern engineering and design principles, with great affinities for the industrial design work that was originating simultaneously in Germany and that would emerge at the BAUHAUS in the interwar period. Key early constructivist works were the Vladimir TATLIN reliefs of 1913–17 and his unrealized but extraordinarily influential design for the *Monument to the Third International* (1920). In the Soviet era the movement quickly split into those who became known as "Productionists,"

led by Tatlin, who turned to straightforward utilitarian industrial design in pursuit of state goals, and those who wished to continue to pursue art as well as socialist goals, led by the brothers Naum GABO and Antoine PEVSNER, who issued their *Realist Manifesto* in 1920 and went into exile in 1922. Constructivist ideas permeated and intertwined with much similar Western thinking during the interwar period, though they still did not generate a unified body of thinking.

Conversation Piece (1974), the Luchino VISCONTI film; Burt LANCASTER was the aging intellectual who ultimately faces the questions of engagement and mortality, with Silvana Mangano, Helmut Berger, Claudia Marsani, and Claudia Cardinale in key supporting roles.

Coogan, Jackie (Jack Leslie Coogan, 1914–84), U.S. actor, on screen from the age of four, who became a child star in silent films with his appearance opposite Charlie CHAPLIN in *The Kid* (1921). He starred in such films as *Peck's Bad Boy* (1921), *Oliver Twist* (1922), and *A Boy of Flanders* (1924), stopped being a child star with the coming of adolescence, came back briefly in *Tom Sawyer* (1930) and *Huckleberry Finn* (1931), and thereafter played character roles in films and on television throughout the rest of his long career.

Cook, Elisha, Jr. (1906–), U.S. actor, who played scores of character roles in a screen career that spanned over five decades; he is best known by far for creating the role of Wilmer, the "gunsel," in THE MALTESE FALCON (1941). On stage he created the role of Richard, the teenage boy in Eugene O'NEILL's AH, WILDERNESS! (1933)

Cool Hand Luke (1967), the Stuart Rosenburg film; Paul NEWMAN was Luke, the archetypal loner on a chain gang, in a cast that included George Kennedy in an OSCAR-winning role as a fellow convict, Strother Martin, Jo Van Fleet, and J.D. Cannon. Donn Pearce and Frank R. Pierson wrote the screenplay, based on Pearce's novel.

Cooper, Gary (Frank James Cooper, 1901–61), U.S. actor, on screen in small roles from 1926, who in the 1930s became one of the stars of Hollywood's Golden Age. He played effectively in some of the screwball comedies of the day, but ultimately became identified with the kinds of films that made him into a strong, laconic, incorruptible American culture hero, such as MR. DEEDS GOES TO TOWN (1936), *The Plainsman* (1936), *Beau Geste* (1939), *The Westerner* (1940), *Sergeant York* (1941), *The Pride of the Yankees* (1942), FOR WHOM THE BELL TOLLS (1943), HIGH NOON (1952), and FRIENDLY PERSUASION (1956). He won best actor OSCARS for *Sergeant York* and *High Noon*.

Cooper, Jackie (John Cooper, Jr., 1921–), U.S. actor, director, and producer, on screen from the age of three, in the OUR GANG comedies 1927–28, and in the 1930s a leading Hollywood child star, playing leads in such films as *Skippy* (1930), *The Champ* (1931), and *Treasure Island* (1934). As an adult he played in several minor films, later turning to television series work, as an actor and then as a director and producer.

Copland, Aaron (1900–90), U.S. composer, best known for his classical work on American folk themes, often using JAZZ, country-and-western, and other popular music as a bases for his work. His three innovative, very popular 1940s ballets fully realized that intent: BILLY THE KID (1938), RODEO (1942), and APPALACHIAN SPRING (1944). In the same vein, he composed such works as *Lincoln Portrait* (1942), *Fanfare for the Common Man* (1942), *Twelve Poems of Emily Dickinson* (1950), and the opera *The Tender Land* (1954). His considerable body of works also includes three symphonies; chamber and piano works; and the scores of several films, including OF MICE AND MEN (1939), OUR TOWN (1940), and THE HEIRESS (1948).

Coppola, Francis Ford (1939–), U.S. director and screenwriter, whose early work drew little attention but who in 1972 emerged as a major figure in modern film history with his direction and co-written screenplay of THE GODFATHER, which won a best picture OSCAR. In 1974 he directed, produced, and wrote the screenplay of THE GODFATHER PART II, winning best picture, best director, and best screenplay OSCARS. He also directed such films as *The Conversation* (1972), the Viet-

nam war epic APOCALYPSE NOW (1979), TUCKER: THE MAN AND HIS DREAM (1988), and *The Godfather Part III* (1990).

Corleone, Vito, the central figure in THE GOD-FATHER, created by Marlon BRANDO and recreated (in youth) in THE GODFATHER, PART II by Robert DE NIRO. Both won OSCARs in the role, Brando as best actor and De Niro as best supporting actor.

Corman, Roger (1926–), U.S. director and producer, from the mid-1950s through the 1960s a prolific director and often producer of low-budget exploitation films, many of them in the horror genre and some of which drew cult followings in the United States and Europe. His "quickie" films provided brief early work for some of Hollywood's young directors, such as Francis Ford COPPOLA and Martin SCORSESE.

Cornell, Katharine (1893–1974), U.S. actress-manager, on stage with the PROVINCETOWN PLAYERS from 1916. She became a leading player in the mid-1920s, as *Candida* (1924), in *The Green Hat* (1925), and later in such roles as Elizabeth Barrett in THE BARRETTS OF WIMPOLE STREET (1931), for which she was actress-manager and which was directed by her husband, Guthrie MCCLINTIC, who subsequently directed many of her plays. Her later work included leads in *The Alien Corn* (1933), *St. Joan* (1936), *No Time for Comedy* (1939), and *Antony and Cleopatra* (1947), for which she won a best actress TONY. Her last major role was as Mrs. Patrick CAMPBELL in *Dear Liar* (1959).

Corn Is Green, The (1938), the Emlyn WIL-LIAMS play, about a young Welsh miner and his devoted teacher; Williams created the Morgan Evans role and Sybil THORNDIKE the Miss Moffat role on stage. Bette DAVIS and John Dall played the leads in Irving Rapper's 1945 screen version, while Katharine HEPBURN and Ian Saynor played the roles in George CUKOR's 1979 remake.

Corso, Gregory (Nunzio Gregory Corso, 1930–), U.S. writer, a poet of the BEAT movement and a key member of the beat community that flourished in San Francisco from the late 1950s, foreshadowing the much larger

COUNTERCULTURE to follow. His poetry is collected in such volumes as *The Vestal Lady of Brattle* (1955), *Gasoline* (1958), *Bomb* (1958), *The Happy Birthday of Death* (1960), and *There Is Yet Time to Run Back Through Life and Expiate All That's Been Sadly Done* (1965).

Cortot, Alfred Denis (1877–1962), French pianist, conductor, and teacher, a notable interpreter of the Romantics, who from 1902 conducted at the Bayreuth Festival and simultaneously emerged as a leading piano soloist. Cortot, Pablo CASALS, and violinist Jacques THIBAUD formed a celebrated trio in 1905. In 1919, Cortot founded the École Normale de Musique in Paris, thereafter powerfully influencing the course of French musical development.

Cosby, Bill (1937–), U.S. actor, whose long-running *The Cosby Show* (1984–), became one of the leading television situation comedies of the late 1980s; with it he became one of the most celebrated Black personalities of his time. His earlier television work includes "I Spy" (1965–68), "The Bill Cosby Show" (1969–71), and "The New Bill Cosby Show" (1972–73). His films include *Uptown Saturday Night* (1974); *Mother, Jugs and Speed* (1976); and *Ghost Dad* (1989).

Costa-Gavras, Constantin (1933–), Greek-French director, who began his directorial career with *The Sleeping Car Murders* (1965) and then went on to direct the group of political films that made him an international figure, including the ACADEMY AWARD-winning *Z* (1969), *State of Siege* (1972), *Missing* (1984), *Betrayed* (1988), and *Music Box* (1989).

Costello, Lou (Louis Francis Cristello, 1906–59), U.S. comedian, of the comedy team of ABBOTT AND COSTELLO.

Cotten, Joseph (1905–), U.S. actor, on stage from 1930, who joined the MERCURY THEATRE in 1937, left it to play opposite Katharine HEPBURN on Broadway in THE PHILADELPHIA STORY (1939), and went to Hollywood in 1941 to join Orson WELLES. Cotten began his long film career on the highest possible note, playing opposite Welles in the classic CITIZEN KANE (1941), and then went on to leads in two other Welles films, the

almost equally classic THE MAGNIFICENT AMBERSONS (1942) and *Journey into Fear* (1942). Later in the same decade he played opposite Welles in another classic, Carol REED's THE THIRD MAN (1949). During the next four decades he played in dozens of other films, in leads and in strong character roles, also appearing in the theater and on television.

Cotton Club, The, the Black Harlem night-club, which from the mid-1920s served as a showcase for such artists as Duke ELLINGTON, Lena HORNE, and Cab CALLOWAY. The 1984 Francis Ford COPPOLA film attempted to re-create the place and its period, with a large cast led by Richard GERE, Gregory Hines, and Diane Lane.

Cotton Comes to Harlem (1965), the Chester Himes novel, about the adventures and misadventures of two Black New York City police detectives working in Harlem; Davis and Arnold Perl adapted it into the 1970 film, starring Godfrey Cambridge as Gravedigger Jones and Raymond St. Jacques as Coffin Ed Johnson, in a cast that included Calvin Lockhart, Redd Foxx, and Judy Pace. Mark Warren directed a sequel, *Come Back, Charleston Blue* (1972).

counterculture, the radical, ill-defined "anti-establishment" youth culture of the 1960s and early 1970s, which focused on alternative life-styles and religious beliefs, holistic therapeutic approaches, and a new ecological awareness and provided artists and audiences for new and altered literary and artistic modes, especially in music and poetry, as in the flowering of a new folk-ROCK movement. The young people in the counterculture also provided much of the basis for several of the protest movements of the 1960s, and especially the anti-Vietnam War movement; in the 1970s, with changed U.S. political and economic circumstances, the counterculture largely faded away, aside from some isolated groupings, but not without having had a powerful and lasting effect on American and world culture.

Country Girl, The (1950), the Clifford ODETS play, about an alcoholic actor with a chance to make a comeback; his strong, self-sacrificing wife; and the director who gives the actor his

chance. Paul Kelly, Uta Hagen, and Steven Hill created the roles on stage; they were played in the 1954 George Seaton film by Bing CROSBY, Grace KELLY, and William HOLDEN. Hagen won a TONY and Kelly an OSCAR for the lead role, and George Seaton won an OSCAR for his adaptation of the Odets play.

Courtenay, Tom (Thomas Daniel Courtenay, 1937–), British actor, on stage from 1960, a replacement lead in BILLY LIAR in 1961, and an immediate star on film in 1962, in THE LONELINESS OF THE LONG DISTANCE RUNNER. He did *Billy Liar* on film in 1963, two years later played a key supporting role in DOCTOR ZHIVAGO, and later played leads in such films as *Otley* (1969) and *The Dresser* (1983), in which he re-created his 1980 stage role. Some of his other notable theater roles were in *Peer Gynt* (1970), *The Norman Conquests* trilogy (1974), and *Otherwise Engaged* (1976).

Covarrubias, Miguel (1904–57), Mexican artist, writer, and teacher; he was a syndicated cartoonist in Latin America in the early 1920s and a notable caricaturist in New York from 1923, often in *Vanity Fair*. He turned to ethnology in the 1930s, publishing the landmark *Island of Bali* in 1937 and his work on Native American art, *Eagle, Jaguar, and Serpent*, in 1950. He also was a leading Mexican muralist.

Coward, Noël Pierce (1899–1973), British writer, actor, composer, and director, on stage from 1911 and on screen from 1918, who emerged as a major playwright with the drama *The Vortex* (1924) and the comedy *Hay Fever* (1925), followed by such musicals as *On with the Dance* (1925) and BITTER SWEET (1929); such comedies as PRIVATE LIVES (1930), DESIGN FOR LIVING (1933), and BLITHE SPIRIT (1941); and such rather sober patriotic works as *Cavalcade* (1931), the wartime play *This Happy Breed* (1943, which became the David LEAN film in 1944), and IN WHICH WE SERVE (1942, a starring vehicle he also co-directed with Lean). Coward also wrote many one-act plays, including *Still Life*, which was part of *Tonight at 8:30* (1936) and which he adapted into the classic David Lean film BRIEF ENCOUNTER (1945). He also wrote hundreds

of songs, including I'LL SEE YOU AGAIN (1929), SOMEDAY I'LL FIND YOU (1930), and probably his best-remembered song, MAD DOGS AND ENGLISHMEN (1932).

Cowell, Henry Dixon (1897–1965), U.S. composer and teacher, largely self-taught, who became a key figure in the exploration of new ways of making music, by finding new approaches and new means of using traditional instruments and through the development of new, often electronic instruments. His enormous output includes well over 600 very substantial classical works.

Cowley, Malcolm (1898–1988), U.S. writer and editor, an expatriate in France during the 1920s and there part of the "lost generation"; later he was one of its literary executors, as an editor and essayist. His essays are collected in such volumes as *An Exile's Return* (1934), *The Literary Situation* (1954), and *Think Back on Us* (1967); his poetry is collected in *Blue Juniata* (1929) and *A Dry Season* (1942).

Cozzens, James Gould (1903–1978), U.S. writer, whose *Guard of Honor* (1948) won a PULITZER PRIZE; he is best remembered for *By Love Possessed* (1957), a very popular novel in which he explored the emotional engagements of his rather neutral central figure.

Craig, Edward Gordon (1872–1966), British theater designer, director, actor, and writer, the son of Ellen TERRY and Edward William Godwin. He was a considerable figure in the 20th-century theater; his theories, difficult to execute in his time, became an essential part of modern theater practice. Some of his more notable works were the sets for *Vikings* and *Much Ado About Nothing*, both produced in 1903 by Ellen Terry; the set design for the Eleanora Duse *Rosmersholm* (1906); and the *Hamlet* he co-produced with Constantin STANISLAVSKY at the MOSCOW ART THEATRE in 1912, which used the moving-screens background concept he had allowed YEATS to use for the first time at the ABBEY THEATRE a year earlier. His best-known written works include the books *The Art of the Theatre* (1905) and *Toward a New Theatre* (1913) and the theater magazine *Mask*, which he edited and for which he wrote hundreds of articles (1908–29).

Crane, Hart (Harold Hart Crane, 1899–1932), U.S. poet, author of *White Buildings* (1926) and the epic poem *The Bridge* (1930), whose small body of mystical, evocative work on American themes had considerable impact on the poets and critics of his time. His career was cut short by alcoholism and then suicide.

Cranes Are Flying, The (1957), the Mikhail Kalatozov film, adapted by Victor Rosov from his own play. It was one of the first true-to-life major works of the post-Stalin thaw, about a young woman who is raped by the man she then feels forced to marry, while her beloved fiancé is off to war. After the war, living in Siberia, she learns that her fiancé has died; she will then try to make a new life, as will her country. The leads were played by Tatyana Samoilova, Alexei Batalov, and Vasili Merkuriev.

Cranko, John (1927–73), British dancer, choreographer, and ballet director, with the Sadler Wells–ROYAL BALLET company from 1946, primarily as a choreographer. He was director of the Stuttgart Ballet 1961–73, building it in those years into a major international ballet company. Cranko was a prolific choreographer throughout his career, of such works as *Beauty and the Beast* (1949), *The Prince of the Pagodas* (1957), and *Antigone* (1960) during the years in Britain and DAPHNIS AND CHLOÉ (1962), FIREBIRD (1964), and *Ebony Concerto* (1970) during the years in Germany. He also choreographed for opera and television.

Crawford, Broderick (William Broderick Crawford, 1911–), U.S. actor, the son of actress Helen Broderick. On stage from 1932, he originated the role of Lenny in John STEINBECK's OF MICE AND MEN (1937). By far his most notable screen role was that of Willie Stark in ALL THE KING'S MEN (1949), for which he won a best actor OSCAR. He also played a lead in the film BORN YESTERDAY and many supporting roles, as well as the lead in television's "Highway Patrol" (1951–56).

Crawford, Cheryl (1902–), U.S. director, producer, and actress, with the THEATRE GUILD from 1925, and in 1931 a co-founder of the GROUP THEATRE. She directed the latter's first production, *The House of Connelly* (1931),

and many supporting roles, as well as the lead in television's "Highway Patrol" (1951–56).

Crawford, Cheryl (1902–), U.S. director, producer, and actress, with the THEATRE GUILD from 1925, and in 1931 a co-founder of the GROUP THEATRE. She directed the latter's first production, *The House of Connelly* (1931), later directing several other plays for the company, including *'Til the Day I Die* (1935), and produced scores of plays in the decades that followed, including *One Touch of Venus* (1943), *Brigadoon* (1947), and *Camino Real* (1953). In 1946 she was a co-founder of the American Repertory Theatre, and in 1947 she co-founded the ACTORS STUDIO.

Crawford, Joan (Lucille Fay le Sueur, 1904–77), U.S. actress, on film from 1925 and a star in silent films as a flapper. She made the transition to sound successfully, then playing leads largely in drama and melodrama, in such films as RAIN (1932); *Strange Cargo* (1940); MILDRED PIERCE (1945), for which she won a best actress OSCAR; *Daisy Kenyon* (1947), and *The Damned Don't Cry* (1950). She was played by Faye Dunaway in 1981 in the film version of *Mommie Dearest*, the highly critical book by her adopted daughter Christina.

Creasey, John (1908–73), British writer, an extraordinarily prolific creator of detective novels in series, who wrote well over 500 novels under several pseudonyms and created several fictional detectives, most notably Commander Gideon and Inspector West of Scotland Yard.

Creedence Clearwater Revival, U.S. ROCK band, consisting of the brothers Tom and John Fogerty, Stu Cook, and Doug Clifford, all of whom had been playing together from early youth. The band became one of the leading groups of the late 1960s with such albums as *Bayou Country* (1969), *Cosmo's Factory* (1970), and *Pendulum* (1971), and such songs as "Proud Mary" (1969), "Born on the Bayou" (1969), "Bad Moon Rising" (1969), and "Travelin' Band" (1970).

Cromwell, John (1888–1979), U.S. actor, director, and producer; after a career in the theater that included direction of *The Silver Cord* (1926), he turned to film direction in 1929, then making such films as *Tom Sawyer* (1930), *The Silver Cord* (1933), OF HUMAN BONDAGE (1934), *The Prisoner of Zenda* (1937), ABE LINCOLN IN ILLINOIS (1940), and ANNA AND THE KING OF SIAM (1946).

Cronin, A.J. (Archibald Joseph Cronin, 1896–1981), British writer, a former doctor who emerged as a popular novelist with his *Hatter's Castle* (1931). He is best known for three novels: THE STARS LOOK DOWN (1935), set in Welsh coal-mining country, which he adapted for the classic 1939 Carol REED film, with Michael REDGRAVE in the lead; THE CITADEL (1937), which became the 1938 film, with Robert DONAT playing a doctor torn between money and ethics; and THE KEYS OF THE KINGDOM (1941), which was the 1944 film with Gregory PECK playing a missionary in China.

Cronyn, Hume (1911–), Canadian actor and director, on stage from 1930 and on screen from 1943, who became a character player and director on Broadway in the 1930s. In 1942 he married and began the long partnership with actress Jessica TANDY that resulted in many joint starring roles, notably including *The Fourposter* (1951), *A Delicate Balance* (1966), *The Gin Game* (1977), and *Foxfire* (1982). On screen he played a wide range of strong supporting roles.

Crosby, Bing (Harry Lillis Crosby, 1904–77), U.S. singer and actor, in vaudeville from 1925, with Paul Whiteman's orchestra from 1927, a member of the Rhythm Boys 1927–30, on radio on his own show from 1931, and on screen from his appearance in *The Big Broadcast of 1932*. Crosby became one of the most popular singers, recording artists, and movie stars of the next quarter century, for such songs as WHITE CHRISTMAS and PENNIES FROM HEAVEN and such movies as ANYTHING GOES (1936), *Holiday Inn* (1942), GOING MY WAY (1944), and the six *Road* movies he made with Bob HOPE, starting with *The Road to Singapore* (1940). He won a best actor OSCAR for *Going My Way*. His brother Bob Crosby (1913–) was also a popular singer and bandleader.

appeared at WOODSTOCK, and made several very-well-received albums.

Cross, Ben (1948–), British actor, best known by far for his starring role as Harold Abrahams in CHARIOTS OF FIRE (1981). His later roles included leads in two television miniseries: THE CITADEL (1983) and "The Far Pavilions" (1983).

Crucible, The (1953), the Arthur MILLER play, quite literally an anti-witch-hunting work. Set during the Salem witch hunts, it was at the time of its presentation a direct attack on McCarthyism, at the height of the Cold War witch hunts of Miller's own day. Beatrice Straight, Arthur Kennedy, Madeleine Sherwood, Fred Stewart, and Walter Hampden played key roles in the original Broadway production. Yet the play did not date; subsequent productions, long after the McCarthy period and in many countries, presented the work in a different light, as an exploration of exceedingly long-term issues and democratic themes. An arresting adaptation was done by Jean-Paul SARTRE for the 1957 Raymond Rouleau film, with Yves MONTAND and Simone SIGNORET in the leads.

Cruel Sea, The (1953), the Charles Frend film about British sailors fighting the Battle of the Atlantic against German submarines during World War II, and about their lives and families ashore; Jack HAWKINS led a cast that included Donald Sinden, Denholm Elliott, John Stratton, Moira Lister, Liam Redmond, and Virginia McKenna. Eric AMBLER adapted the Nicholas Monsarrat novel.

Cruise, Tom (Thomas Cruise Mapother IV, 1962–), U.S. actor, on screen from 1981, who emerged as one of the leading new film stars of the 1980s in such movies as *Taps* (1981); *Risky Business* (1983); *Top Gun* (1986); *The Color of Money* (1986); RAIN MAN (1988); *Cocktail* (1988); and BORN ON THE FOURTH OF JULY (1989), in the Ron Kovic role.

Cry Freedom (1987), the Richard ATTEN-BOROUGH film, about South African Black leader Steven Biko, killed while a police prisoner, and his friend, White journalist James Woods, forced to flee South Africa. Denzel WASHINGTON was Biko and Kevin KLINE was

Woods, heading a cast that included John Thaw, Kevin McNally, Alec McCOWEN, Zakes Mokae, Ian Richardson, and Juanita Waterman.

cubism, a centrally important early-20th-century movement in European art, invented by Pablo PICASSO and Georges BRAQUE, working separately and side by side, in which all of the three-dimensional forms and techniques are supplanted by a flat painting plane in which the forms are broken down and presented simultaneously in several parts. The key early cubist work was Picasso's LES DEMOISELLES D'AVIGNON (1907); during the next several years he and Braque, soon joined by others, continued to work in the cubist style, in the period usually described as analytical cubism, for its focus on analysis of form. From approximately 1912, while continuing to develop earlier cubist painting techniques, they also began to work with the collages, often rough new materials, and new techniques of including objects in paintings that were to characterize much of the avant-garde work of the next several decades. This second period usually is described as synthetic cubism, for its focus on the synthesis of forms, colors, shapes, and materials. Although Picasso, Braque, and many others largely moved on from their cubist periods, the style continued to affect 20th-century visual arts and architecture considerably.

Cukor, George (1899–1983), U.S. director, working in theater from 1919, who went to Hollywood in 1929 and ultimately emerged as one of the major directors of Hollywood's Golden Age, with such films as DINNER AT EIGHT (1933), *Little Women* (1933), CAMILLE (1937), HOLIDAY (1938), THE PHILADELPHIA STORY (1940), GASLIGHT (1944), BORN YESTERDAY, (1946) *Pat and Mike* (1952), and A STAR IS BORN (1954). Late in his career he won a best director OSCAR for MY FAIR LADY (1964).

Cullen, Countee (1903–46), U.S. author, who became one of the leading poets of the HARLEM RENAISSANCE of the 1920s. He is best known for such poetry collections as *Color* (1925), *Copper Sun* (1927), and *The Ballad of*

the Brown Girl (1927); he also wrote a novel, plays, and children's books.

cummings, e. e. (Edward Estlin Cummings, 1894–1962), U.S. writer, whose first work, the narrative THE ENORMOUS ROOM (1922), was based partly upon his 1917 experience of French imprisonment on false charges while an American ambulance-corps volunteer. He went on to become a leading poet, a stylist whose work informed the poetry of his time, and a celebrant of individual freedom in what he perceived as a deadening mass world, in such collections of his work as *Tulips and Chimneys* (1923), *&* (1925), *XLI Poems* (1925), and *is 5* (1926), continuing to publish poetry through the early 1960s, much of it employing highly individual punctuation and typography. He also wrote a considerable variety of other works, including the play *him* (1927), the ballet *Tom* (1935), and his six Harvard "nonlectures," collectively titled *i* (1953).

Cunningham, Merce (1919–), U.S. dancer and choreographer, a leading figure in modern dance. He was with the Martha GRAHAM company 1939–45, established his own company in 1953, and from the late 1940s developed the long series of highly experimental works with which he was linked, many of them in association with John CAGE.

Currie, Finlay (1878–1968), British actor, on stage from 1898 and on screen from 1932. He was a powerful character actor on screen for three decades, in such films as *The 49th Parallel* (1941); *Thunder Rock* (1942); I KNOW WHERE I'M GOING (1945); GREAT EXPECTATIONS (1946), as Magwitch; *Quo Vadis* (1951); and *Ivanhoe* (1952).

Curtis, Tony (Bernard Schwartz, 1925–), U.S. actor, on stage from the late 1940s and on screen from 1949. He emerged as a star in the 1950s in such films as *Houdini* (1953) and *Trapeze* (1956), proved himself an effective dramatic actor in *The Sweet Smell of Success* (1957) and THE DEFIANT ONES (1958), and costarred in the classic comedy SOME LIKE IT HOT (1959). His later films include *Spartacus* (1961), *The Great Imposter* (1961), *The Boston Strangler* (1968), *Lepke* (1975), and *The Last Tycoon* (1976). His television appearances include the series "The Persuaders" (1971–72). He was married to actress Janet LEIGH from 1951 to 1962 and is the father of actress Jamie Lee Curtis.

Curtiz, Michael (Mihaly Kertész, 1888–1962), Hungarian director, working as a director in Hungary from 1912 and then throughout Europe until 1926, when he was hired by Warner Brothers. In Hollywood he became one of the most prolific directors of the next three decades, most notably for CASABLANCA (1943); MILDRED PIERCE (1945); and his action films of the 1930s and the early 1940s, especially the group of Errol FLYNN films that began with *Captain Blood* (1935).

D

Da (1973), the TONY-winning Hugh Leonard play, about an American revisiting his native Ireland and his recollections of his father. Barnard Hughes won a Tony as Da and Brian Murray was his son, in a cast that included Ralph Williams, Sylvia O'Brien, Richard Seer, and Mia Dillon. Leonard adapted the play into the 1988 Matt Clark film; Hughes re-created his Da role, with Martin Sheen as his son, in a cast that included Doreen Hepburn, Karl Hayden, and Hugh O'Connor.

Dada, an anti-art, antiliterature protest movement founded by some young people in the arts at Zurich in 1916, which soon spread to other such small groups in Europe and the United States. In that year there were over one million casualties at Verdun, more than a million on the Somme, and millions more on the eastern and southern fronts. Then, and through the immediate postwar period, one conscious response to what was perceived as madness and the end of European civilization was the mocking, abrasive Dadaist style, which in the visual arts used such techniques as photomontage, collage, and the geometric images of CUBISM as part of what would later be called "happenings," though the Dadaist happenings specifically aimed at derision of all existing forms, structures, and beliefs. Some leading Dadaists were Jean ARP, Marcel DUCHAMP, Hugo Ball, Richard Huelsenbeck, Francis PICABIA, Max ERNST, and Kurt Schwitters. In France such writers as André BRETON, Louis ARAGON, Philip Soupault, and Paul ÉLUARD became Dadaists and in the early 1920s turned to SURREALISM, as did many Dadaists in other countries.

Dale, Jim (James Smith, 1935–), British singer, actor, and composer, on stage from 1951 and in television as a host and singer from 1957. He appeared in several films, and wrote the lyrics of the song "Georgy Girl." Active on the stage, Dale is best known for his TONY-winning creation of the Phineas T. Barnum role in *Barnum* (1980).

Dali, Salvador (1904–89), Spanish painter, from the late 1920s a highly visible member of the SURREALIST movement; he claimed that he painted through the operation of his "critical paranoia," literally the creation of a paranoid state, from which delusions and an advanced form of "automatic painting" were generated. The hallucinatory-looking work that resulted featured the flowing watches and grotesques that, along with his enormously successful self-promotion, made Dali one of the best-known artists of his time. Much of his later work was on religious themes. He also collaborated with Luis BUÑUEL on the landmark 24-minute surrealist film AN ANDALUSIAN DOG (1928) and on the ideas for the script of Buñuel's *The Golden Age* (1930).

Dallapicolla, Luigi (1904–75), Italian composer, who from the late 1930s integrated humane and antifascist concerns, lyrical modes of expression, and 12-tone serial techniques, most notably in such choral works as *Songs of Prison* (1941) and *Songs of Liberation* (1955); in the operas *Night Flight* (1940), *The Prisoner* (1950), and *Ulysses* (1968); and in several song cycles of the 1950s and 1960s, as well as in many other vocal works and several orchestral works.

"Dallas" (1978–), the prototypical prime-time soap opera, about Texas's troubled, oil-rich Ewing family, which achieved immense American and then worldwide viewing audiences. The key roles were originated by Larry

Salvador Dali's *The Persistence of Memory* (1931), with its famous melting watches.

HAGMAN as J.R. Ewing, Barbara Bel Geddes, Jim Davis, Patrick Duffy, Victoria Principal, Charlene Tilton, and Linda Gray. The success of the series generated several similar nighttime soaps, such as "Dynasty," "Falcon Crest," and "The Colbys."

Damned, The (1969), the Luchino VISCONTI film, about the complicity and ultimate destruction of a leading German industrial family during the Nazi period, the family being seen as a metaphor for Germany itself. The key roles were played by Dirk BOGARDE, Ingrid Thulin, Helmut Griem, Helmut Berger, Albrecht Schonhals, and Charlotte Rampling.

Damn Yankees (1955), the long-running TONY-winning Broadway musical, a baseball story, based on *The Year the Yankees Lost the Pennant* by Douglass Wallop, who with George ABBOTT adapted the novel for the stage. Gwen Verdon won a Tony as Lola, singing "Whatever Lola Wants"; Stephen Douglass was the young baseball player; and Ray Walston, also a Tony winner, was the Devil. Richard Adler and Jerry Ross wrote the words and music.

Abbott adapted the play into the 1958 George Abbott–Stanley Donen film, with Tab Hunter as the baseball player; Verdon and Walston re-created their stage roles.

Dandridge, Dorothy (1923–65), U.S. actress, singer, and dancer, on stage in vaudeville as a child and on screen from 1937; she became one of the few Black film stars of the 1950s, with her starring roles in *Carmen Jones* (1954) and PORGY AND BESS (1959), and was also a headliner in cabaret. Her untimely death was related to substance abuse.

Dangerous Moves (1984), the Richard Dembo film, a best foreign film OSCAR-winner set at a world chess championship match, with a cast that included Michele Piccoli, Liv ULLMANN, Leslie CARON, Michel Aumont, and Alexandre Arbatt.

Daniel, Yuli Markovich (1925–88), Soviet writer, whose satirical short works were published abroad in the 1960s. A leading dissident, he was imprisoned from 1966 to 1970, with fellow intellectual Andrei Sinyavsky, despite an international campaign for their release. Their imprisonment ended the short-

lived "thaw" of the period and began a new era of Soviet conservatism.

Danilova, Alexandra (1904–), Soviet dancer, one of the leading ballerinas of her time, who in 1924 joined the BALLET RUSSES company of Sergei DIAGHILEV in Paris and thereafter remained abroad. She was the prima ballerina of the Ballet Russes de Monte Carlo from 1938 to 1952.

D'Annunzio, Gabriele (1863–1938), Italian writer, who worked in a wide range of forms, beginning with the early poems in *Primo* (1879) and *Canto Novo* (1882). His work includes such novels as *The Children of Pleasure* (1889), *The Intruder* (1892), and *The Flame of Life* (1900), based on his affair with actress Eleanora Duse; a considerable body of poetry, much of it expressing his nationalist sentiments; many short stories; and 18 plays, of which the most notable is *The Daughter of Jorio* (1907). His working reputation was very considerably marred by repeated and apparently quite well-founded charges of plagiarism. D'Annunzio, very popular in Italy for his written work, was an equally popular politician and soldier who was a much-decorated flier during World War I and the sponsor of the 1919 attack on and seizure of Fiume, which were repudiated by the Italian government. He became an early and influential supporter of the fascist dictatorship of Benito Mussolini.

"Danny Thomas Show, The" (1953–64), the very-long-running family situation comedy, starring Danny Thomas in a cast that included Jean Hagen, Marjorie Lord, Rusty Hamer, Angela Cartwright, and Hans Conried as Uncle Tonoose. In reruns the show was retitled "Make Room for Daddy."

Daphnis and Chloé, a ballet by Michel FOKINE, with music by Maurice RAVEL. It was first produced in Paris in June 1912 by the BALLET RUSSES company of Sergei DIAGHILEV, with Tamara KARSAVINA as Chloé, Vaslav NIJINSKY as Daphnis, and Adolph Bolm as Darkon.

Darío, Rubén (Félix Rubén García Sarmiento, 1867–1918), Nicaraguan writer and diplomat, one of the leading Latin American poets of his time, who powerfully influenced the Modernist trend that brought Latin American literature into the mainstream of world literature, beginning with his collection of poems and short stories *Azul* (1888). It was followed by *Prosas profanas* (1896), *Cantos de vida y esperanza* (1905), *El canto errante* (1907), and *Poema del otoño* (1910).

Darkness at Noon (1940), the Arthur KOESTLER novel, a very notable exposé of the Stalinist show trials of the 1930s, through the eyes of Rubashov, an old Bolshevik forced into a false confession. Claude RAINS won a TONY for his Rubashov in the 1950 play.

Dark Victory (1939), the Edmund Goulding film, about a brain surgeon who falls in love with his patient, a spoiled rich woman who ultimately returns his love before dying. Bette DAVIS won a best actress OSCAR as the woman, opposite George BRENT as the surgeon, in a cast that included Humphrey BOGART, Geraldine FITZGERALD, and Ronald Reagan. It was remade as *Stolen Hours* in 1963, with Susan HAYWARD in the Davis role; Elizabeth Montgomery was the lead in the 1976 telefilm remake.

Darling (1965), the John SCHLESINGER film, an acerbic look at trendy London life, with Julie CHRISTIE, Dirk BOGARDE, and Laurence HARVEY in the leads. Christie won an OSCAR for her role, as did Frederic Raphael for the screenplay and Julie Harris for the costumes.

Darwell, Jane (Patti Woodward, 1879–1967), U.S. actress. She was the unforgettable Ma Joad in THE GRAPES OF WRATH (1940) and won a best supporting actress OSCAR for the role, one of over 200 supporting roles in a film career that started in 1913.

Dassin, Jules (1911–), U.S. director, whose early work includes three strong Hollywood films: *Brute Force* (1947), THE NAKED CITY (1948), and *Thieves' Highway* (1949). His American career was cut short by blacklisting during the McCarthy years. In exile, he continued to work as a filmmaker, writing, directing, producing, and appearing in *Never on Sunday* (1960) and *Phaedra* (1962), and later directing and producing *Topkapi* (1964) as well as several other fiction and documentary films.

Davies, Robertson (1913–), Canadian writer, a novelist, dramatist, essayist, and critic, best known for such novels as *A Mixture of Frailties* (1958), *Fifth Business* (1970), *The Rebel Angels* (1981), *What's Bred in the Bone* (1985), and *The Lyre of Orpheus* (1988).

Davis, Bette (Ruth Elizabeth Davis, 1908–89), U.S. actress, on stage from 1928 and on screen from 1931, who fought her way through a series of mediocre melodramas to become a leading dramatic actress, in such films as OF HUMAN BONDAGE (1934), *Dangerous* (1935), THE PETRIFIED FOREST (1936), *Jezebel* (1938), DARK VICTORY (1939), THE LITTLE FOXES (1941), NOW, VOYAGER (1942), *Mr. Skeffington* (1944), and ALL ABOUT EVE (1950). She won best actress OSCARS for *Dangerous* and *Jezebel*, though her highly mannered actress in *All About Eve* is often described as her most notable performance.

Davis, Miles (Miles Dewey Davis, Jr., 1926–), U.S. JAZZ musician, a trumpeter and bandleader who from 1945 played and helped originate BOP with his friend and mentor Charlie PARKER. Davis began to lead groups in the late 1940s, won his long fight with a drug habit in the early 1950s, and in 1954 formed the seminal Miles Davis Quintet, which with a varying group of members powerfully influenced the development of jazz throughout the 1950s and 1960s, and in the late 1960s generated his celebrated ROCK-AND-ROLL band. A few of his best-known albums are *Kind of Blue* (1959), *Miles in the Sky* (1968), *Bitches Brew* (1970), and *The Man with the Horn* (1982).

Davis, Ossie (1917–), U.S. actor, writer, director, and producer, on stage from 1941, whose early major roles included the title role in *Jeb* (1946) on Broadway and his 1955 lead in a televised version of THE EMPEROR JONES. In 1959 he emerged as a leading stage player in the Walter Lee Younger role in A RAISIN IN THE SUN, with his wife, Ruby DEE, as Ruth Younger. He wrote and starred in PURLIE VICTORIOUS (1961), re-creating the Purlie Victorious Judson role in the 1963 film, retitled *Gone Are the Days*. Davis directed such films as *Cotton Comes to Harlem* (1970) and *Black Girl* (1972); appeared in such films as *The Hill* (1965), *The Scalphunters* (1968), *Harry and Son*

(1983), and *Do the Right Thing* (1989); and has also appeared in a wide range of television roles.

Davis, Sammy, Jr. (1925–90), U.S. entertainer, a versatile singer, dancer, and actor, the child of a show-business family who was on stage with the Will Mastin Troupe at the age of three. In 1945 he joined his father and Will Mastin in The Will Mastin Trio and in the early 1950s emerged as a major star in cabaret. On Broadway he starred in the musicals *Mr. Wonderful* (1956) and GOLDEN BOY (1964); he also appeared in several films, most notably as Sportin' Life in the 1959 film version of PORGY AND BESS. Davis was one of the first Black American performers to fully break through the color line to equal bookings and straightforward non-ethnically-based popularity, maintaining his status through a pioneering interracial marriage to actress Mai Britt, his conversion to Judaism, and a series of personal problems.

Davis, Stuart (1894–1964), U.S. artist, who began as a realist and studied with Robert HENRI from 1910 but whose life was changed by the ARMORY SHOW of 1913, which turned him toward CUBISM and abstraction. The process eventuated in such work as the modernist *Egg Beater* series (1927–30) and ultimately in his post-World War II works, in which he tried to capture in painting the color, rhythms, and style of the American JAZZ that was then at the center of his thinking, around the kinds of pop artifacts—brightly lit signs, storefronts, and the like—that were favored by the pop artists of a later period. His final works were somewhat more muted and abstracted than the works of his very notable postwar period.

Day, Doris (Doris Kappelhoff, 1922–), U.S. actress and singer; she sang with Les Brown's orchestra in the early 1940s, emerging as a leading popular singer with such songs as "Sentimental Journey" (1944) and "My Dreams Are Getting Better All the Time" (1944). Her film career began in 1948, with *Romance on the High Seas*, in which she sang "It's Magic." She starred in several further musicals, such as *Young Man with a Horn* (1950); *April in Paris* (1952); *Calamity Jane* (1953); LOVE ME OR LEAVE ME (1955), in

which she played singer Ruth ETTING; and in THE PAJAMA GAME (1957). In the late 1950s she turned to light comedy, in such films as *Pillow Talk* (1959) and *With Six You Get Eggroll* (1968). On television she starred in the long-running "The Doris Day Show" (1968–73).

Day After, The (1983), the television film, felt by many at the time to be quite shocking and controversial, about the aftermath of a nuclear holocaust, as seen by those who survived in Lawrence, Kansas. Nicholas Meyer directed a cast that included Jason ROBARDS, JoBeth Williams, John Lithgow, John Cullum, Steve Guttenberg, and Amy Madigan. The script was by Edward Hume.

Daybreak (1939), the Marcel CARNÉ film, screenplay by Jacques Viot and Jacques Prévert, about a factory worker who commits a murder and is then trapped by the police, the story unfolding in a series of flashbacks. Jean GABIN played the lead, with Jules Berry, Jacqueline Laurent, and Arletty in key supporting roles.

Day for Night (1973), the François TRUFFAUT film about filmmaking, in which he plays a director shooting a film. The other key roles were played by Jacqueline BISSET, Jean-Pierre Leaud, Valentina Cortese, and Jean-Pierre AUMONT. The film won a best foreign film OSCAR.

Day Lewis, Cecil (1904–72), British writer, a left poet and colleague of W.H. AUDEN and Stephen SPENDER during the late 1920s and the 1930s. He published such collections of his work as *From Feathers to Iron* (1931) and *Overtures to Death* (1938), then moved away from Marxism in the 1940s, as reflected in such work as *Poems* (1943–47). From 1935 he also wrote detective stories, using the pseudonym Nicholas BLAKE. He was poet laureate from 1968 to 1972.

Day Lewis, Daniel (1958–), Irish actor, with considerable stage experience, who became a leading film player in the 1980s, in such works as *My Beautiful Laundrette* (1985), A ROOM WITH A VIEW (1985), THE UNBEARABLE LIGHTNESS OF BEING (1988), and *Stars and Bars* (1988). He won a best actor OSCAR

for his portrayal of handicapped writer Christy Brown in MY LEFT FOOT (1989).

Day of the Jackal, The (1973), the Fred ZINNEMANN film, a thriller about a nearly successful attempt to assassinate Charles De Gaulle; Kenneth Ross adapted the Frederick Forsyth novel for the screen. Edward Fox was the would-be assassin, in a cast that included Tony Britton, Michael Lonsdale, Donald Sinden, Alan Badel, Eric Porter, Cyril Cusack, Derek JACOBI, Ronald Pickup, and Delphine Seyrig.

Day of the Locust, The (1939), the Nathanael West novel, his surreal, bitter attack on Hollywood and the film industry. Waldo Salt adapted the novel into the screenplay of the 1975 John SCHLESINGER film, with William Atherton as the young writer who is both protagonist and narrative vehicle, in a cast that included Donald SUTHERLAND, Burgess MEREDITH, Karen Black, Geraldine PAGE, Richard Dysart, Bo Hopkins, Pepe Serna, and Billy Barty.

Days of Wine and Roses (1962), the Blake EDWARDS film, about the desperate plight of a loving alcoholic couple. Jack LEMMON was Joe Clay, who goes over the edge of sanity and comes back to become a recovering alcoholic; Lee REMICK was Kirsten Clay, who at film's end was still an afflicted alcoholic. The cast included Jack Klugman, Debbie Megowan, Charles Bickford, Tom Palmer, and Alan Hewitt. The film was written by J.P. Miller, who adapted it from his 1958 PLAYHOUSE 90 television film.

Dead, The (1987), John HUSTON's last film, set in Dublin and adapted by Tony Huston from a James JOYCE short story. Anjelica HUSTON led an Irish cast that included Rachel Dowling, Donal McCann, Cathleen Delany, Dan O'Herlihy, Donal Donnelly, Helena Carroll, and Ingrid Craigie.

Dead End (1935), the Sidney KINGSLEY play, about Depression-era slum life in New York City. It was adapted by Lillian HELLMAN into the classic 1937 William WYLER film, with Sylvia SIDNEY, Joel McCREA, and Humphrey BOGART in leading roles, and introduced the group of young players known as the Dead

End Kids, who went on to collectively star in several "B" films of the period.

Dead of Night (1945), a classic horror film, consisting of five slightly related occult stories directed variously by Alberto CAVALCANTI, Basil Dearden, Robert Hamer, and Charles Crichton. The cast included Michael REDGRAVE, Roland Culver, Mervyn Johns, Judy Kelly, Antony Baird, Sally Ann Howes, Googie Withers, and Ralph Michael.

Dean, James Byron (1931–55), U.S. actor, on screen from 1951, who became the emblematic "rebel without a cause" of his generation. He made three notable films: EAST OF EDEN (1955), REBEL WITHOUT A CAUSE (1955), and GIANT (1956). On September 30, 1955, he died in an auto accident; after his death, he became a major cult figure.

Death in the Family, A (1957), James AGEE's largely autobiographical and posthumously published novel, which won a PULITZER PRIZE and was the basis for the play and film ALL THE WAY HOME.

Death in Venice (1912), the Thomas MANN novella, about Gustav von Aschenbach, an acclaimed author who is ultimately consumed by his own devils, here taking the form of a distanced homosexual fascination for a young boy that causes him to stay on in Venice despite early warning of the cholera outbreak that kills him. The novella became the basis of the 1971 Luchino VISCONTI film, with Dirk BOGARDE in the von Aschenbach role, and of the 1973 Benjamin BRITTEN opera, in which Peter PEARS created von Aschenbach.

Death of a Loyalist Soldier (1936), the Spanish Civil War photograph by Robert CAPA. It became one of the most powerful images to emerge from four decades of wars and revolutions and is easily his best-known work.

Death of a Salesman (1949), the PULITZER PRIZE-winning play by Arthur MILLER, the story of the destruction of Willy LOMAN, symbol of a time, style, and way of life. The role of Willy was created on Broadway by Lee J. COBB, with Mildred Dunnock, Cameron Mitchell, and Arthur Kennedy in strong supporting roles as his wife and two sons. In the 1951 film Fredric MARCH played Willy, with

Dunnock, Mitchell, and Kevin McCarthy in the key supporting roles.

Death Wish (1974), the Michael Winner film, in which a brutally murderous vigilante, played by Charles BRONSON, kills scores of street criminals on sight to avenge his wife's murder. The cast included Hope Lange, Vincent Gardenia, Stuart Margolin, and Olympia Dukakis. The extraordinarily violent, very popular film generated several sequels, all of them exploiting the same themes.

Debussy, Achille Claude (1862–1918), French composer, whose work provided substantial impetus for the move away from traditional forms and structures that was to characterize much of 20th-century classical music. His best-known works include the orchestral *Prelude to The Afternoon of the Faun* (1894) and *La Mer* (1905) and the opera *Pelleas and Melisande* (1902), essentially a musical version of the Maurice MAETERLINCK play.

deconstruction, a contemporary theory of literary criticism, first put forward by Jacques Derrida in the late 1960s and further developed by such other Yale-based critics as Paul de Man and Harold Bloom during the 1970s. It posits a seemingly infinitely regressive kind of textual analysis. In deconstruction a text and its writer are quickly separated, the text becoming an endless series of self-related meanings, subtexts, submeanings, subsubtexts, and so on.

Dee, Ruby (Ruby Ann Wallace, 1924–), U.S. actress, on stage with the American Negro Theatre from 1941, appearing on Broadway as *Anna Lucasta* in 1946 and in that year also appearing in *Jeb*. She emerged as a leading stage player in such works as A RAISIN IN THE SUN (1959), re-creating her Ruth Younger role in the 1961 film; and PURLIE VICTORIOUS (1961), re-creating her Lutiebelle Jenkins role in the 1963 film, retitled *Gone Are the Days*. In both films, as in many of her other roles, she appeared opposite her husband, Ossie DAVIS. She also appeared in such films as *The Balcony* (1963), *Buck and the Preacher* (1972), and *Do the Right Thing* (1989), as well as continuing to pursue her long stage career,

very notably from 1965 at the Stratford, Connecticut American Shakespeare Festival.

Deer Hunter, The (1978), the OSCAR-winning Michael CIMINO film, an extraordinarily powerful Vietnam-era story about the lives of a group of young people from a Pennsylvania steelmaking town, all of whom are deeply and irrevocably affected by the war. The key roles were played by Robert DE NIRO, Christopher Walken, Meryl STREEP, John Savage, and John Cazale. Cimino and Walken as best supporting actor won OSCARS for the film, as did film editor Peter Zinner and Richard Portman, Wiliam McCaughey, Aaron Rochin, and Darin Knights for sound.

"Defenders, The" (1961–65), the television drama, which to some extent pioneered in presenting substantial current social issues to large prime-time audiences. E.G. MARSHALL played defense lawyer Lawrence Preston; Robert Reed was his son and partner in Preston & Preston. The series was based on "The Defender," a 1957 Reginald Rose television two-parter for STUDIO ONE.

Defiant Ones, The (1958), the Stanley KRAMER film, about two convicts who escape from a chain gang, manacled together. Sidney POITIER was the Black convict, Tony CURTIS the White, leading a cast that included Theodore Bikel and Lon Chaney, Jr., in a "message" film whose message was hammered home rather crudely but quite effectively in a United States then deeply engaged in what would become a long series of civil-rights battles. Harold Jacob Smith and Nathan E. Douglas won an OSCAR for the screenplay and Sam Leavitt an Oscar for cinematography.

De Havilland, Olivia Mary (1916–), U.S. actress, on screen from 1935, beginning with Max REINHARDT's *A Midsummer Night's Dream* (1935). She went on to play leads in such films as *Captain Blood* (1935) and *The Adventures of Robin Hood* (1938), played Melanie in GONE WITH THE WIND, did several more standard Hollywood leads, and then emerged as a major dramatic actress in the early postwar period, with *To Each His Own* (1946), for which she won a best actress OSCAR, THE SNAKE PIT (1948), and THE

HEIRESS (1949), winning another Oscar. She is the sister of actress Joan FONTAINE.

De Kooning, Willem (1904–), U.S. painter, who emigrated from Holland in 1926. After moving from early realism to more abstract forms in the early 1930s, and working in somewhat varying styles while doing Federal Arts Project murals during that decade, he moved strongly into abstract, yet often somewhat figurative, forms in the late 1930s. He emerged as a leading ABSTRACT EXPRESSIONIST in the late 1940s, but one also deeply involved in depicting women, whom he portrayed with very notable misogyny for many years, especially in his *Woman* series (1950–53), and *Two Women in the Country* (1954). His later works largely restated earlier approaches and themes.

Delaney, Shelagh (1930–), British writer, best known for her first play, A TASTE OF HONEY (1958), which she adapted into the 1961 film, and for her CHARLIE BUBBLES (1968) screenplay.

Delius, Frederick (1862–1934), British composer, long resident in Paris, whose work was very well received in Germany long before it was appreciated in Britain. His considerable body of work included six operas, including *Koanga* (1897), *A Village Romeo and Juliet* (1901), and *Fenimore and Gerda* (1910); several substantial orchestral and choral works, including *Appalachia* (1902), *Brigg Fair* (1907), and *Requiem* (1916); and many smaller works, such as the still-popular *On Hearing the First Cuckoo in Spring* (1912).

Deliverance (1970), the James DICKEY novel, exploring the events and emotional consequences of a wilderness river trip undertaken by four businessmen, which he adapted into the 1972 John Boorman film, with a cast that included Burt REYNOLDS, Jon VOIGHT, and Ned Beatty.

Del Monaco, Mario (1915–82), Italian tenor, who made his debut in Milan in 1941 and became a leading Italian and international operatic tenor in the late 1940s and throughout the 1950s. He sang many major roles at the Metropolitan Opera, 1951–59. Throughout his career he was an especially notable Othello.

Delon, Alain (1935–), French actor and producer, a major figure in contemporary French cinema who has appeared in a wide variety of films, although often associated with action and underworld roles. Some of his most notable films are ROCCO AND HIS BROTHERS (1960), THE LEOPARD (1963), *The Sicilian Clan* (1969), *Borsalino* (1970), *Mr. Klein* (1976), and *Swann in Love* (1984).

Del Rio, Dolores (Lolita Dolores Negrette, 1905–83), Mexican actress, on screen from 1925 and a star in such American silent films as *The Loves of Carmen* (1927) and *Ramona* (1928), who made the transition to sound successfully, then playing in strong character roles, most notably in *Journey into Fear* (1942). She returned to Mexico in 1943, there becoming a leading player in films and theater, very notably in MARIA CANDELARIA (1943) and *The Fugitive* (1947), made by John FORD in Mexico. Later in her career she also played in a few more Hollywood films, including Ford's CHEYENNE AUTUMN (1964).

De Mille, Agnes George (1905–), U.S. dancer and choreographer, on stage from 1928 and a choreographer from 1929. Her groundbreaking choreography for OKLAHOMA! (1943) set a new dance style for the American musical theater, which she followed up in such musicals as CAROUSEL (1945) and *Brigadoon* (1947). Her work in ballet includes RODEO (1942) and *Fall River Legend* (1948). She is the daughter of playwright William De Mille, granddaughter of playwright Henry De Mille, and niece of Cecil B. DE MILLE.

De Mille, Cecil Blount (1881–1959), U.S. director, screenwriter, and producer, on stage and in stage management from 1900, and from 1913 partnered with Jesse Lasky and Samuel GOLDWYN (then Goldfish) in the pioneering Jesse Lasky film company that later became Paramount Pictures. He co-produced and co-directed the company's first film, *The Squaw Man* (1914), and went on to become a major force in the film industry, producing and directing scores of silent and then sound films, some of them the epics with which he became identified, such as *The Ten Commandments* (1923, and again as his last film, in 1956); *The King of Kings* (1927); *The Sign of the Cross*

(1932); *Cleopatra* (1934); *The Plainsman* (1937); and *The Greatest Show on Earth* (1952), for which he won a best director OSCAR. He also directed and introduced the *Lux Radio Theatre* (1936–45).

Demuth, Charles (1883–1935), U.S. painter, a notable watercolorist who introduced elements of CUBISM into his work in the period 1917–20 while continuing to work with such realistic themes as machinery and urban structures. In the 1920s he developed the technique of the "poster portrait," which used words and artifacts to identify and depict an individual, as in his *I Saw the Figure 5 in Gold* (1928), which takes as its starting point the first line of a William Carlos WILLIAMS poem.

Dench, Judy (Judith Olivia Dench, 1934–), British actress, on stage from 1957 and on screen from 1964. She quickly became a major classical player, at the Old Vic and then at the ROYAL SHAKESPEARE COMPANY, beginning with her Ophelia opposite John Neville's Hamlet, and continued on to play many of the classic roles during the next 25 years. She has appeared on television and in such films as *Wetherby* (1985), A ROOM WITH A VIEW (1986), *A Handful of Dust* (1988), and HENRY V (1989).

Deneuve, Catherine (Catherine Dorléac, 1943–), French actress, on screen from 1956, who became a leading player with *The Umbrellas of Cherbourg* (1963) and went on to become a major international star in such films as *Repulsion* (1965), *Belle de Jour* (1967), and *The Last Metro* (1980).

De Niro, Robert (1943–), U.S. actor, on screen from 1969, who played notable early roles in BANG THE DRUM SLOWLY (1973), MEAN STREETS (1973), and THE GODFATHER, PART II (1974), for which he won a best supporting actor OSCAR, and then emerged as a major star with his leads in such films as TAXI DRIVER (1976); THE DEER HUNTER (1978); and RAGING BULL (1980), for which he won a best actor OSCAR. He then went on to play in such equally demanding films as *Once Upon a Time in America* (1984), *Brazil* (1985), *Midnight Run* (1988), *We're No Angels*

(1989), *Stanley and Iris* (1989), *Goodfellas* (1990), and *Awakenings* (1990).

Denver, John (John Henry Deutschendorf, 1943–), U.S. songwriter and singer, who became one of the most popular recording artists of the 1970s and 1980s, with such songs as "Leaving on a Jet Plane" (1969), "Take Me Home, Country Roads" (1970), "Annie's Song" (1974), "Sweet Surrender" (1974), "Sunshine on My Shoulders" (1974), and "Thank God I'm a Country Boy" (1975). He also appeared in television and films.

Derain, André (1880–1954), French painter and theater designer; his early work before World War I was considerably abstracted and experimental, much of it reflecting his commitment to the use of color and line in the dramatic FAUVIST manner, but from 1916 he moved toward the realism that from then on characterized his work. From 1919 he did the sets for many ballets, by such choreographers as George BALANCHINE, Michel FOKINE, Leonid MASSINE, and Frederick ASHTON.

Derzu Uzala (1975), the Akira KUROSAWA film, about the developing friendship between East Asian hunter Derzu Uzala, played by Maxim Munzuk, and a Russian surveyor, in the wilderness country of eastern Siberia. The Japanese–Soviet coproduction won a best foreign film OSCAR.

De Sica, Vittorio (1902–74), Italian director and actor, on screen as an actor from 1918, who became a leading stage and screen actor during the 1920s and 1930s. In 1940 he began directing films, beginning his long, fruitful collaboration with screenwriter Cesare ZAVATTINI in 1943, in *The Children Are Watching Us.* During the early postwar period he became a major international figure with his OSCAR-winning SHOESHINE (1946) and THE BICYCLE THIEF (1948), both leading films in the new realistic style of the time, then called NEOREALISM, and later making such films as UMBERTO D (1952), YESTERDAY, TODAY, AND TOMORROW (1964), and THE GARDEN OF THE FINZI-CONTINIS (1971). Both of the latter films also won Oscars.

Design for Living (1933), the Noël COWARD comedy. On stage Coward, Alfred LUNT, and Lynn FONTANNE deftly played the participants in the ménage à trois at the center of the work. The play was adapted by Ben HECHT into the 1933 Ernst LUBITSCH film, starring Fredric MARCH, Miriam HOPKINS, and Gary COOPER.

Desire Under the Elms (1924), Eugene O'NEILL's PULITZER PRIZE-winning play, the story of old Ephraim Cabot; his young wife; and Eben Cabot, his third son, in a New England farm setting. Walter HUSTON created the Ephraim Cabot role. A New York City attempt to close the play for alleged obscenity immensely helped its popularity. It was adapted into the 1958 Delbert MANN film, with Burl IVES, Sophia LOREN, and Anthony PERKINS in the leads.

Desk Set (1957), the Spencer TRACY–Katharine HEPBURN classic. In this film they ultimately fall in love after a set of misunderstandings revolving around a research computer are cleared up. Hepburn is the threatened librarian and Tracy the not-so-threatening computer expert, heading a cast that includes Gig Young, Joan BLONDELL, Sue Randall, Dina Merrill, and Nicholas Joy. Phoebe Ephron and Henry Ephron based their screenplay on the William Marchant play; Walter Lang directed.

Desperate Hours, The (1955), the TONY-winning Joseph Hayes play, based on his novel. On Broadway Paul NEWMAN, George Grizzard, and George Mathews played the three escaped convicts, in a cast that included Nancy Coleman, Karl MALDEN, and James Gregory. The 1955 William WYLER film starred Humphrey BOGART in the Newman role, in a cast that included Fredric MARCH, Arthur Kennedy, Martha Scott, Dewey Martin, Mary Murphy, and Gig Young.

de Valois, Ninette (Edris Stannus, 1898–), British dancer, choreographer, and ballet director, on stage from 1914, who danced in leading roles with the BALLET RUSSES from 1923 to 1926, and in 1926 founded the Academy of Choreographic Art in London. She went on to found the Vic-Wells Ballet Company in 1931 and for the next 25 years was the driving force behind the creation of what in

1956 ultimately became Britain's national dance company, the ROYAL BALLET, setting it firmly on course and retiring in 1963. She choreographed many ballets, including JOB (1931), *The Rake's Progress* (1935), *Prometheus* (1936), *Checkmate* (1937), and *Don Quijote* (1950).

Devil and Daniel Webster, The (1937), the Stephen Vincent BENÉT short story; it became the basis of the 1939 Benét-Douglas Moore one-act opera, and of the Benét-Dan Totheroth screenplay for the 1941 William DIETERLE film. In the film, Edward ARNOLD was Daniel Webster, opposite Walter HUSTON as Scratch, the Devil, in a cast that included Simone Simon, Jane DARWELL, and Gene Lockhart. Bernard Herrman won an OSCAR for the music.

Devil in the Flesh (1947), the Claude Autant-Lara film, about a tragic love affair between a married woman and a young college student during World War I. It was thought notorious by some in its time because of its graphic love scenes, compassion for the adulterous lovers, and disrespect for the glories of war. Gerard PHILIPE and Micheline Presle were the lovers; it was Philipe's first great role, and it established him as a major figure in world cinema.

Devil's Disciple, The (1959), the George Bernard SHAW play, written in 1894 and performed privately in the late 1890s; it received its first London performance in 1907, then entering the world repertory. As adapted for the screen by John Dighton and Roland Kibbee, the satire, set during the American Revolution, became the 1959 Guy Hamilton film, starring Burt LANCASTER, Kirk DOUGLAS, and Laurence OLIVIER, with a supporting cast that included Harry ANDREWS, Eva LE GALLIENNE, Janice Scott, and George Rose.

De Vries, Peter (1910–), U.S. writer, whose comic novels satirized suburban lifestyles and concerns. His work was especially popular in the 1950s and early 1960s, then including *Tunnel of Love* (1954), *Comfort Me with Apples* (1956), *The Mackerel Plaza* (1958), *The Tents of Wickedness* (1959), *Through the Fields of Clover* (1961), and *Reuben, Reuben* (1964), which became the basis of the 1983

Robert Ellis film, starring Tom Conti. He was long associated with *The New Yorker*.

Dewhurst, Colleen (1926–), U.S. actress, on stage from 1946, who emerged as a major player with her TONY-winning Mary Follet role in ALL THE WAY HOME (1960) and in such plays as *More Stately Mansions* (1967), MOURNING BECOMES ELECTRA (1972), *A Moon for the Misbegotten* (1973), and in several Shakespearean roles. In films and on television she played largely in strong supporting roles, as in television's "Anne of Green Gables" (1986).

Diaghilev, Sergei (1872–1929), Russian ballet producer, a central figure in 20th-century ballet history, who in 1909 brought a Russian ballet troupe to Paris, founding the Paris-based BALLET RUSSES company. From then until his death he played a major role in creating the modern ballet theater and much of its repertoire.

Dial M for Murder (1954), the Alfred HITCHCOCK film, a suspense thriller featuring Ray MILLAND as the villain and Grace KELLY as his imperiled wife, in a cast that included Robert Cummings, Anthony Dawson, and John Williams. Frederick Knott adapted the film from his play. Angie Dickinson and Christopher PLUMMER played the key roles in the 1981 television remake.

Diamond, Neil (Neil Leslie Diamond, 1941–), U.S. songwriter and singer, best known for such popular songs as "Cherry, Cherry" (1966), "Sweet Caroline" (1969), and "Cracklin' Rosie" (1970), as well as for the soundtrack of the film *Jonathan Livingston Seagull* (1973). He also starred, opposite Laurence OLIVIER, in THE JAZZ SINGER (1980), in a remake that was poorly received.

Diary of a Chambermaid (1964), the Luis BUÑUEL film, with screenplay by Buñuel and Jean-Claude Carriere, based on the Octave Mirbeau novel; about fascism and decay in the French upper bourgeoisie during the early 1930s, with Jeanne MOREAU in the title role. The Mirbeau novel was also the basis of the 1945 Jean RENOIR *Diary of a Chambermaid*, made in Hollywood, with Paulette GODDARD in the title role.

Diary of a Country Priest (1937), the Georges BERNANOS novel, focusing on the trials and ultimate triumph of faith as expressed in the difficult life of a young French country priest. The novel was the basis of the 1950 Robert BRESSON film, with Claude Laydu as the young priest.

Diary of Anne Frank, The (1947), the powerful, archetypal story of a young Jewish girl caught in the Nazi-created Holocaust. It appeared in three forms, the first of which was the actual diary of a young Jewish girl and her family, who were hidden by friends from the Nazis in Amsterdam in World War II, during the Holocaust. She was Anne Frank, who died in a German concentration camp in 1944; her diary, read all over the world after the war, was published in English as *The Diary of a Young Girl* (1952). Frances Goodrich and Albert Hackett used the diary as the basis of their TONY-winning 1955 Broadway play *The Diary of Anne Frank*; Susan Strasberg was Anne, Joseph Schildkraut her father. Goodrich and Hackett adapted their play into the 1959 George STEVENS film; Schildkraut re-created his stage role, Millie Perkins was Anne, and Shelley Winters won a best supporting actress OSCAR as Mrs. Van Daan. William C. Mellor won a cinematography Oscar, as did arts and sets. Melissa Gilbert was Anne in the 1980 television-film remake.

Dickey, James (1923–), U.S. writer, who emerged as a substantial poet with *Into the Stone* (1960); *Drowning with Others* (1962); *Helmets* (1964); and *Buckdancer's Choice* (1965), which won a National Book Award. He adapted his very popular novel DELIVERANCE (1970) into the 1972 John BOORMAN film, and he later published such volumes of poems as *The Zodiak* (1976), *The Strength of Fields* (1979), and *Wayfarer* (1988).

"Dick Tracy," the long-running, widely syndicated comic strip created by Chester GOULD in 1931. The enormously popular, clean-cut, strikingly violent detective hero, facing a range of grotesque criminals, was also featured on radio (1935–48), in several B movies (1945–47), and in a television series (1950–51). Warren BEATTY directed and starred in the 1990 film version of *Dick Tracy*, leading a cast that included MADONNA, Glenne Headly, Dustin HOFFMAN, Al PACINO, Charles Durning, Dick Van Dyke, and Mandy Patinkin.

"Dick Van Dyke Show, The" (1961–66), the long-running television situation comedy, with a story line set in television. Mary Tyler MOORE costarred, in a cast that included Morey Amsterdam, Rose Marie, and Richard Deacon. The series was created by Carl Reiner, who also appeared in many segments.

Didion, Joan (1934–), U.S. writer, best known for such works as her book of essays *Slouching Toward Bethlehem* (1969) and such novels as *Run River* (1963), *Play It As It Lays* (1970), *A Book of Common Prayer* (1977), *The White Album* (1979), and *Democracy* (1984), most of them featuring women confronting an inimical modern world, as typified by the culture of Southern California. She has also done several screenplays, some of them in collaboration with her husband, John Gregory Dunne.

Dieterle, William (1893–1972), German actor and director; he was an actor in Germany during World War I and into the 1920s, moved into directing in the mid-1920s, and then relocated to Hollywood in 1930. During the next three decades he directed a wide range of American films, among them *The Story of Louis Pasteur* (1935), THE LIFE OF ÉMILE ZOLA (1937), *Juarez* (1939), THE HUNCHBACK OF NOTRE DAME (1939), *Dr. Ehrlich's Magic Bullet* (1940), *I'll Be Seeing You* (1944), *Love Letters* (1945), *Portrait of Jennie* (1948), *The Searching Wind* (1947), and *September Affair* (1950).

Dietrich, Marlene (1901–90), German actress, on stage and screen in Germany during the 1920s, who became a major international star in Josef von STERNBERG's German film THE BLUE ANGEL (1930). Then going to Hollywood, she became one of the leading sex symbols of the next two decades, in such films as *Morocco* (1930); SHANGHAI EXPRESS (1932); *The Devil Is a Woman* (1935), the last of the seven films she made with von Sternberg; and *Destry Rides Again* (1939). Later in her career she demonstrated her substantial dramatic talents in such films as WITNESS FOR THE PROSECUTION (1958) and JUDGMENT AT NUREMBERG (1961). She was a notable anti-

Marlene Dietrich's seductive nightclub singer in Josef von Sternberg's *The Blue Angel* (1939).

fascist, who refused a personal invitation from Adolf Hitler to return to Germany in the mid-1930s, ultimately appearing once again in Germany decades after World War II.

Dillon, Matt, the character played by James ARNESS in the long-running television serial GUNSMOKE.

Dine, Jim (1935–), U.S. painter, a leading POP ART figure from the early 1960s, who participated in the development of many "happenings"—artistically connected events designed to fully involve all participants, including those who might otherwise have been spectators. Dine imported everyday artifacts, such as household machines, clothing, and fixtures into his compositions.

Dinesen, Isak (Karen Christence Dinesen Blixen, 1885–1962), Danish writer, many of whose short stories reflect her long residence in Kenya (1914–31). She emerged as a major literary figure with her short-story collection *Seven Gothic Tales* (1934); her most notable later collections were *Winter's Tales* (1942) and *Last Tales* (1957). She used the pseudonym "Osceola" for some of her early stories and

signed her novel *The Angel Avengers* (1947) Pierre Andrézel. She told the story of her African years in OUT OF AFRICA (1937), which was adapted by Kurt Luedtke into Sidney POLLACK's OSCAR-winning 1985 film.

Ding (Jay Norwood Darling, 1876–1962), U.S. cartoonist; from 1913, he was the widely syndicated editorial cartoonist of the *New York Herald Tribune*. He also became a leading conservationist and a friend of Theodore Roosevelt and Herbert Hoover; in 1934 he was appointed head of the Biological Survey of the Department of Agriculture by Franklin D. Roosevelt.

Dinner at Eight (1932), the George S. KAUFMAN–Edna FERBER play, revolving around a dinner for a group of people in and on the fringes of New York moneyed and theater life. Herman J. Mankiewicz, Frances Marion, and Donald Ogden Stewart adapted the play into the notable 1933 George CUKOR film, with a cast that includes John BARRYMORE, Lionel BARRYMORE, Marie Dressler, Jean HARLOW, Wallace BEERY, Billie Burke, Jean Hersholt, Karen Morley, Edmund Lowe, Madge Evans, and Lee Tracy.

Dior, Christian (1905–57), innovative French fashion designer; he introduced the "New Look" in 1947, then becoming one of the dominant fashion designers of the postwar period.

Dirty Harry (1971), a prototypical cops-and-robbers action film of the 1970s. Clint EASTWOOD starred as the San Francisco police detective whose extralegal violence overmatched that of the mad killer he ultimately defeated. Andy Robinson was the killer in this Don Siegel film. It was followed by several sequels, all greatly popular.

Discreet Charm of the Bourgeoisie (1972), the Luis BUÑUEL film, screenplay by Buñuel and Jean-Claude Carriere; a sometimes biting but on the whole rather gentle satire set at a surreal dinner party, with Fernando Rey, Delphine Seyrig, Stephane Audran, Bulle Ogier, and Jean-Pierre Cassel in the key roles. The film won a best foreign film OSCAR.

Disney, Walt (Walter Elias Disney, 1901–66), U.S. film animator, who in 1928, with his partner Ub Iwerks created MICKEY MOUSE, an enormously popular cartoon character, from the appearance of the third cartoon in the series STEAMBOAT WILLIE, which had Disney's first soundtrack. Disney went on to develop a major film and entertainment company, which created DONALD DUCK, Minnie Mouse, Pluto, several other well-known cartoon characters, and the long *Silly Symphony* series. In the late 1930s Disney produced such animated feature films as the trailblazing SNOW WHITE AND THE SEVEN DWARFS (1938), *Pinocchio* (1940), FANTASIA (1940), *Dumbo* (1941), and BAMBI (1942). After World War II his company produced scores of children's entertainment films. In 1954 he moved into television, producing the long-running *Walt Disney* series, and in 1955 opened the first of his amusement parks, Disneyland, at Anaheim, California.

Dmytryk, Edward (1908–), U.S. director, a film editor in the 1930s and a director from 1939, whose early work included *Hitler's Children* (1943), MURDER, MY SWEET (1944); and a pioneering film on antisemitism, *Crossfire* (1947). In 1947 he was caught in the first wave of the McCarthyism that swept the film industry until the mid-1950s and was sentenced to a

year in prison as one of the HOLLYWOOD TEN, later going into exile abroad. In 1951 he returned to the United States, accused others of Communist affiliation before congressional committees, and was rehabilitated, resuming his work in Hollywood. His later work included THE CAINE MUTINY (1954).

Dobell, William (1899–1970), Australian painter, a powerful realist and notable portraitist; after working primarily in Britain from 1929 to 1938, he returned home. His 1943 portrait of Joshua Smith won an Archibald Prize, establishing him as his country's leading modern portraitist, but only after the courts rejected the contention of two other contestants that his freely modern work had been a caricature rather than a portrait.

Döblin, Alfred (1878–1958), German writer, whose experiences as a practicing doctor in Berlin inform his best-known novel, BERLIN ALEXANDERPLATZ (1929). It was adapted for film in 1931 and again into Rainer Werner FASSBINDER's television miniseries, which became the 1980 film. Döblin's novels also include *The Three Leaps of Wang-Lun* (1915), *Wallenstein* (1920), *Giganten* (1924), and the *November 1918 trilogy* (1948–50). He also published essays, short stories, and poetry.

Dr. Jekyll and Mr. Hyde, the classic 1886 Robert Louis Stevenson story of a good doctor, Jekyll, who experiments with altered states of being and turns himself into a monster, Hyde. The story was the basis of several films, most notably including the 1920 John S. Robertson silent-film version, starring John BARRYMORE; the 1932 Rouben MAMOULIAN film, with Fredric MARCH in an OSCAR-winning performance in the title role; and the 1941 Victor FLEMING film, with Spencer TRACY in the lead.

Dr. Mabuse, the central figure in two related classic Fritz LANG films: *Dr. Mabuse, the Gambler* (1923) and *The Last Will of Dr. Mabuse* (1933). In the first, Lang tells the story of master criminal Mabuse locked in a struggle with his equally criminal police adversaries, in an early Weimar German setting depicted as wholly decadent and lawless. In the second, Mabuse is an insane criminal mastermind, his world that of Adolf Hitler and Nazi Germany. In both films

Mabuse was played by Rudolf Klein-Rogge. Three decades later Lang made a sequel, *The Thousand Eyes of Dr. Mabuse* (1960), with Gert Frobe in the role of the detective who ultimately ferrets out Mabuse's criminal son.

Doctorow, E.L. (Edgar Lawrence Doctorow, 1931–), U.S. writer, who emerged as a major novelist with *The Book of Daniel* (1971), evoking the trial and execution of Julius and Ethel Rosenberg. His RAGTIME (1975) was adapted by Michael Weller for the 1981 Milos FORMAN film; he followed it with such novels as *Loon Lake* (1980), *World's Fair* (1986), and *Billy Bathgate* (1988). He also wrote the play *Drinks Before Dinner* (1975).

Dr. Seuss (Theodor Seuss Geisel, 1904–) U.S. children's author, artist, and filmmaker, the enormously popular writer of such books as *The Cat in the Hat* (1957), *Yertle the Turtle* (1958), and *Green Eggs and Ham* (1960). His later works include the best-selling *Oh, the Places You'll Go!* (1990), a book for people of all ages.

Dr. Strangelove, or: How I Learned to Stop Worrying and Love the Bomb (1964), the classic antiwar Stanley KUBRICK comedy, written during the Cold War, when the future of humanity seemed threatened every day. Kubrick produced, directed, and co-wrote the film with Terry Southern and Peter George; the film was based on George's novel *Red Alert*. Peter SELLERS played three roles, including Strangelove, in a cast that included George C. SCOTT, Sterling HAYDEN, Slim Pickens, Keenan Wynn, and Peter Bull, with James Earl JONES appearing in a small role.

Doctor Zhivago (1955), the novel by Boris PASTERNAK, one of the key literary and political works in Soviet history and simultaneously the classic testament of an artist who remained free whatever the cost. The book was first published in Italy in 1957; Pasternak was forced by his government to refuse the NOBEL PRIZE for literature in 1958. The book was adapted by Robert BOLT into the 1965 David LEAN film, with Omar SHARIF as Zhivago and Julie CHRISTIE as LARA, strongly supported by Alec GUINNESS, Ralph RICHARDSON, Tom COURTENAY, Geraldine Chaplin, and Rod STEIGER.

Dodds, Johnny (1892–1940), U.S. musician, a classic New Orleans jazz clarinetist who played and recorded with Louis ARMSTRONG, Lil ARMSTRONG, King OLIVER, Jelly Roll MORTON, Kid ORY, and other jazz luminaries in Chicago during the 1920s. Earlier he had played with Ory, Oliver, and others in New Orleans. His brother Baby Dodds (Warren Dodds, 1898–1959) was a classic New Orleans jazz drummer who also contributed to many of the Chicago recordings in that early period, often playing on wood blocks rather than on drums, for technical reasons. During the 1930s, Baby and Johnny often played together in Baby's Chicago-based bands.

Dodsworth, the 1929 Sinclair LEWIS novel; it was adapted by Sidney HOWARD into the hit 1934 Broadway play, with Walter HUSTON creating the role of retired automobile tycoon Samuel Dodsworth; Fay Bainter as Fran, his restless wife; and Nan Sunderland as Edith Cortwright, his new love. Howard adapted his play into William WYLER's classic 1936 film, with Huston re-creating the title role, Ruth Chatterton as Fran, Mary ASTOR as Edith, Paul LUKAS as one of Fran's European lovers, and such supporting players as David NIVEN and Maria Ouspenskaya.

Dog Day Afternoon (1975), the Sidney LUMET film, set in Brooklyn, about a bank robber and a hostage situation. Al PACINO plays the lead, with John Cazale, Charles Durning, Chris Sarandon, and James Broderick in key supporting roles. Frank Pierson won a best screenplay OSCAR.

"Doin' What Comes Naturally" (1946), the song introduced by Ethel MERMAN in the Broadway musical ANNIE GET YOUR GUN (1946); words and music were by Irving BERLIN.

Dolce Vita, La (*The Sweet Life*, 1960), the classic Federico FELLINI film. Its title, so aptly capturing the decadence and emptiness of the "beautiful people" it described, became a phrase in many languages. Marcello MASTROIANNI played the central role, in a cast that included Anita Ekberg, Anouk Aimee, Yvonne Furneaux, Alain Cuny, and Nadia Gray.

A moment of truth for Ruth Chatterton and Walter Huston as Fran and Sam in William Wyler's film *Dodsworth* (1936).

Dolin, Anton (Sidney Francis Patrick Chippendall Healy-Kay, 1904–), British dancer, choreographer, and director, on stage from 1921 in the BALLET RUSSES company. In the long and varied career that followed, he danced most of the major roles in the repertory, creating leading roles in such works as *The Prodigal Son* (1929), JOB (1931), and BLUEBEARD (1941). He often partnered Alicia MARKOVA. In 1945 he was a cofounder of the Markova-Dolin Company and from 1950 to 1961 was in the London Festival Ballet.

Domingo, Placido (1941–), Spanish tenor, who made his operatic debut in Mexico in 1961, sang with the Israeli National Opera 1962–65 and the New York City Opera from 1965, and made his Metropolitan Opera debut in 1968; a leading contemporary singer in opera, in recital, and on screen, he is also a major recording artist, performing in a very wide range of roles. From the mid-1970s he also occasionally conducted operas.

Domino, Fats (Antoine Domino, 1929–), U.S. musician, a New Orleans pianist who was a rhythm and blues figure from the late 1940s

with such songs as "The Fat Man" (1949) and "Goin' Home" (1952). In the mid-1950s he became an early ROCK-AND-ROLL star with such songs as "Ain't That a Shame" (1955), "Blueberry Hill" (1956), and "I'm Walkin'" (1957). A later hit was his 1968 version of THE BEATLES' song "Lady Madonna."

Donald Duck, the very popular film cartoon character created by the Walt DISNEY company in 1936 and since shown throughout the world.

Donat, Robert (1905–58), British actor, on stage from 1921 and on screen from 1932, who emerged as a star in the 1930s in such films as THE PRIVATE LIFE OF HENRY VIII (1933); THE 39 STEPS (1935); *The Ghost Goes West* (1935); KNIGHT WITHOUT ARMOR (1937); THE CITADEL (1938); and GOOD-BYE, MR. CHIPS (1939), for which he won a best actor OSCAR.

Donleavy J.P. (James Patrick Donleavy, 1926–), U.S. author, whose comedic novel *The Ginger Man* (1955), which he dramatized in 1959, established him as a major writer. He followed it with such works as *Fairy Tales of*

New York (1961), *A Singular Man* (1963), *The Saddest Summer of Samuel S.* (1966), and *The Beastly Beatitudes of Balthazar B.* (1968), all of which he later dramatized, also writing shorter pieces and a book on Ireland.

Doolittle, Eliza, the Cockney flower girl in George Bernard SHAW's PYGMALION, played first on the London stage by Mrs. Patrick CAMPBELL, most memorably on film by Wendy HILLER, and re-created by Julie ANDREWS in the musical MY FAIR LADY, the film version of which starred AUDREY HEPBURN.

"Doonesbury," the very popular, widely syndicated topical comic strip created by Garry TRUDEAU in 1970.

Doors, The, U.S. ROCK band, during its peak years consisting of Jim Morrison, Ray Manzarek, Robby Krieger, and John Densmore. Formed in 1965 and named from Aldous HUXLEY's *The Doors of Perception*, taken as inspirational at the time by some in the "drug culture," the band featured such darkly heavy Morrison song recitations as "The End" and stressed his psychosexual Lizard King stage-performance creation. Both aspects of the group's work upset and activated the censorship movements of the day, considerably enhancing the celebrity of the group. They recorded such albums as *The Doors* (1967); *Strange Days* (1968); *Waiting for the Sun* (1968); *The Soft Parade* (1969); *Absolutely Live* (1970); and *L.A. Woman* (1971), just before Morrison's death that year. He reportedly died of heart failure while in Paris, although some controversy developed as to the manner of his death and even as to whether he had died at all; he remains a considerable cult figure. The band continued to perform and record after Morrison's death.

Dorsey, Jimmy (James Francis Dorsey, 1904–57) and **Tommy** (Thomas Francis Dorsey, 1905–56), U.S. musicians, both luminaries of the big-band era; Jimmy was a clarinetist and saxophonist, while Tommy was a trombonist. They worked together in JAZZ bands during the 1920s, on their own, and with such bandleaders as Paul WHITEMAN and Ted Lewis until the early 1930s, then in 1933 forming

their own Dorsey Brothers band. But they parted acrimoniously after only one year together; both went on to lead their own very well-known bands through the early 1950s, coming together again to lead one band in 1953.

Dos Passos, John Roderigo (1896–1970), U.S. writer, whose experience as a volunteer ambulance driver in World War I provided the setting for his first two novels, *One Man's Initiation-1917* (1920) and *Three Soldiers* (1921). He emerged as a substantial novelist with *Manhattan Transfer* (1925) and as a major figure with his massive work of social criticism in novel form, the *U.S.A.* trilogy, consisting of *The 42nd Parallel* (1930), *1919* (1932), and *The Big Money* (1936). His later work included the *District of Columbia* trilogy—*Adventures of a Young Man* (1939), *Number One* (1943), and *The Grand Design* (1949)—and *Midcentury* (1951). He also wrote several books on his travels and a considerable number of political essays.

Double Indemnity (1936), the James M. Cain novel, about a dissatisfied, mercenary woman who has an affair with a life-insurance salesman and conspires with him to murder her husband for the insurance proceeds. Billy Wilder and Raymond Chandler adapted the novel into Wilder's classic 1944 film; Barbara Stanwyck was the woman, Fred MacMurray the insurance salesman, and Edward G. Robinson the saleman's superior, who ultimately discovers the plot, after the murder has been done. The film was remade for television in 1973, with Samantha Eggar and Richard Crenna in the key roles.

Douglas, Kirk (Issur Danielovich Demsky, 1916–), U.S. actor, on stage from 1941 and on screen from 1946. He became a star as the prizefighter in *Champion* (1949), and in the next three decades starred in a wide range of roles, in such films as THE GLASS MENAGERIE (1950), *Ace in the Hole* (1951), *The Big Sky* (1952), *Ulysses* (1955), *Lust for Life* (1956), *Gunfight at the O.K. Corral* (1957), *Paths of Glory* (1959), *Spartacus* (1960), *Seven Days in May* (1964), *Cast a Giant Shadow* (1966), *Posse* (1975), *The Man from Snowy River* (1982), and

Tough Guys (1986). He is the father of actor Michael DOUGLAS.

Douglas, Melvyn (Melvyn Edouard Hesselberg, 1901–81), U.S. actor, on stage from 1919. Although best known for his films, he played major theater roles for over three decades, from his Broadway debut in *A Free Soul* (1928) to his TONY-winning role in THE BEST MAN (1960). He played leads in several films, including NINOTCHKA (1939), opposite Greta GARBO, and *I Never Sang for My Father* (1970). During most of his career he played very strong supporting roles, in such films as MR. BLANDINGS BUILDS HIS DREAM HOUSE (1948), HUD (1960), THE AMERICANIZATION OF EMILY (1964), and BEING THERE (1979), winning best supporting actor OSCARS for *Hud* and *Being There*. He was the husband of actress and Congresswoman Helen Gahagan Douglas.

Douglas, Michael Kirk (1944–), U.S. actor and producer, on screen from 1969, with major roles in such films as *Romancing the Stone* (1984) and its sequel *The Jewel of the Nile* (1985), both of which he also produced; *Fatal Attraction* (1987); WALL STREET (1987), for which he won a best actor OSCAR; and *The War of the Roses* (1989). He has also produced such films as the Oscar-winning ONE FLEW OVER THE CUCKOO'S NEST (1975) and THE CHINA SYNDROME (1979). Douglas also appeared in television's "The Streets of San Francisco" (1972–75). He is the son of actor Kirk DOUGLAS.

Dove, Arthur Garfield (1880–1946), U.S. painter, who by 1910 was creating some of modern art's earliest abstractions. He exhibited with Alfred STIEGLITZ at the 291 GALLERY in 1910 and at the ARMORY SHOW of 1913 and later continued to work with a variety of abstracted forms, importing many materials into his compositions, much in the style of later POP ART, and also working with collage.

Dovzhenko, Alexander Petrovich (1894–1956), Soviet director, who made several powerful silent films before encountering political obstacles during the Stalin period. A Ukrainian, his first major film, *Zvenigora* (1928) was set in the Ukraine. He followed it with *Arsenal* (1929), and then with another film set in the Ukraine, EARTH (1930), often described as his masterpiece although severely criticized by the Soviet cultural establishment. Dovzhenko continued to create films during the 1930s and early 1940s but considered his work to have been in the main blocked. He later turned away from directing and toward writing.

Doyle, Arthur Conan (1859–1930), British writer, the creator of the fictional detective Sherlock HOLMES and his friend and associate Dr. Watson, in his first novel, *A Study in Scarlet* (1887). Holmes quickly became one of the most popular figures in English fiction and remains so to this day, serving as the basis for numerous dramatizations through the century, long since having become a cult figure. Doyle also wrote several historical novels and plays; converting to spiritualism in 1917, he wrote and lectured widely on that subject in his later years.

Drabble, Margaret (1939–), British author, much of whose work explores the emotional concerns of women emerging into full participation in modern society, while often still deeply concerned with nurturing, in such novels as *The Garrick Year* (1964), *The Millstone* (1965), *The Waterfall* (1969), *In the Realms of Gold* (1975), and *The Ice Age* (1977). She later edited the fourth edition of *The Oxford Companion to English Literature* (1985), then returning to fiction.

Dracula, the fictional Transylvanian vampire created by Bram Stoker in his 1897 story. The story was the basis for the 1921 F.W. MURNAU film, *Nosferatu, the Vampire*, with Max Schreck in the title role. By far the most highly regarded of the several film Draculas was Bela LUGOSI, who created the role in the 1931 Tod Browning film, a classic horror movie that made Lugosi, the gentlest of men, one of the best-known horror-film figures of the century.

"Dragnet" (1949–70), the police investigation series, on radio 1949–56 and on television 1952–59 and 1967–70. Jack Webb, who originated the series, was Sgt. Joe Friday; Barton Yarborough was the first of his succession of partners. The series generated films in 1954

and 1969, both starring Webb. A 1987 film satire starred Dan Aykroyd in the Joe Friday role.

Dreiser, Theodore Herman Albert (1871–1945), U.S. writer; the powerful realism of his first novel, the classic *Sister Carrie* (1900), caused its American publishers to suppress it after publication, for its supposed immorality, although it was well received abroad. His second novel, *Jennie Gerhardt* (1911), established him as a major figure; he quickly followed it with *The Financier* (1912), *The Titan* (1914), and *The "Genius"* (1915). His best-known work was his landmark novel AN AMERICAN TRAGEDY (1925), based on the 1908 Gillette-Brown murder case. He also wrote a wide variety of other, lesser works, including plays, essays, short stories, poetry, autobiographies, and several political works reflecting his socialist political concerns, developed in the late 1920s. He was the brother of songwriter Paul Dresser and may have worked with his brother on the song "On the Banks of the Wabash Far Away" (1899). *Sister Carrie* became the 1952 William WYLER film; *An American Tragedy* became the 1931 Josef von STERNBERG film and in 1951 was remade as the George STEVENS film A PLACE IN THE SUN.

Dreyer, Carl Theodor (1889–1968), Danish director, whose work was on screen from 1919. His epic *The Passion of Joan of Arc* (1928) has been widely recognized as a landmark silent film, as was his sound-film masterwork *Day of Wrath* (1942), a powerfully anti-Nazi film made during the Nazi occupation of Denmark, which caused him to take refuge in Sweden for the balance of the war. His major later films were *The Word* (1955) and *Gertrud* (1964).

Dreyfuss, Richard (1948–), U.S. actor, on stage and screen from the late 1960s, who became a leading supporting player in the early 1970s, in such films as *Dillinger* (1973) and AMERICAN GRAFFITI (1973), and then became a leading contemporary star in *The Apprenticeship of Duddy Kravitz* (1974); JAWS (1975); CLOSE ENCOUNTERS OF THE THIRD KIND (1977); his OSCAR-winning lead in *The Goodbye Girl* (1977); *The Competition* (1980); *Whose Life Is It, Anyway?* (1981); *Down and Out in*

Beverly Hills (1986); *Moon over Parador* (1988); and *Always* (1990).

Driving Miss Daisy (1989), the OSCAR-winning 1989 Bruce Beresford film, with a cast led by Jessica TANDY, Morgan FREEMAN, and Dan Aykroyd. Tandy won a best actress Oscar; Alfred Uhry won an Oscar for his adaptation of his own PULITZER PRIZE-winning play; and Manlio Rocchetti won an Oscar for makeup.

Drury, Allen (1918–), U.S. writer, a journalist and novelist best known for his PULITZER PRIZE-winning first novel, ADVISE AND CONSENT, set in the Washington politics surrounding a secretary of state confirmation fight. Much of his later work was on similar political themes.

Drysdale, George Russell (1912–81), Australian painter, whose powerful early 1940s pictures of the hard life of the Australian bush, and especially of the plight of his country's Aborigines (or Native Australians), helped develop a new realism in Australian painting and significantly contributed to the development of new Australian attitudes on such matters.

Du Bois, Blanche, the classic lead in A STREETCAR NAMED DESIRE (1947); it was created on stage by Jessica TANDY and on screen by Vivien LEIGH.

Dubuffet, Jean (1901–85), French artist; in the late 1940s he became an early exponent of using unusual and previously disfavored materials in artworks, such as gravel, discarded periodicals, and the other materials that were later used in the "junk" art of the 1950s and 1960s, calling his work *art brut* (raw art).

Duchamp, Marcel (1887–1968), French artist, resident in the United States during both world wars and an American citizen from 1955. He was essentially an anti-artist whose life and work became important to Dadaists and surrealists early in the century and to a group of successor movements in midcentury. The most significant of his small body of works was NUDE DESCENDING A STAIRCASE, NO. 2 (1912), a cinematic superimposition of five images perceived as a single, machine-age object. The work was scorned in Paris—and a

great and scandalous success at the 1913 ARMORY SHOW in New York. Another major work was the ultimately unfinished *Large Glass* (1915–23). Duchamp also invented the "ready-made"—any mass-produced object that might be exhibited as if it were an artwork—shocking viewers with such objects as his now-celebrated 1913 bicycle wheel and 1914 bottle rack, and then moving on to such absurdist gestures as the presentation of a urinal for a 1917 New York exhibition. He was the brother of artists Raymond DUCHAMP-VILLON and Jacques VILLON (Gaston Duchamp).

Duchamp-Villon, Raymond (1876–1918), French sculptor, whose early naturalist style became increasingly abstract and CUBIST after the first decade of the century, as indicated by such works as *Baudelaire* (1911); *Maggy* (1912); *The Seated Woman* (1914); and his very notable *Horse*, done in several versions from 1912–14, which became a key modernist work. His life and career were cut short by his war service and resulting death. He was the brother of artists Marcel DUCHAMP and Jacques VILLON (Gaston Duchamp).

Duck Soup (1933), the classic MARX BROTHERS film comedy, a merciless satirical attack on war and the mad politicians who make war, made with the threats of fascism and new wars very much in mind. Groucho played Rufus T. Firefly, prime minister of Freedonia; he, Chico, Harpo, and Zeppo worked in ensemble, as always, and in this film were supported by Margaret Dumont and Louis Calhern. Leo MCCAREY directed the film.

Duel in the Sun (1946), a film directed by King VIDOR but produced and closely supervised by David O. SELZNICK; a sexually charged Western adapted by Selznick and Oliver Garrett from the Niven Busch novel. Jennifer JONES was Pearl, the object of desire of the brothers McCanles, played by Gregory PECK and Joseph COTTEN, in a cast that included Walter HUSTON, Lionel BARRYMORE, Lillian GISH, Charles Bickford, Herbert Marshall, and Harry Carey.

Dufy, Raoul (1877–1953), French painter; in his early work he used color in an Impressionist and then FAUVIST fashion, then in the early 1920s developing his own characteristic style, featuring hard, bright background colors and scenes drawn from French leisure pursuits, especially from the racecourse and seaside. He was also a leading tapestry and pottery decorator, and in the 1930s he produced several large decorative works for public places.

Duhamel, Georges (1884–1966), French writer, who emerged as a substantial literary figure with his two World War I novels, both based on his experiences as an army doctor: *The New Book of Martyrs* (1917) and *Civilization 1914–1917* (1919), both written as Denis Thévenin. He is best known for two long fictional works: the five-volume *Salavin Cycle* (1920–22) and the 10-volume *Pasquier Chronicles* (1933–45).

Dukas, Paul (1865–1935), French composer and critic, best known for *The Sorcerer's Apprentice* (1897), though he also wrote such works as the *Symphony in C Major* (1896); his *Sonata* (1901); the *Variations* (1903); and a ballet, *La Peri* (1912).

Duke, Patty (Anna Marie Duke, 1946–), U.S. actress, a leading child star who was on stage at the age of seven and became a star on Broadway as Helen Keller in THE MIRACLE WORKER (1959). She re-created the role in the 1962 Arthur PENN film, and won a best supporting actress OSCAR. Her most successful later work was in television, including the series "The Patty Duke Show" (1963–66). During her marriage to actor John Astin she used the name Patty Duke Astin.

du Maurier, Daphne (1907–89), British writer, best known for such popular historical novels as *Jamaica Inn* (1936), REBECCA (1938), *Frenchman's Creek* (1941), and *The King's General* (1946). Several of her novels became films, most notably *Rebecca*, which became the OSCAR-winning 1940 Alfred HITCHCOCK film. The daughter of actor Gerald du Maurier and granddaughter of artist and novelist George du Maurier, she wrote *George: A Portrait* (1934) and *The du Mauriers* (1937).

Dunaway, Faye (Dorothy Faye Dunaway, 1941–), U.S. actress, on stage from 1962 and on screen from 1967. Her breakthrough role was that of Bonnie Parker in BONNIE AND

CLYDE (1967); she also played leads in such films as *Three Days of the Condor* (1975), NETWORK (1976), *Mommie Dearest* as Joan CRAWFORD (1981), and *Midnight Crossing* (1988) and appeared on television as Aimee Semple McPherson in 1976 and as Evita Perón in 1982. She won a best actress OSCAR for *Network*.

Dunbar, Paul Laurence (1872–1906), U.S. writer, a pioneering poet and novelist who wrote on Black American themes, often using folk materials. He was best known for such poetry collections as *Lyrics of Lowly Life* (1896), *Lyrics of the Hearthside* (1899), *Lyrics of Love and Laughter* (1903), and *Lyrics of Sunshine and Shadow* (1905) and also wrote several novels and a play.

Duncan, David Douglas (1916–), U.S. photographer; he was a Marine Corps photographer during World War II and covered the Korean War for *Life* magazine, generating the notable collection *This Is War!* (1951). His later work included a photo-essay on the art treasures of the Kremlin and several works on PICASSO, as well as an illustrated autobiography.

Duncan, Isadora (1878–1927), U.S. dancer and teacher, a central early figure in the MODERN-DANCE movement. Duncan developed a free-flowing, loosely draped, neoclassical performance style that reflected her view of natural function; she also developed a free life-style that brought her considerable obloquy in her native land. In Europe she very quickly became a highly popular "cult figure" whose style and views brought her forward as the chief exponent of the modern-dance movement. She visited Russia in 1905 and may have had some influence on the thinking of Sergei DIAGHILEV and Michel FOKINE, who would in 1909 commence the modern movement in ballet, with the Paris-based BALLET RUSSES. She founded several short-lived dance schools, the last in Moscow, in 1921, at the invitation of the new Soviet government. Her life and career were cut short by an automobile accident in which her long scarf was caught in the wheel of a moving car, strangling her. Vanessa REDGRAVE starred in the 1969 film biography ISADORA.

Dunham, Katherine (1910–), U.S. dancer, choreographer, director, and teacher; she was a dancer in New York during the 1930s, moved into choreography with the Federal Theatre Project, and then developed her own company, beginning with the landmark *Tropics and Le Jazz Hot—From Haiti to Harlem* (1940). Dunham became a central figure in the new Black dance movement that then emerged, touring the world with her company and choreographing several new works on African-American themes. She also choreographed such musicals as CABIN IN THE SKY (1940), *Tropical Revue* (1943), and *Carib Song* (1945) and appeared in films and opera.

Dunne, Irene (1901–90), U.S. actress, in musical theater during the 1920s and on screen as a leading dramatic and musical star of Hollywood's Golden Age during the 1930s and 1940s, in such films as CIMARRON (1931), BACK STREET (1932), ROBERTA (1935), SHOWBOAT (1936), *Penny Serenade* (1941), *A Guy Named Joe* (1943), and I REMEMBER MAMA (1948).

Durante, Jimmy (James Francis Durante, 1893–1980), self-described as "The Schnozzola" for his big nose, which he made part of his gently self-deprecating comedy routines during his five decades in U.S. show business. He was in variety as a ragtime pianist and comedian from 1910, a star in vaudeville as part of Clayton, Jackson, and Durante during the 1920s, and a comedy star on Broadway and in films from the early 1930s and later in television. His signature song was INKA DINKA DOO, which he wrote in 1934; his exit line was "Good night, Mrs. Calabash, wherever you are."

Duras, Marguerite (Margaret Donnadieu, 1914–), French writer and director, who emerged as a major literary figure with the novels *The Sea Wall* (1950), which was informed by her early life in Indochina and became the 1958 René CLEMENT film; and *The Sailor from Gibraltar* (1952), which became the 1967 Tony RICHARDSON film. Her best-known novels also include *The Vice Consul* (1965) and *The Lover* (1984). Among her plays are *Days in the Trees* (1965), which she adapted for film and directed in 1976, and *Savannah*

Bay (1983). She also wrote many screenplays, including HIROSHIMA, MON AMOUR (1959) and *India Song* (1975), the latter an adaptation of her own 1973 novel, which she also directed.

Durrell, Lawrence George (1912–90), Anglo-Irish writer, author of the highly regarded ALEXANDRIA QUARTET, consisting of the novels *Justine* (1957), *Balthazar* (1958), *Mountolive* (1958), and *Clea* (1960). His work also includes such lesser but quite notable novels as *The Black Book* (1938) and *Bitter Lemons* (1957), as well as a considerable body of poetry, plays, and essays.

Dürrenmatt, Friedrich (1921–), Swiss writer, working in German, whose plays are largely absurdist in content but rely on the grotesque for impact. He is best known for two plays, *Fools Are Passing Through* (1952) and *The Visit*, and also wrote several novels and a considerable number of essays, including a critical work, *Problems of the Theatre* (1955).

Duvall, Robert (1931–), U.S. actor, on screen in strong character roles and several leads from 1963, in such films as TO KILL A MOCKINGBIRD (1963); THE GODFATHER (1972); THE GODFATHER, PART II (1974); NETWORK (1976); *The Great Santini* (1979); APOCALYPSE NOW (1979); *Tender Mercies* (1983), for which he won a best actor OSCAR; and *Colors* (1988). His work in television includes a notable Dwight D. Eisenhower portrayal in the miniseries IKE (1979).

Duveen, Joseph (1869–1939), New York- and London-based art dealer, who in the late 19th and early 20th centuries played a major role in building the collections of several American "robber barons," such as J.P. MORGAN, Henry Clay Frick, Andrew Mellon, and Benjamin Altman, and thereby of the museum collections to which they ultimately donated their works. From 1900 he often relied on the evaluations of Bernard BERENSON.

Duvivier, Julien (1896–1967), French director, whose work was on screen from 1919,

and who made several notable films in the 1930s, including *Maria Chapdelaine* (1930), *Pepe Le Moko* (1937), and *Un Carnet de Bal* (1937). He made *The Great Waltz* in Hollywood in 1938, returned to Europe, and then returned to the United States during World War II; his work in this period included *Tales of Manhattan* (1942) and *Flesh and Fantasy* (1943). His later work included Vivien LEIGH's *Anna Karenina* (1948) and *The Return of Don Camillo* (1953).

Dwan, Allan (Joseph Aloysius Dwan, 1885–1981), early U.S. film director, who began with one-reelers in 1911 and became one of the leading directors of the silent era, with such films as *A Girl of Yesterday* (1915), starring Mary PICKFORD; *A Modern Musketeer* (1917); and *Mr. Fix-It* (1918), the latter two starring Douglas FAIRBANKS. He continued to make sound films into the 1950s, many of them less than notable; but they did include such films as *Heidi* (1937), *Rebecca of Sunnybrook Farm* (1938), and *The Sands of Iwo Jima* (1949).

Dylan, Bob (Robert Allen Zimmerman, 1941–), U.S. singer and composer, one of the leading folk, ROCK, and protest figures of the 1960s. He quickly became extraordinarily popular, with such songs as "Blowin' in the Wind" (1963), "A Hard Rain's A-Gonna Fall" (1963), and "Masters of War" (1963), and followed these with his signature song, the emblematic THE TIMES THEY ARE A-CHANGIN' (1963), as much as any single work the anthem of the Weathermen, the Yippies, and the entire range of COUNTERCULTURE activists of the time. In the mid-1960s and thereafter he moved toward rock and away from folk styles, and in the late 1970s he announced a Christian religious conversion; although he continued to write new music, record, and play before worldwide audiences, his later work never achieved the enormous impact of his early 1960s songs.

E

Eagels, Jeanne (1894–1929), U.S. actress, on stage as a child from the turn of the century. She began to play major roles in 1916, several of them opposite George ARLISS, but is best known by far for her creation of the Sadie Thompson role in RAIN (1922). She played the role for four years and then one more role, in *Her Cardboard Lover* (1927). Her untimely death was related to substance abuse. Kim NOVAK played Eagels in the 1957 film biography.

Eagles, The, U.S. ROCK band, formed in 1971 by Bernie Leadon (1947–), Glenn Frey (1948–), Randy Meisner (1946), and Don Henley (1947–); it became one of the most popular groups of the 1970s, with such albums as *Eagles*, with the song "Take It Easy" (1972); *Desperado*, with "Tequila Sunrise" (1973); and GRAMMY-winner *Hotel California*, with the title song and "Life in the Fast Lane" (1977). The group disbanded in 1981, all continuing on in careers as soloists.

Eames, Charles (1907–78), U.S. industrial designer, best known for his molded plywood furniture designs, which were exhibited at the Museum of Modern Art in 1946. His most successful single group of designs became known as the "Eames chair." Eames was also an architect, a film set designer, and a design consultant.

Earth (1930), the Alexander DOVZHENKO film, a classic work of the early Soviet cinema set in his native Ukraine, which focuses far more on the lyric, deeper themes of land and nature than on the contemporary Soviet story being told. Dovzhenko's work supported the forced collectivization of the time, which in fact cost millions of Soviet lives; yet the film was sharply criticized by his government, which did not like his honesty and severely censored his work.

earth art, earthworks, alternative terms for a kind of CONCEPTUAL ART involving the use of natural forms to create artworks, as in Walter de Maria's *Mile-Long Drawing* of parallel lines painted on the desert floor; such works are also called "land art."

Earth, Wind, and Fire, U.S. soul band organized in 1969 by brothers Maurice White (1941–) and Verdine White (1951–); it became one of the leading bands of the 1970s with the album *That's the Way of the World*, with its hit song "Shining Star" (1975), and went on to issue such albums as *Gratitude* (1975), *Spirit* (1976), and *All 'n' All* (1977). The band was also featured in the film *Sergeant Pepper's Lonely Hearts Club Band* (1978).

"Easter, 1916," the William Butler YEATS poem, written to commemorate the April 1916 Easter Rising and the executions of Irish revolutionaries that followed; it ended with the prophetic line "A terrible beauty is born."

Easter Parade (1948), the Irving BERLIN film musical, directed by Charles Walters and starring Fred ASTAIRE and Judy GARLAND. It was a slight, very popular film, notable for its stars and the title song, written by Berlin in 1933, introduced by Marilyn MILLER on Broadway in *As Thousands Cheer* (1933), and sung by Bing CROSBY in *Holiday Inn* (1942).

East of Eden (1952), John STEINBECK's California-based Trask family Cain-and-Abel story. The novel was adapted by Paul Osborn into Elia KAZAN's 1955 film, starring Raymond MASSEY and James DEAN, strongly supported by Julie HARRIS; Burl IVES; Albert Dekker; and Jo Van Fleet, who won a best supporting actress OSCAR.

Eastwood, Clint (1930–), U.S. actor and director, on screen from 1955 and in the leading role in the television series "Rawhide" (1958–65). His three Sergio LEONE Italian "spaghetti Westerns," *A Fistful of Dollars* (1964), *For a Few Dollars More* (1965), and *The Good, the Bad, and the Ugly* (1966), established him as one of the leading international film stars of the era. Returning to Hollywood, he continued to make strong, extremely popular action films, sometimes going over into self-parody, as in *Paint Your Wagon* (1969). With *Play Misty for Me* (1971) he began to direct some of his own films. He also appeared in such films as DIRTY HARRY (1971), *The Outlaw Josey Wales* (1976), *Honky Tonk Man* (1982), *Pale Rider* (1985), *The Dead Pool* (1988), and *White Hunter, Black Heart* (1990), which he also produced and directed.

"Easy Aces, The" (1930–46, 1948–49), a 15-minute two-hander comedy serial, starring Goodman Ace and Jane Sherwood Ace, that was one of the most popular of all radio shows; their television version ran only six months in 1949–50. Goodman Ace wrote all their material, continuing on as a leading comedy writer in later years.

Easy Rider (1969), the Dennis Hopper film, a prototypical 1960s story about two motorcyclists pursuing the free, uncluttered life of the road, who ultimately are casually murdered, their fate perhaps intended to be a metaphor for the probable end of the 1960s youth rebellion. Hopper and Peter Fonda were the motorcyclists; Jack NICHOLSON also starred, in a cast that included Luke Askew, Karen Black, and Robert Walker.

Eckstine, Billy (William Clarence Eckstein, 1914–), U.S. musician, a singer, instrumentalist, and bandleader popular from the mid-1940s through the mid-1960s. From the mid-1940s he often recorded with Sarah VAUGHAN; one very notable result was their recording of "It's Magic" (1947).

Eco, Umberto (1932–), Italian writer and communications theorist, who became a popular figure with his novel on medieval themes, *The Name of the Rose* (1981), which became the 1986 film starring Sean CONNERY and directed by Jean-Jacques Annaud. His main work was in aesthetics and language theory; he published several works on the theory of semiotics, as well as his notable *Art and Beauty in the Middle Ages* (1959) and *Foucault's Pendulum* (1988).

Eddy, Nelson (1901–67), U.S. singer and actor, best known by far for his films with Jeannette MACDONALD, including *Naughty Marietta* (1935), *Rose Marie* (1936), *Maytime* (1937), *Sweethearts* (1937), THE GIRL OF THE GOLDEN WEST (1938), *New Moon* (1940), and BITTER SWEET (1940). He also starred in several other musicals, including *Rosalie* (1937), *The Chocolate Soldier* (1941), and *Knickerbocker Holiday* (1944).

"Ed Sullivan Show, The" (1948–71), the very long-running television variety show. For over two decades Ed Sullivan was the host of his Sunday-night show, which became a vehicle for most of the major show-business figures of the period; many of them, such as THE BEATLES, Bob HOPE, and Lena HORNE, made their American television debuts on the Sullivan show.

Edwards, Blake (William Blake McEdwards, 1922–), U.S. director, writer, and actor, on screen as an actor from 1942, who worked as a television and film screenwriter and director from the mid-1950s. Although his work was somewhat uneven, he directed such films as DAYS OF WINE AND ROSES (1963); directed the five *Pink Panther* film comedies (1964, 1975, 1976, 1978, and 1983), also writing and producing all but the first of them; wrote, produced, and directed the extraordinary satire of Hollywood *S.O.B.* (1981); and wrote and produced VICTOR/VICTORIA (1982). The latter two films, like many of his later films, starred his wife, Julie ANDREWS. His later films include *Sunset* (1988) and *Skin Deep* (1989).

Ehrenburg, Ilya Gregorievich (1891–1967), Soviet writer, a journalist for much of his career, who lived abroad during much of the early Soviet period, returning to the Soviet Union in the 1930s. His early novels include *Julio Jurenito* (1922) and *The Love of Jeanne Ney* (1923). He wrote two notable war novels, *The Fall of Paris* (1941) and *The Storm* (1947),

and after Stalin's death wrote the novel *The Thaw* (1954–56), a highly controversial and influential work in the early days of de-Stalinization. He continued to press for greater Soviet democracy in his *Memoirs* (1961–66).

Eight, The, a group of eight early-20th-century American artists, most of them New York-based, all of whom shared a desire to portray contemporary American life and who seceded from the National Academy of Design to exhibit together in 1908. Five of them were realists: Robert HENRI, John SLOAN, William GLACKENS, George LUKS, and Everett SHINN. Earlier in Philadelphia, Henri had been the teacher of the other four, then newspaper ilustrators, and they had followed him to New York. The others were Arthur Davies, Ernest Lawson, and Maurice PRENDERGAST. The Eight's subject matter and the style of the realists brought them harsh criticism from the "establishment" of the time; they were called the ASHCAN SCHOOL by their detractors, whom they quite notably survived. The Eight became the progenitors of the main American national movements and styles of the first 45 years of the century, until the ascendancy of the ABSTRACT EXPRESSIONISTS and their successors.

8 ¹/₂ (1963), the Federico FELLINI film, the semi-autobiographical story of a filmmaker and his midlife crisis, rather tenuously organized into a group of surreal vignettes. Marcello MASTROIANNI played the lead, supported and surrounded by Anouk Aimee, Claudia Cardinale, and Sandra Milo. The film won a best foreign film OSCAR.

Einstein on the Beach (1976), the Philip GLASS opera, first produced at the Avignon Festival and then at the Metropolitan Opera, with sets by Robert Wilson. The work established Glass as a major contemporary opera composer.

Eisenstaedt, Alfred (1898–), German photographer, who worked in Germany from the late 1920s until after the Nazi takeover, then emigrated to the United States in 1935. He was a staff photographer with *Life* magazine from 1936 to 1972, in that period becoming a leading photojournalist and portraitist. Some of his best-known works are collected in such books as *Witness to Our Time* (1966) and *The Eye of Eisenstaedt* (1969).

Eisenstein, Sergei Mikhailovich (1898–1948), Soviet director and film theorist, whose early work significantly influenced the development of the art of film. These included four landmark silent films: *Strike* (1924), THE BATTLESHIP POTEMKIN (1925), OCTOBER/TEN DAYS THAT SHOOK THE WORLD (1927), and *The General Line* (1929). In the late 1920s, the triumph of Stalinism in the Soviet Union brought Eisenstein into constant conflict with Soviet cultural authorities, while a three-year sojourn in Western Europe and Mexico resulted only in the aborted *Qué Viva Mexico!* (1932). He rewon Stalin's favor with the superpatriotic epic ALEXANDER NEVSKY (1938) and again with IVAN THE TERRIBLE, PART I (1945); fell into disfavor with IVAN THE TERRIBLE, PART II (1946), which was not released until 1958; and died of a heart attack before finishing Part III of the work.

Eldridge, Roy (David Roy Eldridge, 1911–89), U.S. JAZZ musician, a versatile instrumentalist and bandleader, who became one of the leading trumpeters of the 1930s in his own and other bands, most notably with Fletcher HENDERSON. He later played with Gene KRUPA and Artie SHAW; as one of the few Black musicans in their bands, he broke the color line artistically but also suffered severe discrimination in the pre-civil-rights-movement United States. From 1969 to 1980, he led the band at Jimmie Ryan's in New York City.

Eleanora Duse (1903), the celebrated portrait photo of the great actress Duse, by Edward STEICHEN; it became a landmark in the history of photography.

"Eleanor and Franklin" (1976), the television film biography of Eleanor and Franklin Roosevelt, from their early years through his death in 1945. Jane ALEXANDER was Eleanor Roosevelt and Edward Herrman was Franklin Roosevelt, in a cast that included Linda Kelsey, Ed Flanders, Irene Tedrow, Lilia Skala, Rosemary Murphy, and Pamela Franklin. James Costigan adapted the work from the Joseph Lash biography; Daniel Petrie

directed. The work generated a sequel: "Eleanor and Franklin: the White House Years" (1977).

Electra, the opera by Richard STRAUSS, adapted by Hugo von HOFMANNSTAL from his own 1903 play; a straightforward retelling of the Sophocles play. It was first produced at Dresden, in 1909.

electronic music, music altered or created by the use of electronic instruments; a major development in music from midcentury, although experimental work had been done in electronic music from before the turn of the century. With the development of tape recorders and electronic means of manipulating music, studios for the production of electronic music were set up in several major cities during the 1950s, and such composers as STOCKHAUSEN and CAGE began to work freely with electronics, as did many popular composers and performers. With the development of the synthesizer, electronic music became a major and very commonly used form.

Elephant Man, The (1977), the TONY-winning Bernard Pomerance play, set in 1880s London, about the last years of injured and grotesquely deformed John Merrick; the story was taken from life. Frederick Treves was Merrick in the 1979 New York production. In the 1980 film, directed by David Lynch, John HURT was Merrick, in a cast that included Anthony Hopkins as the doctor, Wendy HILLER, John GIELGUD, and Anne BANCROFT.

Elgar, Edward William (1857–1934), English composer, whose powerful, essentially optimistic and Romantic work brought him forward as the first English composer of world rank since Henry Purcell, over two centuries earlier, and simultaneously presaged the English musical renaissance of the 20th century. Much of his tonal, very harmonic work—quite at variance with so much of what was to come in classical music throughout the century—is still enormously popular, as is demonstrated most clearly by the *Enigma Variations* (1899), his first popular work. The song "The Land of Hope and Glory" is taken from the first of the five *Pomp and Circumstance* marches (1901–30). His large body of works

also includes the choral oratorios *The Light of Life* (1896) and *Gerontius* (1900), the two symphonies (1908 and 1911), the violin concerto (1910), the symphonic poem *Falstaff* (1913), and the cello concerto (1919).

Eliot, T.S. (Thomas Stearns Eliot, 1888–1965), American-born British writer and critic, a leading 20th-century poet from the appearance of his poem "The Love Song of J. Alfred Prufrock" (1910–11), which appeared in the collection *Prufrock and Other Observations* (1917). This was followed by *Poems* (1919), THE WASTE LAND (1922), and *The Hollow Men* (1925), a body of powerfully negative and despairing works that profoundly influenced the course of 20th-century English-language poetry, technically and thematically; this was also accompanied by a considerable body of critical work. Eliot turned to the Anglican religion in the late 1920s, a decision reflected in the tone and content of much of his later work, including "Ash Wednesday" (1930), "The Rock" (1934), the morality play *Murder in the Cathedral* (1935), and the long, four-part poem *The Four Quartets* (1936–43). His later plays include *The Family Reunion* (1939); *The Cocktail Party* (1949), which won a Best Play TONY; *The Confidential Clerk* (1953); and *The Elder Statesman* (1959). His light poems in *Old Possum's Book of Practical Cats* (1939) formed the basis for the musical CATS.

"Elizabeth R" (1971), the six-part British television serial based on the life of Elizabeth I of England. Glenda JACKSON was Elizabeth, strongly suppported by a cast that included Robert Hardy, Ronald Hines, Rachel Kempson, Bernard Hepton, Vivian Pickles, and Peter Jeffrey.

Ellington, Duke (Edward Kennedy Ellington, 1899–1974), U.S. composer, pianist, and orchestra leader. He emerged as a composer, pianist, and bandleader in the mid-1920s; wrote such classics as "Mood Indigo" (1931) and "Sophisticated Lady" (1933); and began working in longer orchestral forms during the 1930s. His first Carnegie Hall concert, in 1943, featured his 50-minute work *Black, Brown, and Beige,* perhaps the most notable of his several longer JAZZ-based works. Many of the leading jazz instrumentalists of his time played

in his orchestra, often for long periods. The orchestra he developed, working with his arrangements and compositions, was recognized as a unique creation, and Ellington was recognized as one of the leading jazz figures of the century.

Ellis Island Madonna (1905), the Lewis HINE photograph of mother and child, which became one of the central images of the American immigration experience.

Ellison, Ralph Waldo (1914–), U.S. writer, whose first and only published novel, *Invisible Man* (1952), an extraordinarily effective portrayal of what it meant to be a discriminated-against Black American, won a National Book Award. He also published two books of essays.

Elman, Mischa (1891–1967), Russian-American violinist, celebrated for the warmth, beauty, and expressiveness of his work. He was a child prodigy, who studied at Odessa from age six; made his debuts in Berlin in 1904, in London in 1905, and in New York in 1908; and thereafter toured the world for the rest of his life, as one of the leading violinists of the century. He became an American citizen in 1923.

Elmer Gantry (1927), the Sinclair LEWIS novel, a powerful exposé of evangelical religious fakery as practiced in his time in the American Midwest. In 1960 it was adapted by Richard BROOKS into the equally powerful film, which he directed. Burt LANCASTER won a best actor OSCAR in the title role, opposite Jean SIMMONS; Shirley JONES won a best supporting actress OSCAR, while Brooks won an Oscar for his screenplay.

Éluard, Paul (Eugène Grindel, 1895–1952), French writer, who in the early post-World War I period became a founder of SURREALISM and in the interwar period emerged as a leading poet, taking as his theme the centrality of the experience of love, sensual and transcendent, with the wider concerns becoming dominant as his thinking matured. His early works include such collections as *L'Amour la poésie* (1929) and *La Vie immédiate*. In the late 1930s, much affected by the Spanish Civil War and then

by World War II, he turned to other concerns, in *Cours Naturel* (1938); in the poetry published while he was a Resistance fighter during World War II, which included *Liberté*; and in such postwar works as *Poésie ininterompue* (1946) and *Poèmes Politiques* (1948).

"Embraceable You" (1930), the song introduced by Ginger ROGERS and Allan Kearns on Broadway in *Girl Crazy* (1930), with music by George GERSHWIN and words by Ira Gershwin. Judy GARLAND sang it in the 1943 film.

Emmys, The, from 1948 the annual television awards of the National Academy of Television Arts and Sciences. Scores of artistic and technical awards are made each year, among them outstanding drama, comedy, and variety series and single-show awards, as well as outstanding lead and supporting actress and actor awards.

Emperor Jones, The (1920), the play by Eugene O'NEILL, about a former Pullman porter who for a little while becomes a Caribbean dictator. The title role was played by Charles S. Gilpin. Paul ROBESON played the role in a notable 1925 stage revival and went on to star in the 1933 Dudley Murphy film.

Empire of the Sun (1987), the Steven SPIELBERG film, adapted by Tom STOPPARD from the J. G. Ballard novel; an epic treatment of the plight of a young British boy separated from his parents and adrift in the wake of the Japanese seizure of Shanghai's International Settlement early in World War II. The cast included Christian Bale, John Malkovich, Nigel Havers, and Miranda Richardson.

Enesco, George (1881–1935), Rumanian composer and violinist, long resident in Paris, much of whose work is based on Rumanian folk themes. He is best known for the two *Rumanian Rhapsodies* (1901), his large body of work also including the opera *Oedipe* (1936) and five symphonies. He was one of the leading violinists of his time, especially noted for his Bach interpretations.

Enfants du Paradis, Les, original French name for the 1945 film CHILDREN OF PARADISE.

Jacob Epstein's head of Paul Robeson, one of the numerous bronze heads he did from the 1920s on.

Enormous Room, The (1922), the e e CUM-MINGS book, a narrative based partly upon his 1917 French imprisonment on false charges of treason while an American ambulance-corps volunteer during World War I.

Ensor, James (1860–1949), Belgian artist, a painter and printmaker whose main work was created in the 19th century. From the early 1880s his work increasingly included the fantasy themes, grotesques, and masks that so notably made him a progenitor of much that later entered 20th-century art through SURREALISM. Masks, as a metaphor for much of the life of his time, figured heavily in such works as his highly controversial *Entry of Christ into Brussels* (1888) and his bitter *Portrait of the Artist Surrounded by Masks* (1899), created on the verge of a century of wars and revolutions.

Entertainer, The (1957), the John OSBORNE play, in which Laurence OLIVIER created the role of Archie Rice, a has-been music-hall performer. Tony RICHARDSON directed the original Royal Court Theatre production, as well as the 1960 film version, with Olivier in the lead, strongly supported by Brenda De Banzie, Joan PLOWRIGHT, Roger LIVESEY, Alan BATES, Albert FINNEY, and Daniel Massey.

Epstein, Jacob (1880–1959), American-British sculptor; he was born and educated in the United States, studied in Paris from 1902 to 1905, emigrated to Britain in 1905, and became a British citizen in 1907. Epstein was one of the leading sculptors of the century, most notably for his bronze portraits of many of the most celebrated people of his time, such as Albert Einstein, George Bernard SHAW, and Winston Churchill. His first major monumental work, completed in 1908, was the highly controversial group of 18 nude statues on what was then the British Medical Association building on the Strand; these were destroyed in 1937. Some of the other very notable sculptures in his large body of work were *Tomb of Oscar Wilde* (Paris, 1912), *Rock Drill* (1915), *Christ* (1919), *Genesis* (1930), *Ecce Homo* (1935), *Adam* (1939), and *Lazarus* (1949).

Equus (1973), the TONY-winning Peter SHAFFER play, a highly symbolic work centered on the relationship between a psychiatrist and one of his patients, a troubled boy obsessed with horses. On Broadway, Anthony Hopkins was the psychiatrist and Peter Firth the boy. Firth recreated his role in the 1977 Sidney LUMET film, with Richard BURTON, in a role he played on Broadway later in the play's run, as the psychiatrist, in a cast that included Joan Plowright, Colin Blakely, Harry ANDREWS, Jenny Agutter, and Eileen Atkins.

Ernst, Max (1891–1976), German painter resident in France from 1922. He was a psychiatry student who became an artist through his interest in the art of the disturbed; his continuing interest in the art of the irrational remained a main theme throughout his life. He became a DADAIST in Cologne after World War I, creating such forerunners of SURREALISM as *The Elephant of the Celebes* (1921) even before joining the surrealist movement in 1924. A year later he developed *frottage*, the surrealist "automatic art" technique of taking random rubbings from objects under the painting or drawing surface. In 1937 he applied the auto-

matic art technique of *décalcomanie* to painting, in which two wet painted sheets of paper are rubbed against each other to create random patterns.

E.T. (1982), the Steven SPIELBERG film, about an extraterrestrial being, the stranded crew member of a spaceship, and the young boy who becomes his protector and friend. The quiet, nonviolent science fiction film was extraordinarily appealing to wide audiences. Its cast includes Henry Thomas, Dee Wallace, Drew Barrymore, Henry MacNaughton, and Peter Coyote. Sound, music, and visual effects all won OSCARS.

Etting, Ruth (1903–78), U.S. singer, a song stylist known as one of the leading "torch" singers of the interwar period. She was in variety in Chicago in the early 1920s, a star in Broadway musicals from the late 1920s, and on radio and on screen from the early 1930s. Doris DAY played Etting on screen in *Love Me or Leave Me* (1955), opposite James CAGNEY as Etting's Chicago mobster manager-husband.

Evans, Edith Mary (1888–1976), British actress, on stage from 1912 and from the early 1920s one of the leading actresses of the English-speaking theater. Her early major roles in *Back to Methuselah* (1923) and *The Way of the World* (1924) established her as a leading player; she went on to play in a wide variety of classical and modern roles, in Europe and America, playing Lady Bracknell in *The Importance of Being Earnest* on stage in 1939 and on film in 1952 and later in her career also appearing in such films as LOOK BACK IN ANGER (1959) and TOM JONES (1963).

Evans, Maurice Herbert (1901–89), British-American actor, on stage from 1926, who played his first major role in JOURNEY'S END (1928). He became a leading Shakespearean player in the mid-1930s, at first with the Old Vic and then in New York, playing Romeo to Katharine CORNELL's Juliet, then worked with producer-director Margaret WEBSTER in several other Shakespearean roles. During World War II he entertained Allied trooops in his *G.I. Hamlet*. During the postwar period he appeared in many Shavian roles on the New York stage, as well as in films and television.

Evans, Walker (1903–75), U.S. photographer, whose best-known work records the lives of poor American country people during the Great Depression of the 1930s. In the early 1930s his photographs were largely of New England architecture; in 1934 these generated the first one-photographer show at the Metropolitan Museum of Art. Evans's Farm Security Administration photos, taken from 1935, were collected in *American Photographs* (1938). In 1940 he and James AGEE published LET US NOW PRAISE FAMOUS MEN, a study of southern sharecroppers that became one of the central documents of the time.

Evergood, Philip (1901–73), U.S. painter; in the 1930s he became a leading painter of social protest, in many instances as a muralist for the FEDERAL ARTS PROJECT. His best-known work, and one of the emblematic works of the period, was *American Tragedy* (1937), on the Little Steel Massacre in Chicago on Memorial Day 1937. His *The New Lazarus* (1954) joined religious and social themes.

Evergreen (1934), the Victor Saville film musical, adapted by Emlyn WILLIAMS from the Benn W. Levy play. The film, extraordinarily popular in Great Britain in its time, launched Jessie MATTHEWS on what became a major career in British musical films and theater.

"Everything's Coming Up Roses" (1959), a song introduced by Ethel MERMAN in the title role of the Broadway musical GYPSY (1959), with music by Jule STYNE and words by Stephen SONDHEIM.

Evita (1979), the long-running TONY-winning Andrew LLOYD WEBBER-Tim Rice musical based on the life of Argentine politician Eva Perón. Patti Lupone created the title role, winning a best actress Tony; Tonys also went to Harold Prince for direction, Rice for the book, Lloyd Webber for the score, Mandy Patinkin for acting, and David Hershey for lighting.

existentialism, a philosophical system developed in the 19th century by Søren Kierkegaard and others, developed further by Karl Jaspers and Martin Heidegger, and expressed most influentially in the mid-20th century by Jean-Paul SARTRE, who posited the original human state of being as essentially nothingness, with

all in each life determined by the will of each living human. Life then becomes a unique confrontation of each with an uncaring universe, and freedom of individual action becomes all. But in practice, Sartre attempted to reconcile Marxism with existentialism, a hopeless prospect. Although Sartre was the chief theoretician of the movement, it was Albert CAMUS who provided the chief impetus for the articulation of existentialism into the arts and literature. Camus rejected Sartre's system-building, relying instead upon his own perception of the human condition vis-à-vis the universe as "absurd," in that death is inevitable, and so—not entirely as he believed or led his life—created much of the underpinning for "absurdism," the THEATER OF THE ABSURD, and similar endgame movements in the arts and literature.

Exorcist, The (1970), the William Peter Blatty novel, about the demonic possession of a child. Blatty won an OSCAR for his adaptation of the novel into the 1973 William FRIEDKIN film, as did Robert Knudson and Chris Newman for the sound. Linda Blair was the child in the film, in a cast that included Ellen BURSTYN, Jason Miller, Max von SYDOW, and Lee J. COBB. There were two sequels, in 1977 and 1980.

expressionism, in the most general sense a term describing a creative focus on the feeling of the artist or writer, rather than on what is perceived as objective reality, that focus being expressed as needed in often distorted, often violently emotional terms. In this widest sense the term has been used in the 20th century to include works produced in many countries, as in some of the works of Eugene O'NEILL, Sean O'CASEY, and W.H. AUDEN, as well as the works of American ABSTRACT EXPRESSIONISTS of the post-World War II period. Still very widely, but somewhat more specifically, Expressionism generally is used to describe the approach of many German-speaking artists and writers of the first quarter of the century, especially from 1910 to 1924. Wassily KANDINSKY, Franz MARC, and many of the other visual artists of DIE BRÜCKE and DER BLAUE REITER are described as Expressionists, as are such composers as Gustav MAHLER, Arnold SCHOENBERG, and Alban BERG, such writers as Franz WERFEL and Ernst TOLLER, and such filmmakers as Fritz LANG and F.W. MURNAU.

F

Fabrizi, Aldo (1905–90), Italian actor and director, by far best known for his role as the anti-fascist priest in Roberto ROSSELLINI's OPEN CITY (1945). His later work was largely in strong character roles.

Façade (1931), a ballet choreographed by Frederick ASHTON, with music by William WALTON. It was first produced in London, in April 1931, by the Camargo Society, with Lydia Lopokova, Alicia MARKOVA, and Frederick Ashton in leading roles. In 1923 the Walton music had been the setting within which Edith SITWELL gave a celebrated reading of her poems.

Face in the Crowd, A (1957), the Elia KAZAN film, written by Budd Schulberg; Andy GRIFFITH was Lonesome Rhodes, the guitar-playing drifter "discovered" by Marcia Jeffries (Patricia NEAL) and developed into a radio and television star, who is ultimately undone by his own arrogance. The cast included Walter MATTHAU, Lee REMICK, Anthony Franciosa, and Kay Medford.

Fadeyev, Alexander Alexandrovich (1901–56), Soviet writer, whose experience as a Russian Civil War Red partisan was reflected in his first popular novel, *The Nineteen* (also known as *The Rout*, 1927). His later work included the four-part *The Last of the Udegs* (1929–40) and *The Young Guard* (1945). He was a leading Soviet literary bureaucrat as president of the Union of Soviet Writers, 1939–53, later committing suicide.

Fahrenheit 451 (1953), the Ray BRADBURY science-fiction novel, set in a book-burning future state in which the "firemen" burn books, television is a prime instrument of state control, and book people become literally that, committing books to memory in bardic fash-

ion. François TRUFFAUT and Jean-Louis Richard adapted the book into Truffaut's 1966 film, his only English-language movie. Oskar Werner was the fireman who ultimately becomes an outlaw book person, in a cast that included Julie CHRISTIE, Cyril Cusack, Anton Diffring, and Bee Duffell.

Fail-Safe (1964), the Sidney LUMET film, made at the height of the Cold War; the powerful, frightening story of how a humanity-destroying nuclear war might happen. Henry FONDA was the American President facing the apocalypse, leading a cast that included Walter MATTHAU, Larry HAGMAN, Dan O'Herlihy, Fritz Weaver, Sorrell Booke, Frank Overton, and Edward Binns. Walter Bernstein adapted the Eugene Burdick–Harvey Wheeler novel.

Fain, Sammy (Samuel Feinberg, 1902–89), U.S. composer, whose songs were performed on Broadway from the mid-1920s and on screen from 1930; much of his work was written with lyricist Irving Kahal. A few of his best-known works are "Secret Love," sung by Doris DAY in the film *Calamity Jane* (1953); "Love Is a Many-Splendored Thing," the title song of the 1955 film; and "I'll Be Seeing You," written for the unsuccessful Broadway musical *Right This Way* (1938).

Fairbanks, Douglas (Douglas Elton Ulman, 1883–1939), U.S. actor, producer, and screenwriter, on stage and in vaudeville from 1900, who entered films in 1915 and quickly became one of the most popular stars of the silent-film era. He was best known for his leads in such action films as *The Mark of Zorro* (1920), *The Three Musketeers* (1921), *The Thief of Baghdad* (1923), and *The Black Pirate* (1926). In 1920 he married Mary PICKFORD; in 1919 he, Pickford, Charlie CHAPLIN, and D.W. GRIFFITH

Frank Lloyd Wright's famed Fallingwater (1937), built on a rock over a waterfall near Bear Run, Pennsylvania.

formed United Artists. His son **Douglas Fairbanks, Jr.** (1909–) also became a film star, in such films as *The Dawn Patrol* (1930), *The Prisoner of Zenda* (1938), and *Sinbad the Sailor* (1947).

Falk, Peter (1927–), U.S. actor; although he had a considerable theater and film career, he is best known by far for his television police detective, the title role in the long-running (1971–78) series "Columbo," revived later in occasional television films and as a series in 1989. In the theater he won a TONY for his creation of the Mel Edison role in *The Prisoner of Second Avenue* (1971). A few of his more notable films were *Murder, Inc.* (1960), *Pocketful of Miracles* (1961), *Husbands* (1970), *A Woman Under the Influence* (1974), *Murder by Death* (1976), and *The In-Laws* (1979).

Falla, Manuel de (1876–1946), Spanish composer, much of whose work reflects the influence of Andalusian folk themes. His best-known works are the ballet *Love the Magician* (1915); the ballet THE THREE-CORNERED HAT (1919), originally choreographed by Leonid MASSINE for the BALLET RUSSES of Sergei

DIAGHILEV, with set by Pablo PICASSO; and the piano concerto *Nights in the Gardens of Spain* (1915). Much of his later career was spent on the unfinished cantata *Atlantida*, later completed by one of his students.

Fallen Idol, The (1949), the Carol REED film, about a young boy who deeply admires a family servant but ultimately perceives that he has murdered his wife; the boy's account gives him away to the police. Ralph RICHARDSON, as the murderer, leads a cast that includes Bobby Henrey as the boy, Michele MORGAN, Denis O'Dea, Sonia Dresdel, Bernard Lee, and Jack HAWKINS. Graham GREENE adapted the screenplay from his own short story "The Basement Room."

Fallingwater (1937), the celebrated home built by architect Frank Lloyd WRIGHT near Bear Run, Pennsylvania, most notable for its concrete floors and cantilevered terraces set in rock over a waterfall.

Fall River Legend, the ballet choreographed by Agnes DE MILLE, with music by Morton Gould. It was first produced in New York, in April 1948, as *The Accused*, by the Ballet Thea-

tre, with Alicia ALONSO in the Lizzie Borden role.

Fancy Free, a ballet choreographed by Jerome ROBBINS, with music by Leonard BERNSTEIN; a pioneering work on American jazz and popular themes. It was first produced in New York, in April 1944, by the Ballet Theatre.

Fanny (1954), the musical play by S.N. BEHRMAN and Joshua LOGAN, with a score by Harold Rome, based on Marcel PAGNOL's MARIUS trilogy. It became the 1961 Joshua LOGAN film drama, with Leslie CARON, Maurice CHEVALIER, and Charles BOYER in the leads and with Rome's theater score used as background.

Fanny and Alexander (1982), the Ingmar BERGMAN film, originally written as a television series; an OSCAR-winning family story set in Sweden early in the century, with a cast that included Erland JOSEPHSON, Harriet Andersson, Jarl Kulle, and Gunn Wallgren. Sven NYKVIST won a cinematography Oscar; other awards were for art, sets, and costumes.

Fantasia (1940), the pioneering animated Walt DISNEY film, which provided cartoon interpretations of nine classical pieces played by Leopold STOKOWSKI and the Philadelphia Orchestra. Although uneven in execution, the concept, sound system developed, and scope of the enterprise made the work a landmark in the history of animated films.

Farewell, My Lovely (1940), the Raymond CHANDLER mystery novel, which was adapted by John Paxton into the 1944 Edward DMYTRYK film MURDER, MY SWEET, with Dick POWELL in the Philip MARLOWE role, leading a cast that included Claire Trevor as Velma, Mike Mazurski, Ann Shirley, and Otto Kruger. The story had also been used in *The Falcon Takes Over* (1942). It was filmed again quite notably in 1975, as *Farewell, My Lovely*, with Robert MITCHUM as Marlowe and Charlotte Rampling as Velma, in a cast that included Sylvia Miles, John Ireland, Anthony Zerbe, and Harry Dean Stanton.

Farewell to Arms, A (1920), the Ernest HEMINGWAY novel, the story of American ambulance corps lieutenant Frederic Henry and British nurse Catherine Barkley. It was the basis of the 1930 Lawrence Stallings play and also of the 1932 Frank BORZAGE film, a rather straightforward love story that starred Gary COOPER and Helen HAYES. It was remade in 1957, again as a love story, and starred Rock HUDSON and Jennifer JONES; Charles Lang won a cinematography OSCAR, as did Harold C. Lewis for sound.

Farnsworth, Richard (1920–), U.S. actor and stuntman; he began his first film career in 1937 and spent almost four decades as a stuntman before his debut in *The Cowboys* (1972). He then became a highly regarded actor, in such films as *Comes a Horseman* (1978); *Resurrection* (1980); THE GREY FOX (1983), in the title role; *The Natural* (1984); and *Into the Night* (1985), also appearing in a television production of *Anne of the Green Gables* (1986).

Far Pavilions, The (1978), the M.M. Kaye novel, set in 19th-century British-ruled India and Afghanistan. It was adapted by Julian Bond into the three-part 1984 television film, with Ben CROSS and Amy Irving leading a cast that included John GIELGUD, Omar SHARIF, Rossano Brazzi, Saeed Jaffrey, Christopher Lee, Robert Hardy, Jennifer Kendal, Felicity Dean, Art Malik, and Jeremy Sinden.

Farrar, Geraldine (1882–1967), U.S. singer and actress; after her 1901 debut in Berlin she appeared in Europe until her 1906 debut at the Metropolitan Opera, then appearing at the Met from 1906 to 1922 in many major soprano roles, as Butterfly, Tosca, and Carmen, among others. On screen she starred in several silent films, most notably in several early Cecil B. DE MILLE films, such as *Carmen* (1915), *Maria Rosa* (1916), and *Joan the Woman* (1917).

Farrell, James Thomas (1904–79), U.S. writer, best known for his Chicago STUDS LONIGAN novels, a trilogy consisting of *Young Lonigan* (1932), *The Young Manhood of Studs Lonigan* (1934), and *Judgment Day* (1935), which established him as a major Depression-era literary figure. His somewhat sexually explicit novels were widely banned in their day, attracting a much wider readership than they might otherwise have enjoyed. A second major work was

the series of five Danny O'Neill novels, beginning with *A World I Never Made* (1936), in which Farrell clearly expressed his Marxist views. A prolific novelist, Farrell also later generated the four Eddie Ryan novels, beginning with *The Silence of History* (1963).

Farrow, Mia (1945–), U.S. actress, on stage and screen from 1963; she played Allison MacKenzie in the television series "Peyton Place," playing the role from 1964 to 1966, and became a film star in ROSEMARY'S BABY (1968). She was seen on stage in London in the mid-1970s, in such plays as *The Three Sisters* (1972) and *Ivanov* (1976). A few of her other notable films were *Zelig* (1983), *Broadway Danny Rose* (1984), *The Purple Rose of Cairo* (1985), HANNAH AND HER SISTERS (1986), *September* (1988), and *Crimes and Misdemeanors* (1989), all directed by her long-time companion Woody ALLEN. She is the daughter of actress Maureen O'Sullivan and director John Farrow.

"Fascinatin' Rhythm" (1924), the JAZZ-based classic song introduced by Fred and Adele ASTAIRE on Broadway in *Lady Be Good* (1924), with music by George GERSHWIN and words by Ira Gershwin.

Fassbinder, Rainer Werner (1946–82), German director, whose work reflects his anti-establishment, leftist-anarchist political commitment. His best-known films include *The Bitter Tears of Petra von Kant* (1972), *Fear Eats the Soul* (1974), *Fox and His Friends* (1975), BERLIN ALEXANDERPLATZ (1979), and *The Marriage of Maria Braun* (1979).

Fast, Howard (1914–), U.S. writer, best known for such historical novels as *The Unvanquished* (1942), *Citizen Tom Paine* (1943), *Freedom Road* (1944), *Spartacus* (1952), and *The Immigrants* (1981). He also published several collections of short stories, plays, biographies, and children's books and wrote detective novels under the pseudonym E.V. Cunningham.

Father Brown, the fictional priest-detective created by G.K. CHESTERTON in *The Innocence of Father Brown* (1911), the first novel in the series.

"Father Knows Best" (1949–63), a prototypical post-World War II radio and television family situation comedy, on radio from 1949 to 1954 and then moving to television for nine more years. Robert YOUNG and Jane Wyatt were Jim and Jane Anderson, parents able to move wholesomely and serenely in the best of all possible worlds.

Faulkner, William (William Harrison Falkner, 1897–1962), U.S. writer, one of the major novelists of the 20th century, who drew on his family and southern regional history to create the imaginary YOKNAPATAWPHA COUNTY setting within which he developed many of his major characters, situations, and insights, beginning with his third work, *Sartoris* (1929). He had earlier published a volume of poems, *The Marble Faun* (1924), and a novel, *Soldier's Pay* (1926). A prolific author, his major works include such novels as THE SOUND AND THE FURY (1929); SANCTUARY (1931) and its sequel, *Requiem for a Nun* (1951); *Light in August* (1932); *Absalom, Absalom!* (1936); *The Wild Palms* (1939); and the SNOPES family novels, consisting of *The Hamlet* (1940), *The Town* (1957), and *The Mansion* (1960). His INTRUDER IN THE DUST (1948) became a 1949 pioneering antiracist film. *The Fable* (1954) won a PULITZER PRIZE, as did *The Reivers* (1962), which also became the 1969 film. Several of his other novels were also adapted into films, most notably THE LONG HOT SUMMER (1958), adapted from *The Hamlet; The Sound and the Fury* (1959); and *Sanctuary* (1961). He also co-authored several screenplays, including TO HAVE AND HAVE NOT (1945) and THE BIG SLEEP (1946). He was awarded the 1950 NOBEL PRIZE for literature.

Fauré, Gabriel Urbain (1845–1924), French composer and teacher; he worked as a church organist and choirmaster from 1866, taught composition at the Paris Conservatory from 1896, and was Conservatory director from 1905 to 1920. His work most notably included several song cycles and collections, *Requiem* (1877), and the opera *Penelope* (1913); he also produced a considerable body of other orchestral, piano, and vocal works and the musical accompaniment to several plays, one of them

Maurice MAETERLINCK's *Pelleas and Melisande* (1898).

Fauvism, a colorist style developed by a group of French painters who exhibited together during the early years of the 20th century and most notably in 1905 and 1906; their work focused on the powerful use of pure color to express the artist's feelings. The most notable of the Fauvists were Henri MATISSE, Maurice de VLAMINCK, and André DERAIN, with such artists as Georges ROUAULT, Georges BRAQUE, and Kees Van Dongen also generally associated with the group. The name comes from *Les Fauves*, French for "the savage beasts."

Faye, Alice (Alice Jean Leppert, 1912–), U.S. actress and singer, on stage from 1926 and a singer with Rudy VALLEE's band from 1931. She entered films as the star of *George White's Scandals* (1934) and went on to become one of the leading musical-film stars of Hollywood's Golden Age, in such films as ALEXANDER'S RAGTIME BAND (1938), in the Fannie BRICE role in *Rose of Washington Square* (1939), and as *Lillian Russell* (1940).

Federal Arts, Theatre, and Writers' Projects (1935–43), U.S. Works Progress Administration (WPA) programs that preserved and developed the artistic skills and production of much of a whole generation of artists, theater people, and writers during the Great Depression. The Arts Project, directed by Holger Cahill, employed approximately 5,000 artists at its peak and 10,000 visual artists in all between 1935 and 1943, including many of the leading artists of the time. The artists produced over 2,500 of the murals for which the project is best known, plus over 100,000 paintings, over 300,000 prints, over 15,000 sculptures, and tens of thousands of other art objects. The Theatre Project, directed by Hallie Flanagan, from 1935 to 1939 employed well over 10,000 theater people in New York and at a network of regional theaters throughout the country, who produced theater and dance works of many kinds, including the innovative Living Newspaper documentaries and the controversial Orson WELLES–John HOUSEMAN MERCURY THEATRE production of Marc BLITZSTEIN's THE CRADLE WILL ROCK. The

Writers' Project, directed by Henry G. Alsberg, employed over 6,000 writers at its peak and produced hundreds of works, most notably including the *American Guide Series*.

Fedin, Konstantin Alexandrovich (1892–1977), Soviet writer, who became a major literary figure with his first novel, *Cities and Years* (1924), based partly on his experience of internment in Germany throughout World War I. His best-known novels also include *The Brothers* (1928); the two-volume *The Rape of Europe* (1933 and 1935); and the trilogy *Early Joys* (1946), *No Ordinary Summer* (1948), and *Bonfire* (1962).

Feiffer, Jules (1929–), U.S. cartoonist and writer, whose cartoons carry much writing. He became a cartoonist for *The Village Voice* in 1956; was widely syndicated from 1959; and published several collections of his cartoons, beginning with *Sick, Sick, Sick* (1959). The most notable of his several plays is *Little Murders* (1967), which he adapted into the 1971 Alan Arkin film; in that year he also wrote the screenplay for CARNAL KNOWLEDGE. His plays also include *Elliott Loves* (1990). His best-known novel is *Harry, the Rat with Women* (1963). In 1986 he was awarded a PULITZER PRIZE for his editorial cartoons.

Feininger, Andreas (1906–), U.S. photographer; the son of American expatriate artist Lyonel FEININGER, he studied in Germany and was graduated in architecture from the BAUHAUS in 1928. He left Germany in 1933, was an architectural photographer in Stockholm until 1939, and then emigrated to the United States, where from 1943 to 1962 he was a staff photographer for *Life* magazine. He became one of the world's leading nature and urban photographers and also wrote several well-received and widely used textbooks on photography, such as *Feininger on Photography* (1949) and *Color Photography* (1954), and published several collections of his own works.

Feininger, Lyonel (1871–1956), U.S. painter, resident in Germany from 1887 to 1936 and thereafter in the United States. A cartoonist early in his career, he moved into painting before World War I, by 1912 working with color and light in a style all his own. He exhib-

ited with THE BLUE RIDER group in 1913 and from 1919 to 1933 was a teacher at the BAUHAUS, continuing to paint in that period and throughout his life. He was the father of photographer Andreas FEININGER.

Felix the Cat, an immensely popular silent-film animated character created by Pat Sullivan in 1914.

Fellini, Federico (1920–), Italian director and screenwriter, a major figure in the history of Italian and world cinema, whose first very notable work was with Roberto ROSSELLINI, as co-screenwriter of OPEN CITY (1945) and PAISAN (1946). He co-directed *Variety Lights* (1950) and then went on to become a major director, with such films as *The White Sheik* (1952), his ACADEMY AWARD-winning LA STRADA (1954), THE NIGHTS OF CABIRIA (1957), LA DOLCE VITA (1960), the autobiographical 8½ (1963), JULIET OF THE SPIRITS (1965), the nostalgic AMARCORD (1974), *Casanova* (1977), *City of Women* (1981), and *Ginger and Fred* (1985). Several of his films, including *Variety Lights*, *La Strada*, *The Nights of Cabiria*, and *Juliet of the Spirits*, starred his wife, Giulietta MASINA.

Fences (1985), the celebrated August WILSON play, set in contemporary Black life; the play was directed by Lloyd Richards. James Earl JONES created the Troy Maxson role, in a cast that included Ray Aranha, Mary Alice, and Charles Brown. Jones won a TONY for the 1986 Broadway production, as did the play, Richards, and Alice.

Ferber, Edna (1887–1968), U.S. writer, several of whose very popular novels proved greatly adaptable to film. Some of her best-known novels of the interwar period were the PULIT-ZER PRIZE-winning *So Big* (1924), several times adapted into films; SHOW BOAT (1926), which became the classic American operetta and the equally classic Hollywood film, revived often in both versions; CIMARRON (1930), which became the OSCAR-winning film and was later revived; *Come and Get It* (1935), which became the 1936 Howard HAWKS–William WYLER film; and *Saratoga Trunk* (1941), which became the 1945 Gary COOPER–Ingrid BERGMAN film. Her later works include

GIANT (1950), the Texas-based story that as a film won George STEVENS a best director OSCAR; and *Ice Palace* (1958), which became the 1960 film. She also co-authored five plays with George S. KAUFMAN, most notably including their satire of the BARRYMORES, *The Royal Family* (1926), which became George CUKOR's 1930 film *The Royal Family of Broadway*; DINNER AT EIGHT (1932), which became Cukor's star-filled 1933 film; and STAGE DOOR (1936), which became the Gregory La Cava 1937 theatrical boardinghouse film, with a cast led by Katharine HEPBURN and Ginger ROGERS.

Ferlinghetti, Lawrence (1920–), U.S. writer and publisher, a leading modern poet who from the mid-1950s was identified with the BEAT movement and whose San Francisco "City Lights" bookshop was a center of that movement. His work includes many volumes of poetry, beginning with *Pictures of a Gone World* (1955), and several works in other forms, including the novel *Her* (1960). He won a celebrated 1950s obscenity case, after having been prosecuted as the publisher of Allen GINSBERG's HOWL AND OTHER POEMS (1956).

Ferrer, José Vicente (1912–), U.S. actor and director, on stage from 1934 and on screen from 1948. His major Broadway roles were in *Charley's Aunt* (1940); as Iago to Paul ROBE-SON's *Othello* (1942); and in the title role of *Cyrano de Bergerac* (1946), for which he won a TONY, as well as a best actor OSCAR when he repeated it on film in 1950. He won another best actor Tony in *The Shrike* (1951). He also appeared as Toulouse-Lautrec in *Moulin Rouge* (1953) and in such films as THE CAINE MUTINY (1954), SHIP OF FOOLS (1965), and *Voyage of the Damned* (1976).

Feuchtwanger, Lion (1884–1958), German writer, a leading novelist and playwright during the interwar period, whose major works include the historical novels *The Ugly Duchess* (1923) and *Jew Süss* (1925), which he dramatized; and a set of anti-fascist novels, which include *Success* (1930), *The Oppermans* (1933), *Paris Gazette* (1940), and *Simone* (1943). He co-dramatized *Simone* as *The Visions of Simon Machard*, with his old friend Bertolt BRECHT,

whom he had encouraged long before and with whom he had collaborated in a German adaptation of Marlowe's *Edward II* as *The Life of Edward II of England* (1924). A Jew, Feuchtwanger was forced to leave Germany when the Nazis came to power, ultimately settling in California, where he continued to produce a considerable range of German-language novels, short stories, and translations.

Feyder, Jacques (Jacques Frederix, 1885–1948), Belgian-French director, whose work was on screen from 1916; he made the notable silent film *Thérèse Raquin* in 1928, then went to Hollywood, where he directed Greta GARBO's *The Kiss* (1929). His best-known sound films are *Carnival in Flanders* (1935), which starred his wife, Françoise Rosay; and KNIGHT WITHOUT ARMOR (1937).

"Fibber McGee and Molly" (1935–57), the very popular radio show starring vaudeville-trained Jim and Marian Jordan, working with a group of stock characters in a series of vignettes that became familiar to millions of listeners. A television version of the show aired in 1959 but lasted only a few months.

Fiddler on the Roof (1964), the long-running TONY-winning Broadway musical based on Sholom ALEICHEM's *Tevye's Daughters* and set in the lost world of the East European Jewish village, or *shtetl*, early in the century; with music by Jerry Bock, lyrics by Sheldon Harnick, and story by Joseph Stein. Zero MOSTEL created the Tevye role on Broadway, for which he won a Tony; (Chaim) Topol was Tevye in the 1971 Norman JEWISON film.

Fiedler, Arthur (1894–1979), U.S. conductor and violinist. He played the violin and then the viola in the Boston Symphony, 1915–30; founded the Boston Sinfonietta in 1924; and from 1930 led the Boston Pops Orchestra, becoming a highly visible presence on the American musical scene and bringing classical music to large national audiences via radio, television, and records.

Field, Sally (1946–), U.S. actress, who became a star in two television series, "Gidget" (1965–66) and "The Flying Nun" (1967–70), and later became a major dramatic actress, winning best actress OSCARS for

NORMA RAE (1979) and *Places in the Heart* (1984). Some of her other notable films are the telefilm *Sybil* (1977) and the movies *Absence of Malice* (1981) and *Steel Magnolias* (1990).

Field of Dreams (1989), the Phil Alden Robinson film, a fantasy set in an Iowa cornfield that has become a baseball diamond inhabited by legends, ghosts, American myths, and dreams. Kevin Costner, as the farmer at the center of the film, led a cast that included Ray Liotta as the ghost of Shoeless Joe Jackson, Amy Madigan, Burt LANCASTER, James Earl JONES, and Gaby Hoffman. Robinson wrote the screenplay, based on the 1982 W.P. Kinsella novel *Shoeless Joe*.

Fields, Gracie (Grace Stansfield, 1898–1979), British singer, comedian, and actress, in music halls from age 12, who became a leading performer in British musical theater and variety during the 1920s. In the late 1920s she also became a recording star and in the 1930s was also an extremely popular radio personality. She sang her signature song, "Sally," in her first film, *Sally in Our Alley* (1931), and made several other well-received film musicals during the hard years of the Great Depression of the 1930s, including *Sing As We Go* (1934) and *Keep Smiling* (1938). Her career was impaired by her World War II flight to the United States in 1940, with her Italian-born husband, who had been declared an alien in Britain. She had some success during her years in the United States, and again in Britain after the war, but not at the same level she had earlier enjoyed.

Fields, Lew (Lewis Maurice Shanfield, 1867–1941), U.S. vaudeville and musical-theater star, in vaudeville with his partner Joe Weber as Weber and Fields, 1877–1904. After the act dissolved he became a producer in musical theater, often playing leads in his own plays.

Fields, W.C. (William Claude Dukenfield, 1879–1946), U.S. juggler, actor, and writer, on stage in vaudeville as a juggler at the age of 14, and soon a leading vaudeville comedian. From 1915 he was a Broadway star in seven successive *Ziegfeld Follies* and in *Poppy* (1921), which he also did as a D.W. GRIFFITH film, *Sally of the Sawdust* (1923). During the sound

era he became a leading film comedian, celebrated for his bitter misanthropy, which extended to every aspect of his artistic and personal life, in such films as *Tillie and Gus* (1933), *Poppy* (1936), *You Can't Cheat an Honest Man* (1939), *My Little Chickadee* (1940), *The Bank Dick* (1940), and *Never Give a Sucker an Even Break* (1941).

film noir, French for "dark film," a realistic filmmaking style of the 1940s and to some extent the 1950s, which stressed the use of harshly contrasting black-and-white scenes, often at night, in such films as THE MALTESE FALCON (1941), CASABLANCA (1942), DOUBLE INDEMNITY (1944), and SUNSET BOULEVARD (1950). The style later powerfully influenced the filmmaking style of the French NEW WAVE directors. Much of the resistance to colorization of black-and-white films stems from the violence done to original artistic intent when color is later added to movies done in the *film noir* style.

Finch, Peter (William Mitchell, 1916–77), Australian actor, on stage from 1935 and on screen from 1936. He became a star from the mid-1950s, in such films as A TOWN LIKE ALICE (1956); *The Nun's Story* (1959); *The Trials of Oscar Wilde* (1960); *Far from the Madding Crowd* (1967); SUNDAY, BLOODY SUNDAY (1971); LOST HORIZON (1973); and NETWORK (1976), for which he won a posthumous best actor OSCAR.

Fine Madness, A (1966), the Irvin Kershner film, with Sean CONNERY as Samson Shillito, the impoverished New York poet at the center of the work, in a cast that included Joanne WOODWARD, Colleen DEWHURST, Jean Seberg, and Patrick O'Neill. Elliott Baker wrote the screenplay, adapted from his novel.

Finlandia (1899), the orchestral work by Jean SIBELIUS, much of it based on Finnish folk themes, which established him fully as the preeminent Finnish national composer.

Finney, Albert (1936–), British actor, on stage from 1956, until 1958 at the Birmingham Repertory Theatre, and then in the long succession of major classical and modern roles that established him as a leading stage player, in the tradition of Laurence OLIVIER, John

GIELGUD, and Ralph RICHARDSON. A few of these were the title roles in BILLY LIAR (1960) and *Luther* (1961) and his notable lead in the 1978 *Macbeth* at the National Theatre. He has been on screen from 1959, becoming a major film star as TOM JONES (1963) and also playing leads in such films as CHARLIE BUBBLES (1968), *The Dresser* (1983), and UNDER THE VOLCANO (1984).

Fiorello (1959), the long-running Broadway musical, based on the life of New York's celebrated mayor Fiorello LaGuardia; Tom Bosley was LaGuardia, opposite Ellen Haney and Patricia Wilson. Jerry Bock wrote the music, Sheldon Harnick the lyrics, and Jerome Weidman and George ABBOTT the book.

Firebird, the Igor STRAVINSKY ballet, based on a Russian folk tale; it was choreographed by Michel FOKINE and first produced in Paris, in June 1910, by Sergei DIAGHILEV's BALLET RUSSES company, with Tamara KARSAVINA in the title role, opposite Fokine.

Fire Over England (1937), the story of the destruction of the Spanish Armada, as told in the William K. Howard film, with Flora ROBSON as Elizabeth, in a cast that included Laurence OLIVIER, Vivien LEIGH, Raymond MASSEY, Leslie Banks, Robert Newton, and James MASON. Clemance Dane and Sergei Nolbandov adapted the A.E.W. Mason novel.

Fischer-Dieskau, Dietrich (1925–), German baritone, one of the most notable *lieder* singers of the 20th century; he made his concert debut in 1947 and after his 1948 operatic debut appeared in leading roles throughout Europe.

Fisher, Bud (Harry Conway Fisher, 1884–1954), U.S. cartoonist, who in 1907 created the cartoon character "Mutt" and in 1908 further developed the idea into what became the enormously popular comic strip MUTT AND JEFF.

Fisher, Eddie (1928–), U.S. singer, a popular star in the 1950s, best known for such songs as "I'm Walking Behind You" (1953) and "I Need You Now" (1954); a much-publicized marital tangle in which he left Debbie REYNOLDS for Elizabeth TAYLOR considera-

bly impeded his career. He is the father of actress Carrie Fisher.

Fitzgerald, Barry (William Joseph Shields, 1888–1961), Irish actor, on stage at Dublin's ABBEY THEATRE from 1914 and thereafter in supporting roles until he created the Captain Boyle role in Sean O'CASEY's JUNO AND THE PAYCOCK (1924). He then became a leading player in Ireland and England, beginning his screen career in the Alfred HITCHCOCK film version of *Juno and the Paycock* in 1930. He went to Hollywood in 1936 to play in John FORD's version of O'Casey's THE PLOUGH AND THE STARS (1936) and stayed to become a leading supporting actor in American films. He won a best supporting actor OSCAR as Father Fitzgibbon in GOING MY WAY (1944) and did highly regarded work in such films as THE LONG VOYAGE HOME (1940), HOW GREEN WAS MY VALLEY (1941), *None But the Lonely Heart* (1944), THE NAKED CITY (1948), *Union Station* (1950), and *The Quiet Man* (1952). He was the brother of actor Arthur Shields, long with the Abbey Theatre (1914–37) and in film character roles thereafter.

Fitzgerald, Ella (1918–), U.S. singer, with Chick Webb's band from 1934 until his death in 1939; she then led the band until 1942. She became enormously popular with her recording of "A Tisket, a Tasket" (1938), with words and music by Fitzgerald and Al Feldman. She was a leading jazz and popular figure and recording star for the next five decades, perhaps most notably during the late 1950s and early 1960s, in her recordings of GERSHWIN songs and records with Louis ARMSTRONG and with Duke ELLINGTON. She won several GRAMMY Awards, notably for *Ella Fitzgerald Sings The Irving Berlin Songbook* (1958), *But Not for Me* (1959), *Mack the Knife* (1960), and *Ella Sings Brightly with Nelson Riddle* (1962).

Fitzgerald, F. Scott (Francis Scott Key Fitzgerald, 1896–1940), U.S. writer, whose novels and dissipated life-style became emblematic of the early post-World War I period and of the malaise experienced and often courted by many of the cultural figures of the time. He became an instant celebrity with his first novel, *This Side of Paradise* (1920), which was followed by a substantial number of short sto-

ries of varying quality, many of them written as potboilers, and by his second novel, *The Beautiful and the Damned*. His major work was THE GREAT GATSBY (1925), which was filmed three times; his sole substantial work after that was *Tender Is the Night* (1934), which became the 1962 film. His unfinished novel *The Last Tycoon* (1941) was adapted by Harold PINTER into the 1976 Elia KAZAN film. His first wife, Zelda Sayre Fitzgerald (1899–1948), suffered disabling nervous breakdowns from 1930. Seriously hampered by his own emotional and alcoholism problems, Fitzgerald was unable to function very effectively as a writer after the early 1930s, although he did co-author several screenplays, including THREE COMRADES (1938). During his Hollywood period he developed a long liaison with columnist Sheila Graham, who memorialized the relationship in her memoir, *Beloved Infidel* (1951), which was adapted into the 1959 film, with Gregory PECK playing Fitzgerald.

Fitzgerald, Geraldine (1914–), Irish actress, on stage from 1932 at the Gate Theatre, Dublin; on screen in Britain from 1934; and on Broadway from 1938, in the MERCURY THEATRE production of *Heartbreak House*. On screen she generally played strong supporting roles, as in WUTHERING HEIGHTS (1943), WATCH ON THE RHINE (1943), *Wilson* (1944), *Ten North Frederick* (1958), and RACHEL, RACHEL (1969).

Fitzpatrick, Daniel Robert (1891–1969), U.S. cartoonist; he began as a cartoonist for the *Chicago Daily News* in 1911. In 1913, at the age of 21, he became chief editorial cartoonist for the *St. Louis Post-Dispatch*, and there he became a leading American political cartoonist, for almost half a century taking up the main reform causes of his time and exerting tremendous influence on further generations of cartoonists and journalists. He was succeeded in 1958 by Bill MAULDIN.

Five Easy Pieces (1970), the Bob Rafelson film, about a fine young classical musician who had pursued the musical career ordained by his family background and then given it all up for unskilled oilfield work, then returns home for a visit, with the brassy, uneducated woman with whom he has been living. He gains self-

awareness in the process, and at film's end he presumably is about to move on. Jack NICHOLSON played the musician, in a cast that included Karen Black, Susan Anspach, Billy Green Bush, Ralph Waite, Fannie Flagg, Sally Struthers, and Helena Kallioniotes.

Flagg, James Montgomery (1877–1960), U.S. cartoonist and illustrator; from the mid-1890s he was a leading American magazine illustrator, especially popular for his drawing of society women in the "Gibson girl" style that was fashionable at the time. He also did comics, most notably "Nervy Nat," and a considerable variety of other magazine art for such leading magazines as *Life* and *Judge*. Later in his career, his quickly drawn celebrity sketches were also very popular. Perhaps his best-known work was the World War I recruiting poster UNCLE SAM WANTS YOU!, used again in World War II.

Flagstad, Kirsten (1895–1962), Norwegian soprano, who made her Oslo debut in 1913, sang in Europe until 1935, and appeared at the Metropolitan Opera from 1935 to 1941, in that period emerging as the leading Wagnerian soprano of her time. She spent World War II in Norway with her husband, a Nazi sympathizer, and therefore found it difficult to resume her career after the war. She sang again in Europe from 1947 and in the United States from 1949, retiring in 1953, though continuing to record and appear in concert.

Flaherty, Robert J. (1884–1951), pioneer U.S. documentary filmmaker, whose NANOOK OF THE NORTH (1922) was a major influence on the development of nonfiction film. On Aran, an island off the Irish Atlantic coast, he created the equally celebrated MAN OF ARAN (1934).

Flash Gordon, the comic-strip science-fiction hero, created by Alex RAYMOND in 1934; Flash, Dale, and Dr. Zharkov then appeared in comic books, a radio serial, several film serials, feature films from the mid-1930s to the early 1940s, and the Mike Hodges 1980 film.

Flatiron Building (1905), the celebrated photo of the New York building by Edward STEICHEN; it became a landmark in the history of photography.

Flatt and Scruggs (Lester Raymond Flatt, 1914–79; and Earl Scruggs, 1924–), U.S. bluegrass musicians. Flatt was a singer and guitarist; Scruggs, a very notable five-string banjoist working in three-finger style. They initiated the Foggy Mountain Boys in 1948 and from then until the late 1960s were popular figures in bluegrass and country music, best known for their renditions of such songs as "Foggy Mountain Breakdown" (1948) and "Ballad of Jed Clampett" (1962), the theme song of television's "The Beverly Hillbillies" and a country and popular hit.

Fleetwood Mac (1967–), British BLUES and then ROCK band; its original members were Mick Fleetwood (1942–), John McVie (1945–), Peter Green (1946–), and Jeremy Spencer (1948–). The group quickly moved through its early blues period, as expressed in the albums *Fleetwood Mac* and *Mr. Wonderful*, both done in 1968, to such very popular later albums as GRAMMY-winner *Rumours* (1976) and *Mirage* (1982).

Fleming, Ian (1908–64), British author, best known for his James BOND Cold War espionage novels, many of which became highly popular films starring Sean CONNERY in the James Bond role, including *Dr. No* (1963), *From Russia, with Love* (1964), *Goldfinger* (1965), *Thunderball* (1965), *You Only Live Twice* (1967), *Diamonds Are Forever* (1971), and *Never Say Never Again* (1983). Other James Bond films starred Roger Moore and others in the role.

Fleming, Victor (1883–1949), U.S. director, a cameraman from 1910 and a director from 1919, often of action films. In 1939 he directed two classic films, THE WIZARD OF OZ and GONE WITH THE WIND, winning a best director OSCAR for the latter. He also directed DR. JEKYLL AND MR. HYDE (1941), TORTILLA FLAT (1942), and *A Guy Named Joe* (1943).

Flesh and the Devil (1927), the film in which Greta GARBO emerged as a major popular screen star. Based on the Hermann Sudermann novel *The Undying Past*, it is the story of two lifelong friends, played by John GILBERT and Lars Hanson, who quarrel over a woman,

Felicitas, played by Garbo. It was the first of four Garbo–Gilbert films.

Flynn, Errol (1909–59), Australian actor, on screen in Australia from 1933 and in Hollywood from 1935. He became an action-film star that year, as *Captain Blood* (1935), and went on to star in such films as *The Charge of the Light Brigade* (1936), *Robin Hood* (1938), *Dodge City* (1939), *The Sea Hawk* (1940), and *They Died with Their Boots on* (1942). From the late 1940s his career was increasingly damaged by his addictive life-style.

Fokine, Michel (1880–1942), Russian dancer and choreographer, a member of Petrograd's Maryinsky Theatre company from 1898 and its chief soloist from 1904, who moved into choreography in 1905 and very memorably created *The Dying Swan* for Anna PAVLOVA in 1907. In 1909 he went to Paris with Sergei DIAGHILEV, as the first choreographer of the BALLET RUSSES troupe, and in the next several years became the central choreographer in the development of the 20th-century ballet, creating such powerful, innovatively presented works as SCHEHERAZADE (1910), FIREBIRD (1910), LE SPECTRE DE LA ROSE (1911), PETRUSHKA (1911), and DAPHNIS AND CHLOÉ (1912). His relationship with Diaghilev was uneven and came to an end with the outbreak of World War I, when Fokine returned to Petrograd. He left the Soviet Union in 1918, later settling in the United States, while continuing to reprise his early great works and to create dozens of new ballets, although his later works were far less notable than those of his Ballet Russes years. His last work was BLUE-BEARD (1941).

Fonda, Henry (1905–82), U.S. actor, on stage from 1925 and a member of the University Players from 1929 to 1932. His first lead on Broadway was in *The Farmer Takes a Wife* (1934). In 1935 he re-created the role on film, going on to become one of the major stars of Hollywood's Golden Age and long beyond, in such films as *The Trail of the Lonesome Pine* (1936); *Young Mr. Lincoln* (1939); THE GRAPES OF WRATH (1940); MY DARLING CLEMENTINE (1946); MISTER ROBERTS (1955); TWELVE ANGRY MEN (1957); FAIL-

SAFE (1964); and finally ON GOLDEN POND (1981), for which he won a very long overdue best actor OSCAR. Starting in the late 1940s he often went back to the theater, in such plays as *Mister Roberts* (1948), for which he won a best actor TONY; THE CAINE MUTINY COURT-MARTIAL (1954); and *First Monday in October* (1978). He was the father of actress Jane FONDA and actor Peter Fonda.

Fonda, Jane (1937–), U.S. actress, on stage and screen from 1960, who after starring in such imaginative light films as CAT BALLOU (1965) and *Barbarella* (1968), the latter directed by Roger VADIM, then her husband, emerged as one of the leading international film stars of the modern period, in such films as THEY SHOOT HORSES, DON'T THEY? (1969), KLUTE (1971), JULIA (1977), COMING HOME (1978), THE CHINA SYNDROME (1979), AGNES OF GOD (1985), *Old Gringo* (1989), and *Stanley and Iris* (1990). She won best actress OSCARS for *Klute* and *Coming Home*. She is the daughter of Henry FONDA and the sister of Peter Fonda. She was also a leading opponent of the Vietnam War, touring with an antiwar theater company and making two antiwar films, *Free the Army* (1972) and *Introduction to the Enemy* (1974).

Fontaine, Joan (Joan De Havilland, 1917–), U.S. actress, the sister of OLIVIA DE HAVILLAND. On stage and screen in the 1930s, she emerged as a major film star opposite Laurence OLIVIER in REBECCA (1940) and followed it with *Suspicion* (1941), for which she won a best actress OSCAR; *This Above All* (1942); *The Constant Nymph* (1943); and the title role in JANE EYRE (1944), opposite Orson WELLES. She continued to play leads in the 1940s and into the 1950s.

Fontanne, Lynn (Lillie Louise Fontanne, 1887–1983), British-American actress, on stage from 1905 and in leading roles from 1921. In 1924 she and her husband, Alfred LUNT, co-starred on Broadway in *The Guardsmen*. Although she appeared during the 1920s in several plays that did not include her husband, their main work thereafter was together; as LUNT AND FONTANNE they became major figures in the English-speaking theater.

Fonteyn, Margot (Peggy Hookam, 1919–), British dancer, who joined the Vic-Wells company in 1934 and moved into leading roles in 1935, when Alicia MARKOVA left the company. Fonteyn became by far the most celebrated of British ballerinas, in long association with Frederick ASHTON and the company, which ultimately became the ROYAL BALLET. She originated leading roles in many Ashton ballets, such as *Le Baiser de la Fée* (1935), *Apparitions* (1936), *Symphonic Variations* (1946), and *Ondine* (1958), also creating roles in the works of several other choreographers, including John CRANKO and Rudolph NUREYEV. The latter provided a very notable stage partnership during the 1960s.

Forces' Sweetheart, The, popular World War II nickname for singer Vera LYNN.

Ford, Ford Madox (Ford Madox Hueffer, 1873–1939), British writer, editor, and critic, best known for his *The Good Soldier* (1915) and four post-World War I novels collectively titled PARADE'S END, consisting of *Some Do Not* (1924), *No More Parades* (1925), *A Man Could Stand Up* (1926), and *The Last Post* (1928). He also wrote several rather apocryphal biographical and autobiographical works, an early book of poetry, and critical works; edited *The English Review* (1908–10); and was a founder and editor of *Transatlantic Review* (1924–25). He and Joseph CONRAD co-authored the novels *The Inheritors* (1901) and *Romance* (1903).

Ford, Glenn (Gwyllyn Samuel Newton Ford, 1916–), U.S. actor, on screen from 1939, who played in such films as SO ENDS OUR NIGHT (1941) and *The Adventures of Martin Eden* (1942), before moving into leads in such films as *Gilda* (1946), *A Stolen Life* (1946), THE BLACKBOARD JUNGLE (1955), and *The Teahouse of the August Moon* (1956).

Ford, Harrison (1942–), U.S. actor, who suddenly emerged as a major international film star as Han Solo in STAR WARS (1977) and went on to star in such films as *The Empire Strikes Back* (1980), RAIDERS OF THE LOST ARK (1981), *Return of the Jedi* (1983), *Indiana Jones and the Temple of Doom* (1986), *The Mosquito Coast* (1986), *Working Girl* (1988), *Frantic*

(1988), *Indiana Jones and the Last Crusade* (1989), and *Presumed Innocent* (1990).

Ford, John (Sean Aloysius O'Feeney, 1895–1973), U.S. film director, a leading figure in 20th-century cinema, who went to Hollywood in 1913, there working as an assistant director and sometimes actor in the films of his brother Francis Ford. He began directing his own films in 1917, becoming a prolific creator of silent films, most of them Westerns. During the 1930s he became one of the major directors of Hollywood's Golden Age and during the following three decades created such American film classics as ARROWSMITH (1932), THE INFORMER (1935), STAGECOACH (1939), THE GRAPES OF WRATH (1940), THE LONG VOYAGE HOME (1940), HOW GREEN WAS MY VALLEY (1941), MY DARLING CLEMENTINE (1946), FORT APACHE (1948), SHE WORE A YELLOW RIBBON (1949), THE QUIET MAN (1952), THE LAST HURRAH (1958), and CHEYENNE AUTUMN (1964). He won six best director OSCARS for *The Informer*, *The Grapes of Wrath*, *How Green Was My Valley*, the wartime documentaries *The Battle of Midway* (1942) and *December 7* (1943), and *The Quiet Man*.

Ford, Tennessee Ernie (Ernest Jennings Ford, 1919–), U.S. country singer, who became one of the most popular singers and television personalities of the late 1940s and 1950s, with such songs as "Mule Train" (1949); "Ballad of Davy Crockett" (1955); and "Sixteen Tons" (1956), with which he became identified. From the mid-1950s he was a leading gospel singer. He starred in three of his own television shows (1955–57; 1956–61; and 1962–65).

Forman, Milos (1932–), Czech director, working in Czechoslovakia from 1963, whose films there included *Black Peter* (1964) and *The Fireman's Ball* (1967). He went into exile in the West after the 1968 Soviet invasion of his country. Some of Forman's most notable American films are *Taking Off* (1971), ONE FLEW OVER THE CUCKOO'S NEST (1975), for which he won a best director OSCAR; HAIR (1979); RAGTIME (1981); AMADEUS (1983), which won him a second best director Oscar; and *Valmont* (1989).

Forster, E.M. (Edward Morgan Forster, 1879–1970), British writer and critic, whose novels, short stories, and essays made him a major figure in the development of 20th-century culture. His first four novels were *Where Angels Fear to Tread* (1905), *The Longest Journey* (1907), his celebrated A ROOM WITH A VIEW (1908), and his thoughtful *Howard's End* (1910). His fifth novel, *Maurice*, written in 1913–14, was on homosexual themes and was published posthumously, in 1972. His sixth novel was his best known: A PASSAGE TO INDIA (1924). His critical work includes the notably influential *Aspects of the Novel* (1927), and his essays include the equally influential collections *Abinger Harvest* (1936) and *Two Cheers for Democracy* (1951). He was a leading participant in the BLOOMSBURY GROUP, though no more classifiable by that than the other "members" of that group of sympathetic friends. During the mid-1980s three of his novels became films: the David LEAN *A Passage to India* (1984), the Ismael Merchant–James IVORY *A Room with a View* (1985), and *Maurice (1987).*

Forsyte Saga, The (1906–21), the John GALSWORTHY trilogy, and more widely the whole series of novels following the lives of the Forsyte family for almost five decades, from the late Victorian period through the mid-1920s. In 1967 the trilogy was adapted into a notable 26-part BBC television series, with Kenneth MORE, Eric Porter, Nyree Dawn Porter, and Susan HAMPSHIRE in leading roles.

Fort Apache (1948), the first film in John FORD's CAVALRY TRILOGY.

Forty-five Minutes from Broadway (1906), the George M. COHAN Broadway play, which introduced such songs as MARY'S A GRAND OLD NAME, "So Long, Mary," and the title song. Fay Templeton and Victor Moore starred.

42nd Street (1933), the classic film musical, directed by Lloyd Bacon and featuring the trendsetting Busby BERKELEY dance extravaganzas that were to be identified with Hollywood in a world grievously beset by the Great Depression, the onset of fascism and genocide, and the prospect of a second world war.

Warner Baxter played the director in this show-business story, which also featured Ruby Keeler; Bebe Daniels; George BRENT; a very young Ginger ROGERS; and an equally young Dick POWELL, in a singing lead. The film featured such songs as "42nd Street," "About a Quarter to Nine," "Lullaby of Broadway," and "Shuffle Off to Buffalo." In 1980 the film was very lightly adapted by Michael Stewart and Mark Bramble into the long-running Broadway musical, with Jerry Orbach in the Baxter role, Wanda Richert in the Keeler role, and Tammy Grimes in the Daniels role.

For Whom the Bell Tolls (1940), the Ernest HEMINGWAY Spanish Civil War novel. Dudley Nichols adapted it into the 1943 Sam Wood film, with a cast that included Gary COOPER, as the American fighting with Republicans; Ingrid BERGMAN; Akim Tamiroff; Joseph Calleia; Arturo de Cordova; and Katina PAXINOU, who won a best supporting actress OSCAR.

Fosse, Bob (1927–87), U.S. dancer, choreographer, actor, and director. A dancer in cabaret, theater, and films in the late 1940s and early 1950s, he moved into choreography with THE PAJAMA GAME (1954), also choreographing the 1957 film, and with DAMN YANKEES (1955), which he choreographed on film in 1958. He directed, as well, with *Redhead* (1959) and a succession of hit shows that included *How to Succeed in Business Without Really Trying* (1961) and SWEET CHARITY (1966); he directed the latter on film in 1969. He won a best director Oscar for CABARET (1972), directed *Lenny* (1974), and directed and choreographed the semi-autobiographical ALL THAT JAZZ (1979).

Foster, Jodie (1962–), U.S. actress, who as a child played major roles in such films as ALICE DOESN'T LIVE HERE ANYMORE (1974) and TAXI DRIVER (1976), successfully made the transition to adult roles, and emerged as a powerful dramatic actress in her OSCAR-winning lead as the rape victim in *The Accused* (1988).

Four Feathers, The (1902), the A.E.W. Mason novel, set during the reconquest of the Sudan by British-Egyptian forces in the late 1890s; a romance about an English officer accused of

cowardice, who ultimately redeems himself. The novel was adapted for the screen several times, by far most notably by R.C. SHERRIFF in the 1939 Zoltan Korda film, which starred John CLEMENTS and Ralph RICHARDSON, in a cast that included C. Aubrey Smith, June Duprez, Clive Baxter, Jack Allen, John Laurie, and Donald Gray.

Four Horsemen of the Apocalypse, The (1916), the Vicente BLASCO IBAÑEZ novel about the fate of the French-German-Argentinian Madariaga family during World War I. It became the 1921 Rex Ingram epic, with Rudolph VALENTINO in his first starring role, and was redone in 1961 by Vincente MINNELLI in a less successful version, with a cast led by Glenn FORD and Charles BOYER.

400 Blows, The (1959), François TRUFFAUT's first feature film, an autobiographical work about his impoverished and troubled childhood and adolescence. The film was a key work in the development of the French NEW WAVE. Jean-Pierre Leaud played the young Truffaut.

Fowles, John (1926–), British writer, whose work in the main consists of such highly textured, complex novels as *The Collector* (1963), *The Magus* (1965), and *The Ebony Tower* (1974). His *The French Lieutenant's Woman* (1969) was adapted by Harold PINTER into the 1981 Karel Reisz film, with Meryl STREEP and Jeremy Irons in the leading roles.

Fox, Fontaine Talbot (1884–1964), U.S. cartoonist, who in 1908 created the long-running comic strip "Toonerville Trolley"; the widely syndicated strip ran almost five decades, until his retirement in 1955.

Foy, Eddie (Edwin Fitzgerald, 1854–1928), U.S. vaudeville and theater comedian, on stage from 1869. From 1910 his act was Eddie Foy and the Seven Little Foys; one of his seven children was Eddie Foy, Jr., who became a popular stage and screen player. On December 30, 1903, Eddie Foy was doing a matinee in *Mr. Bluebeard* at Chicago's Iroquois Theatre when a backstage fire broke out. He tried but was unable to calm the matinee audience; 602 died in the heavy smoke and panic that followed.

Frame, Janet (1924–), New Zealand writer, whose psychologically oriented novels, beginning with *Owls Do Cry* (1957), probe for anticipated madness under the quiet surfaces of everyday life. Her work includes *Faces in the Water* (1961), *The Edge of the Alphabet* (1962), *Scented Gardens for the Blind* (1963), *The Adaptable Man* (1965), *A State of Siege* (1967), *Yellow Flowers in the Antipodean Room* (1968), *Intensive Care* (1971), *Daughter Buffalo* (1972), and *Living in the Maniototo* (1979). She has also written short stories and poetry.

Frankenheimer, John (1930–), U.S. director, whose work was on screen in television often in the 1950s; he was one of the key directors of the series "Danger" (1954–55) and the leading director of PLAYHOUSE 90 (1956–61). His most notable films include BIRDMAN OF ALCATRAZ (1962), *The Manchurian Candidate* (1962), SEVEN DAYS IN MAY (1962), THE ICEMAN COMETH (1973), *The French Connection II* (1975), *The Holcroft Covenant* (1985), and *Dead-Bang* (1989).

Frankenstein (1931), the most notable of the many films based on or related to the classic Mary Wollstonecraft Shelley novel. The film, directed by James WHALE, featured Boris KARLOFF as the monster, with Colin Clive as Frankenstein, the scientist who created him.

Frankenthaler, Helen (1928–), U.S. artist, a leading ABSTRACT EXPRESSIONIST from 1951. Such early works as *Mountains and Sea* (1952) and *Open Wall* were notable for their use of color, stemming in considerable part from her treatment of raw canvas with her own paint-soaking and staining technique.

Frankie and Johnny, a ballet choreographed by Ruth Page and Bentley Stone, with music by Jerome Moross; the story of the old JAZZ song in dance, and a trendsetting work on American jazz and folk themes. It was first produced at Chicago, in June 1938, by the Page-Stone Ballet.

Franklin, Aretha (1942–), U.S. singer. She began as a gospel singer, with her sisters, in her father's Detroit church; in the early 1960s emerged as a rhythm-and-blues figure; and in 1967 became the leading soul singer of her generation, with such hits as "I Never

Loved a Man—the Way I Love You," "Respect," and "Baby, I Love You." She quickly became known as "The Queen of Soul" and was an inspirational figure in those days of an emerging, triumphant civil-rights movement. She continued to be enormously popular through the early 1970s, also returning to her gospel roots with her celebrated performance of "Amazing Grace" in 1972.

Freeman, Morgan (1938–), U.S. actor, who emerged from a long and varied career in the theater to become a leading film player in the late 1980s. He created the Hoke Colburn role in DRIVING MISS DAISY off-Broadway in 1987 and re-created it in the 1989 film; created the Joe Clark role in *Lean on Me* (1989), and played a leading role in GLORY (1989). He also appeared in such films as *Street Smart* (1987) and *Clean and Sober* (1988).

French, Daniel Chester (1850–1931), U.S. sculptor, whose first commission also was one of the two best known of his scores of major works. It was *The Minute Man*, commissioned in 1873 and unveiled in 1875 by Ralph Waldo Emerson at Concord's Old North Bridge, the birthplace of the American Revolution. The other was unveiled in 1922, almost half a century later: It was his statue *Abraham Lincoln* at the Lincoln Memorial, which quickly became one of the most celebrated historical emblems of the American nation.

French Connection, The (1971), the William FRIEDKIN film, a detective thriller about the drug trade, in a New York setting. Gene HACKMAN was police detective Popeye Doyle, in a cast that included Roy SCHEIDER, Fernando Rey, Tony LoBianco, and Marcel Bozzuffi. The film, Friedkin, Hackman as best actor, screenwriter Ernest Tidyman, and editor Jerry Greenberg all won OSCARS. A sequel, *The French Connection II* (1975), took the action to France.

Frick, Henry Clay (1849–1919), U.S. steel magnate and art collector. On his death the Frick art collection and home became New York's Frick Museum.

Friedkin, William (1939–), U.S. director, who began his career in television and who moved into films in the late 1960s. His most notable films include *The Birthday Party* (1968); *The Boys in the Band* (1970); THE FRENCH CONNECTION (1971), for which he won a best director OSCAR; THE EXORCIST (1973); and *To Live and Die in L.A.* (1985).

Friel, Brian (1929–), Irish writer, best known for such plays as *Philadelphia, Here I Come!* (1964), his story of an emigrant on the eve of his parting with the old country; *Translations* (1981), his account of an attack on the old Gaelic culture by the conquering English; *Making History* (1988); and *Dancing at Lughnosa* (1990).

Friendly Persuasion, The (1945), the Jessamyn West novel, set in Indiana, about a Quaker farm family caught in the midst of the Civil War. It was adapted by Michael Wilson into the 1956 William WYLER film, with Gary COOPER heading a cast that included Dorothy McGuire, Anthony PERKINS, Phyllis Love, Marjorie Main, Richard Eyer, and Robert Middleton.

Friml, Rudolph (1879–1972), Czech-American composer and musician, best known for such popular 1920s operettas as *Rose Marie* (1924), *The Vagabond King* (1925), and *The Three Musketeers* (1928).

From Here to Eternity (1951), the James JONES novel, about U.S. Army life in Hawaii on the eve of Pearl Harbor. It was adapted by Frank Taradash into the 1953 Fred ZINNEMANN film, with Burt LANCASTER and Deborah KERR in the leads, in a cast that included Montgomery CLIFT, Frank SINATRA, Donna REED, and Ernest Borgnine. The film, Zinnemann, Taradash, Frank Sinatra as best supporting actor, Donna Reed as best supporting actress, cinematographer Burnett Guffey, and editor William Lyon all won OSCARS.

Front Page, The (1928), the play by Ben HECHT and Charles MACARTHUR, about fast-talking reporters covering a scheduled execution in Chicago. Lee Tracy created the Hildy Johnson role on Broadway; Osgood Perkins was Walter Burns, his editor. Pat O'Brien and Adolf Menjou played the roles in the 1931 Lewis MILESTONE film. The often-revived play has also been on screen several times,

most notably as *His Girl Friday* (1940), the Howard HAWKS version, starring Cary GRANT as the editor, Rosalind RUSSELL as Hildy Johnson, and Ralph BELLAMY; and as Billy WILDER's 1974 *The Front Page*, starring Jack LEMMON and Walter MATTHAU.

Frost, Robert Lee (1874–1963), U.S. writer, the quintessential New England poet of the century, whose second book, *North of Boston* (1914), established him as a leading American poet. It contained some of his best-known and most characteristic works, such as "Mending Wall," "The Death of the Hired Man," and "Home Burial." He followed it with four more collections in the next 14 years and in 1930 with his PULITZER PRIZE-winning *Collected Poems*. "Stopping By Woods on a Snowy Evening" was in his Pulitzer Prize-winning *New Hampshire* (1923). In all he won four Pulitzers, and toward the end of his long career he became a revered national figure.

Fry, Christopher (Christopher Harris, 1907–), British writer, who emerged as a major modern verse dramatist with *The Lady's Not for Burning* (1948), *Venus Observed* (1950), and *The Dark Is Light Enough* (1954). Later in his career, he turned more toward translations and work in films and television.

Fry, Roger Eliot (1866–1934) British art critic and painter. From 1906, he was the leading British proponent of the work of Paul Cézanne and the other leading modernist French painters of the period, whom he dubbed "Post-Impressionists," sponsoring centrally important exhibitions of their work in London in 1910 and 1912, at which were shown the works of such artists as Cézanne, Vincent Van Gogh, Paul Gauguin, Henri MATISSE, Pablo PICASSO, Georges ROUALT, and Maurice de VLAMINCK. His essays and biographies include *Vision and Design* (1920), *Transformations* (1926), *Cézanne* (1926), and *Last Lectures* (1939).

Fuentes, Carlos (1928–), Mexican writer and diplomat, a leading figure in modern Latin American literature and on the political left, whose best-known novels include *Where the Air Is Clear* (1958), a sharply critical portrayal of the upper-class Mexican society from which he

came; *The Death of Artemio Cruz* (1962); *A Change of Skin* (1967); *Terra Nostra* (1975); *Old Gringo* (1985), set in the Mexican Revolution, which became the 1989 film, starring Gregory PECK and Jane FONDA; and *Cristobal Nonato* (1987). He also wrote several plays and was a highly regarded critic and essayist.

Fugard, Athol (1932–), South African writer, actor, and director, much of whose powerful, eloquent work stems from his experience as a White artist seeking to portray Black and White South Africans caught in and yet transcending the system of apartheid and the racial violence it engenders. He emerged as a major playwright with his Port Elizabeth trilogy, *Blood Knot* (1961), *Hello and Good-bye* (1965), and *Boesman and Lena* (1969), and went on to write several more plays that almost immediately became part of the modern international repertory, including *Sizwe Bansi Is Dead* (1972); *The Island* (1973); *A Lesson from Aloes* (1979), which he directed on Broadway in 1980; *Master Harold and the Boys* (1981); and *A Place with the Pigs* (1988).

"Fugitive, The" (1963–67), the popular television drama series. David Janssen was Dr. Richard Kimble, the falsely accused protagonist pursued for years by Barry Morse, as Lt. Philip Girard, in a cast that included Jacqueline Scott and Fred Johnson as the actual killer. William Conrad was the narrator.

Fuller, Richard Buckminster (1895–1983), U.S. designer and inventor, largely self-trained. After an apprenticeship in a family construction firm, from 1927 he developed several unsuccessful but innovative enterprises, including experimental prefabricated houses and an experimental automobile. From 1954 he developed and popularized the strong, lightweight GEODESIC DOME, which became a major feature of the 1967 Montreal Exposition and was later used throughout the world. He later also developed a series of unrealized major projects, such as underwater farms and airborne cities. Fuller was a very popular and highly visible advocate of technological innovation to maximize scarce resources, for some achieving the status of a prophet in his time, although little beyond the geodesic dome directly resulted.

Funny Girl (1964), the long-running Isobel Lennart stage biography of Fanny BRICE, with music by Jule STYNE and lyrics by Bob Merrill. Barbra STREISAND was Brice, opposite Sidney Chaplin as Nicky Arnstein. Lennart adapted the play into the 1968 William WYLER film; Streisand won a best actress OSCAR, opposite Omar SHARIF as Arnstein, in a cast that included Walter PIDGEON, Anne Francis, and Kay Medford. In the 1975 sequel, *Funny Lady*, Streisand played opposite James CAAN, as Billy Rose; Herbert Ross directed.

Funny Thing Happened on the Way to the Forum, A (1962), the long-running TONY-winning Broadway musical, an antic comedy set in Rome. Zero MOSTEL, also a Tony winner, was the slave Pseudolus, heading a cast that included John CARRADINE, Jack Gilford, and Brian Davies. Stephen SONDHEIM wrote the words and music, Burt Shevelove and Larry Gelbart the book. Mostel re-created the role in the 1966 Richard Lester film, with a cast that included Phil Silvers, Buster KEATON, Michael Hordern, Jack Gilford, and Michael Crawford.

Furtwängler, Wilhelm (1886–1954), German conductor, a leading interpreter of Wagner from the 1920s. His conducting career began in 1907. He was director of the Mannheim Opera (1915–20); of the Berlin Philharmonic Orchestra from 1922; and of the Berlin State Opera from 1933, conducting often at Bayreuth. He was a leading conductor in Germany throughout the Nazi period. Although he was not prosecuted after the war, public criticism of his record forced withdrawal from American appearances after World War II. He continued to conduct in Germany, however.

Fury (1936), the Fritz LANG film, a powerful, bitter look at lynch justice. Spencer TRACY was the victim and later accuser, heading a cast that included Sylvia SIDNEY, Walter Brennan, Bruce Cabot, and Walter Abel. Lang and Bartlett Cormack based their screenplay on a Norman Krasna story. This was Lang's first American film, reflecting the moral concerns that permeated much of his work and that he had brought with him in his flight from Nazi Germany.

futurism, an Italian modernist movement in literature and the arts, developed by Filippo Marinetti. In 1909 he published the futurist *Manifesto*, which attempted to develop a nationalistic Italian movement based on modern technology, stressing speed, violence, and machine technology, while advocating destruction of traditional culture and its proponents. In 1910 the artists Umberto BOCCIONI, Gino Severini, Giacomo BALLA, Luigi Rossolo, and Carlo Carra published a futurist *Manifesto* in the arts; this was followed by a Paris futurist exhibition in 1912. The movement soon fragmented, and it had effectively dissolved by 1916. Marinetti, an early fascist, attempted to revive futurism in the 1920s but accomplished little. In the early years, some interest in futurism also developed in other European countries, most notably in Russia, where Vladimir MAYAKOVSKY became the leading figure in what after the Bolshevik Revolution briefly became a leading avant-garde movement in Soviet culture. With the ascendency of Stalinism came a new conservatism and the effective end of Soviet futurism.

G

Gabin, Jean (Jean-Alexis Moncorgé, 1904–76), French actor, on stage in variety and musical theater from 1923, on screen from 1930, and a leading tragedian in French cinema in the 1930s, in such films as *Maria Chapdelaine* (1934), *Pepe le Moko* (1936), GRAND ILLUSION (1937), *Port of Shadows* (1938), and DAYBREAK (1939). His postwar career was considerably less central to the French cinema, although it included starring roles in such films as *Les Misérables* (1958) and *The Cat* (1971).

Gable, Clark (William Clark Gable, 1901–60), U.S. actor, on stage from 1922 and on screen in a few small parts during the mid-1920s. He began playing film leads in 1931 and became a major star of Hollywood's Golden Age in IT HAPPENED ONE NIGHT (1934), then going on to play Fletcher Christian in MUTINY ON THE BOUNTY (1935); his most celebrated role was that of Rhett BUTLER in GONE WITH THE WIND (1939). Gable starred in a score of other action and comedy films, always as one of the leading male Hollywood sex symbols of his time, as in *Red Dust* (1932); SAN FRANCISCO (1936); *Saratoga* (1937); *Command Decision* (1948); *Mogambo* (1953, a remake of *Red Dust*); and his last film, THE MISFITS (1961), also the last film of his costar, Marilyn MONROE.

Gabo, Naum (Naum Neemia Pevsner, 1890–1977), Soviet artist, resident in Western Europe during World War I and 1922–46 and thereafter in the United States. With his brother Antoine PEVSNER he was a pioneering abstract sculptor and a leading figure in the CONSTRUCTIVIST MOVEMENT. In 1920 the brothers issued their *Realist Manifesto*, a basic constructivist document that also, and quite unsuccessfully, opposed the use of art for primarily political purposes. He experimented with kinetic sculpture while still in the Soviet Union and produced a body of work that stressed kinetic-related themes, as in *Spiral Theme* and *Linear Construction*.

Galli-Curci, Amelita (1882–1963), Italian soprano; after her 1906 Italian debut she toured widely for a decade, then appeared with the Chicago Opera (1916–24) and at the Metropolitan Opera from time to time from 1921, until her retirement in 1936. She became a very popular recording artist during her years in the United States.

Galsworthy, John (1867–1933), British writer, a prolific novelist and dramatist who emerged as a major figure with his first novel, *A Man of Property* (1906), which became the first work in his trilogy THE FORSYTE SAGA. In that year his play *The Silver Box* was also produced, establishing him as a foremost playwright and social critic. He wrote two other trilogies, which were ultimately collected as *A Modern Comedy* (1929) and *End of a Chapter* (1935), both about the Forsytes and often loosely considered part of *The Forsyte Saga*. His best-known plays include *Strife* (1909), *The Skin Game* (1910), and *Loyalties* (1922). *The Forsyte Saga* was adapted into a 26-part BBC television series (1967), as a family drama that followed the lives of the Forsytes for almost five decades, from Victoria through the mid-1920s.

Galway, James (1939–), Irish-British flautist, one of the leading soloists of his time. He worked with several orchestras before settling down as leading flautist of the Berlin Philharmonic from 1969 to 1975, and then became a flute soloist and a conductor, recording and touring in both the classical and popu-

lar repertoires, often with such folk groups as THE CHIEFTAINS.

Gance, Abel (1889–1981), pioneer French film director, on stage and screen as an actor from 1909 and on screen as a director from 1911. He emerged as a major silent-film director during World War I and after the war was one of the most innovative and influential directors of the period, with his antiwar film J'ACCUSE (1919), followed by his massive *La Roué* (1923). His masterpiece, shown in triple-screen form and introducing a wide range of techniques that profoundly influenced the development of world cinema, was NAPOLEON (1927), which was damaged and essentially lost in the decades that followed but during the 1970s was carefully reconstituted by Kevin Brownlow and then shown in a five-hour version very close to the original, with a new musical score.

Gandhi (1982), the epic Richard ATTENBOROUGH film biography of Mohandas K. Gandhi, with Ben KINGSLEY in the title role, supported by a massive cast that included Edward Fox, Candice BERGEN, John MILLS, John GIELGUD, Ian CHARLESON, Athol FUGARD, Saeed Jaffrey, Trevor HOWARD, and Martin Sheen. The film, Attenborough, John Briley for his screenplay, Kingsley as best actor, editing, costumes, and art all won OSCARS.

"Gangbusters" (1936–1957), the long-running radio police drama created by Philip H. Lord in semidocumentary form, although often only loosely based on actual events. It received the enthusiastic cooperation of J. Edgar Hoover and other law enforcement officials of the era. A television version was aired March–December 1952.

Garbo, Greta (Greta Louise Gustafsson, 1905–90), Swedish actress, on screen in Sweden from 1922, who was brought to Hollywood in 1925 by her mentor, Swedish director Mauritz STILLER. With her first American film, *The Torrent* (1926), she became a major star, going on to become one of the most notable figures in world cinema, in such silent films as *Love* (1927) and *The Kiss* (1929). She made the transition to sound spectacularly, in ANNA CHRISTIE (1930), followed by such films as *Mata*

Hari (1931); *Queen Christina* (1933); *Anna Karenina* (1935); CAMILLE (1937); and her only comedy, NINOTCHKA (1939). Garbo retired in 1941, her legend entirely intact.

García Lorca, Federico (1899–1936), Spanish writer, who emerged as Spain's leading 20th-century poet in the 1920s, most notably with the collections *Canciones* (1927) and *Gypsy Ballads* (1928), both set in his native Andalusia, and *Lament for the Death of a Bullfighter* (1937). He spent 1929–30 in New York; the collection *Poet in New York* (1940) stemmed from this period. In the 1930s Lorca also became a major dramatist, with *Blood Wedding* (1933), *Yerma* (1934), *Doña Rosita la Soltera* (1935), and *The House of Bernardo Alba* (1936). Although wholly nonpolitical, he worked with what was new and growing in Spanish culture and with the leading cultural figures of the Spanish Republic; he was murdered by Spanish fascists in Granada on August 19, 1936.

García Márquez, Gabriel (1928–), Colombian writer, a leading Latin American novelist and short-story writer, much of whose work is set in the imaginary town of Macondo, modeled after his hometown of Aracataca, beginning with the novel *Leaf Storm* (1955). *No One Writes to the Colonel and Other Stories* (1961), *The Bad Hour* (1962), and a collection of short stories, *Grand Mama's Funeral* (1962), preceded his celebrated ONE HUNDRED YEARS OF SOLITUDE (1967). His further work includes such works as *Innocent Endira and Other Stories* (1972), *Death of a Patriarch* (1975), *Chronicle of a Death Foretold* (1981), *Love in the Time of Cholera* (1984), and *The General in his Labyrinth* (1989). He was awarded the NOBEL PRIZE for literature in 1982.

Garden, Mary (1864–1967), British soprano, quite notably an actress as well as a singer. In 1900 she became a star of the Paris Opéra-Comique overnight, as a last-minute replacement in *Louise*. In 1902, she created Melisande in Claude DEBUSSY's *Pelleas and Melisande*, a role with which she was associated throughout her career; she brought it to the Manhattan Opera in 1908. She was also a celebrated SALOME. From 1910 to 1930 she appeared at

the Chicago Opera as one of the leading sopranos of her time.

Garden of the Finzi-Continis, The (1971), the Vittorio DE SICA film, about a highly placed, seemingly secure Italian Jewish family that is ultimately destroyed by fascism during the late 1930s. Dominique Sanda played the lead, in a cast that included Lino Capolicchio, Helmut Berger, Romolo Valli, and Fabio Testi. The film won a best foreign film OSCAR.

Gardens of Stone (1987), the Francis Ford COPPOLA film, a home-front Vietnam War story set in Washington, D.C., with a cast that included James CAAN, James Earl JONES, Anjelica HUSTON, J.B. Sweeney, Mary Stuart Masterson, Sam Bottoms, and Lonette McKee.

Gardner, Ava (1922–90), U.S. actress, on screen from 1942, who became a major Hollywood sex symbol in the mid-1940s, with such films as *The Killers* (1946), *The Hucksters* (1947), *One Touch of Venus* (1948), *Mogambo* (1953), *The Barefoot Contessa* (1954), and *Bhowani Junction* (1956). Later leaving the studio system and its typecasting, she emerged as a serious actress in such films as ON THE BEACH (1959) and SEVEN DAYS IN MAY (1964).

Gardner, Erle Stanley (1889–1970), U.S. writer and lawyer, who created the fictional lawyer Perry MASON in a long series of extraordinarily popular mystery novels, beginning with *The Case of the Velvet Claws* (1933). His books were the basis of the long-running Perry Mason radio series (1943–55), and, with Raymond BURR in the title role, of the highly popular television series (1956–66) and several later films.

Garfield, John (Julius Garfinkle, 1913–52), U.S. actor, on stage from 1930 and in the mid-1930s a leading player in the GROUP THEATRE, most notably in *Awake and Sing!* (1935). His first substantial film role was in *Four Daughters* (1938); later films include *The Sea Wolf* (1941), TORTILLA FLAT (1942), THE POSTMAN ALWAYS RINGS TWICE (1946), *Body and Soul* (1947), and GENTLEMEN'S AGREEMENT (1947). He was blacklisted in the early 1950s, after having refused to name others as Communists before the House Un-American Activities Committee, and died of a heart attack in 1952.

Garland, Hamlin (1860–1940), U.S. writer, a turn-of-the-century populist whose work reflected his commitment to the small farmers and ranchers of the Midwest and West. He is best known for his early and late work; his early short stories were collected in several volumes, beginning with *Main-Travelled Roads* (1891) and *A Boy's Life on the Prairie* (1899). The first two of his eight autobiographical volumes, *A Son of the Middle Border* (1917) and his PULITZER PRIZE-winning *A Daughter of the Middle Border* (1921), were very well received.

Garland, Judy (Frances Gumm, 1922–69), U.S. actress and singer, on stage at the age of three and on screen from 1936. She became a major film star at 17, as Dorothy in THE WIZARD OF OZ (1939), and went on to become one of the leading musical-theater players and actresses of her time in such films as *For Me and My Gal* (1942); MEET ME IN ST. LOUIS (1944); EASTER PARADE (1948); *In the Good Old Summertime* (1949); A STAR IS BORN (1954); and, late in her career, JUDGMENT AT NUREMBERG (1961), in which she played a brief but powerful dramatic role. Garland was also a leading performer in concert. Her well-publicized personal difficulties contributed to a far-too-early downward career spiral in the 1950s and to her untimely death from a sleeping-pill overdose. She was the mother of Liza MINNELLI, her daughter by director Vincente MINNELLI.

Garner, James (James Baumgarner, 1928–), U.S. actor, on stage from 1954 and on screen from 1956, who was television's "Maverick" (1957–61) and later played the title role in "The Rockford Files" (1974–80). His films include THE AMERICANIZATION OF EMILY (1964), *Marlowe* (1969), *They Only Kill Their Masters* (1972), VICTOR/VICTORIA (1982), and *Sunset* (1987).

"Garry Moore Show, The" (1958–64), the long-running television variety show hosted by Garry Moore, most notable for its regular feature "That Wonderful Year." The show's regulars included Durward Kirby, Carol BUR-

NETT, Marion Lorne, and Dorothy Loudon. An earlier "Garry Moore Show" ran on radio and television in 1950–51. The later show was briefly revived in 1966.

Garson, Greer (1908–), British actress, on stage from 1934; on screen in leading roles with her first film, GOOD-BYE, MR. CHIPS (1939); and a Hollywood star with her OSCAR-winning title role in MRS. MINIVER (1942). She also played leads in such films as RANDOM HARVEST (1942), *Mrs. Parkington* (1944), and SUNRISE AT CAMPOBELLO (1960).

Gary, Romain (Roman Kacew, 1914–80), French writer and diplomat, whose best-known novels include his World War II story of the Polish underground, *A European Education* (1943); *Tulip* (1946); *The Roots of Heaven* (1956), set in modern Africa, which became the 1958 John FORD film, with Errol FLYNN, Juliette Greco, and Trevor HOWARD in the leads; *Lady L* (1959), which became the 1966 Peter USTINOV film, starring Sophia LOREN and Paul NEWMAN; and his satirical treatment of bigotry, *White Dog* (1970), which became the 1982 Samuel Fuller film, with Paul Winfield and Kristy McNichol in the leads. His wife, actress Jean Seberg, was a suicide in 1979; he was also a suicide.

Gaslight (1944), the George CUKOR film, a Victorian thriller based on Patrick Hamilton's 1938 play, with Ingrid BERGMAN in an OSCAR-winning role as the wife being driven insane, opposite Charles BOYER as the villainous husband, in a cast that included Joseph COTTEN, Angela LANSBURY, and May Whitty. An earlier, at least equally notable British version was made in 1939 by Thorold Dickinson, with Anton Walbrook and Diana Wynyard in the leads; it was retitled *Angel Street* for American release.

"Gasoline Alley," the comic strip created by cartoonist Frank O. KING in 1918, which for half a century brought Skeezix and Walt to a very wide audience.

Gate of Hell (1954), the Teinosuke Kinugasa film, the story of the murder of a wronged woman by a samurai, set in a noble house in 12th-century Japan. Kinugasa wrote the screenplay, based on a Kan Kichuki novel; the

cast included Michiko Kyo, Kazuo Hasegawa, and Isao Yamagata. The film won a best foreign film OSCAR.

Gaudí, Antonio (1852–1926), Spanish architect, whose work was done in Catalonia, most of it in and near Barcelona. His most celebrated work by far was the church of the SAGRADA FAMILIA, which he began in 1884 and did not finish, although it was his sole and all-absorbing work from 1910. Gaudí's main early intent was to develop structures that wholly represented the nature and form of their materials, all presented as an organic whole and all in a highly colorful Catalonian Moorish-related style. While those aims were realized, what very notably also eventuated was a profusion of highly ornamented, intricate forms, especially when the religious elements were in play, as in the Sagrada Familia church; so much so that his work, unappreciated by most architects early in the 20th century, was later in the century admired by architects and surrealist painters alike.

Gaumont, Léon (1864–1946), early French motion-picture inventor and producer. He invented a sound system in 1902, produced motion pictures from the first decade of the 20th century, and was a major producer and exhibitor through the 1920s.

Gayle, Crystal (Brenda Gail Webb, 1951–), U.S. singer, who emerged as a major country and popular figure in the mid-1970s, with her renditions of such songs as "Brown Eyes," "Cry Me a River," and "Talking in Your Sleep," and went on to become one of the most popular singers of the 1980s. She is the sister of singer Loretta LYNN.

Gaynor, Janet (Laura Gainor, 1906–84), U.S. actress, on screen from 1926, who quickly became a star in such silent-film classics as SEVENTH HEAVEN (1927), SUNRISE (1927), and *Street Angel* (1928), winning the first best actress OSCAR ever awarded, for her work in all three films taken together. She later starred in such sound films as *State Fair* (1933), A STAR IS BORN (1937), and *The Young at Heart* (1938).

General, The (1926), the classic Buster KEATON silent-film comedy, in which he starred as

the head of a group of Northern guerrillas who seize a Confederate train during the Civil War. It was based on the William Pittenger story *The Great Locomotive Chase*, which was also the basis of the 1956 Francis D. Lyon film, a straightforward retelling of the story that starred Fess Parker.

Genet, Jean (1910–86), French writer; a criminal during much of his early life, he began writing in prison and was serving a life sentence when pardoned in 1948, after the intervention of a group of leading French writers. He took as his main subject the emotional condition of those functioning as outsiders in society and as his theme the implications of alienation, which he viewed as a natural state of being. His plays were seen as an integral part of the THEATER OF THE ABSURD. His plays include *The Maids* (1947), *Deathwatch* (1949), *The Balcony* (1956), *The Blacks* (1959), and *The Screens* (1960). His novels, largely autobiographical, include *Our Lady of the Flowers* (1942), *Querelle of Brest* (1947), and *Thief's Journal* (1949). He also published several poetry collections.

Gentlemen's Agreement (1947), the groundbreaking Elia KAZAN film, a powerful attack on antisemitism in American life. Gregory PECK starred, in a cast that included John GARFIELD, Dorothy McGuire, Celeste HOLM, and Anne Revere. The work was adapted by Moss HART from the Laura Z. Hobson novel. The film, Kazan, and Holm as best supporting actress all won OSCARS.

geodesic dome, the lightweight, strong, easily erected structure composed of metal tetrahedrons developed by Buckminster FULLER from 1954, which became popular after the 1967 Montreal Exposition, later being used throughout the world.

"Georgia on My Mind" (1930), the Hoagy CARMICHAEL song. Mildred Bailey introduced it in the 1930s; Ray CHARLES renewed it in his celebrated 1960 version; and Willie NELSON did the same a generation later, in his 1978 version. Music was by Carmichael; words were written by Stuart Gorrell in 1930 and revised by Mitchell Parrish in 1931.

Georgy Girl (1966), the Silvio Narizzano film, set in the "swinging" London of the 1960s. Lynn Redgrave was plain Georgy, leading a cast that included James MASON, Charlotte Rampling, Alan BATES, and Rachel Kempson. Margaret Forster and Peter Nichols adapted Forster's novel.

Gerasimov, Sergei (1906–85), Soviet actor and director, on screen from 1925. He is best known as the director of such films as *City of Youth* (1938), the two-part *The Young Guard* (1947–48), and his two-part film adaptation of Mikhail SHOLOKHOV's novel *And Quiet Flows the Don* (1958).

Gere, Richard (1949–), U.S. actor, on stage from the early 1970s and on screen from 1975. He quickly emerged as a leading player in such films as *Report to the Commissioner* (1975), *Baby Blue Marine* (1976), *Looking for Mr. Goodbar* (1977), *Yanks* (1979), *An Officer and a Gentleman* (1982), *The Cotton Club* (1984), *Miles from Home* (1989), *Internal Affairs* (1990), and *Pretty Woman* (1990).

Gershwin, George (1898–1937), U.S. composer; his first hit song was "Swanee," sung by Al JOLSON in *Sinbad* (1919). Gershwin went on to become a leading musical-theater composer, from 1924 with his brother **Ira Gershwin** (1896–1983) writing the lyrics for such songs as FASCINATIN' RHYTHM, from *Lady Be Good* (1924); SOMEONE TO WATCH OVER ME, from *Oh, Kay!* (1926); the title song of STRIKE UP THE BAND (1930); EMBRACEABLE YOU, from *Girl Crazy* (1930); and the title song of the PULITZER PRIZE-winning play OF THEE I SING (1931). Simultaneously, George Gershwin wrote several major compositions, including *Rhapsody in Blue* (1924), *Concerto in F* (1925), *An American in Paris* (1928), and *Second Rhapsody* (1931). In 1935 he wrote PORGY AND BESS (1935), a folk opera on African-American themes, based on Dubose Heyward's *Porgy*, which included such songs as IT AIN'T NECESSARILY SO and SUMMERTIME. After George's death, Ira continued on as a leading lyricist, most notably collaborating with Kurt WEILL on *Lady in the Dark* (1941).

Get Out Your Handkerchiefs (1978), a film comedy written and directed by Bernard Blier.

The cast included Carol Laure as the compliant wife; Gerard Depardieu as the husband; Patrick Dewaere as the friend; Eleanore Hir; Riton; and Jean Rougeris. The movie won a best foreign film OSCAR.

Getty, Jean Paul (1892–1976), U.S. oil magnate and art collector. On his death his estate funded and his art collection was the original basis of California's J. Paul Getty Museum.

Getz, Stan (1927–), U.S. musician, a leading contemporary JAZZ tenor saxophonist. He was a key figure in the introduction of bossa nova in the early 1960s, continuing to record and appear in concert for the next three decades. His *Girl from Ipanema* won a GRAMMY as record of the year in 1964.

Ghost and Mrs. Muir, The (1947), the Joseph L. MANKIEWICZ film, with Gene TIERNEY as Mrs. Muir and Rex HARRISON as the ghost of the sea captain whose home she occupied, in a cast that included George SANDERS, Edna Best, Vanessa Brown, and Natalie WOOD. Philip Dunne adapted the R.A. Dick novel.

Giacometti, Alberto (1901–66), Swiss sculptor and painter, who moved through several styles before finding the mature style that marked him as a major figure in 20th-century sculpture. He moved from CUBIST-related work in the early 1920s to SURREALISM in the late 1920s and early 1930s, and in 1935 broke with that to begin again essentially, then doing figurative work in an effort to find the reality of each individual portrayed. That search, parallelling EXISTENTIAL thinking, created affinities with the leading existentialists and absurdists of his time, greatly enhancing the legendary status he and his work achieved in midcentury. Giacometti began to create matchsticklike figures in the early 1940s and in the late 1940s the elongated human figures, such as *Tall Figure I* (1947) and *Three Men Walking* (1949) for which he is best known. From the early 1950s he began a final attempt to invest his figures and portrait heads with the force of life, as in the late works *Bust of Annette* (1962) and *Head of Diego* (1965).

Giant (1956), the George STEVENS film, set in Texas and based on the 1950 Edna FERBER novel. The cast was led by Elizabeth TAYLOR;

Rock HUDSON; and James DEAN, in his last film. Stevens won a best director OSCAR.

Gibran, Khalil (1883–1931), Lebanese writer and artist, who spent much of his early life in the United States. He is best known for his mystical work *The Prophet* (1923), which he also illustrated.

Gibson, Mel (1956–), Australian actor, who became a popular film star in the 1980s, with such movies as the three *Mad Max* science-fiction adventure films (1979, 1982, and 1985), *Gallipoli* (1981), THE YEAR OF LIVING DANGEROUSLY (1983), the two *Lethal Weapon* films (1987 and 1989), *Bird on a Wire* (1990), and *Hamlet* (1990).

Gide, André (1869–1951), French writer, a powerful moralist who deeply influenced the course of 20th-century French literature. His large body of notable works began with a satire, *Marshlands* (1895), and a prose poem, *Fruits of the Earth* (1897), in which he faced and accepted his own homosexuality, while at the same time beginning to develop his own concept of the rational, humane, moral, and intellectual life, which he would continue to shape for the next half-century. His major works also include *Prometheus Misbound* (1898); *The Immoralist* (1902); *Strait Is the Gate* (1909); *Isabelle* (1911); *The Vatican Swindle* (1914), seen by many as sharply anticlerical; *The Pastoral Symphony* (1919); *Corydon* (1924), an open defense of homosexuality that was bitterly and widely attacked; *The Counterfeiters* (1927); *Travels in the Congo* (1930), a personal account that attacked French colonialism; *Oedipus* (1931), the most notable of his several plays; and *Theseus* (1946). Gide was also a prolific essayist, letter writer, and translator. During the 1930s he briefly embraced communism, but he rejected the Soviet dictatorship in *Return from the USSR* (1936). From 1889, Gide compiled his ultimately massive *Journals;* these were published in English in four volumes, 1947–51. He was awarded the NOBEL PRIZE for literature in 1947.

Gielgud, John (1904–), British actor and director, one of the leading players of the English-speaking theater for over six decades, on stage from 1921 and on screen from 1924. In

1929 he became a leading Shakespearean player at the Old Vic, going on to play most of the major roles in Shakespeare during the next half-century and becoming best known for his *Hamlet*. He directed the notable 1935 *Romeo and Juliet* in which he and Laurence OLIVIER alternated as Romeo and Mercutio. In 1958 he created his celebrated recital *The Ages of Man*. He also appeared in several modern plays, as in *Nude with Violin* (1956), *Tiny Alice* (1964), HOME (1970), and *No Man's Land* (1975). Until the mid-1970s he appeared infrequently on film, though he did play the leads in *The Secret Agent* (1936) and *Julius Caesar* (1970). But late in his career he played in many strong supporting roles on film, winning an OSCAR for his role in *Arthur* (1981) and also appearing in such television productions as BRIDESHEAD REVISITED (1981) and WAR AND REMEMBRANCE (1988).

Gigi (1958), the Vincente MINNELLI film musical; the Alan Jay LERNER screenplay, set in turn-of-the-century Paris, was an adaptation of the 1945 COLETTE novel, with music by Lerner and Frederick LOEWE. Leslie CARON led a cast that included Maurice CHEVALIER, Louis Jourdan, and Hermione Gingold. The film, Minnelli, Lerner for his screenplay, Lerner and Loewe for the title song, cinematographer Joseph Ruttenberg, editing, costumes, and music direction all won OSCARS.

Gigli, Beniamino (1890–1957), Italian tenor; after his 1914 Italian debut, he sang in Italy and abroad, his Metropolitan Opera debut coming in 1920. He sang at the Met from 1920 to 1932, succeeding Enrico CARUSO in many of the lyric tenor roles. Gigli was a leading singer in Italy during the balance of the fascist period, also appearing in Italian and German films, a record that made it difficult for him to resume his career in the United States during the postwar period.

Gilbert, Cass (1859–1934), U.S. architect, a leading neoclassicist of the early 20th century, whose most notable works include New York's Woolworth Building (1913), for some years the world's tallest building, and the U.S. Supreme Court Building (1935).

Gilbert, John (John Pringle, 1895–1936), U.S. actor, on screen from 1916, who became one of the leading film stars and sex symbols of the silent era, in such films as *The Merry Widow* (1925), *The Big Parade* (1925), *Flesh and the Devil* (1927), *Love* (1927), and *A Woman of Affairs* (1928), the latter three made with Greta GARBO. His career effectively ended in the early 1930s, with the advent of sound and less flamboyant acting styles.

Gilels, Emil Grigoryevich (1916–85), Soviet pianist, one of the leading soloists of his generation. He played within the Soviet Union from 1933 and toured internationally from 1945, first appearing in the United States in 1955. A powerful, versatile artist, Gilels was the first major Soviet pianist to appear on the postwar international scene.

Gillespie, Dizzy (John Birks Gillespie, 1917–), U.S. JAZZ musician, a trumpeter with several bands in the 1930s and early 1940s. In the mid-1940s he was one of the originators of the BOP jazz style, and he continued for four decades to be a highly innovative figure in jazz. With the passing of bop he moved toward Latin-influenced styles, though always expressing himself in an original fashion, as trumpeter, bandleader, composer, and arranger.

Gimme Shelter (1970), the David and Albert Maysles documentary film, featuring THE ROLLING STONES in their December 1969 Altamont Speedway concert, which resulted in the killing of an armed concertgoer by Hell's Angels members entrusted with security arrangements. "Gimme Shelter" is also the title of their 1969 song, long identified with the group, with words and music by Mick JAGGER and Keith Richard.

Ginastera, Alberto Evaristo (1916–83), Argentinian composer, whose work strongly reflected the influence of folk themes, especially in such early works as the ballets *Panambi* (1940) and *Estancia* (1941). He is best known for his operas, which were far more abstracted and atonal, including *Don Rodrigo* (1964), the chamber opera *Bomarzo* (1967), and *Beatrix Cenci* (1971).

Ginsberg, Allen (1926–), U.S. writer, one of the leading poets of the BEAT GENERATION from 1956, when Lawrence FERLINGHETTI published Ginsberg's HOWL AND OTHER POEMS. Charges of alleged obscenity generated a celebrated right-to-publish case of the period, won by Ferlinghetti. In the decades that followed, Ginsberg was a leading American spokesperson of dissent. His second collection, *Kaddish and Other Poems* (1961), was well received, and his *The Fall of America: Poems of These States* (1973) won a National Book Award. He also wrote the lyrics of the Philip GLASS opera *The Hydrogen Jukebox* (1990).

Giraudoux, Hippolyte Jean (1882–1944), French writer and diplomat, who became a well-known novelist during the 1920s, with such works as *Suzanne and the Pacific* (1921), *Bella* (1926), and *Eglantine* (1927). His plays begin with *Siegfried* (1928) and include several works that have become part of the international repertory, including *Amphitryon 38* (1929), *Intermezzo* (1933), *A Tiger at the Gates* (1935), *Ondine* (1939), and *The Madwoman of Chaillot* (1945).

Girl of the Golden West, The (1910), the opera by Giacomo PUCCINI, based on the 1905 David BELASCO play; a romance, in which the lovers, created in the opera by Jenny Destinn and Enrico CARUSO, ultimately ride off into the sunset.

Gish, Lillian (Lillian de Guiche, 1896–), U.S. actress, on stage at the age of five, often with her sister **Dorothy Gish** (1898–1968). The sisters entered movies together in 1912. Dorothy played in scores of films, becoming a popular player throughout the silent-film era; Lillian became one of the most notable dramatic stars of the period, in such films as BIRTH OF A NATION (1914); BROKEN BLOSSOMS (1919); ORPHANS OF THE STORM (1922), costarring with Dorothy; *Romola* (1924); and *The Scarlet Letter* (1926), as Hester Prynne. Both sisters ultimately returned to the stage, although Lillian Gish played several strong supporting film roles late in her career.

"Give My Regards to Broadway" (1904), the George M. COHAN song, introduced by Cohan in his Broadway musical *Little Johnny Jones* (1904), with words and music by Cohan.

Glackens, William James (1870–1938), U.S. painter and illustrator, who worked at several newspapers and magazines in the 1890s, covering the war in Cuba for *McClure's*, and then moved toward painting. He became a leading member of the ASHCAN SCHOOL of early 20th-century American realism, exhibiting with his teacher Robert HENRI, John French SLOAN, Maurice PRENDERGAST, and other realists in 1908 and at the 1913 ARMORY SHOW, though even his early work showed the Impressionist affinities that were to predominate in his later work.

Gladkov, Fyodor Vasilievich (1883–1958), Soviet writer, best known for his novels *Cement* (1924), an early proletarian novel on the theme of reconstruction after the 1917–22 civil war, and *Energy* (1938), set around the building of the Dnesrostroi Dam; and for his autobiography, *Story of Youth* (1949).

Glasgow, Ellen (1874–1945), U.S. writer, whose work was set in her native Virginia and focused on the demise of the old southern aristocracy and the emergence of new currents in southern life. Her works include such novels as *The Descendants* (1897), *In Virginia* (1913), *Barren Ground* (1925), and the PULITZER PRIZE-winning *In This Our Life* (1932), as well as poetry and short stories.

Glass, Philip (1937–), U.S. composer, who in the mid-1960s became interested in South Asian music, worked with Ravi SHANKAR while studying with Nadia BOULANGER in Paris, and developed a "minimalist" approach based on his perception of Indian stylistic and tonal patterns, creating several highly experimental works in the mid- and late 1960s. He founded the Philip Glass Ensemble in 1968 and began to record in 1971, thereafter creating such popular recorded works as *Music in Twelve Parts* (1971–74) and *Glassworks* (1982). He turned to opera in the mid-1970s, becoming a major figure, and is best known for EINSTEIN ON THE BEACH (1976), *Satyagraha* (1980), *Akhnaten* (1984), and *The Hydrogen Jukebox* (1990).

Jackie Gleason as Ralph Kramden in "The Honeymooners," flanked by Audrey Meadows (right) as his wife, Alice, and Joyce Randolph as Trixie Norton.

Glass Box, The (1949), the New Canaan, Connecticut home of architect Philip JOHNSON; it helped introduce and became a centerpiece of the emerging INTERNATIONAL STYLE.

Glass Menagerie, The (1945), the play by Tennessee WILLIAMS, which established him as a major playwright. On stage, Laurette TAYLOR created the classic Amanda Wingfield role, with Eddie Dowling and Julie Haydon in the other leads. The play was filmed three times: The 1950 Irving Rapper film starred Jane WYMAN, Kirk DOUGLAS, and Gertrude LAWRENCE (as Amanda); in the 1973 Anthony Harvey film, Katharine HEPBURN was Amanda, opposite Sam WATERSTON and Joanna Miles; and in the 1987 Paul NEWMAN film, Joanne WOODWARD was Amanda, opposite John Malkovich and Karen Allen.

Gleason, Jackie (Herbert John Gleason, 1916–87), U.S. comedian and actor, in variety from 1931, on screen from 1941, and a major comedy-variety star in television from 1950 to 1970, most notably as Ralph KRAMDEN in the classic THE HONEYMOONERS. He won a best actor TONY in the musical *Take Me Along*

(1960); his film roles included that of Minnesota Fats in *The Hustler* (1961).

Glory (1989), the Edward Zwick film, about the Civil War service of the Massachusetts 54th Regiment, one of the earliest and most distinguished of the Black regiments to fight for the Union, with particular focus on the near-suicidal frontal assault on Fort Wagner, at Charleston, South Carolina, on July 18, 1863. Kevin Jarre's screenplay was based on the letters of Col. Robert Gould Shaw, the White abolitionist who headed the regiment, and on the Lincoln Kirsten book *Lay the Laurel* and the Peter Burchard book *One Gallant Rush*. The cast was led by Matthew BRODERICK as Shaw and included Denzel Washington, Morgan FREEMAN, Cary Elwes, Jihmi Kennedy, John David Cullum, John Finn, André Braugher, Jay O. Sanders, and Bob Gunton. Washington won an OSCAR as best supporting actor, as did Freddie Francis for cinematography and Donald O. Mitchell, Gregg C. Rudloff, Elliott Tyson, and Russell Williams II for sound.

Go-Between, The (1953), the L.P. Hartley novel, about class, caste, and sexual relationships in the turn-of-the-century English countryside. Harold PINTER adapted the novel into the 1971 Joseph LOSEY film, with Julie CHRISTIE and Alan BATES as the class-crossed lovers, Edward Fox as her aristocratic future husband, Dominic Guard as the bewildered boy who passes messages among them, and Michael REDGRAVE as the boy 50 years later, at midcentury.

Godard, Jean-Luc (1930–), French director, a leading figure in the NEW WAVE, who became a major director with the appearance of his innovative first full-length film, BREATHLESS (1960); he then went on to direct such films as *A Woman Is a Woman* (1961), *Contempt* (1963), *Alphaville* (1965), and *La Chinoise* (1967), the latter signaling a move toward direct political statement, which in his instance proved extremely damaging to his artistic output.

"God Bless America" (1918), the Irving BERLIN song, written for *Yip Yip Yaphank* but not used; it became an emblematic American patriotic song after being reintroduced on radio by Kate SMITH in 1939. Words and music were by Berlin.

Goddard, Paulette (Marion Levy, 1911–90), U.S. actress, a ZIEGFELD girl in her teens who became a Hollywood star in the mid-1930s; her first major role was opposite Charlie CHAPLIN, then her husband, in MODERN TIMES. She also starred with Chaplin in THE GREAT DICTATOR (1940). She played leads in such other films as *The Cat and the Canary* (1939), *Reap the Wild Wind* (1942), and DIARY OF A CHAMBERMAID (1946) and a key supporting role in HOLD BACK THE DAWN (1941).

Goddess, The (1958), the John CROMWELL film, written by Paddy CHAYEVSKY. Kim Stanley played the poor country girl who becomes a glamorous movie star, perhaps on the model of Marilyn MONROE or Ava GARDNER, and ultimately is destroyed by her Hollywood life and personal history, in a cast that included Lloyd BRIDGES, Patty DUKE, and Betty Lou Holland.

Godfather, The (1972), the classic Francis Ford COPPOLA film, about a turn-of-the-century young immigrant from violence-ridden Sicily who builds a powerful Mafia family in America. Marlon BRANDO created the role of Don Vito CORLEONE, in a cast that included Al PACINO, Robert DUVALL, James CAAN, Diane KEATON, John Cazale, Richard Castellano, Talia Shire, Richard Conte, Sterling HAYDEN, and John Marley. Coppola and Mario Puzo won an OSCAR for their screenplay, based on Puzo's novel, as did the film and Brando as best actor.

Godfather, The, Part II (1974), Francis Ford COPPOLA's sequel to THE GODFATHER, which expanded upon the original film and took the story into the next generation. Al PACINO played Michael Corleone, succeeding his father to Mafia family leadership; and Robert DE NIRO was the young Vito CORLEONE, in a series of flashbacks. The cast included Robert DUVALL, Diane KEATON, John Cazale, Lee STRASBERG, Talia Shire, Morgana King, Troy Donahue, Harry Dean Stanton, and Danny Aiello. The film, Coppola as director, De Niro as best supporting actor, Coppola and Mario Puzo for their screenplay, the score, and art all won OSCARS. In 1977 both films were merged into *The Godfather Saga*, for television presentation.

Godfrey, Arthur (1903–83), U.S. entertainer, in radio from 1929, who became a popular personality in the late 1940s, moving into television with "Arthur Godfrey's Talent Scouts" in 1948 and becoming a major early television host with *Arthur Godfrey and His Friends* (1949–59). His 1953 dismissal of singer Julius La Rosa while on the air seriously damaged his career.

Going My Way (1944), the OSCAR-winning Leo MCCAREY film, about two priests and their conflicting generational styles. Bing CROSBY starred as Father Chuck O'Malley, with a cast that included Barry FITZGERALD as Father Fitzgibbon, Risë Stevens, Frank McHugh, Jean Heather, and Gene Lockhart. Frank Butler and Frank Cavett won an Oscar for their screenplay, based on a McCarey story, as did McCarey for direction and again for his story. Crosby and Fitzgerald also won

Oscars, as did the song "Swinging on a Star." McCarey directed a sequel, *The Bells of St. Mary's* (1945), starring Crosby and Ingrid BERGMAN.

Goldberg, Rube (Reuben Lucius Goldberg, 1883–1970), U.S. cartoonist, so well remembered for his extraordinarily inventive, technically complex means of achieving simple tasks that his name went into the language as a satirical synonym for that kind of device. He created the devices in several comic strips and many single cartoons, beginning with the strip "Boob McNutt," in 1907. He turned to editorial cartooning in the late 1930s and was awarded a PULITZER PRIZE in 1948 for the antinuclear *Peace Today*.

"Goldbergs, The" (1929–45), the Depression-era radio situation comedy, set in a Bronx Jewish community. It was created by Gertrude Berg, who played and became identified with the role of Molly Goldberg. James R. Waters was her husband, Jake. Berg also played the role in the play *Molly and Me* (1948) and in the very popular 1949–54 television series.

Gold Diggers, The (1919), the Avery Hopwood play, a very slim piece about a gaggle of New York chorus "girls" and their various campaigns to marry rich men. The play was the basis of a series of early Hollywood musicals, beginning with *Gold Diggers of Broadway* (1929), directed by Roy Del Ruth. *Gold Diggers of 1933* was Busby BERKELEY's second film musical; it was directed by Mervyn LEROY, with a cast that included Joan BLONDELL, Ruby Keeler, Dick POWELL, and Ginger ROGERS, singing "We're in the Money." Berkeley directed and choreographed *Gold Diggers of 1935*, with its "Lullaby of Broadway." Lloyd BACON directed and Berkeley choreographed *Gold Diggers of 1937*, with its "Plenty of Money and You." Ray Enright directed and Berkeley choreographed *Gold Diggers in Paris* (1938).

Golden Bowl, The (1904), the last completed novel of Henry JAMES, thought by many to have been his most notable work. The interplay between the Americans Maggie Verver, Adam Verver, and Charlotte Stant and the European, Prince Amerigo, carries forward James's lifelong personal and literary concerns, while the style, structure, and insight of the book are clearly James at his best.

Golden Boy (1937), the Clifford ODETS Depression-era play, about a violinist turned prizefighter, with ultimately tragic results. On stage Luther Adler created the Joe Bonaparte role, opposite Frances Farmer, with Morris CARNOVSKY as his father. William HOLDEN made his film debut as Joe in the 1939 Rouben MAMOULIAN film version, with a cast that included Barbara STANWYCK, Lee J. COBB, Adolphe Menjou, and Joseph Calleia. Sammy DAVIS, Jr., starred on Broadway in the 1964 musical version.

Golding, William (1911–), British writer, who scored a great early success with his first novel, LORD OF THE FLIES (1954), a highly allegorical adventure story about a group of shipwrecked young people who quickly turn to savagery. The novel was adapted into the 1963 Peter BROOK film, remade in 1990 by Henry Hook. Golding's later works included the play *Brass Butterfly* (1958), *Pincher Martin* (1959), *The Hot Gates* (1965), *Rites of Passage* (1980), *The Paper Men* (1984), and *Fire Down Below* (1989). In 1983 he won a NOBEL PRIZE for literature.

Gold Rush, The (1925), Charlie CHAPLIN's comedy classic, set in Alaska during a turn-of-the-century gold rush. Chaplin, in his Little Tramp persona, was supported by Mack Swain, Tom Murray, and Georgia Hale. He produced, directed, wrote, and starred in the film.

Goldwyn, Samuel (Samuel Goldfish, 1882–1974), colorful U.S. producer, a major Hollywood figure from his 1913 co-production of *The Squaw Man*. He produced scores of films; some of the most notable were ARROWSMITH (1931), DODSWORTH (1936), WUTHERING HEIGHTS (1939), THE LITTLE FOXES (1941), THE BEST YEARS OF OUR LIVES (1946), and PORGY AND BESS (1959).

Gone with the Wind (1936), the historical novel by Margaret MITCHELL, set in the American South during the Civil War and Reconstruction and written from the Confederate point of view. It won a PULITZER PRIZE,

became a worldwide bestseller, and was the only book she ever wrote. In 1939 it was adapted by Sidney HOWARD into the four-hour-long Victor FLEMING film, one of the most popular ever made, with Clark GABLE as Rhett BUTLER, Vivien LEIGH as Scarlett O'HARA, and Leslie HOWARD, Olivia DE HAVILLAND, and Hattie McDaniel in strong supporting roles. The film, Fleming, Howard, Leigh, and McDaniel all won OSCARS.

Gonzáles, Julio (1876–1942), Spanish sculptor, a pioneering metal sculpturist. He and his brother Juan began as painters, who were befriended by Pablo PICASSO in Paris in the early 1900s; but Julio produced nothing after the death of his brother in 1908 until, with Picasso's encouragement, he began to work in welded metals in the mid-1920s. He then worked in both highly abstracted and naturalistic forms, as in *Woman Combing Her Hair* (1936); the *Cactus Man* series, the last of which appeared in 1940; and his celebrated *Montserrat* (1937), depicting a country woman and her child, his homage to the people of the Spanish Republic and their cause during the Spanish Civil War.

Good-bye, Mr. Chips (1934), the James HILTON novel, a fictional biography of a gentle British teacher. It became the 1939 Sam Wood film, with Robert DONAT winning an OSCAR in the title role opposite Greer GARSON, and with Terry Kilburn, John MILLS, and Paul HENREID in supporting roles. Herbert Ross remade it as a musical in 1969, with Peter O'TOOLE and Petula Clark in the leads.

Good Earth, The (1931), the novel about China by Pearl BUCK, the first of a trilogy that included *Sons* (1932) and *A House Divided* (1935). In 1937 it was adapted into the Sidney Franklin film, which starred Paul MUNI and Louise RAINIER, who won a best actress OSCAR for the role.

Goodfellas (1990), the Martin SCORSESE film, set in the subculture of the American Mafia; Robert DENIRO, Ray Liotta, Paul Sorvino, and Joe Pesci were the mob figures at the center of the work, and Lorraine Bracco played Liotta's wife. Nicholas Pileggi and

Scorsese wrote the screenplay, based on Pileggi's novel *Wise Guy*.

Goodman, Benny (Benjamin David Goodman, 1909–86), U.S. musician, the clarinetist and bandleader who from 1934 emerged as the "King of Swing," with his extraordinarily popular radio show "Let's Dance" and a series of dance records and national tours that defined what came to be known as the swing era. He developed the most popular JAZZ orchestra of that era, with some of the leading jazz musicians, singers, and arrangers of the period, very notably including the arrangements of Fletcher HENDERSON. Goodman also developed many smaller groups from the mid-1930s and played a major role in integrating jazz from 1936, beginning with a quartet that included Goodman, Lionel HAMPTON, Gene KRUPA, and Teddy Wilson. Goodman, who played a significant role in taking jazz into the concert hall, was also a classical musician, appearing with symphony orchestras and recording classical works from the late 1930s.

"Goodnight Irene," a song associated with THE WEAVERS, and extremely popular in their 1950 version; words and music were by LEADBELLY.

"Good night, Mrs. Calabash, wherever you are," Jimmy DURANTE's exit line.

Good Soldier Schweik, The (1920–23), the four-volume satire by Czech novelist Jaroslav HASEK, in which his Schweik becomes a kind of 20th-century Everyman, powerless and yet able to triumph over a huge modern bureaucratic system.

Gordimer, Nadine (1923–), South African writer, most of whose work is set in South Africa. Her work is informed by her deep understanding of the impact of racism on the lives of all South Africans, while focusing on personal matters, dilemmas, and often agonies, rather than on directly political questions. Her many volumes of short stories began with *Face to Face* (1949) and *The Soft Voice of the Serpent* (1951) and include *Friday's Footprints* (1960), *Not for Publication* (1965), *Livingstone's Companions* (1972), and *A Soldier's Embrace* (1980). Some of her best known novels are *The Lying Days* (1953), *A World of Strangers* (1958),

Occasion for Loving (1963), *The Late Bourgeois World* (1966), *Guest of Honor* (1970), *The Conservationist* (1974), *Burger's Daugher* (1979), and *A Sport of Nature* (1987).

Gordon, Dexter (1923–90), U.S. JAZZ saxophonist, who began his career with Lionel HAMPTON's band in 1940 and became a leading BOP saxophonist of the immediate post-World War II period. He spent much of the 1950s in jail, on drug-related charges, but emerged as a leading Copenhagen-based European jazz figure from the early 1960s through the early 1980s. He reemerged to star as the declining, alcoholic jazz saxophonist in the film ROUND MIDNIGHT (1986).

Gorky, Arshile (Vosdanig Adoian, 1905–48), Armenian-American painter, who emerged as a substantial American surrealist (see SURREALISM) and Abstract Expressionist (see ABSTRACT EXPRESSIONISM) in the early 1940s, after having worked derivatively and in several styles from the mid-1920s. Gorky worked with the FEDERAL ARTS PROJECT in the late 1930s, producing a large mural for Newark Airport, and in the 1940s painted such works as *Garden in Sochi* (1941) and *The Water of the Flowery Hill* (1944).

Gorky, Maxim (Aleksei Maksimovich Peshkov, 1868–1936), Russian writer and revolutionary, a central figure in the development of 20th-century Soviet literature. He first gained recognition for the short story "Chelkash" (1895), the first of his many works about the people at the bottom of the Russian social structure, collected in the first of his several volumes of short stories (1898). His early novels include *Foma Gordeyev* (1899); *The Three of Them* (1900); *Comrades* (1906); and his best-known novel, MOTHER (1911), which in 1926 became the classic Vsevolod PUDOVKIN film and was adapted by Bertolt BRECHT for the theater in 1931. His later novels include *The Artamonov Business* (1925) and the four-volume *The Life of Klim Samghin* (1927–36). He also wrote many plays; his classic is THE LOWER DEPTHS (1902), a theater piece about the people "at the bottom," a phrase sometimes used as an alternate title. Another major work is his three-volume autobiography, *My Childhood* (1914), *In the World* (1916), and *My*

Universities (1923). Although often seen as the leading writer of the early Soviet period, Gorky spent the years 1918–28 abroad, then returning, and in 1934 became the first president of the Soviet Writers' Union. The cause of his death became a matter of controversy afterward, the Soviet government claiming that it had been engineered by antigovernment former leaders later executed in the Great Purge of the late 1930s, while some observers believed that it had been ordered by Josef Stalin.

Gossett, Louis, Jr. (1936–), U.S. actor, who emerged as a major Black figure with his EMMY-winning lead as Fiddler in ROOTS (1977). He won a best supporting actor OSCAR for *An Officer and a Gentleman* (1982), played the lead in the television series "The Lazarus Syndrome" (1979), and played leads and strong character roles in several other films and teleplays, including *Backstairs at the White House* (1979), *Sadat* (1983), and *Firewalker* (1986).

Go Tell It on the Mountain (1953), the largely autobiographical first novel by Black novelist James BALDWIN, rooted in his formative years in Harlem and in his pivotal relationship with his minister father.

Gottlieb, Adolph (1903–74), U.S. painter, who in the 1940s emerged as a leading Abstract Expressionist (see ABSTRACT EXPRESSIONISM), most notably with his *Pictograph* series (1941–51), which were succeeded by the abstract *Landscapes* and *Bursts* series of the 1950s, the latter series also often called "cosmic landscapes."

Gould, Chester (1900–85), U.S. cartoonist, who in 1931 created the long-running comic strip DICK TRACY, featuring the prototypical detective hero opposite a menagerie of criminal grotesques.

Gould, Elliott (Elliott Goldstein, 1938–), U.S. actor, on stage in the 1950s; he played on Broadway in I CAN GET IT FOR YOU WHOLESALE (1962) and *Little Murders* (1967) before briefly emerging as a leading film star in BOB AND CAROL AND TED AND ALICE (1969); *Getting Straight* (1970); M*A*S*H (1970); *The Touch* (1971); *Little Murders* (1971); and *The*

Long Good-bye (1972), as Philip MARLOWE. His later work has been considerably less effective.

Gould, Glenn (1932–82), Canadian pianist, a child prodigy who was a soloist with the Toronto Symphony Orchestra at 14. He was a powerful, often innovative interpreter of Bach and the Romantics and a prolific recording artist, who reached large worldwide audiences in scores of recordings. He retired from the concert stage very early, in 1964, but continued to record.

Grable, Betty (Elizabeth Ruth Grable, 1916–73), U.S. actress, on screen from 1930, who after a decade of supporting roles in B movies became a star in such film musicals as *Tin Pan Alley* (1940) and *Moon over Miami* (1941). Her popularity continued during the early postwar period but waned in the early 1950s.

Graduate, The (1967), the Mike NICHOLS film comedy, with Dustin HOFFMAN in the role of the innocent just out of school; Anne BANCROFT as the older woman with whom he has an affair; and Katharine ROSS as her daughter, with whom he falls in love. Calder Willingham and Buck Henry based their screenplay on the Charles Webb novel. Nichols won an OSCAR for his direction, as did SIMON AND GARFUNKEL for the score.

Graham, Martha (1893–91), U.S. dancer, choreographer, and teacher, on stage as a dancer with the Denishawn company from 1916 to 1923, and with the Greenwich Village Follies from 1923 to 1924. She founded the Martha Graham School of Contemporary Dance in 1927 and her own company in 1929. During the next six decades she became a dominant force in American MODERN DANCE, choreographing well over 150 works, most of them thematic works based on a wide range of American and classical subjects, and training much of three generations of American modern dancers. A few of her best-known works are *Primitive Mysteries* (1931), *American Document* (1938), APPALACHIAN SPRING (1944), *Night Journey* (1947), *Clytemnestra* (1958), and *Phaedra* (1962). She continued to create new works into the 1980s.

Grainger, Percy (1882–1961), Australian-American composer, pianist, conductor, teacher, and musicologist. He was a notable British folk-song collector until 1914, then continuing his work in the United States, and in 1935 established the Grainger museum of Australian music in Melbourne. As a composer he is best remembered for such works as *Molly on the Shore* and *Mock Morris*, part of a very large body of work greatly influenced by folk themes.

Grammys, The, from 1958, the annual music awards of the National Academy of Recording Arts and Sciences. Scores of artistic and technical awards are made each year, among them record of the year, album of the year, song of the year, and best male and best female vocalist.

Granados, Enrique (1867–1916), Spanish composer and pianist, whose songs and Spanish dances played a considerable role in developing a distinctive national style. His major work was the piano suite *Goyescas* (1913), a thematic approach to Francisco Goya's works. Granados adapted the suite into the 1916 opera, which opened at the Metropolitan Opera; he died while returning to Europe that year, when his ship, the *Sussex*, was sunk by a German submarine.

Grand Hotel (1932), the Edmund Goulding film, set in a Berlin hotel and one of the first to feature many film stars and vignettes standing almost alone, save for a very tenuous plot line joining them, an approach that would become very familiar in the decades ahead. Among those in the large cast were Greta GARBO, John BARRYMORE, Lionel BARRYMORE, Joan CRAWFORD, Wallace BEERY, Lewis Stone, and Jean Hersholt. William A. Drake adapted the Vicki Baum novel. A musical version of *Grand Hotel* was produced on Broadway in 1989; Luther Davis based the book on the Baum novel, Robert Wright and George Forrest wrote the score, and Tommy Tune won TONYs for direction and choreography.

Grand Illusion, The (1937), the classic Jean RENOIR antiwar film, made when Europe was on the brink of yet another world war, about the escape of French prisoners from a German

prisoner-of-war camp during World War I. It reflected the widely held pacifist interwar view that a common humanity was capable of transcending nationalism. Jean GABIN, Erich von STROHEIM, Pierre Fresnay, Marcel Dalio, and Dito Parlo played key roles.

Grand Ole Opry (1925–), the classic Nashville-based country-music show, on the air from the early days of radio right into the 1990s and carrying such regular performers as Minnie Pearl, Hank SNOW, Roy ACUFF, and June CARTER. A television version aired briefly in 1955–56.

Granger, Stewart (James Stewart, 1913–), British actor, on screen from 1933, who became a leading romance-adventure star in the 1940s. A few of his many films are *Waterloo Road* (1944), CAESAR AND CLEOPATRA (1945), *Captain Boycott* (1947), *King Solomon's Mines* (1950), *Scaramouche* (1952), and *Bhowani Junction* (1956).

Grant, Cary (Archibald Alexander Leach, 1904–86), British actor, in variety from 1917 and on screen from 1932, who emerged as a star in the late 1930s, in such comedies as *Topper* (1936), *The Awful Truth* (1937), HOLIDAY (1938), *Bringing Up Baby* (1938), and THE PHILADELPHIA STORY, then going on to play a considerable range of leads in such films as *Suspicion* (1941), *Arsenic and Old Lace* (1944), *Night and Day* (1946), MR. BLANDINGS BUILDS HIS DREAM HOUSE (1948), NORTH BY NORTHWEST (1959), and *Charade* (1963).

Grant, Lou, the tough-talking, socially conscious newspaper editor played by Edward ASNER in television's THE MARY TYLER MOORE SHOW (1970–77), a role and stance he transferred to his own dramatic series, THE LOU GRANT SHOW (1977–82).

Grapes of Wrath, The (1939), the John STEINBECK novel, which powerfully told the story of the "Okies," the dust-bowl farmers forced to become migrants in the late 1930s. A moving, extraordinarily effective work of social protest, it was adapted by Nunnally Johnson into the classic 1940 John FORD film, with Henry FONDA, Jane DARWELL, and John CARRADINE in key roles. Ford won best director OSCAR; Darwell won a best support-

ing actress Oscar. Frank Gelati adapted the novel into the TONY-winning 1990 play, directing a cast led by Terry Kinney, Gary Sinise, and Lois Smith.

Grass, Günter (1927–), German writer, who emerged as a major postwar literary figure with his first novel, THE TIN DRUM (1959), a powerful, bitter satire of Nazi Germany before and during World War II. His *Cat and Mouse* (1961) and the massive *The Dog Years* (1963) completed the Danzig trilogy, by far his best-known work. His later novels include *Local Anaesthetic* (1970), *From the Diary of a Snail* (1972), and *The Rat* (1987). He also wrote several plays and published several volumes of poetry, illustrating some of them himself. *The Tin Drum* became the OSCAR-winning 1979 Volker Schlondorff film, with 12-year-old David Bennent in the dwarf's role.

Grateful Dead, The, U.S. rock band, formed in 1965 by Jerry Garcia (1942–), Bob Wier (Robert Hall, 1947–), Ron McKernan (1945–73), Phil Lesh (Philip Chapman, 1940–), and Bill Kreutzmann (1946–). The San Francisco-based band was in its early years a psychedelically oriented Haight-Ashbury blues-folk-rock group. It became and has remained a highly improvisational touring group, playing largely to an established body of supporters, the "Deadheads." A few of its best-known albums are *Live Dead* (1970), *Workingman's Dead* (1970), *American Beauty* (1970), and *The Grateful Dead* (1971).

Graves, Peter (Peter Aurness, 1925–), U.S. actor, best known for his leading role in the television series "Mission Impossible" (1966–72). On screen from 1950, he played largely in supporting roles, in such films as STALAG 17 (1953) and *Airplane* (1980) and in such television films as *The Underground Man* (1974) and THE WINDS OF WAR (1983). He is brother of actor James ARNESS.

Graves, Robert Ranke (1895–1985), British writer, a leading poet for six decades, from the publication of his first volume of wartime poems, *Over the Brazier* (1916), and through many volumes of collected poems. He is best known for such historical novels as *I, Claudius* (1934), *The Golden Fleece* (1943), and *King*

Jesus (1946). His critical work includes *The White Goddess* (1958) and his translation of and comments on *The Greek Myths* (1955). *I, Claudius* was the basis of the 1977 television serial, starring Derek JACOBI.

Gray, Harold Lincoln (1894–1968), U.S. cartoonist, the creator of the enormously popular, widely syndicated comic strip LITTLE ORPHAN ANNIE (1924). The strip was the basis of the long-running Broadway musical ANNIE (1977), which was adapted into the 1982 John HUSTON film.

Gray, Simon James Holliday (1936–), British writer, primarily a playwright and novelist. He is best known for such plays as BUTLEY (1971), which became Harold PINTER's 1974 film, with Alan BATES and Jessica TANDY in leading roles; *Otherwise Engaged* (1975); *Common Pursuit* (1984); and *Melon* (1987). He also wrote such screenplays as *After Pilkington* (1987) and *A Month in the Country* (1988).

Grease (1972), the long-running Broadway musical, a nostalgic look at some aspects of the youth culture of the 1950s; Jim Jacobs and Warren Casey wrote the book and score. It was adapted into the 1978 film musical, starring John TRAVOLTA and Olivia NEWTON-JOHN and directed by Randal Kieser. *Grease 2*, directed by Patricia Birch, who had choreographed the first film, was the 1982 sequel.

Great Dictator, The (1940), the classic antifascist satire; Charles CHAPLIN wrote, directed, and starred, playing the dual roles of a Jewish barber and Adenoid Hynkel, a broad caricature of Adolf Hitler that soon proved less grotesque and brutal than the real man. Chaplin was supported by Jack Oakie, caricaturing Mussolini, as well as by Paulette GODDARD, Reginald Gardner, Henry Daniell, and Billy Gilbert.

Great Expectations (1946), David LEAN's version of the Dickens classic, the most notable of the several film versions, with a cast led by John MILLS and including Finlay CURRIE, Valery Hobson, Jean SIMMONS, Alec GUINNESS, Bernard Miles, and Martita Hunt.

Great Gatsby, The (1925), the novel by F. Scott FITZGERALD, which became emblematic of the dissipated life lived by some of the more opulent members of the "flaming youth" movement of the 1920s, decidedly including the Fitzgeralds themselves. The novel became the 1926 play and was filmed three times, most notably in 1974, as adapted by Francis Ford COPPOLA into the Jack Clayton film, with Robert REDFORD in the Gatsby role.

Great Train Robbery, The (1903), the first American feature film and the first Western. It was made by Edwin M. Porter and ran a little less than 12 minutes, in contrast to the Nickelodeon shorts of the time, which commonly ran about one minute. Viewed in isolation, it is a short film of little intrinsic merit, but it is a landmark in the history of 20th-century culture.

Great White Hope, The (1968), the TONY-winning Howard SACKLER play, a hit on Broadway, with James Earl JONES also winning a Tony for his portrayal of Black heavyweight champion Jack Jefferson and with Jane ALEXANDER as Ellie, his White lover; the work was based on the life of Jack Johnson. Both re-created their roles in the 1970 Martin RITT film, heading a cast that included Moses Gunn, Hal Holbrook, Beah Richards, and Lou Gilbert.

Great Ziegfeld, The (1936), Robert Z. Leonard's film biography of Florenz ZIEGFELD, with William POWELL in the title role, playing opposite Myrna LOY as Billie Burke and Louise RAINIER as Anna Held, in a cast that included Fannie BRICE, Ray BOLGER, Frank Morgan, and Virginia Bruce. The film won a best picture OSCAR and Rainier a best actress Oscar.

Greed (1924), the Erich von STROHEIM film, based on the 1899 Frank Norris novel *McTeague*, with Gibson Gowland as McTeague, ZaSu Pitts as the wife he murders for her money, and Jean Hersholt as his ultimately fatal enemy. Von Stroheim made a film 10 hours long, immensely overlong for his day, but lost control of the work, which was later cut down to 2.5 hours by others, for commercial release. The original film, now lost, is a legend; the commercial version, disowned by

von Stroheim, is regarded by many as a classic silent film.

Green, Paul (1894–1981), U.S. playwright, often on southern populist and Black themes, who published several collections of his one-act plays in the early 1920s. His first full-length play was the PULITZER PRIZE-winning *In Abraham's Bosom* (1926), which was produced by the PROVINCETOWN PLAYERS. His best-known works include *The House of Connelly* (1931), the first play produced by the GROUP THEATRE; the pacifist musical play *Johnny Johnson* (1936), with music by Kurt WEILL; and NATIVE SON (1941), a dramatization of the Richard WRIGHT novel.

Greene, Graham (1904–91), British writer, among the most notable novelists of the century, whose works reflect deep moral concerns. Among his best-known novels are *The Power and the Glory* (1940), *The Heart of the Matter* (1948), *Our Man in Havana* (1959), *The Honorary Consul* (1973), and *The Human Factor* (1978).

Green Pastures, The (1930), the long-running PULITZER PRIZE-winning play by Marc CONNELLY, based on the Roard Bradford stories; an epic based on Bible themes as seen through Black American eyes, with an all-Black cast led by Richard B. Harrison as The Lord. Connelly adapted the play into the 1936 film, which he codirected.

Greenstreet, Sydney (1879–1954), British actor, on stage from the turn of the century through the next four decades as a durable and versatile character actor. He is best known for his first film role, as Kasper Gutman in THE MALTESE FALCON (1941). He went on to play strong second leads, usually as some species of villain, in such films as *Across the Pacific* (1942), CASABLANCA (1942), *Background to Danger* (1942), *The Mask of Dimitrios* (1944), *The Hucksters* (1947), and *Malaya* (1950).

Greenwood, Joan (1921–87), British actress, on stage from 1938 and on screen from 1940, in such films as *The October Man* (1947), TIGHT LITTLE ISLAND (1949), KIND HEARTS AND CORONETS (1949), THE MAN IN THE WHITE SUIT (1950), *The Importance of Being Earnest* (1952), *Moonfleet* (1955), and TOM JONES (1963).

Grey, Zane (1872–1939), U.S. writer, a prolific and extremely popular author of adult and children's novels, best known for his more than 50 Western novels, many of them adapted into what became hundreds of films. His most popular novel was *The Riders of the Purple Sage* (1912), done as a film three times, most notably as a Tom Mix vehicle in 1925.

Grey Fox, The (1982), the Philip Borsos film, a gentle Western about an old-time stagecoach robber who enjoys a brief career as a train robber in the Canadian Northwest after spending decades in jail. Richard FARNSWORTH was Bill Minor, the real person at the heart of the story; the cast included Jackie Burroughs, Wayne Robson, and Timothy Webber.

Greystoke: The Legend of Tarzan, Lord of the Apes (1984), the most recent but probably not the last of the Tarzan films, directed by Hugh Hudson. The cast included Christopher Lambert as Tarzan, Ralph RICHARDSON in his last screen role, Ian HOLM, Ian CHARLESON, James Fox, Christopher Lambert, and Cheryl Campbell.

Grierson, John (1898–1972), British director and producer, a founder of the British documentary-film movement, who profoundly influenced the development of nonfiction film. He organized the pioneering Empire Marketing Board film unit in 1928, moved his group to the General Post Office in 1933, and in the period 1928–37 developed a group of documentary filmmakers that produced hundreds of documentaries, including the classics *The Song of Ceylon* (1935) and *Night Mail* (1936). He was Canadian film commissioner from 1939 to 1945, continuing his work during the post-war period in the United States and from 1947 with the United Nations.

Griffith, D.W. (David Lewelyn Wark Griffith, 1875–1948), pioneering U.S. director and producer, a central figure in the development of film as an art form. He worked in the theater as an unsuccessful actor and writer from 1897, moved into films as an actor in 1907, and from 1908 to 1913 was director and then production head at Biograph, personally directing hundreds of one- and two-reelers, innovatively working with cinematographer Billy BITZER,

and developing a body of early screen stars, including Mary PICKFORD and Lillian GISH. His epic THE BIRTH OF A NATION (1915) was a landmark in film history; it was also a film widely attacked as anti-Black and encouraging race hatred. His next epic was INTOLERANCE (1916), a massive, commercially unsuccessful pro-tolerance film that for its technical side was equally important in film history. His later films include BROKEN BLOSSOMS (1919), *Way Down East* (1920), and the epic ORPHANS OF THE STORM (1922).

Gris, Juan (José Victoriano González, 1887–1927), Spanish artist, a CUBIST who with his colleagues Pablo PICASSO and George BRAQUE worked with paper collage from 1912 and extended cubist theory to include the conscious development of structural composition of the picture. The extended theory was called "synthetic cubism."

Gropius, Walter (1883–1969), German architect, designer, and teacher, who became a major influence on the development of 20th-century design as director of the Weimar BAUHAUS (1919–28). Upon becoming director, he initiated a reorganization and major redirection of the existing art schools at Weimar. Then, with a faculty and student body that included architects, designers, painters, and sculptors, many of them at the time or later world figures, such as Marcel BREUER, Paul KLEE, Wassily KANDINSKY, and his successor, Ludwig Mies VAN DER ROHE, he led in the development of the consciously ahistorical, smooth, featureless, machine-oriented forms that were to dominate modern design and produce the INTERNATIONAL STYLE during the next several decades. He moved the Bauhaus to Dessau in 1925, there designing the new school building, which became his most notable work. After leaving the school in 1928 he practiced architecture in Germany, fled the Nazis in 1934, practiced in Britain, and emigated to the United States in 1937. He taught architecture at Harvard from 1937 to 1952, and in that period was greatly influential in introducing Bauhaus thinking into American architecture and design.

Grosz, George (1893–1959), German artist, an art student and caricaturist before World War

I. After war service (1914–16) he became a bitterly antiwar caricaturist; later in the war he was recalled but was ultimately institutionalized. He emerged after the war as a powerful, effective left social critic whose caricatures, collected in such works as *The Face of the Ruling Class* (1921) and *Ecce Homo* (1927), sharply attacked the rich and powerful during the Weimar period. He fled the Nazis and in 1933 resettled in the United States, continuing as a major critical voice from the left, but with far less virulence than that displayed in his German work. He died a few weeks after returning to Berlin in 1959.

Grotowski, Jerzy (1933–), Polish experimental director and teacher, who founded the Theatre Laboratory in 1965 and then toured with it throughout the world, developing his variation on the acting method of Constantin STANISLAVSKY, and stressing the primacy of the actor within a physically stripped-down theater.

Group of Seven, the group of Canadian northern landscape painters who exhibited together from 1920 to 1931, and who began to form around James MACDONALD and Lawren HARRIS from 1911 to 1912. It early included Canada's greatest landscape painter, Tom THOMSON, who died in 1917, and Alexander JACKSON, Arthur Lismer, Frederick Varley, Franklin Carmichael, and Frank Johnston.

Group Theatre (1931–41), U.S. repertory company organized in 1931 by Harold CLURMAN, Lee STRASBERG, and Cheryl CRAWFORD, as a Constantin STANISLAVSKI-oriented company dedicated to developing a theater of left political commitment. Its first play was *The House of Connelly* (1931); later plays included *Men in White* (1933), *Awake and Sing!* (1935), *Waiting for Lefty* (1935), GOLDEN BOY (1937), and *My Heart's in the Highlands* (1937). The company fostered the talents of many who became leading players and writers in theater and films, including Clifford ODETS, Elia KAZAN, John GARFIELD, and Franchot TONE.

Guare, John (1938–), U.S. writer, whose work was on stage from 1966. He is best known for the *The House of Blue Leaves*

(1970), a black comedy about a papal visit to New York; *The Landscape of the Body* (1977); and *Six Degrees of Separation* (1990).

Guernica, Pablo PICASSO's huge, landmark painting, done for the Spanish Pavilion at the 1937 Paris Exposition and inspired by the destruction of the Basque town of Guernica, an entirely defenseless, nonmilitary target in northern Spain, on April 28, 1937, by Nazi bombers during the Spanish Civil War. The bombing, taken as an augury of the wars and further massacres that would soon follow, generated worldwide protests. The Alain RESNAIS's *Guernica* (1950) was a brief art film on Picasso, with the painting as its centerpiece and with commentary by Paul Éluard.

Guerre Est Finie, La (The War Is Over, 1966), the Alain RESNAIS film, written by Jorge Semprun and shot by Sacha Vierny; a complex, multilayered work about a left Spanish Republican underground leader who continues his fight against Spanish fascism long after the Spanish Civil War has been lost, although increasingly doubtful about his own relevance and that of his corevolutionaries. The cast is led by Yves MONTAND, with Ingrid Thulin and Genevieve BUJOLD in key roles.

Guess Who's Coming to Dinner (1967), the Stanley KRAMER film, about two liberal White parents fully coming to terms with their daughter's proposed interracial marriage. Katharine HEPBURN won an OSCAR as Christina Drayton, opposite Spencer TRACY as Matt Drayton, who ultimately blesses the union; it was Tracy's last film. Sidney POITIER was the superachieving Black protagonist of the piece, and Katharine Houghton (Hepburn's real-life daughter) the daughter, in a cast that included Isabell Sanford, Beah Richards, and Roy E. Glenn, Sr. William Rose won an OSCAR for his screenplay.

Guggenheim, Solomon Robert (1861–1949), U.S. industrialist who became a leading art collector, focusing especially on modern art, and who in 1939 founded New York's Guggenheim Museum, originally named the Museum of Non-Objective Painting, and commissioned the museum structure, designed by Frank Lloyd WRIGHT and finished in 1959. His

brother Simon established the Guggenheim Fellowships program. His niece **Peggy Guggenheim** (1898–1979) was a leading modern-art collector.

Guillén, Nicolás (1902–89), Cuban writer and diplomat, who from the early 1930s was a leading figure in the Black poetry movement, which sought to infuse Afro-Cuban rhythms into Cuban poetry. He was also Cuba's leading poet of social protest, from his collection *West Indies Ltd.* (1934). His work became increasingly political as he moved more directly into left politics, beginning with his collection *España* (1937), reflecting his experience as a war correspondent during the Spanish Civil War. During the Castro era he was the leading poet of Communist Cuba, and his later work reflected his direct commitment. From 1961 he was president of the Cuban Union of Artists and Writers.

Guinness, Alec (1914–), British actor, on stage from 1934, from 1937 in strong supporting classical roles, and from 1946 in the considerable range of modern and classic stage plays that during the next four-plus decades would take him from *Hamlet* through *Macbeth* and from Ionesco to John Mortimer. In 1946 he began his extraordinarily versatile screen career with GREAT EXPECTATIONS, then going on to such films as OLIVER TWIST (1948); KIND HEARTS AND CORONETS (1949); THE LAVENDER HILL MOB (1951); THE BRIDGE ON THE RIVER KWAI (1957), for which he won best actor OSCAR; TUNES OF GLORY (1960); LAWRENCE OF ARABIA (1962); DOCTOR ZHIVAGO (1965); STAR WARS (1976); A PASSAGE TO INDIA (1984); and *A Handful of Dust* (1988). He also created the George SMILEY role in the television miniseries "Tinker Tailor Soldier Spy" (1979) and "Smiley's People" (1982), based on John LE CARRÉ's novels.

Guitry, Sacha (Alexander Pierre George Guitry, 1885–1957), French writer, actor, and director, the son of actor Lucien Guitry and one of the most prolific and popular figures in the 20th-century French theater. His work includes approximately 130 light plays, beginning with *Le Page* (1902). He also made 30 films, most of them adaptations of his own

plays; he directed and appeared in most of his plays and films.

Gulag Archipelago, The (three volumes, 1973–1975), Alexander SOLZHENITSYN's classic portrayal of the Soviet prison and labor camp system, before and during the Stalin era. It was refused publication in the Soviet Union; its ultimate publication abroad caused the author's expulsion from that country.

Gunfight at the O.K. Corral (1957), the classic, myth-filled Earp–Clanton confrontation, directed by John Sturges and featuring Burt LANCASTER as Wyatt Earp and Kirk DOUGLAS as Doc Holliday. The equally classic and somewhat earlier John FORD version was MY DARLING CLEMENTINE (1946), featuring Henry FONDA as Earp and Victor Mature as Holliday.

"Gunsmoke" (1952–75), the prototypical realistic Western series, which began on radio in 1952, the same year that Gary COOPER made his reluctant sheriff in HIGH NOON a rather antiheroic Western hero. William Conrad created the Matt Dillon role in the 1952–61 radio version. James ARNESS created the role and played it for 20 years in the 1955–75 television version, which became television's most-watched series in the late 1950s and a long-term worldwide hit.

Guston, Philip (1913–80), U.S. artist; in the late 1930s he was a muralist with the FEDERAL ARTS PROJECT, working figuratively, though in a somewhat abstract manner. This style gave way in the late 1940s to the highly colored, considerably abstract approach that dominated his work until the early 1970s. In the 1970s much of his work reflected sharp social criticism, some of it in a near-cartoon style.

Guthrie, A.B. (Alfred Bertram Guthrie, (1901–), U.S. writer, best known for his first two novels, both on Western themes: *The Big Sky* (1947), which Dudley Nichols adapted into the 1952 Howard HAWKS film of that name, with Kirk DOUGLAS in the lead; and his PULITZER PRIZE-winning *The Way West* (1949), which was the basis of the 1967 Andrew McLaughlin film of that name, with Kirk DOUGLAS, Robert MITCHUM, and Richard WIDMARK in

the leads. *These Thousand Hills* (1956) was the basis of the 1959 Richard Fleischer film of that name, with Don Murray in the lead; it completed Guthrie's Western trilogy, although several of his other works were also on Western themes.

Guthrie, Tyrone (1900–71), British director and actor, on stage as an actor from 1924 and as a director from 1931. During the 1930s and 1940s he directed a considerable range of classics, though focusing on Shakespeare and including the 1937 Laurence OLIVIER *Hamlet*, followed by a 1938 modern-dress Alec GUINNESS *Hamlet*. He was a prime mover in the creation of the Stratford (Ontario) Festival Theatre and was its chief director from 1953 to 1957. From 1963, in Minneapolis, he developed the Guthrie Theater, which became a major American regional theater.

Guthrie, Woody (Woodrow Wilson Guthrie, 1912–67), U.S. folksinger, composer, and guitarist, the archetypal wandering American folksinger-activist of the Great Depression. Two of the best-known of his more than 1,000 songs are "So Long, It's Been Good to Know

Forever linked with the Depression—folksinger Woody Guthrie during the 1930s.

You" (1939) and "This Land Is Your Land" (1956). David Carradine played Guthrie in the 1976 Hal ASHBY film biography BOUND FOR GLORY. Guthrie was the father of folksinger and composer **Arlo Guthrie,** best known for his song-story ALICE'S RESTAURANT.

Guys and Dolls (1950), the long-running, TONY-winning Broadway musical, based on the Damon Runyon New York short stories, with words and music by Frank LOESSER and book by Jo Swerling and Abe Burrows; Sam Levene created the Nathan Detroit role, Robert Alda won a best actor TONY as Sky Masterson, Isabel Bigley was Sister Sarah, and Vivian Blaine was Adelaide. Joseph L. MANKIEWICZ wrote and directed the 1955 film, which starred Frank SINATRA, Marlon BRANDO, and Jean SIMMONS, in a cast that included Vivian Blaine, Stubby Kaye, Sheldon Leonard, and Robert Keith.

Gwenn, Edmund (1875–1959), British actor, who was and still is Santa Claus to many millions of viewers every Christmas, on replay of THE MIRACLE ON 34TH STREET (1947); he won a best supporting actor OSCAR in the role. Gwenn was on stage in Britain from the turn of the century and on screen from 1916; he became a leading Hollywood character actor in the late 1930s, appearing in such films as *Anthony Adverse* (1936), PRIDE AND PREJUDICE (1940), THE KEYS OF THE KINGDOM (1945), OF HUMAN BONDAGE (1946), *Mister 880* (1950), and *The Trouble with Harry* (1955).

Gypsy (1959), the long-running Stephen SONDHEIM–Jule STYNE musical, based on the Gypsy Rose LEE autobiography, adapted for the stage by Arthur LAURENTS. Ethel MERMAN created the central character of Rose, who ultimately pushes her daughter Louise into stardom as burlesque star Gypsy Rose Lee; Sandra Church was Gypsy. In the 1962 Mervyn LEROY film Rosalind RUSSELL was Rose, in a cast that included Natalie WOOD, Betty Bruce, and Karl MALDEN. Angela LANSBURY won a TONY as Rose in the 1973 Broadway revival. Laurents directed the 1989 Broadway revival; Tyne Daly also won a Tony for her Rose.

H

Hackman, Gene (1930–), U.S. actor, on screen from 1961, who played character roles in such films as BONNIE AND CLYDE (1967) and *I Never Sang for My Father* (1970) before becoming a star in his best actor OSCAR-winning role as Popeye Doyle in THE FRENCH CONNECTION (1971). He went on to star in such films as *The Conversation* (1972), *The French Connection II* (1975), *Night Moves* (1976), MISSISSIPPI BURNING (1988), *Loose Cannons* (1990), and *Narrow Margin* (1990).

Haggard, Merle (1937–), U.S. country singer and composer, who in the mid-1960s emerged as a major figure in country music, with such songs as "The Fugitive," "The Bottle Let Me Down," and "Swinging Doors," all in 1967; and for such late-1960s Vietnam-era patriotic songs as "Okie from Muskokie" and "The Fightin' Side of Me." He continued to be a very popular country singer and composer into the early 1990s, also appearing in films and television.

Hagman, Larry (1931–), U.S. actor, best known by far for his role as the villainous J.R. Ewing in DALLAS. He was also a lead in television's "I Dream of Jeannie" (1965–70) and played many strong supporting roles in films and on television. He is the son of actress Mary MARTIN.

Hair (1967), the long-running rock musical; Gail MacDermott wrote the music, with book and lyrics by Gerome Ragni and James Rado. Michael Weller adapted the play into the 1979 Milos FORMAN film, with a cast that included John Savage, Treat Williams, Beverly D'Angelo, Annie Golden, and Dorsey Wright.

Haley, Alex (1921–), U.S. writer, a journalist and novelist who worked with Malcolm X on *The Autobiography of Malcolm X* (1965) and is best known for his exploration of his own African-American ethnic origins, traced from slavery days through seven American generations, in the PULITZER PRIZE-winning ROOTS (1976). The book became the record-breaking 12-hour television miniseries in 1977; a 12-hour sequel was broadcast in 1979.

Hall, Peter Reginald Frederick (1930–), British director and producer, in the theater from 1953 and a major director from 1955, when he directed WAITING FOR GODOT in London. He was managing director of the ROYAL SHAKESPEARE COMPANY from 1960 to 1968 and was co-director of the National Theatre from 1973 to 1988. In addition to the classics, his work has included the direction of such modern classics as *The Homecoming* (1965) and its 1973 film adaptation; *No Man's Land* (1975); AMADEUS (1979); and *Orpheus Descending* (1989). From the early 1970s he also directed several operas. In 1990 he directed the film *She's Been Away*.

Hallmark Hall of Fame (1952–55), the television anthology series; its title became the umbrella name for a series of television "specials" in the decades that followed. Strongly oriented toward the classics, it produced a good deal of Shakespeare, Ibsen, and Shaw, as well as many modern classics, and cast many of the leading players of the day.

Hamlet, the classic Shakespearean play, a staple in the world repertory; the play has been produced in many media and forms during the century. Perhaps the most enduring of all the productions is the 1948 Laurence OLIVIER film; he produced, directed, played Hamlet, and with Alan Dent wrote the screenplay. The film won a best picture OSCAR, as did Olivier in the title role, in a cast that included Felix

Aylmer, Basil Sydney, Eileen Herlie, Jean SIMMONS, and Stanley HOLLOWAY. Roger K. Furse won an Oscar for his art direction and costumes, as did Carmen Dillon for her sets.

Hammerstein, Oscar, II (1895–1960), U.S. lyricist and librettist, grandson of impresario Oscar Hammerstein. From the 1920s through the late 1950s, he collaborated on a large number of the most enduring landmarks of the American musical theater and wrote the lyrics of hundreds of memorable songs, in such works as SHOW BOAT (1927), written with Jerome KERN; *The Desert Song* (1926) and *The New Moon* (1928), written with Sigmund ROMBERG; and the extraordinary run of nine musicals written with Richard RODGERS from 1943 to 1959, which includes such classics as OKLAHOMA! (1943), CAROUSEL (1945), SOUTH PACIFIC (1949), and THE SOUND OF MUSIC (1959).

Hammett, Dashiell (Samuel Dashiell Hammett, 1894–1961), U.S. writer, a former Pinkerton detective whose short stories and novels greatly influenced the development of the mystery genre. He was the creator of the prototypical tough, cynical private detective in the persons of the Continental Op, Sam SPADE, and Nick CHARLES. He wrote five novels, including *Red Harvest* (1929); *The Dain Curse* (1929); THE MALTESE FALCON (1930), which was filmed several times, most notably as the classic John HUSTON film in 1941, with Humphrey BOGART as Sam Spade; *The Glass Key* (1931), on film in 1935 and 1942; and THE THIN MAN (1932), which in 1934 became the first of the six *Thin Man* films, with William POWELL and Myrna LOY in the Nick and Nora Charles roles. Hammett collaborated on many screenplays during the 1930s and early 1940s and adapted the play WATCH ON THE RHINE (1941), by his longtime companion Lillian HELLMAN, into the 1943 film. During the McCarthy period Hammett was imprisoned for defying the House Un-American Activities Committee; Hellman later wrote about Hammett and that period in her autobiographical *Scoundrel Time* (1976).

Hammond, John Henry (1910–87), U.S. record producer, who from the early 1930s played a central role in introducing JAZZ and many of the key musicians who played it into the mainstream of American music. Among the scores of musicians he "discovered" and recorded in the 1930s were such figures as Fletcher HENDERSON, Billie HOLIDAY, and Count BASIE; decades later he found Aretha FRANKLIN, Bruce SPRINGSTEEN, and Bob DYLAN. His pioneering "From Spirituals to Swing" concerts at CARNEGIE HALL (1938–39) brought jazz, BLUES, and integrated groups of musicians into American concert halls. He was the father of blues singer John Paul Hammond.

Hampshire, Susan (1942–), British actress, best known abroad for her television roles. Most notably she was Fleur in THE FORSYTE SAGA (1968), the Duchess of Marlborough in "The First Churchills" (1971), Becky Sharp in "Vanity Fair" (1973), and Glencora Palliser in THE PALLISERS (1975).

Hampton, Lionel (1913–), U.S. JAZZ musician, a drummer and pianist who became a vibraphonist while playing with Louis ARMSTRONG's band. Hampton organized his own big band in 1940, became a very popular bandleader with his rendition of his own "Flying Home" in 1942, and was for decades one of the leading jazz musicians of his time.

Hamsun, Knut (Knud Pedersen Hamsund, 1859–1952), Norwegian writer, his country's leading 20th-century novelist, who gained recognition with his first novel, *Hunger* (1890), which he followed with such novels as *Mysteries* (1892), *Pan* (1894), *Victoria* (1898), and *Dreamers* (1904). He is best known throughout the world for his *Growth of the Soil* (1917), the work most directly responsible for his being awarded the 1920 NOBEL PRIZE for literature. His most notable later work is the trilogy *Vagabonds* (1927), *August* (1930), and *The Road Leads On* (1933).

Handy, W.C. (William Christopher Handy, 1873–1958), U.S. musician and composer, who worked with Black folk themes and in the BLUES style to create such notable pieces as "Memphis Blues" (1912), ST. LOUIS BLUES (1914), "Yellow Dog Blues" (1914), BEALE STREET BLUES (1916), and "Careless Love" (1921; with Spencer Williams). Nat "King"

COLE played Handy in the 1958 film biography.

Hannah and Her Sisters (1986), the Woody ALLEN film, set in the New York milieu favored in much of his work. He wrote the screenplay, directed, and starred, in a cast that included Michael CAINE, Mia FARROW, Dianne Wiest, Barbara Hershey, Carrie Fisher, Max von SYDOW, Daniel Stern, Sam WATERSTON, Maureen O'Sullivan, and Lloyd Nolan. Wiest won a best supporting actress OSCAR, Caine won a best supporting actor Oscar, and Allen won an Oscar for his screenplay.

Hansberry, Lorraine (1930–65), U.S. writer, whose first play, RAISIN IN THE SUN (1959), on the life of a Black Chicago family, was adapted into the 1961 Daniel Petrie movie, with Sidney POITIER, Claudia McNeil, and Ruby DEE in leading roles; it also became the musical *Raisin* (1971). Hansberry also wrote *The Sign in Sidney Brustein's Window* (1964).

Hanson, Howard (1896–1981), U.S. composer, conductor, and teacher; he was director of the Eastman School of Music (1924–64). His considerable body of work, much influenced by Jean SIBELIUS and Edvard Grieg, included the PULITZER PRIZE-winning *Fourth Symphony* (the "Requiem," 1943), as well as the *First Symphony* (the "Nordic," 1923) and the *Second Symphony* (the "Romantic," 1930).

"Happy Days Are Here Again," Franklin Delano Roosevelt's campaign song, which became the unofficial anthem of the Democratic Party in the 1930s. It is from the film *Chasing Rainbows* (1930), with music by Milton Agar and words by Jack Yellen.

Harburg, Yip (Edgar Yip Harburg, 1898–1981), U.S. lyricist, whose first hit, BROTHER, CAN YOU SPARE A DIME? (1932), became the emblematic Great Depression song. He also wrote the lyrics of such standards as "April in Paris" (1932) and "It's Only a Paper Moon" (1933); won an OSCAR for the lyrics of OVER THE RAINBOW, from THE WIZARD OF OZ (1939); and wrote the book and lyrics for *Finian's Rainbow* (1947).

Hard Day's Night, A (1964), the first BEATLES film, directed by Richard Lester and featuring Paul MCCARTNEY, John LENNON, Ringo STARR, and George HARRISON, singing many of their songs. "A Hard Day's Night" also was the film's very popular title song, with words and music by Lennon and McCartney.

Hardin, Lillian, the given name of musician Lil ARMSTRONG, and the name she used as a jazz pianist with King OLIVER, before her early-1920s marriage to Louis ARMSTRONG. She continued to work as Lil Armstrong after parting with Armstrong in 1931 and divorcing him in 1938.

Hardy, Andy, character played by Mickey ROONEY in a popular series of films about this "typical" 1930–40s teenager, starting with *A Family Affair* (1937) and *You're Only Young Once* (1938).

Hardy, Oliver (1892–1957), U.S. actor and comedian, on screen in supporting roles from 1914, and from 1927 the stout half of the memorable comedy team of LAUREL AND HARDY.

Hare, David (1947–), British writer and director, whose work includes the plays *Slag* (1970); *Fanshen* (1975); *Plenty* (1978), which became the 1985 film with Meryl STREEP, Charles Dance, and John GIELGUD; *A Map of the World* (1982); *Pravda* (1985); *The Secret Rapture* (1988); and *Racing Demon* (1990). He also wrote and directed the film WETHERBY (1985).

Harlem Renaissance, the emergence of a group of Harlem-based literary and artistic figures during the 1920s, forming a self-conscious Black cultural movement. It included such figures as Langston HUGHES, Countee CULLEN, Claude McKAY, and Jean Toomer and in a somewhat wider sense such notable figures as Paul ROBESON and James Weldon JOHNSON.

Harlow, Jean (Harlean Carpenter, 1911–37), U.S. actress, on screen from 1928, who became a major sex symbol and star of the early 1930s, in such films as *Red Dust* (1932), DINNER AT EIGHT (1934), and *Saratoga* (1937). She died of an illness contracted while working on the latter film.

Harper (1966), the movie version of Ross MACDONALD's *The Moving Target*, in which his fictional detective, Lew Archer, renamed

Harper, was played by Paul NEWMAN. The cast included Lauren BACALL, Shelley Winters, Julie HARRIS, Janet LEIGH, Robert WAGNER, Robert Webber, and Strother Martin. Jack Smight directed, from a screenplay by William Goldman. A decade later Newman played Harper–Archer again, in Stuart Rosenberg's *The Drowning Pool*, based on the MacDonald novel.

Harris, Emmylou (1944–), U.S. country singer and bandleader, popular from the mid-1970s, with such albums as *Pieces of the Sky* (1975); *Elite Hotel*; and the very notable *Trio* (1987), with Dolly PARTON and Linda RONSTADT.

Harris, Frank (James Thomas Harris, 1856–1931), Irish-American writer and editor, who worked primarily as an editor in London from the early 1880s and is best known for his then-scandalous autobiography *My Life and Loves* (1923–27). Along similar lines, he wrote *Oscar Wilde: His Life and Confessions* (1916) and several other biographical works that were widely viewed as more sensational than they were accurate. He also wrote several novels and short stories.

Harris, Julie (Julia Ann Harris, 1925–), U.S. actress, on stage from 1945; she became a leading player on Broadway in MEMBER OF THE WEDDING (1950), re-creating the role in the 1952 film version, her first film. She also starred in the plays I AM A CAMERA (1951) and *The Lark* (1955), for which she won best actress TONYs. In 1969, Harris won a third best actress Tony for *Forty Carats*; she won a fourth Tony as Emily Dickinson in the solo *The Belle of Amherst* (1976). Later in her career, she appeared in several television series.

Harris, Lawren Stewart (1885–1970), Canadian artist; he emerged as a major northern landscape painter from 1920, with the first show of the GROUP OF SEVEN, exhibiting the Algoma, Ontario paintings he had created from 1918 to 1920. For much of the interwar period he continued to find his subjects in the Canadian north, very notably in the long series of Lake Superior northern shore paintings, and at Nova Scotia, the Gaspé, the Rockies,

and in the Arctic. He moved toward abstraction after going to Dartmouth as an artist in residence in 1934, became associated with the Wassily KANDINSKY-influenced Transcendental Group at Santa Fe from 1938 to 1940, and lived in Vancouver from 1940, there becoming a considerable figure in the development of Canadian modernism, although it is his earlier association with the Group of Seven that is best remembered.

Harris, Roy (1898–1979), U.S. composer, whose work was greatly influenced by American folk and inspirational themes. He wrote 16 symphonies, including such works as the often-played No. 3, the *Folksong Symphony* (No. 4), and the *Abraham Lincoln Symphony* (No. 10), as well as many other orchestral and choral works.

Harrison, George (1943–), British musician, with John LENNON, Paul McCARTNEY, and Ringo STARR a member of THE BEATLES; Harrison was lead guitarist and sometimes sang. He also studied with Ravi SHANKAR and from 1965 very occasionally played the sitar with the group, because of the central position of the Beatles therefore sharing responsibility for the infusion of Indian music into Western popular music. He was a songwriter and record producer as well; in both areas his main work developed after the Beatle years. He established two benefit concerts for Bangladesh relief in 1971 and produced the GRAMMY-winning *Concert for Bangladesh* records with Shankar and Bob DYLAN. Harrison also wrote the song "Bangladesh" (1971).

Harrison, Rex (Reginald Carey Harrison, 1908–90), British actor, on stage from 1924 and on screen from 1930, who became a leading light-comedy stage player in *French Without Tears* (1936) and went on to leads in such plays as *Anne of the Thousand Days* (1950), for which he won a best actor TONY, and *Bell, Book, and Candle* (1954). He became a major star in his Tony-winning performance as Henry HIGGINS in MY FAIR LADY (1956), re-creating the role on film in 1964 and winning a best actor OSCAR for the role. Several of his more notable films are *St. Martin's Lane* (1938), MAJOR BARBARA (1940), BLITHE SPIRIT (1945), ANNA AND THE KING OF SIAM

(1946), *The Ghost and Mrs. Muir* (1947), and *The Fourposter* (1952).

Harrison, Wallace Kirkman (1895–1981), U.S. architect, whose most notable work includes collaboration on the building of Rockefeller Center (1929–40), design responsibility for the United Nations complex (1947–50) and Lincoln Center (1962), and the design of the Metropolitan Opera House (1962). Harrison and Max ABRAMOVITZ were partners from 1941 to 1976; their firm in that period also designed many major office buildings, such as Pittsburgh's Alcoa Building (1953) and New York's Corning Glass Building (1959).

Harry and Tonto (1974), the Paul MAZURSKY film. Art CARNEY won a best actor OSCAR for his portrayal of a retired, dispossessed man who journeys from New York all the way to the Pacific shore and the setting sun. Tonto is his cat, who shares his life and journey, in a cast that includes Ellen BURSTYN, Geraldine FITZGERALD, Chief Dan George, Larry HAGMAN, Arthur Hunnicutt, Melanie Mayron, and Barbara Rhoades.

Hart, Lorenz (1895–1943), U.S. lyricist, long partnered with composer Richard RODGERS. He wrote the lyrics for such Broadway musicals as *Garrick Gaieties* (1925 and 1926), *The Girl Friend* (1926), *A Connecticut Yankee* (1927), *Jumbo* (1935), *Pal Joey* (1940), and *By Jupiter* (1942).

Hart, Moss (1904–61), U.S. writer and director, who coauthored several plays with George S. KAUFMAN, including *Once in a Lifetime* (1930), YOU CAN'T TAKE IT WITH YOU (1936), and *The Man Who Came to Dinner* (1939). He wrote the libretto for Kurt WEILL's *Lady in the Dark* (1941) and on his own wrote such plays as *Winged Victory* (1943), which he adapted into the 1944 film; *Light Up the Sky* (1948); and *The Climate of Eden* (1952). He also wrote the screenplays of such films as GENTLEMEN'S AGREEMENT (1947) and A STAR IS BORN (1954). Hart directed many plays, including MY FAIR LADY (1956) and CAMELOT (1960).

Hart, William S. (1870–1946), U.S. actor and director, on stage from 1899. He played Western and other action leads in the theater, in such plays as BEN-HUR (1899) and *The Virginian* (1907), before going into the movies in 1914. From 1914 to 1920, he was a major, very early star in Westerns, losing his following in the early 1920s.

Hartley, Marsden (1877–1943), U.S. painter, who early in his career was a highly experimental MODERNIST, moving through several styles, as in the expressionist work (see EXPRESSIONISM) he exhibited at the 1913 ARMORY SHOW and the somewhat more abstract work done in Germany during World War I. During the interwar period, he turned more toward figurative work and most notably toward the Maine landscapes for which he is most highly regarded.

Harvey (1944), the PULITZER PRIZE-winning Mary Chase play revolving around the six-foot-tall white rabbit of the title, seen by an often-inebriated Elwood P. Dowd. Frank Fay created Dowd, while Josephine Hull and Jane Van Duser were his sister and niece in the long-running Broadway play. Chase and Oscar Brodney adapted the play into Henry Koster's 1950 film; James STEWART was Dowd, and Hull won a best supporting actress OSCAR as his sister, in a cast that included Victoria Horne, Peggy Dow, Cecil Kellaway, and Charles Drake.

Harvey, Laurence (Lauruska Mischa Skikne, 1928–73), South African actor, on stage from 1943 and on screen from 1948. He became a major film star with ROOM AT THE TOP (1958), also appearing in such films as BUTTERFIELD 8 (1960), SUMMER AND SMOKE (1961), and DARLING (1965).

Háry János (1926), an opera by Zoltán KODALY, like much of his work strongly influenced by Hungarian folk music. It also generated the often-played *Háry János Suite* (1927).

Hasek, Jaroslav (1883–1923), Czech writer, best known for his anti-bureaucratic satire THE GOOD SOLDIER SCHWEIK (1920–23).

Hassam, Childe (Frederick Childe Hassam, 1859–1935), U.S. painter, a leading American Impressionist whose work bridged the 19th and 20th centuries. His early work includes such dark cityscapes as *Rainy Day* and *Columbus Avenue, Boston* (1885) and such sunny,

bright works as *Grand Prix Day* (1887), done during a three-year stay in Paris (1886–89). He is best known for his celebrated New York cityscapes and New England landscapes, as in *Union Square in the Spring* (1896), *Church at Old Lyme* (1906), and *Sunset at Sea* (1911), and for such later works as *Allies Day* (1917) and *The Union Jack, New York, April Morn* (1918).

Hatful of Rain, A (1955), the Michael V. Gazzo play. On stage, Ben Gazzara created Johnny Pope, a man with a drug habit, in a cast that included Shelley Winters as his wife, Anthony Franciosa as his brother, and Joey Silvera as his father. Gazzo and Alfred Hayes adapted the play into the 1957 Fred ZINNEMANN film, with Don Murray and Eva Marie SAINT in the leads, in a cast that included Franciosa, Lloyd Nolan, and Henry Silva.

Hauptmann, Gerhart (1862–1946), German writer, whose early plays were landmarks in the history of German naturalism. These include his first play, *Before Dawn* (1889); *The Coming of Peace* (1890); *Lonely Lives* (1891); his best-known play, *The Weavers* (1892), set in a 19th-century Silesian weavers' revolt; and *Rose Bernd* (1903). Some of his works explore a wider range of themes and techniques; these include such romantic plays as *The Sunken Bell* (1896) and *And Pippa Dances* (1906). Much of Hauptmann's later work was based on mythological themes, including *The Bow of Odysseus* (1914) and his last major work, the *Atrides Tetrology* (1941), a set of verse dramas. He was awarded the NOBEL PRIZE for literature in 1912.

Havel, Vaclav (1936–), Czech writer and political leader, a playwright of social protest whose works include *The Garden Party* (1963), *The Memorandum* (1965), *The Increased Difficulty of Concentration* (1968), *Protest* (1978), and *Largo Desolato* (1985). Many of his plays, written while his work was banned from the Czech stage, were unproduced until after the reestablishment of democracy, which Havel led as president of his country after the Czechoslovak revolution of 1989.

Hawkes, John (Clendennin Burne, Jr., 1925–), U.S. writer, much of whose work is black comedy, exploring a world perceived as beyond hope of redemption or possibility of communication, in such novels as *The Beetle Leg* (1951), *The Lime Twig* (1961), *The Blood Oranges* (1971), and *Adventures in the Alaskan Skin Trade* (1985). He has also written plays and shorter fiction.

Hawkins, Coleman (1904–69), U.S. JAZZ musician, a leading tenor saxophonist from his early days with Fletcher HENDERSON in the mid-1920s. He recorded the very notable "Body and Soul" at the head of his own group in 1939, and he continued to tour and record through the late 1960s.

Hawkins, Erick (1909–), U.S. dancer and choreographer. He danced with the Ballet Theatre, 1935–38, and was a leading modern dancer with the Martha GRAHAM company from 1938 to 1951, creating key roles in such works as *American Document* (1938), APPALACHIAN SPRING (1944), and *Night Journey* (1947). He founded his own company in 1951. Hawkins created some early works on American themes, most notably *God's Angry Man* (1945); his later work became highly abstract, often reflecting a bent toward East Asian mysticism, and includes such pieces as *Cantilever* (1963), *Naked Leopard* (1965), and *The Joshua Tree* (1984).

Hawkins, Jack (1910–73), British actor, on stage from 1923 and on screen from 1930, who played in scores of strong character roles and B-picture leads before his notable lead in THE CRUEL SEA (1943). His many later films include THE BRIDGE ON THE RIVER KWAI (1957) and LAWRENCE OF ARABIA (1962). His career was cut short by the loss of his voice after an operation for cancer of the larynx in 1966, although he continued to appear with his voice dubbed in.

Hawks, Howard (1896–1977), U.S. director, writer, and producer, on screen as a director from 1926, who in 45 years in Hollywood directed such diverse and major films as *The Dawn Patrol* (1930), SCARFACE (1932), *Sergeant York* (1941), TO HAVE AND HAVE NOT (1944), THE BIG SLEEP (1946), RED RIVER (1948), and *Hatari* (1962).

Hawn, Goldie (1945–), U.S. actress, who became a popular comedian in television's

"Laugh-In" (1968–73). She won a best supporting actress OSCAR in *Cactus Flower* (1969), her first substantial film role, and went on to such films as *There's a Girl in My Soup* (1970), *Butterflies Are Free* (1972), *Shampoo* (1975), *Private Benjamin* (1980), *Best Friends* (1982), *Swing Shift* (1984), *Overboard* (1987), and *Bird on a Wire* (1990).

Hayden, Sterling (John Hamilton, 1916–86), U.S. actor, on screen from 1940, who played leads in several action films during the 1940s and 1950s, and several strong supporting roles in such films as THE NAKED CITY (1950), DR. STRANGELOVE (1964), and THE GODFATHER (1972).

Hayes, Helen (Helen Hayes Brown, 1900–), U.S. actress, on stage from the age of five and a star as a teenager in such roles as *Pollyanna* (1917). She emerged as a leading player in the 1920s, in such plays as CAESAR AND CLEOPATRA (1925); *What Every Woman Knows* (1926); *Coquette* (1927); and *Mary of Scotland* (1933); and in her most notable role, that of *Victoria Regina* (1935). Hayes appeared infrequently in films, though she won a best actress OSCAR for *The Sin of Madelon Claudet* (1931) and a best supporting actress Oscar for *Airport* (1970).

Hayes, Roland (1887–1976), U.S. tenor, who in 1917 made his concert debut in Boston and made his major international breakthrough appearance in London in 1921. His American career was impeded by anti-Black discrimination; like Marian ANDERSON, he therefore spent much of his career abroad, as one of the most celebrated singers of his time, whose concerts very notably included Black American spirituals while at the same time covering a wide range of classical vocal music.

Hayward, Susan (Edythe Marrener, 1918–75), U.S. actress, on screen from 1937, who emerged as a leading dramatic actress in the late 1940s in such films as *Smash-Up: The Story of a Woman* (1947); *Tulsa* (1949); *David and Bathsheba* (1951); *With a Song in My Heart* (1952); *I'll Cry Tomorrow* (1956); THE CONQUEROR (1956); and *I Want to Live* (1958), for which she won a best actress OSCAR. She died of cancer, probably enhanced or caused by her three-month-long radiation exposure while filming *The Conqueror* on location near the Nevada Test Site in 1954.

Hayworth, Rita (Margarita Carmen Cansino, 1918–87), U.S. dancer and actress, on stage as a dancer from 1930 and on screen from 1935, who became one of Hollywood's leading sex symbols of the 1940s, in such films as BLOOD AND SAND (1941), *You'll Never Get Rich* (1941), *You Were Never Lovelier* (1942), *Cover Girl* (1944), *Gilda* (1946), and *The Lady from Shanghai* (1948).

Head, Edith (1907–81), U.S. costume designer. She was Hollywood's leading costumer for several decades and won eight OSCARS, for THE HEIRESS (1949), ALL ABOUT EVE (1950), *Samson and Delilah* (1950), A PLACE IN THE SUN (1951), *Roman Holiday* (1953), *Sabrina* (1954), *The Facts of Life* (1960), and THE STING (1973). Head was chief designer at Paramount from the late 1930s, moving to Universal in 1967.

Heat and Dust (1975), a Ruth Prawer JHABVALA novel, set in modern India, with long flashbacks to a parallel story in 1920s colonial India. Jhabvala adapted it into the 1983 James IVORY film, with a cast that included Julie CHRISTIE, Greta Scacchi as her 1920s grandmother in the parallel love-story metaphor, Shashi Kapoor, Mahdur Jaffrey, Christopher Cazanove, Barry Foster, and Julian Glover.

Heaven's Gate (1980), the Michael CIMINO film, a massively staged immigrant-farmers-against-land-barons period piece set in post–Civil War Wyoming. Cimino wrote and directed the film, with a very large cast that included Kris KRISTOFFERSON, Christopher Walken, John HURT, Sam WATERSTON, Isabelle Huppert, Jeff BRIDGES, Joseph COTTEN, and Brad Dourif.

Hecht, Ben (1894–1964), U.S. writer, a journalist who during the 1920s became a prolific author in several forms, most notably of two plays co-authored with Charles MACARTHUR: the often-revived newspaper drama, THE FRONT PAGE (1928), first done on screen by Lewis MILESTONE in 1931 and several times thereafter; and *Twentieth Century* (1932),

which he adapted into the 1934 Howard HAWKS film comedy, starring John BARRYMORE and Carole LOMBARD. From the late 1920s Hecht wrote scores of film stories and screenplays, including *Underworld* (1927), *The Scoundrel* (1935), WUTHERING HEIGHTS (1939), *Spellbound* (1945), and *Notorious* (1946). He also directed several films.

Heflin, Van (Emmett Evan Heflin, Jr., 1910–71), U.S. actor, on stage from 1928 and on screen from 1936. His first screen role was a lead, opposite Katharine HEPBURN in *A Woman Rebels* (1936); he also played opposite Hepburn on stage, in THE PHILADELPHIA STORY (1939). On screen he won a best supporting actor OSCAR for *Johnny Eager* (1942) and later starred in such films as the classic Western SHANE (1953) and *Patterns* (1956). In 1955 he created the Eddie Carbone role in Arthur MILLER's A VIEW FROM THE BRIDGE.

Heidi Chronicles, The (1988), the Wendy WASSERSTEIN play, about a woman's search for self-definition and those around her. On stage Joan Allen created the title role, in a cast that included Ellen Parker, Anne Lange, Joanne Camp, Drew McVety, Sarah Jessica Parker, and Boyd Gaines. The work won a best play TONY and a PULITZER PRIZE.

Heifetz, Jascha (1901–87), Russian-American violinist, a child prodigy, on stage in recital from the age of six. He made his first Berlin appearance in 1912, thereafter touring with the Berlin Philharmonic. He left Russia for America in 1917, during the next six decades becoming one of the world's leading violinists, who also transcribed classic works and commissioned contemporary works for the violin.

Heinlein, Robert Anson (1907–88), U.S. writer, best known for his large body of work in science fiction, which includes his most popular work, *Stranger in a Strange Land* (1961), a novel that became a major literary feature of the youth COUNTERCULTURE of the early 1960s. His earlier works include the body of novellas comprising his *Future History*, originally published in science-fiction magazines of the 1950s.

Heiress, The (1947), the play by Ruth and Augustus Goetz, based on the Henry JAMES novel, which they further adapted into the 1949 William WYLER film. On stage Wendy HILLER played Catherine Sloper, opposite Basil RATHBONE, as her father; on screen, Olivia DE HAVILLAND won an OSCAR as Catherine, opposite Ralph RICHARDSON as Austin Sloper, in a cast that included Montgomery CLIFT, Miriam HOPKINS, Vanessa Brown, and Mona Freeman. Art, set, and costumes all won OSCARS, as did Aaron COPLAND's score.

Held, John, Jr. (1889–1958), U.S. cartoonist, who in the 1920s set the image of the "flapper" and her young men as flaming youth in the hard, fast, jazz-age urban life of the Prohibition era in the United States. His work was published in such magazines as *Life, College Humor, Vanity Fair*, and *The New Yorker* and in several collections. He also did two comic strips in the 1920s and later published several books.

Heller, Joseph (1923–), U.S. writer, whose first novel, CATCH-22 (1961), a satire of military life, became so popular that it contributed its title to the language. He later wrote such works as the play *We Bombed in New Haven* (1968) and the novels *Something Happened* (1974), *Good as Gold (1979), and Picture This* (1988).

Hellman, Lillian (1905–84), U.S. writer, who emerged as a substantial American playwright with her first play, THE CHILDREN'S HOUR (1934), which she adapted into the 1936 William WYLER film *These Three*, with Miriam HOPKINS, Joel McCREA, and Merle Oberon in leading roles. Her play THE LITTLE FOXES (1939), about a bitter, decadent southern family, established her as a major 20th-century literary figure; in 1941 she adapted it into the William WYLER film. She turned to anti-fascist themes with WATCH ON THE RHINE (1941), which in 1943 was adapted by Hellman's longtime companion Dashiell HAMMETT into the Herman Shumlin film. Along similar lines, she wrote *The Searching Wind* (1944), which she adapted into the 1946 William Dieterle film. Later plays include *Another Part of the Forest* (1946); *The Autumn Garden* (1951); and *Toys in the Attic* (1960), which became the 1963 George Roy HILL film. Hellman also wrote several other screenplays,

including DEAD END (1937) and *The North Star* (1946). She and Hammett were harassed and blacklisted during the witch hunts of the early 1950s, Hammett being imprisoned for defying the House Un-American Activities Committee. She also wrote three autobiographical works: *An Unfinished Woman* (1969), *Pentimento* (1973), and *Scoundrel Time* (1976). Fred ZINNEMANN's film JULIA (1977) was based on *Pentimento*; Jane FONDA played Hellman and Jason ROBARDS played Hammett.

Hello, Dolly! (1964), the long-running TONY-winning Broadway musical; Carol Channing won a Tony in the title role, as matchmaking Dolly Levi. The musical was adapted by Michael Stewart from Thornton WILDER's *The Matchmaker* (1955), originally *The Merchant of Yonkers* (1938), with words and music by Jerry Herman. Channing's title song was the centerpiece of the show. Barbra STREISAND was Dolly Levi in Gene KELLY's 1969 film, in a cast that included Walter MATTHAU and Louis ARMSTRONG. Music direction, art, and sets won OSCARS.

Helpmann, Robert Murray (1909–86), Australian dancer, actor, choreographer, and director, on stage as a dancer and actor from 1923. He joined the Vic-Wells, later the ROYAL BALLET, in 1933. He became its leading male dancer in 1934, creating the lead opposite Alicia MARKOVA in *The Haunted Ballroom*, and from 1935 to 1950 was partnered with Margot FONTEYN, creating the male leads in such works as *Apparitions* (1936), *Checkmate* (1937), and *The Wanderer* (1941), and in his own works, including *Hamlet* (1942), *Miracle in the Gorbals* (1944), and *Adam Zero* (1946). He was director of the Australian National Ballet (1965–76). In the theater, he was Oberon at the Old Vic in *A Midsummer Night's Dream* (1937) and went on to play such roles as Hamlet, Shylock, King John, and Richard III and to act in and direct a considerable range of other classic and modern plays. On screen he played in such films as *One of Our Aircraft Is Missing* (1942); HENRY V (1944); THE RED SHOES (1948); and *Don Quixote* (1973), in the title role.

Hemingway, Ernest Miller (1899–1961), U.S. writer, whose work during the 1920s made him a leading spokesperson for the "lost generation." He emerged as a major literary figure with his short-story collection *In Our Time* (1925) and his novel THE SUN ALSO RISES (1926), which was followed by another tale of disillusion, A FAREWELL TO ARMS (1929), largely drawn from his experience as an ambulance driver during World War I. TO HAVE AND HAVE NOT (1937) preceded his voyage into the Spanish Civil War as a war correspondent, which yielded his only play, *The Fifth Column* (1938), and the celebrated war novel FOR WHOM THE BELL TOLLS (1940). His later novels include *Across the River and Into the Trees* (1950) and the PULITZER-PRIZE-winning THE OLD MAN AND THE SEA (1952). Many of Hemingway's short stories were as notable as his novels, including "The Snows of Kilimanjaro," "The Killers," and "The Short Happy Life of Francis Macomber," all published in *The Fifth Column and the First Forty-nine Stories* (1938). He also wrote several nonfiction works and scores of poems. He received a NOBEL PRIZE for literature in 1954. He committed suicide in 1961. Posthumously published works include *A Moveable Feast* (1964), *Island in the Stream* (1970), and *88 Poems* (1979). Among the notable film adaptations of his work are *For Whom the Bell Tolls* (1943), the Sam Wood film starring Gary COOPER and Ingrid BERGMAN; John Sturges's *The Old Man and the Sea* (1958), starring Spencer TRACY; Henry KING's *The Snows of Kilimanjaro*, starring Gregory PECK; Robert Siodmak's *The Killers*, starring Burt LANCASTER; Frank BORZAGE's *A Farewell to Arms*, starring Gary COOPER and Helen HAYES; and Henry KING's *The Sun Also Rises* (1957), starring Tyrone POWER.

Henderson, Fletcher (James Fletcher Henderson, 1897–1952), U.S. JAZZ musician, a pianist, arranger, composer, and bandleader whose arrangements from the early 1920s considerably influenced the development of the jazz form. Most of the leading Black jazz musicians of the interwar period played with his band at some time; he also arranged much of Benny GOODMAN's work of the mid-1930s.

Hendrix, Jimi (1942–70), U.S. ROCK guitarist and singer, a key figure in the development of the electric guitar as a primary instrument in rock, who emerged as a rock star in Britain in the late 1960s at the head of the trio The Jim Hendrix Experience and with such songs as "Hey Joe" and "Purple Haze," both in 1967. He became a major American rock star after the appearance of his group at the Monterey Pop Festival in 1967. His untimely death apparently was related to substance abuse.

Henley, Beth (1952–), U.S. playwright, best known for her PULITZER PRIZE-winning *Crimes of the Heart* (1981), which she adapted into the 1986 Bruce Beresford film, with Diane KEATON, Jessica LANGE, and Sissy SPACEK as the sisters at the center of the work. Her plays include *The Wake of Jamey Foster* (1982); *Am I Blue* (1982); *The Miss Firecracker Contest* (1984), which she adapted into the 1989 Thomas Schlamme film *Miss Firecracker*; *The Debutante Ball* (1985); and *Abundance* (1990).

Henreid, Paul (Paul von Hernreid, 1908–), Austrian actor and director, on stage in Austria from 1933 and on screen from 1935. He is best known for his Victor Laszlo role in CASABLANCA (1942), opposite Ingrid BERGMAN; and for his Jerry Durrance role, opposite Bette DAVIS, in NOW, VOYAGER (1942). He also appeared in such films as OF HUMAN BONDAGE (1946) and *Song of Love* (1947).

Henri, Robert (1865–1929), U.S. painter and teacher, who was the central figure in the development of a new school of American realism, later called the ASHCAN SCHOOL, or THE EIGHT, from the 1908 exhibition of eight loosely joined artists led by Henri. While teaching in Philadelphia from 1891 to 1898, such young artists as William James GLACKENS, George LUKS, Everett SHINN, and John SLOAN were drawn to him. They followed Henri to New York, where he taught at the New York School of Art and from 1909 at his own school; his further students included such artists as George BELLOWS, Stuart DAVIS, and Edward HOPPER. His main impact was as a teacher, although his own work was well received; it includes such paintings as *Storm Tide* (1903), *Laughing Child* (1908), and *Herself* (1913).

Henry V (1945), Laurence OLIVIER's notable screen version of Shakespeare's classic, in which he also played the title role, with a supporting cast that included George Robey as Falstaff, Max Adrian, Renée Asherson, Felix Aylmer, and Robert Newton. Olivier won a special OSCAR for the film. In 1989 Kenneth BRANAGH directed and starred in a quite notable contemporary film of the play, leading a cast that included Derek JACOBI, Ian HOLM, Judi DENCH, Paul SCOFIELD, Emma Thompson, Robbie Coltrane, and Alec McCOWEN.

Henson, Jim (James Maury Henson, 1937–90), U.S. puppeteer, the creator of THE MUPPETS; he made his television debut in 1955 and created Kermit the Frog in 1956. His enormously popular *The Muppet Show* ran from 1976 to 1981, and continues to rerun all over the world, while his Muppets have from 1969 been the centerpiece of SESAME STREET. The Muppets also were featured in several other television shows and films.

Henze, Hans Werner (1926–), German composer, best known for such operas as *Boulevard Solitude* (1952), *The Stag King* (1956), *Elegy for Young Lovers* (1961), *The Young Lord* (1965), *We Come to the River* (1976), and *The English Cat* (1983). His large body of work also includes such ballets as *Jack Pudding* (1951), *Ondine* (1958), and *Orpheus* (1979); seven symphonies; and much other instrumental and vocal music.

Hepburn, Audrey (Audrey Hepburn-Ruston, 1929–), U.S. actress, on stage and screen from 1951. She played on Broadway in GIGI (1951) and won a best actress TONY for *Ondine* (1954). On screen she became one of the leading actresses of the 1950s and 1960s, in such films as *Roman Holiday* (1953), for which she won a best actress OSCAR; *Sabrina* (1954); *War and Peace* (1956); *Funny Face* (1957); *The Nun's Story* (1959); BREAKFAST AT TIFFANY'S (1961); *Charade* (1963); and MY FAIR LADY (1964).

Hepburn, Katharine (1907–), U.S. actress, on stage from 1928. In 1932 she began her extraordinary film career with a lead opposite John BARRYMORE in *A Bill of Divorcement*. She won her first best actress OSCAR for

Morning Glory (1936). In 1939 she starred in THE PHILADELPHIA STORY on Broadway, then re-created the role in the 1940 film. In 1940 she also starred in *Woman of the Year*, the first of nine classic films with her longtime professional and personal partner Spencer TRACY, which included such works as STATE OF THE UNION (1948); DESK SET (1957); and their last film together, made just before his death, GUESS WHO'S COMING TO DINNER (1967), for which she won another OSCAR. Other very notable films include THE AFRICAN QUEEN (1951) and THE LION IN WINTER (1968); she won a third best actress OSCAR for the latter. Her later work included the Broadway lead in *Coco* (1969) and the film ON GOLDEN POND (1981), for which she won yet another best actress Oscar.

Hepworth, Barbara (Jocelyn Barbara Hepworth, 1903–75), British sculptor. Although her earlier work, as in the group *Doves* (1926), was largely naturalistic, she turned in the early 1930s toward abstraction, together with her longtime friend and colleague Henry MOORE and her husband, Ben NICHOLSON, the three emerging as the center of Britain's abstract sculpture movement. She first explored what became her characteristic use of internal space with the "hole" in *Pierced Hemisphere Form* (1931), which, like many of her other works, was destroyed during World War II. Later she would use more than one hole, paint the insides of the hole, and use stringed forms. Later, too, she created several monumental works, as in the Dag Hammarskjöld memorial at the United Nations, *Single Form*. Quite late in her career she added work in bronze to her work in wood, stone, and marble, as in *Square Stones with Circles* (1963). Throughout her life and work, the unifying thread was her relation to what she perceived as elemental and pantheistic in the natural world.

Herbert, Frank (1920–86), U.S. writer, best known by far for the classic science-fiction novels set on the mythical desert planet of Dune, consisting of *Dune* (1965), *Dune Messiah* (1970), *The Children of Dune* (1976), *The God Emperor of Dune* (1981), and *The Heretics of Dune* (1985).

Herbert, Victor (1859–1924), Irish-American composer and musician, best known as the composer of such greatly popular operettas as *The Fortune Teller* (1898), *Babes in Toyland* (1903), *Mlle. Modiste* (1905), *The Red Mill* (1906), *Naughty Marietta* (1906), and *Sweethearts* (1913) and for such songs as "Thine Alone," "Ah, Sweet Mystery of Life," "Kiss Me Again," "Toyland," and "The Gypsy Love Song." He composed in several other musical forms, as well. *Babes in Toyland* became a film three times, most notably as the 1934 LAUREL AND HARDY vehicle. *Naughty Marietta* (1935) and *Sweethearts* (1938) became popular Nelson EDDY–Jeanette MACDONALD movie musicals.

Herblock (Herbert Lawrence Block, 1909–), U.S. cartoonist, one of the most celebrated political satirists of the century; his awards include three PULITZER PRIZES (1942, 1954, and 1979). He was an editorial cartoonist for the *Chicago Daily News* (1929–33), the Newspaper Enterprise Association (1933–43), the U.S. armed forces (1943–45), and the *Washington Post* (1946–), being very widely syndicated. Some of his chosen targets were Senator Joseph McCarthy, Richard M. Nixon, the conduct of the Vietnam War, and government bureaucracy.

Herman, Woody (Woodrow Charles Herman, 1913–87), U.S. bandleader, singer, and clarinetist. From 1936 he led his own band, which became one of the leading groups of the big-band era, recording such hits as "The Woodchopper's Ball" (1939) and "Blues in the Night" (1942). He also appeared in several films. In 1946 the band introduced Igor STRAVINSKY's *Ebony Concerto* at Carnegie Hall. Herman continued to play, lead, and record through the early 1980s.

Herriman, George (1881–1944), U.S. cartoonist, the creator in 1910 of the highly regarded comic strip KRAZY KAT.

Hersey, John Richard (1914–), U.S. writer, best known for three early works: his PULITZER PRIZE-winning novel *A Bell for Adano* (1944), about the postwar American occupation of an Italian village, which became the 1945 Henry KING film; *Hiroshima*, a fac-

tual treatment of the atomic bombing (1946); and a novel about the Warsaw Ghetto uprising, *The Wall* (1950), which was the basis for the 1960 Millard Lampell play and the 1982 film. His later works includes such novels as *The Child Buyer* (1960) and *White Lotus* (1965) and his factual treatment of a portion of the Detroit race riots of 1967, *The Algiers Motel Incident* (1968).

Herzog (1964), the novel by Saul BELLOW, on the multiple midlife crises of an American Jewish intellectual.

Herzog, Werner (1942–), German filmmaker, who wrote, directed, and produced all his intensely personal, often greatly abstracted, and sometimes rather obscure films. These include, most notably, *Signs of Life* (1968), *Aguirre: the Wrath of God* (1973), *The Mystery of Kaspar Hauser* (1974), WOZZECK (1979), *Fitzcarraldo* (1982), and *Where the Green Ants Dream* (1987).

Hess, Myra (1890–1965), British pianist, a leading interpreter of Bach, Brahms, Beethoven, Mozart, and Schumann during the first half of the 20th century. She is best remembered for her National Gallery lunchtime concerts during World War II; the now-legendary image is that of Dame Myra Hess indomitably playing on, even at the height of the Blitz.

Hesse, Hermann (1877–1962), German writer, long resident in Switzerland and a Swiss citizen from 1921. He was a lyrical romanticist, whose celebrated later novels sought to fuse artistic and intellectual commitment with the search for inner peace, which for him was best satisfied by some aspects of South and East Asian religious beliefs. In those senses, he prefigured and became greatly attractive to the people of the 1960s COUNTERCULTURE. His major works include *Demian* (1919), *Siddhartha* (1922), *Steppenwolf* (1927), and *Magister Ludi* (1943). *Siddhartha* became the 1973 Conrad Rooks film, with Shashi Kapoor in the leading role; *Steppenwolf* was filmed by Fred Haines in 1974, with Max von SYDOW and Dominique Sanda in the leads. Hesse opposed German militarism in both world wars and denounced Nazism. He was awarded the NOBEL PRIZE for literature in 1946.

Heston, Charlton (Charles Carter, 1923–), U.S. actor, on stage from 1947 and on screen from 1950, who became a major Hollywood star in the 1950s, largely in a long series of action epics, such as *The Ten Commandments* (1956), his best actor OSCAR-winning BEN-HUR (1959), *El Cid* (1961), and *Khartoum* (1966). On stage, his work has included leads in *Macbeth*, last performed in London in 1976; THE CAINE MUTINY COURT-MARTIAL (1985); and A MAN FOR ALL SEASONS, last done in London in 1987.

Higgins, Henry, the linguist and teacher in George Bernard SHAW's PYGMALION, played first on the London stage by Herbert Beerbohm TREE, portrayed memorably on film by Leslie HOWARD, and re-created by Rex HARRISON in MY FAIR LADY.

High Noon (1952), the Fred ZINNEMANN Western, a classic of the genre, starring Gary COOPER in an OSCAR-winning role as an aging sheriff who is about to retire, but who decides to face one more challenge, from a killer who has just been pardoned and three associated gunmen. Key supporting roles were played by Grace KELLY, as his Quaker wife; Lloyd BRIDGES; Thomas Mitchell; and Katy Jurado.

High Sierra (1941), the Raoul WALSH film, written by John HUSTON and W.R. BURNETT, based on the Burnett novel. Humphrey BOGART was the ultimately cornered killer "Mad Dog" Earle, opposite Ida LUPINO, in a cast that included Alan Curtis, Arthur Kennedy, and Joan Leslie.

Hikmet, Nazim (1902–63), Turkish writer, who became a communist while a student in the Soviet Union in the early 1920s; on return to Turkey in 1924, he became his country's leading leftist poet and playwright, while at the same time powerfully influencing the development of Turkish poetry through the introduction of free verse and other modern forms. His best-known works are *The Epic of Sheik Bedrettin*, about a 15th-century Turkish revolution, and his five-volume *Portraits from My Country* (1966–67). He also wrote several plays and a considerable body of essays. Hikmet was imprisoned from 1938 to 1950 and lived abroad for the rest of his life. His play *Has*

Ivan Ivanovich Lived at All? (1956) attacked Stalinism, during the period of the first Soviet thaw.

Hill, George Roy (1923–), U.S. director, whose work was on stage from 1957 and included *Period of Adjustment* (1957), which in 1962 was also his first film. He went on to direct such films as *The World of Henry Orient* (1964); BUTCH CASSIDY AND THE SUNDANCE KID (1967); THE STING (1973), for which he won a best director OSCAR; and THE WORLD ACCORDING TO GARP (1982).

Hiller, Wendy (1912–), British actress, on stage from 1930, who became a leading player with *Love on the Dole* (1935). On screen from 1937, she became a star as Eliza DOOLITTLE in the classic PYGMALION (1938), a role she had previously done in the theater. She followed it with such films as MAJOR BARBARA (1941) and I KNOW WHERE I'M GOING (1945); later in her career she played several strong supporting roles, in such films as SEPARATE TABLES (1958), for which she won a best supporting actress OSCAR, and A MAN FOR ALL SEASONS (1966). The bulk of her work was in the theater, where she played in a wide range of classical and modern roles, as in *The Heiress* (1947), *A Moon for the Misbegotten* (1957), and later in her career most notably in *Crown Matrimonial* (1972) and *John Gabriel Borkman* (1975).

"Hill Street Blues" (1981–87), the long-running television police series, set in a primarily Black and Hispanic big-city neighborhood, which powerfully took up many of the key social issues of the 1980s. Its cast, playing strongly in ensemble, was led by Daniel J. Travanti as Captain Frank Furillo and included Michael Conrad, Veronica Hamel, Bruce Weitz, Michael Warren, Charles Haid, Betty Thomas, Rene Enriquez, Taurean Blacque, Kiel Martin, James B. Sikking, Joe Spano, Barbara Bosson, and Ed Marinaro.

Hilton, James (1900–54), British writer, whose first novel, LOST HORIZON (1933), with its mythical high Tibetan land of Shangri-La, established him as a very popular novelist. It became the 1937 Frank CAPRA film, with Ronald COLMAN in the lead. His best-known novels also include GOOD-BYE, MR. CHIPS

(1934), which became the 1939 Sam Wood film, with Robert DONAT winning an OSCAR in the title role; and *Random Harvest* (1941), which became the 1942 Mervyn LEROY film, starring Colman and Greer GARSON. In Hollywood from 1935, he also adapted his novel *We Are Not Alone* into the 1939 Edmund Goulding film and wrote such screenplays as CAMILLE (1937) and MRS. MINIVER (1942).

Himes, Chester (1909–84), U.S. writer, whose early novels, beginning with *If He Hollers, Let Him Go* (1945), focus on discrimination against Black Americans. He became an expatriate in 1954; much of his later work, written in France, consists of mysteries set in Harlem, such as the comedy COTTON COMES TO HARLEM (1965), which became the 1970 Ossie DAVIS film, with Godfrey Cambridge and Raymond St. Jacques playing the Black detectives Himes had created.

Hindemith, Paul (1895–1963), German composer. Although one of the leading composers of the 20th century, his very large body of work sharply contrasted with the main atonal, unstructural modern classical movements of his time. Hindemith's attempt was to renovate traditional approaches by developing an expanded tonality, as expressed in such early major works as the first four string quartets (1919–23) and the opera *Cardillac* (1926). His opera *Mathis der Maler* (1935) was banned by the Nazis and was first produced in 1938, after he had left Germany, going first to Turkey (1935–37) and then to Switzerland, before his emigration to the United States in 1940. He returned to Switzerland in 1953. He wrote several other operas, including *The Harmony of the World* (1957), and a great many other orchestral and vocal works.

Hine, Lewis Wickes (1874–1940), U.S. photographer and social historian, the pioneer and preeminent photo-essayist of his time; such classic Ellis Island pictures as *Albanian Woman with Headcloth* (1905) and ELLIS ISLAND MADONNA (1905) were part of the large body of work he did at the immigration station, 1904–8. He followed the immigrants into America as well, with such equally classic works as *Steel Workers at a Russian Boarding House*, many of them published in the maga-

zine *Charities and Commons*. From 1909 to 1917, as photographer for the National Committee on Child Labor, he produced a massive body of work, documenting the antihuman child-labor conditions of the time, and in the process shot such classic pictures as *Breaker Boys in Coal Mine* (1911). Hine was a photographer with the Red Cross during and after World War I and in the 1920s worked with industrial photography, ultimately documenting the construction of the Empire State Building (1930–31). In the 1930s, he worked with such federal agencies as the Tennessee Valley Authority and the Works Progress Administration.

Hines, Earl "Fatha" (1903–83), U.S. JAZZ pianist, bandleader, and songwriter, who emerged as a leading jazz pianist in the mid-1920s. In Chicago he recorded with Louis ARMSTRONG's HOT FIVE in 1927–28, led his own big band in broadcasts from the Grand Terrace during the 1930s, and continued as a bandleader until 1948. His career then waned somewhat, until he reemerged as a classic and historic jazz figure in the mid-1960s.

Hiroshima, Mon Amour (1959), the Alain RESNAIS film, a major work of the French NEW WAVE and a powerful morality tale placed at one of the centers of 20th-century history, setting the doomed affair of a French actress and a Japanese architect into the massive fact of postwar Hiroshima, so recently destroyed by the atom bomb. Marguerite DURAS wrote the screenplay; Emmanuele Riva and Eiji Okada played the leads.

Hirschfeld (Albert Hirschfeld, 1903–), U.S. artist; although he has written several books, he is best known by far as one of the foremost caricaturists of his time, and especially, from 1929, as the theater caricaturist of *The New York Times*. In each caricature he has hidden the name of his daughter, Nina, at least once.

Hirshhorn, Joseph Herman (1899–1981), U.S. art collector. He donated his collection, especially strong in 20th-century works, to the U.S. government; in 1974 it became Washington, D.C.'s Hirshhorn Museum and Sculpture Garden.

Hitchcock, Alfred (1899–1980), British director and producer, on screen from 1923, who established himself in Britain during the 1930s as a foremost thriller director, with such films as his *The Man Who Knew Too Much* (1934), the classic THE 39 STEPS (1935), and THE LADY VANISHES (1938). Going to Hollywood, he at first directed a variety of movies, including his first American film, the OSCAR-winning REBECCA (1940), but soon emerged as the most notable and inventive thriller director of the next three decades, with such films as *Suspicion* (1941), *Spellbound* (1945), REAR WINDOW (1954), NORTH BY NORTHWEST (1959), and PSYCHO (1960).

Hobson's Choice (1954), a film produced and directed by David LEAN; he also cowrote the screenplay, based on the Harold Brighouse play. Charles LAUGHTON starred in the title role, as the crusty bootmaker ultimately forced into partnership with his former apprentice, played by John MILLS, now married to his daughter, played by Brenda De Banzie.

Hochhuth, Rolf (1931–), Swiss writer, best known for two early political plays: *The Deputy* (1962), which was perceived as accusing Pope Pius XII of complicity in the Holocaust for failure to intervene on behalf of the Jewish victims of the Germans; and *Soldiers* (1967), which was perceived as accusing Winston Churchill of ordering mass murder through the saturation firebombing of German cities and other war crimes. His later work, most of it also political, includes such plays as *Anatomy of Revolution* (1969), *The Guerrillas* (1970), and *Lysistrata and the NATO* (1973).

Hockney, David (1937–), British artist, whose work includes paintings, graphics, photography, set design, and costuming. He and the British pop-art movement simultaneously emerged in the early 1960s, a period in which he also became an international media celebrity. His series of 16 etchings, *A Rake's Progress* (1963), were also well received. Hockney, who did not regard himself as a pop artist, later turned toward a clearly realistic style, featuring some elements of fantasy and caricature. In the late 1970s he also worked in the theater, designing sets at Glyndebourne, Covent Garden, La Scala, and the Metropolitan Opera.

Hoffman, Dustin (1937–), U.S. actor, on stage during the early 1960s and on screen from 1967, who became a major film star in THE GRADUATE (1967), and went on to star in a wide variety of dramatic roles in such movies as MIDNIGHT COWBOY (1969), LITTLE BIG MAN (1970), *Lenny* (1974), ALL THE PRESIDENT'S MEN (1976), KRAMER VS. KRAMER (1979), TOOTSIE (1982), RAIN MAN (1988), *Family Business* (1989), and DICK TRACY (1990), winning best actor OSCARS for *Kramer vs. Kramer* and *Rain Man*. His work on stage includes DEATH OF A SALESMAN (1984, and the 1985 film) and *The Merchant of Venice* (1989).

Hofmannsthal, Hugo von (1874–1929), Austrian writer, who worked in a variety of forms. He is best known for his work in the theater, which includes the librettos of several Richard STRAUSS operas, most notably ELECTRA (1909), based on Hofmannsthal's 1903 play; THE ROSENKAVALIER (1911); *Ariadne on Naxos* (1912); and *Arabella* (1933). He also wrote several mystery plays, the best-known being *Everyman* (1917) and *Das Salzburger grosse Welttheater* (1922), as well as several other original plays and adaptations, a considerable body of early lyrical poetry, and several volumes of essays.

Hokinson, Helen Edna (1900–49), U.S. cartoonist. From 1925 until her 1949 death in an airplane crash, her rather deprecating drawings of overweight, amiable, vague, and quite useless clubwomen, who came to be called the "Hokinson Girls," were a prominent feature of *The New Yorker*.

Hold Back the Dawn (1941), the Mitchell Leisen film, written by Billy WILDER and Leigh Brackett, about a sophisticated refugee stranded in Mexico, who marries a plain, young American teacher to gain entrance into the United States. Charles BOYER and Olivia DE HAVILLAND led a cast that included Paulette GODDARD, Walter Abel, and Rosemary DeCamp.

Holden, William (William Franklin Beedle, 1918–81), U.S. actor, on screen from 1938, who quickly became a dramatic star in his first substantial role, that of the fighter in GOLDEN BOY (1939). A decade later he emerged as a major star, in the next three decades appearing in such films as SUNSET BOULEVARD (1950); BORN YESTERDAY (1951); STALAG 17 (1953), for which he won a best actor OSCAR; PICNIC (1956); THE BRIDGE ON THE RIVER KWAI (1957); *The Counterfeit Traitor* (1962); and late in his career NETWORK (1976) and *Fedora* (1978).

Holiday (1928), the Philip BARRY comedy-drama, about a young man who falls in love with a conventional society girl while vacationing, quietly recoils when he sees her real setting and expectations of him, and quickly falls in love with her sister, a thoroughly unconventional rebel. Donald Ogden Stewart and Sidney Buchman adapted the play into the 1938 George CUKOR film, starring Katharine HEPBURN and Cary GRANT, in a cast that included Lew AYRES, Doris Nolan, Edward Everett Horton, Jean Dixon, and Henry Kolker.

Holiday, Billie (Eleanora Fagan, "Lady Day," 1915–59), U.S. JAZZ singer, who began singing in Harlem clubs as a teenager in the early 1930s. She was discovered by John HAMMOND, made her first record in 1933, and emerged as a uniquely talented jazz singer with her appearance at the Apollo in 1935. From then until 1942 she made scores of records, usually backed by small groups led by pianist Teddy Wilson. None of her records of that period was greatly popular or well known, and most were very badly produced; they are now recognized as containing many classic performances, for Holiday's stature grew enormously after her brief career had essentially ended. Her 1939 recording of the powerful, antilynching "Strange Fruit" was a classic from the start, however, and some recognition came in the mid-1940s; in 1946 she had her first concert. But in 1947 she ran into the long series of substance-abuse-related problems that were to ruin her voice and career; a year-long jail term was followed by a long period in and out of treatment and increasing resort to drugs and alcohol. Diana ROSS played the Holiday role in the 1972 Sidney J. Furie biofilm, *Lady Sings the Blues*.

Holliday, Judy (Judith Tuvim, 1922–65), U.S. actress, one of the leading comedians of her day, on stage in cabaret with Betty COMDEN and Adolph GREEN before making her screen debut in 1944 and her Broadway debut in 1945. She is best remembered for her memorable creation of not-at-all-stupid Billie Dawn on Broadway in the long-running BORN YESTERDAY (1946); she re-created the role and won a best actress OSCAR for the 1950 film. She also starred on Broadway in the musical *The Bells Are Ringing* (1956), re-creating the role in the 1960 film version. Among her other films are *Adam's Rib* (1949), *The Marrying Kind* (1952), and *The Solid Gold Cadillac* (1956).

Holloway, Stanley (1890–1982), British actor and multitalented variety performer. For world audiences, he is best remembered as Alfred P. Doolittle in MY FAIR LADY, a role he created on stage in 1956 and on screen in 1964. He began in variety, played supporting roles in London's West End from 1919, and made his screen debut in 1921. A few of his many films are MAJOR BARBARA (1941), *This Happy Breed* (1944), BRIEF ENCOUNTER (1945), CAESAR AND CLEOPATRA (1945), *Nicholas Nickleby* (1947), HAMLET (1948), *Passport to Pimlico* (1949), THE LAVENDER HILL MOB (1951), and *In Harm's Way* (1965).

Holly, Buddy (Charles Hardin Holley, 1938–59), U.S. ROCK composer and singer, whose brief career was cut off by his death in an airplane crash. He became a considerable celebrity after his death, with the posthumous release of much of his recorded work. Gary Busey played Holly in the film *The Buddy Holly Story* (1978), directed by Steve Rash.

Hollywood, that portion of Los Angeles that from 1913 became the center of the American movie industry, in the process developing an image that turned it into a mythical place for artists and audiences all over the world. It remained so even after the breakup of the studio system in the late 1940s, later also becoming the West Coast center of the television industry.

Hollywood Ten, ten U.S. directors and screenwriters—Alvah Bessie, Herbert Biberman, Lester Cole, Edward DMYTRYK, Ring LARDNER, Jr., John Howard Lawson, Albert Maltz, Samuel Ornitz, Adrian Scott, and Dalton TRUMBO—who were BLACKLISTED by the film industry in 1947 and jailed for contempt of Congress in 1948, after having claimed the protection of the First Amendment in refusing to testify before the House Un-American Activities Committee, then beginning the first of the major witch hunts that were to characterize the McCarthy period. All 10 were jailed, fined, and blacklisted; Dmytryk was later welcomed back into the film industry, after becoming a prominent accusatory witness before the committee. Before the witch hunts had ended, with the national revulsion against McCarthyism that began after the Army–McCarthy hearings of 1954, hundreds of cultural figures had been blacklisted, many of them forced to work abroad or under pseudonyms, others forced to entirely give up their creative work. Some of those blacklisted resumed their previous work in later years.

Holm, Celeste (1919–), U.S. actress, on stage from 1936 and on screen from 1946. On Broadway she created the Ado Annie role in OKLAHOMA! (1943) and starred in *Bloomer Girl* (1944). On screen, she won a best supporting actress OSCAR in GENTLEMEN'S AGREEMENT (1947) and played strong supporting roles in such films as THE SNAKE PIT (1948), ALL ABOUT EVE (1950), and *High Society* (1956). She has also appeared in several television films.

Holm, Hanya (Johanna Eckert, 1898–), German-American modern dancer, choreographer, and teacher, who danced and taught with Mary WIGMAN in Germany during the Weimar period, in 1931 opened the New York branch of the Wigman School, and from 1936 to 1967 ran her own highly influential New York school. She choreographed several Broadway musicals, including *Kiss Me Kate* (1948), MY FAIR LADY (1956), and CAMELOT (1960).

Holm, Ian (Ian Holm Cuthbert, 1931–), British actor, on stage from 1954, who played in many major roles with the ROYAL SHAKESPEARE COMPANY (1958–67), including leads in Peter HALL's *The Wars of the Roses* (1963–64). On screen from 1968, his work includes

the films OH! WHAT A LOVELY WAR (1969); *Young Winston* (1972); *The Homecoming* (1973), in which he re-created his role in the 1965 stage play; CHARIOTS OF FIRE (1981); *Wetherby* (1985); *Dreamchild* (1985); and HENRY V (1989), and such telefilms as *Mr. and Mrs. Edgehill* (1985) and *The Endless Game* (1989).

Holmes, Sherlock, the fictional detective created by Arthur Conan DOYLE in his first novel, *A Study in Scarlet* (1887). Holmes and his friend and associate Dr. Watson quickly became extraordinarily popular figures, through a series of novels and short stories. They were dramatized by William Gillette in his play *Sherlock Holmes* (1899); Gillette played Holmes on stage often in the next three decades, as did many others, on stage, screen, radio, and television, including John BARRYMORE (1922), with Basil RATHBONE becoming by far the most notable Holmes of them all.

"Holocaust" (1978), the four-part television miniseries, a massive work that had great impact in the United States and even greater impact in Europe, especially in Germany. It was the story of a Jewish family in Nazi Germany, set within the larger story of genocidal mass murder and of those who did the murders. The screenplay was written by Gerald Green and directed by Marvin J. Chomsky; the huge cast included Sam WANAMAKER, Michael Moriarty, Meryl STREEP, Blanche Baker, Fritz Weaver, James Woods, Rosemary Harris, Joseph Bottoms, Deborah Norton, Tovah Feldshuh, Ian HOLM, David Warner, and Marius Goring.

Holst, Gustav Theodore (1874–1934), British composer, whose interests in the English folk song, Sanskrit, and modern classical music influenced his diverse body of work. Best known as the composer of *The Planets* (1916), he also wrote such works as the opera *Savitra* (1908), *Choral Hymns from the Rig Vida* (1912), *Ode to Death* (1919), *Egdon Heath* (1927), and *A Choral Fantasia* (1930).

Home (1970), the David STOREY play, an exploration of the inner worlds and personal histories of two elderly men, both living in a mental institution, both perceived to be emi-

nently sane in an insane world; the institution is at least in part a metaphor for modern Britain. John GIELGUD and Ralph RICHARDSON created the roles.

Home, William Douglas (1912–84), British writer and actor, best known for such comedies as *The Reluctant Debutante* (1955), *The Jockey Club Stakes* (1970), *Lloyd George Knew My Father* (1972), and *The Kingfisher* (1977).

Home of the Brave (1945), the Arthur Laurents play, his first, about discrimination against a Jewish soldier by some of his soldier "buddies" during World War II. Carl Foreman adapted it into the 1949 Mark Robson film, with the Jewish soldier of the play transmuted into a Black soldier, played by James Edwards; the cast included Lloyd BRIDGES, Steve Brodie, Frank Lovejoy, Jeff Corey, and Douglas Dick. Stanley KRAMER produced the film, the first of the several notable films of social conscience he was to produce in coming decades.

Honegger, Arthur (1892–1955), Swiss-French composer, who emerged as a major figure with such works as the *King David* oratorio (1921), *Pacific 231* (1923), the operas *Antigone* (1926) and *Judith* (1927), and the oratorio *Jeanne d'Arc au Bucher* (1938). His considerable body of work includes five symphonies; several ballets; many other orchestral and vocal works; and aproximately 40 film scores, including those for Abel GANCE's NAPOLEON (1926), *Mayerling* (1936), and PYGMALION (1938).

"Honeymooners, The" (1951–71), the celebrated series of television comedy episodes, featuring Jackie GLEASON as violently bitter Ralph Kramden, a New York City bus driver, trapped, like his wife, Alice, in a broken-down Brooklyn apartment; their friends were Ed Norton, created by Art CARNEY, and Trixie Norton. Audrey Meadows was the best known of several Alice Kramdens. The episodes were carried in several television series over a 20-year period.

Hooker, John Lee (1917–), U.S. BLUES composer, singer, and guitarist, who became a popular blues recording artist, beginning with "Boogie Chillen" in the late 1940s, and who emerged as a major figure in the blues revival

of the 1960s with such albums as *It Serves You Right* (1966) and *Urban Blues* (1968).

Hope, Bob (Leslie Townes Hope, 1903–), U.S. actor and comedian, on stage in vaudeville from the 1920s and on screen from 1938. In his first film, *The Big Broadcast of 1938*, he introduced his signature song, THANKS FOR THE MEMORY. He was a leading comedian and host on radio from 1938, moving to television in the early 1950s with less success. He, Bing CROSBY, and Dorothy Lamour starred in *The Road to Singapore* in 1940, the first of the seven *Road* films that were to make him one of the best-known film stars of his time. During World War II and thereafter, he became an indefatigable armed-services entertainer, as well as a major public personality.

Hope and Glory (1987), the John Boorman film, an autobiographical look at his own experiences as a young boy living with his family in London during World War II, with a cast that included David Hayman, Sarah Miles, Sammi Davis, Ian Bannen, Derrick O'Connor, and Susan Wooldridge.

Hopkins, Miriam (Ellen Miriam Hopkins, 1902–72), U.S. actress, on stage from 1921, notably in *Anatol* (1931) and *Jezebel* (1933). She was on screen from 1930, became a leading movie star of the 1930s in such films as DESIGN FOR LIVING (1933), *Becky Sharp* (1935), and *These Three* (1936; a remake of THE CHILDREN'S HOUR), and played opposite Bette DAVIS in the *The Old Maid* (1939) and OLD ACQUAINTANCE (1943).

Hopkins, Sam "Lightnin'" (1912–82), U.S. country BLUES singer, composer, and guitarist, a Houston-based street singer and creative song storyteller, some of whose enormously prolific output was captured on hundreds of records from the late 1940s through the mid-1950s. He reemerged, as a concert and recording artist, during the blues revival of the 1960s and continued to work, though less actively, through the 1970s. He also appeared in several films and on television.

Hopper, Edward (1882–1967), U.S. artist, one of the leading American realists of the century. He studied with Robert HENRI in the early 1900s, made several trips to Europe before

One of Edward Hopper's prototypical urban landscapes, *New York Pavements* (1924).

1910, and became neither social realist nor modernist, instead developing a unique view of reality, in which he depicted urban landscapes and their essential qualities as he saw them, and their people as part of those landscapes. Hopper exhibited before World War I but focused on commercial work and graphics until the mid-1920s, thereafter emerging as a major figure, with such works as *House by the Railroad* (1925), *Early Sunday Morning* (1930), *Gas* (1940), *Nighthawks* (1942), *Rooms by the Sea* (1951), *Morning Sun* (1954), and *Sunlight in a Cafeteria* (1958).

Hordern, Michael (1911–), British actor, on stage from 1937, who became a leading character actor after World War II and played several leads as well, in such classics as *A Doll's House* (1946), *Ivanov* (1950), and *The Tempest* (1977), and in such modern plays as *Relatively Speaking* (1967), *A Delicate Balance* (1969), *Jumpers* (1972), and *Bookends* (1990). On screen from 1939, he has appeared in a long series of strong supporting roles.

Horne, Lena (1917–), U.S. singer, actress, and dancer, on stage from 1933 as a dancer at Harlem's COTTON CLUB, and from the late 1930s a major cabaret entertainer and recording artist. In the early 1940s she appeared in such films as CABIN IN THE SKY (1943), STORMY WEATHER (1943), and *Broadway Rhythm* (1944), but found her screen opportunities severely limited by anti-Black discrimination in the film industry of the time. She continued to be a headliner in variety through the 1980s.

Horne, Marilyn (1934–), U.S. mezzo-soprano; she made her debut in 1954, in that year also singing for Dorothy DANDRIDGE in the film *Carmen Jones*. Horne sang in Europe from 1956 and at the Metropolitan Opera from 1970, throughout her career in a very wide range of roles, although later focusing somewhat on the bel canto portion of the repertory, as exemplified by Rossini.

Horowitz, Vladimir Samoylovich (1904–89), Soviet-American pianist; he made his debut in 1921, toured Europe from the mid-1920s, and made his London and New York debuts in 1928. For six decades thereafter he was one of the world's leading pianists, especially notable for his interpretations of Tchaikovsky, RACHMANINOV, and PROKOFIEV, and also for his range, power, control, and, sometimes, his quite notable stylistic eccentricities. He continued to play in concert and make recordings through the mid-1980s; in 1986 he returned to play in the Soviet Union after an absence of decades.

Hotel Terminus: The Life and Time of Klaus Barbie (1989), the OSCAR-winning Marcel OPHULS documentary, which once more explored the questions of guilt, complicity, and subsequent protestations of innocence regarding Nazism and the Holocaust, to a considerable extent carrying forward the themes explored in THE SORROW AND THE PITY, and largely using the same interview techniques.

Hot Five, The the group composed of Louis ARMSTRONG, Lillian Hardin ARMSTRONG, Kid ORY, Johnny DODDS, and Johnny St. Cyr, who recorded a long series of what became classic JAZZ works in Chicago from 1925 to 1927.

Houseman, John (Jacques Haussman, 1902–88), British-American producer, actor, writer, and director. He was a Broadway director in the mid-1930s, co-founded the MERCURY THEATRE with Orson WELLES in 1937, produced several films from the mid-1940s through the mid-1960s, and late in his career became a very well-received actor in films and television, most notably as Professor Kingsfield in *The Paper Chase* (1973), a role that he re-created in the television series of that name.

Howard, Leslie (Leslie Stainer, 1893–1943), British actor, who became a leading player on the American stage in *Outward Bound* (1924), which later became his first film, in 1930. He also appeared in such works as *The Green Hat* (1925) and *Berkeley Square* (1933), and he starred in *Hamlet* in 1936. During the mid-1930s he became a major film star, in such movies as OF HUMAN BONDAGE (1935) and THE PETRIFIED FOREST (1936), in which he re-created his Broadway leading role. In 1938 he played Henry HIGGINS in the film classic PYGMALION, then going on to such films as *Intermezzo* (1939), GONE WITH THE WIND

(1939), and *The 49th Parallel* (1941). His career was cut short in 1943, when his flight from Lisbon to London was shot down by German fighters.

Howard, Sidney Coe (1891–1939), U.S. writer, who emerged as a major playwright with his PULITZER PRIZE-winning *They Knew What They Wanted* (1924). It was adapted for film three times, most notably by Howard himself for the 1940 Garson Kanin film, with Charles LAUGHTON and Carole LOMBARD in the leads; it later became the musical *The Most Happy Fella* (1956). His other works include *The Silver Cord* (1926), which he adapted for the 1933 John CROMWELL film; *The Late Christopher Bean* (1932); *Alien Corn* (1933); DODSWORTH (1934), based on the 1929 Sinclair LEWIS novel, which Howard also adapted into the 1936 William WYLER film, with Walter HUSTON as Dodsworth; and *Yellow Jack* (1934). Among his other screenplays are *Raffles* (1930), ARROWSMITH (1931), and GONE WITH THE WIND (1939).

Howard, Trevor (1916–88), British actor, on stage from 1934 and on screen from 1944, who became a film star in BRIEF ENCOUNTER (1945) and went on to play several leads and many strong character roles during the next four decades, in such films as THE THIRD MAN (1949), SONS AND LOVERS (1960), *Ryan's Daughter* (1970), and STEVIE (1977).

Howe, Irving (1920–), U.S. writer, teacher, and critic, whose work includes studies of Sherwood ANDERSON, William FAULKNER, Thomas Hardy, and Leon Trotsky, as well as several collections of essays. His work in American Jewish ethnic history, *World of Our Fathers* (1976), won a National Book Award.

Howe, James Wong (1899–1976), Chinese-American cinematographer, whose work was on screen from 1917 and who in almost six decades shot scores of major Hollywood films, such as ABE LINCOLN IN ILLINOIS (1940), *Body and Soul* (1947), and THE OLD MAN AND THE SEA (1958). He won OSCARS for *The Rose Tattoo* (1955) and HUD (1963).

How Green Was My Valley (1941), the John FORD film, about the tide of change and destruction of the old ways and relationships in a turn-of-the-century Welsh mining valley. Philip Dunne wrote the screenplay, adapted from the Richard Llewellyn novel. Walter PIDGEON and Maureen O'Hara played the leads; Donald Crisp, Anna Lee, Roddy McDowell, and Sara ALLGOOD were in key supporting roles. The film, Ford, Crisp as best supporting actor, cinematographer Arthur Miller, art, and interiors all won OSCARS.

Howl and Other Poems (1956), Allen GINSBERG's first volume of poetry, which established him as one of the leading poets of the BEAT GENERATION. It generated a celebrated right-to-publish case, ultimately won by publisher Lawrence FERLINGHETTI.

Hud (1963), the Martin RITT film, a contemporary western story. Melvyn DOUGLAS won a best supporting actor OSCAR as the highly moral rancher who ultimately dies after seeing his last herd destroyed; Paul NEWMAN in the title role was his son, whose amorality is at the center of the work. Patricia NEAL won a best actress OSCAR as the ranch housekeeper, who refuses Hud. Brandon de Wilde was Hud's nephew, who ultimately rejects him and his values. Irving Ravetch and Harriet Frank adapted the film from the Larry McMurtry novel *Horseman, Pass By*.

Hudson, Rock (Roy Scherer, 1925–85), U.S. actor, on screen from 1948, who became a leading Hollywood star of the 1950s, in such films as *Magnificent Obsession* (1954), GIANT (1956), *Written on the Wind* (1956), A FAREWELL TO ARMS (1957), and *Pillow Talk* (1959). His later work included *Ice Station Zebra* (1968) and *Darling Lili* (1970). He also appeared on television, most notably as McMillan in "McMillan and Wife" (1971–77).

Hughes, Langston (James Langston Hughes, 1902–67), U.S. writer, who emerged as a major Black poet in the 1920s and became a leading figure in the HARLEM RENAISSANCE. He is best known as the creator of SIMPLE, actually Jesse B. Semple, the Harlem folk character who generated five books of collected stories, beginning with *Simple Speaks His Mind* (1950). Hughes based his musical *Simply Heavenly* (1963) on the Simple stories. His

work includes the novels *Not Without Laughter* (1930) and *Tambourines to Glory* (1958), which he adapted into a musical in 1963.

Hughes, Ted (Edward James Hughes, 1930–), British writer, a leading poet of the modern period from the appearance of his first collection, *The Hawk in the Rain* (1957). He is noted for his powerful evocation and intertwining of nature and myth, and is also a leading children's poet, as in *Under the North Star* (1981). In 1984 he succeeded John Betjeman as Britain's poet laureate. He was married to poet Sylvia PLATH from 1957 until her 1963 suicide.

Humphrey, Doris (1895–1958), U.S. dancer, choreographer, and teacher. She was in the Denishawn Company from 1917 to 1928, left with Charles Weidman to co-found the Humphrey-Weidman school and company (1928–44), and continued on as a choreographer with the José LIMON company after illness ended her dancing career in 1945. Some of her best-known works are *The Shakers* (1931), the *New Dance* trilogy (1935–36), *Passacaglia in C Minor* (1938), *Day on Earth* (1947), *Night Spell* (1951), and *Ruins and Visions* (1953).

Hunchback of Notre Dame, The (1939), the epic Hugo DIETERLE film version of Victor Hugo's 1831 novel, with Charles LAUGHTON as Quasimodo, the deformed servant of the ultimately evil priest Frollo, in the film Cedric Hardwicke, who lusts for the Gypsy girl Esmeralda, played by Maureen O'Hara. Thomas Mitchell and Edmond O'Brien were in key supporting roles. Several other films have been based on the novel, most notably William Worsley's 1923 silent version, with Lon CHANEY as Quasimodo.

Hunter, Alberta (1895–1984), U.S. BLUES singer, who recorded with Fletcher HENDERSON and Louis ARMSTRONG in Chicago in the 1920s. In that decade she also toured widely with her own trio, worked on stage as Bessie SMITH's replacement in *How Come* (1923), and played opposite Paul ROBESON in the London production of SHOW BOAT (1928). She toured Europe and the Near East from the late 1920s and worked in radio and cabaret throughout

the 1930s, continuing on in cabaret through the mid-1950s. Hunter largely retired in 1957, and worked as a nurse, doing little in music for the next 20 years. She made a startlingly successful comeback in 1977, at the age of 82, resuming a career that now included recordings, cabaret, television, film, and concert work.

Hurston, Zora Neale (1901–60), U.S. writer and folklorist, who wrote several articles and books on African-American folklore, and such novels as *Jonah's Gourd Vine* (1934), *Their Eyes Were Watching God* (1937), and *Seraph on the Sewanee* (1948).

Hurt, John (1940–), British actor, on stage and screen from 1962, whose work includes several notable television appearances, as Quentin Crisp in "The Naked Civil Servant" (1975); as Caligula in "I, Claudius" (1976); in "Treats" (1977); and as Raskolnikov in "Crime and Punishment" (1979). He appeared in such films as A MAN FOR ALL SEASONS (1962), THE ELEPHANT MAN (1980), *White Mischief* (1988), and *Scandal* (1989), and also in such plays as *Inadmissible Evidence* (1965), THE CARETAKER (1972), *Travesties* (1974), and *The Shadow of a Gunman* (1978).

Hurt, William (1950–), U.S. actor, best known for his starring roles in such films as *Body Heat* (1978); *Gorky Park* (1985); THE KISS OF THE SPIDER WOMAN (1985), for which he won an OSCAR; CHILDREN OF A LESSER GOD (1987), and *Broadcast News* (1987).

Huston, Anjelica (1952–), U.S. actress, on screen from 1969, who is best known for her OSCAR-winning performance as best supporting actress as Maerose Prizzi in PRIZZI'S HONOR (1985), also playing major roles in such films as GARDENS OF STONE (1987); THE DEAD (1987), the last film directed by her father, John HUSTON; *A Handful of Dust* (1988); *Crimes and Misdemeanors* (1989); *Enemies: A Love Story* (1989); and *The Grifters* (1990). She is the granddaughter of actor Walter HUSTON.

Huston, John (1906–87), U.S. director, actor, and writer, the son of actor Walter HUSTON and the father of actress Anjelica HUSTON.

After an intermittent career during the 1920s and 1930s as an actor and screenwriter, he directed his first film in 1941; it was the classic THE MALTESE FALCON, which established him as a major director. Some of his other films of the next several decades are his best director OSCAR-winning THE TREASURE OF THE SIERRA MADRE (1947), KEY LARGO (1948), THE ASPHALT JUNGLE (1950), THE AFRICAN QUEEN (1952), *Beat the Devil* (1952), MOBY DICK (1956), *Freud* (1960), *The Night of the Iguana* (1964), *The Mackintosh Man* (1973), UNDER THE VOLCANO (1984), PRIZZI'S HONOR (1985), and THE DEAD (1987). He co-wrote and acted in several of his own films and acted in such other films as *Myra Breckinridge* (1970), CHINATOWN (1974), and *The Wind and the Lion* (1975).

Huston, Walter (Walter Houghston, 1884–1950), Canadian-American actor, father of director-actor John HUSTON and grandfather of actress Anjelica HUSTON. He toured in theater and vaudeville (1902–5 and 1909–24), then worked with the PROVINCETOWN PLAYERS and starred in several notable roles, including that of Ephraim Cabot in Eugene O'NEILL's DESIRE UNDER THE ELMS (1924). His early films include *Abraham Lincoln* (1930); *Law and Order* (1932), in which he played Wyatt Earp; and RAIN (1932). In 1934 he created the title role in Sidney HOWARD's play DODSWORTH, adapted from the Sinclair LEWIS novel, two years later re-creating the role in the classic William WYLER film. In 1938 he created the Pieter Stuyvesant role in Broadway's *Knickerbocker Holiday*. After that his main roles were in film, playing, among others, the Devil in *All That Money Can Buy* (1941); a bit part in his son John's first film as a director, THE MALTESE FALCON (1941); a lead in the wartime *The North Star* (1943); and his great role as Howard in John Huston's THE TREASURE OF THE SIERRA MADRE (1948), for which he won a best supporting actor OSCAR. He was on stage again in 1950, in *September Affair*. His recording of the Kurt WEILL–Maxwell ANDERSON SEPTEMBER SONG from *Knickerbocker Holiday* became a popular classic in 1950, after his death.

Huxley, Aldous Leonard (1894–1963), British writer, grandson of Thomas Henry Huxley and brother of Julian Huxley, who emerged as a leading post-World War I literary figure with his first novels, *Crome Yellow* (1921) and *Antic Hay* (1923). He also published a volume of short stories, *Mortal Coils*, in 1922. His *Point Counterpoint* (1928) was followed by what was by far his best-known work, the prophetic and despairing BRAVE NEW WORLD (1932), and such novels as *Eyeless in Gaza* (1936) and *After Many a Summer Dies the Swan* (1939). Almost blind from 1908, he went to America for treatment in 1940 and settled in California, collaborating on several screenplays, including PRIDE AND PREJUDICE (1940) and JANE EYRE (1943). He continued to write novels, essays, and poems, his works including *Ape and Essence* (1948) and *Brave New World Revisited* (1958). He also became greatly interested in mysticism and the enhancement of mystic experience through the use of hallucinogenic drugs, such later work as *The Doors of Perception* (1954) reflecting these interests.

I

I Am a Camera (1951), the play by John VAN DRUTEN, based on Christopher ISHERWOOD's *Good-bye to Berlin* (1939). The play, in which Julie HARRIS created the Sally Bowles role, was the basis for the musical CABARET (1966).

I Am a Fugitive from a Chain Gang (1932), a bitter, powerful film, indicting the Georgia chain-gang system and the system of injustice out of which it grew, based directly on the Robert E. Burns autobiography, *I Am a Fugitive from a Georgia Chain Gang*, and adapted into the Mervyn LEROY film by Burns, Sheridan Gibney, and Brown Holmes. Paul MUNI was a memorable Burns, in the film called James Allen, leading a cast that included Glenda Farrell, Helen Vinson, Preston Foster, Edward J. MacNamara, and Allen Jenkins.

Ibert, Jacques (1890–1962), French composer, whose generally light, often comic, very diverse body of work includes such operas as *Angelique* (1927) and *L'Aiglon* (1937); such ballets as *Diane de Poitiers* (1934) and *The Ballad of Reading Gaol* (1947); such orchestral and instrumental pieces as *Escales* (1922) and *Divertissement* (1930); and many film scores, such as *Don Quixote* (1933), *The Phantom Coach* (1939), and *Macbeth* (1948). He was the director of the French Academy from 1937 to 1960.

Iceman Cometh, The (1946), the long play by Eugene O'NEILL, his first after his 1934 retirement from the theater. Set in a New York bar, very late in O'Neill's career, it focuses on illusion, reality, and death, much of it filtered through an alcoholic haze. James Barton created the Hickey role; Jason ROBARDS, JR., notably re-created the role in a 1956 revival. The play became the 1973 John FRANKENHEIMER film, with Lee MARVIN as Hickey, strongly supported by Fredric MARCH and Robert RYAN.

"Ida, Sweet as Apple Cider" (1903), the theme song of Eddie CANTOR's 1930s radio show and his weekly public tribute to his wife, Ida Tobias; words and music were by Eddie Leonard and Eddie Munson.

Idiot's Delight (1936), the PULITZER PRIZE-winning Robert E. SHERWOOD comedy, an anti-fascist, antiwar work prophetically set in an Italian resort near the Austrian border, on the eve of a new European war. Alfred LUNT and Lynn FONTANNE created the Harry and Irene roles on stage; Clark GABLE and Norma SHEARER played the roles in the 1939 Clarence BROWN film, in a cast that included Edward ARNOLD, Burgess MEREDITH, Joseph Schildkraut, and Charles Coburn.

"I Don't Care" (1905), the jaunty signature song of U.S. vaudeville headliner Eva TANGUEY; words and music were by Jean Lenox and Harry Sutton.

"If I Had a Hammer" (1949), the Pete SEEGER song, with words and music by Seeger and Lee Hays. The song was written as the McCarthy period was fully taking hold and the composers and their associates in THE WEAVERS were beginning to be blacklisted; it became one of the protest anthems of the 1960s, especially as revived by PETER, PAUL AND MARY in 1962.

"I Get a Kick Out of You" (1934), the song introduced by Ethel MERMAN in the Broadway musical ANYTHING GOES (1934); words and music were by Cole PORTER.

"I Got Rhythm" (1930), the song inroduced by Ethel MERMAN in the Broadway musical *Girl Crazy* (1930), with music by George GERSHWIN and words by Ira Gershwin.

"Ike" ("Ike: The War Years," 1979), the three-part television film, about the war years of Dwight D. Eisenhower, also focusing in part on the affair between Eisenhower and his assistant, Kay Summersby. Robert DUVALL was Ike and Lee REMICK was Kay, in a cast that included Dana ANDREWS, Ian Richardson, and Darren McGavin. Melvin Shavelson adapted the work from Kay Summersby Morgan's book *Past Forgetting*.

I Know Where I'm Going (1945), the Michael POWELL–Emeric Pressburger film, which they wrote and directed, set in a Scottish Highlands seacoast town. Wendy HILLER was the smart girl going to meet her wealthy husband-to-be, opposite Roger LIVESEY as the impoverished local laird with whom she falls in love. The cast included Pamela Brown, Finlay CURRIE, John Laurie, Petula Clark, and Nancy Price.

I Know Why the Caged Bird Sings (1970), Maya ANGELOU's autobiography, focusing on how it was to grow up as a Black woman in a segregated United States. She, Leonora Thuna, and Ralph B. Woolsey adapted it into Fielder Cook's 1979 television film, with a large cast that included Ruby DEE, Diahann Carroll, Paul Benjamin, Constance Good, Esther Rolle, Roger E. Mosley, and Madge Sinclair.

"I'll See You Again" (1929), a song introduced by Peggy Wood in the Noël Coward 1929 operetta BITTER SWEET, and on screen by Jeanette MACDONALD opposite Nelson EDDY in the 1940 W.S. VAN DYKE film version; words and music were by Coward.

"I'm Gonna Wash That Man Right Outta My Hair" (1949), the Nellie Forbush song from SOUTH PACIFIC, introduced by MARY MARTIN on Broadway, with music by Richard RODGERS and words by Oscar HAMMERSTEIN II.

"I'm Just Wild About Harry" (1921), the popular song introduced by Lottie Gee in the Black musical SHUFFLE ALONG (1921), with words and music by Eubie BLAKE and Noble SISSLE. It later became President Harry S Truman's theme song.

Ince, Thomas Harper (1882–1924), U.S. writer, director, and producer; a child actor from the age of six, he moved into film in 1910 and by 1912 was a leading early writer-director-producer. In 1916 he gave up directing, though he still wrote screenplays and produced, employing several directors who worked under his close supervision. The star of many of his most successful Westerns was William S. HART. Ince died of either heart failure or a gunshot wound on November 19, 1924, aboard the yacht of William Randolph Hearst. His brothers John and Ralph were also early film actors and directors.

In Cold Blood (1966), the Truman CAPOTE book, a recountal of the murder of a Kansas farm family by robbers and of the ultimate capture and execution of the murderers. Capote called the work a "nonfiction novel," rather than a work in the "true crimes" genre, and it was as a nonfiction novel that the book became popular. Using the same approach, Richard BROOKS adapted the Capote book into his 1967 film, with a cast that included Robert Blake and Scott Wilson as the murderers, John Forsythe, Jeff Corey, Paul Stewart, and Will Geer.

incomparable Max, the, a phrase referring to Max BEERBOHM, as introduced to the readers of Britain's *Saturday Review* by George Bernard SHAW, when Beerbohm succeeded Shaw as drama critic of the publication in 1898.

Indiana, Robert (Robert Clark, 1928–), U.S. artist, a leading POP painter, sculptor, and graphic artist of the 1960s, who drew his often highly colored works from everyday life, such as the rather notable decoration of the New York State Pavilion at the 1964–65 New York World's Fair, consisting of the large sign *EAT*, also the title of his 1964 movie, done in collaboration with Andy WARHOL. His signature theme, however, and quite in keeping with the times, was the literally emblematic *Love*, the title of his celebrated 1962 one-man show and of his widely circulated 1960s poster.

Informer, The (1925), the Liam O'FLAHERTY novel, set in the Irish Revolution, the story of the last day on Earth of an alcoholic, Gyppo Nolan, who has betrayed one of his comrades to the British for money. Several films were based on the novel; the most notable by far was the 1935 Dudley Nichols adaptation for the classic John FORD film. Ford won an OSCAR for his direction, as did Victor

MCLAGLEN for his Gyppo, Nichols for the screenplay, and Max Steiner for the music. Heather Angel, Preston Foster, Margot Grahame, Wallace Ford, and Una O'Connor played key supporting roles.

Inge, William (1913–73), U.S. writer, who emerged in midcentury as a major American playwright with COME BACK, LITTLE SHEBA (1950), which became the 1952 Daniel MANN film, with Burt LANCASTER and Shirley BOOTH in the leads; she won a best actress OSCAR for the role she had created on stage. Inge's most notable subsequent works include the PULITZER PRIZE-winning PICNIC (1953), which became the 1955 Joshua LOGAN film, with William HOLDEN and Kim NOVAK in leading roles; BUS STOP (1955), which became the 1956 Joshua Logan film, starring Marilyn MONROE in a strong, straight dramatic role; *The Dark at the Top of the Stairs* (1957), which became the 1960 Delbert MANN film starring Robert PRESTON; and *A Loss of Roses* (1959). He also wrote several other plays and two late novels.

Inherit the Wind (1955), the play by Jerome Lawrence and Robert E. Lee, about the landmark 1925 Scopes trial, concerning the teaching of evolution in Tennessee. On stage, Paul MUNI was Henry Drummond, clearly Clarence Darrow; Ed Begley was Matthew Harrison Brady, modeled on William Jennings Bryan; and Tony Randall was E.K. Hornbeck, the H.L. Mencken role. The play was adapted into the 1960 Stanley KRAMER film, with Spencer TRACY as Drummond–Darrow, Fredric MARCH as Brady–Bryan, and Gene KELLY as Hornbeck–Mencken, in a cast that included Florence Eldridge, Dick York, Harry Morgan, and Donna Anderson.

"Inka Dinka Doo" (1933), Jimmy DURANTE's signature song, with music by Durante and words by Ben Ryan.

Ink Spots, The, U.S. quartet, formed in 1934 by Orville "Hoppy" Jones (1905–44), Jerry Daniels, Ivory Watson, and Charles Fuqua; they became very popular in 1939 with "If I Didn't Care" and went on to do scores of hits, such as "We Three (My Echo, My Shadow, and Me)" (1940), "Don't Get Around Much Any More" (1943), and "To Each His Own" (1946).

Innes, Michael, the pseudonym of writer J.I.M. STEWART, used for his celebrated mysteries featuring Inspector John APPLEBY.

International Style, an architectural style that developed mainly at the BAUHAUS during the Weimar period, under the leadership of such figures as Walter GROPIUS, Ludwig MIES VAN DER ROHE, and Marcel BREUER, and which focused on the creation of the consciously ahistorical, smooth, featureless, machine-oriented forms that were to dominate modern architecture and design during the next several decades. It was introduced into American architecture in the early 1930s, most notably by Philip JOHNSON, in his landmark 1932 book *The International Style* (with Henry-Russell Hitchcock), which played a major role in introducing and defining that style. Johnson was a leading postwar International Style architect, most notably with his centrally significant GLASS BOX (1949), his own home at New Canaan, Connecticut, and also with the SEAGRAM BUILDING (1958), done in collaboration with Mies van der Rohe. Mies had emigrated to the United States in 1937, in 1938 becoming head of the School of Architecture at the Armour Institute, which later became the Illinois Institute of Technology; there for two decades he developed a new "Chicago School," working largely in the International Style.

In the Heat of the Night (1967), the Norman JEWISON film, with Sidney POITIER and Rod STEIGER in the leads, in which a northern Black forensic pathologist accused of murder in a racist southern town joins the town's sheriff in finding the real murderer. Appearing at the height of the civil-rights struggles of the 1960s, the film made a powerful interracial statement in its time; it is also a classic detective story. The film, Stirling Silliphant's screenplay, adapting the John Ball novel, Steiger as best actor, editor Hal ASHBY, and Walter Goss for sound all won OSCARS. Poiter played the Tibbs role in two sequels: *They Call Me MISTER Tibbs* (1970) and *The Organization* (1971).

Intolerance (1916), an epic, technically innovative film written, directed, and produced by D.W. GRIFFITH and shot by Billy BITZER. It set forth four interlinked stories, the first about a broken modern strike and its tragic

aftermath; the second derived from incidents in the life of Christ; the third set in the French St. Bartholomew's Day Massacre of 1572; and the fourth about Babylon falling to the Persians. The common theme, never clearly developed, seemed to be generally pacifist and possibly civil libertarian in tone, although Griffith's focus on spectacle and rapid crosscutting overwhelmed all but the rather straightforward modern story. For some, the film is Griffith's second masterpiece, after THE BIRTH OF A NATION (1915), while for others it is largely a costly and unsuccessful attempt to atone for the rampant bigotry of the earlier film. There is little disagreement, however, as to the importance of the Griffith–Bitzer technical contribution to the development of the cinema.

Intruder in the Dust (1948), the William FAULKNER novel, about a Black man falsely accused of murder in a southern town. It became the pioneering antiracist 1949 Clarence BROWN film, with Juano Hernandez, Claude Jarman, Jr., David Brian, Will Geer, Porter Hall, and Elizabeth Patterson in key roles.

Investigation of a Citizen Above Suspicion (1970), the best foreign film OSCAR-winning Elio Petri film, about a police chief who murders his mistress, with a cast that included Gian Maria Volonte, Florinda Bolkan, Gianni Santuccio, and Salvo Randone.

Invisible Man, The (1933), the James WHALE film, based on the 1897 H.G. WELLS novel, as adapted by R.C. SHERRIFF and Philip Wylie, with Claude RAINS in the title role as the scientist who cuts a wide swath through the English countryside after learning how to make himself invisible. The highly innovative special effects were by John B. Fulton.

In Which We Serve (1942), the classic British wartime film, written and scored by Noël COWARD, co-directed by Coward and David LEAN, and starring Coward as the captain of a British warship in the early days of World War II, supported by a group of players that included Bernard Miles, John MILLS, Celia JOHNSON, and Richard ATTENBOROUGH. Coward was awarded a special OSCAR for the film.

Ionesco, Eugène (1912–), Rumanian-French writer, from the early 1950s identified with the focus on alienation, expressed as inability to communicate or take effective action, that was later called the THEATER OF THE ABSURD. He is best known for such one-act plays as *The Bald Soprano* (1956, alternatively *The Bald Prima Donna*) and *The Chairs* (1957) and for such full-length plays as *Rhinoceros* (1960), which starred Laurence OLIVIER in London and Zero Mostel in New York a year later, and *Exit the King* (1968), which starred Alec GUINNESS in London.

I Remember Mama (1944), the long-running John VAN DRUTEN play, based on the Kathryn Forbes novel *Mama's Bank Account*. Mady Christians created the role of the immigrant San Francisco Norwegian mother on stage. Irene DUNNE re-created the role in the 1948 George STEVENS film, while Peggy Wood re-created it once again in "Mama" (1949–56), one of the most popular series to run on early television.

Ironweed (1983), the William KENNEDY novel, about two alcohol-ridden drifters, set in late-1930s Albany, New York. Kennedy adapted it into the 1984 Hector Babenco film, starring Jack NICHOLSON and Meryl STREEP.

Isadora (1969), the Karel Reisz film biography of pioneering modern dancer Isadora DUNCAN. Vanessa REDGRAVE was Isadora, in a cast that included James Fox as Gordon CRAIG, Jason ROBARDS, Ivan Tchenko as poet Sergei Essenin, John Fraser, and Bessie Love.

Isherwood, Christopher (1904–86), British writer, a close friend and collaborator of W.H. AUDEN from the late 1920s, who lived in Berlin 1929–33 and made his observation of the rise of fascism the basis of several works, including the novels *The Last of Mr. Norris* (1935) and *Goodbye to Berlin* (1939). The latter was the basis for the John VAN DRUTEN play I AM A CAMERA (1951), itself the basis for the musical play and film CABARET. Isherwood also collaborated with Auden on the plays *The Dog Beneath the Skin* (1936), *The Ascent of F-6* (1936), and *On the Frontier* (1938), and on the prose-and-poetry *Journey to a War* (1939), written after he and Auden had traveled to China in 1938. His novels also include *Prater Violet* (1945) and *Down There on a Visit* (1962) and the autobiographical *Christopher and His Kind* (1976).

"It Ain't Necessarily So" (1935), the classic song introduced on Broadway by John W. BUBBLES (of BUCK AND BUBBLES) as Sportin' Life in the opera PORGY AND BESS (1935), and sung memorably by Sammy DAVIS, Jr., in the 1959 film; music was by George GERSHWIN and words by Du Bose Heyward.

I Tatti, from 1900 until his death in 1969 the home and workplace of art critic, historian, and authenticator Bernard BERENSON, near Florence, Italy.

"It Girl," Clara BOW, who was one of the more successful movie-studio promotion-department creations of the 1920s; she acquired the nickname after starring in *It* (1927).

It Happened One Night (1934), the Frank CAPRA film, a classic comedy-romance made early in the Golden Age of American films, starring Claudette COLBERT and Clark GABLE in a cast that included Roscoe Karns, Walter Connolly, Alan Hale, and Arthur Hoyt. Robert Riskin based his screenplay on the Samuel Hopkins Adams story "Night Bus." The film, Capra, Colbert as best actress, Gable as best actor, and Riskin all won OSCARS.

It's a Wonderful Life (1946), the Frank CAPRA film, about a much-loved small-town banker fallen on hard times who decides to end it all but is pulled back by the intervention of, quite literally, a guardian angel. James STEWART starred, with DONNA REED, Lionel BARRYMORE, Thomas Mitchell, and Henry Travers as the angel in key supporting roles.

Ivan the Terrible, Part 1 and ***Part 2*** (1944 and 1946), two linked films based on the life of the 16th-century Russian ruler, written, directed, and edited by Sergei M. EISENSTEIN, with scores by Sergei PROKOFIEV. Nikolai CHERKASSOV played Ivan, with Ludmila Tselikovskaya, Serafima Birman, Mikhail Nazvanov, Piotr Kadochnikov, and Andrei Abrikosov in key supporting roles. Part 2, portraying Ivan as having significant weaknesses and his palace guard as viciously murderous, was suppressed by Stalin, who saw invidious comparisons; it was not released until 1958.

Ivens, Joris (George Henri Anton Ivens, 1898–1989), Dutch documentary filmmaker, on screen from 1928, whose early work greatly influenced the development of nonfiction film. It included two classic works, the pro-Republican THE SPANISH EARTH (1937) and the pro-Chinese *The 400 Million* (1938).

Ives, Burl (Burle Icle Ivanhoe Ives, 1909–), U.S. folksinger and actor, who in the 1940s popularized several folk standards, becoming identified with "Wayfaring Stranger." He appeared on stage in the folk-based *Sing Out, Sweet Land* (1944). On Broadway he also created the role of Big Daddy in CAT ON A HOT TIN ROOF (1957), which he recreated in the 1958 Richard BROOKS film. He also appeared in such films as *Smoky* (1946); EAST OF EDEN (1955); and *The Big Country* (1958), winning a best supporting actor OSCAR.

Ives, Charles Edward (1874–1954), U.S. composer; his highly innovative, often very complex works drew upon American folk, popular, and philosophical themes and European musical styles and structures, while at the same time experimenting with and in many instances successfully introducing the new kinds of harmonies, tonal patterns, and structures that were to characterize much of 20th-century classical music. Some of his most notable works are the *Holidays Symphony* (1913), *Three Places in New England* (1914), the *Concord Sonata* (*Second Sonata*, 1915), and *114 Songs* (1924).

Ivory, James (1928–), U.S. director, whose work was on screen from 1953 and who emerged as a major artfilm director, in India and in the West, with such films as SHAKESPEARE WALLAH (1965), *Autobiography of a Princess* (1957), HEAT AND DUST (1983), A ROOM WITH A VIEW (1985), *Maurice* (1987), *Slaves of New York* (1989), and *Mr. and Mrs. Bridges* (1990). He has often worked in collaboration with producer Ismail Merchant and writer Ruth Prawer JHABVALA.

"I Want to Hold Your Hand" (1963), the BEATLES song, one of their earliest worldwide hits, which became their signature song; words and music were by John LENNON and Paul MCCARTNEY.

J

J'Accuse (*I Accuse*, 1919), the powerful, technically innovative antiwar film written and directed by Abel GANCE, which he developed after the French troop revolts of 1917 and shot immediately after the war. The title echoed the celebrated Émile Zola letter defending Alfred Dreyfus, unjustly accused of treason a generation earlier. Romauld Joube, Severin-Mars, and Marise Dauvray played the leads.

Jackson, Alexander Young (1882–1974), Canadian painter, who emerged as a major northern landscape painter in the years before World War I, as in *The Edge of the Maple Wood* (1910) and *April Snow* (1910). He was wounded in France, completed his war memorials series for the Canadian government in 1919, and from 1920, when he was a founding member of the GROUP OF SEVEN, was recognized as one of Canada's leading painters. For the next half-century he continued to find his subjects and themes throughout the Canadian North, as in *March Storm, Georgian Bay* (1920), *North Shore, Lake Superior* (1926), *Grey Day, Laurentians* (1933), and *The Far North: A Book of Drawings* (1928).

Jackson, Glenda (1936–), British actress, on stage from 1957 and on screen from 1963, who became a leading stage player with her Charlotte Corday role in MARAT/SADE (1964), a role she re-created in the 1966 film. It was the first lead in a screen career that has also included starring roles in such films as WOMEN IN LOVE (1969), for which she won a best actress OSCAR; SUNDAY, BLOODY SUNDAY (1971); *A Touch of Class* (1973), winning another best actress Oscar; and STEVIE (1978), her memorable portrait of poet Stevie Smith, in which she re-created her 1977 stage role. She was also a memorable Elizabeth I in the television series ELIZABETH R (1971). A few of her other most notable plays are *Hedda Gabler* (1975), *The White Devil* (1976), *Rose* (1980), and *Macbeth* (1988).

Jackson, Gordon Cameron (1923–90), British actor, on screen from 1940 and on stage from 1951, who played a series of strong supporting roles in theater and cinema for two decades and then emerged a star as Hudson in the television series UPSTAIRS, DOWNSTAIRS (1970–75). He later played leads in such television series as "The Professionals" (1981) and such miniseries and telefilms as A TOWN LIKE ALICE (1980), *My Brother Tom* (1986), and *The Winslow Boy* (1988).

Jackson, Mahalia (1911–72), U.S. singer, by far the most popular gospel singer of the century and an artist of enormous emotional and vocal range and quality. She became a major recording star in the mid-1930s, and with the development of the civil-rights movement emerged as a worldwide symbol of truth and social justice; her rendition of AMAZING GRACE was emblematic of the time.

Jackson, Michael Joe (1958–), U.S. singer; he became a star as the very young lead singer of his family group, **The Jackson Five**, from the late 1960s, and began to record on his own in the early 1970s, with such songs as "Got to Be There," "Rockin' Robin," and "Ben," all in 1972. In 1978 he starred in *The Wiz*, opposite Diana ROSS, and in the late 1970s began the run of massive hit albums and songs that established him as one of the key popular music stars of the 1980s. These included such albums as *Off the Wall* (1979), GRAMMY winner *Thriller* (1982), and *Bad* (1987), and over a dozen hit songs from these and other albums, such as "Don't Stop Till

You Get Enough," "Billie Jean," and "I Can't Stop Loving You." Several other Jackson siblings pursued musical careers, most notably **Jermaine Jackson** (1954–), middle member of the original Jackson Five, and the youngest, **Janet Jackson** (1966–).

Jackson, Shirley (1916–65), U.S. writer, whose best-known work is the shocking story of institutionalized small-town murder in "The Lottery." Her diverse body of work includes such novels as *The Road Through the Wall* (1948), *The Bird's Nest* (1954), and *We Have Always Lived in the Castle* (1962), as well as occult fiction, children's fiction, and autobiographical works.

Jacobi, Derek George (1938–), British actor, on stage from 1960, who became a leading classical player; he starred in an especially notable *Hamlet* in 1978. He is best known abroad for his title role in "I, Claudius" (1977), also appearing in THE PALLISERS (1977) and in such films as THE DAY OF THE JACKAL (1973), THE HUNCHBACK OF NOTRE DAME (1981), *Inside the Third Reich* (1982), and HENRY V (1989).

Jagger, Mick (Michael Philip Jagger, 1941–), British singer and songwriter; the leading performer and co-songwriter (with Keith Richards) of the ROCK group the ROLLING STONES, which he organized in 1962. He also appeared in the films *Ned Kelly* (1970) and *Performance* (1970) and did some recordings on his own, while continuing to be identified with the Stones.

James, Henry, Jr. (1843–1916), U.S. writer, resident in London from 1876 and a major literary figure on both sides of the Atlantic from the late 1870s, whose lifelong interest was in the interplay between European and American cultural styles and personal motives. He is generally regarded as a leading literary stylist and simultaneously as an early master of the psychological novel, whose work explores and reveals the inner worlds of his protagonists. Although most of his large body of work belongs to the 19th century, he published three major novels in the first decade of the 20th: *The Wings of the Dove* (1902); *The Ambassadors* (1903); and THE GOLDEN BOWL

(1904), his last completed novel, regarded by many as his most notable single work. He also wrote a miscellany of plays, essays, and autobiographical works in his later years. He was the son of writer and religious philosopher Henry James and the brother of philosopher William James.

Janáček, Leoš (1854–1928), Czech composer, whose work drew strongly on Czech folk themes and greatly influenced the development of Czech national music. Although much of his work was instrumental and orchestral, he is best known for his operas, such as *Jenufa* (1904); *Katia Kabanova* (1921); *The Cunning Little Vixen* (1924); *The Makropulos Affair* (1926); and *From the House of the Dead* (1930), completed after his death by two of his students. His work began to find international acceptance quite late in his career; it also included the choral work *Glagolithic Mass* (1926) and his *Sinfonietta* (1926).

Jane Eyre (1944), the most notable of the several films based on the 1847 Charlotte Brontë novel. It was directed by Robert Stevenson and starred Orson WELLES opposite Joan FONTAINE in the title role, in a cast that included Elizabeth TAYLOR, Peggy Ann Garner, Margaret O'Brien, Agnes Moorehead, Henry Daniell, and John Sutton.

Jannings, Emil (Theodor Friedrich Emil Janenz, 1884–1950), German actor, on stage from 1902 and on screen from 1914, who during the Weimar period became a leading German film star, in such movies as *Peter the Great* (1922), *The Last Laugh* (1924), *Faust* (1926), and the classic THE BLUE ANGEL (1930). He won a cumulative best actor OSCAR for two films done in Hollywood, *The Way of All Flesh* (1927) and *The Last Command* (1928). He unreservedly supported the Nazis, from 1933 turned his art to propaganda purposes, was a much-praised and decorated Nazi cultural leader, and was blacklisted after World War II.

Jarrell, Randall (1914–65), U.S. writer, teacher, and critic, whose poetry is collected in several volumes, beginning with *Blood for a Stranger* (1942) and including the National Book Award-winning *The Woman at the Wash-*

ington Zoo (1960) and *Complete Poems* (1969). His many volumes of critical work began with *Poetry and the Age* (1953). His single novel is *Pictures from an Institution* (1954).

Jaws (1974), the Peter Benchley novel, about a huge shark attacking and killing bathers off the New England shore. Benchley and Carl Gottlieb adapted it into the 1975 Steven SPIELBERG horror film, with a cast that included Roy SCHEIDER, Richard DREYFUSS, Robert Hamilton, Lorraine Gary, and Murray Hamilton. Verna Field won an editing OSCAR, as did John Williams for his music and John Carter, Roger Herman, Robert L. Hoyt, and Earl Madery for sound. There were three sequels: *Jaws 2* (1978), *Jaws 3-D* (1983), and *Jaws: The Revenge* (1987).

jazz, a kind of music, originating in Black, largely New Orleans musical culture early in the 20th century, that fused several existing BLUES, African, gospel, RAGTIME, and other elements into a new style that would in the balance of the century become the only entirely unique American musical form, one that articulated out into several subforms and spread throughout the world, its main practitioners becoming world cultural figures. Jazz moved up the Mississippi through Memphis and to Chicago in the 1920s, such figures as Louis ARMSTRONG, Lillian Hardin ARMSTRONG, Kid ORY, King OLIVER, and Jelly Roll MORTON emerging as recording artists in the process. It entered the mainstream of American life through the work of such White bandleaders as Paul WHITEMAN and Benny GOODMAN in the 1920s and 1930s, beginning to become racially integrated in the 1930s, during the big-band era, when jazz took the form of SWING. During the postwar period, jazz articulated out into several forms, including greatly improvisional and complex BOP or bebop, the "cool" form, and the highly experimental "free jazz" form.

Jazz Singer, The (1925), the historic film-musical melodrama that signaled the beginning of the sound era. It was directed by Alan Crosland and written by Alfred A. Cohn, as adapted from Samson Raphaelson's 1925 play *The Day of Atonement.* Al JOLSON starred as Jakie Rabinowitz, a cantor's son who has

become a popular singer against his father's wishes, with Warner Oland, May McAvoy, and Bobby Gordon in key supporting roles.

J.B. (1958), the TONY- and PULITZER PRIZE-winning play by Archibald MACLEISH, a powerful allegorical work in which Pat Hingle created the grievously beset, ultimately redeemed-by-faith J.B., opposite Raymond MASSEY as Zuss and Christopher PLUMMER as Nickles.

Jeffers, Robinson (1887–1962), U.S. writer, a California-based poet and verse dramatist whose work increasingly reflected his wholly negative view of humanity and its prospects, coupled with appreciation of a natural world that he perceived as brutally rational. His major works include such volumes as *Tamar and Other Poems* (1924), which include "The Tower Beyond Tragedy," his bitter re-creation of the Orestes–Electra tale; *Cawdor, and Other Poems* (1928); *Dear Judas, and Other Poems* (1929); *Give Your Heart to the Hawks, and Other Poems* (1933); *Solstice, and Other Poems* (1935); and *Medea* (1946), his adaptation of Euripides, which was produced on Broadway in 1947, with Judith ANDERSON and John GIELGUD creating the Medea and Jason roles.

Jefferson, Blind Lemon (1897–1930), U.S. singer, composer, and guitarist, a blind Black street singer who sang and wrote the BLUES throughout the American South from early in the second decade of the century until his death, probably in Chicago in the winter of 1929–30; he is reported by some to have died of exposure on a snowy northern street. He began his brief, very prolific recording career in the mid-1920s, his music and style surviving to influence deeply all who sang, wrote, and heard the blues.

Jefferson Airplane; Jefferson Starship, U.S. ROCK band, formed as The Jefferson Airplane in 1965; it began as a Haight-Ashbury-based San Francisco folk-BLUES group, moved quickly into acid rock, and moved through many changes of membership and musical approach in the two decades that followed. The group became The Jefferson Starship in 1974. Some of those most often identified with the band were Marty Balin, Paul Kantner,

Grace Slick, Jorma Kaukonen, Jack Casady, and Spencer Dryden. Some of their best-known albums are *Jefferson Airplane Takes Off* (1966), *Crown of Creation* (1968), *Red Octopus* (1975), *Spitfire* (1976), and *Earth* (1978).

Jennings, Waylon (1937–), U.S. country singer, a leading figure in the "outlaw" break-through country-music movement of the 1970s, which moved to some extent away from the smoother "Nashville sound" and toward a partial merger with the harder, rougher sound of ROCK music. He emerged as a major figure with such popular albums as *Honkytonk Heroes* (1973), *This Time* (1974), and *Wanted! The Outlaws* (1976), and such singles as "Luchenback, Texas" (1977) and "Mamas, Don't Let Your Babies Grow Up to Be Cowboys" (1978, with Willie NELSON).

Jeritza, Maria (1887–1982), Czech soprano; she made her debut in 1910 and was a leading singer at Vienna's Court Opera from 1911. She sang at the Metropolitan Opera from 1921, performing Tosca, Turandot, Salome, Fedora, and many other major roles in the repertory.

Jesus Christ, Superstar (1971), the innovative Andrew LLOYD WEBBER ROCK opera, with lyrics by Tim Rice. The play, about the last days of Jesus Christ, was conceived and directed by Tom O'Horgan. Ben VEREEN was Judas and Jeff Fenhold Jesus Christ, in a cast that included Yvonne Elliman, Barry Dennen, Michael Jason, Paul Ainsley, and Bob Bingham. The cast of the 1973 Norman JEWISON film version included Ted Neeley, Carl Anderson, Yvonne Elliman, Bob Bingham, and Barry Denham.

"Jewel in the Crown, The" (1984), the 14-part television serial, adapted from the Paul Scott tetralogy *The Raj Quartet* (1966–73). The story is set in India in the years 1942–47, around the events of the last days of the Raj and on the eve of partition. The key players included Peggy ASHCROFT, Charles Dance, Fabia Drake, Geraldine James, Rachel Kempson, Art Malik, Susan Wooldridge, Judy Parfitt, and Tim Piggott-Smith.

Jewison, Norman (1926–), Canadian director and producer; after early work in television he turned to film direction, most nota-

bly with *The Cincinnati Kid* (1965), *The Russians Are Coming, the Russians Are Coming* (1966), IN THE HEAT OF THE NIGHT (1967), FIDDLER ON THE ROOF (1971), *Jesus Christ, Superstar* (1973), *And Justice for All* (1979), *A Soldier's Story* (1984), AGNES OF GOD (1985), and *Moonstruck* (1987).

Jhabvala, Ruth Prawer (1927–), British writer, resident in India 1951–75 and in the United States from 1975, much of whose work is set in India. Her best known novels include *The Householder* (1960), HEAT AND DUST (1975), and *The Nature of Passion* (1986). She was the screenwriter of several James IVORY films, most notably including SHAKESPEARE WALLAH (1965); *Autobiography of a Princess* (1975); HEAT AND DUST (1983); ROOM WITH A VIEW (1985), for which she won a best screenplay OSCAR; and *Mr. and Mrs. Bridge* (1990). She has also published several collections of short stories.

Job, a ballet choreographed by Ninette DE VALOIS, with music by Ralph VAUGHAN WILLIAMS. It was first produced in London, in July 1931, by the Camargo Society, with Anton DOLIN and Stanley Judson in leading roles.

Joffrey, Robert (Abdullah Jaffa Anver Khan, 1930–88), U.S. dancer, choreographer, and dance-company director. He made his debut as a dancer in 1949 and as a choreographer in 1952, founded the Robert Joffrey Ballet Concert in 1954, and founded the Robert Joffrey Ballet in 1956. In the next decade the Joffrey became one of the world's leading ballet companies, changing its name to the City Center Joffrey Ballet in 1966. Joffrey choreographed several ballets, including *Persephone* (1952), *Astarte* (1967), and *Remembrances* (1973).

John, Augustus Edwin (1878–1961), British artist, a leading portraitist and landscape painter, who was also a rather celebrated Bohemian in the years before World War I, as he and his family lived for long periods in Britain's Gypsy subculture. The Gypsy life was reflected in much of his early work, a great deal of it exhibited at the ARMORY SHOW (1913). His best-known works of that period are *The Smiling Woman* (1908) and the *Provençal Sketches* (1910). Much of his later work consisted of portraits of some of the cele-

brated people of the interwar period, such as George Bernard SHAW, Dylan THOMAS, and James JOYCE.

John, Elton (Reginald Kenneth Dwight, 1947–), British singer, composer, and pianist, who emerged as one of the leading ROCK stars of the 1970s with such albums as *Elton John* (1970), *Tumbleweed Connection* (1970), *Friends* (1971), and *Madman Across the Water* (1971), all products of his long collaboration with lyricist Bernie Taupin. John became a touring phenomenon as well, his total impact much like that of the BEATLES a decade earlier and enhanced by his flamboyant singing style and wardrobe.

John Brown's Body (1928), the PULITZER PRIZE-winning epic poem by Stephen Vincent BENÉT, set before and during the Civil War.

Johnny Belinda (1940), the Elmer Harris play, about a deaf-mute girl, the doctor who falls in love with her, and the father of her illegitimate child, whom she kills when he tries to take the child from her. Helen Craig, Horace McNally, and Willard Parker created the three roles on stage. Jane WYMAN won a best actress OSCAR as the girl in the 1948 Jean Negulesco film; Lew AYRES was the doctor and Stephen McNally the villain, in a cast that also included Charles Bickford, Agnes Moorehead, and Jan Sterling.

Johns, Jasper (1930–), U.S. artist, a painter, sculptor, and printmaker whose work succeeded that of the American Abstract Expressionists (see ABSTRACT EXPRESSIONISM) and prefigured the reality-based POP ART that would follow. He emerged as a major figure in the mid-1950s, with a body of work that featured flags, targets, numbers, and alphabet letters, all rendered realistically. By the early 1960s he was producing such sculptures as the well-known set of two beer cans called *Painted Bronzes* (1960) and including real artifacts set into his paintings, such as paintbrushes and beer cans. His work has sometimes been described as "neo-Dadaist" (see DADA), although much of it seems to have been a straightforwardly serious attempt to move into a new aspect of American realism.

Johnson, Celia (1908–82), British actress, on stage from 1928 and a leading stage player for four decades, in such plays as *Pride and Preju-*

dice (1936), *St. Joan* (1947), and *The Master Builder* (1964). She is best known abroad for her relatively infrequent screen roles, beginning with her first film, IN WHICH WE SERVE (1942), and including *This Happy Breed* (1944) and the classic BRIEF ENCOUNTER (1945).

Johnson, Eyvind (Olof Verner, 1900–1976), Swedish writer, best known for *The Novel of Olof* (1934–37), a series of four autobiographical novels; and *Return to Ithaca* (1946), a modern version of the *Odyssey*. A prolific writer, his work also includes several novels of social protest. He shared the 1974 NOBEL PRIZE for literature.

Johnson, James Weldon (1871–1938), U.S. writer, a novelist, poet, lyricist, and political activist who became one of the leading Black cultural and political figures of his time. With his brother, composer John Rosamond Johnson (1873–1954), he wrote "Lift Every Voice and Sing," long known as the "Negro National Anthem." His work includes the novel *Autobiography of an Ex-Colored Man* (1912) and several volumes of poems, including *God's Trombones: Seven Negro Sermons in Verse* (1927). He was in the American consular service from 1906 to 1912, a field secretary of the National Association for the Advancement of Colored People (NAACP) from 1916 to 1920; and NAACP national executive secretary from 1920 to 1930.

Johnson, Philip Cortelyou (1906–), U.S. architect. In 1932, while director of the Architecture and Design Department of the Museum of Modern Art (1932–40, and again 1946–54), he published his landmark book *The International Style* (with Henry-Russell Hitchcock), a work that played a major role in introducing and defining that style. He studied architecture at Harvard from 1940 to 1943, with BAUHAUS luminaries Ludwig MIES VAN DER ROHE and Marcel BREUER and emerged as a leading postwar INTERNATIONAL STYLE architect, most notably with the centrally significant GLASS BOX (1949), his own home at New Canaan, Connecticut, and also with the SEAGRAM BUILDING (1958), done in collaboration with Mies van der Rohe. Two very notable later works were the New York State Theater (1963) at Lincoln Center and the

American Telephone and Telegraph headquarters building (1983), both in New York City. The first reflected his move toward a powerful, historically relevant American style and away from the ahistoricism of the International Style, while the second was a landmark in the development of what had by then come to be called the postmodernist style.

Johnson, Van (1919–), U.S. actor, on screen from 1942, who became a star in the 1940s in such films as *The Human Comedy* (1943), *Thirty Seconds over Tokyo* (1944), *Weekend at the Waldorf* (1945), *Till the Clouds Roll By* (1946), *Battleground* (1949), *Miracle in the Rain* (1956), and *23 Paces to Baker Street* (1956), and later also played supporting roles in such films as THE CAINE MUTINY (1954).

Jolson, Al (Asa Yoelson, 1886–1950), U.S. singer and actor, on stage as a child in variety from 1897, a recording artist and headliner in vaudeville, and on the New York stage from 1911, often playing in blackface. He starred in such Broadway musicals as *Sinbad* (1918), *Bombo* (1921), and *Big Boy* (1925), before starring in the screen's first "talkie," THE JAZZ SINGER (1927). Jolson later appeared in such films as *Mammy* (1930), the movie version of *Big Boy* (1930), and *Rose of Washington Square* (1939). He was identified with such songs as APRIL SHOWERS, CALIFORNIA, HERE I COME, MY MAMMY, and AVALON.

Jones, James (1921–77), U.S. author, whose military experience provided the basis for his highly regarded first novel, FROM HERE TO ETERNITY (1951), which became the 1953 OSCAR-winning Fred ZINNEMANN film. His most notable work also includes *Some Came Running* (1957), which became the 1958 Vincente MINNELLI film; and another World War II story, *The Thin Red Line* (1962), which became the 1964 Andrew Marton film.

Jones, James Earl (1931–), U.S. actor, on stage from 1955 and on screen from 1964, who became a leading Shakespearean stage player in the mid-1960s and despite a paucity of leading roles for Black players became a star, as Jack Jefferson in THE GREAT WHITE HOPE (1968), re-creating the role on screen in 1970. He continued to play major roles on the American stage, as Hickey in THE ICEMAN COMETH

The young James Earl Jones in one of his finest roles, as boxer Jack Jefferson in *The Great White Hope* (1968).

(1973), as *Othello* (1982), and in his TONY-winning lead in FENCES (1988). He has also appeared in such films as *The River Niger* (1976), *A Piece of the Action* (1977), *Conan the Barbarian* (1982), GARDENS OF STONE (1987), *Coming to America* (1988), and FIELD OF DREAMS (1989), and was memorably the voice of Darth Vader in STAR WARS (1977). He has also often appeared on television, most notably in the Alex HALEY role in ROOTS II.

Jones, Jennifer (Phyllis Isley, 1919–), U.S. actress, on screen from 1939, who emerged in leading roles with her OSCAR-winning title role in *The Song of Bernadette* (1943) and went on to star in such films as *Since You Went Away* (1944), *Love Letters* (1945), *Cluny Brown* (1946), *Duel in the Sun* (1947), *Carrie* (1950), and A FAREWELL TO ARMS (1957).

Jones, LeRoi, the former name of African-American writer Imamu Amiri BARAKA.

Jones, Shirley (1934–), U.S. actress and singer, on stage from 1952 and on screen from 1955, beginning with her starring role as Laurie in the film version of OKLAHOMA. In 1956 she starred as Julie in CAROUSEL. She won a best supporting actress OSCAR in ELMER GANTRY (1960) and played opposite Robert PRESTON in THE MUSIC MAN (1962). Much of her later career was in television, most notably as the star of the series "The Partridge Family" (1970–74).

Jong, Erica Mann (1942–), U.S. writer, a novelist and poet whose first novel, *Fear of Flying* (1973), became a bestseller; it was followed by such novels as *How to Save Your Own Life* (1977) and *Serenissima* (1987). She has also published several collections of poems.

Joplin, Janis (1943–70), U.S. singer. She joined the San Francisco-based group Big Brother and the Holding Company in 1967 and in the next three years became one of the leading BLUES singers of the time, on tour and with the albums *Big Brother and the Holding Company* (1967), *Cheap Thrills* (1968), and the single "I Got Dem Ol' Kozmic Blues Again, Mama" (1969). Her life and career were cut short by a heroin overdose. In later years her celebrity grew; Bette MIDLER's self-destruc-

tive ROCK singer role in the Mark Rydell film *The Rose* (1979) was modeled on Joplin.

Joplin, Scott (1868–1917). U.S. composer and pianist, the foremost RAGTIME composer, whose first ragtime works, *Original Rags*, were published in 1899. In that year John S. Stark also published the best-known work of Joplin's lifetime, "The Maple Leaf Rag." Joplin continued to write rags, ultimately about 50 in all, including "The Entertainer" (1902); he also wrote the ballet *The Ragtime Dance* (1902), the ragtime opera *A Guest of Honor* (1903), and the folk opera *Treemonisha* (1911). Joplin was fully recognized and revived in the 1970s; his rags were well recorded by such classical artists as Joshua Rivkin and Itzhak Perlman, and *Treemonisha*, only self-produced on a bare stage in his lifetime, was given a full production by the Houston Opera in 1976. He also became enormously popular; Marvin Hamlisch won an OSCAR for his arrangement of Joplin's work, most notably "The Entertainer," as theme music for the Oscar-winning film THE STING (1973). Afterward, ragtime was for a time reborn, and Joplin's music was heard everywhere.

Josephson, Erland (1923–), Swedish actor and theater director, best known abroad for his roles in such films as *Cries and Whispers* (1972), SCENES FROM A MARRIAGE (1973), *Autumn Sonata* (1978), *Montenegro* (1980), FANNY AND ALEXANDER (1983), *After the Rehearsal* (1984), THE UNBEARABLE LIGHTNESS OF BEING (1988), and *Rasmussen* (1989). In addition to his international career he was also a major figure in the Swedish theater, from 1956 a leading player at Stockholm's Royal Dramatic Theatre and director of that theater from 1966 to 1975.

Journey's End (1928), the R.C. SHERRIFF play, set in the trenches during World War I; on stage, Laurence OLIVIER and then Colin Clive played the Captain Stanhope role. It was the basis of the 1930 James WHALE film, with Colin Clive as Stanhope, in a cast that also included Ian MacLaren, David Manners, Anthony Bushell, and Billy Beven.

Jouvet, Louis (1887–1951), French actor, director, and manager, on stage from 1910 and

a major figure in the French theater, as a leading classical and modern player, notably in Molière, GIRADOUX, and Shakespeare. His work in cinema was also highly regarded, in such movies as THE LOWER DEPTHS (1936), *Hotel du Nord* (1938), and *Volpone* (1940).

Joyce, James (1882–1941), Irish writer, one of the seminal novelists of the 20th century, whose two final novels, ULYSSES (1922) and *Finnegan's Wake* (1939), explored the uses of language and the forms of narration to illuminate the inner worlds of his protagonists, and in so doing introduced the "stream-of-consciousness" approach into the mainstream of world literature. His other works include *Chamber Music* (1907), a volume of poems; *Dubliners* (1914), a volume of short stories; *Exiles* (1918), a play; and a largely autobiographical novel, A PORTRAIT OF THE ARTIST AS A YOUNG MAN (1916; serialized in the magazine *The Egoist*, 1914–15). *Exiles* was most notably revived by Harold PINTER in 1970. There have been several stage and screen adaptations of his novels and short stories, such as John HUSTON's THE DEAD (1987).

J. Pierpont Morgan (1903), the celebrated portrait photo of the financier, by Edward STEICHEN; it became a landmark in the history of photography.

Judgment at Nuremberg (1961), the powerful Stanley KRAMER film, about the trial of a group of German judges for crimes against humanity committed during the Nazi period, at the second round of Nuremberg war-crimes trials; the OSCAR-winning screenplay was adapted by Abby Mann from his own PLAYHOUSE 90 television play. The cast was led by Spencer TRACY as American judge Dan Haywood and Burt LANCASTER as German judge Ernst Janning, strongly supported by Maximilian Schell and Richard WIDMARK as the German and American prosecuting and defending attorneys, Marlene DIETRICH as a Prussian general's widow, and Judy GARLAND and Montgomery CLIFT as German victims of the Nazis. Schell won an Oscar for his role.

Jules and Jim (1961), the François TRUFFAUT film, about a post-World War I ménage à trois

that proves impossible to sustain and later results in a double suicide. Jeanne MOREAU, Oskar Werner, and Henri Serre played the leads in this key French NEW WAVE film.

Julia (1977), the Fred ZINNEMANN film; the Alvin Sargent screenplay is based on Lillian HELLMAN's autobiographical *Pentimento* (1973). Jane FONDA played Hellman; Jason ROBARDS her lover, Dashiell HAMMETT; and Vanessa REDGRAVE Hellman's childhood friend Julia, who became an activist in the anti-Nazi underground during the 1930s and for whom Hellman once took money into Germany, as ransom for Jews. Mann, Redgrave as best supporting actress, and Robards as best supporting actor all won OSCARS.

Juliet of the Spirits (1965), a film written and directed by Federico FELLINI and starring Giulietta MASINA in a very notable exploration of the inner world of a woman at first crushed by knowledge of her husband's infidelity and later able to find her own strength and sense of self.

Jungle, The (1906), the Upton SINCLAIR novel, a powerful exposé of the meat-packing practices of the time and a landmark work in the development of "muckraking," later a routine part of investigative journalism. The work furthered the passage of American pure food and drug laws.

junk art, from the mid-1950s a term used to describe collages or assemblages made by such American artists as Robert RAUSCHENBERG, which literally used "junk" materials, such as bits of used cloth, papers, rusted metal parts, and splintered wood. Such work has been done in many countries since the second decade of the century.

Juno and the Paycock (1924), the Sean O'CASEY play, the middle of his three Irish Civil War plays, which include *The Shadow of a Gunman* and THE PLOUGH AND THE STARS. Sara ALLGOOD created the central role of Juno Boyle in the original 1924 ABBEY THEATRE production, opposite Barry FITZGERALD. Allgood re-created the role in the 1930 film, adapted from the play by Alfred HITCHCOCK and Alma Reville and directed by Hitchcock; the cast also included John Laurie, Edward Chapman, and Maire O'Neill.

K

Kafka, Franz (1883–1924), Austrian-Czech writer, who spent most of his life in Prague and wrote in German. His relatively small body of deeply introspective and imaginative work profoundly influenced the development of 20th-century literature. Only a small portion of his work was published during his lifetime; this includes three major stories—"The Judgment" (1913), "The Metamorphosis" (1915), and "In the Penal Colony" (1919)—as well as several shorter works. He had instructed his friend Max Brod to destroy his unpublished work; instead Brod edited and issued Kafka's three landmark novels: *The Trial* (1925), *The Castle* (1926), and *Amerika* (1927). Brod also posthumously published several short works and Kafka's diaries and letters.

Kagemusha (1980), the Akira KUROSAWA film epic, set in the late feudal Japan that is his preferred period, with Tatsuya Nakadai, Tsutomu Yamazaki, and Kenichi Hagiwara in leading roles.

Kahn, Louis (1901–74), U.S. architect; late in his career he emerged as a major innovator and theorist, moving from the INTERNATIONAL STYLE into a massive, monumental style often characterized by the use of huge slabs of rough-cut concrete and equally massive spaces, the whole often seeming unfinished. A few of his most notable works are his first major work, the Yale Art Gallery (1954); the Richards Medical Center at the University of Pennsylvania (1960); the Salk Institute at La Jolla, California (1965); and the Kimbell Art Museum at Fort Worth, Texas (1972). His last major work, the Yale Center for British Art, was completed after his death.

Kandinsky, Wassily (1866–1944), Russian painter and teacher, who during the period 1908–14, then resident in Germany, became one of the pioneer fully nonobjective artists of the century. Although the matter continues to be a matter of controversy, he may indeed have in 1910 painted the first fully nonobjective work, a then-untitled gouache now called *First Abstract Watercolor*. He was also a key theorist of the new movement in art; in 1911 he and others established THE BLUE RIDER group, and in 1912 his seminal essay "On the Question of Form" appeared as part of *The Blue Rider Almanac*, which he edited. In 1912 his *Concerning the Spiritual in Art* was also published; his autobiographical *Reminiscences* was published in 1913. Kandinsky returned to Russia in 1914, worked with the new Bolshevik government until 1921, and then emigrated to Germany, where he taught at the BAUHAUS until it was forced to close by the Nazis in 1933. In Germany his work, while still fully nonobjective, became somewhat more geometric; while in Paris, where he lived from 1933 until his death, it became rather more fluid, colorful, and filled with signs and symbols.

Kane, Robert (1916–), U.S. cartoonist, who in 1939 created BATMAN, then a hugely popular comic-book series, which later generated radio, television, and film versions, most notably the 1966–68 television series and the 1989 film starring Michael Keaton as Batman and Jack NICHOLSON as the Joker.

Kanin, Garson (1912–), U.S. actor, director, and writer, on stage from 1933 and a director on stage and screen from the late 1930s, most notably of the film *They Knew What They Wanted* (1940). He wrote and directed BORN YESTERDAY (1946) on Broadway, later directing such plays as THE DIARY OF ANNE FRANK (1955) and FUNNY GIRL

(1964). He also wrote several screenplays, including the Spencer TRACY–Katharine HEPBURN films *Adam's Rib* (1949) and *Pat and Mike* (1952); his later books include *Tracy and Hepburn* (1971).

Kantor, McKinley (1904–77), U.S. writer, a prolific historical novelist who is best known for his PULITZER PRIZE-winning *Andersonville* (1955), about life and death in that Confederate prison camp. He also wrote several screenplays, including THE BEST YEARS OF OUR LIVES (1946), adapted from his novel *Glory for Me*.

Karajan, Herbert von (1908–89), Austrian conductor, a leading figure in German music. He conducted opera at Ulm (1929–34), joined the Nazi Party in Austria in 1933, joined it again in Germany in 1934, was music director at Aachen from 1934, became a major figure in German music as conductor of the Berlin Opera from 1938 to 1942, and then worked in Italy for the balance of the war. In the late 1930s he also began his long recording career. He fully resumed his career in 1947, after his "de-Nazification," although his first postwar American appearance, in 1955, was picketed by anti-Nazi protesters. He was director of the Berlin Philharmonic from 1954 to 1989 and of the Vienna Philharmonic and the Salzburg Festival for some years, as well. During the postwar period he became one of the world's leading conductors, while continuing to be a controversial figure, personally and professionally.

Karloff, Boris (William Henry Pratt, 1887–1969), British actor with early stage experience; on screen in supporting roles from 1919, he became identified with his first starring role, that of the doctor's creation in FRANKENSTEIN (1931), then becoming one of the most notable horror-film stars in movie history, in dozens of such films as *The Mummy* (1932), *The Bride of Frankenstein* (1935), and *The Body Snatcher* (1945). He periodically returned to the theater, and created the Jonathan Brewster role in ARSENIC AND OLD LACE (1941). Later he also worked in television and apparently took particular pleasure in narrating children's stories on records and working with children, being by all accounts a notably gentle person.

Karsavina, Tamara Platonovna (1885–1978), Russian dancer, who became one of the most celebrated ballerinas of the century as the leading ballerina of the BALLET RUSSES company of Sergei DIAGHILEV. From 1909 to 1922, she created leads in such works as *Cleopatra* (1909), FIREBIRD (1910), LE SPECTRE DE LA ROSE (1911), PETRUSHKA (1911), DAPHNIS AND CHLOÉ (1912), *Le Coq d'Or* (1914), THE THREE-CORNERED HAT (1919), and *Pulcinella* (1920), many of them in the early years opposite Vaslav NIJINSKY. From 1902 to 1918, she was also a leading member of Leningrad's Maryinsky Theatre (later the KIROV BALLET). She left the Soviet Union in 1918 with her husband, British diplomat Henry J. Bruce; in Britain she danced with the Rambert company from 1930 to 1931, coached (among others, Margot FONTEYN), helped form and was until 1955 vice president of the Royal Academy of Dancing, and wrote several works on the ballet.

Karsh, Yousuf (1908–), Armenian-Canadian photographer, a leading portraitist from his appointment as Canadian government photographer in 1935 and a world figure from the publication of his 1941 Winston Churchill portrait. His main work was with notables and other celebrities, as published in such collections as *Faces of Destiny* (1946), *Faces of Our Time* (1971), and *Karsh Portraits* (1976), though he also did such works as *This Is the Holy Land* (1961) and the film *Karsh: The Searching Eye* (1986).

Kaufman, George Simon (1889–1961), U.S. writer, director, and critic, much of whose work was written in collaboration with others, beginning with his first hit, *Dulcy* (1921), written with Marc CONNELLY. Some of his most notable works were *Merton of the Movies* (1924), written with Connelly; *The Royal Family* (1927), DINNER AT EIGHT (1932), and STAGE DOOR, all written with Edna FERBER; and OF THEE I SING (1931), for which he, Morris Ryskind, and Ira Gershwin won a PULITZER PRIZE. He and Moss HART collaborated on several plays, most notably on their Pulitzer Prize-winning YOU CAN'T TAKE IT WITH YOU (1936) and *The Man Who Came to Dinner* (1939). Kaufman also wrote the librettos of

such musicals as *The Cocoanuts* (1925), *Animal Crackers* (1928), and *I'd Rather Be Right* (1937). Many of his plays were adapted for film, although his only screenplay, with Ryskind, was A NIGHT AT THE OPERA (1935).

Kawabata, Yasunari (1899–1972), Japanese writer, a popular novelist in Japan from the publication of his *The Izu Dancer* (1926). International recognition came after World War II, with such novels as *Snow Country* (1947), *Thousand Cranes* (1951), *The Sound of the Mountain* (1954), and *Beauty and Sadness* (1963). He was awarded the NOBEL PRIZE for literature in 1968.

Kaye, Danny (David Daniel Kaminsky, 1913–1987), U.S. actor and comedian, in variety and on stage from the late 1930s, who became a film star with his first movie, *Up in Arms* (1944), and then went on to star in such films as *Wonder Man* (1945), *The Secret Life of Walter Mitty* (1947), and *Knock on Wood* (1954). He also hosted his own television variety show, "The Danny Kaye Hour" (1963–67).

Kaye, Sammy (1910–87), U.S. bandleader and composer, popular from the late 1930s for his big band's "sweet" renditions of such songs as "Rosalie" (1937), "Love Walked In" (1938), his own "Remember Pearl Harbor" (1942), and "Harbor Lights" (1950). He had his own radio and television shows in the 1940s and 1950s.

Kazan, Elia (Elia Kazanjoglou, 1909–), U.S. director, writer, and actor, who began his career as an actor with the GROUP THEATRE and moved into directing. He scored his first major success with THE SKIN OF OUR TEETH (1942), then went on to direct such major plays as ALL MY SONS (1947), A STREETCAR NAMED DESIRE (1947), and DEATH OF A SALESMAN (1949). In 1947 he was one of the founders of the ACTORS STUDIO. On screen his directorial work began with A TREE GROWS IN BROOKLYN (1945) and includes GENTLEMEN'S AGREEMENT (1947), for which he won a best director OSCAR; the film version of *Streetcar* in 1951; ON THE WATERFRONT (1954), a best picture and best director Oscar-winner; EAST OF EDEN (1955); and AMERICA,

AMERICA (1969), adapted from one of his several novels.

Kazantzakis, Nikos (1883–1957), Greek writer, much of whose powerful work is set on his native Crete. A prolific writer, he is best known for his epic poem *The Odyssey: A Modern Sequel* (1938) and four major late novels. The novels are *Zorba the Greek* (1946), which became the 1964 Michael Cacoyannis film, with Anthony QUINN in the title role; *The Greek Passion* (1951); *Freedom or Death* (1954); and *The Last Temptation of Christ* (1955), which was bitterly attacked by the Greek Orthodox Church as anti-Christian. The latter book was the basis of the 1988 Martin SCORSESE film, which provoked yet another controversy, this one worldwide.

Kazin, Alfred (1915–), U.S. critic and teacher, best known for such works as *On Native Grounds* (1942), such volumes of essays as *The Inmost Leaf* (1955), and such autobiographical works as *Starting Out in the Thirties* (1965) and *New York Jew* (1978).

Keaton, Buster (Joseph Francis Keaton, 1895–1966), U.S. actor, writer, and director, on stage at the age of three in his family's vaudeville act and on screen from 1917, who became a major film comedian and director of the silent era in such films as *The Playhouse* (1922), *The Navigator* (1924), and THE GENERAL (1927). Personal problems, including alcoholism, coupled with a difficult transition to sound, seriously impaired his career from the late 1920s, although he made a comeback during the 1950s and 1960s.

Keaton, Diane (1946–), U.S. actress, whose brief theater career included a lead in Woody ALLEN's PLAY IT AGAIN, SAM, which she re-created in the 1972 film. On screen from 1970, she also played leads in several other Allen films, including ANNIE HALL (1977), for which she won a best actress OSCAR; *Interiors* (1978); and MANHATTAN (1979). She also played substantial roles in such films as THE GODFATHER (1972), THE GODFATHER, PART II (1974), REDS (1981), *Crimes of the Heart* (1986), *The Good Mother* (1988), and *The Godfather Part III* (1990).

Kelly, Emmett (1898–1979), U.S. circus clown, who in 1931 created sad-faced WEARY WIL-LIE, the best-known clown character of the next several decades. Kelly was by far the most popular clown of his time.

Kelly, Gene (Eugene Curran Kelly, 1912–), U.S. actor, dancer, singer, and choreographer, whose work powerfully influenced the development of the film musical from the early 1940s. He was on stage as a dancer from 1938 and as a choreographer from 1940. He became a movie-musical star with his first role, opposite Judy GARLAND in *For Me and My Gal* (1942), and went on to star and often to also choreograph such films as *Cover Girl* (1944), *Anchors Aweigh* (1945), *The Pirate* (1948), *The Three Musketeers* (1948), ON THE TOWN (1949), AN AMERICAN IN PARIS (1951), SINGIN' IN THE RAIN (1952), and *Brigadoon* (1954). His work includes a notable straight dramatic role in INHERIT THE WIND (1960).

Kelly, Grace (1928–82), U.S. actress, on stage from the late 1940s. She emerged as a leading film player as Gary COOPER's wife in HIGH NOON (1952) and quickly starred in such films as DIAL M FOR MURDER (1954); REAR WINDOW (1954); THE COUNTRY GIRL (1954), for which she won an OSCAR; *To Catch a Thief* (1955); *The Swan* (1956); and *High Society* (1956). She then married Prince Rainier III of Monaco and retired, maintaining a very considerable celebrity but ending her acting career.

Kelly, Walt (1913–73), U.S. cartoonist, the creator of POGO, the rather sophisticated political possum who lived in Okeefenokee Swamp, there observing the other creatures of the swamp, many of whom closely resembled the real political figures of the era. Kelly created Pogo in the mid-1940s; his work appeared as a daily comic strip in the *New York Star* in 1948, the *New York Post* in 1949, and later in syndication and in many Pogo collections.

Kennedy, William Joseph (1928–), U.S. writer, best known for his Albany trilogy: *Legs* (1975), *Billy Phelan's Greatest Game*, and the PULITZER PRIZE-winning IRONWEED (1983), all set in late-1930s Albany, New York. He adapted *Ironweed* into the 1987 Hector Babenco film, with a cast led by Jack NICHOLSON and Meryl STREEP. He has also written several other novels and short stories and the screenplay for THE COTTON CLUB (1984).

Kent, Rockwell (1882–1971), U.S. illustrator and painter, a realist whose landscapes and seascapes include such very popular works as *Road Roller* (1909), *Down to the Sea* (1910), and *Adirondacks* (1930). He is probably best known for such early illustrated books as *Wilderness! A Journal of Quiet Adventure in Alaska* (1920) and *Voyaging: Southward from the Straits of Magellan* (1924) and for his woodcuts in illustrated editions of Shakespeare, Chaucer, Whitman, and Melville. In the 1930s he was also a muralist.

Kern, Jerome David (1885–1945), U.S. composer, a major figure in the development of the American musical theater from his first hit song, THEY DIDN'T BELIEVE ME, in *The Girl from Utah* (1914). Some of his best-known theater musicals are *Oh, Boy!* (1917); *Sally* (1920) and *Sunny* (1925), both vehicles for Marilyn MILLER; SHOW BOAT (1924); *The Cat and the Fiddle* (1931); and ROBERTA (1933). He also wrote the scores for such film musicals as *Swingtime* (1936) and *Lady Be Good* (1941). He wrote many enduring standards, such as OL' MAN RIVER; MAKE BELIEVE; WHY DO I LOVE YOU?; LOOK FOR THE SILVER LINING; SMOKE GETS IN YOUR EYES; and "Till the Clouds Roll By," the title of his 1946 film biography.

Kerouac, Jack (1926–69), U.S. writer, who became a leading literary figure of the BEAT GENERATION with publication of his autobiographical novels *On the Road* (1957) and *The Dharma Bums* (1958). His work also includes such novels as *The Subterraneans* (1958) and *Big Sur* (1962), poetry, and memoirs of travel.

Kerr, Deborah (Deborah Kerr-Trimmer, 1921–), British actress, on stage from 1938 and on screen from 1941, playing leads and sometimes strong character roles in such films as MAJOR BARBARA (1941), *Love on the Dole* (1941), THE LIFE AND DEATH OF COLONEL BLIMP (1943), BLACK NARCISSUS (1947), FROM HERE TO ETERNITY (1953), THE KING AND I (1956), TEA AND SYMPATHY (1956),

SEPARATE TABLES (1958), *Beloved Infidel* (1959), *The Chalk Garden* (1963), and *Night of the Iguana* (1964). She later appeared on television, as in WITNESS FOR THE PROSECUTION (1984) and "A Woman of Substance" (1985).

Kertész, André (1894–1985), Hungarian photographer; from the mid-1920s to the mid-1930s, while based in Paris, he became one of the leading European photojournalists of the interwar period. He emigrated to the United States in 1936, then doing largely commercial work until being "rediscovered" in the early 1960s.

Kesey, Ken (1935–), U.S. writer, best known for his 1962 novel ONE FLEW OVER THE CUCKOO'S NEST, which became the basis for the OSCAR-winning 1975 Milos FORMAN film, starring Jack NICHOLSON. He also wrote *Sometimes a Great Notion* (1964), which became the 1971 Paul NEWMAN film.

Key Largo (1939), the Maxwell ANDERSON play; Paul MUNI played the disillusioned Spanish Civil War loyalist veteran who was the plot pivot. In 1948 it was adapted by John HUSTON and Richard BROOKS into Huston's classic film, with Humphrey BOGART in the starring role opposite a villainous Edward G. ROBINSON and with Lauren BACALL, Lionel BARRYMORE, and Claire Trevor in key supporting roles. Trevor won a best supporting actress OSCAR for the film.

Keys of the Kingdom, The (1941), the A.J. CRONIN novel, the fictional biography of a Scottish priest, focusing on his decades of missionary work in China and especially on the years of civil war. Joseph L. MANKIEWICZ and Nunnally Johnson adapted the novel into the 1944 John M. Stahl film; Gregory PECK was Father Francis Chisholm, in his first starring role, with a cast that included Roddy McDowell, Thomas Mitchell, Rosa Stradner, Vincent Price, Cedric Hardwicke, and Benson Fong.

Keystone Kops (Cops), a group of extraordinarily inventive silent-film comedians, developed by director Mack SENNETT at Keystone Studios from 1912. Their wild chases and other slapstick antics were superbly timed and directed, and they became a leading feature of many of the most notable film comedies of the time.

Khachaturian, Aram Ilich (1903–78), Soviet-Armenian composer, much of whose work was strongly influenced by Armenian folk themes. He emerged as a major figure with such works as his *Piano Concerto* (1936); *Violin Concerto* (1940); and the ballet *Gayane* (1942), which contains the well-known "Saber Dance." His considerable body of work also includes the ballet *Spartacus* (1954) and several film scores.

Killers, The (1946), the Robert Siodmak film, adapted by Anthony Veiller and John HUSTON from the Ernest HEMINGWAY short story of that name, about a thief on the run who is murdered by two professional murderers and the long, ultimately successful attempt to unravel the case. Burt LANCASTER made his film debut as the murdered Swede, opposite Ava GARDNER as Kitty Collins, in a cast that included Edmond O'Brien, Albert Dekker, Charles McGraw, and William Conrad as the killers; Jack Lambert; and Sam Levene. A 1964 remake was notable primarily as Ronald Reagan's last film, as the leader of a criminal gang, in the Big Jim Colfax role.

Killing Fields, The (1984), the Roland Joffe film, based on Sidney Schanberg's account of his time in Cambodia after the Americans had gone, while the civil war was being won by the Khmer Rouge, and as the Cambodian Holocaust began. Sam WATERSTON was reporter Schanberg and Haing S. Ngor his imperiled assistant, in a cast that included John Malkovich, Bill Paterson, Craig T. Nelson, and Julian Sands. Ngor won a best supporting actor OSCAR; Chris Menges won an Oscar for cinematography and Jim Clark for editing.

Kind Hearts and Coronets (1949), the Robert Hamer film comedy, starring Alec GUINNESS as all eight of the members of a titled family murdered by low-ranking family member Dennis Price, determined to kill all those above him on the family tree. The cast included Joan GREENWOOD and Valerie HOBSON. Hamer and John Dighton coauthored the screenplay, based on the Roy Horniman novel *Israel Rank*.

kinetic art, a very diverse body of work, all aimed at adding movement or the illusion of movement to the kinds of artwork regarded as fixed or immobile early in the century, as in such paintings as NUDE DESCENDING A STAIRCASE and many FUTURIST works, from the early 1930s most successfully in Alexander CALDER's unpowered "mobiles," and from the mid-1950s also in a wide range of powered and unpowered constructions or sculptures with moving parts.

King, B.B. (Riley B. King, 1925–), U.S. BLUES singer, guitarist, and bandleader, who became a leading rhythm-and-BLUES performer and recording artist in the early 1950s. As the blues revival of the 1960s unfolded, he was recognized as a major figure by White and Black audiences alike and was particularly well received in Britain and the Soviet Union. Some of his most notable works are the albums *Live at the Regal* (1965), *Live and Well* (1969), *Live in Cook County Jail* (1971), *Midnight Believer* (1978), and *There Must Be a Better World Somewhere* (1981). On tour he made a considerable point of appearing in prisons, part of his long-standing work in prisoner relief and rehabilitation.

King, Carole (Carole Klein, 1942–), U.S. singer and songwriter, who became a leading songwriter during the early 1960s, when she and her first husband, Gerry Goffin, wrote many hit songs, including "Will You Love Me Tomorrow?" (1961) and "The Loco-Motion" (1962). In the early 1970s she emerged as a major singer and songwriter, with such albums as *Tapestry* (1971), *Wraparound Joy* (1974), *Simple Things* (1975), *One to One* (1982), and *Speeding Time* (1983).

King, Frank O. (1883–1969), U.S. cartoonist, who in 1918 created the GASOLINE ALLEY comic strip.

King, Henry (1888–1982), U.S. director, an actor before turning to directing in 1915. Some of the best known of his scores of films were *Tol'able David* (1921), *Stella Dallas* (1925), *Lloyds of London* (1936), ALEXANDER'S RAGTIME BAND (1938), *Jesse James* (1939), *Stanley and Livingstone* (1939), *Chad Hanna* (1940), THE SONG OF BERNADETTE (1943), *A Bell for Adano* (1945), CAROUSEL (1956), and THE SUN ALSO RISES (1957).

King, Stephen Edwin (1947–), U.S. writer, best known by far for such bestselling horror novels as *Carrie* (1974), *Salem's Lot* (1975), *The Shining* (1976), *Firestarter* (1980), *Cujo* (1981), and *Pet Sematary* (1983). Many of his novels have become films.

King and Country (1964), the Joseph LOSEY antiwar film, about a World War I deserter who is captured, court-martialed, and killed to deter others from doing the same. Tom COURTENAY and Dirk BOGARDE, as the deserter and his defending officer at the court-martial, led a cast that included Leo McKern, Barry Foster, Peter Copley, and John Villiers.

King and I, The (1949), the long-running Richard RODGERS and Oscar HAMMERSTEIN II musical, based on the play ANNA AND THE KING OF SIAM, itself based on Margaret Langdon's autobiographical work. Yul BRYNNER, for the rest of his life identified with the role, created the king, opposite Gertrude LAWRENCE as Anna; the play and Lawrence both won TONY AWARDS. Ernest Lehman adapted the musical into the 1956 Walter Lang film, with a cast that included Brynner, Deborah KERR as Anna, Rita Moreno, Martin Benson, and Geoffrey Toone. Brynner and the music direction won OSCARS.

King Kong (1933), a prototypical monster film, about a huge ape captured on a Southeast Asian island and brought to New York City, where he escapes and terrorizes the city before being killed by fighter planes atop the Empire State Building. Fay Wray played the role of the woman he loved; her nonstop screaming occupies a considerable portion of the film's soundtrack. Various sequels and copies followed over the years, including the 1976 John Guillerman remake, notable mostly for the film debut of Jessica LANGE, and for its special effects, which won a special OSCAR.

Kingsley, Ben (1943–), British actor, best known for his OSCAR-winning title role in GANDHI (1982). He has also appeared in such films as *Betrayal* (1982), *The Turtle Diary* (1985), and *Pascali's Island* (1988). A strong classical actor, he was with the ROYAL SHAKE-

SPEARE COMPANY 1970-80, and with the National Theatre 1977–78.

Kingsley, Sidney (1906–), U.S. writer, whose plays include *Men in White* (1933), the first commercial success of the GROUP THEATRE; DEAD END (1935), which Lillian HELLMAN adapted into the classic 1937 William WYLER film; *Detective Story* (1949), which became the 1951 William Wyler film; and DARKNESS AT NOON (1951), adapted from the Arthur KOESTLER novel.

Kingston Trio, The, U.S. folk-singing group formed in 1957 by Bob Shane (1934–), Nick Reynolds (1933–), and Dave Guard (1933–). They became a leading folk group with their first and best-received hit, "Tom Dooley" (1958), and continued to be a popular recording and touring group through the early 1960s, when a new generation of social activists reached for sharper, stronger songs and singers.

Kirby, Rollin (1875–1952), U.S. cartoonist; from 1913 to 1931, he was an editorial cartoonist with the *New York World*, winning three PULITZER PRIZES during that period (1921, 1924, and 1928) and inventing *Mr. Dry*, who became the detested symbol of Prohibition. Kirby also attacked bigotry in the 1920s, and in particular the then-resurgent Ku Klux Klan, while closer to home taking on the Tammany machine. Although the *World* was sold in 1931, he stayed on with the far more conservative *World-Telegram and Sun*, strongly supporting the New Deal throughout the period, and in 1939 moving to the *New York Post*.

Kirchner, Ernst Ludwig (1880–1938), German artist; as a founding member of THE BRIDGE (*Die Brücke*) group in 1905 he played a significant role in developing the more personal and emotional styles generally described as the German version of EXPRESSIONISM. He is best known for his colorful, bitterly erotic Berlin street scenes, done in 1912 and 1913. He went to war in 1914, was invalided out with a breakdown that year, and lived in Switzerland from 1917, painting colorful, rather quiet Swiss landscapes that became more abstract in the late 1920s. During the Nazi period his work was denounced as "decadent" in Germany; the

resulting stress is thought to have contributed to his suicide.

Kirov Ballet, the historic Leningrad ballet company dating back to the mid-18th century, which began the 20th century as the Maryinsky Theatre, home of the extraordinary troupe that included, among others, Anna PAVLOVA, Vaslav NIJINSKY, Tamara KARSAVINA, and Michel FOKINE. The latter three went to Paris with Serge DIAGHILEV in 1909, with other members of the troupe, to found the BALLET RUSSES. The Maryinsky—the Kirov from 1935—continued to be a major classical company during the Soviet period, although several of its major dancers, including Rudolf NUREYEV, Mikhail BARYSHNIKOV, and Natalia MAKAROVA, defected to the West in the 1960s and 1970s.

Kiss Me, Kate (1948), the long-running, TONY-winning Cole PORTER musical, the book by Bella and Sam Spewack; a partial modern retelling of *The Taming of the Shrew*, featuring such songs as "Wundebar," "So in Love," and "Another Openin', Another Show," with a cast led by Alfred Drake and Patricia Morison. Dorothy Kingsley adapted the play into the 1953 George Sidney film, with a cast that included Howard Keel, Kathryn Grayson, Ann Miller, Keenan Wynn, James Whitmore, Bobby Van, Bob FOSSE, and Kurt Kasznar.

Kiss of the Spider Woman, The (1985), the Hector Babenco film, about two men locked into a prison cell together; Raul Julia was the committed political activist and William HURT won a best actor OSCAR as the gay prisoner. The Leonard Schrader screenplay was based on the Manuel Puig novel.

Klee, Paul (1879–1940), Swiss artist, resident in Munich from 1906 and associated with THE BLUE RIDER group from 1911 to 1914. His work, prolific from the early years, developed many of the playful, mythologically informed, childlike images that were to characterize all but the final phase of his art; yet it was during a trip to Tunis in 1914 that he felt he had finally mastered the use of color that was so vital to his mature work. Klee emerged as a major figure after World War I, with an exhi-

bition of over 250 of his works at Munich in 1920. He taught at the BAUHAUS from 1921 to 1931, for him also a decade of enormous artistic production in which he created works in many forms and styles; ultimately he created an estimated 8,000 to 9,000 works in his lifetime. In this period he also published his *Pedagogical Sketchbook* (1925). He left the Bauhaus in 1931 and taught at Dusseldorf from 1931 to 1933, but was fired by the Nazis and fled to Switzerland, where his later work became larger, somewhat rougher, and much darker in tone as he fell ill in the mid-1930s with the disease that ultimately took his life.

Klemperer, Otto (1885–1973), German conductor, a leading interpreter of such major Austrian and German composers as Ludwig von Beethoven, Anton Bruckner, and Gustav MAHLER, who also introduced much 20th-century music in almost seven decades of conducting. He was a leading opera conductor in Central Europe from his debut in 1906, conducting in Prague and several other cities (1907–17), in Cologne (1917–24), and at the Kroll Opera in Berlin (1927–31). He left Nazi Germany in 1933, and led the Los Angeles Philharmonic (1933–39), the Budapest Orchestra (1947–50), and London's Philharmonia Orchestra (1959–72).

Klimt, Gustav (1862–1918), Austrian artist, who moved from traditional work to the highly decorative, rather erotic ART NOUVEAU style during the 1890s, emerging as a leading figure in the Vienna Secession of 1897. Among his murals were those for the Vienna City Theatre (1886); the unfinished murals for the ceiling of the great hall at the University of Vienna (1894–1905), which proved unacceptable because he painted them in the Art Nouveau style; and the murals for the Palais Stoclet in Brussels (1911). His Art Nouveau paintings include such works as *Portrait of Emilie Flöge* (1902) and *The Kiss* (1908).

Kline, Franz (1910–62), U.S. painter, whose work was representational, largely focusing on Manhattan cityscapes, until in 1949 he moved directly into ABSTRACT EXPRESSIONISM through an expansion of his own black-and-white line sketches. He then produced large, powerful black-and-white paintings, often using housepaint and housepainters' brushes, achieving works that have been compared with rough calligraphy. With such works as *Chief* (1950) and *Mahoning* (1956), Kline became an acknowledged leader of the new Abstract Expressionist movement. Later in the decade, he also reintroduced color and mass into his work.

Kline, Kevin (1947–), U.S. actor, who became a leading stage player in the late 1970s, winning TONY AWARDS for *On the Twentieth Century* (1978) and *Pirates of Penzance* (1980), and also appearing in *Loose Ends* (1979), *Richard III* (1983), *Henry V* (1984), and *Hamlet* (1986). His films include *Sophie's Choice* (1982); *The Big Chill* (1983); *Silverado* (1985); *A Fish Called Wanda* (1988), for which he won a best supporting actor OSCAR; and *The January Man* (1989).

Klute (1971), the Alan J. PAKULA film, a thriller set in New York about a prostitute and a small-town detective, deepened by the OSCAR-winning performance of Jane FONDA in the Bree Daniels role and by Donald SUTHERLAND as the detective. It was written by Andy K. Lewis and Dave Lewis.

Knight, Gladys and the Pips (Gladys Knight, 1942– ; Merald Knight, 1942– ; Edward Patten, 1939– ; and William Guest, 1941–), U.S. family singing group, formed in 1952, that was very popular from 1967 through the mid-1970s, with such recording hits as "I Heard It Through the Grapevine" (1967), "Neither One of Us Wants to Be the First to Say Goodbye" (1973), "Midnight Train to Georgia" (1973), and "On and On" (1974). Their popularity waned somewhat after the mid-1970s, although Gladys Knight continued to be a major pop figure.

Knight Without Armour (1937), the Jacques FEYDER film, based on the James HILTON novel and set during the Russian Civil War that followed the Bolshevik Revolution. Robert DONAT was the British agent making his way home, opposite Marlene DIETRICH as the Russian countess in flight, in a cast that included John CLEMENTS, Irene Vanbrugh, David Tree, Herbert Lomas, Austin Trevor, and Basil Gill.

Kodály, Zoltán (1882–1967), Hungarian composer and teacher, whose work was deeply influenced by Hungarian folk music; he and Béla BARTOK worked together in folk music from 1906, developing much of 20th-century Hungarian music. His best-known work is the opera HÁRY JÁNOS (1926), the orchestral *Háry János Suite* (1927), the orchestral *Marosszék Dances* (1930) and *Dances of Galánta* (1933), and such choral works as *Psalmus hungaricus* (1930) and *Missa brevis* (1944). He taught at the Budapest Academy of Music from 1907 to 1941, developing the Kodály Method of musical training for children, which was adopted by his government after World War II.

Koestler, Arthur (1905–83), Hungarian-British writer, a journalist from the mid-1920s and a Communist from 1932 to 1938, whose best-known work is DARKNESS AT NOON, an anti-Communist novel based on the Moscow show trials of the 1930s. He also wrote several philosophical works, including *The Act of Creation* (1964). He and his wife committed suicide together in 1983, while he was ill.

Kokoschka, Oskar (1886–1980), Austrian painter; he studied in Vienna from 1904 to 1909, in that period painting in the highly decorative ART NOUVEAU style, although his work soon turned in a highly emotional, Expressionist direction (see ABSTRACT EXPRESSIONISM), in his paintings, magazine and book illustrations, and two plays, *Sphinx and Strawman* and *Murderer, Hope of Women* (both 1909). He was a notable portraitist and landscape painter before World War I; during the interwar period he produced many large cityscapes. He left Vienna for Prague in 1934; fled to Britain in 1938, after the Nazis had labeled his work degenerate, and settled in Switzerland in 1953.

Kollwitz, Käthe (Käthe Schmidt, 1867–1945), German artist, much of whose work expressed her socialist and pacifist views; she emerged as a major figure with two powerful groups of etchings: *The Weavers' Revolt* (1897–88), based on the 1892 Gerhard HAUPTMANN play; and *The Peasants' War* (1908–10). After she lost a son in World War I, much of her work focused on antiwar themes. A good deal of her later work focused on the theme of death, most notably in her 1930s work, done in Nazi Ger-

many, much of it prefiguring the photographs and drawings that would later memorialize the Nazi concentration camps and the Holocaust.

Kopit, Arthur (1937–), U.S. playwright, notable for the play and title *Oh Dad, Poor Dad, Mamma's Hung You in the Closet and I'm Feelin' So Sad* (1964). His later works include *Indians* (1968) and *Wings* (1978).

Korda, Alexander (Sándor Laszlo Korda, 1893–1956), Hungarian director and producer, whose work was on screen from 1916. After working in Europe and the United States during the 1920s, he became during the 1930s one of Britain's leading directors and producers and the head of London Studios, directing such films as THE PRIVATE LIFE OF HENRY VIII (1933) and REMBRANDT (1936), and producing such films as *The Scarlet Pimpernel* (1934), *Sanders of the River* (1935), THE FOUR FEATHERS (1939), THE FALLEN IDOL (1948), *The Winslow Boy* (1948), THE THIRD MAN (1949), OUTCAST OF THE ISLANDS (1951), and HOBSON'S CHOICE (1953). He often worked with his brothers, director **Zoltan Korda** and art director **Vincent Korda.**

Kosinski, Jerzy (1933–), Polish-American writer, best known for his first novel, *The Painted Bird* (1965), about a homeless child's travails in German-occupied Europe during World War II. His further work includes such novels as *Steps* (1968); BEING THERE (1971), which he adapted into the 1979 Hal ASHBY film; and *Pinball* (1982).

Koussevitsky, Sergei Alexandrovich (1874–1951), Russian-American conductor and teacher, who introduced, popularized, and in some instances commissioned a good deal of 20th-century classical music. He began as a double bassist in 1896, also composing some of his own work, most notably the *Double Bass Concerto* (1905). He founded a Moscow-based orchestra and a music publishing house focusing on modern music in 1909. He left the Soviet Union in 1920, conducted in Europe, was conductor of the Boston Symphony Orchestra from 1924 to 1949, and established the Berkshire Music Center in 1940. At Boston, he strongly presented the works of such contemporary composers as Charles IVES,

Samuel BARBER, Aaron COPLAND, and Roy HARRIS and commissioned works by Igor STRAVINSKY, Paul HINDEMITH, Sergei PROKOFIEV, and others.

Kowalski, Stanley, the character created by Marlon BRANDO in Tennessee WILLIAMS's A STREETCAR NAMED DESIRE, (1947), which so memorably launched Brando on his career.

Kramden, Ralph, the character created by Jackie GLEASON in THE HONEYMOONERS.

Kramer, Stanley (1913–), U.S. producer and director, noted for his films of social commentary, whose work was on film from 1941. Early in his career he produced such films as HOME OF THE BRAVE (1941), DEATH OF A SALESMAN (1951), HIGH NOON (1952), and THE CAINE MUTINY (1954), then directing and producing such films as THE DEFIANT ONES (1958), ON THE BEACH (1959), INHERIT THE WIND (1960), JUDGMENT AT NUREMBERG (1961), SHIP OF FOOLS (1965), and GUESS WHO'S COMING TO DINNER (1967).

Kramer vs. Kramer (1979), the Robert BENTON film, about divorced young parents and their child, the life of the father as a single parent, and a later court fight over custody in an affluent New York setting. Dustin HOFFMAN and Meryl STREEP won OSCARS in the leading roles, as did the film and Benton for the screenplay, based on the Avery Corman novel.

"Krazy Kat," the comic strip created in 1910 by cartoonist George HERRIMAN, which featured Krazy Kat, Ignatz Mouse, and Offissa Pup, all engaged for 34 years in a highly inventive ritual dance. The strip attracted and held a large mass audience, while also appealing to many artists and intellectuals of the time for its artistry and surreal quality.

Kreisler, Fritz (1875–1962), Austrian-American violinist, extremely popular in concert and on records throughout the first half of the 20th century, from a breakthrough concert with the Berlin Philharmonic in 1899. In 1910 he introduced Edward ELGAR's *Violin Concerto*. Kreisler was much esteemed for his performances of many shorter pieces, often played as encores; late in his career he admitted that he had composed some of them, rather than the composers to whom he attributed them for decades.

Kristofferson, Kris (1936–), U.S. actor and country-and-western songwriter and singer; he wrote such songs as "Me and Bobby McGee" (1969) and "Help Me Make It Through the Night" (1971) before beginning his film career, and then appeared in such movies as *Cisco Pike* (1972), *Pat Garrett and Billy the Kid* (1973), *Blume in Love* (1973), ALICE DOESN'T LIVE HERE ANYMORE (1975), HEAVEN'S GATE (1980), and *Welcome Home* (1989).

Krupa, Gene (1909–73), U.S. drummer and bandleader, who played with Benny GOODMAN in the mid-1930s and then led his own band (1938-43), becoming the most popular drummer of the big-band era. His later career included periods as a drummer with such bandleaders as Goodman and Tommy DORSEY, as well as leadership of his own band again in the late 1940s. He also appeared in several films. Sal Mineo played Krupa in the 1959 film biography *The Gene Krupa Story*, directed by Don Weis.

Krutch, Joseph Wood (1893–1970), U.S. critic and writer, whose work includes studies of Poe, Samuel Johnson, and Thoreau. It also includes a substantial number of essays, collected in such works as *The Modern Temper* (1929) and *The Measure of Man* (1954); and a large body of reviews, written as drama critic of *The Nation* (1924-52). His later work was largely on naturalist themes, reflecting a move to the southwestern desert, as in *The Desert Year* (1952) and *Human Nature and the Human Condition* (1959).

Kubrick, Stanley (1928–), U.S. director, whose work was on film from 1953 and who directed and produced several quite diverse and very notable films early in his career, including PATHS OF GLORY (1958), the classic DR. STRANGELOVE (1963), and 2001: A SPACE ODYSSEY (1969), also writing the latter two films. He has also directed such films as A CLOCKWORK ORANGE (1971), *The Shining* (1980), and *Full Metal Jacket* (1987).

Kuhn, Walt (1877–1949), U.S. painter, a realist best known for his pictures drawn from circus life, as in his *Dressing Room* (1926), *The Blue Clown* (1931), *Trude* (1931), *Trio* (1937), *Musical Clown* (1938), and *Girl with Plume*

Setting the scene in *The Throne of Blood* (1957), Akira Kurosawa's version of *Macbeth*.

(1939). He was a cartoonist before World War I and in 1912 was a chief organizer of the 1913 ARMORY SHOW.

"Kukla, Fran and Ollie" (1948–57, 1961–62, 1969–71), the long-running children's television puppet show created by Burr Tillstrom and featuring Fran Allison. Some of the best-known puppets in the troupe were Kukla, Ollie, Beulah the Witch, Cecil Bill, and Fletcher Rabbit.

Kundera, Milan (1929–), Czech writer, a leading dissident of the mid-1960s Prague Spring, whose work was banned in his country after 1969; he was published abroad for two decades. His novels include *The Joke* (1967); *Life Is Elsewhere* (1973); *The Farewell Party* (1976); *The Book of Laughter and Forgetting* (1979); and his best-known work, THE UNBEARABLE LIGHTNESS OF BEING (1984), which became the 1988 Philip Kaufman film. He also published short stories and plays.

Kupka, Frank (1871–1957), Czech painter, resident in France from 1896, who became one of the earliest European abstractionists of the modern period. His aim, in such works as *Fugue in Two Colors* (1912) and *Disks of Newton* (1912), was to use color and line to produce an emotional impact like that generated by music. This led Guillaume APOLLINAIRE in 1913 to call his and other such lyrically colorful works "Orphism," after Orpheus as a spell-casting singer.

Kurosawa, Akira (1910–), Japanese director and writer, a major figure in Japanese and world film, whose directorial work was on screen from 1943. He directed such notable films as RASHOMON (1950); THE SEVEN SAMURAI (1954); THRONE OF BLOOD, his adaptation of *Macbeth* (1957); THE LOWER DEPTHS, adapted from Maxim GORKY's play (1957); DERSU UZALA (1975); KAGEMUSHA (1980); RAN, his adaptation of *King Lear* (1984); and *Dreams* (1990).

Kyser, Kay (James Kyser, 1906–85), U.S. bandleader, popular from the mid-1930s; on radio his musical quiz show was called "Kay Kyser's Kollege of Musical Knowledge."

L

Lachaise, Gaston (1882–1935), French sculptor, resident in the United States from 1906. He is best known by far for his female nude, an "earth goddess" figure that appears in many versions in his work, most notably in *Standing Woman* (1912–27). In his later work he articulated the concept considerably further, creating figures and partial figures much like those found in Magdalenian cave paintings and thought by some to be early religious objects. Lachaise also produced several notable portrait sculptures.

Ladd, Alan (1913–1964), U.S. actor, on screen from 1932, who became a star in such 1940s and 1950s Hollywood action films as *This Gun for Hire* (1942), *The Glass Key* (1942), *Whispering Smith* (1948), and *The Iron Mistress* (1952), and who played a memorable role in the classic Western SHANE (1953). He was the father of film producer Alan Ladd, Jr. and actor David Ladd.

Lady Chatterley's Lover (1928; unexpurgated edition, 1929), the D.H. LAWRENCE novel, set in the English countryside; the story of the relationship between a lady named Constance and the gamekeeper Mellors, which was widely perceived as obscene in its time, was banned for decades, and therefore became by far the best known of his works.

Lady from Shanghai, The (1948), the Orson WELLES film; he directed, wrote the rather convoluted screenplay, and starred as Irish seaman Michael O'Hara, opposite Rita HAYWORTH as Elsa Bannister, who plans to use him to kill her husband and lover, played by Everett Sloane and Glenn Anders.

Lady Vanishes, The (1938), the Alfred HITCH-COCK film thriller, set in Central Europe during the run-up to World War II. May Whitty was the elderly Englishwoman who disappears from the train; Margaret Lockwood and Michael REDGRAVE starred as the innocents who ultimately save her, in a cast that included Paul LUKAS, Naunton Wayne, Basil Radford, Josephine Wilson, and Cecil Parker. Sidney Gilliat and Frank Launder adapted *The Wheel Spins*, the Ethel Lina White novel. The 1979 remake was directed by Anthony Page.

Laemmle, Carl (1867–1939), pioneer U.S. film producer, who began as a nickelodeon operator; became a film distributor; in 1909 founded the Independent Motion Picture Company, which merged into Universal in 1912; and is generally credited with having initiated the Hollywood star system.

Lagerkvist, Par Fabian (1891–1974), Swedish writer, a central figure in the development of 20th-century Swedish literature, beginning with several early works, including the theoretical work *Verbal Art and Pictorial Art* (1913), the poetry collection *Anguish* (1914), the play *The Secret Heaven* (1921), and his autobiographical *Guest of Reality* (1925). During the 1930s he wrote several antifascist works, including *The Hangman* (1936), which he later dramatized. Much of his later work reflects a continuing exploration of matters of belief from a humanistic point of view, as expressed in his best-known works, the novels *The Dwarf* (1944), *Barabbas* (1952), and *The Sibyl* (1956) and the play *The Philosopher's Stone* (1948). He adapted *Barabbas* for the stage in 1953; it also became the 1962 Richard Fleischer film, with Anthony QUINN in the title role. Lagerkvist was awarded the NOBEL PRIZE for literature in 1951.

Lagerlöf, Selma Ottiliana Louisa (1858–1940), Swedish writer, who emerged as a major literary figure with her first and best-known novel, *Gösta Berling's Saga* (1891), which in 1921 became the

classic Mauritz STILLER film, with Lars Hanson and Greta GARBO in the leads; it was Garbo's breakthrough role. Lagerlöf's most notable later novels include the two-part *Jerusalem* (1901–2), her antiwar *The Outcast* (1918), and the trilogy *The Ring of the Lowens-kölds* (1925–28). She also wrote the very popular children's books *The Wonderful Adventures of Nils* (1907) and *The Further Adventures of Nils* (1911). She was awarded the NOBEL PRIZE for literature in 1909 and in 1914 became the first woman member of the Swedish Academy.

"L.A. Law" (1986–), the long-running television drama series, set in a Los Angeles law firm. The cast includes Richard Dysart, Jill Eikenberry, Harry Hamlin, Susan Dey, Alan Rachins, Michael Tucker, Corbin Bernsen, Michele Greene, Jimmy Smits, Susan Ruttan, Ellen Drake, Larry Drake, and Blair Underwood. The series was created by Steven Bochco and Terry Louise Fisher.

Lamarr, Hedy (Hedvig Kiesler, 1913–), Austrian actress, on screen from 1931; in 1933 she appeared nude in the Czech film *Ecstasy*, creating something of a sensation. She was a highly publicized Hollywood star from 1938, appearing in such films as *Algiers* (1938), *White Cargo* (1942), and *Samson and Delilah* (1949).

"Lambeth Walk, The," the extraordinarily popular song introduced in 1937 by Lupino LANE in ME AND MY GIRL, with words and music by Noël Gay and Douglas Furber.

Lamour, Dorothy (Mary Leta Dorothy Kaumeyer, 1914–), U.S. actress, a singer in the early 1930s and on screen from 1936; she became identified with the sarong that was her costume in several films. She is best remembered for her roles opposite Bob HOPE and Bing CROSBY in such comedies as *The Road to Zanzibar* (1941), *The Road to Morocco* (1942), and *The Road to Utopia* (1946), also appearing in a wide range of other roles.

Lancaster, Burt (Burton Stephen Lancaster, 1913–), U.S. actor, on stage as an acrobat in the late 1930s and on screen as a star from the appearance of his first film, *The Killers* (1946). He went on to become an international film figure in such major dramatic films as ALL MY SONS (1948); COME BACK, LITTLE SHEBA (1952); *The Rose Tattoo* (1955); *The Sweet Smell of Success* (1957); *The Rainmaker* (1957); ELMER GANTRY (1960), for which he won a best actor OSCAR; BIRDMAN OF ALCATRAZ (1962); THE LEOPARD (1963); SEVEN DAYS IN MAY (1964); THE SWIMMER (1968); CONVERSATION PIECE (1975); 1900 (1976); ATLANTIC CITY (1980); and FIELD OF DREAMS (1989). Simultaneously he starred and became a major box-office draw in such action films as *The Flame and the Arrow* (1950), GUNFIGHT AT THE O.K. CORRAL (1957), and *The Professionals* (1966), and late in his career he starred in such comedies as *Local Hero* (1983) and *Tough Guys* (1986).

land art, a kind of CONCEPTUAL ART in which natural forms are used to create artworks, as in Walter de Maria's *Mile-Long Drawing* of parallel lines painted on the desert floor; such works are also called EARTH ART, or earthworks.

Landowska, Wanda (1897–1959), Polish harpsichordist, the leading modern exponent of the instrument, who in 1900 began to develop the body of research and technique that would reclaim and expand the uses of the harpsichord for the balance of the century. She appeared in concert from 1903, taught many of the leading players of the instrument, and inspired such composers as Manuel de FALLA and Francis POULENC to write new music for the harpsichord.

Lane, Lupino (Henry George Lupino, 1892–1959), one of the leading modern members of the great British Lupino stage family, with his father **George**, his uncle **Stanley**, and his cousin Ida LUPINO, all descended from a family of Italian puppetmasters who migrated to England in the early 17th century. Lupino Lane began his long stage career at age four, as Nipper Lane; in 1937, as Bill Snibson in ME AND MY GIRL, he originated THE LAMBETH WALK.

Lang, Fritz (1890–1987), Austrian director, whose work was on screen from 1919 and who became a major figure in German and world cinema during the Weimar period, with such films as DR. MABUSE (1922) and his two classics, METROPOLIS (1927) and M (1921). He fled the Nazis in 1933 and began making Hollywood films in 1936, directing the notable

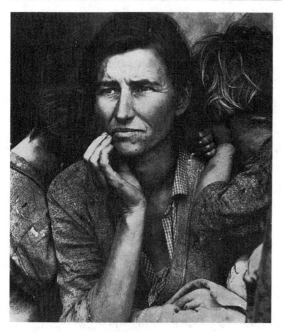

Dorothea Lange's classic Depression-era photograph *Migrant Mother, Nipomo, California* (1936).

FURY (1936). He made several well-received Westerns and dramatic films during the next two decades, but created nothing to compare with his German silent-film classics.

Lange, Dorothea (1895–1965), U.S. photographer; her classic MIGRANT MOTHER, NIPOMO, CALIFORNIA (1936) became one of the central images of the Great Depression. The picture was one of many taken by Lange for the state of California after she had been hired to document the condition of homeless migrant farm workers. Her work stimulated amelioration of their conditions and also stimulated the massive federal Farm Security Administration photography project, for which Lange also shot many pictures. Her work of this period generated *An American Exodus: A Record of Human Erosion*. In 1941 she documented the forcible eviction and detention camp imprisonment of West Coast Japanese-Americans.

Lange, Jessica (1950–), U.S. actress, on screen from 1976. She made her debut as a lead in *King Kong* (1976) and went on to appear in such films as ALL THAT JAZZ (1979); THE POSTMAN ALWAYS RINGS TWICE (1981); TOOTSIE (1982), for which she won a best supporting actress OSCAR; *Country* (1984); *Crimes of the Heart* (1986); *Music Box* (1989); and *Men Don't Leave* (1990).

Lansbury, Angela (1925–), British actress, on screen in character roles from 1944, in such films as GASLIGHT (1944), *The Picture of Dorian Gray* (1945), STATE OF THE UNION (1948), and *The Dark at the Top of the Stairs* (1960). Later in her career she became a star on Broadway, winning TONY AWARDS for *Mame* (1966), *Dear World* (1969), *Gypsy* (1973), and SWEENEY TODD (1979). In television she starred in the long-running series MURDER, SHE WROTE (1984–).

Lara, Zhivago's lover in DOCTOR ZHIVAGO, to whom he dedicated the "Lara Poems"; she was played by Julie CHRISTIE in the film.

Lardner, Ring (Ringgold Wilmer Lardner, 1885–1933), U.S. writer, a leading sports journalist from 1913 and a prolific and highly regarded short-story writer from 1914. His work includes poetry and the play *June Moon* (1920), a collaboration with George S. KAUFMAN.

Lardner, Ring Jr. (1915–), U.S. writer, the son of Ring LARDNER. He shared an OSCAR for the screenplay of *Woman of the Year* (1942) and co-wrote the screenplays of such films as *The Cross of Lorraine* (1943), *Tomorrow the World* (1944), and *Forever Amber* (1947) before his conviction, prison term, and BLACKLISTING as a member of the HOLLYWOOD TEN in the late 1940s. He then worked under pseudonyms until the mid-1960s, emerging under his own name to cowrite the screenplay for *The Cincinnati Kid* (1965) and to win a best screenplay Oscar for M*A*S*H (1970).

Larkin, Philip (1922–85), British writer, a leading contemporary poet whose themes and approach reflect his identification with his northern English background. His poetry collections include *The North Ship* (1946), *The Less Deceived* (1955), *Whitsun Weddings* (1964), and *High Windows* (1974). He also wrote two early novels: *Jill* (1946) and *A Girl in Winter* (1947).

Lassie, a collie—actually many collies, who since 1943 have played the role in film, radio,

Charles Laughton's Captain Bligh (right) pitted against Clark Gable's Fletcher Christian, in *Mutiny on the Bounty* (1935).

and television, from the appearance of the first Lassie film, *Lassie, Come Home* (1943).

Last Emperor, The (1987), the epic Bernardo BERTOLUCCI film, about the life of Pu Yi, the last of the Manchu emperors of China. Jon Lone played the title role, with Joan Chen, Peter O'TOOLE, Ying Ruocheng, Maggie Han, and Victor Wong in key supporting roles. The film, Bertolucci, the Mark Peploe–Bertolucci screenplay, cinematographer Vittorio Storaro, editing, art, costumes, and score all won OSCARS.

Last Hurrah, The (1958), the John FORD film, based on Edwin O'Connor's 1956 novel; both were informed by the life of James Michael Curley, four-time mayor of Boston, though both were fictive works. Spencer TRACY led a cast that included Jeffrey Hunter, Dianne Foster, Pat O'Brien, Basil RATHBONE, John CARRADINE, Jane DARWELL, and Donald Crisp.

Last Picture Show, The (1971), the Peter BOGDANOVICH film, an elegiac work set in a small Texas town in the 1950s; it was adapted from the Larry McMurtry novel of that name by Bogdanovich and McMurtry, with a cast that included Timothy Bottoms, Jeff BRIDGES, Cloris

Leachman, Ben Johnson, Ellen BURSTYN, Eileen Brennan, and Cybill Shepherd. Leachman won a best supporting actress OSCAR; Johnson was best supporting actor. Bogdanovich wrote and directed a sequel, *Texasville* (1990), which starred Bridges and Shepherd, in a cast that included Leachman, Bottoms, Brennan, Randy Quaid, and Annie Potts.

Last Tango in Paris (1973), the Bernardo BERTOLUCCI film, about the decay and ultimate destruction of an American expatriate, played by Marlon BRANDO, in the course of a highly charged affair with a much younger French woman, played by Maria Schneider, which fully ends only when she kills him. The film was seen as sexually explicit at the time, and Brando's participation made it a cause célèbre.

Lauder, Harry (1870–1950), British music-hall singer and comedian, a headliner throughout the English-speaking world in the early part of the century. He is best known for such songs as ROAMIN' IN THE GLOAMIN' and "I Love a Lassie."

Laughton, Charles (1899–1962), British-American actor, on stage from 1926 and on screen

from 1928, who became a star with his title role in THE PRIVATE LIFE OF HENRY VIII (1933), for which he won a best actor OSCAR. He went on to become a leading international dramatic star, in such films as *Ruggles of Red Gap* (1935), MUTINY ON THE BOUNTY (1935), REMBRANDT (1936), THE HUNCHBACK OF NOTRE DAME (1939), HOBSON'S CHOICE (1954), and WITNESS FOR THE PROSECUTION (1958). He also directed the film NIGHT OF THE HUNTER (1955). Laughton also continued to work intermittently in the theater, in such works as his adaptation and appearance in *Galileo* (1947) and his adaptation and direction of JOHN BROWN'S BODY (1953).

Laura (1944), the Otto PREMINGER film, based on the Vera Caspary novel and set in a sophisticated New York milieu; Gene TIERNEY was Laura, who was thought to have been murdered but later turned up quite alive, though a murder had indeed been committed. Dana ANDREWS also starred, as the police detective who fell in love with her image, even before she reappeared, in a cast that included Clifton Webb, Judith ANDERSON, and Vincent Price.

Laurel, Stan (Arthur Stanley Jefferson, 1890–1965), British actor and comedian, on stage from 1906, on screen from 1917, and from 1927 the thin half of the memorable comedy team of LAUREL AND HARDY.

Laurel and Hardy (Stan LAUREL, 1890–1965; and Oliver HARDY, 1892–1957), the most popular comedy team in film history. Beginning in 1927 they made over 100 films, becoming worldwide favorites in silent films and successfully making the transition to sound, with such 1930s feature films as *Babes in Toyland* (1934), *Way Out West* (1937), and *Flying Deuces* (1939).

Laurents, Arthur (1918–), U.S. writer and director; his best-known plays include HOME OF THE BRAVE (1945), *The Time of the Cuckoo* (1952), WEST SIDE STORY (1952), and GYPSY (1959). He also directed several plays, winning a TONY for his direction of LA CAGE AUX FOLLES (1983). He wrote two novels: THE WAY WE WERE (1972), which he adapted into the 1973 Sidney POLLACK film, and *The Turning Point* (1977), which he adapted into the

1977 Herbert Ross film. His other screenplays include *The Snake Pit* (1948), *Anna Lucasta* (1949), and ANASTASIA (1956).

Lavender Hill Mob, The (1951), the Charles Crichton film, a classic comedy starring Alec GUINNESS as Henry Holland, the mild-mannered bank clerk who long and carefully planned the perfect robbery of gold bullion from his own bank's vault. The cast included Marjorie Fielding, Edie Martin, and—as his "mob"—Stanley HOLLOWAY, Sidney James, and Alfie Bass.

Lawrence, D.H. (David Herbert Lawrence, 1885–1930), British writer, who became a leading literary figure with the appearance of such major works as SONS AND LOVERS (1913), *The Rainbow* (1915), and WOMEN IN LOVE (1920). His work also included such novels as *Kangaroo* (1923); *The Plumed Serpent* (1926); and LADY CHATTERLEY'S LOVER (1928; unexpurgated edition, 1929), which was widely perceived as obscene in its time and therefore became by far the best known of his works. A prolific writer, he also wrote plays, short stories, poetry, travel books, and essays on a wide range of matters. Several of his novels have been adapted into other forms, most notably in the films *Sons and Lovers* (1960), with Trevor HOWARD, Dean Stockwell, and Wendy HILLER in the leads; and *Women in Love* (1970), with Glenda JACKSON in an OSCAR-winning role.

Lawrence, Gertrude (Alexandra Lawrence-Klasen, 1898–1952), British actress, on stage as a child, who became a leading player in musical theater on both sides of the Atlantic in such plays as *Charlot's Revue* (1924) and *Oh, Kay!* (1926). She played opposite Noël COWARD in his PRIVATE LIVES (1930) and *To-Night at 8:30* (1936), in several other leading roles, and was playing on Broadway in THE KING AND I (1949), when she fell ill and died. She appeared only occasionally in films, most notably in THE GLASS MENAGERIE (1950). Lawrence was played by Julie ANDREWS in the 1968 film biography *Star!*.

Lawrence of Arabia (1962), the epic David LEAN biographical film, on the experiences of Thomas Edward Lawrence, the British officer

who became the legendary leader of the World War I Arab revolt against the Turks and later wrote of his experiences in the very popular *Seven Pillars of Wisdom* (1926). The film had Peter O'TOOLE in the title role, powerfully supported by Alec GUINNESS as Feisal, Omar SHARIF, Anthony QUINN, Claude RAINS, Anthony QUAYLE, and Arthur Kennedy. Robert BOLT wrote the screenplay. The film, Lean, O'Toole, cinematographer Freddie Young, and Maurice Jarre for the music all won OSCARS.

Laxness, Halldor Kiljan (1902–), Icelandic writer, his country's most important 20th-century literary figure, a Catholic who became a Communist in the late 1920s, and in the early 1930s began to publish a series of powerful novels reflecting his concern for those on the underside of Icelandic life, often built around historical themes. His most notable works include the two volumes of *Salka Valka* (1931–32), the two-volume *Independent People* (1934–35), the four-volume *World Light* (1937–40), the trilogy *Copenhagen Burning* (1943–46), *Happy Warriors* (1952), and *The Fish Can Sing* (1957). He was awarded the NOBEL PRIZE for literature in 1955.

Leadbelly (Huddie Ledbetter, 1889–1949), U.S. singer and composer, who performed on several instruments, most notably the 12-string guitar, and was a song- and storyteller in the tradition of Blind Lemon JEFFERSON. Leadbelly was a Southern BLUES singer who was "discovered" by folk-song collectors John and Alan LOMAX in 1933, while in a Louisiana jail. He emerged as a major new folk presence in New York in 1936, recording hundreds of songs and appearing in concert, although less popular than influential in the development of such singers as Pete SEEGER and Woody GUTHRIE. A few of the many songs he introduced to wide audiences, some of which he may have written, were GOOD NIGHT IRENE, "Boll Weevil," "The Rock Island Line," and "The Midnight Special." Roger Moseley played Leadbelly in the 1976 Gordon Parks film biography.

Lean, David (1908–), director and film editor, who edited such films as PYGMALION (1938) and *The 49th Parallel* (1941) before becoming a director. After co-directing IN WHICH WE SERVE (1942) with Noël COWARD, he went on to become one of the major directors of the modern period, with such films as the classic BRIEF ENCOUNTER (1945); GREAT EXPECTATIONS (1946); HOBSON'S CHOICE (1954); THE BRIDGE ON THE RIVER KWAI (1957), for which he won a best director OSCAR; the epic LAWRENCE OF ARABIA, another directorial OSCAR-winner; the equally epic DOCTOR ZHIVAGO (1965); the failed epic *Ryan's Daughter* (1970); and, much later, A PASSAGE TO INDIA (1984).

Le Carré, John (David John Cornwell, 1931–), British writer, whose work includes such thrillers as *Call for the Dead* (1961); THE SPY WHO CAME IN FROM THE COLD (1963); and the Cold War trilogy *Tinker, Tailor, Soldier, Spy* (1974), *The Honorable Schoolboy* (1977), and *Smiley's People* (1980). Two memorable television miniseries, "Tinker, Tailor, Soldier, Spy" (1977) and "Smiley's People" (1982), were adapted from the first and third works in the trilogy, with Alec GUINNESS creating George SMILEY, who also appeared in several other Le Carré novels. Le Carré's later novels include *The Little Drummer Girl* (1983), *A Perfect Spy* (1986), and *Russia House* (1989). Several other theater and television films were also derived from his novels, most notably including Martin Ritt's 1965 film, *The Spy Who Came in from the Cold*, with Richard BURTON in the central role.

Le Corbusier (Charles Edouard Jeanneret, 1887–1966), Swiss-French architect and painter known as Jeanneret until 1921 and thereafter as Le Corbusier. Although he was an active painter, and with Aimee Ozenfant co-founded the Purist movement in 1918, his primary work was as a very influential modernist theoretician (see MODERNISM) in architecture. He was an advocate of much that later came to characterize mid-20th-century architecture, as in the lean toward geometric forms; the development of uniform high-rise clusters surrounded by open space; and the use of rough, unfinished concrete. Such concrete was very much in evidence, and quite massively, when he was able to put some of his theories into practice in the post-World War II period, in

such projects as his UNITÉ D'HABITATION (1952), a high-rise dwelling complex in Marseilles, and in his group of government buildings in Chandrigarh, India (1964).

Led Zeppelin, British heavy-metal ROCK AND ROLL group, organized in 1968 by Jimmy Page (1944–), John Bonham (1948–80), Robert Plant (1948–), and John Paul Jones (John Baldwin, 1946–). They became one of the most popular groups of the 1970s, with such albums as *Led Zeppelin I, II,* and *III* (1960–70), the "Runes" album (1971), *Houses of the Holy* (1973), *Presence* (1976), and *In Through the Out Door* (1979). The group disbanded after Bonham died in 1980.

Lee, Canada (Leonard Lionel Canegata, 1907–51), U.S. actor; he created the Bigger Thomas role on Broadway in the Orson WELLES–John HOUSEMAN production of NATIVE SON (1941), adapted from the landmark Richard WRIGHT book by Wright and Paul Green. It was the highlight of a career that started in the New Deal's Works Progress Administration (WPA) theater of the 1930s and included roles in such films as LIFEBOAT and *Cry, the Beloved Country* (1951).

Lee, Gypsy Rose (Rose Louise Hovick, 1914–70), U.S. actress, burlesque dancer, and writer, the best-known stripper of her time, on stage in vaudeville at the age of four, a headliner in burlesque throughout the 1930s, and a star on Broadway in *Star and Garter* (1942). She wrote several books and plays, including *The G-String Murders,* the basis of the film *Lady of Burlesque* (1943). Her autobiography, *Gypsy,* was the basis of the Broadway musical GYPSY (1959).

Lee, Peggy (Norma Deloris Engstrom, 1920–), U.S. popular singer, composer, and actress; she sang with the Benny GOODMAN band in 1943 and went on to four decades of very well-received recording and cabaret work, also composing such songs as "Mañana" (1948) and "Golden Earrings" (1947). She appeared in several films, most notably in *Pete Kelly's Blues* (1955), and won a GRAMMY in 1969 for the song "Is That All There Is?".

Le Gallienne, Eva (1899–), British-born U.S. actress and director, on stage in London from 1914. She became a leading player on Broadway with her Julie in *Liliom* (1921) and in *The Swan* (1923). She founded the pioneering CIVIC REPERTORY THEATRE (1926–33), presenting the classics and noncommercial new plays in repertory and at low prices, often playing leading roles herself, but ultimately ran out of financing. She also co-founded the short-lived American Repertory Company (1946–48) and directed and acted in the National Repertory Company (1961–66). Late in her career she was back on Broadway, in a revival of *The Royal Family* (1975).

Léger, Fernand (1881–1955), French painter, whose work from 1909 began to merge his interest in CUBISM and in the machine age, as best expressed in his cubist *Nude Figures in a Wood* (1910). After World War I, those interests resulted in such works as *The City* (1919) and *The Mechanic* (1920), and in his association with Aimee Ozenfant and LE CORBUSIER in the Purist movement. In this period he also made an art film, *The Mechanical Ballet* (1924), and designed several ballets, including *The Creation of the World* (1923) and *David* (1926). He later did such works as the Bastogne memorial (1950) and the stained-glass windows at Audincourt (1951), both in France, and the murals at the UN General Assembly, as well as many figurative paintings, the machine-age interest of his early period having waned.

Lehar, Franz (1870–1948), Hungarian composer and musician, a prolific composer of operettas, of which by far the best known is the often-revived *The Merry Widow* (1907). His *The Count of Luxembourg* (1910) and *Gypsy Love* (1911) are also sometimes performed.

Lehmann, Lotte (1888–1976), German soprano; she made her debut in Hamburg in 1910, sang at the Vienna Court Opera from 1916, and was a leading opera singer of the interwar period, appearing often at Covent Garden, the Metropolitan Opera, and throughout Europe and the Americas. Some of the best-regarded roles in her large repertory were in Richard STRAUSS, as in *Der Rosenkavalier* and in *Arabella,* in a role she created. She fled the Nazis in 1938, continuing her career in America. Lehmann was also a highly regarded

lieder singer, especially in the songs of Robert Schumann.

Lehmann, Rosamond Nina (1903–90), British writer, best known for such novels as *Dusty Answer* (1927), *Invitation to the Waltz* (1932), and *The Ballad and the Source* (1944). She wrote one play, *No More Music* (1939); a short-story collection, *The Gypsy's Baby* (1946); and several later novels, including *The Echoing Grove* (1953).

Lehmbruck, Wilhelm (1881–1919), German sculptor, who during the first decade of the century moved from naturalistic forms to the sadly thoughtful, elongated figures for which he is best known, as in his *Kneeling Woman* (1911) and *Standing Youth* (1913). He was greatly disheartened by his World War I hospital work experiences, as reflected in such powerful, deeply disturbing works as *Dying Warrior* (1916), an entirely antiheroic war memorial. He took his own life.

Leigh, Janet (Jeannette Morrison, 1927–), U.S. actress, on screen from 1947 in such films as THE FORSYTE SAGA (1949), *Scaramouche* (1952), *Houdini* (1954), *My Sister Eileen* (1955), *Touch of Evil* (1958), PSYCHO (1960), and HARPER (1966). She was married to actor Tony CURTIS from 1951 to 1962 and is the mother of actress Jamie Lee Curtis.

Leigh, Vivien (Vivian Mary Hartley, 1913–67), British actress, on stage from 1934 and on screen from 1935. She became a leading player on stage and screen in 1937, opposite Laurence OLIVIER in the film FIRE OVER ENGLAND, which made both of them movie stars, and also opposite Olivier on stage, as Ophelia to his Hamlet. She continued to play in major classical roles, many of them opposite Olivier, who became her husband in 1940. Her most notable stage role was as Blanche DU BOIS in A STREETCAR NAMED DESIRE (1949). Leigh became an international film figure as Scarlett O'HARA in GONE WITH THE WIND (1939), going on to play in such films as *Waterloo Bridge* (1940); CAESAR AND CLEOPATRA (1945); and the 1951 film version of *Streetcar*, for which she won a best actress OSCAR. In 1963, she won a best actress TONY in the musical *Tovarich*.

Lelouch, Claude (1937–), French director, whose work was on film from 1956. He wrote, directed, produced, and shot the OSCAR-winning A MAN AND A WOMAN (1966), which established him as a major film figure, and followed it with several similar romances, such as *Live for Life* (1967) and *And Now My Love* (1974).

Lemmon, Jack (John Lemmon III, 1925–), U.S. actor, on screen from 1954, who won a best supporting actor OSCAR as Ensign Pulver in MISTER ROBERTS (1954), going on to appear in such films as THE APARTMENT (1960); SOME LIKE IT HOT (1959); DAYS OF WINE AND ROSES (1962); *The Odd Couple* (1968); *Save the Tiger* (1973), for which he won a best actor OSCAR; *The Prisoner of Second Avenue* (1975); THE CHINA SYNDROME (1979); MISSING (1982); *That's Life* (1986); and *Dad* (1989).

Leningrad Symphony (1941), the *Seventh Symphony* of Dmitri SHOSTAKOVICH, a patriotic piece written in besieged Leningrad during World War II.

Lennon, John (1940–80), British musician; with George HARRISON, Paul MCCARTNEY, and Ringo STARR a member of the BEATLES. Lennon was rhythm guitarist, sang, and collaborated with McCartney on most of the Beatles' songs. From late 1968, Lennon and conceptual artist Yoko Ono were inseparable, and much of his post-Beatles work was done in association with Ono; they married in 1969, thereafter developing highly visible anti-Vietnam War and then left-oriented political activities, as well as several popular albums and single records. Lennon was murdered in New York City on December 8, 1980, by Mark David Chapman; the motiveless act of violence seemed to many to signal the end of an era.

Lenya, Lotte (Karoline Blamauer, 1900–81), Austrian actress and singer, in variety in Berlin in the 1920s. She is by far best known for her Jenny role in THE THREEPENNY OPERA (1928), which she re-created in the 1931 film, and once again in the long-running 1954 New York revival. She also appeared in *Mahagonny* (1930); after she and her husband, composer Kurt WEILL, fled the Nazis, she appeared in

America in several plays, including *Candle in the Wind* (1937), *Barefoot in Athens* (1951), *Brecht on Brecht* (1962), and CABARET (1966). Lenya was also featured in several films, notably in *To Russia, with Love* (1963).

Leone, Sergio (1921–89), Italian director, who worked in films as a screenwriter and assistant director from 1939, his own directorial work appearing on screen from 1961. He became an international film figure with his commercially successful "spaghetti Westerns." His best-known films were his 1960s Clint EASTWOOD Westerns, beginning with *A Fistful of Dollars* (1964). He later made *Once Upon a Time in the West* (1969) and *Once Upon a Time in America* (1984).

Leonov, Leonid Maksimovich (1899–), Soviet writer, whose first novel, *The Badgers* (1924), reflected his experience as a Red Army soldier during the Russian Civil War. His powerful second novel, *The Thief*, was set on the underside of Moscow life during the New Economic Policy period and brought substantial recognition. Much of his further work was on orthodox Soviet themes during the Stalin era and included the novels *Road to the Ocean* (1934) and *The Russian Forest* (1953), as well as several other novels and plays.

Leopard, The (1958), the novel by Giuseppe Tomasi de Lampedusa, set in Sicily during the 1860s, during the struggle to free and unite Italy. It was the basis for the 1963 Luchino VISCONTI film, with Burt LANCASTER, Alain DELON, and Claudia Cardinale in leading roles.

Lerner, Alan Jay (1918–86), U.S. writer and lyricist, long partnered with composer Frederick LOEWE; together they wrote such theater musicals as *Brigadoon* (1947), *Paint Your Wagon* (1951), MY FAIR LADY (1956), and CAMELOT (1960), adapting all of these into films. They also collaborated on GIGI (1958), sharing an OSCAR for the title song; Lerner won an Oscar for the screenplay. He also won an Oscar for his 1951 AN AMERICAN IN PARIS screenplay. Lerner later collaborated with Burton Lane on *On a Clear Day You Can See Forever* (1965) and did the 1970 film adaptation.

LeRoy, Mervyn (1900–86), U.S. director, on stage as an actor from 1912 and in films in the 1920s. He became a director in 1927; some of his best-known films are LITTLE CAESAR (1931), I AM A FUGITIVE FROM A CHAIN GANG (1932), *Waterloo Bridge* (1940), RANDOM HARVEST (1942), and *Thirty Seconds Over Tokyo* (1944). He produced THE WIZARD OF OZ (1939) and directed and produced the short *The House I Live In* (1945), a plea for tolerance that won him a special OSCAR in 1945.

Les Demoiselles d'Avignon, the landmark, unfinished painting done by Pablo PICASSO in 1906–7, which began the processes that were to lead quickly to the revolutionary development of CUBISM.

Les Misérables, the 1935 Richard Boleslawski film version of the often-dramatized, classic Victor Hugo novel, with Fredric MARCH in the lead, pursued by Charles LAUGHTON as police inspector Javert, in a cast that included Cedric Hardwicke and Florence Eldridge. The long-running 1980s Tim Rice musical version won eight TONY AWARDS, including best musical.

Lessing, Doris (1919–), British writer, who emerged as a major literary figure in the 1950s, with her two early Africa-based novels, *The Grass Was Singing* (1950) and *This Was the Old Chief's Country* (1951). She then explored feminist and left political themes and concerns, in such novels as *Martha Quest* (1952), *The Golden Notebook* (1962), and *Briefing for a Descent into Hell* (1971). She began the multi-volume "Canopus in Argos" science-fiction series in 1979, with *Shikasta*. Lessing is also a prolific short-story writer.

"Let's Have Another Cup of Coffee" (and let's have another piece of pie), Irving BERLIN's quintessential Depression-era song, from the 1932 Broadway musical *Face the Music*, with words and music by Berlin.

Let Us Now Praise Famous Men (1941), the James AGEE–Walker EVANS book on the life of southern tenant farmers during the Great Depression, which joined Agee's essay to Evans's photographs to produce a landmark work.

Lever House (1952), the pioneering glass-walled Manhattan building, set on an open plaza, which was designed by Gordon BUN-SHAFT in accordance with the theories of Ludwig MIES VAN DER ROHE. It became a prototypical INTERNATIONAL STYLE work and was emulated for decades by architects in many countries, who produced thousands of austere, minimalist, ahistorical structures.

Levertov, Denise (1923–), British-American writer; her early poems were published in *The Double Image* (1946). In the United States after 1948, she published such collections as *Here and Now* (1957), *With Eyes in the Back of Our Heads* (1959), and *The Jacob's Ladder* (1961), and later much work of social commentary, as in the collections *Relearning the Alphabet* (1970), *To Stay Alive* (1971), and *Footprints* (1972). She has also written the poems collected in *The Freeing of the Dust* (1975) and *Candles in Babylon* (1982), as well as a considerable body of essays.

Levi, Carlo (1902–75), Italian writer and painter; he is best known for his autobiographical *Christ Stopped at Eboli* (1948), based on his 1935–36 internal exile for antifascist activities in poverty-stricken Lucania, in southern Italy. The book was the basis of Francesco Rosi's 1979 film, with Gian Maria Volonte in the Levi role.

Levine, Jack (1915–), U.S. painter, a bitter social realist and caricaturist in the 1930s, with such works as *Brain Trust* (1936) and *The Feast of Pure Reason* (1937). A notable later work was *Gangster Funeral* (1953).

Levine, James (1943–), U.S. conductor; he became principal conductor of the Metropolitan Opera in 1973, music director in 1976, and artistic director in 1986. He has been music director of the Ravinia Festival since 1973 and has often guest-conducted and appeared as a pianist, also pursuing a recording career.

Lewis, Jerry (Joseph Levitch, 1926–), U.S. actor and comedian, on stage at the age of five and in variety with his partner, singer Dean MARTIN, from 1946. Martin and Lewis became headliners in variety, moving into films together, where they made a string of comedies, until they parted in 1956. Lewis went on alone as a comedian in film, variety, and television, often producing and directing his own films. He became a major figure in Europe and in France achieved a highly regarded critical success as well, although losing much of his American popularity.

Lewis, Jerry Lee (1935–), U.S. singer, an early ROCK star best known for such songs as "Whole Lotta Shakin' Going On," "Great Balls of Fire," "Breathless," and "High School Confidential," all in 1957 and 1958. His career was largely aborted by negative public reaction to his highly publicized marriage to a young teenage cousin. From the late 1960s he made a comeback as a country singer. Dennis Quaid played Lewis in the 1989 film biography *Great Balls of Fire*.

Lewis, Sinclair (Harry Sinclair Lewis, 1885–1951), U.S. writer, whose sixth novel established him as a major literary figure; it was *Main Street* (1920), a satire of small-town America. He followed it with four more powerful 1920s novels: *Babbitt* (1922), his satire of the fictional midwestern city of Zenith; ARROWSMITH (1925), his portrait of an idealistic doctor, for which he declined the PULITZER PRIZE; ELMER GANTRY (1927), his exposé of religious fakery; and DODSWORTH (1929). In 1930 he was the first American to win the NOBEL PRIZE for literature. His later works include such novels as *It Can't Happen Here* (1935), *Gideon Planish* (1943), *Cass Timberlane* (1945), and *Kingsblood Royal* (1947). Several of his works were adapted for other forms, with notable results. Sidney HOWARD adapted *Arrowsmith* into the John FORD film (1931), with Ronald COLMAN in the title role, opposite Helen HAYES. Howard also adapted *Dodsworth* into the 1934 play and then into the 1936 William WYLER film, starring Walter HUSTON and Ruth Chatterton. *Elmer Gantry* became the 1960 Richard BROOKS film, starring an OSCAR-winning Burt LANCASTER and Jean SIMMONS. Lewis's second wife was journalist **Dorothy Thompson**.

Lewis, Wyndham (Percy Wyndham Lewis, 1882–1957), British writer and artist, a considerable literary figure during the interwar period, whose work includes such bitterly

satirical novels as *Tarr* (1918), *The Childermaas* (1928), and *The Apes of God* (1930). A prolific essayist, he attacked what he perceived to be the decadence of modern literature and in the early 1930s moved toward open support of fascism, a position he later changed.

Liberace (Wladziu Valentino Liberace, 1919–87), U.S. entertainer, a pianist who developed one of the most successful variety acts of his time. Flamboyantly costumed, and playing popular tunes in a rococo pseudoclassical style, he delighted millions of devoted followers on television, on records, and in concert, his career spanning almost six decades.

Lichtenstein, Roy (1923–), U.S. painter and sculptor, an ABSTRACT EXPRESSIONIST before he emerged in 1962 as a leading POP parodist, who used candy wrappers, comic-book heroes, advertisements, and other such popular-culture artifacts and images in his works, creating parodies of popular culture, of other artists and their work, and even sometimes of his own work.

Lifar, Serge (1905–86), Russian-French dancer, choreographer, ballet director, and writer; he was with the BALLET RUSSES company of Sergei DIAGHILEV from 1923 to 1929, there creating leading roles in such works as APOLLO (1928) and THE PRODIGAL SON (1929) and choreographing his first work, *Renard* (1929). He became a leading figure in French ballet as director of the Paris Opera Ballet (1929–44 and 1947–58), the break occurring after he had been accused of collaboration with the Germans during World War II. He was also chief dancer until 1956. Lifar brought major changes to the ballet company during his tenure and staged many new works, often on classical themes, including *Prometheus* (1929), *Icarus* (1935), and *Phaedre* (1950). He was also a prolific writer on ballet-related themes.

Life and Death of Colonel Blimp, The (1943), the Michael POWELL and Emeric Pressburger film, set in the first four decades of the century, with Roger LIVESEY in the title role of the British officer and Deborah KERR as all of his four loves, with Anton Walbrook in the key supporting role. It was thought to be less-than-

sufficiently patriotic by some in Britain when made but soon emerged as an enduring classic.

Lifeboat (1944), the Alfred HITCHCOCK film, adapted by Jo Swerling from the John STEINBECK short story, about a group of survivors of a torpedoed ship during World War II—including the captain of the German submarine that sank their ship. Tallulah BANKHEAD led a cast that included Walter Slezak as the submarine captain, William BENDIX, Hume CRONYN, Canada LEE, Heather Angel, John Hodiak, and Mary Anderson.

"Life Is Just a Bowl of Cherries," the Depression-era song introduced by Ethel MERMAN in the 1931 edition of *George White's Scandals*, with music by Ray Henderson and words by Lew Brown.

Life of Émile Zola, The (1937), the OSCAR-winning William DIETERLE film biography, focusing on Zola's campaign to free the unjustly accused Alfred Dreyfus. Paul MUNI was Zola, and Joseph Schildkraut won a best supporting actor OSCAR as Dreyfus, in a cast that included Donald Crisp, Louis Calhern, Gale Sondergaard, Morris CARNOVSKY, and Gloria Holden. The Norman Reilly Raine screenplay also won an Oscar.

"Life of Riley, The" (1953–58), the long-running television situation comedy series. William BENDIX was blue-collar Chester A. Riley, in a cast that included Marjorie Reynolds, Lugene Sanders, Wesley Morgan, and Tom D'Andrea. Bendix had created the role on radio in 1943. A previous television version, starring Jackie GLEASON, had been broadcast in the 1949–50 season.

Life With Father (1939), the very long-running Howard LINDSAY–Russel Crouse comedy, based on Clarence Day's autobiographical essays and set in turn-of-the-century New York. On stage Lindsay created the role of Day's father, opposite Dorothy Stickney as his wife. Donald Ogden Stewart adapted the play into the 1947 Michael CURTIZ film, with William POWELL as the father and Irene DUNNE as the mother, in a cast that included Elizabeth TAYLOR, Jimmy Lydon, Edmund Gwenn, and ZaSu Pitts.

"L'il Abner" (1934), the very popular comic strip created by cartoonist Al CAPP, which also featured Daisy Mae and the rest of the Yokum family. The very popular comic strip was the basis of the Broadway play and two films.

Lili (1953), the Charles Walter film musical; Leslie CARON starred in the title role, as a girl attracted to the circus and its people, in a cast that included Jean-Pierre AUMONT, Mel Ferrer, Kurt Kasznar, and Zsa Zsa Gabor. Bronislaw Kaper won an OSCAR for the music, which most notably included "Hi-Lili-Hi-Lo." The Helen Deutsch screenplay was based on the Paul Gallico short story "The Man Who Hated People."

Lillie, Beatrice (1894–1988), Canadian-British actress and singer, on stage in musical theater from 1914 and a star from her 1924 Broadway appearance in *Charlot's Revue*, which was followed by roles in several other editions of the show. During the 1930s she continued to star on stage, becoming a leading radio personality as well, and then spent World War II on a very nearly perpetual tour of the battlefronts. Late in her career, she went on tour again, in her single, *An Evening with Beatrice Lillie* (1952–56). Her signature song was Noël COWARD's MAD DOGS AND ENGLISHMEN (1931).

Lime, Harry, the Orson WELLES role in THE THIRD MAN; he was the seldom-seen postwar profiteer whose persona was at the center of the work.

"Limehouse Blues," the classic Gertrude LAWRENCE song, which she introduced in the 1924 edition of *Charlot's Revue*. Julie ANDREWS sang it memorably on screen in the Lawrence film biography *Star!* (1968). Music was by Philip Braham, with words by Douglas Furber.

Limelight (1952), the film written, produced, and directed by Charlie CHAPLIN, who starred in the work and also wrote the score; it is a May–December story, about a has-been variety artist who is ultimately redeemed in the course of saving a young ballerina from despair and suicide. Claire BLOOM was the ballerina; Sidney Chaplin, Nigel Bruce, and Buster KEATON played key supporting roles. The film appeared at the height of the McCarthy period,

when Chaplin was being accused of communist affiliations; the American Legion and other witch-hunters of the time led a successful boycott of the film—so successful that the frightened film industry refused it ACADEMY AWARD participation because it did not "qualify," as the boycott prevented it from being shown in Los Angeles. In 1972, the witch-hunts long over, Chaplin returned to the United States to accept a special OSCAR; that year, his *Limelight* score won an Oscar too.

Limon, José (1908–72), U.S. dancer and choreographer; he was a student of Doris HUMPHREY and Charles Weidman and danced with their company from 1939 to 1940. When he founded his own American Dance Company in 1947, Humphrey became his artistic director and choreographed such works as *Day on Earth* (1947), *Night Spell* (1951), and *Ruins and Visions* (1953). Limon choreographed such works as *The Moor's Pavane* (1947), *La Malinche* (1949), *The Exiles* (1950), and *Missa Brevis* (1958).

Lindsay, Howard (1889–1968), U.S. actor, writer, director, and producer, best known for two notable collaborations with Russel Crouse: LIFE WITH FATHER (1939), adapted from the Clarence Day short stories; and their PULITZER PRIZE-winning STATE OF THE UNION (1945). They also wrote the books for such musicals as ANYTHING GOES (1934) and THE SOUND OF MUSIC (1959). Lindsay played "Father" on Broadway; Donald Ogden Stewart adapted the play into the 1947 Michael CURTIZ film, with William POWELL in the lead. *State of the Union* became the 1948 Frank CAPRA film, with Spencer TRACY and Katharine HEPBURN in the leads.

Lindsay, Vachel (1879–1931), U.S. poet. His first published poetry collection was *General William Booth Enters into Heaven and Other Poems*; for much of the previous decade he had been a hobo poet in a populist mode, trading poetry for his supper as he traveled throughout the United States. His second collection was *The Congo and Other Poems* (1914), the title poem again becoming a popular recitation piece for him. This collection also contained "Abraham Lincoln Walks at Midnight" and "The Santa Fe Trail," two of his best-known

poems. Lindsay's third and last notable collection was *The Chinese Nightingale and Other Poems*. His later work was considerably less notable. His death was by suicide, in a period of severe personal problems.

Lion in Winter, The (1966), the James Goldman play, set late in the lives of Henry II and Eleanor of Aquitaine. Goldman won an OSCAR for his adaptation of the play into the 1968 Anthony Harvey film, as did John Barry for the score. On stage, Robert PRESTON and Rosemary Harris created the roles of Henry and Eleanor; Harris won a TONY. On film, Peter O'TOOLE was Henry, opposite an Oscar-winning Katharine HEPBURN, with Jane Merrow, John Castle, Anthony Hopkins, Nigel Terry, and Timothy Dalton in key supporting roles.

Lipchitz, Jacques (Chaim Jacob Lipschitz, 1891–1973), Lithuanian Jewish sculptor, resident in France from 1909 and in the United States from 1941. He worked largely as a cubist (see CUBISM) until the mid-1920s, while also beginning to explore the questions of inner space that became a central aspect of modern sculpture, as in his *Sailor on Horseback* (1914). From the mid-1920s he moved into the bronze openwork called "transparent" sculptures, as in *Harpist* (1928), *The Couple* (1929), *Mother and Child* (1930), and *Song of the Vowels* (1932). Much of his later work reflects a developing interest in mythological and biblical themes, as in his *Prometheus Strangling the Vulture* (1937 and 1953) and *Prayer* (1943).

Little Big Man (1964), the Thomas Berger novel, a satirical look at the mythical American West, looking back through the eyes of fictional Jack Crabb, from his kidnapping by Indians through Custer's Last Stand; the work is rather more sympathetic to its Native Americans than to the invading Americans who dispossess them. Calder Willingham adapted the novel into the 1970 Arthur PENN film, with Dustin HOFFMAN as Crabb leading a cast that included Faye DUNAWAY, Chief Dan George, Jeff Cory, Martin Balsam, Carole Androsky, and Richard Mulligan.

Little Caesar (1930), a prototypical Depression-era gangster film, directed by Mervyn

LEROY, based on the W.R. BURNETT novel, and starring Edward G. ROBINSON in the title role, with Douglas FAIRBANKS, Jr., Glenda Farrell, and William Collier, Jr. in key supporting roles.

Little Foxes, The (1939), the Lillian HELLMAN play, about a bitter, decadent southern family. On stage, Tallulah BANKHEAD created the central role of Regina, in a cast that included Frank Conroy, Carl Benton Reid, Charles Dingle, Patricia Collinge, Dan Duryea, and Teresa Wright. Hellman adapted the play into the 1941 William WYLER film, with Bette DAVIS as Regina, in a cast that included Herbert Marshall, Reid, Dingle, Collinge, Duryea, and Wright.

Little House on the Prairie (1935), the autobiographical Laura Ingalls Wilder children's book, which generated several sequels, about growing up on a Minnesota farm in the 1870s. It was the basis of the long-running television series "Little House on the Prairie" (1974–83), with a cast that included Michael Landon as Charles Ingalls, Karen Grassle as Caroline Ingalls, Melissa Gilbert as Laura Ingalls Wilder, Melissa Sue Anderson, Sidney Greenbush, Richard Bull, and Karl Swenson. The series also generated several telefilms.

Little Night Music, A (1973), the long-running TONY-winning Broadway musical play adapted by Hugh Wheeler from the Ingmar BERGMAN film romance SMILES OF A SUMMER NIGHT, with words and music by Stephen SONDHEIM. Glynis Johns and Len Cariou starred on stage, Johns singing "Send in the Clowns." Elizabeth TAYLOR played opposite Cariou in the 1978 Harold Prince film, with a cast that includes Hermione Gingold, Diana RIGG, and Lesley-Anne Down.

"Little Orphan Annie," the long-running, enormously popular comic strip created by Harold GRAY in 1924; Annie's costars were Daddy Warbucks and Sandy, her dog. The strip became the basis of the Martin Charnin–Harold Strouse Broadway musical *Annie* (1977), with Andrea McArdle in the title role. The play became the 1982 John HUSTON film,

with Aileen Quinn in the title role and Albert FINNEY as Warbucks.

"Little Rascals, The," the name under which the OUR GANG comedies were syndicated on television.

Little Richard (Richard Wayne Penniman, 1935–), U.S. musician, a singer and band-leader who suddenly emerged as an early ROCK-AND-ROLL star with his unique, high-pitched rendition of "Tutti Frutti" (1955), which he followed with several other hits in the next two years, also appearing in several films. He experienced a religious conversion in 1957 and renounced his career, then returned in 1964; but although he continued to record and tour, he was not able to recapture his early reception.

Litvak, Anatole (Michael Anatol Litwak, 1902–74), Soviet-American director and producer, who made his first film, *Tatiana*, in the Soviet Union in 1925 and then worked in Germany during the Weimar period, as a director from 1930. He fled Nazi Germany in the early 1930s, then directed films in Great Britain and France, most notably *Mayerling* (1936). In Hollywood from 1937, he directed such films as *Tovarich* (1937), *Sorry, Wrong Number* (1948), and THE SNAKE PIT (1949).

Livesey, Roger (1906–76), British actor, in strong character roles on stage and screen from the early 1920s. His most notable film role was the lead in THE LIFE AND DEATH OF COLONEL BLIMP (1943), which was closely followed by his lead opposite Wendy HILLER in I KNOW WHERE I'M GOING (1945). Late in his career, he played a strong supporting role on television, in THE PALLISERS (1976).

Lloyd, Frank (1888–1960), British-American director, on stage as an actor in his teens, who emigrated to Canada and then the United States, beginning in films as an actor in 1914 and as a director in 1915. Thereafter, he spent four decades as one of Hollywood's most durable and productive directors, with such films as *The Riders of the Purple Sage* (1919); *The Divine Lady* (1929), which won a best director OSCAR; *Cavalcade* (1933), and another best director Oscar; MUTINY ON THE BOUNTY

(1935), which won a best picture Oscar; and *Blood on the Sun* (1945).

Lloyd, Harold (1893–1971), U.S. actor and comedian, on screen from 1912. From 1917, as the soberly dressed comic hero of scores of films, he became a world figure in silent films in such movies as *Safety Last* and *The Freshman* (1925), rivaling Charlie CHAPLIN and Buster KEATON in popularity. Until 1923 he worked with producer Hal ROACH, then formed his own company to produce his films.

Lloyd Webber, Andrew (1948–), British composer of several very notable contemporary works for the theater, including *Joseph and the Amazing Technicolor Dreamcoat* (1968), *Jesus Christ Superstar* (1970), EVITA (1978), CATS (1981), *Starlight Express* (1984), PHANTOM OF THE OPERA (1986), and *Aspects of Love* (1989). He also composed *Requiem Mass* (1975) and *Variations* on a theme by Paganini (1977), as well as the scores for the films *Gumshoe* (1971) and *The Odessa File* (1974) and the 1974 film adaptation of *Jesus Christ Superstar*.

Loesser, Frank (1910–69), U.S. songwriter; he wrote the scores of several Broadway musicals, including *Where's Charley?* (1948), GUYS AND DOLLS (1950), *The Most Happy Fella* (1956; score and book), and *How to Succeed in Business Without Really Trying* (1961). A few of his best-known songs are "Once in Love with Amy," from *Where's Charley?*; "A Bushel and a Peck," from *Guys and Dolls*; his OSCAR-winning "Baby, It's Cold Outside," from the film *Neptune's Daughter* (1949); and "Spring Will Be a Little Late This Year," from the film *Christmas Holiday* (1944).

Loewe, Frederick (1904–), Austrian-American composer and musician, a classical pianist as a youth; he was the longtime collaborator of Alan Jay LERNER on such musicals as *Brigadoon* (1947), *Paint Your Wagon* (1951), MY FAIR LADY (1956), and CAMELOT (1960). They also collaborated on GIGI (1958), sharing an OSCAR for the title song.

Logan, Joshua (1908–88), U.S. director, whose first major success was *On Borrowed Time* (1938). He went on to direct such plays as *Knickerbocker Holiday* (1938), *This Is the Army* (1942), ANNIE GET YOUR GUN (1946), MIS-

TER ROBERTS (1948), SOUTH PACIFIC (1949, and the 1958 film), PICNIC (1953, and the l956 film), and FANNY (1954, and the 1961 film). His work on film also includes BUS STOP (1956), CAMELOT (1967), and *Paint Your Wagon* (1969).

Lola Montès (1955), a film written and directed by Max OPHÜLS, based on the Cecil Saint-Laurent novel and starring Martine Carol in the title role, as the celebrated 19th-century courtesan. The cast included Anton Walbrook, Peter USTINOV, Oskar Werner, and Ivan Desny.

Lolita (1955), the Vladimir NABOKOV novel, portraying a romance between middle-aged Humbert Humbert and a 12-year-old girl, whom he calls Lolita, a "nymphet." The work was widely attacked as obscene and was banned in several countries and American states, assuring the enormous popular success that followed. It turned Nabokov, a highly respected literary figure, into a major popular figure as well. He adapted the novel into the 1962 Stanley KUBRICK film, with James MASON in the Humbert role, Sue Lyon as Lolita, and Shelley Winters and Peter SELLERS in strong supporting roles. Edward ALBEE wrote a stage adaptation of *Lolita* in 1979.

Lollobrigida, Gina (1927–), Italian actress, on screen from 1946, who became an international sex symbol in the 1950s, playing in such films as *Beauties of the Night* (1952), *Bread, Love, and Dreams* (1953), and *Where the Hot Wind Blows* (1959).

Loman, Willy, the salesman in Arthur MILLER's DEATH OF A SALESMAN, created on Broadway by Lee J. COBB.

Lomax, Alan and **John** (John Avery Lomax, 1875–1948, and Alan Lomax, 1915–), father and son, both American folklorists who went into the field to gather and record thousands of sides of folksongs and JAZZ, saving them for future generations. Among the artists whose work and recollections they preserved were LEADBELLY, Muddy WATERS, and Jelly Roll MORTON. Their work did a great deal to spark the folk-song revival that began in the 1940s and 1950s.

Lombard, Carole (Jane Alice Peters, 1908–42), U.S. actress, on screen in silent films from 1921, who became a star playing opposite John BARRYMORE in *Twentieth Century* (1934) and went on to become one of the major comedy stars of Hollywood's Golden Age, in such films as *My Man Godfrey* (1936), *Nothing Sacred* (1937), *In Name Only* (1939), and *To Be or Not to Be* (1942). Her career was cut short by her death in a plane crash. She was married to actor Clark GABLE at the time of her death.

London, Jack (John Griffith London, 1876–1916), U.S. writer, much of whose work was based on seafaring and Klondike gold-rush experience, beginning with the short stories collected in his first book, *The Son of the Wolf* (1900). He was a prolific, often savagely naturalistic writer, whose best-known novels are *The Call of the Wild* (1903), *The Sea Wolf* (1904), *White Fang* (1906), and the largely autobiographical *Martin Eden* (1909). A socialist, his best-known political novel was *The Iron Heel* (1908). *The Call of the Wild* became a film several times, most notably as William WELLMAN's 1935 film, starring Clark GABLE and Loretta YOUNG. So, too, did *The Sea Wolf*, most notably as Michael CURTIZ's 1941 film, with Edward G. ROBINSON in the title role, strongly supported by John GARFIELD, Ida LUPINO, and Alexander Knox.

Loneliness of the Long Distance Runner, The (1962), the Tony RICHARDSON film, adapted by Alan SILLITOE from his own 1959 story; a classic 1960s story of alienated British youth, set in a borstal, with Tom COURTENAY as the boy chosen to represent the institution in a long-distance race. The cast included Michael REDGRAVE, James Bolam, Alec MCCOWEN, Julia Foster, James Fox, John Thaw, and Joe Robinson.

Lonely Are the Brave (1962), the David Miller film, a story of the modern American West, long past its romantic glorification of the cowboy as hero. Kirk DOUGLAS was the cowboy loner who no longer fits in the West of his youth and who ultimately finds himself fleeing on horseback from a modern mechanized posse. The cast included Walter MATTHAU, Gena Rowlands, Michael Kane, George Kennedy, William Schallert, and Carroll

O'Connor. The Dalton TRUMBO screenplay was adapted from the Edward Abbey novel *Brave Cowboy.*

Long Day's Journey into Night (1956), Eugene O'NEILL's TONY-winning autobiographical play, written in 1940 and posthumously produced; the story of the Tyrone family. Fredric MARCH won a TONY for his creation of the alcoholic father, Florence Eldridge was the drug-addicted mother, Jason ROBARDS, Jr. the alcoholic older brother, and Dean Stockwell the tubercular younger son. In Sidney LUMET's 1962 film version, the key roles were played by Ralph RICHARDSON, Katharine HEPBURN, and again by Robards and Stockwell.

Longest Day, The (1962), a large-scale portrayal of the World War II Normandy invasion, based in part on the Cornelius Ryan book of that name, with segments of the work directed by Ken Annakin, Andrew Marton, and Bernhard Wicki, and with the entire project developed by producer Darryl F. ZANUCK. The large cast included such leading players as Robert MITCHUM, John WAYNE, Robert RYAN, Henry FONDA, Richard BURTON, Peter Lawford, Red Buttons, Robert Wagner, and many others.

Long Hot Summer, The (1958), the Martin RITT film, based on the William FAULKNER novel *The Hamlet* (1940), which was the first of the three SNOPES family novels, all set in Faulkner's imaginary YOKNAPATAWPHA COUNTY, Mississippi. The cast included Paul NEWMAN, Joanne WOODWARD, Orson WELLES, Anthony Franciosa, Angela LANSBURY, and Lee REMICK.

Long Voyage Home, The (1917), the one-act Eugene O'NEILL play, first presented by the PROVINCETOWN PLAYERS. It was also the title of the 1940 John FORD film, developed by Dudley Nichols from four O'Neill one-act plays: *The Long Voyage Home, Bound East for Cardiff, The Moon of the Caribbees,* and *In the Zone,* with Thomas Mitchell, John WAYNE, Barry FITZGERALD, Ian Hunter, Ward Bond, Wilfred Lawson, and Mildred Natwick in key roles.

Look Back in Anger (1956), the landmark postwar British play by John OSBORNE, a bit-

ter attack on then-current social and economic conditions and social strictures. The play established Osborne as a leading playwright and his Jimmy Porter character as the prototypical "angry young man" of the postwar generation. Richard BURTON played the role in the 1958 Tony RICHARDSON film.

"Look for the Silver Lining" (1920), the song introduced by Marilyn MILLER in the Broadway musical *Sally* (1920), with music by Jerome KERN and words by Buddy DeSylva. The song became identified with Miller and was the title of the 1949 biographical film.

Lorca, Federico García, see GARCÍA LORCA.

Lord of the Flies (1954), the William GOLDING novel, an allegorical story about a group of shipwrecked boys who quickly turn to savagery. Peter BROOK adapted the novel into his 1963 film, with a cast that included James Aubrey, Hugh Edwards, Roger Elwin, Tom Chapin, and Tom Gaman. The story was remade as the 1990 Harry Hook film.

Loren, Sophia (Sofia Scicolone, 1934–), Italian actress, on screen from 1950, who became a leading sex symbol in the 1950s, in such films as *Two Nights with Cleopatra* (1954), then went on to become a leading film actress in such films as *Two Women* (1961), for which she won a ACADEMY AWARD for best actress; YESTERDAY, TODAY, AND TOMORROW; *Marriage Italian Style* (1964); *Arabesque* (1966); *Sunflower* (1970); *The Cassandra Crossing* (1977); and *Blood Feud* (1981).

Lorre, Peter (Laszlo Lowenstein, 1904–64), Hungarian actor, on screen in Germany from 1928, who became a star in Fritz LANG's classic *M* (1931). He fled the Nazis in 1933, was in Hollywood from 1935, and there played in many strong character roles, in such films as THE MALTESE FALCON (1941), CASABLANCA (1942), and *The Mask of Dimitrios* (1944), as well as starring in the *Mr. Moto* mid-1930s B-film series.

Losey, Joseph (1909–84), U.S. director, in the theater from 1930, whose work was on stage from 1932 and included his notable direction of Bertholt BRECHT's *Galileo* (1947). On screen from 1939, he directed several Hollywood feature films from 1948 through 1951

and was then BLACKLISTED during the McCarthy period. He resettled in Britain, there becoming one of the major film directors of the modern period, with such films as *These Are the Damned* (1961), *The Servant* (1963), KING AND COUNTRY (1964), *Accident* (1967), THE GO-BETWEEN (1971), and *Galileo* (1974).

Lost Horizon (1933), the James HILTON novel, about the mythical high Tibetan land of Shangri-La, blessed with all the lost and mourned virtues of older times—a familiar and much-loved theme in human history, and never more so than in the early 1930s. Robert Riskin adapted the novel into the 1937 Frank CAPRA film, with Ronald COLMAN in the lead, supported by Jane Wyatt, Edward Everett Horton, Margo, Thomas Mitchell, John Howard, Sam Jaffe, H. B. Warner, and Isabel Jewell. Charles Jarrott remade the film in 1973.

Lost Weekend, The (1945), the pioneering film treatment of alcoholism, directed by Billy WILDER, with a screenplay by Wilder and Charles Brackett, based on the Charles R. Jackson novel. Ray MILLAND starred in the central Don Birnam role, opposite Jane WYMAN as his lover, with Philip Terry, Howard da Silva, and Doris Dowling in key supporting roles. The film, Milland as best actor, Wilder as director, and Wilder and Brackett for their screenplay all won OSCARS.

"Lou Grant Show, The" (1977–82), the long-running television series, starring Edward ASNER as Lou Grant, the tough-talking, socially conscious Los Angeles city editor, which searchingly explored many of the key social issues of the period; Asner had created the role in "The Mary Tyler Moore Show" (1970–77). The cast included Mason Adams, Nancy Marchand, Linda Kelsy, Jack Bannon, Robert Walden, and Daryl Anderson.

Love Me or Leave Me (1955), the King VIDOR film musical, a biography of torch singer Ruth ETTING. Doris DAY was Etting, opposite James CAGNEY as "Gimp" Snyder, the crippled, violent Chicago gangster who managed and dominated her, in a cast that included Cameron Mitchell, Tom Tully, and Robert Keith. Daniel Fuchs and Isobel Lennart won an OSCAR for their screenplay, adapted from a Fuchs story.

Low, David (1891–1963), British cartoonist, born in New Zealand, who worked as a cartoonist for the *Sydney Bulletin* before emigrating to Britain in 1919, then drawing for the *Star* from 1919 to 1927. He went to Beaverbrook's *Evening Standard* in 1927 and during the next 23 years became the leading editorial cartoonist of his time, by agreement with Beaverbrook drawing with complete freedom. He was usually in direct opposition to the very conservative Beaverbrook, who honored his commitment to Low; indeed, in this period Low invented and pilloried COLONEL BLIMP, the archetypal British conservative. Particularly notable were Low's classic anti-Hitler cartoons; Hitler was reported to have been very satisfactorily angered by them. Low moved to the *Daily Herald* in 1950 and to the *Manchester Guardian* in 1953. His works were collected in more than a score of books, as in *Political Parade* (1936), *Cartoon History of Our Times* (1939), *The World at War* (1942), and *The Years of Wrath* (1949).

Lowell, Amy (1874–1925), U.S. writer and critic, whose first collection of poems was *A Dome of Many-Coloured Glass* (1912) and who from 1913 was a leader of the Imagist movement in poetry. She published several collections of poems, among them *Sword Blades and Poppy Seed* (1914); *Men, Women, and Ghosts* (1916), which contains her best-known and often anthologized "Patterns"; *Legends* (1921); and *What O'Clock* (1925), which contains her "Lilacs," for which she won a posthumous PULITZER PRIZE.

Lowell, Robert (Traill Spence, Jr., 1917–77), U.S. poet. Much of his considerable body of work deals with his own conflict with and partial adjustment to a rather inimical world, as he journeyed from his Boston Lowell family roots through Catholicism, World War II incarceration for conscientious objection, family difficulties, and continuing political dissent. His first collection was *Land of Unlikeness* (1944), followed by his PULITZER PRIZE-winning *Lord Weary's Castle* (1946), *The Mill of the Kavanaughs* (1951), *Life Studies* (1959), *For the Union Dead* (1964), *Notebooks 1967–68* (1969),

History (1973), the Pulitzer Prize-winning *The Dolphins* (1973), and *Day by Day* (1977). He published three one-act plays in 1965, collectively titled *The Old Glory* and based on Melville's "Benito Cereno" and two Hawthorne stories, and also did several translations of prose and poems from other languages, most notably his *Prometheus Bound* (1969).

Lower Depths, The (1902), the Maxim GORKY play, the best known of his many works about the people at the bottom of the Russian social structure. It has become part of the standard international repertory and has been adapted for the screen several times, most notably in Japanese, as the 1957 Akira KUROSAWA film.

Lowry, Malcolm (1909–57), British writer, whose works include his first novel, *Ultramarine* (1933), and his single major novel, UNDER THE VOLCANO (1947), which was adapted into the 1984 John HUSTON film, with Albert FINNEY in the central role. Many of his poems and short stories were published posthumously.

Loy, Myrna (Myrna Williams, 1905–), U.S. actress, on screen from 1925, who in the 1930s became one of the major stars of Hollywood's Golden Age, beginning with her comedy role opposite William POWELL in THE THIN MAN (1934), which was followed by five more *Thin Man* films in the next 13 years. She also played major roles in such films as *The Rains Came* (1939), the classic THE BEST YEARS OF OUR LIVES (1946), and MR. BLANDINGS BUILDS HIS DREAM HOUSE (1948) and later also appeared on television.

Lubitsch, Ernst (1892–1947), German director, on stage as an actor from 1908, and on screen as an actor from 1912 and as a director from 1914, who is celebrated for the comedic style decribed as "the Lubitsch touch." He became a leading silent-film director, with such films as *The Marriage Circle* (1924), *Lady Windermere's Fan* (1925), and *The Student Prince* (1927). During the sound era, he made such films as DESIGN FOR LIVING (1933), NINOTCHKA (1939), *The Shop Around the Corner* (1940), and *Heaven Can Wait* (1943).

Lucas, George (1945–), U.S. actor, writer, and producer, whose work was on screen from 1970, most notably as director and co-writer of AMERICAN GRAFFITI (1973) and STAR WARS (1977) and as producer of such films as *The Empire Strikes Back* (1980), RAIDERS OF THE LOST ARK (1981), *The Return of the Jedi* (1982), *Indiana Jones and the Temple of Doom* (1984), *Willow* (1988), and TUCKER: THE MAN AND HIS DREAM (1988).

Lucy, the fictional Lucy Ricardo, first created by Lucille BALL in the TV family situation comedy "I Love Lucy" (1951–59) and developed for the rest of her long career, most notably in "The Lucy Show" (1962–74). In the original series, Desi Arnaz, then her husband, was Ricky Ricardo, and Vivian Vance and William Frawley were their neighbors Ethel and Fred Mertz. Vance was Vivian Bagley in "The Lucy Show." As Lucy, Ball became an American and then a worldwide phenomenon.

Lugosi, Bela (Bela Blasco, 1882–1956), Hungarian actor, on stage from 1901 and on screen from 1917, who fled Hungary after the failure of the Bela Kun government in 1919. He did several films in Germany 1919–21, then pursued his stage career in the United States, most notably as DRACULA on Broadway (1927). He re-created Dracula in his first starring role on screen, in 1931, and went on to become an archetypal horror film star in scores of further genre films.

Lukas, Paul (Pal Lukàcs, 1894–1971), Hungarian actor, on stage from 1916, and on screen in Europe from 1917 and in Hollywood from 1928. During the 1930s he often appeared in strong character roles, in such films as DODSWORTH (1936), THE LADY VANISHES (1938), and *Confessions of a Nazi Spy* (1939). In 1941 he starred on Broadway in Lillian HELLMAN's antifascist play WATCH ON THE RHINE, and he re-created the role on screen in 1943, winning a best actor OSCAR.

Luks, George Benjamin (1867–1933), U.S. painter. In the mid-1890s, while working as a newspaper illustrator in Philadelphia, he became one of the group of young realists who coalesced around Robert HENRI, there and later in New York City, where Luks was a cartoonist for the *World*. In 1908 they exhibited their work together as THE EIGHT and

later were known as the ASHCAN SCHOOL. Luks is best known for such paintings of city life as *The Butcher Cart* (1901), *The Spielers* (1905), and *The Wrestlers* (1905).

Lulu (1935), the Alban BERG opera, based on two Frank Wedekind plays, *Earth Spirit* (1902) and *Pandora's Box* (1905), which were also the bases of the 1928 G.W. PABST film PANDORA'S BOX.

Lumet, Sidney (1924–), U.S. director, who from the age of four played in the theater as a child actor; he moved into theater and television direction in the early 1950s. He emerged as a major film director with 12 ANGRY MEN (1957) and went on to direct such films as LONG DAY'S JOURNEY INTO NIGHT (1962), FAIL-SAFE (1964), THE PAWNBROKER (1965), DOG DAY AFTERNOON (1975), NETWORK (1976), *The Verdict* (1982), *The Morning After* (1987), and *Family Business* (1989).

Lunt, Alfred David (1892–1980), U.S. actor, on stage from 1912 and in leading roles from 1919. Although he appeared during the 1920s in several plays that did not include his wife, Lynn FONTANNE, their main work was together, beginning with *The Guardsmen* (1924); as LUNT AND FONTANNE they became major figures in the English-speaking theater. Lunt won a best actor TONY for his role in *Quadville* (1954).

Lunt and Fontanne, Alfred LUNT (1892–1980) and Lynn FONTANNE (1887–1983), one of the best-known performing partnerships in the English-speaking theater. They acted together in a wide range of classic and modern plays, beginning with their costarring roles in *The Guardsmen* (1924), and were probably best appreciated for their work in such sophisticated light comedies as *The Doctor's Dilemma* (1927) and DESIGN FOR LIVING (1933). Although much of their later work was in negligible vehicles, they scored a major success late in their joint careers, in *The Visit* (1958).

Lupino, Ida (1918–) British actress, director, writer, and producer, on screen from 1933, who appeared in such films as *The Light That Failed* (1940), *They Drive by Night* (1940), and HIGH SIERRA (1941), later directing, writing, and producing for films and television. She is the daughter of British actor and variety performer **Stanley Lupino** (1893–1942) and the niece of British actor Lupino LANE, who introduced the LAMBETH WALK in London's ME AND MY GIRL (1937); all were members of the historic Lupino stage family.

Lurie, Alison (1926–), U.S. writer, best known for her novels *The War Between the Tates* (1974), which became the 1977 television film starring Elizabeth Ashley and Richard Crenna; and *Foreign Affairs* (1984), which won a PULITZER PRIZE.

Lust for Life (1934), the Irving Stone fictionalized biography of painter Vincent Van Gogh; it was adapted by Norman Corwin into the 1956 Vincente MINNELLI film, with Kirk DOUGLAS as Van Gogh. Anthony QUINN won a best supporting actor OSCAR as Gauguin, in a cast that included James Donald, Pamela Brown, Henry Daniell, Lionel Jeffries, and Everett Sloane.

Lynn, Loretta (Loretta Webb, 1935–), U.S. singer and songwriter; she first appeared on GRAND OLE OPRY in 1960 and became one of the most popular singers in country music, with such songs as "Success" (1962), "Don't Come Home Drinkin'" (1962), and her own COAL MINER'S DAUGHTER (1970). The latter was also the title of her 1976 autobiography, which was the basis for the 1988 film biography of that name, with Sissy SPACEK in the Lynn role. Lynn has also written many other songs, one of them the controversial "The Pill" (1975), expressing a social concern; Lynn had been married at 14 and had quickly become the mother of four children.

Lynn, Vera (Vera Welch, 1919–), British singer, from the mid-1930s a band singer and radio personality in Britain, and after World War II a very popular radio and television entertainer in Britain and the United States. She is by far best remembered as "The Forces' Sweetheart" for her indefatigable entertainment of servicemen and -women during World War II and her identification with many of the songs of the day, most notably WE'LL MEET AGAIN.

M

M (1931), the Fritz LANG film, with Peter LORRE as the psychopathic murderer of children, who evades the police until he is finally caught by the people of the town's underworld, who ultimately are prevented from killing him by the police. Otto Wernicke played the police chief and Gustaf Grundgrens the underworld leader.

Maazel, Lorin (1930–), U.S. conductor and violinist; he was conductor of the American Symphony Orchestra in 1939 and made his concert debut as a violinist in 1945, playing throughout the world from 1953. His long conducting career includes six years as artistic director of the Deutsche Opera Berlin (1965–71) and 11 years as director of the Cleveland Orchestra (1971–81); he was music director of the Pittsburgh Symphony from 1988.

McAnally, Ray (1926–89), Irish actor and director, whose long and varied career included appearances in hundreds of plays, scores of television plays, and over a dozen films. He is best known abroad for his starring roles in two television miniseries: as Rick Pym in "A Perfect Spy" (1986) and as Labor prime minister Harry Perkins in "A Very British Coup" (1988).

MacArthur, Charles (1895–1956), U.S. writer, director, and producer, a journalist who became a leading playwright in the late 1920s; he is best known in the theater for THE FRONT PAGE (1928), *Twentieth Century* (1932), and the musical *Jumbo* (1935), all written in collaboration with Ben HECHT. He and Hecht also wrote, directed, and produced several mid-1930s films, including *Crime Without Passion* (1934) and *The Scoundrel* (1935). MacArthur and Hecht also collaborated on several other screenplays, including the adaptation of his own *Twentieth Century* (1934), *Gunga Din* (1939), and WUTHERING HEIGHTS (1939). He was the husband of actress Helen HAYES.

Macaulay, Rose (1889–1958), British writer, best known for such satirical novels as *Potterism* (1920), *Told by an Idiot* (1923), and *Going Abroad* (1934). Two notable later works are a travel book, *The Pleasure of Ruins* (1953), and her last novel, *The Towers of Trebizond* (1956).

McCabe and Mrs. Miller (1971), the Robert ALTMAN film, about a gunfighter and a madam who set up a house of prostitution in a turn-of-the century mining town in the American Northwest. Altman's emphasis is on his perception of the realities; the film takes place in weather conditions that approximate a monsoon, and the river of mud on which the ramshackle town seems to rest never dries. Warren BEATTY was John McCabe, opposite Julie CHRISTIE as Constance Miller, in a cast that included Shelley Duvall, Keith Carradine, William Devane, René Auberjonois, and Bert Remsen. Altman and Brian McKay adapted the screenplay from the Edmund Naughton novel *McCabe*.

McCarey, Leo (1898–1969), U.S. director, whose films include some of the most notable comedies—and a few of the most successful sentimental dramas—of Hollywood's Golden Age, including DUCK SOUP (1933); *Ruggles of Red Gap* (1935); *The Awful Truth* (1937), for which he won a best director OSCAR; GOING MY WAY (1944), and another best director Oscar, as well as a best screenplay Oscar; and *The Bells of St. Mary's* (1945).

McCarthy, Charlie, puppet character created by ventriloquist Edgar BERGEN.

McCarthy, Mary Therese (1912–89), U.S. writer and critic, whose best-known novels

often satirized modern intellectuals and academics; these include *The Company She Keeps* (1942); *The Oasis* (1949); *The Groves of Academe* (1952); and *The Group* (1963), which was adapted into Sidney LUMET's 1966 film. Other works include *Venice Observed* (1956) and *The Stones of Florence*, as well as a wide variety of essays, reviews, and short stories.

McCartney, Paul (1942–), British musician; with George HARRISON, John LENNON, and Ringo STARR, a member of the BEATLES. McCartney was rhythm guitarist in the early years, becoming bass guitarist in 1961. He was also often lead singer and collaborated with Lennon on most of the Beatles' songs. After the dissolution of the Beatles, he went on to build a second career as a songwriter and as founder of the group **Wings** in 1971.

McClintic, Guthrie (1893–1961), U.S. actor, director, and producer, on stage as an actor from 1913 and a director and producer from 1921, the year he married Katharine CORNELL. He emerged as a major theater figure as her director in *The Green Hat* (1925) and directed much of her later work, including her celebrated THE BARRETTS OF WIMPOLE STREET (1931), *Romeo and Juliet* (1934), and *Candida* (1937). McClintic also directed such plays as WINTERSET (1935), the John GIELGUD *Hamlet* (1936), *High Tor* (1937), and KEY LARGO (1939).

McCormack, John (1884–1945), Irish tenor, from 1919 an American citizen; he was one of the most celebrated singers of his time. He made his Italian debut in 1906; in 1907 he sang at Covent Garden; and in 1909 first sang in the United States, where he had his greatest success. He is by far best known for his work in concert, which often combined opera, lieder, popular songs, and the Irish songs that brought him to huge popular audiences, such as "Macushla," "Molly Bawn," "The Rose of Tralee," and "I Hear You Calling Me." McCormack was also one of the leading recording artists of his time. On screen, he appeared in *Song of My Heart* (1930) and *Wings of the Morning* (1937).

McCowen, Alec (Alexander Duncan McCowen, 1925–), British actor, in a wide

range of leading roles from the late 1950s, notably in Shakespeare with the Old Vic (1959–60), as *Hadrian VII* (1968) in London and New York; in *The Misanthrope* (1972); in *Equus* (1972); in PYGMALION (1974); in his solo performances of *St. Marks Gospel* (1978); and as *Kipling* (1983). His films include STEVIE (1978), *The Assam Garden* (1985), and HENRY V (1989).

McCrea, Joel (1905–90), U.S. actor, on screen from 1923, who became a film star in the mid-1930s, playing a wide variety of leads in such films as *These Three* (1936, a version of THE CHILDREN'S HOUR), DEAD END (1937), *Foreign Correspondent* (1940), and *Sullivan's Travels* (1941). He was also one of Hollywood's most durable Western stars, playing leads in dozens of films, from *Wells Fargo* (1937) and *Buffalo Bill* (1944) through *Ride the High Country* (1962).

McCullers, Carson Smith (1917–67), U.S. writer, who emerged as a major American literary figure with her first novel, *The Heart Is a Lonely Hunter* (1940), which was followed by *Reflections in a Golden Eye* (1941); both novels reflected her southern roots, as did much of her other work. She adapted her novel THE MEMBER OF THE WEDDING (1946) into the 1950 play, with Julie HARRIS creating the leading role on Broadway and re-creating it in the 1952 Fred ZINNEMANN film. In addition, she wrote the play *The Square Root of Wonderful* (1958); the novel *Clock Without Hands* (1951); and the novella *The Ballad of the Sad Café* (1951), which was dramatized by Edward ALBEE in 1960.

Macdonald, Dwight (1906–82), U.S. writer and editor, whose several magazine affiliations reflected his post-World War II move from left to middle, from the *Partisan Review* and his own *Politics* (1944–49) to a staff position on *The New Yorker*. He was a prolific essayist whose work was collected in several volumes, including *Memoirs of a Revolutionist* (1957) and *Against the American Grain* (1963).

MacDonald, James Edward Hervey (1873–1922), Canadian painter, who began to paint in the Canadian North in the years before World War I, producing such works as *Tracks and*

Traffic (1912) and *The Lonely North* (1913), and with Lawren HARRIS beginning the process that would eventuate in the 1920 formation of the GROUP OF SEVEN. In 1918 he began the series of trips to Algoma, north of Lake Superior, that would result in such notable works as *The Solemn Land* (1921) and *Autumn in Algoma* (1921). Much of his later work was done in the Rockies.

MacDonald, Jeanette (1901–65), U.S. singer and actress, who became a star playing opposite Maurice CHEVALIER in her first film, *The Love Parade* (1929), and went on to play opposite Nelson EDDY in a series of enormously popular and very syrupy film musicals, which included *Naughty Marietta* (1935), *Rose Marie* (1937), *Maytime* (1937), THE GIRL OF THE GOLDEN WEST (1938), *Sweethearts* (1938), *New Moon* (1940), and BITTERSWEET (1940).

Macdonald, Ross (Kenneth Millar, 1915–83), U.S. writer, the creator of a series of California-based detective novels featuring private detective Lew Archer, all in the hard-boiled detective mode introduced by Dashiell HAMMETT. Some of his best-known novels are *The Moving Target* (1949), *The Good-bye Look* (1964), *The Far Side of the Dollar* (1965), *The Underground Man* (1971), and *The Blue Hammer* (1976). *The Moving Target* became the 1966 Paul NEWMAN film, in which Archer was renamed HARPER.

McGhee, Brownie (Walter Brown McGhee, 1915–), guitarist and BLUES singer, most notably partnered with Sonny TERRY.

McKay, Claude (1890–1948), Jamaican-American writer, a leader of the HARLEM RENAISSANCE of the 1920s, who is best known for the novels *Home to Harlem* (1928), *Banjo* (1929), and *Banana Bottom* (1933). He also published several collections of poems and a collection of short stories.

Macke, August (1887–1914), German painter, a co-founder of THE BLUE RIDER group in 1911; his colorful, representational, light work is often described as expressionist (see EXPRESSIONISM). In 1914 he painted several well-regarded watercolors while traveling with Paul KLEE in Tunisia. Macke was an early casualty of World War I.

McKellan, Ian Murray (1939–), British actor, on stage from 1961, who played in a wide range of leading roles from the mid-1960s, including a series of leads with the ROYAL SHAKESPEARE COMPANY in the late 1970s. He is best known abroad for his leads in *Bent* (1979) and AMADEUS (1980). His films include *Alfred the Great* (1969), *Plenty* (1985), and *Scandal* (1988).

McKenna, Síobhán (1923–86), Irish actress, on stage from 1940 and with the ABBEY THEATRE 1944–46, who played with equal fluency in Gaelic and English. She became a major star in the Irish theater with her Pegeen Mike role in THE PLAYBOY OF THE WESTERN WORLD (1954) and her ST. JOAN (1954), going on to play in a wide range of classic and modern leads, including her notable Juno in JUNO AND THE PAYCOCK, first done by her in 1966. She recreated Pegeen Mike on film in 1962, also appearing in such films as OF HUMAN BONDAGE (1964) and DR. ZHIVAGO (1965).

McKim, Charles (1847–1909), U.S. architect, a major figure in late-19th-century neoclassicism and from 1879 the senior partner in McKim, Mead, and White. His later work included such structures as the Morgan Library (1903) and New York's Pennsylvania Station, completed in 1910.

"Mack the Knife" (1928), the Kurt WEILL song, from THE THREEPENNY OPERA. It became popular in the 1950s, as introduced by Lotte LENYA in Marc BLITZSTEIN's English-language version of the work, and reached wide popular audiences as sung by Bobby Darin and in a very notable Louis ARMSTRONG rendition.

McKuen, Rod (1933–), U.S. writer and composer, whose very simple life-and-love-affirming poetry, as expressed in verse and popular song, achieved enormous mass audience popularity from the mid-1960s.

McLaglen, Victor (1886–1959), British actor, on screen for almost five decades. In 1926 he was Captain Flagg in WHAT PRICE GLORY?, directed by Raoul WALSH, and in 1936 won a best actor OSCAR as Gyppo Nolan in the title role of John FORD's THE INFORMER. He largely played strong supporting roles in scores

of adventure films, though he played several silent-film leads in the 1920s.

MacLaine, Shirley (Shirley MacLean Beaty, 1934–), U.S. actress, briefly on stage in the early 1950s and on screen from 1955, who became a star in such films as THE APARTMENT (1960) and *Irma La Douce* (1963). Later in her career she emerged as a major dramatic actress, in such films as *The Turning Point* (1977); BEING THERE (1979); TERMS OF ENDEARMENT (1983), for which she won a best actress OSCAR; *Madame Sousatzska* (1989); *Steel Magnolias* (1989); *Postcards on the Edge* (1990); and *Waiting for the Light* (1990). She is the sister of actor Warren BEATTY.

MacLeish, Archibald (1892–1982), U.S. poet, dramatist, and public official, whose mature work began to emerge in the mid-1920s, during his period as a Paris-based expatriate, in the collection *Streets of the Moon* (1926) and the verse play *Nobodaddy*. He emerged as a major literary figure in the 1930s with such works as his PULITZER PRIZE-winning narrative poem *Conquistador* (1932) and such socially conscious works as the poems *Frescoes for Mr. Rockefeller's City* (1933), the verse play *Panic* (1935), and the radio verse play *The Fall of the City* (1937). His *Collected Poems* (1952) won a Pulitzer Prize, as did his most notable verse play, J.B. (1958). MacLeish was librarian of Congress (1939–44) and an assistant secretary of state (1944–45).

MacLennan, Hugh (1907–90), Canadian writer, a novelist identified with the search for a coherent, meaningful national character that has preoccupied many Canadian cultural figures during the 20th century. *Two Solitudes* (1945) established him as a major literary figure and was followed by such novels as *The Precipice* (1948), *Each Man's Son* (1951), and *The Watch That Ends the Night* (1959).

McLuhan, Marshall (1911–80), Canadian teacher and essayist, whose main work was in communications theory. In *The Gutenberg Galaxy* (1962), *Understanding Media* (1964), *The Medium Is the Message* (1967, with Quentin Fiore), and associated writings he theorized that the new electronic media had transformed a previously atomized world into a "global vil-

lage" and that the electronic media would replace books.

McManus, George (1884–1954), U.S. cartoonist; he created several comic strips but is best known by far for BRINGING UP FATHER, featuring Maggie and Jiggs, which he originated in 1913 and drew until his death.

MacMurray, Fred (1908–), U.S. actor, a musician early in his career and on screen from 1934, who played in a wide range of film roles for over three decades, perhaps most notably in DOUBLE INDEMNITY (1944) and as Lt. Kiefer in THE CAINE MUTINY (1954). He also was one of television's most durable series leads, as Steve Douglas in "My Three Sons" (1960–72).

MacNiece, Louis (1907–63), British writer, a poet closely associated with W.H. AUDEN and Stephen SPENDER on the left in the 1930s, though his work was considerably less political than theirs in that period. His poetry is collected in *Blind Fireworks* (1929), *Poems* (1935), *Out of the Picture* (1937), and many other volumes. His work also includes translations of *Agamemnon* and *Faust*, many BBC radio plays, and his collaboration with Auden in *Letters from Iceland* (1937).

McQueen, Steve (Terrence Steven McQueen, 1930–80), U.S. actor, on stage from 1952, most notably in *A Hatful of Rain* (1955), and on screen from 1956. He became a major Hollywood star in such films as *The Great Escape* (1963), *The Cincinnati Kid* (1965), THE SAND PEBBLES (1966), *Bullitt* (1968), *Le Mans* (1971), and *Papillon* (1973), and also produced and starred in Ibsen's *An Enemy of the People* in 1979. On televison, he starred in "Wanted: Dead or Alive" (1958–61).

Madame Butterfly (1904), the opera by Giacomo PUCCINI, based on the 1900 David BELASCO play, itself based on the John Luther Long story; a melodrama in which Madame Butterfly, the Japanese geisha Cho-Cho-San, ultimately commits suicide after being betrayed by her American lover, father of her child. M. BUTTERFLY (1988), the David Henry Hwang play, was also loosely based on the Belasco play, though with considerably altered emphases.

Madame Rosa (1977), the Moshe Mizrachi film, a best foreign film OSCAR-winner. Simone SIGNORET was the Jewish prostitute who as an act of charity cares for the children of prostitutes; the film focused on her loving care of a teenage Arab boy. The film was written by Mizrachi, based on the Emile Ajar novel; the cast also included Samy Ben-Youb, Claude Dauphin, and Gabriel Jabbour.

"Mad Dogs and Englishmen" (1932), a song introduced by Beatrice LILLIE in *The Third Little Show* (1931); it became one of her standards. Words and music were by Noël COWARD; it is probably his best-known song.

Madonna (Madonna Louise Ciccone, 1958–), U.S. singer and actress, a leading popular-music star of the 1980s, with such albums as *Madonna* (1983), *Like a Virgin* (1984), and *True Blue* (1986). She has also appeared in several films, most notably in *Desperately Seeking Susan* (1985) and *Dick Tracy* (1990), and in the 1987 Broadway production of David MAMET's *Speed-the-Plow*.

Maeterlinck, Maurice (1862–1949), Belgian writer and naturalist. After two early volumes of poetry, he became a pioneer symbolist playwright, whose best-known plays include *Pelléas and Mélisande* (1892), which was adapted into the 1902 Debussy opera; *Monna Vanna* (1902); *The Blue Bird* (1909); and *The Burgomaster of Stilemonde*. The most notable of the several *Blue Bird* films was the 1940 Walter Lang version, starring Shirley TEMPLE. Maeterlinck also wrote two classic naturalist works, *The Life of the Bee* (1901) and *The Life of the White Ant* (1926), as well as a wide range of essays. He was awarded the 1911 NOBEL PRIZE for literature.

Magician, The (1958), the classic Ingmar BERGMAN film, a dark, highly allusive story featuring an illusionist and his troupe in rural 19th-century Sweden. Max von SYDOW was in the title role, in a cast that included Ingrid Thulin, Gunnar Bjornstrand, and Naima Wifstrand.

Magic Mountain, The (1924), the Thomas MANN novel. The tuberculosis sanatorium in which Hans Castorp finds himself was meant to be a powerful metaphor for pre-World War

I Europe and for the coming death of European life and art; the timing of the novel itself was later seen by many as a direct, prophetic warning of what German fascism would soon bring to Germany and the world.

Magnani, Anna (1908–73), Italian actress, in variety during the early 1920s, on stage from 1926, and on screen from 1927. In 1945 she emerged as a major international film star in Roberto ROSSELLINI's classic OPEN CITY, going on to do such films as *The Miracle* (1950) and *The Rose Tattoo* (1955), for which she won a best actress OSCAR.

Magnificent Ambersons, The (1918), the PULITZER PRIZE-winning turn-of-the-century novel by Booth TARKINGTON, which became the classic 1942 film in the hands of Orson WELLES, who wrote the screenplay and directed the film, although the final cut was not his. The cast included Joseph COTTEN, Dolores Costello, Anne BAXTER, Tim Holt, Agnes Moorehead, and Richard BENNETT.

Magnificent Seven, The (1960), the John Sturges film, a remake of Akira KUROSAWA's 1954 THE SEVEN SAMURAI. The cast included Yul BRYNNER, Steve MCQUEEN, James COBURN, Robert VAUGHN, Charles BRONSON, Horst Buchholz, Brad Dexter, and Eli Wallach. The film generated three sequels.

Magritte, René (1898–1967), Belgian painter, who became a surrealist (see SURREALISM) in the mid-1920s, spent the years 1927–30 in Paris, and then spent the rest of his life in Belgium. In the main body of his work, he painted fantastic images and situations in a completely realistic style, as in his paintings *The False Mirror* (1928), *Perpetual Motion* (1934), and *The Empire of Light* (1950).

Mahabharata (1987), the Jean-Claude Carriere–Peter BROOK translation and adaptation of the Indian epic into the nine-hour play, with a huge cast drawn from the Brook Center of Theatre Research. Brook also directed the three-hour 1989 film adaptation.

Mahler, Gustav (1860–1911), Austrian composer and conductor, whose songs and early symphonies strongly reflect the influence of German folk music. Some of his songs became integral parts of his first four symphonies

(1894–1900); others were presented in his later symphonies and in such works as *Songs of a Wayfarer* (1885), *Songs of the Deaths of Children* (1904), and *The Song of the Earth* (1909). His middle works were the wholly instrumental *Symphonies 5–7* (1902–5). His largest work was the massive *Symphony No. 8 (The Symphony of a Thousand)* (1907), which was followed by *No. 9* (1909) and the unfinished *No. 10*. Mahler was also one of the leading opera conductors of his time; he conducted in several cities before becoming artistic director of the Vienna Court Opera (1897–1907), a position for which he converted from Judaism to Catholicism, although Austrian anti-Semitism ultimately was a major factor in forcing his resignation. He was later conductor of the Metropolitan Opera (1908–9) and of the New York Philharmonic Society (1909–11).

Maigret, the fictional French police inspector created by Georges SIMENON in 1930, and subsequently the protagonist of over 100 mystery novels.

Mailer, Norman (1923–), U.S. writer, who emerged as a major literary figure with his first published novel, THE NAKED AND THE DEAD (1945), a World War II story later adapted into the 1958 Raoul WALSH film. His further novels include *Barbary Shore* (1951); *The Deer Park* (1955); *An American Dream* (1965); and the PULITZER PRIZE-winning "nonfiction novel" *The Executioner's Song* (1979), about condemned murderer Gary Gilmore, which he adapted into the 1982 Lawrence Schiller film, with Tommy Lee Jones in the Gilmore role. Among his later works are the novels *Ancient Evenings* (1983) and *Tough Guys Don't Dance* (1983), which he adapted into the 1987 film and directed. He has also been a prolific essayist and has written short stories; his *Armies of the Night* (1968), combining reportage and commentary, also won a Pulitzer Prize.

Maillol, Aristide (1861–1944), French artist, best known for his many, quite similar, formal versions of the female nude, beginning with his first large work, *The Mediterranean* (1905). His focus on form, without direct allusion to history, prefigured the development of more abstract modernist approaches to sculpture. A few of his other representative sculptures are *Action in Chains* (1906); *Monument to Cézanne* (1916); and *Dina* (1940), one of the many modeled by his wife, Dina Vierny. Maillol had been a painter and tapestry-maker before the turn of the century. From about 1910 through the interwar period, he was also recognized as a talented book illustrator.

Major Barbara (1905), the George Bernard SHAW play, which was adapted into the 1941 Gabriel Pascal film, starring Wendy HILLER as the Salvation Army major and Rex HARRISON as her admirer, in a cast that included Robert Morley, Robert Newton, Sybil THORNDIKE, Deborah KERR, and Emlyn WILLIAMS.

Makarova, Natalia Romanovna (1940–), Soviet dancer, a leading ballerina of the KIROV BALLET, 1959–70. After she defected to the West in 1970, she became a principal dancer of the American Ballet Theater and appeared as a guest artist all over the world, most notably in *Giselle.*

Makeba, Miriam (1932–), South African Black singer, a popular singer in her country from the mid-1950s and a powerful anti-apartheid voice from the late 1950s. She was soon forced to leave South Africa; her records were also banned there. Makeba became an international star, largely based in the United States from 1960 to 1969, and then moved to Guinea with her second of five husbands, Black activist Stokeley Carmichael, while continuing to tour widely, record, and remain a key figure in the South African freedom movement. In 1990 she returned to South Africa for the first time in over three decades.

"Make Believe" (1927), the duet from SHOW BOAT introduced on Broadway by Norma Terris and Howard Marsh in 1927 and sung most notably on screen by Irene DUNNE and Alan Jones in the classic 1936 film version. Music is by Jerome KERN, with words by Oscar HAMMERSTEIN II.

Malamud, Bernard (1914–86), U.S. writer, whose first novel, *The Natural* (1952), later became the 1984 Robert Gist film, with Robert REDFORD in the title role. Malamud was primarily a chronicler of Jewish life, in such novels as *The Assistant* (1957); *A New Life* (1961); *The Fixer* (1966), which won a PULIT-

ZER PRIZE; *Dubin's Lives* (1979); and *God's Grace* (1982) and in his several short-story collections, including *The Magic Barrel* (1958), *Idiot's First* (1961), *Pictures of Fidelman* (1969), and *Rembrandt's Hat* (1973).

Malden, Karl (1914–), U.S. actor, on stage from the mid-1930s, in such plays as GOLDEN BOY (1937), KEY LARGO (1939), *Truckline Cafe* (1946), and ALL MY SONS (1947). He played Mitch in the landmark A STREETCAR NAMED DESIRE (1947), a role he re-created in the 1951 film, for which he won a best supporting actor OSCAR. He subsequently appeared in such films as ON THE WATERFRONT (1954), *One-Eyed Jacks* (1961), and CHEYENNE AUTUMN (1964) and in leads in two television series: "The Streets of San Francisco" (1972–76) and "Skag" (1984).

Malevich, Kasimir (1878–1935), Russian painter. In 1913 he began to paint in a style built of abstract geometrical symbols, and especially the square, triangle, and circle. He first exhibited works in this style in 1915, calling them the beginning of the new art of SUPREMATISM; the most notable of these works, which became a centerpiece of the new movement, was his *Black Square* (1915). His best-known work is *Suprematist Composition: White on White* (1918), which for decades after was to many emblematic of the worldwide modern-art movement.

Malle, Louis (1932–), French director, whose first film was the documentary *The Silent World* (1956), which he co-directed and co-photographed with Jacques Cousteau. He went on to direct such fiction films as *The Lovers* (1958), *The Fire Within* (1963), *Pretty Baby* (1978), and ATLANTIC CITY (1980); he also directed and produced *Au Revoir, les Enfants* (1987).

Malraux, André (1901–76), French writer; as a novelist of social engagement, one of the seminal literary figures of the 20th century. His three novels of the Chinese Revolution, all informed by his own experience as a journalist in East Asia, are *The Conquerors* (1928); *The Royal Way* (1930); and his most notable work, MAN'S FATE (1933), set in the 1927 Shanghai Republican–Communist split that began the

Chinese Civil War. He wrote two antifascist novels in the 1930s: *Days of Wrath* (1935) and MAN'S HOPE (1936), the latter based upon his experiences in the Republican Air Force during the Spanish Civil War. Malraux adapted and directed the 1945 film version of *Man's Hope*. In the postwar period, he turned more toward theoretical questions of art and culture, in such major works as *The Voices of Silence* (1951) and *The Metamorphosis of the Gods* (1960). He was French minister of culture in the de Gaulle era, 1958–69.

Maltese Falcon, The (1941), the classic John HUSTON film, revolving around the search for a unique jewel-encrusted black bird; adapted from the equally classic 1930 Dashiell HAMMETT mystery, with Humphrey BOGART as Sam SPADE and Mary ASTOR, Sydney GREENSTREET, Peter LORRE, Elisha COOK, Jr., and Lee Patrick in strong supporting roles and with Walter HUSTON (John's father) unnamed in a bit part. It was Huston's first film as a director; he also wrote the screenplay. The novel was adapted for film on several occasions.

Mamas and the Papas, The, U.S. folk band, formed in 1965 by John Phillips (1935–), Cass Elliott (1943–74), Michelle Gilliam Phillips (1944–), and Dennis Doherty (1941–). The group was very popular during 1966 and 1967, with the albums *The Mamas and the Papas, If You Can Believe Your Eyes and Ears*, and *Deliver*, and for such songs as "California Dreaming" and "Monday, Monday." The group disbanded in 1968 and unsuccessfully attempted a reunion in 1970. John Phillips, his daughter Mackenzie Phillips, Dennis Doherty, and Elaine McFarlane formed a new group of the same name in 1982.

Mamet, David Alan (1947–), U.S. writer and director, whose best-known plays include *American Buffalo* (1976); *A Life in the Theatre* (1976); *Glengarry Glen Ross* (1984), which won a PULITZER PRIZE; and *Speed-the-Plow* (1987). His screenplays include *The Verdict* (1984) and *The Untouchables* (1986). He wrote and directed the films *House of Games* (1987) and *Things Change* (1987).

Mamoulian, Rouben (1898–1987), Armenian-Soviet director, on stage as a director in the

Soviet Union from 1918 and in the West from 1920. He worked and taught in Great Britain from 1920 to 1923, then emigrated to the United States, directing such plays as *Porgy* (1927) and *Wings over Europe* (1928) for the THEATRE GUILD and later PORGY AND BESS (1935), OKLAHOMA! (1943), and CAROUSEL (1945). He directed such films as *Applause* (1929), DR. JEKYLL AND MR. HYDE (1932), *Becky Sharp* (1935), GOLDEN BOY (1939), and *Silk Stockings* (1957; a version of NINOTCHKA).

Man and a Woman, A (1966), the Claude LELOUCH film, a love story starring Anouk Aimee and Jean-Louis Trintignant; it won best foreign film and best screenplay OSCARS. Lelouch did a sequel in 1986, *A Man and a Woman: 20 Years Later*.

Mancini, Henry (1924–), U.S. composer, arranger, and conductor, best known for his film scores for such movies as *Touch of Evil* (1958), BREAKFAST AT TIFFANY'S (1961), DAYS OF WINE AND ROSES (1963), *The Pink Panther* (1964), *Darling Lili* (1970), and VICTOR/VICTORIA (1982).

Mandelstam, Osip Emilevievich (1891–1938), Russian writer, a highly regarded poet whose modest body of early work appeared in the collections *Stone* (1913) and *Tristia* (1922). He was arrested in 1934, for having published a poem perceived as anti-Stalinist, and died in prison. His later poems, among them some of his finest work, were published long after his death.

Man for All Seasons, A (1960), the Robert BOLT play, in which Paul SCOFIELD created a memorable Thomas More, at fatal odds with his king, Henry VIII, on a matter of principle. The play and Scofield both won TONY AWARDS. Bolt adapted the work into the 1966 Fred ZINNEMANN film, with Scofield and Robert Shaw as the antagonists, in a cast that included Wendy HILLER, Leo McKern, Orson WELLES, John HURT, Susannah YORK, Vanessa REDGRAVE, and Nigel Davenport. The film, Bolt, Zinnemann, Scofield, and cinematographer Ted Moore all won OSCARS.

Manhattan (1979), the Woody ALLEN film; Allen stars as a New York-based writer dissatisfied with the limited, shallow personal concerns of his seemingly intellectual friends, who

tries to find wider, deeper meanings, presumably intrinsic to his favorite cityscape. The cast includes Diane KEATON, Michael Murphy, Meryl STREEP, Mariel Hemingway, and Anne Byrne. Allen and Marshall Brickman wrote the screenplay.

Manilow, Barry (1946–), U.S. singer and songwriter, who became a very popular singer in the mid-1970s, with such songs as "Mandy"(1974) and "Could It Be Magic" (1975) and such albums as *Trying to Get the Feeling* (1975) and *Barry Manilow Live* (1977); he was a major figure on tour and appeared in several television concerts.

Man in the White Suit, The (1952), the Alexander McKendrick film, a comedic and satirical work about a scientist who finally discovers the indestructible fabric he has been seeking, only to find manufacturers, mill workers, and the government all against him; ultimately, he escapes from a mob only because his fabric proves far from indestructible and disintegrates in a rainstorm. Alec GUINNESS starred, in a cast that included Joan GREENWOOD, Cecil Parker, Michael Gough, and Ernest Thesinger. McKendrick, Roger MacDougall, and John Dighton wrote the screenplay.

Mankiewicz, Joseph Leo (1909–), U.S. writer, producer, and director, who worked in Hollywood as a writer from 1929 and as a producer from 1936. In 1946, he began a relatively brief and rather distinguished directing career, with such films as *Dragonwyck* (1946), for which he wrote the screenplay; *The Ghost and Mrs. Muir* (1947); *A Letter to Three Wives* (1949), for which he received both best director and best screenplay OSCARS; ALL ABOUT EVE (1950), which also won him best director and best screenplay Oscars; *No Way Out* (1950), a pioneering study of bigotry; *Five Fingers* (1952); *Julius Caesar* (1953), for which he also wrote the screenplay; GUYS AND DOLLS (1955); and the Elizabeth TAYLOR–Richard BURTON *Cleopatra* (1963).

Mann, Daniel (1912–), U.S. director, who did several notable films early in his career, including COME BACK LITTLE SHEBA (1952), THE ROSE TATTOO (1955), *The Teahouse of the August Moon* (1956), *The Last Angry Man* (1959),

and BUTTERFIELD 8 (1960). His later work includes the telefilm *Playing for Time* (1980).

Mann, Delbert (1920–), U.S. director, who worked very successfully in television during the 1950s. He won a best director OSCAR for his first film, the Oscar-winning MARTY, an adaptation by Paddy CHAYEFSKY of his own 1953 teleplay, which Mann had directed. His strong early films include *The Bachelor Party* (1957), SEPARATE TABLES (1958), *Middle of the Night* (1959), and *The Dark at the Top of the Stairs* (1960). Much of his later work was once again in television.

Mann, Thomas (1875–1955), German writer, a central figure in 20th-century European literature from the appearance of his first novel, *Buddenbrooks* (1901). Mann took as a main theme the destruction of art and the artist in pre-World War I bourgeois society, a theme further developed in such works as the novellas *Tonio Kroger* (1903) and DEATH IN VENICE (1911). His novel *The Magic Mountain* (1924) expressed a wider and deeper view, his sanatorium a metaphor for the dying Europe that went to war in 1914; coming in the interwar period, with fascism approaching in Germany, his work was also prophetic. He also more directly opposed fascism, in such works as the novel *Mario and the Magician* (1930). Mann left Germany in 1933, then lived in Switzerland and the United States; while the Germans were burning his books, he wrote the four-volume *Joseph and His Brothers* (1934–42). His later works include *The Beloved Returns* (1939), *Doctor Faustus* (1947), and *The Confessions of Felix Krull* (1954). *Death in Venice* became the 1971 Luchino VISCONTI film, with Dirk BOGARDE in the leading role.

Man of Aran (1934), the Robert FLAHERTY film, a landmark documentary, with extraordinary film footage, about the lives of poor fishermen and their families on remote Aran Island, off the Atlantic coast of Ireland. Flaherty wrote, directed, and shot the film.

Man of a Thousand Faces, The, nickname of Lon CHANEY and the title of Joseph Pevney's 1957 film biography of Chaney, with James CAGNEY in the title role.

Man of La Mancha (1965), the TONY-winning Dale Wasserman musical, with music by Mitch Leigh and lyrics by Joe Darion, loosely based on the life and work of Cervantes. Richard Kiley won a TONY in the Don Quixote–Cervantes role. Peter O'TOOLE starred in the 1972 Arthur Hiller film, in a cast that included Sophia LOREN, Harry ANDREWS, and James Coco.

Man's Fate (1933), the André MALRAUX novel, set in the 1927 Shanghai Republican–Communist split that began the Chinese Civil War and based largely upon his experience as a journalist in East Asia in that period. His central character, the Communist leader Kyo, was taken from life: He was Zhou Enlai (Chou En-lai).

Mansfield, Katherine (Kathleen Beauchamp-Murry, 1888–1923), New Zealand-British writer, whose highly regarded work was entirely in the short story. Much of her modest output is contained in *Bliss and Other Stories* (1920), *The Garden Party* (1922), and *The Dove's Nest* (1923). From 1911 she lived with critic John Middleton Murry, whom she later married; together they were associated with the BLOOMSBURY GROUP. After her death Murry edited her letters, journals, and some unpublished fiction and poetry.

Manship, Paul Howard (1885–1966), U.S. sculptor, whose realistic work was in many instances inspired by mythological and classical themes, as in his *Centaur and Dryad* (1913) and the well-known *Prometheus Fountain* at New York's Rockefeller Center. He also did several notable portrait and animal sculptures.

Man's Hope (1936), the novel by André MALRAUX, based on his experiences in the Republican Air Force during the Spanish Civil War. Malraux adapted and directed the 1945 film version.

Man with the Golden Arm, The (1949), the Nelson ALGREN novel, a story of drug addiction and suicide set in Chicago. Frank SINATRA was the doomed addict in the 1955 Otto PREMINGER film, in a cast that included Eleanor Parker, Kim NOVAK, and Darren McGavin.

Manzù, Giacomo (1908–), Italian sculptor; during the 1930s, he developed the themes and techniques that would in the next several

decades establish him as a leading 20th-century sculptor, in 1933 doing the first of the many versions of *Girl on a Chair* and in 1936 doing the first of his series of more than 50 cardinals. Among his most notable works are the doors of Salzburg Cathedral (1958); the portrait bust of Pope John XXIII (1963); and the doors of St. Peter's, in Rome (1964), dedicated as the *Portal of Death*.

Mapplethorpe, Robert (1947–89), U.S. photographer and filmmaker, a leading figure in photography, whose career was cut short by AIDS. In his last years, he used his celebrity and his funds to help focus public attention on the fight against the disease. After his death, a memorial exhibition of his work, which included sexually explicit and homoerotic photographs, became a cause célèbre.

Marat/Sade (1964; complete title: *The Persecution and Assassination of Marat as Performed by the Inmates of the Charenton Asylum Under the Direction of the Marquis de Sade*), the TONY-winning Peter WEISS play, a play-within-a-play set in a French insane asylum. Adrian Mitchell adapted the play into the 1966 film; Richard BROOK again directed the original ROYAL SHAKESPEARE COMPANY cast, with Patrick McGee as de Sade, Ian Richardson as Marat, and Glenda JACKSON as Charlotte Corday.

Marc, Franz (1880–1916), German painter, a founder of THE BLUE RIDER group in 1911. He was a lyrical, emotional painter of animals in their natural settings, whose work in the years immediately before World War I became increasingly abstract and suffused with color as he moved toward EXPRESSIONISM, as in his *Blue Horses* (1911), *The Tiger* (1913), and *Animal Destinies* (1913). He died at Verdun.

Marceau, Marcel (1923–), French mime, on stage from 1945, the leading exponent and teacher of the art of mime in the postwar period and the creator of the Pierrot-like character of Bip, a role in which he toured the world many times over, from 1949 as director of his own company. He developed his own mime pieces, many of them brief, but including the mime drama *Don Juan* (1964), and also often appeared in films and television.

March, Fredric (Ernest Frederick McIntyre Bickel, 1897–1975), U.S. actor, on stage from 1920 and on screen from 1921, who played leading theater roles from 1926 and from the early 1930s was one of the major dramatic stars of his time. On screen, his early work includes such notable comedies as *The Royal Family of Broadway* (1931), playing a John BARRYMORE-like actor, and DESIGN FOR LIVING (1933), and such dramas as DR. JEKYLL AND MR. HYDE (1932), for which he won a best actor OSCAR; THE BARRETTS OF WIMPOLE STREET (1934); *Death Takes a Holiday* (1934); *Les Misérables* (1935); A STAR IS BORN (1937); and SO ENDS OUR NIGHT (1941). His role in the classic THE BEST YEARS OF OUR LIVES (1946) won him another OSCAR, and was followed by such roles as that of Willy LOMAN in DEATH OF A SALESMAN (1951) and William Jennings Bryant in INHERIT THE WIND (1960). Throughout his career he returned to the stage, most notably opposite his wife, Florence Eldridge, as Mr. Antrobus in THE SKIN OF OUR TEETH (1942), in *A Bell for Adano* (1944), and in his TONY-winning role as James Tyrone in LONG DAY'S JOURNEY INTO NIGHT (1956).

"March of Time, The" (1931–45), the radio docudrama series presented by *Time* magazine, which dramatized current events. As the series was presented in a period characterized by such major events as the Great Depression, the New Deal, the rise of fascism, the wars in Spain and China, and World War II, it developed a very large, attentive mass audience.

Maria Candelaria (1943), the Emilio Fernandez film, a landmark work of the Mexican cinema. It starred Dolores DEL RIO, who had just returned home from almost two decades in Hollywood, and Pedro ARMENDARIZ, then a leading star in the Mexican cinema, who would later go to Hollywood. Del Rio stayed on to become Mexico's leading actress.

Marin, John (1870–1953), U.S. painter, a very notable 20th-century watercolorist, who also worked in oils and created prints and who found his main themes in the New York cityscape and the Maine coastal landscape. He lived in Paris from 1905 to 1909, and again from 1910 to 1911, in those years becoming familiar with and using some of the techniques offered by the modernist

movements of the time, such as CUBISM and FAUVISM. But he developed his own objective approach, tempered by modernist perceptions, in such works as *Brooklyn Bridge* (1910), *Lower Manhattan* (1922), and his well-known *Maine Islands* (1922).

Marini, Marino (1901–80), Italian sculptor; he pursued an independent course outside the schools and movements of his time and from the mid-1930s emerged as a major figure, with his long *Horse and Rider* series, such portrait busts as that of Igor *Stravinsky* (1951), and such female figures as *Dancer* (1953).

Marius, the Marcel PAGNOL trilogy, set in Marseilles, consisting of *Marius* (1929), *Fanny* (1931), and *César* (1936). Pagnol adapted all three plays into films; Alexander KORDA directed the 1931 *Marius*, Marc Allégret the 1931 *Fanny*, and Pagnol the 1936 *César*, with Raimu, Pierre Fresney, Orane Demazis, and Charpin playing leading roles in all three films. The 1954 stage musical FANNY was based on the Pagnol plays, as was the 1961 Joshua LOGAN film.

Markandaya, Kamala (Kamala Purnaiya, 1924–), Indian-British writer of English-language novels. Her most widely known work, on Indian village life, was her first novel, *Nectar in a Sieve* (1954). She also wrote such novels as *A Silence of Desire* (1960), *Coffer Dams* (1969), and *Shalimar* (1983).

Mark of Zorro, The (1920), a classic Fred Niblo action film, with Douglas FAIRBANKS in the title role, as a romantic, disguised outlaw in Spanish California; Fairbanks also wrote the script, based on a Johnston McCulley story. It was remade several times, most notably by Rouben MAMOULIAN in 1940, with Tyrone POWER as Zorro and Basil RATHBONE as his archenemy. From 1957 to 1959, it was a very popular television series, with Guy Williams as Zorro.

Markova, Alicia (Lillian Alicia Marks, 1910–), British dancer, in the BALLET RUSSES company of Sergei DIAGHILEV from 1925 to 1929, who became Britain's first major international ballerina in the early 1930s. She danced the main classical roles in the Ballet Rambert and Vic-Wells companies and created the leads

in such works as FAÇADE (1931), *Lysistrata* (1932), and *The Haunted Ballroom* (1934). She and Anton DOLIN formed the Markova-Dolin Company (1935–38); after World War II it ultimately became the London Festival Ballet. She was a leading ballerina and created several roles with the Ballet Russe de Monte Carlo (1938–41) and the Ballet Theatre (1941–45), and she appeared throughout the world until the early 1960s.

Marley, Bob (Nesta Robert Marley, 1945–81), Jamaican singer, songwriter, and guitarist, a popular figure in Jamaica from the mid-1960s as the leading member of the Wailers, a REGGAE singing group, which in 1973 became Bob Marley and the Wailers. By the mid-1970s he was Jamaica's leading popular musician and had also become a popular figure in Western Europe and the United States, playing a major role in introducing reggae to world audiences. Marley was active in Jamaican politics and in the late 1970s in Black African political movements, as especially reflected in his late album *Survival* (1979), which included the song "Zimbabwe."

Marlowe, Philip, the hard-boiled fictional detective created by Raymond CHANDLER in his first novel, THE BIG SLEEP (1939); he was played on screen by Humphrey BOGART, Dick POWELL, and Robert MITCHUM, among others.

Marple, Jane, the fictional detective, an elderly spinster from the small village of St. Mary Mead, created by Agatha CHRISTIE in *Murder at the Vicarage* (1930) and subsequently the star of many works. She was played on screen by various actresses and most notably on television by Joan Hickson.

Marquand, J.P. (John Philips Marquand, 1893–1960), U.S. writer, whose early career included several light novels, many short stories, and the *Mr. Moto* detective series; he emerged as a substantial novelist with his PULITZER PRIZE-winning *The Late George Apley* (1937), followed by such popular novels as *H.M. Pulham, Esquire* (1941), *So Little Time* (1943), *B.F.'s Daughter* (1946), *Point of No Return* (1949), and *Melville Goodwin, U. S. A.* (1951).

Mary Martin getting ready to fly, in rehearsal for a 1955 television production of *Peter Pan*.

Márquez, Gabriel García, see GARCÍA MÁR-
QUEZ, GABRIEL.

Marsalis, Wynton (1961–), U.S. musi-
cian, the leading JAZZ trumpeter of the 1980s;
he began recording in 1980 and found wide
audiences with such albums as *The Young
Lions* (1982), *Think of One* (1983), *Hothouse
Flowers* (1984), and *Standard Time* (1987). In
the mid-1980s Marsalis also moved into classi-
cal works featuring the trumpet, though later
in the decade he announced a decision to con-
centrate on jazz. He is the son of pianist Ellis
Marsalis and the brother of jazz saxophonist
Branford Marsalis.

Marsh, Ngaio (Edith Ngaio Marsh, 1899–
1982), New Zealand writer and producer, who
wrote scores of very popular mystery novels,
many set in Britain but some in New Zealand,
many of them set in her own theater world and
most of them featuring her central character,
detective Roderick Allyn.

Marsh, Reginald (1898–1954), U.S. painter
and illustrator; in the 1920s he was an illustra-
tor for the New York *Daily News* and *The New
Yorker*. He is best known for his paintings of

New York City life, in the 1930s catching
much of the bitterness and desperation so
characteristic of the Great Depression, in such
works as *The Bowery* (1930), *Tattoo and Hair-
cut* (1932), and *The Park Bench* (1933).

Marshall, E.G. (Edward G. Marshall, 1910–
), U.S. actor, on stage from 1933 and on
screen from 1945, appearing in strong charac-
ter roles in such films as THE CAINE MUTINY
(1954) and 12 ANGRY MEN (1957). He is best
known by far for his creation of defense lawyer
Lawrence Preston in the television series THE
DEFENDERS (1961–65).

Martin, Dean (Dino Paul Crocetti, 1917–
), U.S. singer and actor, from 1946 to
1956 partnered with Jerry LEWIS in variety,
films, and television. On his own thereafter, he
emerged as a capable light comedian and actor,
in such films as *The Young Lions* (1958), *Rio
Bravo* (1959), *Toys in the Attic* (1963), and *The
Sons of Katie Elder* (1965). He also appeared as
a headliner in cabaret.

Martin, Mary (1913–90), U.S. singer and
actress, who introduced the song MY HEART
BELONGS TO DADDY on Broadway in *Leave It*

The Marx Brothers go Scottish—from left, Groucho and Harpo Marx, outsider Sid Grauman, and Chico and Zeppo Marx.

to Me (1938). She appeared in several early 1940s Hollywood films, then returned to Broadway to become a leading star in musical theater, in such plays as *One Touch of Venus* (1943), *Lute Song* (1946), SOUTH PACIFIC (1949), PETER PAN (1954), and THE SOUND OF MUSIC (1961). She won TONY AWARDS as best actress in a musical for the latter three plays. Actor Larry HAGMAN is her son.

Martin du Gard, Roger (1881–1958), French writer. His masterwork, the eight-volume *The Thibaults* (1922–40), was a greatly detailed fictional history of a family from the beginning of the 20th century through World War I and at the same time a fictional social history of the time. He was awarded the NOBEL PRIZE for literature in 1937.

Marty (1955), the Delbert MANN film, adapted by Paddy CHAYEVSKY from his own 1953 television film, with a cast that included Ernest Borgnine in the title role, Betsy Blair, Joe DeSantis, and Joe Mantell. The film, Borgnine as best actor, Chayevsky, and Mann all won OSCARS. Rod STEIGER and Nancy

Marchand created the leading roles in the earlier telefilm.

Marvin, Lee (1924–86), U.S. actor, on stage from the late 1940s and on screen from 1951. Until the mid-1960s, he played a long series of villains, in such films as *Bad Day at Black Rock* (1955), *The Comancheros* (1961), and *The Man Who Shot Liberty Valance* (1962), but then displayed a very considerable talent for comedy in his best actor OSCAR-winning dual role in CAT BALLOU (1965). He went on to appear in such films as *The Professionals* (1966), *Paint Your Wagon* (1969), THE ICE-MAN COMETH (1973), *The Big Red One* (1979), and *Gorky Park* (1983). He also starred in the television series "M Squad" (1957–60).

Marx Brothers, The (**Groucho**: Julius Henry, 1890–1977; **Chico**: Leonard, 1886–1961; **Harpo**: Adolph, 1888–1964; **Zeppo**: Herbert, 1901–79; and **Gummo**: Milton, 1893–1977), U.S. comedy team, in vaudeville from 1909 and on Broadway in *I'll Say She Is* (1924), *The Cocoanuts* (1925), and *Animal Crackers* (1928). They recreated *The Cocoanuts* on screen in 1929 and were launched as antic, slapstick,

enormously popular world film figures, going on to do such films as *Animal Crackers* (1930), *Monkey Business* (1931), *Horse Feathers* (1932), DUCK SOUP (1933), A NIGHT AT THE OPERA (1935), *A Day at the Races* (1937), and *Room Service* (1938). Their last film as a team was *Love Happy* (1950). Groucho later did a popular television show, "You Bet Your Life" (1956–61).

Mary Poppins (1964), the Robert Stevenson film musical, starring Julie ANDREWS in the title role as the magical airborne "nanny" who equally well dispenses wisdom and song. It was Andrews's film debut, and she won a best actress OSCAR in the role, in a cast that included Dick Van Dyke, Glynis Johns, David Tomlinson, Karen Dotrice, and Matthew Garber. Richard M. Sherman and Robert B. Sherman won OSCARS for music and for the song "Chim Chim Cher-ee," as did Cotton Warburton for editing and Peter Ellenshaw for special effects.

"Mary's a Grand Old Name" (1905), the George M. COHAN song, introduced in his Broadway musical *Forty-five Minutes from Broadway* (1905); words and music were by Cohan.

"Mary Tyler Moore Show, The" (1970–77), the long-running television situation-comedy series, starring Moore as Mary Richards, a woman pursuing her career at a Minneapolis television station, in a cast that included Edward ASNER as Lou Grant, Valerie Harper as Rhoda Morgenstern, Cloris Leachman as Phyllis Lindstrom, Ted Knight, and Gavin MacLeod. The Asner, Harper, and Leachman roles later developed into series—THE LOU GRANT SHOW, "Rhoda," and "Phyllis."

Masakela, Hugh (1939–), South African JAZZ musician, a trumpeter, composer, singer, and bandleader. Self-exiled from his country's system of apartheid in the late 1950s, he settled in the United States, began recording in the early 1960s, and in the late 1960s emerged as a worldwide recording star, with such albums as *The Promise of the Future* (1968), *Reconstruction* (1970), *Hugh Masakela and the Union of South Africa* (1971), and *Home Is Where the Music Is* (1972). His later work includes such albums as

Waiting for the Rain (1986). He has been a powerful advocate of change in South Africa.

Masefield, John (1878–1967), British writer, whose first collection of poems, *Salt Water Ballads* (1902), carried by far his best-known poems, the often-anthologized "Sea-Fever" and "Cargoes." He followed it with *Ballads and Poems* (1910) and the narrative poems *The Everlasting Mercy* (1911), *The Widow in the Bye Street* (1912), *Dauber* (1913), *The Daffodil Fields* (1913), and *Reynard the Fox* (1919). A prolific writer, his work also includes plays, short stories, further poems, and essays. He was Britain's poet laureate from 1930 until his death.

M*A*S*H (1970), the Robert ALTMAN film, a black comedy about an American medical unit in the field during the Korean War, with key roles played by Donald SUTHERLAND, Elliott GOULD, Tom Skerritt, Sally Kellerman, Gary Burghoff, and Robert DUVALL. The OSCAR-winning screenplay, written by Ring LARDNER, Jr., was based on the Richard Hooker novel. A long-running television series (1972–83) was also based on the novel; some of its key players over the years were Alan ALDA, Wayne Rogers, Loretta Swit, Gary Burghoff, and Harry Morgan.

Masina, Giulietta (Giulia Anna Masina, 1920–), Italian actress, on stage from 1942 and on screen from 1946, starting with a small role in PAISAN, and playing in supporting roles in such films as *Variety Lights* (1951), *Behind Closed Shutters* (1951), and *The White Sheik* (1952). She became an international star as Gelsomina in the classic LA STRADA (1954), directed by her husband, Federico FELLINI, and also starred in his NIGHTS OF CABIRIA (1956) and JULIET OF THE SPIRITS (1965), as well as in several other European films.

Mason, James (1909–84), British actor, on stage from 1931 and on screen from 1935, who became a star with such films as *The Seventh Veil* (1945) and ODD MAN OUT (1946). He then went to Hollywood, where he played both leads and character roles in scores of movies, in such films as *The Desert Fox* (1951), *Five Fingers* (1952), LOLITA (1962), and *Autobiography of a Princess* (1975).

Mason, Perry, the fictional lawyer, famed for his courtroom skills, created by Erle Stanley GARDNER in his very long series of mystery novels. He has been played by several actors on radio, on television, and in films, most notably by Raymond BURR in the long-running, very popular television series (1957–66, 1973–74) and several subsequent revivals.

Massey, Raymond (1896–1983), Canadian-British actor and director, on stage from 1922 and on screen from 1931, who played in leading and character roles on both sides of the Atlantic, notably including his leads in *Hamlet* (1931) and in ABE LINCOLN IN ILLINOIS (1938), which he re-created on film in 1940. He also played major roles in such films as *The Scarlet Pimpernel* (1935), THINGS TO COME (1936), *The 49th Parallel* (1941), and EAST OF EDEN (1955) and costarred in the television series "Dr. Kildare" (1961–66), while continuing to be active in the theater as a director and actor. He was the father of actor Daniel Massey and actress Anna Massey.

Massine, Leonid Fedorovich (1895–1979), Russian dancer and choreographer; he was a leading dancer with the BALLET RUSSES company of Sergei DIAGHILEV 1914–21 and 1925–28, beginning with his lead in the *The Legend of Joseph* (1914). He also began his career as a major 20th-century choreographer with Diaghilev, creating such works as PARADE (1917), THE THREE-CORNERED HAT (1919), *Pulcinella* (1920), and later such works as *The Blue Danube* (1924) and *Gaité Parisienne* (1938). He was choreographer and principal dancer of the Ballet Russe de Monte Carlo from 1932 to 1938, there beginning the series of symphonic ballets that were his unique contribution to the form with *Les Présages*, set to Peter Ilich Tchaikovsky's *Fifth Symphony*. On screen he most notably choreographed and appeared in THE RED SHOES (1948) and *Tales of Hoffman* (1951).

Masson, André (1896–1986), French painter, whose notable early painting *The Four Elements* (1924) brought him together with André BRETON and the surrealists (see SURREALISM), with whom he was associated until 1928. In that period he did much "automatic" painting—spontaneously produced work perceived

to be generated by the subconscious. He lived in Spain from 1934 to 1936 and rejoined the surrealists in 1936, after fleeing Spain at the beginning of the Civil War, exhibiting at international surrealist exhibitions in 1936 and 1938. He spent World War II in the United States, considerably influencing the precursors of ABSTRACT EXPRESSIONISM. Masson also worked as a set designer and lithographer.

"Masterpiece Theatre" (1971–), the public-television dramatic anthology series, a format for presenting a substantial number of major multipart series, many of them British, including such major works as ELIZABETH R, UPSTAIRS, DOWNSTAIRS, and several of the Dorothy SAYERS mystery series.

Masters, Edgar Lee (1868–1950), U.S. writer, who emerged as a major poet with *Spoon River Anthology* (1915). His later collections include *Songs and Satires* (1916), *The Domesday Book* (1920), *The Fate of the Jury* (1929), and *Illinois Poems* (1941). His novels include the semi-autobiographical trilogy *Mitch Miller* (1920), *Skeeters Kirby* (1923), and *Mirage* (1924), and several biographies, most notably the highly critical *Lincoln, the Man* (1931).

Mastroianni, Marcello (1923–), Italian actor, on screen from 1947 and on stage from 1948, who became a major international star in the late 1950s. A few of his most notable early films are *White Nights* (1957), LA DOLCE VITA (1960), *The Night* (1961), *Divorce Italian Style* (1961), YESTERDAY, TODAY, AND TOMORROW (1963), and 8 1/2 (1963); he then went on to play in scores of other films, such as *City of Women* (1980), *Dark Eyes* (1986), and *The Beekeeper* (1987).

Mathis, Johnny (1935–), U.S. singer, best known for his renditions of such songs as "Wonderful Wonderful," "It's Not for Me to Say," and "Chances Are," all in 1957; "Misty" (1959); and "What Will Mary Say?" (1962). He continued to be a very popular singer for the next three decades.

Matisse, Henri (1869–1954), French artist, one of the leading painters of the 20th century; he moved toward the explosive use of color that came to be called FAUVISM in the first few years of the century and emerged as a leader of

the short-lived but influential Fauvist movement in 1905, joining abstraction to color for the next five decades, in a long series of major works. A few of his most notable works are *Joy of Life* (1906); *The Blue Nude* (1907), which created a sensation at the 1913 ARMORY SHOW; *Dance* (1909); *Interior with a Violin Case* (1918); the *Dance* murals for the Barnes Foundation (1932); and the decorative work at the Rosaire Chapel at Vence, France (1951). He was also a considerable sculptor, set designer, and lithographer.

Matthau, Walter (Walter Matuschanskavasky, 1920–), U.S. actor, on stage from 1948 and on screen from 1955, who became a star on Broadway in his TONY-winning lead in *The Odd Couple* (1965), a role he re-created on screen in 1968. He won a best actor OSCAR for *The Fortune Cookie* (1966), also starring in such films as *Kotch* (1971), *Charley Varrick* (1973), *The Sunshine Boys* (1975), *Hopscotch* (1980), and *The Couch Trip* (1988).

Matthews, Jessie (1907–81), British actress, singer, and dancer, on stage from 1919 and on screen from 1923, who became a musical-theater star with her role in EVERGREEN (1930), a role she re-created on film in 1934. She then went on to play leads in several other films and plays during the 1930s and 1940s.

Maugham, Somerset (William Somerset Maugham, 1874–1965), British writer, who created a wide range of novels, plays, short stories, travel memoirs, and essays. His first novel was *Liza of Lambeth* (1897); his best-known novels are OF HUMAN BONDAGE (1915), *The Moon and Sixpence* (1919), *Cakes and Ale* (1930), and *The Razor's Edge* (1944). His scores of shorter works include RAIN (1921) and *Ashenden, or the British Agent* (1928), based on his own World War I experience. He wrote or adapted over 30 plays, scoring early success with *Lady Frederick* (1907) and going on to produce such highly popular works as *Our Betters* (1917), *Home and Beauty* (1919), *The Circle* (1921), *East of Suez* (1922), and *The Constant Wife* (1926). Several of his works have been adapted into plays and films, most notably including *Rain*, which became the John Colton–Clemence Randolph play in 1922 and then the Lewis MILESTONE film in

1932, with Joan CRAWFORD and Walter HUSTON in the leads; Alfred HITCHCOCK's *Secret Agent* (1936), with John GIELGUD in the Ashenden role; Albert Lewin's *The Moon and Sixpence* (1942), with George Sanders in the lead; and Edmund Goulding's *The Razor's Edge* (1946), with Tyrone POWER, Herbert Marshall, Gene TIERNEY, and Anne BAXTER in the key roles.

Mauldin, Bill (William Henry Mauldin, 1921–), U.S. cartoonist and writer; he created GIs WILLIE AND JOE while attached to *Stars and Stripes* in the Mediterranean theater during World War II; took them through the war, winning a PULITZER PRIZE in 1944; and then brought them home to a difficult peace. His best-known collection of wartime cartoons was UP FRONT (1945); his soldiers came home in *Coming Home* (1947). Mauldin focused on writing after 1947, covering the Korean War for *Colliers* as a correspondent, but moved back into cartooning in the late 1950s, succeeded Daniel FITZPATRICK as editorial cartoonist for the *St. Louis Post-Dispatch* in 1958, and won another Pulitzer in 1959, this time for a cartoon on the absence of civil liberties in the Soviet Union. He moved to the *Chicago Sun-Times* in 1962, becoming very widely syndicated.

Mauriac, François (1885–1970), French writer, whose earliest published work was the poetry collection *Clasped Hands* (1909). It was as a novelist that he emerged as a leading Catholic literary figure, beginning with *Young Man in Chains* (1913), and moving on to such well-received works as *The Kiss to the Leper* (1922), *The Desert of Love* (1925), *Thérèse Desqueyroux* (1927), *Viper's Tangle* (1932), and *The Woman of the Pharisees* (1941). He was also a prolific essayist and a playwright, best known for *Asmodee* (1938), and wrote several biographies, including his controversial *The Life of Jesus* (1936). He was awarded the NOBEL PRIZE for literature in 1952.

Maurois, André (Émile Salomon Wilhelm Herzog, 1885–1967), French writer, whose most popular work consists of such fictionalized biographies as *Ariel: The Life of Shelley* (1924), *Disraeli: A Picture of the Victorian Age* (1927), *Voltaire* (1932), and *Lelia: The Life of*

George Sand (1952). In the same vein he also did biographies of Turgenev, Chopin, the Brownings, Chateaubriand, and Hugo, among others. He also wrote several popular novels; the first, *The Silence of Colonel Bramble*, was based on his World War I experiences. Maurois was a prolific writer, who also did histories, short stories, and children's books.

Mayakovsky, Vladimir Vladimirovich (1893–1930), Soviet writer and painter, an active revolutionary and a leading poet and playwright of the early Soviet period. His major works include the long antiwar poem *War and Peace* (1917); the verse drama *Mystery-Bouffe* (1918), which celebrated the first anniversary of the Bolshevik Revolution; and such long poems as *Vladimir Ilich Lenin* (1924) and *At the Top of My Voice* (1930). But Mayakovsky was also an honest individualist; he attacked the developing Soviet bureaucracy in his late plays, *The Bedbug* (1928) and *The Bathhouse* (1929), quickly falling into official disfavor. He was a suicide; his work, including his late plays, continued to be highly respected in the Soviet Union.

Mayer, Louis B. (1885–1957), U.S. film-studio head, who started as a movie-house operator in 1907, became general manager of Metro-Goldwyn-Mayer in 1924, and until 1951 was a powerful and very conservative motion-picture industry leader.

Mazursky, Paul (1930–), U.S. director, writer, producer, and actor. He directed such films as BOB AND CAROL AND TED AND ALICE (1970), *Blume in Love* (1973), HARRY AND TONTO (1974), *An Unmarried Woman* (1978), *Down and Out in Beverly Hills* (1985), and *Enemies: A Love Story* (1989) and also produced, co-authored, and appeared in some of his films.

M. Butterfly (1988), the TONY-winning David Henry Hwang play, a retelling and refocusing of the story of Giacomo PUCCINI's opera MADAME BUTTERFLY and of the John Luther Long story on which it was based. John Lithgow and B.D. Wong starred; John Dexter won a Tony for his direction.

Mc, see MAC.

Me and My Girl (1937), the British musical, in which Lupino LANE so memorably introduced THE LAMBETH WALK; Britons were to sing and dance the song right through six years of world war. Music was by Noel Gay, with book and lyrics by L. Arthur Rose and Douglas Furber. Robert Lindsay re-created the role in the 1984 London revival; he and Maryann Plunkett won TONYs in the 1986 Broadway production.

Mean Streets (1973), the semi-autobiographical Martin SCORSESE film, set in New York's Little Italy, and his first major success. Robert DE NIRO was Johnny Boy, who is ultimately murdered while trying to run away from a loan shark in a car driven by Harvey Keitel as Charlie, who is perhaps Scorsese. The cast also included Amy Robinson, Richard Romanus, David Proval, and Cesare Danova. Scorsese and Mardik Martin wrote the screenplay.

Medium, The (1946) and **The Telephone** (1946), two short operas by Gian Carlo MENOTTI. They were produced as a trailblazing double bill on Broadway, rather than at a traditional opera house or festival, and thereby became directly accessible to wide popular audiences. *The Medium* also became a 1951 film, directed by Menotti.

Meet John Doe (1941), the Frank CAPRA film; Gary COOPER was Long John Willoughby, the unemployed drifter hired to be the figurehead of a fake populist movement, actually aimed at bringing fascism to the United States, but who ultimately defeats the politicians behind the movement. The cast included Barbara STANWYCK, Edward ARNOLD, Walter Brennan, James Gleason, Spring Byington, and Gene Lockhart. Robert Riskin wrote the screenplay.

Meet Me in St. Louis (1944), the Vincente MINNELLI film musical, set before the 1904 Louisiana Purchase Exposition in St. Louis. Judy GARLAND sang the title song and a group of old and new songs, including "The Trolley Song," in a cast that included Margaret O'Brien, Lucille Bremer, Leon Ames, Tom Drake, Mary ASTOR, June Lockhart, and Marjorie Main. The Irving Brecher–Fred Finklehoffe screenplay was based on the Sally Benson novel of that name.

Mehta, Zubin (1936–), Indian conductor, a leading contemporary figure who has been musical director of the Montreal Symphony Orchestra (1960–67), Los Angeles Philharmonic Orchestra (1962–77), Israel Philharmonic Orchestra (1968–), and New York Philharmonic Orchestra (1979–90).

Melba, Nellie (Helen Porter Armstrong, 1861–1931), Australian soprano; she made her European debut at Brussels in 1887 and went on to become a leading opera singer in Europe, America, and Australia from the late 1880s through her retirement performance at Covent Garden in 1926. She was also a very popular figure, for whom peach melba and melba toast are named.

Melchior, Lauritz (Lembricht Hommel, 1890–1973), Danish tenor, who early in his career was a baritone. He made his debut as a tenor at Copenhagen in 1918 and began his long career as a leading Wagnerian tenor at Covent Garden and at Bayreuth, in 1924, and as *Tannhäuser* at the Metropolitan Opera, in 1926. He also sang in some non-Wagnerian roles, most notably as *Otello*, and appeared in several films.

Méliès, Georges (1861–1938), pioneer French filmmaker, whose short films were on screen from 1896. He was a major technical innovator, using and in many instances originating such techniques as stop-motion shots, multiple exposures, climatic effects, fades, dissolves, and fictional reenactment, to create such movies as *One Man Band* (1900), the prototypical fantasy film *A Trip to the Moon* (1902), *A Thousand and One Nights* (1905), *20,000 Leagues Under the Sea* (1907), and *The Conquest of the Pole* (1912). His film career ended before World War I, when his fantasy films lost their earlier popularity and his funds ran out.

Mellon, Andrew William (1855–1937), U.S. financier, Treasury secretary, and art collector. In 1937, he funded the building of and donated his collection to the National Gallery of Art.

Mellors, the gamekeeper who is the object of Lady Chatterley's passion in D.H. LAWRENCE's LADY CHATTERLEY'S LOVER.

Member of the Wedding, The (1946), the Carson MCCULLERS novel, about a 12-year-old girl who comes to terms with her brother's impending marriage. In McCullers's 1950 dramatization of the novel, Julie HARRIS created Frankie Addams, Brandon de Wilde was her six-year-old brother, and Ethel WATERS created Berenice Sadie Brown, the Black cook and mother figure. Waters, Harris, and de Wilde re-created the roles in the 1952 Fred ZINNEMANN film, adapted from the novel and play by Edna Anhalt and Edward Anhalt.

Memory of Justice, The (1976), the Marcel OPHULS documentary, which explores the concept of justice itself, as between nations and peoples, by reexamining the Nuremberg Trials, the French performance during the Algerian War of Independence, and the American intervention in Vietnam.

Mencken H.L. (Henry Louis Mencken, 1880–1956), U.S. writer and editor, an iconoclastic journalist and defender of free speech, who is best known for his landmark "word book" *The American Language* (1919) and for his three-volume autobiography, *Happy Days* (1940), *Newspaper Days* (1941), and *Heathen Days* (1943).

Menotti, Gian Carlo (1911–), Italian composer, many of whose operas have become directly accessible to wide popular audiences through their production in the theater and on screen. His best-known operas include *Amelia Goes to the Ball* (1937); THE MEDIUM (1946) and THE TELEPHONE (1946), produced as a trailblazing double bill on Broadway; the PULITZER PRIZE-winning *The Consul* (1950), also produced on Broadway; AMAHL AND THE NIGHT VISITORS (1951), written for television, and a perennial children's favorite; and *The Saint of Bleecker Street* (1954), another Pulitzer Prize-winning Broadway opera-play. *The Medium* became a 1951 film, directed by Menotti. He also wrote the libretto for Samuel BARBER's opera *Vanessa*, several children's operas, other adult operas, and instrumental works. In 1958 he founded the Spoleto Festival.

Menuhin, Yehudi (1916–), U.S. violinist, generally regarded as one of the leading violinists of the 20th century. A child prodigy, he was in concert from the age of seven and a

celebrity after his 1925 New York debut. His first full-scale world tour was in 1935; he retired for further study until 1937, and then reemerged as a leading soloist, who very notably encouraged the creation of new works and the restoration of neglected works to the repertory. He also engaged in a wide range of educational, philanthropic, and world peace projects, becoming a most honored figure in the world of music and beyond.

Mephisto (1981), the Istvan Szabo film, based on the novel by Klaus Mann, with Klaus Maria Brandauer in the title role, as an opportunistic German actor who cooperates with the Nazis to further his career. The movie won a best foreign film OSCAR.

Mercer, Johnny (1909–76), U.S. lyricist and composer, best known for the lyrics of such songs as BLUES IN THE NIGHT (1941; music by Harold ARLEN); "One for My Baby" (1943; music by Harold Arlen), "Laura" (1945; music by David Raksin), "On the Atchison, Topeka, and the Santa Fe" (1946; music by Harry WARREN), "In the Cool Cool Cool of the Evening" (1951; music by Hoagy CARMICHAEL), "Moon River" (1961; music by Henry MANCINI), and "Days of Wine and Roses" (1962; music by Henry Mancini), the latter four songs all OSCAR-winners.

Mercouri, Melina (1923–　), Greek actress and political leader. As an actress, she is best known by far for her role in *Never on Sunday* (1960) and also appeared in such films as *Stella* (1955), *Where the Hot Wind Blows* (1960), *Phaedra* (1962), and *Topkapi* (1964). She has been on stage since 1940 and was a leading Greek classical actress until forced into exile by a right-wing Greek government in the late 1960s. She was a Greek government minister during the 1980s.

Mercury Theatre, the short-lived but highly productive repertory company formed by Orson WELLES and John HOUSEMAN in 1937, which in its single year of life produced several plays, including a notable modern-dress *Julius Caesar*, an innovative *Danton's Death*, and Marc BLITZSTEIN's political play *The Cradle Will Rock*, the last after overcoming several major obstacles. It was also the genesis of *The*

Mercury Theatre on the Air, which on October 30, 1938 did the extraordinary WAR OF THE WORLDS radio broadcast that frightened a whole nation. The theater also served as a cradle for Welles, who quickly used much of what he had learned on film, in CITIZEN KANE (1941), THE MAGNIFICENT AMBERSONS (1942), and JOURNEY INTO FEAR (1943).

Meredith, Burgess (1909–　), U.S. actor, director, and producer, on stage from 1929 and on screen from 1936. On Broadway, he created the Mio role in Maxwell ANDERSON's WINTERSET (1935); he re-created the role in the 1936 film, his first. On stage, he also appeared in such plays as *High Tor* (1937), *The Star Wagon* (1937), and *Liliom* (1940), continuing to return to the theater throughout his career. On film, he was George in OF MICE AND MEN (1940), and appeared in such films as *The Story of G.I. Joe* (1945); *The Man on the Eiffel Tower*, which he also directed (1949); ADVISE AND CONSENT (1962); and THE DAY OF THE LOCUST (1975). He has also directed and appeared on television.

Merman, Ethel (Ethel Zimmerman, 1909–84), U.S. singer and actress, who became a Broadway musical-theater star with her rendition of I GOT RHYTHM in George GERSHWIN's *Girl Crazy* (1930). She went on to star as Reno Sweeney in ANYTHING GOES (1934), re-creating the role in the 1936 film, and also starred in such other musicals as *Panama Hattie* (1940); ANNIE GET YOUR GUN (1946); *Call Me Madam*, for which she won a TONY (1950) re-creating the role in the 1953 film; and GYPSY (1959). Another major film role was in *There's No Business Like Show Business* (1954). An ebullient singer with a big voice, she introduced such songs as THERE'S NO BUSINESS LIKE SHOW BUSINESS, I GET A KICK OUT OF YOU, DOIN' WHAT COMES NATURALLY, and EVERYTHING'S COMING UP ROSES, and was also a popular recording artist.

Merrill, Robert (1919–　), U.S. baritone; he made his debut in 1943, and from 1945 for three decades sang leading roles as a lyric baritone at the Metropolitan Opera. He also appeared with several other opera companies, in concert, and on screen and was a popular recording artist.

Messiaen, Olivier (1908–), French composer, teacher, and organist; he considerably influenced the development of modern music, as a teacher at the Schola Cantorum (1936–39) and at the Paris Conservatory (1941–78). His large body of work reflected his Catholic religious beliefs, with the later additions of love themes and, in the 1950s, of the bird songs that were for a time basic to his work. His large-scale late works include the choral *The Transfiguration* (1969) and the opera *St. Francis of Assisi* (1983).

Mestrovic, Ivan (1883–1962), Yugoslav sculptor, who became a major figure during the interwar period, most notably for such monumental works as his *Tomb of the Unknown Soldier* at Mount Avala. He also did many works on religious themes, some of them in 1942–43, after having been released by the Germans to work in Rome for the Vatican. He settled in the United States in 1947.

Method, The, the acting technique developed by the ACTORS STUDIO from 1947, which stressed finding the emotional wellsprings from which an actor might create each role.

Metropolis (1926), the technically innovative, massive Fritz LANG science-fiction film; otherwise a rather simplistic story of a battle between stereotypical workers and capitalists in a highly mechanized future world, finally resolved by the power of Christian love, as both sides manage to accommodate.

Meyerhold, Vsevolod Emilievich (1874–1940), Soviet actor and director, a major figure in the development of the Russian and world theater. He was on stage as an actor with the MOSCOW ART THEATRE from its formation in 1898 to 1902; he then left to found his own company and as a director developed his own highly abstracted and formalized style of theatrical presentation. A Bolshevik, he headed the new government theater organization from 1920 and from 1921 developed his own Moscow theater, later known as the Meyerhold Theatre. With the advent of Stalinism in the late 1920s, his work was increasingly impeded by the authorities. He was arrested in 1939 and died in prison. Meyerhold was posthumously rehabilitated by the Soviet government in 1955.

Michener, James Albert (1907–), U.S. author and editor, whose PULITZER PRIZE-winning first novel, *Tales of the South Pacific* (1947), was adapted into the play SOUTH PACIFIC in 1949. During the next four decades, Michener developed a series of heavily researched best-selling novels, many of them on regional and historical themes, including *The Bridges at Toko-Ri* (1953); *Sayonara* (1954); *Hawaii* (1959); *The Source*, about Israel (1965); *Iberia* (1968); CENTENNIAL (1974), adapted for a noted television miniseries; *Chesapeake* (1978); *The Covenant*, about South Africa (1978); *Space* (1982); *Poland* (1983); *Texas* (1985); and *Alaska* (1988). Several of his books have been adapted into films, including Mark Robson's *The Bridges at Toko-Ri* (1954), with William HOLDEN in the lead; Joshua Logan's *Sayonara* (1957), with Marlon BRANDO in the lead; Logan's *South Pacific* (1958); and George Roy HILL's *Hawaii* (1966).

Mickey Mouse, probably the world's most popular film cartoon character, created by Walt DISNEY and his partner, Ub Iwerks, in 1928. Mickey was introduced in the silent cartoon *Plane Crazy* (1928) and became widely popular with the appearance of the third cartoon in the series, STEAMBOAT WILLIE (1928), which had their first soundtrack, with Disney supplying Mickey's voice.

Midler, Bette (1945–), U.S. singer, actress, and variety entertainer, who in the early 1970s became something of a cult figure as a featured act at the Continental Baths, a New York gay men's club. She soon found wider audiences, with such albums as *The Divine Miss M* (1972), *Songs for a New Depression* (1976), and GRAMMY winner *The Rose* (1980), the latter a soundtrack album from the 1979 Mark Rydell film, in which Midler played a ROCK singer patterned after Janis JOPLIN. Some of her later films were *Divine Madness* (1980), *No Frills* (1983), *Down and Out in Beverly Hills* (1986), *Ruthless People* (1986), *Outrageous Fortune* (1987), *Big Business* (1988), and *Stella* (1990).

Midnight Cowboy (1969), the powerful John SCHLESINGER film, adapted by Waldo Salt from the James Leo Herlihy novel, with Jon VOIGHT as male prostitute Jon Buck; Dustin

HOFFMAN as Ratzo Rizzo; and Sylvia Miles, Brenda Vaccaro, and Barnard Hughes in strong supporting roles. The groundbreaking film was thought obscene and was X-rated. Schlesinger, Salt, and the film won OSCARS.

Mielziner, Jo (1901–76), U.S. designer, one of the leading stage designers of the century, who designed the sets and usually also did the lighting of over 350 dramatic and musical plays, beginning with *The Guardsmen* (1924); a few of the most notable were STRANGE INTERLUDE (1928), *Street Scene* (1929), WINTERSET (1935), *Hamlet* (1936), THE GLASS MENAGERIE (1945), A STREETCAR NAMED DESIRE (1947), DEATH OF A SALESMAN (1949), SOUTH PACIFIC (1949), THE KING AND I (1951), and CAT ON A HOT TIN ROOF (1955).

Mies van der Rohe, Ludwig (1886–1969), German architect; he was a leading theoretician of the modernist movement (see MODERNISM) in Germany after World War I. In Germany, Mies advocated and designed—but was seldom able to develop—the kinds of glass-walled, often boxlike minimalist structures that in the early 1930s began to be identified with the INTERNATIONAL STYLE. His major piece of work during the 1920s was the German pavilion at the Barcelona Exposition (1929), and with it his "Barcelona chair." Mies headed the BAUHAUS from 1930 to 1933, until the Nazis forced its closure. He emigrated to the United States in 1937 and in 1938 became head of the School of Architecture at the Armour Institute, which later became the Illinois Institute of Technology. He designed a new campus for the college, 1939–41, and for the next two decades developed a new "Chicago School," working largely in the International Style. During the postwar period he created such major International Style monuments as Manhattan's SEAGRAM BUILDING (1958), done in collaboration with Philip JOHNSON; Chicago's Federal Center (1964); and Berlin's Gallery of the Twentieth Century (1968).

Mifune, Toshiro (1920–), Japanese actor, on stage from 1946, who became a major international star in Akira KUROSAWA's RASHOMON (1950), and went on to star in such films as THE SEVEN SAMURAI (1954), THRONE OF BLOOD (1957), *Yojimbo* (1961),

and *Red Beard* (1965), as well as playing major roles in such coproductions as *Midway* (1976).

Migrant Mother, Nipomo, California (1936), the classic Dorothea LANGE photograph of a migrant farm mother and her children; it became one of the central images of the Great Depression.

Mildred Pierce (1941), the James M. CAIN novel, about a woman who singlemindedly moves out of her housewife status into a successful business career and loses her daughter in the process. The novel was the basis of the 1945 Michael CURTIZ film; Joan CRAWFORD won a best actress OSCAR in the title role, in a cast that included Ann Blyth as her daughter, Zachary Scott, Jack Carson, Eve Arden, and Bruce Bennett.

Milestone, Lewis (1895–1980), U.S. director, whose work was on screen from 1925 and whose *Two Arabian Knights* (1927) won him the first best director OSCAR. The classic ALL QUIET ON THE WESTERN FRONT (1930) won another best director OSCAR. He went on to direct such films as THE FRONT PAGE (1931), RAIN (1932), *The General Died at Dawn* (1936), OF MICE AND MEN (1940), and ARCH OF TRIUMPH (1948), and he continued to direct through the early 1960s.

Milhaud, Darius (1892–1974), French composer, who produced a huge body of over 400 works, much of it polytonal, which included, among others, 15 operas, 13 symphonies, 17 ballets, and 18 string quartets, from such early ballets as *Man and His Desire* (1918) and *The Creation of the World* (1923), through such operas as *Christopher Columbus* (1930), *Medea* (1939), and *Bolivar* (1954). He also wrote the incidental music for over 40 plays and many radio and film scores.

Milland, Ray (Reginald Truscott-Jones, 1905–86), British actor, on screen from 1929, who began to play Hollywood B-movie leads in the mid-1930s and emerged as a major 1940s dramatic star in *The Uninvited* (1944); *Ministry of Fear* (1944); and THE LOST WEEKEND (1945), for which he won a best actor OSCAR. He also starred in *Dial M for Murder* (1954), as well as in scores of other films and television plays and series.

Millay, Edna St. Vincent (1892–1950), U.S. writer, who emerged as a leading American poet with her early works, *Renascence and Other Poems* (1917); *A Few Figs from Thistles* (1920); *Second April* (1921); and *The Harp-Weaver and Other Poems* (1923), which won a PULITZER PRIZE. She continued to write prolifically through the early 1940s, her work including such collections as *The Buck in the Snow* (1928), *Wine From These Grapes* (1934), several verse plays, and a wide variety of stories and essays. From the late 1920s, some of her work dealt with matters of social justice, as in her Sacco–Vanzetti case poem, *Justice Denied in Massachusetts* (1928), and her wartime *The Murder of Lidice* (1942).

Miller, Arthur (1915–), U.S. writer, who emerged as a major playwright with ALL MY SONS (1947). This was followed in 1949 by his TONY AWARD and PULITZER PRIZE-winning DEATH OF A SALESMAN, the story of the destruction of Willy LOMAN, symbol of a time, style, and way of life, a role created on Broadway by Lee J. COBB. THE CRUCIBLE (1953), also a Tony winnner, was quite literally Miller's antiwitch-hunting play, the Salem witchcraft trials serving as a vehicle for current social commentary. He also wrote such works as A VIEW FROM THE BRIDGE (1955), which also won a Pulitzer Prize; the screenplay for THE MISFITS (1961), which starred Clark GABLE in his final role and Marilyn MONROE, Miller's second wife, who committed suicide in 1962; *After the Fall* (1964), about a Monroe-like woman; *Incident at Vichy* (1965); *The Price* (1968); *The American Clock* (1979); and several later plays. He also wrote two travel books in collaboration with his third wife, photographer Inge Morath. *All My Sons* became the 1948 Irving Reis film, starring Edward G. ROBINSON. *Death of a Salesman* became the 1951 Laslo Benedek film, with Fredric MARCH in the Willy Loman role. Dustin HOFFMAN notably revived the role on Broadway in 1984 and again in the 1985 film.

Miller, Glenn (1904–44), U.S. bandleader and trombonist; after playing with several bands from the late 1920s, he formed his own dance band in 1938, and in the following four years became a very popular figure. He joined the armed forces in 1942; his plane went down in the English Channel on December 15, 1944.

Miller, Henry (1891–1980), U.S. author, best known for his autobiographical *Tropic of Cancer* (1934), *Tropic of Capricorn* (1939), *Sexus* (1949), *Nexus* (1959), and *Plexus* (1960). His early works, written while an expatriate in France, were sexually rather explicit, long deemed obscene by American censors, and banned in the United States, greatly adding to their avant-garde appeal. His other works include *The Colossus of Maroussi* (1941); much of his prolific correspondence was also published. He was a precursor of the BEAT GENERATION and powerfully influenced the development of the beat movement in American literature.

Miller, Jonathan Wolfe (1934–), British director, producer, writer, and doctor; he co-authored *Beyond the Fringe* (1960), directed John OSBORNE's *Under Plain Cover* at the Royal Court Theatre in 1964, and went on to direct a wide range of modern and classical plays. From 1973 to 1975 he was associate director of Britain's National Theatre. He later directed such plays as *Three Sisters* (1977) and *King Lear* (1989). From the late 1970s he directed several operas, including *The Marriage of Figaro* (1978), *Falstaff* (1982), *The Mikado* (1986), and *Tosca* (1987). He also produced a long Shakespeare series for television from 1979 to 1981 and directed several television films.

Miller, Marilyn (Mary Ellen Reynolds, 1898–1936), U.S. singer, dancer, and actress, on stage in vaudeville from the age of five, who became a leading Broadway musical theater star in *Sally* (1920), singing LOOK FOR THE SILVER LINING, and went on to appear in such musicals as *Sunny* (1925); *Rosalie* (1928); and *As Thousands Cheer* (1933), in that show singing EASTER PARADE. She was played on screen by Judy GARLAND in *Till the Clouds Roll By* (1946) and by June Haver in *Look for the Silver Lining* (1949).

Mills, John (1908–), British actor, on stage from 1929 and on screen from 1932, who continued to appear on stage for five decades, while becoming an international movie star in

such films as IN WHICH WE SERVE (1942), GREAT EXPECTATIONS (1946), *Scott of the Antarctic* (1948), HOBSON'S CHOICE (1954), TUNES OF GLORY (1960), *The Wrong Box* (1966), OH! WHAT A LOVELY WAR (1969), and GANDHI (1982). He is the father of actresses **Hayley Mills** and **Juliet Mills.**

Mills Brothers, U.S. singing quartet, organized in the 1920s, composed of Herbert (1912–89); Donald (1912–); Harry (1913–82); and John, Jr. (1889–1935), who was replaced by their father, John, Sr. (d. 1967). They were a very popular group on radio and on many hit recordings from the early 1930s through the mid-1960s, especially for "Paper Doll" (1943) and "You Always Hurt the One You Love" (1944), both becoming their signature songs.

Milne, A.A. (Alan Alexander Milne, 1882–1956), British writer, the creator of Christopher Robin and his teddy bear WINNIE-THE-POOH (1926), whose further adventures were chronicled in *The House at Pooh Corner* (1928). Milne was also a playwright and novelist, whose work included the play *Mr. Pim Passes By* (1919).

Milosz, Czeslaw (1911–), Polish writer, a leading poet of the late 1930s, who fought in the underground during World War II, became a diplomat in the early postwar period, and went into exile in 1951. His work includes many poetry collections, from 1936 through his *Collected Poems* (1988); such novels as *The Usurpers* (1955) and *The Issa Valley* (1955); *The Captive Mind* (1952), about the condition of the intellectual under communism; and a wide range of essays and translations. He was awarded the NOBEL PRIZE for literature in 1980.

Milsap, Ronnie (1946–), U.S. singer and multitalented instrumentalist, a leading figure in country music from the mid-1970s, with such songs as "I Hate You" (1973), "Pure Love" (1973), "Stand By My Woman Man" (1976), and many popular records. Blind from birth, he used his celebrity status to do a great deal of work on behalf of the blind.

Mingus, Charles (1922–79), U.S. JAZZ musician, a composer and bandleader who is generally recognized as one of the leading bassists in the history of jazz. He was a bassist in several bands from the early 1940s, including those of Lionel HAMPTON, Duke ELLINGTON, and Max ROACH, and also did such records as *Pithecanthropus Erectus* (1956), *Blues and Roots* (1958), and *Tijuana Moods* (1962). His later career was considerably impeded by personal problems, although he became active again in the mid-1970s.

minimal art, from the late 1960s, a New York City-based movement in painting and sculpture that focused on the production of simple, largely undifferentiated works that expressed nothing of the painter's persona or feelings and communicated nothing to those viewing the work, as in flat, monochromatic paintings, featureless cubes, and repetitive mass-produced objects and images. In the latter sense, much of minimal art can be related to POP ART, and much can also be described as purposively anti-art.

Minnelli, Liza (1946–), U.S. actress and singer, daughter of Judy GARLAND and Vincente MINNELLI, on screen from the age of two. She was on stage professionally from 1963, on screen professionally from 1967, became a headliner in variety and a popular recording artist from the late 1960s, and won a best actress OSCAR in CABARET (1972). She has also appeared in several other films, including CHARLIE BUBBLES (1967), *Lucky Lady* (1976), *New York, New York* (1977), the two *Arthur* films (1981 and 1988), and *Rent-a-Cop* (1988), as well as on television. In the theater she has won TONY AWARDS for leading roles in the musicals *Flora, the Red Menace* (1964) and *The Act* (1977).

Minnelli, Vincente (1910–86), U.S. director, who began as a Broadway theater designer and director in the 1930s, and moved into films as a director in the early 1940s. He became one of the most effective film-musical directors of his time, for such movies as MEET ME IN ST. LOUIS (1944); AN AMERICAN IN PARIS (1951); *Brigadoon* (1954); GIGI (1958), for which he won a best director OSCAR; and *On a Clear Day You Can See Forever* (1970). He also directed many other films, such as *Father of the Bride* (1950) and TEA AND SYMPATHY (1956).

He was married to Judy GARLAND and was the father of actress and singer Liza MINNELLI.

Minor, Robert (1884–1952), U.S. cartoonist; he was chief editorial cartoonist for the *St. Louis Post-Dispatch* from 1904 to 1912, then was succeeded by Daniel FITZPATRICK. He became an editorial cartoonist for the *New York World* and subsequently drew for two Socialist publications: *The New York Call* and *The Masses*. A Communist from 1919, his later work was carried in such party publications as *The Daily Worker*.

Mintz, Schlomo (1957–), Israeli violinist, who emerged in the 1980s as a leading recording and touring figure, especially notable for his recordings of Bruch, Mendelssohn, Bartók, Prokofiev, and Vivaldi.

Miracle on 34th Street (1947), the George Seaton fantasy, a perennial Christmas favorite. Seaton directed, and won an OSCAR for the screenplay, as did Valentine Davies for the original story on which it was based. Edmund Gwenn won a best supporting actor OSCAR as Kris Kringle, who ultimately turns out to be Santa Claus, in a cast that included Maureen O'Hara, John Payne, Natalie WOOD, William Frawley, Porter Hall, and Gene Lockhart.

Miracle Worker, The (1959), the TONY-winning William Gibson play, based on his 1957 television film. On stage, Anne BANCROFT created the role of teacher Annie Sullivan, opposite Patty DUKE as Helen Keller; Bancroft won a best actress TONY. Arthur PENN directed the telefilm, the play, and the 1962 film, for which Bancroft and Duke both won OSCARS. In a 1979 television remake, Duke, then Patty Duke Astin, played the Annie Sullivan role.

Miró, Joan (1893–1983), Spanish artist, alternately resident in France and Spain for most of the interwar period, who emerged as a major fantasist from the mid-1920s. Although he was directly associated with the surrealists (see SURREALISM) for only a few years, from 1925 to 1928, much of his highly abstracted, often dreamlike work reflects surreal approaches and early influences. His *Dutch Interiors* series (1928); *Imaginary Portraits* (1929); and first paper collages, exhibited in 1930, were key

products of this period. He left Spain at the beginning of the Civil War, in 1937 doing a large mural for the Spanish Republican pavilion at the Paris Exposition, and in that year also painting his *Aidez l'Espagne* poster. He spent 1940–48 in Spain, from 1944 and through the 1950s devoting much of his time to ceramics, and from 1948 also creating the highly symbolic paintings, sculptures, and graphics that occupied the rest of his working life. In 1950 he created a large mural at Harvard University and in 1958 did two large glazed tile walls for the Paris UNESCO headquarters.

Misfits, The (1961), the John HUSTON film, a modern Western about a group of cowboys who hunt wild horses. The Arthur MILLER screenplay, based on his own story of that name, focused on the essential alienation of the characters in the work, who are quite obviously the misfits of his title, although there is some play with the horses being hunted called "misfits." The cast included Clark GABLE, Marilyn MONROE, Montgomery CLIFT, Thelma Ritter, Eli Wallach, and Estelle Winwood. For Gable and Monroe, this was to be the last film.

Mishima, Yukio (Hiraoka Kimitake, 1925–70), Japanese writer, whose best-known novels include the autobiographical *Confessions of a Mask* (1948), *Thirst for Love* (1950), *The Temple of the Golden Pavilion* (1956), and the four-volume *The Sea of Fertility* (1969–71). He also wrote a considerable body of plays, novellas, and short stories. His novel *The Sailor Who Fell from Grace with the Sea* (1965) became the 1976 Lewis John Carlino film, with Sarah Miles and Kris KRISTOFFERSON in the leads. Mishima was a right-wing nationalist, who identified with the young fascist military officers of the 1930s. He publicly committed ritual suicide after leading an abortive raid on Japanese national military headquarters.

Missing (1982), the Constantin COSTA-GAVRAS film, set in Chile; Jack LEMMON was the American father frustrated in his search for his missing son by American and Chilean officials alike, in a cast that included Sissy SPACEK, Charles Shea, Melanie Mayron, Charles Cioffi, and Janice Rule. Costa-Gavras and

Donald Stewart wrote the OSCAR-winning screenplay, based on the Thomas Hauser book.

"Mission: Impossible" (1966–73), the long-running television adventure series. Leading players included Peter Graves, Martin Landau, Barbara Bain, Glen Morris, Peter Lupus, and Leonard Nimoy.

Mississippi Burning (1988), the Alan Parker film, about the 1964 murders of civil-rights workers James Chaney, Andrew Goodman, and Michael Schwerner by racists in Neshoba County, Mississippi. Gene HACKMAN and Willem Dafoe played the leads, as law-enforcement officers who ultimately bring the murderers to justice. Cinematographer Peter Biziou won an OSCAR. The film was criticized by some as giving too much credit to the FBI; but the truth of its powerful portrayal of the era's southern racism was unassailable.

Mister Roberts (1948), the long-running Thomas Heggen–Joshua LOGAN play, based on Heggen's novel of that name, and set on a U.S. naval freighter in the Pacific during World War II. Henry FONDA created the title role of Lt. Douglas Roberts on stage; William Harrigan was the dictatorial captain and David Wayne was Ensign Pulver. The play and Fonda as best actor won TONY AWARDS. Logan and Frank Nugent adapted the play into the 1955 John FORD film (Mervyn LEROY completed the direction of the work). Fonda re-created the title role, James CAGNEY was the captain, and Jack LEMMON played an OSCAR-winning Ensign Pulver, in a cast that also included William POWELL, Ward Bond, Betsy Palmer, and Harry Carey, Jr. Joshua Logan directed the 1964 sequel, *Ensign Pulver*.

Mistinguett (Jean-Marie Bourgeois, 1875–1956), French entertainer, on stage from 1895, who enjoyed worldwide celebrity as a star of the Paris music hall, as a comedienne, and as the centerpiece of the shows at such nightclubs as the Moulin Rouge and Folies Bergère. She provided Maurice CHEVALIER, then her lover, with his first major break, partnering him at the Folies-Bergère from 1909 to 1913.

Mistral, Gabriela (Lucila Godoy Alcayaga, 1889–1957), Chilean writer, teacher, and diplomat whose first published work, the three "Sonnets of Death" (1914), were included in her first collection, *Desolation* (1922), which established her as a major Latin American poet. These and such further collections as *Tenderness* (1925), *Questions* (1930), and *Tala* (1938) brought her the 1945 NOBEL PRIZE for literature.

Mitchell, Joni (Roberta Joan Anderson, 1943–), Canadian folksinger, composer, and guitarist, and during the late 1960s and early 1970s one of the leading figures of the folk and BLUES revival. Several of her songs, such as *Woodstock* (1970) and BOTH SIDES NOW (as sung by Judy COLLINS in 1968), were emblematic of the countercultural movements of the time. A few of her best-known early albums are *Clouds* (1969), *Ladies of the Canyon* (1970), *Blue* (1971), *For the Roses* (1972), and *Court and Spark* (1974). In the mid-1970s she moved to considerably more experimental work, perhaps most notably in her collaboration with Charles MINGUS in the album *Mingus '79*. Her later work includes such albums as *Dog Eat Dog* (1986) and *Chalk Mark in a Rainstorm* (1988).

Mitchell, Margaret (1900–49), U.S. writer, who wrote one book, the PULITZER PRIZE-winning GONE WITH THE WIND (1936). The historical novel became a massive worldwide bestseller and in 1939 was adapted into the enormously popular OSCAR-winning Victor FLEMING film, with Clark GABLE as Rhett Butler and Vivien LEIGH as Scarlett O'Hara.

Mitchum, Robert (1917–), U.S. actor, on screen from 1943, who attracted attention and an OSCAR nomination for his strong character role in *The Story of G.I. Joe* (1945), then going on to play leads and character roles in scores of films, including his notable lead in *The Night of the Hunter* (1955). Late in his career he emerged as a major dramatic star, in such films as *Ryan's Daughter* (1971), FAREWELL, MY LOVELY (1975), and ultimately in the Pug Henry role in the massive television miniseries THE WINDS OF WAR (1983) and WAR AND REMEMBRANCE (1987).

Mix, Tom (Thomas Mix, 1880–1940), U.S. actor, a cowboy star in short films from 1911

and one of the leading cowboy stars of the silent era. He made a few soundfilms in the early 1930s and retired in 1934.

Mizoguchi, Kenji (1898–1956), Japanese director, whose work was on screen from 1922. A major figure in Japanese cinema, he is best known abroad for such later films as *Ugetsu* (1953); *Sansho the Bailiff* (1954); and his last film, *Street of Shame* (1956).

Moberg, Carl Arthur Vilhelm (1898–1973), Swedish writer, best known for his semiautobiographical trilogy *The Earth Is Ours* (1940); the historical novel *Ride This Night;* and his trilogy on the emigration to America: *The Emigrants* (1949), *Unto a Good Land* (1952), and *The Last Letter Home* (1961). The latter trilogy became a set of two Jan Troell films, both with Max von SYDOW and Liv ULLMANN in the leads: *The Emigrants* (1971) and *The New Land* (1972); the two films were also woven into a television miniseries, "The Emigrant Saga."

Moby Dick (1956), the most notable of the several films based on the Herman Melville novel; the John HUSTON film starred Gregory PECK as Captain Ahab, in a cast that included Richard BASEHART, Orson WELLES, Leo Genn, James Robertson Justice, Harry ANDREWS, and Bernard Miles. John BARRYMORE played Ahab in the 1930 film version.

modern dance, a group of related 20th-century dance forms and dancers, all sharing an anti-classical-ballet inspiration and reflecting a desire for artistic and personal freedom, much enhanced by personal identification with contemporary women's freedom movements. Leading pioneers included Isadora DUNCAN in the United States and Mary WIGMAN in Europe, followed by such later figures as Martha GRAHAM, Hanya HOLM, and Doris HUMPHREY. The movement also included a small but significant number of male dancers, such as Ted SHAWN and Charles Weidman.

modernism, a term that describes a tendency, rather than being a school or movement, and attempts to describe a wide range of 20th-century approaches in all the arts, such as CUBISM, DADA, and SURREALISM in the visual arts, the BAUHAUS and INTERNATIONAL STYLE in architecture, SERIALISM and the 12-

NOTE COMPOSITION in music, and EXPRESSIONISM in literature and the visual arts. The term, thought by some writing in midcentury to have described a tendency that ended during the interwar period, continued to be used to describe contemporary developments in the post-World War II period, becoming so spongy as to lose relevance. In the 1960s and 1970s it was generally replaced by the term "postmodernism," a quite contemporary-sounding but no more useful descriptor generally and rather indiscriminately applied to further developments in the directions that were once thought modernist.

Modern Times (1936), a silent film written, produced, and directed by Charlie CHAPLIN, who also starred as the Tramp, with Paulette GODDARD in the chief supporting role. In form a satire, it dwells at length upon the trials of a sane little man in what Chaplin sees as an increasingly oppressive industrial society. Several of its images—Charlie on an assembly line, caught in the machine, innocently waving a red flag at the head of a parade—are widely recognized as classics of the genre.

Modigliani, Amedeo (1884–1920), Italian artist, a painter and sculptor resident in Paris from 1906, who from then until his untimely death of tuberculosis 16 years later lived and worked in poverty, surrounded by many celebrated artists and bohemians, some of whom he painted. He exhibited seldom, sold little in his lifetime, and was recognized as one of the leading artists of his time only after his death, then being widely recognized for his characteristically elongated nudes and for such portraits as *Diego Rivera* (1914), *Paul Guillaume* (1916), *Jacques Lipchitz and His Wife* (1917), and *Chaim Soutine* (1917).

Mofolo, Thomas (1875–1948), Lesotho writer, whose first two novels were stories of Black Christian South Africans. His third and last novel was *Chaka the Zulu*, written in 1910 and finally published in 1925, which established him as a leading early Black African novelist.

Moholy-Nagy, László (1895–1946), Hungarian artist and photographer, who became a key figure in the BAUHAUS from 1923 to 1928, in the same period becoming an experimental still

photographer and filmmaker. His first film was *Berlin Still-Lifes* (1926), followed in 1930 by *Light Play, Black and White and Grey.* After leaving the Bauhaus, he was a design consultant in Germany and from 1935 in Britain, emigrating to the United States in 1937 to found Chicago's New Bauhaus, which was ultimately succeeded by the Institute of Design. His major book was *Vision in Motion* (1947).

Moiseyev, Igor (1906–), Soviet dancer and choreographer, a member of the BOLSHOI BALLET company from 1924 to 1939. His choreography for the company includes such works as *The Footballer* (1930) and *Spartacus* (1958). He became chief choreographer for the Moscow Theatre of Folk Art in 1936, and from 1937 built the Moscow Folk Art Ensemble into the world's leading folk-music-based dance company, consisting of well over 100 professionals presenting hundreds of theater pieces based on Soviet folk-dance styles and themes, many of them by Moiseyev. A few of his best-known works are *Partisans, Pictures from the Past, Soccer Dance,* and *The Ukrainian Suite.*

Molnár, Ferenc (1878–1952), Hungarian writer, a journalist and prolific writer in several forms, who is best known for several of his plays, including *The Devil* (1907), a George ARLISS vehicle staged in New York in 1908 while a competing production of the same play opened in a different New York theater on the same night; *Liliom* (1909), which in 1945 was the basis for the musical CAROUSEL; *The Guardsmen* (1910), in 1924 a LUNT AND FONTANNE vehicle on Broadway; *The Swan* (1914); and *The Good Fairy* (1931), adapted by Preston STURGES into the 1935 William WYLER film. A refugee from fascism late in his life, he lived in the United States from 1940.

Mondrian, Piet (Pieter Cornelis Mondriaan, 1877–1944), Dutch artist, who passed through several schools, including symbolism and CUBISM, before emerging in 1917 as a co-founder of the DE STIJL group and of the style he named "neoplasticism," in which areas of red, yellow, blue, and white were defined by strong black lines that created rectangles; examples are *Composition with Red, Yellow, and Blue* (1921) and *Composition with Yellow and Blue* (1929). His work was created in pursuit of universalist theosophical beliefs, in which he had been interested since the early 1900s. He parted from De Stijl in 1925, in a dispute over the use of diagonal lines by others in the group. He emigrated to the United States in 1940, entering a brief American period that saw the adoption of a considerably wider range of color, as in *New York City* (1942) and *Broadway Boogie Woogie* (1943).

Monk, Thelonius Sphere (1917–82), U.S. JAZZ musician, a highly innovative pianist and composer who in the mid-1940s was part of the BOP movement in jazz, and later developed on his own as an exceedingly independent, creative, often difficult figure. He created a considerable body of new work, some of his works becoming classics, as were "Round Midnight," "Epistrophy," "Blue Monk," and "Straight No Chaser."

Mon Oncle (1958), the Jacques TATI film comedy, an almost-silent set of visual comments on highly technological modern life; one of the four MR. HULOT films. Tati directed, cowrote, and starred, in a cast that included Adrienne Servantie, Alain Bercoirt, and Jean-Pierre Zola.

Monroe, Bill (William Smith Monroe, 1911–), U.S. country music singer, composer, bandleader, and mandolinist, widely credited with having provided the "bluegrass" name for his style of country music, now often called "roots" music. He played and recorded with his brothers Birch and Charlie during the late 1920s, and until 1938 with Charlie, as The Monroe Brothers. Bill then formed the Bluegrass Boys, a historic group in country music. He began his long association with GRAND OLE OPRY in 1939, with "Mule Skinner's Blues." Monroe continued to be a leading performer in country music for decades, finding wider audiences as the folk-BLUES revival of the 1960s developed. A few of his own best-known songs are "Uncle Pen," "Scotland," "My Little Georgia Rose," and "Blue Moon of Kentucky."

Monroe, Marilyn (Norma Jean Mortenson, 1926–62), U.S. actress, on screen from 1948, and a very talented light comedienne. She became the reigning Hollywood sex symbol of

her time, largely due to enormous studio publicity, her 1954 marriage to baseball star Joe DiMaggio, and a very popular nude calendar photo. She starred in such films as *Gentlemen Prefer Blondes* (1953), *How to Marry a Millionaire* (1953), *The Seven-Year Itch* (1955), BUS STOP (1956), and the classic comedy SOME LIKE IT HOT (1959). Her last film, THE MISFITS, also the last film of her costar, Clark GABLE, was written for Monroe by Arthur MILLER, then her husband. She died of an overdose of barbiturates.

Monroe, Vaughn (1911–73), U.S. singer, bandleader, and trombonist, who became a very popular singer in the mid-1940s, with such songs as "There! I've Said It Again" (1945), "Let It Snow! Let It Snow! Let It Snow" (1945), "Cool Water" (1948), and "Mule Train" (1949). He also appeared in several films.

Monsieur Verdoux (1947), a film written, produced, and directed by Charlie CHAPLIN, who also starred, as a Bluebeard who murders a series of wives for their money; Martha Raye played a key supporting role. Set in Paris, the story is based on the criminal career of Charles Landru, from a suggestion by Orson WELLES. The film reflected Chaplin's antiwar views, at a time when he was being attacked by American witch-hunters, at the beginning of the Cold War and the McCarthy period, and was therefore controversial in its time, though in content a rather mild satiric work that a few years later might well have been described as absurdist.

Montale, Eugenio (1896–1981), Italian writer, a leading 20th-century poet whose best-known collections include *Cuttlefish Bones* (1925), *Opportunities* (1939), *The Blizzard* (1956), and *Xenia* (1972), poems in memory of his wife. He was also a translator, essayist, and critic. He was awarded the NOBEL PRIZE for literature in 1975.

Montand, Yves (Ivo Levi, 1921–), French actor and singer, a French music-hall singer, from 1939, and during the 1940s a protégé of singer Edith PIAF. He was on screen from 1946, in such light comedies and musicals as *Let's Make Love* (1960) and *On a Clear Day*

You Can See Forever (1970), and much more notably in strong dramatic leads, in such films as LA GUERRE EST FINIS (1966), Z (1969), *State of Siege* (1973), *Jean de Florette* (1986), and *Manon of the Springs* (1986). He was married to actress Simone SIGNORET.

Monteux, Pierre (1875–1964), French composer; he conducted the BALLET RUSSES of Sergei DIAGHILEV 1911–14, including the first productions of PETRUSHKA (1911), DAPHNIS AND CHLOÉ (1912), and THE RITE OF SPRING (1913). He later directed the Boston Symphony (1919–24), founded and conducted the Paris Symphony (1929–38), was music director of the San Francisco Symphony (1938–52), and conducted the London Symphony (1961–64).

Montgomery, Robert (Henry Montgomery, Jr., 1904–81), U.S. actor and director, on stage from 1924 and on screen from 1929. He became a leading man in such light films as PRIVATE LIVES (1931), WHEN LADIES MEET (1933), and *The Last of Mrs. Cheyney* (1937), but in the the the late 1930s was able to move into stronger roles, in such films as YELLOW JACK (1938); *Busman's Honeymoon* (1940); *Here Comes Mr. Jordan* (1941); and *The Lady in the Lake* (1946), which he also directed. He was later host of his own television anthology series, "Robert Montgomery Presents" (1950–57). He was the father of actress **Elizabeth Montgomery.**

"Monty Python's Flying Circus" (1969–71), the British comedy-satire series, which quickly developed a cult following in Britain and the United States. The players included Graham Chapman, John Cleese, Eric Idle, Terry Jones, Michael Palin, and Terry Gilliam. The group also generated several films, beginning with *Monty Python's Holy Grail* (1974), directed by Gilliam.

Moog, Robert Arthur (1934–), U.S. inventor and designer, who in 1964 introduced the first commercial modular synthesizer; for some years such synthesizers and related devices and musical systems were often described as Moog Synthesizers.

Moonlighting (1982), the Jerzy Skolimowski film, about a group of Polish workers renovat-

ing a London apartment in secret, as they have no permits to work in Britain; the declaration of martial law in Poland while they are away makes them even more vulnerable. Jeremy Irons, Eugene Lipinski, Jiri Stanislav, and Eugeniusz Haczkiewicz played the workers; the screenplay was written by Skolimowski.

Moore, Henry (1898–1986), British sculptor, whose powerful work drew its inspiration from what he perceived as the "vitality" inherent in works drawn from many older cultures and from all the races of humankind. He emerged as a major figure from the late 1920s, with such works as *Reclining Figure* (1929), *Two Forms* (1934), *Mother and Child* (1938), and *Madonna and Child* (1943). During World War II, as a government war artist, he made drawings of people in the London Tube bomb shelters—and suffered a huge loss when his Hampstead studio was damaged by German bombs during the Blitz. In the postwar period he became a world figure, and some of his work became massive, as in the Lincoln Center *Reclining Figure* (1965) and the University of Chicago *Atom Piece* (1966).

Moore, Marianne Craig (1887–1972), U.S. writer, whose precisely put, spare, often nature-based poems reflect her commitment to the theory of objectivism, which sought to deal with the perceived truth in the material object portrayed rather than with its symbolic connotations. Her first collection was *Poems* (1921), which was followed by several other volumes stretching over four decades. Her *Collected Poems* won a 1951 PULITZER PRIZE.

Moore, Mary Tyler (1936–), U.S. actress, best known for her television portrayal of Mary Richards, an independent, self-sufficient 1970s career woman, in "The Mary Tyler Moore Show" (1970–77), with Edward ASNER as Lou GRANT, Valerie Harper as Rhoda Morgenstern, and Cloris Leachman as Phyllis Lindstrom. Previously, Moore had been the second lead in "The Dick Van Dyke Show" (1961–65). Her films include *Thoroughly Modern Millie* (1967) and ORDINARY PEOPLE (1980).

Morante, Elsa (1912–85), Italian writer, whose three major novels are *House of Liars* (1943);

Arturo's Island (1957); and *The Story* (1974), a work informed by her World War II experiences. An antifascist, she and her husband, writer Alberto MORAVIA, spent much of the war in exile or in hiding on the mainland. Morante also wrote a considerable body of poetry and essays.

Moravia, Alberto (Alberto Pinchale, 1907–), Italian writer, a central figure in 20th-century Italian literature from his first novel, *The Time of Indifference* (1929), a penetrating analysis of the decadent society within which he wrote. His major works also include *Mistaken Ambitions* (1935); *Two Adolescents* (1944); *A Woman of Rome* (1947); *The Conformist* (1951); and *Two Women* (1957), based in part on his experiences of exile and underground life in Italy during World War II, which were shared with his wife, writer Elsa MORANTE. *Two Women* was the basis of the 1960 Vittorio DE SICA film, starring Sophia LOREN, and *The Conformist* was the basis of the 1969 Bernardo BERTOLUCCI film. Moravia also published several collections of short stories and a collection of essays.

More, Kenneth (1914–82), British actor, on screen from 1935, who emerged as a star in the 1950s, with such films as *Genevieve* (1953), *Doctor in the House* (1954), *The Deep Blue Sea* (1955), *Reach for the Sky* (1956), *A Night to Remember* (1958), and *Sink the Bismarck* (1960). His later career included very notable television roles in THE FORSYTE SAGA (1968) and "An Englishman's Castle" (1978).

Moreau, Jeanne (1928–), French actress, on stage and screen from 1948, who became a major international film star in the 1950s with *Frantic* (1957) and *The Lovers* (1958), then going on to such films as *Les Liaisons Dangereuses* (1959); JULES AND JIM (1961); DIARY OF A CHAMBERMAID (1964); and *Lumière* (1976), which she also wrote and directed.

Morgan, Helen (Helen Riggins, 1900–41), U.S. torch singer, in cabaret from the early 1920s. On Broadway she created the role of Julie in SHOW BOAT (1927), singing BILL and "Can't Help Lovin' Dat Man," and re-created the role in the 1929 and 1936 film versions. She also introduced the Jerome KERN and

Oscar HAMMERSTEIN II songs "Why Was I Born?" and "Don't Ever Leave Me," in *Sweet Adeline* (1929). On screen she played in such films as *Applause* (1929), *You Belong to Me* (1934), and *Frankie and Johnny* (1936). Ann Blyth played Morgan and Gogi Grant sang her songs in the 1957 film biography *The Helen Morgan Story*, directed by Michael CURTIZ.

Morgan, John Pierpont (1837–1913), U.S. financier and art and book collector. On his death, much of his art collection went to the Metropolitan Museum of Art, and his book collection and home later became the Morgan Library. He was depicted in Edward STEICHEN's landmark photograph J. PIERPONT MORGAN.

Morgan, Michele (Simone Roussel, 1920–), French actress, on screen from 1935, who became a major international film star from the mid-1930s, with such movies as *Port of Shadows* (1938), *Stormy Waters* (1941), *La Symphonie Pastorale* (1946), and THE FALLEN IDOL (1948).

Morris, Wright (1910–), U.S. writer and photographer, who places his work largely in midwestern settings. Several of his novels, such as *The Inhabitants* (1946), *The Home Place* (1948), and *Love Affair* (1972), use pictures and words in complementary fashion. A few of his most notable works are the novels *The Field of Vision* (1956), *Love Among the Cannibals* (1957), and *Plains Song* (1980). He also wrote essays and autobiographical works.

Morrison, Toni (Chloe Anthony Wofford, 1931–), U.S. writer and editor, whose novels focus on the Black experience in America and most notably on the difficult, often tragic lives of Black women. Her works include *The Bluest Eye* (1969), *Sula* (1973), *Song of Solomon* (1977), *Tar Baby* (1981), and the PULITZER PRIZE-winning *Beloved* (1987).

Mortal Storm, The (1940), the Frank BORZAGE film, based on the 1938 Phyllis Bottome novel, an anti-Nazi drama about a family and friends destroyed by the onset of German fascism. Margaret SULLAVAN and James STEWART played the young lovers ultimately forced to flee their country; she is killed by Nazi border guards during the attempt, the

order to fire coming from her former suitor and his former friend, played by Robert YOUNG. Frank Morgan was her Jewish university professor father, whose books are burned and who dies in a concentration camp. The cast also included Irene Rich, Maria Ouspenskaya, Robert Stack, William Orr, Ward Bond, and Dan Dailey.

Mortimer, John Clifford (1923–), British writer, whose plays include the autobiographical *A Voyage Round My Father* (1970) and *I, Claudius* (1972), and whose novels include the several Rumpole books, beginning with *Rumpole of the Bailey* (1978), which he adapted into the Rumpole series for television. He also wrote the television adaptation of BRIDESHEAD REVISITED (1981).

Morton, Jelly Roll (Ferdinand Joseph La Menthe, 1890–1941), U.S. musician, a composer, pianist, and bandleader who was a leading figure in the development of JAZZ. He began playing in his native New Orleans as a teenager, probably in 1905, and then pursued a varied and traveling career, beginning to record at Chicago in the mid-1920s, with King OLIVER and then as a piano soloist, emerging in late 1926 at the head of Jelly Roll Morton and his Red Hot Peppers. In the next several years he became established as a leading jazz composer, bandleader, and recording artist, with such classics as "Original Jelly Roll Blues," "Dead Man Blues," "Sidewalk Blues," "Black Bottom Stomp," and "Wolverine Blues." His career sagged as musical styles changed in the 1930s, but he is now recognized as a seminal jazz musician.

Moscow Art Theatre, the theater founded by Konstantin STANISLAVSKY and Vladimir Nemirovich-Danchenko in 1898, which served as the vehicle for Stanislavsky's production of four Anton CHEKHOV plays—*The Seagull* (1898), *Uncle Vanya* (1899), THE THREE SISTERS (1901), and THE CHERRY ORCHARD (1904)—as well as for the introduction of Maxim GORKY'S THE LOWER DEPTHS (1902). In the theater, as actor and director, Stanislavsky developed what later came to be called THE METHOD, the naturalistic style that was to revolutionize 20th-century acting, especially as adapted in the United States after a cele-

brated visit by the Moscow Art Theatre in the early 1920s. The Stanislavsky method was the basis of the work of the GROUP THEATRE and later of the ACTORS STUDIO; it also profoundly influenced the development of the Soviet theater.

Moscow Does Not Believe in Tears (1980), the Vladimir Menshev film, a realistic portrayal of Soviet urban life that indicated the presence of new currents in Soviet cinema; Irina Muravyova, Raisa Ryazonova, and Natalie Vavilova played key roles. The movie won a best foreign film OSCAR.

Moses, Grandma (Anna Mary Robertson Moses, 1860–1961), self-taught U.S. painter, who began to paint in her mid-seventies. After her work was exhibited at the Museum of Modern Art in 1939 she became a popular painter, later also painting on ceramic tiles, in what has been described as a "primitivist" or "naive" style, continuing to produce new work past her 100th birthday.

Mostel, Zero (Samuel Joel Mostel, 1915–77), U.S. actor, one of the leading stage and screen comedians of his time. His early films include *DuBarry Was a Lady* (1943) and *Panic in the Streets* (1950). He was blacklisted and forced out of films after appearing before the House Un-American Activities Committee, finding himself unemployable for several years, but came back to become a leading stage player, winning a best actor TONY for *Rhinoceros* (1961), a second Tony as Pseudolus in A FUNNY THING HAPPENED ON THE WAY TO THE FORUM (1962), and a third Tony for his creation of Tevye in FIDDLER ON THE ROOF (1964). Fifteen years after his blacklisting, he starred in the film version of *A Funny Thing Happened on the Way to the Forum* (1966), and he went on to star in such films as THE PRODUCERS (1967); *Rhinoceros* (1974); and *The Front* (1975), in which he played a blacklisted movie actor.

Mother (1911), the Maxim GORKY novel, a story of the Russian revolutionary movement, which in 1926 became the classic Vsevolod PUDOVKIN silent film, and was adapted by Bertolt BRECHT for the theater in 1931.

Motherwell, Robert (1915–), U.S. painter, a leading ABSTRACT EXPRESSIONIST from the beginnings of the movement in the late 1940s. His *Elegy to the Spanish Republic*, a series of almost 150 black-on-white paintings, began in 1949 and ran through the mid-1970s. He also began producing brightly colored collages in the late 1940s and working in color-field painting in the early 1960s; by the late 1960s he was beginning to produce the large color-saturated paintings that characterized much of his later work.

Mourning Becomes Electra (1931), the Eugene O'NEILL trilogy, the story of the self-destruction of the Mannon family; an adaptation of the *Oresteia* in a New England, post-Civil War setting, consisting of *Homecoming*, *The Hunted*, and *The Haunted*. It was adapted into the 1947 Dudley Nichols film, with Raymond MASSEY, Michael REDGRAVE, Rosalind RUSSELL, and Katina PAXINOU in key roles.

Mphahlele, Ezekiel (1919–), South African writer and teacher, a leading interpreter of the Black South African experience, in such novels as the semiautobiographical *The Wanderers* (1972), *Chirundu* (1981), and *Father Come Home* (1984) and in his essays, short stories, and autobiographies. He spent much of his life in exile, after having opposed his country's racist educational system.

Mr. Blandings Builds His Dream House (1948), the Cary GRANT–Myrna LOY film comedy, about a city-dwelling couple who find themselves building a far-too-expensive suburban house, a theme very familiar in the early postwar period. Melvyn DOUGLAS played a key supporting role.

Mr. Deeds Goes to Town (1936), the Frank CAPRA film, one of the classic comedies of the Golden Age of American film, with Gary COOPER in the Stringfellow Deeds role, as the honest, democratic small-town hick who goes to the big city and bests a bunch of crooked big-city plutocrats. The film is very much in the populist mainstream of the Depression era. Jean ARTHUR played a pivotal supporting role. Robert Riskin wrote the screenplay, based on a Clarence Buington Kelland story. Capra won a best director OSCAR for the film.

Mr. Hulot, the fictional central character in the four Jacques TATI *Mr. Hulot* films, beginning with *Mr. Hulot's Holiday* (1953).

Mrs. Miniver (1942), the OSCAR-winning William WYLER film, based on the Jan Struther novel, portraying the life of a British family during the difficult early days of World War II. Greer GARSON won an Oscar in the title role, opposite Walter PIDGEON, as did Wyler, Teresa Wright in a supporting role, cinematographer Joseph Ruttenberg, and the several writers of the screenplay.

Mr. Smith Goes to Washington (1939), the Frank CAPRA film, with James STEWART in the title role as a naive, idealistic young U.S. senator who goes to Washington, D.C. and ultimately exposes and destroys a group of corrupt big-money politicians. The film is essentially a Depression-era fantasy romance in a populist vein, very much like Capra's earlier MR. DEEDS GOES TO TOWN (1936). Once again, Jean ARTHUR plays a key supporting role, here joined by Claude RAINS, Edward ARNOLD, Harry Carey, and Thomas Mitchell. Sidney Buchman wrote the screenplay, based on an OSCAR-winning story by Lewis R. Foster.

Mr. Television, nickname for Milton BERLE in his heyday.

Muldaur, Maria (Maria D'Amato, 1943–), U.S. folksinger, very popular in the 1970s, with such albums as *Mud Acres* (1972), *Maria Muldaur* (1972), *Waitress in a Donut Shop* (1974), *Sweet Harmony* (1976), and *Southern Winds* (1978).

Mumford, Lewis (1895–1990), U.S. writer and cultural historian, best known for his work in the philosophy of modern architecture and urban planning in what he perceived as a machine-dominated age. His lifelong insistence was on the primacy of human needs, as expressed through his advocacy of ecology-conscious urban planning and the development of "garden cities." He wrote such seminal works as *Technics and Civilization* (1934), *The Culture of Cities* (1938), and *The City in History* (1961).

Münch, Charles (1891–1968), French conductor, whose interwar European career included the direction of the Strasbourg Orchestra (1919–25) and of the Leipzig Gewandhaus Orchestra (1926–33); he was also a founder of and conducted the Paris Philharmonic Orchestra (1935–38). He was best known as the conductor of the Boston Symphony Orchestra (1949–62) and of the Berkshire Music Festival, at Tanglewood (1951–62).

Munch, Edvard (1863–1944), Norwegian artist, who from the late 1880s began to produce a powerful, personally anguished, socially critical body of work, as in *The Sick Child* (1886), *The Cry* (1893), and *The Dance of Life* (1900), while living and working mainly in Germany and France. He anticipated the anguished, emotional German expressionists (see EXPRESSIONISM) of the next decade. After recovering from a 1908 nervous breakdown, he went home to Norway; his later work became far more optimistic, most notably in his murals for Oslo University and the landscape paintings of this period. Munch was also a leading graphic artist, often translating his paintings into woodcuts.

Muni, Paul (Muni Weisenfreund, 1895–1967), U.S. actor, on stage in the Yiddish theater as a child in Austria and in the American Yiddish theater from the age of seven. He was on the Broadway stage from 1926, playing leads in such plays as *Counsellor-at-Law* (1931), KEY LARGO (1939), and INHERIT THE WIND (1955), for which he won the best actor TONY. On screen from 1929, he became a leading Hollywood dramatic actor as SCARFACE (1932) and in I AM A FUGITIVE FROM A CHAIN GANG (1932), going on to such films as *The Story of Louis Pasteur* (1936), for which he won a best actor OSCAR; THE GOOD EARTH (1937); *The Life of Émile Zola* (1937), *Juarez* 1939); *Hudson's Bay* (1941); and his final movie, *The Last Angry Man* (1959).

Muppets, the puppet characters created by Jim HENSON in the mid-1950s and then developed by Henson and his associates. From 1969, some of the Muppets became well-known figures in the children's series SESAME STREET, and many became worldwide celebrities in their own films and on television's "The Muppet Show" (1976–81). They included Kermit the Frog, Miss Piggy, Gonzo, Fozzie

Bear, Zoot, The Swedish Chef, and Dr. Teeth and the Electric Mayhem Band.

Murder, My Sweet (1945), the second, classic film adaptation of the Raymond CHANDLER mystery novel FAREWELL MY LOVELY (1940), adapted by John Paxton into the Edward DMYTRYK film. It starred Dick POWELL as Philip MARLOWE, in a cast that included Claire Trevor, Mike Mazurki, and Miles Mander.

Murder on the Orient Express (1974), the Sidney LUMET film, based on the Agatha CHRISTIE novel and set on the *Orient Express* in the 1930s. Albert FINNEY was a memorable Hercule POIROT, in a cast that included John GIELGUD, Richard WIDMARK, Lauren BACALL, Ingrid BERGMAN, Sean CONNERY, Martin Balsam, Jacqueline BISSET, Jean-Pierre Cassel, Wendy HILLER, Anthony PERKINS, Michael YORK, Colin Blakely, and George Coulouris.

"Murder, She Wrote" (1984–), the long-running television series, starring Angela LANSBURY as mystery writer Jessica Fletcher, who solves mysteries, as well, sometimes assisted by such series characters as Sheriff Amos Tupper and Dr. Seth Hazlitt.

Murdoch, Iris (Jean Iris Murdoch, 1919–), British writer and philosopher, whose first published work was *Sartre: Romantic Rationalist* (1953). Her work intricately explores matters of love, relationships, sexual conflict, commitment, and personal freedom, and includes such novels as *Under the Net* (1954); *The Sandcastle* (1957); *A Severed Head* (1961), which first established her as a major novelist and also became the 1963 play; *The Italian Girl* (1964), which also became the 1967 play; *The Sacred and Profane Love Machine* (1974); the Booker-winning *The Sea, the Sea* (1978); *The Book and the Brotherhood* (1987); and *The Message to the Planet* (1989).

Murnau, F.W. (Friedrich William Plumpe, 1888–1931), German director, an assistant to Max REINHARDT before World War I; his work was on screen from 1919. He became one of the major directors of the silent era with his two German classics, *Nosferatu the Vampire* (1922, a version of DRACULA) and *The Last*

Laugh (1924). He went to Hollywood in 1927, there making another classic, SUNRISE (1927). He died in an automobile crash, cutting short an extraordinarily creative film career.

Murphy, Eddie (1961–), U.S. comedian and actor; he was a featured player in SATURDAY NIGHT LIVE from 1980 to 1984, a recording artist, and a very popular film star, in such movies as *48 Hours* (1982), *Trading Places* (1983), *Beverly Hills Cop* (1984, and its 1987 sequel), *The Golden Child* (1986), *Coming to America* (1988), and *Harlem Nights* (1989).

Music Man, The (1957), the TONY AWARD-winning musical by Meredith Willson. On stage, Robert PRESTON also won a Tony in the title role, as a turn-of-the-century grifter who sells nonexistent instruments to small-town bands he has organized for that purpose. He re-created the role in the 1962 Morton Da Costa film, opposite Shirley JONES, in a cast that included Hermione Gingold, Buddy Hackett, and Paul Ford. The show's best-known song is "76 Trombones."

Mutiny on the Bounty (1935), the Frank LLOYD film, based on the trilogy of novels by Charles Nordhoff and Norman Hall: *Mutiny on the Bounty* (1932), *Men Against the Sea* (1934), and *Pitcairn's Island* (1934), all based on a 1787 British Navy mutiny in the South Pacific. The leads were played by Charles LAUGHTON as Captain Bligh and Clark GABLE as Fletcher Christian, in a cast that included Franchot TONE, Dudley Digges, Henry Stephenson, and Donald Crisp. The film won an OSCAR and was later remade twice, most notably in the 1962 Lewis MILESTONE version, with Trevor HOWARD as Bligh and Marlon BRANDO as Christian.

"Mutt and Jeff," the very popular comic strip created by cartoonist Bud FISHER in 1908; it was continued after his death by his assistant, cartoonist Al Smith, who had drawn much of the strip for many years.

My Darling Clementine (1946), the most notable of the several films dealing with the legendary American Western shootout between the Earps and the Clantons at the O.K. Corral. This was the John FORD film, with Henry FONDA in the Wyatt Earp role and Victor

Mature as Doc Holiday, in a cast that included Walter Brennan, Linda Darnell, Cathy Downs, and Ward Bond. A later version was GUNFIGHT AT THE O.K. CORRAL (1957).

My Fair Lady (1960), the musical by Alan Jay LERNER and Frederick LOEWE, adapted from George Bernard SHAW'S PYGMALION (1914). Rex HARRISON and Julie ANDREWS played Henry HIGGINS and Eliza DOOLITTLE, and Moss HART directed the original TONY-winning stage version, with Stanley HOLLOWAY in the Alfred Doolittle role; Harrison also won a Tony. In 1964, Lerner adapted the play into the George CUKOR film, with Harrison and Holloway re-creating their stage roles and Audrey HEPBURN as Eliza, in a cast that included Gladys Cooper, Wilfrid Hyde-White, Jeremy Brett, Mona Washbourne, and Theodore Bikel. The film, Cukor, Harrison, cinematographer Harry Stradling, costumes, art, set, sound, and music all won OSCARS.

"My Heart Belongs to Daddy," the song that became identified with Mary MARTIN; from the Broadway musical *Leave It to Me* (1938). Words and music were by Cole PORTER.

My Left Foot (1989), the Jim Sheridan film, based on the Christy Brown autobiography; Sheridan and Shane Connaughton wrote the screenplay. Daniel DAY LEWIS won a best actor OSCAR as Brown, the Irish writer and artist who triumphed over cerebral palsy, in a cast that included Ray MCANALLY and Brenda Fricker; she won a best supporting actress Oscar.

"My Mammy" (1918), the Al JOLSON song, which he sang in the Broadway musical *Sinbad* (1920), with music by Walter Donaldson and words by Sam Lewis and Joe Young.

"My Man" (1920), the torch song introduced by Fanny BRICE in the *Ziegfeld Follies of 1920*. The song became a great hit, her signature song, and the title of her 1928 film *My Man*. It was publicly associated with her failed marriage to gambler Nicky Arnstein. In Europe, as sung in French by MISTINGUETT, the song was an equally great hit. Music was by Maurice Yvain, with words by Channing Pollock.

N

Nabokov, Vladimir Vladimirovich (1899–1977), Russian-American writer, a post-Revolution émigré who wrote such novels as *Mary* (1926), *King, Queen, Knave* (1928), and *Invitation to a Beheading* (1938) in Russian, while living in Europe during the interwar period, and who began writing in English after his emigration to the United States in 1940. His English-language works include such novels as *The Real Life of Sebastian Knight* (1941); *Bend Sinister* (1947); *Pnin* (1957); and LOLITA (1955), the story of a romance between the aging Humbert Humbert and a 12-year-old girl, which caused considerable outcry at the time, assuring Nabokov's emergence as a major popular figure, apparently to his surprise. Nabokov adapted *Lolita* into the 1962 Stanley KUBRICK film, with James MASON in the Humbert role and Sue Lyon as Lolita. Edward ALBEE wrote a stage adaptation of *Lolita* in 1979. Nabokov's later works include *Ada* (1969) and collections of poems, short stories, and essays.

Naipaul, V.S. (Vidiadhar Surajprasad Naipaul, 1932–), Trinidadian-British writer, who takes as his main themes the search for identity of formerly colonial peoples and the clash between colonizing and colonized cultures. His earliest novels are satires set in Trinidad: *The Mystic Masseur* (1957), *The Suffering of Elvira* (1958), and *Miguel Street* (1959). He gained recognition with the multigenerational *A House for Mr. Biswas* (1961), also set in Trinidad. His later works include the novels *The Mimic Men* (1967), *Guerrillas* (1975), and *A Bend in the River* (1979). He also published several volumes of short stories, and is a prolific essayist.

Naked and the Dead, The (1945), the Norman MAILER war novel, set in the Pacific during World War II and based in part on his own war experiences. The powerful work became the 1958 Raoul WALSH film, with Aldo Ray, Cliff ROBERTSON, and Joey Bishop in key roles.

Naked City, The (1948), the Jules DASSIN film, a darkly realistic treatment of the underside of New York life, as seen by a group of homicide detectives investigating a murder and as discussed by producer Mark Hellinger in a commentary that runs throughout the entire work. Barry FITZGERALD, as homicide lieutenant Dan Muldoon, led a cast that included Don Taylor, Howard Duff, Dorothy Hart, House Jameson, and Ted DeCorsica. Albert Maltz and Melvin Ward wrote the screenplay. William Daniels won an OSCAR for cinematography, as did Paul Weatherwax for editing. The film was the basis of the popular television series of that name (1959–60 and 1961–63).

Nanook of the North (1922), the classic early documentary film, written, directed, photographed, and edited by Robert FLAHERTY; a moving, humane ethnological study of Eskimo life in the Arctic. Nanook was the head of the Eskimo family at the center of the work.

Napoleon (1927), the epic, technically innovative film, written and directed by Abel GANCE; a landmark in film history that had been largely lost until its reconstruction and reissue by Kevin Brownlow in 1981, with a new score by Carmine Coppola. Albert Dieudonné played the mature Napoleon, supported by a huge cast, with Antonin ARTAUD, Alexandre Koubitsky, Gina Manes, Pierre Batcheff, Harry Krimer, and Gance himself in key supporting roles.

Narayan, Rasipuram Krishnaswami (1906–), Indian writer, the creator of the fictional South Indian village of Malgudi, the setting of his novels. The best known of these are the autobiographical *Swami and His Friends* (1935), *The Bachelor of Arts* (1937), and *The English Teacher* (1945); his work also includes such novels as *Mr. Sampath* (1949), *Waiting for the Mahatma* (1955), *The Guide* (1958), *The Man-Eater of Malgudi* (1961), *The Painter of Signs* (1977), and *A Tiger for Malgudi* (1983). He also wrote several collections of short stories. Narayan wrote in English and translated several classic Indian works, including *The Ramayana*.

Nash, Ogden (1902–71), U.S. writer, a sophisticated creator of satirical light verse, whose work was from 1930 largely carried in *The New Yorker* and then collected in his many volumes of poetry. He also wrote the lyrics for several musicals, including *One Touch of Venus* (1943) and *Two's Company* (1952).

Nash, Paul (1889–1946), British painter; he became a landscape painter in the years immediately before World War I, and was an official war artist from late 1917, making drawings at the front that became the basis for such highly regarded war paintings as *We Are Making a New World* (1918) and *The Menin Road* (1919). During the interwar period he moved from such landscapes as *The Wall Against the Sea* (1922) and *Wood on the Downs* (1929) to the more surrealist-influenced work of the 1930s and 1940s, such as *The Three Rooms* (1937) and *Solstice of the Sunflower* (1945). In the 1920s he also emerged as a leading book illustrator. He was a war artist again in World War II, focusing on the air war in such works as *Night Fighter* (1940) and *Totes Meer* (1941).

Nashville (1975), the Robert ALTMAN film, a highly textured work set in the country-music world, with Lily Tomlin, Ronee Blakley, Henry Gibson, Karen Black, Geraldine Chaplin, Keith Carradine, Barbara Harris, and Ned Beatty among those in a large cast playing very effectively in ensemble. Altman produced and directed; the screenplay was by Joan Tewkesbury. Carradine's song "I'm Easy" won an OSCAR.

Native Son (1940), the Richard WRIGHT novel, set in Chicago's South Side Black ghetto. It was dramatized by Wright and Paul GREEN in 1941 and produced on Broadway by Orson WELLES and John HOUSEMAN, with Canada LEE creating the Bigger Thomas role. Wright himself played the role in Pierre Chenal's 1950 low-budget film version of the work, while Victor Love played the role in Jerrold Freedman's 1986 film.

Nazimova, Alla (1879–1945), Russian actress, who studied with Constantin STANISLAVSKY at the MOSCOW ART THEATRE and was on stage in St. Petersburg in 1904. She emigrated to the United States in 1905, and began playing English-language roles in 1906, becoming a Broadway star with her *Hedda Gabler* (1906), and then starred for over three decades in the major modern classics, most notably in Ibsen and Chekhov. She was on screen from 1916, in such roles as CAMILLE (1921), Nora in *A Doll's House* (1922), and *Salome* (1923), and during the early 1940s also played several substantial character roles on film.

Neagle, Anna (Marjory Robertson, 1904–87), British actress, a major film star, often in biographical works, from the early 1930s through the 1950s, in such movies as BITTER SWEET (1933), *Nell Gwyn* (1934), *Victoria the Great* (1937), *Nurse Edith Cavell* (1939), *They Flew Alone* (1942), *The Courtneys of Curzon Street* (1947), and *The Lady with the Lamp* (1951).

Neal, Patricia (1926–), U.S. actress, on stage from 1946 and on screen from 1949. She won a TONY for her creation of Regina in *Another Part of the Forest* (1946), and a best actress OSCAR as Alma in HUD (1963). She also appeared in such films as *John Loves Mary* (1949), *The Fountainhead* (1949), *The Hasty Heart* (1950), A FACE IN THE CROWD (1957), BREAKFAST AT TIFFANY'S (1961), *In Harm's Way* (1965), and *The Subject Was Roses* (1968). The latter was a personal triumph, for it came after three years of confinement following a series of strokes that left her partially paralyzed. Her later career included many television appearances. Glenda JACKSON played Neal in the 1981 film biography *The Patricia Neal Story*. Neal was married to writer Roald Dahl.

Negri, Pola (Apollonia Chalupiec, 1894–1987), Polish actress, on stage from 1913 and on screen from 1914. In Germany from 1917, she became a star in such films as *Carmen* (1918) and *Madame Dubarry* (1919). She then went to Hollywood in 1923, and became a leading star of the silent-film era, though far more for her heavily publicized offstage romance with Rudolph VALENTINO than for the quality of her films. She did not make the transition to sound successfully, and she went back to Germany in the mid-1930s.

Nelson, Willie (1933–), U.S. singer, songwriter, and guitarist, who composed, recorded, and toured with modest success from the early 1960s through the mid-1970s, and then emerged as a major country-music and popular-music star, beginning with his album *Redheaded Stranger* (1975), led by BLUE EYES CRYIN' IN THE RAIN. It was followed by such albums as *Wanted: The Outlaws* (1976); *Waylon and Willie* (1978); *Stardust* (1978), with his versions of GEORGIA ON MY MIND and BLUE SKIES; *Willie and Family Live* (1979); *Honeysuckle Rose* (1980), the soundtrack of his film of that name, with the song ON THE ROAD AGAIN; and ALWAYS ON MY MIND (1982). On screen, he also appeared in such films as *The Electric Horseman* (1979), *Barbarossa* (1982), *Songwriter* (1984), and *Redheaded Stranger* (1986). He continued to be one of the most popular of American singers throughout the 1980s and into the 1990s.

neorealism, the movement toward stark, dark-toned, often bitter realism that characterized the Italian cinema in the post-World War II period, developed most fully for wide Italian and international audiences by OPEN CITY (1945), PAISAN (1946), SHOESHINE (1946), and THE BICYCLE THIEF (1948).

Neruda, Pablo (Ricardo Neftali Reyes Basualto, 1904–73), Chilean writer and diplomat; his first two collections of poems, *Crepusculario* (1923) and *Twenty Love Songs and a Song of Despair* (1924), established him as a major popular poet, while his three-volume *Residence on Earth* (1931–37), much of the work written while Chilean consul in Burma, established him as one of the leading Spanish-language poets of the 20th century. Neruda was in Spain in 1936, at the outbreak of the Spanish Civil War; much of his further work reflected the impact of war and fascism and of his growing commitment to communism. His most notable later work was the epic *General Song* (1950), much of it written while he was underground in Chile during a period of repressive right-wing government. He was awarded the NOBEL PRIZE for literature in 1971.

Nervi, Pier Luigi (1891–1979), Italian engineer, whose main work was with reinforced construction forms and techniques. Some of his major projects were his collaboration on the Paris UNESCO headquarters (1958); Milan's Pirelli Building, the first Italian skyscraper (1959); several structures for the 1960 Rome Olympics; the Dartmouth College fieldhouse (1962); and Sydney's Australia Square (1969).

Network (1976), the Sidney LUMET film, set in a frenzied, vicious American television world; a satire that was in some significant specifics—though far from all—as much prophecy as fantasy. The cast included William HOLDEN, Faye DUNAWAY, Peter FINCH, Robert DUVALL, Beatrice Straight, Ned Beatty, and Wesley Addy. Paddy CHAYEVSKY wrote the screenplay. Chayevsky, Finch as best actor, Dunaway as best actress, and Straight as best supporting actress all won OSCARS.

Neutra, Richard (1892–1970), Austrian architect, who worked in Europe from 1911, emigrated to the United States in 1923, and became a leading modernist American architect (see MODERNISM). His main strength was in home design, as expressed in the landmark INTERNATIONAL STYLE Lovell House (Los Angeles, 1929), and then for several decades in a body of California-centered work that more and more amended the International Style to create work that integrated nature and natural forms with habitations. Two very notable works of the early postwar period, which helped set West Coast styles for generations, were the Palm Springs Kaufmann desert house (1947) and the Santa Barbara Tremaine house (1948).

Nevelson, Louise (Louise Berliawsky, 1900–88), U.S. sculptor, who emerged as a major

figure in the 1950s. She is best known for such wood assemblages as *Sky Cathedral* (1958), reliefs made up into walls with compartments containing a variety of "found" and created objects, and painted a uniform white, black, or gold. Her later work went beyond wood to such materials as steel, aluminum, and Lucite, and included a considerable number of environmental and outdoor sculptures, such as *Night Presence IV* (1972) and *Transparent Horizon* (1975).

new age music, a rather spongy name for a considerable range of contemporary popular music, all sharing a soft, low-volume profile antithetical to the main trends in contemporary ROCK music. The term awaits adequate definition, as the body of music it describes has considerable affinities with what in an earlier time was called "background music."

Newhart, Bob (1929–), U.S. entertainer, in television from the late 1950s, who became a leading comedy star of the 1970s in his long-running "The Bob Newhart Show" (1972–78), in which he played a gentle psychologist. He has also appeared in many films and telefilms, including CATCH-22 (1970) and *Little Miss Marker* (1982).

Newley, Anthony (1931–), British actor, composer, and director, best known for the stage musical *Stop the World—I Want to Get Off* (1961; co-written and co-composed with Leslie Bricusse); Newley also directed and starred. He also appeared in such films as OLIVER TWIST (1948) and *Cockleshell Heroes* (1956), and with Bricusse wrote the James BOND "Goldfinger" theme in 1964 and the score for the film *Willy Wonka and the Chocolate Factory* (1970).

Newman, Barnett (1905–70), U.S. artist, who in the late 1940s emerged as an Abstract Expressionist (see ABSTRACT EXPRESSIONISM), notably with the monochromatic red *Onement* (1948). He was to explore monochromes of varying sizes and shapes for the rest of his life, in such works as his *Stations of the Cross* series (1966) and *Jericho* (1969).

Newman, Paul (1925–), U.S. actor, director, and producer, on stage from 1953 and on screen from 1955, who became a major international star from the late 1950s, with such films as *Somebody Up There Likes Me* (1956); CAT ON A HOT TIN ROOF (1958); *The Hustler* (1961); HUD (1963); *Cool Hand Luke* (1967); BUTCH CASSIDY AND THE SUNDANCE KID (1969); THE STING (1973); *Absence of Malice* (1982); *The Color of Money* (1986), for which he won a best actor OSCAR; *Blaze* (1989); and *Mr. and Mrs. Bridge* (1990). He directed such films as *Rachel, Rachel* (1968), which starred his wife, Joanne WOODWARD, and directed and starred in *Fort Apache, the Bronx* (1981).

Newman, Randy (1944–), U.S. singer, songwriter, and pianist, from the late 1960s a leading satirist who was especially well received on college campuses and with such albums as *Randy Newman* (1968), *12 Songs* (1970), *Live* (1971), *Sail Away* (1972), *Good Old Boys* (1974), *Little Criminal* (1977), *Born Again* (1979), and *Trouble in Paradise* (1983). He also did the score of the film RAGTIME (1981).

Newton-John, Olivia (1948–), British singer and actress, raised in Australia, who became a very popular singer in the United States with such albums as *Let Me Be There* (1973), *If You Love Me, Let Me Know* (1973), *Totally Hot* (1977), and *Physical* (1981). She starred opposite John TRAVOLTA in the film version of GREASE (1978).

New Wave, a name loosely applied to the work of a group of young French directors of the late 1950s, including François TRUFFAUT, Roger VADIM, Jean-Luc GODARD, and Louis MALLE. Many of them in the early 1950s had written for CAHIERS DU CINÉMA, in that earlier period developing the AUTEUR theory, which described the director as the "author" in films and so justified the highly personal, often idiosyncratic films favored by the New Wave filmmakers.

New York City Ballet, The, U.S. ballet company, from 1964 housed at the New York State Theater at Lincoln Center. It is descended from the School of American Ballet, founded in 1934 by Lincoln Kirstein and George BALANCHINE, who was brought to the United States by Kirstein for that purpose. The school was succeeded by the American Ballet (1935),

Ballet Caravan (1936), and the Ballet Society (1946), in 1948 becoming part of the New York City Center for Music and Drama under its present name. Under Balanchine's artistic direction, it became one of the world's great ballet companies.

New York School, a synonym for the school of ABSTRACT EXPRESSIONISM, developed in and around New York City in the immediate post-World War II period.

Nexö, Martin Andersen (1869–1954), Danish writer and revolutionary, best known for his two massive novels about the underside of Danish life: the four-volume *Pelle the Conqueror* (1906–10) and the five-volume *Ditte, Daughter of Man* (1917–21). *Pelle the Conqueror* was the basis for the 1988 Bille August film, with Max von SYDOW and Pelle Hvenegaard in the leads.

Nicholas Nickleby (*The Life and Adventures of Nicholas Nickleby*, 1980), the David Edgar play, adapted from the Dickens novel and directed by Trevor NUNN and John Caird, with words and music by Stephen Oliver. The ROYAL SHAKESPEARE COMPANY presented the work in London in 1980 and on Broadway in 1982, with a huge cast that included Roger Rees in a TONY-winning title role and Emily Richard, John Woodvine, and Priscilla Morgan as the rest of the Nickleby family. The work won a best play Tony.

Nichols, Mike (Michael Igor Peschkowsky, 1931–), U.S. director and actor, in cabaret with Chicago's Compass group in the mid-1950s and on Broadway in *An Evening with Mike Nichols and Elaine May* (1960). He then moved into directing, in the early years primarily of such comedies as *Barefoot in the Park* (1963), *Luv* (1964), and *The Odd Couple* (1965), and later of a wider range of plays. He directed such films as WHO'S AFRAID OF VIRGINIA WOOLF? (1965), THE GRADUATE (1967), CARNAL KNOWLEDGE (1971), *The Fortune* (1975), *Silkwood* (1983), *Heartburn* (1985), and *Postcards from the Edge* (1990).

Nichols, Peter (1927–), British writer, who emerged as a major modern playwright with his black comedy *A Day in the Death of Joe Egg* (1967), which became the 1972 Peter Medak film, with Alan BATES and Janet SUZMAN in the leads. He followed it with a second hit black comedy, *The National Health* (1969), and then such plays as *Forget-Me-Not Lane* (1971), *Chez Nous* (1974), and *Passion Play* (1981).

Nicholson, Jack (1937–), U.S. actor and director, on screen from 1958, who was recognized as a strong supporting player with his best supporting actor OSCAR for EASY RIDER (1969) and then became a major international star, with such films as FIVE EASY PIECES (1971); CHINATOWN (1974); ONE FLEW OVER THE CUCKOO'S NEST (1975), for which he won a best actor OSCAR; TERMS OF ENDEARMENT (1983), winning a best supporting actor OSCAR; PRIZZI'S HONOR (1984); IRONWEED (1987); BATMAN (1989); and *The Two Jakes* (1990).

Nielsen, Asta (1883–1972), Danish actress, on stage from the early 1900s and on screen from 1910. She became a major film star after going to Germany in 1911, in such roles as *Hamlet* (1920), *Miss Julie* (1922), and *Hedda Gabler* (1924). Her film career did not survive the transition to sound, though she continued to appear on stage through the end of the interwar period, in Germany until 1933, and back home in Denmark after Hitler came to power.

Nielsen, Carl (1865–1911), Danish composer, whose early work includes the first two symphonies (1892 and 1902) and the opera *Saul and David* (1902). He emerged as a major figure with such works as the opera *Masquerade* (1906), the *Third Symphony* (1911), and the *Violin Concerto* (1911). His later work, which included three more symphonies and much instrumental and choral music, further established him as Denmark's foremost modern composer. In these works he moved toward the polytonal forms characteristic of much of 20th-century classical music.

Niemeyer, Oscar Soares Filho (1907–), Brazilian architect; he is best known for his design of the public buildings of the capital city of Brasília (1956–61), done largely in massive free-form concrete.

"Night and Day" (1932), the Cole PORTER song, introduced by Fred ASTAIRE and Claire Luce on Broadway in *The Gay Divorcé* (1932). Words and music were by Porter.

Night at the Opera, A (1935), the classic MARX BROTHERS comedy film, directed by Sam Wood, written by George S. KAUFMAN and Morrie Ryskind, and starring Groucho, Chico, and Harpo, strongly supported by Margaret Dumont, Sig Rumann, and Walter Woolf King, with Kitty Carlisle and Allan Jones in the main singing roles.

Night Must Fall (1935), the Emlyn WILLIAMS play, in which he also played the central role of the psychopathic killer, Danny, in London and New York (1935 and 1936). The play was adapted by John VAN DRUTEN into the 1937 Richard Thorpe film, starring Robert MONT-GOMERY as Danny, in a cast that included Rosalind RUSSELL, May Whitty, Alan Marshal, and Kathleen Harrison. The 1954 remake, directed by Karel Riesz, starred Albert FINNEY and Susan HAMPSHIRE.

Night of the Hunter (1955), the Charles LAUGHTON film, his only directorial outing. Robert MITCHUM was Harry Powell, the self-styled preacher who is both homicidal fanatic and outlaw. Shelley WINTERS was the woman he murdered for the money her husband had stolen; Sally Jane Bruce and Billy Chapin were her children, whom he pursues downriver with murder in mind; and Lillian GISH was the old woman who ultimately shields them and turns him away. James AGEE wrote the screenplay, based on the David Grubb novel of that name.

Nights of Cabiria (1956), a film written and directed by Federico FELLINI, with Giulietta MASINA in the title role as an indomitable Roman prostitute, supported by François Perier, Franca Marzi, Amedeo Nazzari, and Dorian Gray. The movie won a best foreign film OSCAR. The 1966 American musical SWEET CHARITY was based on the film.

Night to Remember, A (1958), the Roy Baker film, a disaster movie re-creating the sinking of the passenger liner *Titanic*, on colliding with an iceberg in the North Atlantic on April 15, 1912; the Eric AMBLER screenplay was based on the Walter Lord novel. The cast included

Vaslav Nijinsky dancing in the Ballet Russes production of *Giselle*, in 1910.

Kenneth MORE, Laurence Naismith, Alec McCOWEN, Honor Blackman, George Rose, Michael Goodliffe, and Frank Lawson.

Nijinska, Bronislava Fominitshna (1891–1972), Russian dancer and choreographer, the sister of Vaslav NIJINSKY. She was with the Maryinsky Theatre (1908–11), a dancer with the BALLET RUSSES of Sergei DIAGHILEV in Paris (1909–14), and briefly with her brother's company in 1914, before returning to Russia at the outbreak of World War I. She was back with Diaghilev from 1921 to 1924, then becoming the choreographer of such works as *Renard* (1922), *Les Noches* (1923), and *Les Biches* (1924), all of which became part of the standard repertory. Nijinska worked with several troupes, briefly had her own company during the 1930s, and founded a ballet school in Los Angeles in 1938.

Nijinsky, Vaslav (1890–1950), Russian dancer and choreographer, whose extraordinary gifts made him by far the most celebrated male ballet dancer of the first half of the 20th century. On graduation from the Imperial School of Ballet in 1907, he quickly became the leading

soloist at Leningrad's Maryinsky Theatre, dancing all the leads to enormous acclaim until he left the company in 1911. He became a world figure in 1909, on joining the Paris-based BALLET RUSSES of Sergei DIAGHILEV. With the Ballet Russes, Nijinsky originated leading roles in such landmark Michel FOKINE works as SCHEHERAZADE (1910), LE SPECTRE DE LA ROSE (1911), PETRUSHKA (1911), and DAPHNIS AND CHLOÉ (1912). He also choreographed and danced in such works as THE AFTERNOON OF THE FAUN (1912), THE RITE OF SPRING (1913), and *Till Eulenspiegel* (1916). When Nijinsky married in 1913, Diaghilev broke with him; Nijinsky then formed his own London-based company, which quickly failed. He was in Hungary at the outbreak of World War I and was interned; Diaghilev secured his release and sent him on an American tour. It was his last, for by 1916 the psychiatric problems that would confine him to mental hospitals for the rest of his life were evident.

Nilsson, Birgit (1918–), Swedish soprano. She made her debut at Stockholm in 1946, moved into Wagnerian roles during the early 1950s, and sang at Bayreuth and Covent Garden from 1957 and at the Metropolitan Opera from 1959 to 1975, as Isolde, as Turandot, and in other major roles in the repertory.

Nin, Anaïs (1903–77), U.S. writer, best known for her six-volume *Diary* (1966–76), covering her life and relationships with several literary figures, from 1931 to 1966. A seventh diary volume, covering her adolescence, appeared in 1978. Her novels include *The House of Incest* (1936), *Winter of Artifice* (1939), and *The Four-Chambered Heart* (1950); she also wrote short stories and essays. Some of her pornographic potboilers of the 1930s were reissued as *Delta of Venus* (1968).

1984 (1949), the George ORWELL novel, in which he portrays a viciously manipulative totalitarian state masquerading as a Utopia, as exemplified by the slogan "Big Brother is watching you," seen everywhere. It became a movie twice, as the 1956 Michael Anderson film, with Edmond O'Brien and Michael REDGRAVE in the central roles, and as the 1984 Michael Radford film, with John HURT and Richard BURTON in the leads.

1900 (1976), the Bernardo BERTOLUCCI film, an epic set in Italy and spanning much of the century. The huge cast was led by Burt LANCASTER, Robert DENIRO, Gerard DEPARDIEU, Donald SUTHERLAND, and Dominique Sanda.

Ninotchka (1939), the Ernst LUBITSCH comedy, with Greta GARBO as the solemn, humorless Russian trade representative in Paris and Melvyn DOUGLAS as the American with whom she ultimately falls in love. The story, by Charles Brackett, Billy WILDER, and Walter Reisch, was the basis for the 1955 Cole PORTER musical *Silk Stockings*, which became the 1957 Rouben MAMOULIAN film musical, with Fred ASTAIRE and Cyd Charisse in the leads.

Niven, David (James Graham David Niven, 1909–83), British actor, on screen in Hollywood from 1934, who played several substantial supporting roles during the late 1930s, beginning with his role in DODSWORTH (1936). He went on to leads in such films as *Raffles* (1940); *The Moon Is Blue* (1953); *Around the World in 80 Days* (1956); SEPARATE TABLES (1958), for which he won a best actor OSCAR; and *Casino Royale* (1967). Later in his career he played strong supporting roles on screen and on television.

Nobel Prizes, from 1901, a series of what have become the world's most prestigious annual prizes, in peace, literature, chemistry, physics, and physiology and medicine, established by the terms of the will of Swedish explosives inventor Alfred Nobel; from 1969 a prize in economics was also awarded.

Noguchi, Isamu (1904–88), U.S. sculptor and designer; after an apprenticeship with Constantin BRANCUSI in the late 1920s, he emerged as a versatile, abstract sculptor in a several materials, as in his bronze reliefs for New York's Associated Press building (1938), the aluminum *Kouros* (1946), and his stone *Euripides* (1946). He was a leading set designer for the dance from the mid-1930s, for such works as Martha GRAHAM's APPALACHIAN SPRING (1935), Merce CUNNINGHAM's *The Seasons* (1947), and George BALANCHINE's ORPHEUS (1948). Noguchi also designed furniture, playgrounds, a bridge sculpture for the

Hiroshima Peace Park, and several sculpture gardens, including those for the Paris UNESCO headquarters and Connecticut General Life Insurance Company.

Nolan, Sidney Robert (1917–), Australian painter; his best-known work is on historical themes, as in his late 1940s and mid-1950s series on bushranger Ned Kelly, and his late 1940s series on shipwrecked Eliza Fraser and on the Eureka Stockade uprising. In his later work, he drew series themes from such events as Gallipoli and such mythology as Leda and the Swan. He was also a set designer, beginning with Serge LIFAR's *Icarus* (1940).

Nolte, Nick (1942–), U.S. actor, who emerged as a film star in the late 1970s, with such films as *Who'll Stop the Rain* (1978), *North Dallas Forty* (1979), *Cannery Row* (1982), *48 Hours* (1982), *Under Fire* (1983), *Down and Out in Beverly Hills* (1986), *Extreme Prejudice* (1987), *Farewell to the King* (1989), *Three Fugitives* (1989), and *Everybody Wins* (1990).

Norma Rae (1979), the Martin Ritt film, with Sally FIELD in the title role, as a rank-and-file southern textile union organizer, playing opposite Ron Liebman and Beau BRIDGES, with Pat Hingle and Barbara Baxley in key supporting roles. Field won an OSCAR, as did David Shire and Norman Gimbel for the song "It Goes Like It Goes."

North by Northwest (1959), the Alfred HITCHCOCK film, written by Ernest Lehman; a suspense story that starts in New York, becomes a long, complicated chase, and includes some scenes that have become suspense classics, notably the crop-dusting attack and the Mount Rushmore denouement. Cary GRANT was the protagonist, opposite Eva Marie SAINT, in a cast that included James MASON, Leo G. Carroll, Jesse Royce Landis, Martin Landau, and Philip Ober.

Novak, Kim (1933–), U.S. actress, on screen from 1954. She quickly became a major Hollywood star of the mid-1950s and early 1960s, in such films as PICNIC (1956), *Pal Joey* (1957), *Vertigo* (1958), *Bell, Book, and Candle* (1958), *Strangers When We Meet* (1960), and OF HUMAN BONDAGE (1964). Then her career

A key example of early modernism—Marcel Duchamp's *Nude Descending a Staircase, No. 2* (1912).

faded, although her later work included several television and film appearances.

Nowlan, Philip, and **Richard Calkins,** the creators, in 1929, of comic-strip science-fiction hero Buck ROGERS.

Now, Voyager (1942), the Irving Rapper film, with Bette DAVIS in the role of a repressed, then flowering moneyed Boston woman, playing opposite Paul HENREID and Claude RAINS, in a cast that included Gladys Cooper, John Loder, Bonita Granville, Ilka Chase, and Lee Patrick. Casey Robinson's screenplay was based on an Olive Higgins Prouty novel. Max Steiner won an OSCAR for the music.

Noyes, Alfred (1880–1958), British writer, best known for his narrative poems, most notably the popular *Drake: An English Epic* (1906–8), which was serialized in *Blackwood's Magazine,* and for the often-anthologized "The Highwayman."

Nude Descending a Staircase, No. 2 (1912), the celebrated early modernist painting (see MODERNISM) by Marcel DUCHAMP, a cinematic superimposition of five images, perceived as a single machine-age object. The

A prime ballet partnership: Rudolf Nureyev and Margot Fonteyn rehearse a scene from Roland Petit's *Paradise Lost* in 1967.

work was refused exhibition in Paris but was highly controversial and a great success when shown a year later at the 1913 ARMORY SHOW in New York. It became one of the emblems of the modern-art movement, and Duchamp, although his output was very small, became one of the legendary progenitors of DADA, SURREALISM, and such later movements as POP ART and KINETIC ART.

Nunn, Trevor (1940–), British director, whose work was on stage from 1965, most of it in the classics, and done in association with the ROYAL SHAKESPEARE COMPANY, which he joined in 1964. He was artistic director of the company, 1978–87, and chief executive from 1987. He directed his own adaptation of *Hedda Gabler* in 1975 and adapted it into the film *Hedda* (1985). Nunn collaborated with Andrew LLOYD-WEBBER on several 1980s plays and directed *The Life and Adventures of Nicholas Nickleby* (1980), CATS (1981), *Starlight Express* (1984), *Les Misérables* (1985), and *Aspects of Love* (1989). On film his work includes *Lady Jane* (1985); he has also directed several television plays.

Nureyev, Rudolf Hametovich (1938–), Soviet dancer and choreographer, a leading contemporary dance figure, whose work has often been compared to that of Vaslav NIJINSKY. He was on stage from the age of 15 and was a soloist at the KIROV BALLET from 1958 until his defection to the West in 1961. From 1962 he danced often opposite Margot FONTEYN at the ROYAL BALLET, as well as worldwide in a wide range of classical and modern leading roles. He choreographed such works as *Tancredi* (1966), *Romeo and Juliet* (1977), *The Tempest* (1982), *Washington Square* (1985), and *Cinderella* (1986), as well as restaging several other ballets. He also appeared in such films as *I Am a Dancer* (1972), *Don Quixote* (1972), *Valentino* (1977), *Exposed* (1982), and *Cinderella* (1986).

Nykvist, Sven (1922–), Swedish cinematographer, whose work was on screen from 1945 and who in 1960, with THE VIRGIN SPRING, began the long association with Ingmar BERGMAN that was to make him one of the leading cinematographers of the period, although he also worked with many other directors. He won an OSCAR for his *Cries and Whispers* (1972) and later shot such films as *Swann in Love* (1985) and AGNES OF GOD (1987).

O

Oates, Joyce Carol (1938–), U.S. writer, who emerged as a major literary figure in the mid-1960s, with such powerful, despairing novels as *With Shuddering Fall* (1964); *A Garden of Earthly Delights* (1967); *Expensive People* (1968); and *them* (1969), which won a National Book Award, all of them peopled with characters at the edge of madness in an America perceived as an insane culture. Her work includes a substantial number of short stories, several volumes of poetry, and a considerable body of critical work, as well as such further novels as *Childwold* (1976), *Son of the Morning* (1978), *Bellefleur* (1980), and *Solstice* (1985).

O'Casey, Sean (John Casey, 1880–1964), Irish writer, three of whose early plays, all related to the Irish Revolution and Civil War, and all produced at the ABBEY THEATRE, established him as one of the leading playwrights of the century. These were his Civil War stories *The Shadow of a Gunman* (1923); JUNO AND THE PAYCOCK (1924); and his Easter Rising story THE PLOUGH AND THE STARS (1926), which satirized some of those nationalists who later went on to establish the new Irish state and generated riots when produced by the Abbey in Dublin. O'Casey left Ireland in 1927. In 1928, the Abbey refused to produce his anti–World War I *The Silver Tassie*, which was then produced in London in 1929. His later plays, many of them reflecting his communist convictions, include *Within the Gates* (1934), *The Star Turns Red* (1940), *Purple Dust* (1943), *Red Roses for Me* (1943), *Oak Leaves and Lavender* (1947), *Cock-a-Doodle-Dandy* (1949), *The Bishop's Bonfire* (1955), and *Behind the Green Curtains* (1961). His best-known collection of theater-related essays is *The Green Crow* (1956). His six-volume autobiography (1939–

54) was published as *Mirror in My House* (1956).

O'Connor, Edwin (1918–68), U.S. writer, whose novels include *The Oracle* (1951), THE LAST HURRAH (1956), his PULITZER PRIZE-winning *The Edge of Sadness* (1961), *I Was Dancing* (1964), and *All in the Family* (1966). *The Last Hurrah* became the 1958 John FORD film, with Spencer TRACY in the role of Irish-American Boston mayor Frank Skeffington, based loosely on the life of James M. Curley.

O'Connor, Flannery (Mary Flannery O'Connor, 1925–64), U.S. writer, whose Georgia-based, religiously oriented novels include *Wise Blood* (1952) and *The Violent Bear It Away* (1960) and whose short-story collections include *A Good Man Is Hard to Find* (1955) and the posthumous *Everything That Rises Must Converge* (1965).

O'Connor, Frank (Michael John O'Donovan, 1903–66), Irish writer, best known for his short stories, including the collections *Guests of the Nation* (1931), in part reflecting his own experiences during the Irish Civil War; *Bones of Contention* (1936); *Crab-Apple Jelly* (1944); *The Common Chord* (1947); *Traveller's Samples* (1950); and *Domestic Relations* (1957).

October (1928), the alternative name for the Sergei EISENSTEIN film TEN DAYS THAT SHOOK THE WORLD.

Odd Man Out (1947), the Carol REED film, set in Northern Ireland. James MASON was Irish Republican Army leader Johnny McQueen, wounded in a robbery in which a murder was done and on the run from the police, entirely disoriented and on his way to an early death. The cast included Kathleen Ryan, Dan O'Herlihy, Robert Newton, Cyril Cusack, Robert Beatty, Fay Compton, and Denis

O'Dea. R.C. SHERRIFF and F.L. Green adapted the work from the Green novel of that name.

Odets, Clifford (1906–63), U.S. writer and director, whose work included the one-act *Waiting for Lefty*, about a taxi drivers' strike; the play established him as a major 1930s playwright of left social commitment. It was produced by the GROUP THEATRE, which also produced his full-length *Awake and Sing!* (1935) and the one-act, anti-Nazi *Till the Day I Die* (1935). His most notable plays also include the Group Theatre-produced GOLDEN BOY (1937), which became the 1939 Rouben MAMOULIAN film; *The Big Knife* (1949), a bitter attack on Hollywood that became the 1955 Robert ALDRICH film; and THE COUNTRY GIRL, (1950) which became the 1954 George Seaton film. Odets also wrote the screenplays for such films as *The General Died at Dawn* (1936); *None but the Lonely Heart* (1944), which he also directed; and *The Sweet Smell of Success* (1957).

Odetta (Odetta Holmes Felious Gorden, 1930–), U.S. folksinger, songwriter, and actress, on stage in cabaret from the early 1950s. From the mid-1950s, she made such records as *Odetta Sings Ballads and Blues* (1956), *Odetta at the Gate of Horn* (1957), *Odetta and the Blues* (1962), and *Odetta Sings Folk Songs* (1963). She continued to record through the mid-1970s and appeared in concert worldwide for well over three decades.

O'Faoláin, Seán (John Whelan, 1900–), Irish writer, who emerged as a major figure with his first short-story collection, *Midsummer Night Madness and Other Stories* (1932), and his first novel, *A Nest of Simple Folk* (1933). His later work includes several biographies, a play, and such novels as *Come Back to Erin* (1940) and *And Again* (1979). His collected short stories were published in three volumes (1980–82).

Official Story, The (1985), the Luis Penzo film, a best foreign film OSCAR-winner about ordinary Argentinians caught in the antihuman maelstrom that was right-wing-ruled Argentina. Penzo and Aida Bortnik wrote the screenplay; the cast included Norma Aleandro, Analia Castro, and Hector Alterio.

Of Human Bondage (1915), the Somerset MAUGHAM novel, probably partly autobiographical in its early sections, about the life and development of Philip Carey, a handicapped boy who struggles to become an artist while a poor medical student, and of his obsessional affair with Mildred, an uneducated waitress; he ultimately finds himself a defeated country doctor married to a conventional woman. Lester Cohen adapted the novel into the 1934 John CROMWELL film, with Leslie HOWARD as Philip opposite Bette DAVIS as Mildred; the cast included Kay Johnson, Frances Dee, Reginald Denny, and Alan Hale. The film was remade twice: by Edmund Goulding in 1946, with Paul HENREID and Eleanor Parker in the starring roles; and by Henry Hathaway in 1964, with Laurence HARVEY and Kim NOVAK in the leads.

O'Flaherty, Liam (1896–1984), Irish writer, whose best-known work, THE INFORMER (1925), was rooted in his own experiences of working-class life in Dublin during the Irish Revolution and Civil War. His work includes such novels as *The Assassin* (1928) and *Famine* (1937) and several volumes of lyrical short stories, many of them set in his native Aran Islands, in such collections as *Spring Sowing* (1926) and *Two Lovely Beasts and Other Stories* (1948). *The Informer* was quite notably adapted by Dudley Nichols into the 1935 John FORD film, with Victor MCLAGLEN giving an OSCAR-winning performance in the title role and with Ford, Nichols, and Max Steiner also winning Oscars.

Of Mice and Men (1937), the John STEINBECK novel; the story of huge, slow Lenny and his friend George, both migrant workers in Depression-era California. Steinbeck made it the basis of his 1937 play, with Broderick CRAWFORD as Lenny and Wallace Ford as George. Lon Chaney, Jr., was Lenny in the classic 1939 Lewis MILESTONE film, with Burgess MEREDITH as George.

"Of Thee I Sing" (1931), the title song of the PULITZER PRIZE-winning musical introduced on Broadway by William Gaxton, with music

by George GERSHWIN and words by Ira Gershwin.

O'Hara, John Henry (1905–70), U.S. writer, who emerged as a popular novelist in the mid-1930s, with such novels as *Appointment in Samarra* (1934) and BUTTERFIELD 8 (1935), in the same period prolifically writing short stories, many of them published in *The New Yorker* and in such collections as *The Doctor's Son and Other Stories* (1935) and *Files on Parade* (1939). In 1940 he adapted several of his short stories into the book of the Richard RODGERS and Lorenz HART musical *Pal Joey*. His best-known later novels include *A Rage to Live* (1949), *Ten North Frederick* (1955), and *From the Terrace* (1958). He published several later collections of short stories and also wrote several screenplays. Many of his works later became films, most notably *Pal Joey*, the 1957 George Sidney film starring Rita HAYWORTH and Frank SINATRA; *Ten North Frederick*, the 1958 Philip Dunne film, with Gary COOPER, Geraldine FITZGERALD, and Suzy Parker in leading roles; *Butterfield 8*, the 1960 Daniel MANN film, for which Elizabeth TAYLOR won a best actress OSCAR; and *From the Terrace*, the 1960 Mark Robson film, with Paul NEWMAN in the central role, strongly supported by Joanne WOODWARD and Myrna LOY.

O'Hara, Scarlett, the classic lead in GONE WITH THE WIND (1939), the self-centered southern belle created in the film by Vivien LEIGH.

"Oh, How I Hate to Get Up in the Morning" (1918), the Irving BERLIN song; he sang it in his World War I play *Yip Yip Yaphank* (1918) and again in his *This Is the Army* (1942). Both words and music were by Berlin.

"Oh, What a Beautiful Morning" (1943), the opening song of OKLAHOMA!, introduced by Alfred Drake on Broadway, with music by Richard RODGERS and words by Oscar HAMMERSTEIN II.

Oh! What a Lovely War (1963), the antiwar play, set in World War I and produced by Joan Littlewood at the Theatre Workshop; it was based on Charles Chilton's 1961 BBC radio feature "The Long, Long Trail." Len Deighton adapted the work into the 1969

Richard ATTENBOROUGH film, his first, with a cast that included many of the most luminous figures in the British theater, including Laurence OLIVIER, John MILLS, John GIELGUD, Ralph RICHARDSON, Michael REDGRAVE, Vanessa REDGRAVE, John CLEMENTS, Kenneth MORE, and Jack HAWKINS.

Oistrakh, David Fyodorovich (1908–74), Soviet violinist, generally recognized as one of the leading violinists of the 20th century, who was noted for his playing of modern Soviet works, as well as of Beethoven, Brahms, Tchaikovsky, and other classical composers. He made his Moscow debut in 1933, beginning to record in the same period; his work was available to the rest of the world mainly on records, until he began to tour more freely in 1951. His son **Igor Davidovich Oistrakh** is also a leading Soviet violinist; late in David Oistrakh's career, he and his son sometimes played and toured together.

O'Keeffe, Georgia (1887–1986), U.S. artist; from the mid-1920s, she emerged as one of the most celebrated American artists of the century, whose figurative paintings notably caught and abstracted the qualities of the objects and scenes painted. Her early life as a painter was deeply intertwined with that of Alfred STIEGLITZ, who was the first to exhibit her work, at the 291 Gallery in 1916 and again in 1917, the year he began his long series of photos of O'Keeffe. She and Stieglitz were married in 1924. During the 1920s O'Keeffe painted such cityscapes as *Radiator Building—Night, New York* (1927), *East River from the Shelton* (1928), and *New York Night* (1929). She also then began the long series of enlarged flowers and other plants that became a major aspect of her work, such as *Red Poppy* (1927), *The White Trumpet Flower* (1932), and *An Orchid* (1941). In 1929 she made her first summer visit to New Mexico, settling there permanently in 1948, two years after Stieglitz's death. There she spent almost four more decades, in that long period creating a massive further body of work, much of it reflecting her lifelong affinity for the sky, land, bones, structures, and artifacts of the American West; her works in this vein include *Cow's Skull—Red, White and Blue* (1930), *Ram's Head with Holly-*

hock (1935), *Pelvis with Moon* (1943), *Black Place III* (1944), *Ladder to the Moon* (1958), *The Winter Road* (1963), and the huge *Sky Above Clouds* (1965).

Oklahoma! (1943), the classic Richard ROD-GERS–Oscar HAMMERSTEIN II musical, a landmark in the history of the American musical theater. It was adapted from the 1931 Lynn Riggs play *Green Grow the Lilacs*, with a score that included such songs as "Oklahoma!," OH, WHAT A BEAUTIFUL MORNING, "Surrey with the Fringe on Top," and PEOPLE WILL SAY WE'RE IN LOVE, and a set of Agnes DE MILLE ballets that set a new musical-theater style for a generation. Alfred Drake was Curly, Joan Roberts was Laurey, and Celeste HOLM was Ado Annie. In Fred ZINNEMANN's 1955 film version Gordon MacRae, Shirley JONES, and Shirley Grahame, respectively, played those roles.

Old Acquaintance (1943), the Vincent Sherman film, about the long, complex relationship between two childhood friends. Bette DAVIS was Katherine Marlowe, a highly literary author and entirely admirable human being, opposite Miriam HOPKINS as her antithesis, as writer and human being; yet they remain life-long friends. John VAN DRUTEN and Lenore Coffee adapted the Van Druten play of that name. The film was remade by George CUKOR in 1981, as RICH AND FAMOUS, with Jacqueline BISSET and Candice BERGEN in the leads.

Oldenburg, Claes Thure (1929–), U.S. artist, a leading POP figure from the late 1950s, who became well known for his organization of "happenings" and related events, and for his creation of such "giant objects" and "soft sculptures" as his *Giant Hamburger* (1962) and *Soft Typewriter* (1963). He later did a series of pop "colossal monument" proposals.

Old Man and the Sea, The (1952), the Ernest HEMINGWAY story, of the aging fisherman whose courage, alone against the elements and the sharks who attack his catch at sea, represents Hemingway's view of what is best in the human spirit. Spencer TRACY played the old man and Felipe Pazos the boy in the 1958 John Sturges film; Hemingway's story was the basis

of the Peter Viertel screenplay. Dmitri Tiompkin's score won an OSCAR.

Old Wives' Tale, The (1908), the novel by Arnold BENNETT, about two sisters through the years; it established him as one of the leading British realists of the early 20th century.

Olitski, Jules (1922–), U.S. painter and sculptor, from the mid-1960s best known as a painter for his sprayed, monochromatic color-field paintings, and as a sculptor for his large sprayed aluminum and later steel sheet sculptures of the late 1960s and 1970s.

Oliver! (1960), the Lionel Bart musical adaptation of OLIVER TWIST, which became Carol REED's 1963 OSCAR-winning film.

Oliver, King (Joseph Oliver, 1885–1938), U.S. musician, a New Orleans trumpeter, cornetist, bandleader, and composer, who became one of the leading JAZZ figures of his time, playing with and deeply influencing Louis ARM-STRONG and many other early jazz musicians. He led the Creole Jazz Band in Chicago in the early 1920s and in 1923 made several classic early jazz recordings; the band included Armstrong, Lillian Hardin (later Lil ARMSTRONG), Honoré Dutrey, Baby DODDS, and others. Oliver also played and recorded with Jelly Roll MORTON, Clarence WILLIAMS, and many other central figures in early jazz, leading his own band again in the late 1920s and early 1930s.

Oliver Twist (1948), the David LEAN version of the classic Dickens novel, the most notable of the several film versions, with a cast led by Alec GUINNESS, Robert Newton, and Anthony Newley. Frank Lloyd's 1922 silent version starred Jackie COOGAN and Lon CHANEY. The novel was also the basis of Lionel Bart's stage musical *Oliver!* (1960), which became the OSCAR-winning Carol REED film in 1963; Reed was among the several Oscar winners for the film.

Olivier, Laurence (1907–89), British actor, director, and producer, a major figure in world theater and cinema and an actor of extraordinary range and versatility. He was on stage from 1922 and on screen from 1930, and became a leading stage player in the mid-1930s, with his memorable alternation of

Laurence Olivier in the film that made him an international matinee idol, *Wuthering Heights* (1939), with Geraldine Fitzgerald.

Romeo and Mercutio with John GIELGUD at the New Theatre, followed by his Shakespeare season at the Old Vic, in which he played in the title roles in *Hamlet*, *Macbeth*, and *Henry V*. He became a film star with FIRE OVER ENGLAND (1937), in which he first worked with Vivien LEIGH; they married in 1940. On screen, he went on to become Heathcliffe in WUTHERING HEIGHTS (1939); Maxim de Winter in REBECCA (1940); HENRY V (1944); HAMLET (1948); *Richard III* (1955); Archie Rice in THE ENTERTAINER (1960); and much more, winning a special OSCAR for his acting, directing, and production of *Henry V* and best actor and best picture Oscars for *Hamlet*, as well as many other awards and nominations across the whole range of his film work. On stage he played in most of the great classic roles and in many of the modern classics, and from 1965 to 1973 he was the first director of Britain's National Theatre.

"Ol' Man River" (1927), the classic American song from SHOW BOAT (1927). It was introduced by Jules Bledsoe as Joe, and then became identified with Paul ROBESON, who sang it on stage in London and New York, recorded it, and sang it in the 1936 film and in concert for decades after, from the late 1930s altering the lyrics somewhat to suit his militant egalitarian political views. Music was by Jerome KERN, with words by Oscar HAMMERSTEIN II.

"Omnibus" (1953–61), the pioneering U.S. commercial television cultural series, hosted by Alistair Cooke and sponsored by the Ford Foundation. The series presented a wide variety of serious work drawn from all the arts to mass television audiences; its body of work pointed the way to the later development of public television.

Ondine, a ballet choreographed by Frederick ASHTON, with music by Hans Werner Henze; it was first produced in London, in October 1958, with Margot FONTEYN in the title role.

One Day in the Life of Ivan Denisovich (1962), the powerful, trailblazing novel by Alexander Isayevich SOLZHENITSYN, an indictment of the Soviet prison system that presaged much of the literature of dissent that followed.

One Flew Over the Cuckoo's Nest (1962), the Ken Kesey novel, about the life of a free, sane spirit trapped and destroyed in an insane asylum. Dale Wasserman adapted it for the stage in 1963, with Kirk DOUGLAS in the Randel P. McMurphy role. In 1975, it was adapted by Lawrence Hauben and Bo Goldman into the Milos FORMAN film, with Jack NICHOLSON and Louise Fletcher in the leads. The film, Forman, Nicholson as best actor, Fletcher as best actress, and the screenwriters all won OSCARS.

One Hundred Years of Solitude (1967), the novel by Gabriel GARCÍA MÁRQUEZ; a surreal portrayal of six generations of a family in the imaginary town of Macondo, modeled after his home town of Aracataca, and a metaphor for all of Latin American history.

O'Neill, Eugene Gladstone (1888–1953), U.S. writer, the foremost playwright of the American theater. He began to write plays in 1914 and joined the PROVINCETOWN PLAYERS in 1916; his first professional work, the one-acter *Bound East for Cardiff*, was produced by the

company in that year and was followed by a series of other one-act plays, which included THE LONG VOYAGE HOME (1917) and *The Moon of the Caribbees* (1918). With his PULITZER PRIZE-winning BEYOND THE HORIZON (1920), he was recognized as a major playwright. During the next 14 years, his extraordinary body of work grew to include such plays as THE EMPEROR JONES (1920), ANNA CHRISTIE (1921), *The Hairy Ape* (1922), ALL GOD'S CHILLUN GOT WINGS (1924), DESIRE UNDER THE ELMS (1924), *The Great God Brown* (1926), *Marco's Millions* (1928), his Pulitzer Prize-winning STRANGE INTERLUDE (1928), the trilogy MOURNING BECOMES ELECTRA (1931), and AH, WILDERNESS! (1933). O'Neill retired in 1934, largely due to illness, but came back with THE ICEMAN COMETH (1946). He wrote the autobiographical LONG DAY'S JOURNEY INTO NIGHT in 1940; it was produced posthumously, in 1956, winning a TONY and another Pulitzer Prize. *A Touch of the Poet* (1958) and *More Stately Mansions* (1964) were also posthumously produced. O'Neill was awarded the NOBEL PRIZE for literature in 1936.

One Man's Family (1932–59), the long-running, tremendously popular daytime radio series; the saga of the Barbour family of Sea Cliff, San Francisco, as they lived through the middle decades of the 20th century. The series was conceived and written by Carlton E. Morse; J. Anthony Smythe enjoyed a 27-year-long run in the title role, as Henry Barbour. A television version ran for three years (1949–52), with Bert Lytell in the title role.

On Golden Pond (1981), the film marking Henry FONDA's final starring role, 46 years after *The Farmer Takes a Wife*, for which he finally was awarded a long-overdue best actor OSCAR, playing opposite Katharine HEPBURN and his daughter Jane FONDA. The film was directed by Mark Rydell, while the Oscar-winning screenplay was adapted by Ernest Thompson from his play. Frances Sternhagen and Tom Aldredge starred in the 1979 Broadway production.

On the Beach (1957), the Nevil SHUTE novel, a post-atomic-war story set in an Australia waiting for the atomic cloud that will end life on Earth. At the height of the Cold War it became Stanley KRAMER's powerful 1959 anti-war film, with Gregory PECK, Ava GARDNER, Fred ASTAIRE, and Anthony PERKINS in leading roles.

"On the Good Ship Lollipop" (1934), the Shirley TEMPLE song; she sang it in *Bright Eyes* (1934), in the first year of her enormous worldwide popularity. Words and music were by Sidney Clare and Richard A.Whiting.

"On the Road Again," the Willie NELSON song, introduced by him in his 1980 film HONEYSUCKLE ROSE; words and music were by Nelson.

On the Town (1944), a COMDEN AND GREEN musical, with music by Leonard BERNSTEIN; it was based on the Jerome ROBBINS–Bernstein ballet FANCY FREE. Comden and Green adapted the play into the 1949 Gene KELLY–Stanley Donen film; the three sailors in the film were Kelly, Frank SINATRA, and Jules Munshin, playing opposite Betty Garrett, Ann Miller, and Vera-Ellen. Roger Eden and Lennie Hayton won an OSCAR for their film music.

On the Waterfront (1954), the Elia KAZAN film, a story of longshore union corruption set in New York, with a cast that included Marlon BRANDO, Eva Marie SAINT, Karl MALDEN, Lee J. COBB, and Rod STEIGER. Budd Schulberg based the screenplay on his own novel. The film, Kazan, Brando as best actor, Saint as best supporting actress, Schulberg, cinematographer Boris Kaufman, editor Gene Milford, and art director Richard Day all won OSCARS.

op art (optical art), artworks that seek to produce visual illusions with variations of form and color, usually coupled with geometrical abstraction; its precursors are to be found in FUTURISM, the flickering *cinétisme* of Victor VASARELY, and standard ophthalmological textbooks. Contemporary interest in op art as an art form blossomed in the mid-1960s. During the late 1960s and early 1970s, a briefly popular variant of op art was PSYCHEDELIC ART, an attempt to create forms portraying the sensory distortions produced by such drugs as LSD.

Open City (1945), the classic Roberto ROSSEL-LINI film, set in Rome, then declared an "open city," during the German occupation. Conceived during the Nazi occupation and shot soon after the liberation of Rome, this is a landmark antifascist work and simultaneously a landmark work in Italian and film history, ushering in a dark, new kind of realism, formally Italian NEOREALISM. The cast was led by Aldo FABRIZI as the priest; Anna MAGNANI as the pregnant young woman; and Marcello Paglieri as the Resistance leader, all of whom are ultimately murdered by the Germans. The film was shot by Ubaldo Arata.

Ophüls, Marcel (1927–), German-French director, the son of Max OPHÜLS; his work was on screen from 1960. He became one of the major documentary filmmakers of the century and a centrally important interpreter of the experience of World War II and its aftermath, with his THE SORROW AND THE PITY (1971), *A Sense of Loss* (1972), THE MEMORY OF JUSTICE (1976), and HOTEL TERMINUS: THE LIFE AND TIME OF KLAUS BARBIE (1989).

Ophüls, Max (Max Oppenheimer, 1902–57), German director, whose work was on stage from 1923 and on screen from 1930. He fled Germany after the Nazis came to power and worked in several European countries until 1941, then fleeing to the United States. His work is notable for the mobility and romanticism of his camera, rather than for its content, and includes such films as *Letter from an Unknown Woman* (1948), *La Ronde* (1948), and *Lola Montès* (1955). He was the father of director Marcel OPHÜLS.

Orbison, Roy Kelton (1936–88), U.S. musician, a singer and composer, who became a popular ROCK figure of the 1960s, for his renditions of such songs as "Only the Lonely" (1960), his own "In Dreams" (1963), and "Oh, Pretty Woman" (1964; with Bill Dees). His career sagged after the mid-1960s, but considerably revived in the late 1980s.

Ordinary People (1980), the Robert REDFORD film, illuminating a set of troubled family relationships. Donald SUTHERLAND and Mary Tyler MOORE played the parents; Timothy Hutton was their son, saved from a breakdown by his psychiatrist, played by Judd Hirsch. The Alvin Sargent screenplay was based on a novel by Judith Guest. The film, Redford, Sargent, and Hutton as best supporting actor all won OSCARS.

Orff, Carl (1895–1982), German composer, best known for the oratorio *Carmina Burana* (1937) and its two sequels, *Songs of Catullus* (1943) and *The Triumph of Aphrodite* (1953), sometimes described as a trilogy. He also wrote several other musical-theater dramas, including *Orpheus* (1925), *Antigone* (1949), *Oedipus* (1959), and *Prometheus* (1966).

Ormandy, Eugene (1899–1985), Hungarian conductor, resident in the United States from 1921. He conducted the Minneapolis Symphony from 1931 to 1936; from 1936 to 1938 he co-conducted and from 1938 to 1980 conducted the Philadelphia Orchestra, developing it into one of the world's leading symphony orchestras.

Orozco, José Clemente (1883–1949), Mexican painter, a leading 20th-century muralist; his most notable early work was a series of paintings of prostitutes, the *House of Tears* (1912). He painted several murals in Mexico City in the mid-1920s and emerged as a major figure while resident in the United States from 1927 to 1934, with the *Prometheus* mural at California's Pomona College (1930); the New School for Social Research murals (1931); the painting *Zapatistas* (1931); and the massive Dartmouth College murals, *An Epic of American Civilization* (1934). He returned to Mexico in 1934, then painted several major murals, most notably in Guadalajara, at the University of Guadalajara (1936), the provincial government palace (1937), and the Hospicio Cabañas orphanage (*Man on Fire*, 1939).

Orphans of the Storm (1922), the D.W. GRIFFITH film, a silent epic set in France before and during the French Revolution and based on the play *The Two Orphans* by Adolphe Dennery and Eugene Corman. The cast is led by Lillian GISH as the blind orphan, Dorothy Gish as her sister, and Joseph Schildkraut.

Orpheus (1924), the Jean COCTEAU play, a modern retelling of the legend of Orpheus and

Eurydice; he adapted the play for film and directed the sometimes surreal 1949 *Orpheus*, with a cast led by Jean Marais, Maria Casares, François Perier, and Juliette Greco. *Orpheus* was also the celebrated ballet by Igor STRAVINSKY, choreographed by George BALANCHINE, and with sets by Isamu NOGUCHI; it was first produced in New York by the Ballet Society in 1948. The Marcel Camus film BLACK ORPHEUS (1959) was based on the same legend.

Orwell, George (Eric Arthur Blair, 1903–50), British writer and socialist, whose work in the 1930s included three books of reportage: *Down and Out in Paris and London* (1933); *The Road to Wigan Pier* (1937), a classic Depression-era work on northern England that established him as a major writer of social protest; and *Homage to Catalonia* (1938), based upon his experiences as a volunteer in the Spanish Civil War. His most notable novels include *Burmese Days* (1934), *Coming Up for Air* (1939), and by far his most popular works, ANIMAL FARM (1945) and *1984* (1949), both of them attacks upon authoritarianism masked as socialism, aimed at Stalinism and also intended as a more general warning.

Ory, Kid (Edward Ory, 1886–1973), U.S. JAZZ musician, a bandleader and trombonist who played many other instruments as well. He led his own band in New Orleans from about 1910, moved to California after World War I, and was in Chicago in the mid-1920s, recording as a member of THE HOT FIVE. Later in the 1920s he played with King OLIVER's band. His career waned in the 1930s, but he became active again with the jazz revival of the 1940s and was a bandleader through the mid-1950s, also appearing in several films.

Osborne, John James (1929–), British writer, whose play LOOK BACK IN ANGER (1956) established him as a major playwright and as the most significant of Britain's "angry young men." It became the 1958 Tony RICHARDSON film, with Richard BURTON in the Jimmy Porter role. His next play was THE ENTERTAINER (1957), in which Laurence OLIVIER created the Archie Rice role, re-creating it on screen in the 1960 Tony Richardson film, which was co-adapted by Osborne. Among his

other plays are the TONY-winning *Luther* (1961); *Inadmissible Evidence* (1964), which he adapted into the 1968 film, with Nicol Williamson re-creating his stage lead; *A Patriot for Me* (1965); and *West of Suez* (1971). Osborne won an OSCAR for his 1963 TOM JONES screenplay. He has also written many screenplays for television.

Oscars, the U.S. ACADEMY AWARDS, voted annually since 1927 by the members of the Academy of Motion Picture Arts and Sciences.

Oshima, Nagisa (1932–), Japanese director, a filmmaker of personal and social protest, whose works attack Japanese social norms, especially alleging a pervading hypocrisy in the area of sexual behavior, in such films as *A Town of Love and Hope* (1959), *Night and Fog in Japan* (1960), *The Pleasures of the Flesh* (1965), *Death by Hanging* (1968), *In the Realm of the Senses* (1976), *Empire of Passion* (1978), and *Max, Mon Amour* (1985).

O'Toole, Peter (1932–), British actor, on stage from 1957 and on screen from 1960, who became a major international star with LAWRENCE OF ARABIA (1960), and then went on to such films as BECKET (1964), THE LION IN WINTER (1968), *The Ruling Class* (1971), *My Favorite Year* (1982), and THE LAST EMPEROR (1986).

Our Gang (1922–44), a series of hundreds of short U.S. comedy films, featuring a changing group of juveniles, developed by Hal ROACH and later continued by MGM and syndicated from the early 1950s on television as THE LITTLE RASCALS. The original gang consisted of Joe Cobb, Jackie Condon, Mickey Daniels, Jackie David, Allen Hoskins, Mary Kornman, and a dog named Pete. Some of the later players were Jackie COOPER, Spanky McFarland, Darla Hood, and Carl "Alfalfa" Spitzer.

Our Town (1938), the PULITZER PRIZE-winning Thornton WILDER play, celebrating small-town, democratic New England values, which established him as a major playwright. He co-adapted it into the 1940 Sam Wood film, with William HOLDEN joining Martha Scott and Frank Craven, who re-created their theater roles.

Outcast of the Islands, An (1896), the novel by Joseph CONRAD, set in Malaya and revolving around the deterioration of a European unable to cope with local conditions and culture, in this instance becoming a criminal—a set of themes explored by Conrad in several of his most notable works. The book was adapted into the memorable 1951 Carol REED film, with a cast that included Ralph RICHARDSON, Trevor HOWARD, Kerima, Robert Morley, Wendy HILLER, and George Coulouris.

Out of Africa (1937), the book by Isak DINESEN, telling the story of her African years, which was adapted by Kurt Luedtke into Sidney POLLACK's OSCAR-winning 1985 film, with Meryl STREEP in the Dinesen role, playing opposite Robert REDFORD as her lover, Denys Finch-Hatton. Pollack and Luedtke also won Oscars.

"Over the Rainbow" (1939), the classic, OSCAR-winning Judy GARLAND song from THE WIZARD OF OZ, with music by Harold ARLEN and words by Yip HARBURG.

"Over There" (1917), the George M. COHAN song, which became the leading American war song of World War I, with words and music by Cohan.

Owen, Wilfred (1893–1918), British writer, who died in France in 1918. In 1920 his work was published by his friend Siegfried SASSOON and quickly established him as one of Britain's leading war poets.

Oz, Amos (Amos Klausner, 1939–), Israeli writer, much of whose work reflects his attempt to find peace and reconciliation for his country. He is best known for his novels, including *Elsewhere, Perhaps* (1966), *My Michael* (1978), *Touch the Water, Touch the Wind* (1973), *A Perfect Peace* (1982), and *A Black Box* (1987). He has also written shorter fiction and children's books, and is a prolific essayist.

Ozawa, Seiji (1935–), Japanese conductor, music director of the Toronto Symphony (1965–69), the San Francisco Symphony (1970–76), and the Boston Symphony (1973–). A leading contemporary conductor, Ozawa has appeared all over the world and has also made a considerable body of recordings.

Ozick, Cynthia (1928–), U.S. writer, whose work focuses largely on Jewish sensibility in an American setting, in such novels as *Trust* (1966), *The Pagan Rabbi and Other Stories* (1971), *Five Fictions* (1982), *The Cannibal Galaxy* (1983), and *The Messiah of Stockholm* (1987).

Ozu, Yasujiro (1903–63), Japanese director, whose work was on screen from 1927. A prolific director, whose work is little shown in the West, he was greatly popular in Japan for such films as *Woman of Tokyo* (1933), *Tea and Rice* (1952), and *An Autumn Afternoon* (1962).

P

Pabst, G.W. (Georg Wilhelm Pabst, 1885–1967), Viennese-born director, on stage as an actor from 1912, whose directorial work was on screen in Germany from 1923. He soon became a major figure, with such films as *The Street of Sorrow* (1925); *Secrets of a Soul* (1926); *The Love of Jeanne Ney* (1927); and two Louise BROOKS films, PANDORA'S BOX and *Diary of a Lost Girl*, both shown in 1929. He also directed the film adaptation of Bertolt BRECHT and Kurt WEILL's THE THREEPENNY OPERA (1930) and *Kameradshaft/Tragédie de la Mine* (1931). He fled Nazi Germany in 1933 and made *The Lost Hero* (1934) in the United States and several films in France; upon his return to Germany, however, he made two pro-Nazi propaganda films. He also made several films during the postwar period.

Pacino, Al (Alfredo Pacino, 1940–), U.S. actor, on stage from the early 1960s and on screen from 1969, who became a major film figure in the Michael Corleone role in THE GODFATHER (1972) and THE GODFATHER, PART II (1974). He also starred in such films as *Serpico* (1973), DOG DAY AFTERNOON (1975), *Cruising* (1980), *Revolution* (1985), *Sea of Love* (1989), and *The Godfather Part III* (1990). Trained in the ACTORS STUDIO, he periodically returned to the stage, in such plays as *Richard III* (1973); *The Basic Training of Pavlo Hummell* (1976) for which he won a TONY; *American Buffalo* (1981); and *Julius Caesar* (1988).

Paderewski, Ignace Jan (1860–1941), Polish pianist and national leader; from 1887 he developed into one of the leading pianists of his time, with a large popular following. He also composed such works as the *Piano Concerto* (1888), the opera *Manru* (1901), and the *Symphony in C Major* (1909). Paderewski became a leader in the fight for Polish independence, and in 1919 was the first prime minister of Poland.

Page, Geraldine (1924–87), U.S. actress, on stage from 1941 and on screen from 1947, who emerged a leading stage player in such plays as SUMMER AND SMOKE (1952), re-creating the role on screen in 1961, and SWEET BIRD OF YOUTH (1959), which she did on film in 1962. She continued to appear in a wide range of plays, including AGNES OF GOD (1982). She won a best actress OSCAR for *The Trip to Bountiful* (1985).

Pagnol, Marcel (1895–1974), French writer, director, and producer, who became a leading playwright and filmmaker in the 1930s, with the MARIUS trilogy, set in Marseilles, consisting of the plays *Marius* (1929), *Fanny* (1931), and *César* (1936). Pagnol adapted all three into films; Alexander KORDA directed the 1931 *Marius*, Marc Allégret the 1932 *Fanny*, and Pagnol the 1936 *César*, with Raimu, Pierre Fresney, Orane Demazis, and Charpin playing leading roles in all three films. The 1954 stage musical FANNY and the 1962 film were based on the *Marius* plays. Pagnol also wrote, produced, and directed such notable films as *Harvest* (1937), *The Baker's Wife* (1938), and *Manon of the Spring* (1952), based on his novel. The novel was also the basis of two later Claude Berri films, *Jean de Florette* (1986) and another *Manon of the Spring* (1986), the first starring Yves MONTAND and Gerard Depardieu, the second Montand and Emmanuelle Beart as Manon.

Paisan (1946), the classic Roberto ROSSELLINI film, set during the invasion and liberation of Italy, 1943–45. It was written by Rossellini and Federico FELLINI, who was also assistant director, and shot by Otello Martelli, with a huge cast that included only a few professionals. The film was a powerful evocation of desperate times; of the war just won; and of the Italian partisan movement, engaged in a chaotic series of battles side by side with the Allies, then moving north through Italy.

Pajama Game, The (1954), the long-running TONY-winning Broadway musical, a New York garment-district love story, with Janis Paige as the union activist and John Raitt as the manager she ultimately wins over; it includes such songs as "Hernando's Hideaway" and "Steam Heat." Richard Adler and Jerry Ross wrote the words and music, George ABBOTT and Richard Bissell wrote the book, and Bob FOSSE choreographed. Abbott and Bissell adapted their play into the 1957 Stanley Donen film, starring Doris DAY, with Raitt, Carol Haney, and Eddie Foy, Jr. re-creating their Broadway roles.

Pakula, Alan J. (1928–), U.S. director and producer, who produced several films, most notably TO KILL A MOCKINGBIRD (1962), before becoming a director, with such films as KLUTE (1971), ALL THE PRESIDENT'S MEN (1976), *Starting Over* (1979), and *Sophie's Choice* (1982). He also wrote and directed *See You in the Morning* (1989) and co-wrote and directed *Presumed Innocent* (1990).

"Pallisers, The" (1977), the 22-part British television serial, adapted from six Anthony Trollope novels, set in English society and politics in the late 19th century. Philip Latham and Susan HAMPSHIRE were Plantagenet and Glencora Palliser and Roland Culver the duke of Omnium, in a cast that included Roger LIVESEY, Barbara Murray, Donal McCann, Anna Massey, Caroline Mortimer, Gary Watson, and Barry Justice.

Pandora's Box (1928), the G.W. PABST film, with Louise BROOKS as Lulu, the young woman whose sexuality becomes the center of a widening whirlpool that ultimately destroys her and all around her. The film was based on two Franz Wedekind plays, *Earth Spirit* and *Pandora's Box*, which also served as the bases for the Alban BERG opera WOZZECK.

Paper Moon (1973), the Peter BOGDANOVICH film, about con man Moses Pray and orphan Addie Loggins, on the road together in mid-America in the 1930s. Ryan O'Neal was Moses; his daughter, Tatum O'Neal, won a best supporting actress OSCAR as Addie, in a cast that included Madeline Kahn, John Hillerman, Burton Gilliam, and Randy Quaid. The Alvin Sargent screenplay was based on the Joe David Brown novel *Addie Pray*. The television series "Paper Moon" (1974–75) starred Chris Connelly and Jodie FOSTER.

Papp, Joseph (Joseph Papirovsky, 1921–), U.S. producer and director, who after working with the Actors Laboratory and directing off-Broadway plays founded New York's Shakespeare Workshop in 1954. During the next 35 years, he developed it into the New York Shakespeare Festival, which mounted well over 100 productions of Shakespeare, introduced over 200 new plays, and created both the Public Theater off-Broadway complex and the New York Shakespeare Festival in Central Park, as well as developing a program of classics for young people and several television and film projects.

Parade, a ballet choreographed by Léonid MASSINE, with music by Eric SATIE, book by Jean COCTEAU, and decor by Pablo PICASSO; a trailblazing production that has been variously described as cubist (see CUBISM) and a precursor of SURREALISM. It was first produced at Paris in May 1917, with Massine and Maria Chabelska in the leads, by the BALLET RUSSES company of Sergei DIAGHILEV.

Parade's End, the collective title of Ford Madox FORD's four post-World War I novels, consisting of *Some Do Not* (1924), *No More Parades* (1925), *A Man Could Stand Up* (1926), and *The Last Post* (1928).

Parker, Charlie (Charles Christopher Parker, Jr., "Bird," or "Yardbird," 1920–55), U.S. JAZZ alto saxophonist, composer, and bandleader, in the mid-1940s one of the creators of the BOP jazz style. He composed such works as

the "Yardbird Suite," "Marmaduke," "Confirmation," and "Now's the Time" and recorded from the early 1940s, often with Dizzy GILLESPIE, Miles DAVIS, Max ROACH, and other jazz luminaries of the time. Substance-abuse problems hastened his early death.

Parker, Dorothy Rothschild (1893–1967), U.S. writer and critic, noted for her acerbic wit, whose work includes several volumes of poetry, collected in *Not So Deep a Well* (1936), and the short stories collected in *Laments for the Living* (1930) and *After Such Pleasures* (1933). She also worked as a journalist, reporting from Spain during the Spanish Civil War. Her work includes several filmscripts and two Broadway plays: *Close Harmony* (1924, with Elmer RICE) and *Ladies of the Corridor* (1953, with Armand d'Usseau).

Parton, Dolly (1946–), U.S. country singer, actress, and songwriter; she began composing and singing in the mid-1960s and emerged as a major figure in the early 1970s, with such albums as *Coat of Many Colors* (1971), *My Tennessee Mountain Home* (1973), and *Jolene* (1974). With the album *New Harvest . . . First Gathering* (1977), she began to merge country and ROCK, reaching even wider audiences. A very highly regarded later work was the album *Trio* (1987), with Linda RONSTADT and Emmylou HARRIS. She also appeared in several films, most notably in *9 to 5* (1980), *The Best Little Whorehouse in Texas* (1982), and *Steel Magnolias* (1989).

Pasolini, Pier Paolo (1922–75), Italian director and writer, whose often controversial work was on screen from 1961. His first film, *Accatone!* (1961), was a dramatization of one of his own novels. Some of his later films, such as *The Gospel According to St. Matthew* (1964), *Oedipus Rex* (1967), and *The Decameron* (1971), were based on classical sources; others, such as *Teorema* (1968) and *Pig Pen* (1969), were of modern inspiration, sharply exposing the underside of Italian life from a Marxist point of view. Several, including *The Canterbury Tales* (1972) and *Salo, or the 120 Days of Sodom* (1975), were prosecuted as obscene. His career was cut short by his murder.

Passage to India, A (1924), the novel by E. M. FORSTER, on Indian–British cross-cultural and racial themes, and on deeper and more personal matters of relationship, as well. It is by far the best known of his works, widely recognized for its sensitivity and its quality as a novel. In 1984 it was adapted by David LEAN into his own long, rather massive film, with a cast that included Alec GUINNESS, Judy Davis, Victor Bannerjee, James Fox, Peggy ASHCROFT, and Nigel Havers.

Passion of Sacco and Vanzetti, The (1932), Ben SHAHN's emblematic work of 1930s SOCIAL REALISM, consisting of 23 paintings based on the 1920s trial and execution of anarchists Nicola Sacco and Bartolomeo Vanzetti, who were in a later era posthumously exonerated.

Pasternak, Boris Leonidovich (1890–1960), Soviet writer, who began the career that would ultimately make him one of his country's leading literary figures with several collections of poems: *The Twin in the Clouds* (1914), *Over the Barriers* (1917), *My Sister Life* (1922), and *Themes and Variations* (1923), the latter two establishing him as a major poet. But from the mid-1920s, he encountered increasing difficulty with the Communist bureaucracy, and although he continued to work, publishing such poetry collections as *Spektorsky* (1931); short stories; and an autobiography, *Safe Conduct* (1931), from the early 1930s he was forced to turn to translations of classics from other languages. He began to publish again only during World War II, with two small poetry collections. Then, in 1955, he completed his masterwork, the epic novel of war and revolution that was DOCTOR ZHIVAGO; it was at once the classic testament of an artist who remained free and whole, and one of the key literary works of the Soviet period. His book was published in Italian in 1957 and in English in 1958, the year he was awarded the NOBEL PRIZE for literature. Although Pasternak was forced by his government to reject the Nobel, his work achieved worldwide impact, and nowhere more than in the Soviet Union, although it was officially published there only long after his death. His

book was adapted by Robert BOLT into the 1965 David LEAN film.

Pathé, Charles (1863–1957), turn-of-the-century film pioneer, who from 1901 built what became the world's largest film production company, an integrated film-related materials manufacturer, producer, and exhibitor; before World War I it had also developed color films and a weekly newsreel to show in its worldwide theater chain. After World War I, his empire failed, as the American film industry achieved worldwide dominance.

Pather Panchali (1955), the first Satyajit RAY film, which introduced Ray and the modern Indian film to a greatly appreciative world audience; it was the first film in the APU TRILOGY. The cast included Karu Banerjee, Karuna Banerjee, Subir Banerjee, Uma Das Gupta, Runki Banerjee, and Chunibala Devi. Ray wrote and directed the film, based on the Bibhuti Bhusan BANERJI novel; the music was by Ravi SHANKAR.

Paths of Glory (1957), the Stanley KUBRICK antiwar film, set in World War I; the story of a murderous court-martial ordered after a regiment on a suicide mission retreats under fire. The cast included Kirk DOUGLAS, George Macready, Ralph Meeker, Adolphe Menjou, Wayne Morris, Timothy Carey, and Richard Anderson. Kubrick, Calder Willingham, and Jim Thompson wrote the screenplay, based on the Humphrey Cobb novel.

Paton, Alan Stewart (1903–), South African writer, whose novel *Cry, the Beloved Country* (1948) drew international attention to developing South African racism, as did his novel *Too Late the Phalarope* (1953). His work also includes several collections of short stories and a considerable body of social commentary on the plight of South Africa. He was a founder and leader of the South African Liberal Party, 1958–68. *Cry, the Beloved Country* was the basis for the Maxwell ANDERSON–Kurt WEILL musical *Lost in the Stars* (1949) and was also adapted into the 1951 Zoltan Korda film.

Patton (1970), the Franklin SCHAFFNER World War II film biography of Gen. George Patton, with George C. SCOTT in the title role

and Karl MALDEN as Gen. Omar Bradley, in a cast that included Stephen Young, James Edwards, Michael Strong, and Frank Latimore. The screenplay, by Francis Ford COPPOLA and Edmund North, was based on the Ladislas Farago biography *Patton* and on Bradley's autobiography, *A Soldier's Story*. The film, Schaffner, Scott as best actor, the screenwriters, art, editing, sound, and sets all won OSCARS.

Pavarotti, Luciano (1935–), Italian tenor, a leading contemporary singer in opera, in concert, on screen, and on records. He made his Italian debut in 1961, sang in Europe in the early 1960s, toured Australia opposite Joan SUTHERLAND in 1965, sang in the United States from 1967, became a fixture at the Metropolitan Opera from 1968, and was a major international singing star for well over two decades, in a career that has often been compared with that of Enrico CARUSO.

Pavlova, Anna (1882–1931), Russian ballerina, who in 1906 became premier ballerina at the Maryinsky Theatre in St. Petersburg; in 1908 danced with Vaslav NIJINSKY at Sergei DIAGHILEV's BALLET RUSSES in Paris; created her own company in 1910; and from 1913 toured the world, never again going home to Russia. A classicist in a time of great change in ballet, she was also an extraordinary dancer whose work greatly popularized ballet throughout the world. Her best-known role was that of *The Dying Swan* created for her by Michel FOKINE in 1905.

Pawnbroker, The (1965), the Sidney LUMET film, set in East Harlem; Rod STEIGER played pawnbroker Sol Nazerman, the embittered, deadened Jewish concentration camp survivor who merely exists, with insupportable memories, and who ultimately begins to be able to feel pain, guilt, and the stirring of new life. The cast included Jaime Sanchez, Geraldine FITZGERALD, Brock Peters, Raymond St. Jacques, and Thelma Oliver. The David Friedkin–Morton Fine screenplay was based on the Edward Lewis Wallant novel of that name.

Paxinou, Katina (Katina Constantopoulos, 1900–73), Greek actress, director, and transla-

tor, on stage from 1924 and a leading figure in the Greek National Theater from 1932, playing again and again in many of the great Greek and English-language roles, some of which, like ANNA CHRISTIE, she also translated. She was also a substantial figure in the English-language theater, in 1939 appearing in *Electra* and *Hamlet* in London, and in 1942 appearing as *Hedda Gabler* in New York. On screen, she is best remembered for her Pilar in FOR WHOM THE BELL TOLLS (1942).

Paz, Octavio (1914–), Mexican writer, editor, and critic, a key figure in modern Latin American literature, whose work was deeply affected by Mexico's Indian heritage and by his experiences as a Republican supporter in Spain during the Spanish Civil War. He founded his first literary review at the age of 17; published his first volume of poetry, *Forest Moon*, in 1933; and is best known for such works as the long poem *Sun Stone* (1957), its 584 lines matching the 584 lines of the Aztec calendar, and for such essays as those in *The Labyrinth of Solitude* (1962) and *Alternating Current* (1973). The most recent edition of his *Collected Poems* was published in 1989. He was awarded the NOBEL PRIZE for literature in 1990.

Peanuts, the popular comic strip created by cartoonist Charles SCHULZ in 1950, featuring Charlie Brown, Snoopy, Lucy, and Linus. They also appeared off-Broadway in *You're a Good Man, Charlie Brown* (1967) and in many books and several television specials.

Pears, Peter (1910–86), British tenor, who created many of the leading roles in the operas of his longtime companion and colleague Benjamin BRITTEN, who often wrote with Pears's voice in mind. These roles included leads in such works as PETER GRIMES (1945), *Albert Herring* (1947), BILLY BUDD (1951), OWEN WINGATE (1970), and DEATH IN VENICE (1973). Britten also created song cycles for him, such as *Seven Sonnets of Michelangelo* (1940), *The Holy Sonnets of John Donne* (1945), and *Songs and Proverbs of William Blake* (1965), as well as becoming his piano accompanist in concert and on records.

Peck, Gregory (Eldred Gregory Peck, 1916–), U.S. actor, on stage from 1942 and on screen from 1944, who quickly became a major Hollywood film star in some of the strongest roles of the following four decades, most of them projecting a powerful, incorruptible American archetype. Some of his most notable roles were in THE KEYS OF THE KINGDOM (1945); *The Yearling* (1946); the trailblazing GENTLEMEN'S AGREEMENT (1947); *Twelve O'Clock High* (1950); *Captain Horatio Hornblower* (1951); *The Snows of Kilimanjaro* (1952); *The Man in the Grey Flannel Suit* (1956); MOBY DICK (1956); ON THE BEACH (1959); TO KILL A MOCKINGBIRD (1962), for which he won a best actor OSCAR; *The Stalking Moon* (1969); *MacArthur* (1977); and *Old Gringo* (1988). He has also worked in theater and on television.

Peckinpah, Sam (1925–85), U.S. director and writer, in television as a writer and director during the late 1950s, whose work was on screen from 1961, and was in its time quite notable for its level of violence, in such films as *The Wild Bunch* (1969), *Straw Dogs* (1971), and *The Killer Elite* (1975).

Peerce, Jan (Jacob Pincus Perelmuth, 1904–84), U.S. tenor, who during the 1930s and early 1940s sang at the Radio City Music Hall and on radio, often with the New York Philharmonic. He sang with the Metropolitan Opera from 1941 to 1966, in many of the major roles in the repertory, as well as continuing to appear on stage in concert and on radio and television.

Pei, I.M. (Ieoh Ming Pei, 1917–), U.S. architect, who came to the United States from China as a student in 1935. He practiced from 1948, originally designing skyscrapers for the Zeckendorf organization, and from 1955 was in his own firm. His works include such major structures as Place Ville Marie (Montreal, 1965), the John Hancock Tower (Boston, 1973), Cornell's Herbert F. Johnson Museum (1975), the East Building of the National Gallery (1978), the John F. Kennedy Library (Dorchester, Mass., 1979), and the Fragrant Hills Hotel (Peking, 1982).

Pelle the Conqueror (1906–10), the massive Martin Andersen NEXÖ novel, a four-volume work that traces the life of Pelle, a poor young Swedish immigrant into Denmark, as he ultimately develops into a labor leader. An early portion of the novel was adapted for the screen by Bille August, who directed the 1988 film, a best foreign film OSCAR-winner, with Max von SYDOW as Pelle's father leading a cast that included Pelle Hvenegaard, Eric Passke, and Morten Jorgenson.

Penderecki, Krzysztof (1933–), Polish composer, who emerged as a major figure with such highly innovative works as *Strophes* (1959), *Anaklasis* (1960), and *Threnody to the Victims of Hiroshima* (1960), as well as his *Stabat Mater* (1962), *St. Luke Passion* (1965), and *Utrenia* (1971). His operas include *The Devils of Loudon* (1969), *Paradise Lost* (1971), and *The Black Mask* (1986). His considerable body of choral and instrumental work also includes the *Polish Requiem* (1984).

Penn, Arthur (1922–), U.S. director and writer, in television during the early 1950s, who left television to direct several notable plays and films. On Broadway he directed such plays as *Two for the Seesaw* (1958); THE MIRACLE WORKER (1959), which he did on film in 1962; *Toys in the Attic* (1960); and ALL THE WAY HOME (1960). He also directed such films as BONNIE AND CLYDE (1967), ALICE'S RESTAURANT (1969), LITTLE BIG MAN (1971), and *Night Moves* (1975).

"Pennies from Heaven" (1936), the title song of the 1936 film *Pennies from Heaven*, which became one of the most popular songs of the 1930s. It was also used as the title of the 1981 Herbert Ross film, based on the Dennis POTTER television miniseries. Words and music were by Johnny Burke and Arthur Johnston.

"People Will Say We're in Love" (1943), the duet from OKLAHOMA! (1943) introduced by Alfred Drake and Joan Roberts on Broadway, with music by Richard RODGERS and words by Oscar HAMMERSTEIN II.

Percy, Walker (1916–90), U.S. author, a satirist whose novels are set in the Deep South and to a considerable extent reflect his existentialist and Catholic views. He is best known for his first novel, *The Moviegoer* (1961), which won a National Book Award, and also wrote the novels *The Last Gentleman* (1966), *Love in the Ruins* (1971), *Lancelot* (1977), *The Second Coming* (1980), and *The Thanatos Syndrome* (1987).

Perelman, S.J. (Sidney Joseph Perelman, 1903–79), U.S. writer, a leading American humorist and satirist whose work was long identified with *The New Yorker*. He published many collections of his articles, including such books as *Dawn Ginsbergh's Revenge* (1929); *Parlor, Bedroom, and Bath* (1930); *Strictly from Hunger* (1935); *Westward Ha!* (1948); *The Road to Miltown; or, Under the Spreading Atrophy* (1957); *The Rising Gorge* (1961); and *Baby, It's Cold Inside* (1970). He and Ogden NASH wrote the book for the musical *One Touch of Venus* (1943), and Perelman wrote *The Beauty Part* (1962). His most notable screenplay collaborations include *Monkey Business* (1931); *Horsefeathers* (1932); and AROUND THE WORLD IN 80 DAYS (1956), for which he shared an OSCAR. A late and very popular work was his travel book *Eastward Ha!* (1977).

Perils of Pauline, The (1914), the film serial starring Pearl WHITE, in a series of death-defying exploits; it is probably the most popular silent-film serial ever made.

Perkins, Anthony (1932–), U.S. actor, on screen from 1953 and on stage from 1954; he created the Eugene Gant role in *Look Homeward, Angel* (1957). Many of his most notable screen roles came early, in such films as *The Actress* (1953), FRIENDLY PERSUASION (1956), *Fear Strikes Out* (1957), DESIRE UNDER THE ELMS (1958), and his starring role as the psychopathic killer in *Psycho* (1960). Much of his later work was in horror films, as in the three *Psycho* sequels (1983, 1986, and 1990). He has also continued to work in the theater.

Perlman, Itzhak (1945–), Israeli violinist, a child prodigy; after his American debut in 1963, he quickly emerged as a major figure, who has since played throughout the world and has also become a celebrated recording artist. He is one of the world's leading violinists,

Former child prodigy, then internationally acclaimed violin virtuoso, Itzhak Perlman performs in 1986.

an accomplishment especially remarkable for its triumph over the crippling poliomyelitis that struck him as a child.

Perse, Saint-John (Alexis Saint-Legér Léger, 1887–1975), French writer and diplomat, who gained recognition as a major 20th-century poet with the epic *Anabasis* (1924), set in East Asia and written while he was on the staff of the French embassy in Peking. He left the foreign service after opposing the French surrender to the Germans in May 1940 and fled abroad; his next major work was *Exile* (1942). Then followed the epics *Winds* (1946) and *Seamarks* (1957) and a NOBEL PRIZE for literature in 1960.

Peter and the Wolf (1936), the Sergei PROKOFIEV symphonic fairy tale, a perennial worldwide favorite that is by far his most popular work.

Peter Grimes (1945), the opera by Benjamin BRITTEN, with libretto by Montagu Slater, adapted from the George Crabbe poem *The Borough* (1910). Peter PEARS created the title role, that of an English fisherman who is suspected by the local folk of having murdered his child apprentice. A second apprentice, whom he is known to have abused, accidentally dies; ultimately Grimes escapes victimization. *Peter Grimes* was the first of the several works that established Britten as one of the leading opera composers of the century.

Peter Pan (1904), the children's play by James M. BARRIE, which became a starring vehicle for Maude ADAMS on Broadway a year later; almost half a century afterward, its musical version became identified with Mary MARTIN, who played the role on Broadway in 1954.

Peter, Paul and Mary (Peter Yarrow, 1938– , Paul Stookey, 1937– , and Mary Travers, 1937–), U.S. folk-singing group, formed in 1961. During the early 1960s, they were leading voices in the civil rights and antiwar movements then taking shape, popularizing such songs as BLOWIN' IN THE WIND and IF I HAD A HAMMER, and through such albums as *Peter, Paul, and Mary* (1962), *Peter, Paul and Mary—Moving* (1963), and *Peter, Paul and Mary—in the Wind* (1963). They also sang many children's songs, most notably *Puff*

the Magic Dragon (1963), and did the children's album *Peter, Paul, and Mommy* (1969).

Peters, Roberta (1930–), U.S. soprano; she made her debut at the Metropolitan Opera in 1950 and stayed on to become a fixture at the Met, in her 35-year-long career playing a very wide range of roles, while appearing with other major companies, in recital, on screen, and on records.

Petrified Forest, The (1935), the Robert SHERWOOD play, set in an Arizona cafe, the petrified forest nearby serving as a metaphor for the human situation. On stage, Leslie HOWARD created the Alan Squire role, with Peggy Conklin as the young woman and Humphrey BOGART as gangster Duke Mantee. Charles Kenyon and Delmer Daves adapted the play into the 1936 Archie Mayo film; Howard and Bogart re-created their stage roles, and were joined by Bette DAVIS, in a cast that included Dick Foran, Joe Sawyer, and Genevieve Tobin.

Petrushka, a ballet by Igor STRAVINSKY; it was choreographed by Michel FOKINE and first produced in Paris, in June 1911, by Sergei DIAGHILEV's BALLET RUSSES company, with Vaslav NIJINSKY and Tamara KARSAVINA in the leading roles.

Pevsner, Antoine (1886–1962), Soviet artist, resident in France from 1923; with his brother Naum GABO he was a pioneering abstract sculptor and a leading figure in the constructivist movement (see CONSTRUCTIVISM). In 1920 the brothers issued their *Realist Manifesto*, a basic constructivist document.

Phantom of the Opera (1925), the Gaston Leroux novel, often adapted into other forms. The first and by far the most notable of the several film versions was the prototypical horror film directed by Rupert Julian, featuring Lon CHANEY as the mad composer who resides underground, far below the Paris Opera, emerging to kidnap Christine, played by Mary Philbin. Claude RAINS played the phantom in the 1943 soundfilm version; Herbert Lom and Maximilian Schell also played the phantom, as did William Finley in Brian DePalma's 1974 musical version, *The Phantom of the Paradise*. The 1988 Andrew LLOYD

WEBBER musical version won seven TONYs, including best musical.

Philadelphia Story, The, the 1939 Philip BARRY play, in which Katharine HEPBURN created the Tracy Lord role, opposite Joseph COTTEN and Van HEFLIN. In 1940, the film adaptation, written by Donald Ogden Stewart, became the classic George CUKOR film, with Hepburn opposite James STEWART and Cary GRANT; Stewart won a best actor OSCAR for the role. In 1956 the play became the musical film *High Society*, with Grace KELLY, Bing CROSBY, and Frank SINATRA in leading roles, along with Louis ARMSTRONG, singing a Cole PORTER score.

Philipe, Gérard (1922–59), French actor, on stage from 1943 and on screen from 1944, who became a major figure in the French theater during the postwar period, most notably for his *El Cid* (1951), though also for many other major roles. On screen he became an international star with *Devil in the Flesh* (1947), which he followed with such films as LA RONDE (1950), *Fanfan the Tulip* (1952), *The Red and the Black* (1954), and *Les Liaisons Dangereuses* (1959).

Photo-Secession, the group founded by Alfred STIEGLITZ in 1902, which played a large role in establishing photography as a major, recognized art form. Some other key early members of the Photo-Secession were Edward STEICHEN, Clarence H. White, Gertrude Käsebier, and John Bullock. From 1905 to 1917, the group operated 291, THE LITTLE GALLERIES OF THE PHOTO-SECESSION, at 291 Fifth Avenue, in New York City, which became a showcase for modern photography and the other visual arts.

Piaf, Edith (Giovanna Gassion, 1915–63), French singer and recording artist, in variety from the 1930s, who became a headliner in France during the postwar period, and was from the late 1940s a well-known singer throughout the world. Her signature song was her own "La Vie en Rose."

Piano Lesson, The (1988), the PULITZER PRIZE-winning August WILSON play, about a symbolic confrontation between two members of a Depression-era Black family over the fate

Pablo Picasso, thumbing through the book *Picasso's Picassos* (1961), released to celebrate his 80th birthday.

of an heirloom, the family piano; it is set in Pittsburgh in 1936. The play opened on Broadway in 1990, winning a best play TONY; it was directed by Lloyd Richards, with Charles S. Dutton as Boy Willie opposite S. Epatha Merkerson as Berniece, in a cast that included Lou Myers, Carl Gordon, Tommy Hollis, Rocky Carroll, Lisa Gay Hamilton, and Apryl R. Foster.

Piatigorsky, Gregor (1903–76), Russian cellist, who left the Soviet Union in 1921, was lead cellist with the Berlin Philharmonic (1924–28), and made his American debut as a soloist with the New York Philharmonic, then emerging as one of the leading cellists of his time. From 1961, he did many joint concerts with violinist Jascha HEIFETZ.

Picabia, Francis (1879–1953), French painter, who from 1909 moved successively from Impressionism through CUBISM, DADA, and SURREALISM. He exhibited at the ARMORY SHOW and 291, THE LITTLE GALLERIES OF THE PHOTO-SECESSION; helped found the American Dada movement; wrote and edited several movement periodicals; did some set

designs; and probably most notably created the imaginary, nonfunctional machines that became a feature of much of his work from about 1913, after his cubist period.

Picasso, Pablo Ruiz (1881–1973), Spanish artist; he was one of the leading painters of the century, whose estimated 15,000 to 20,000 works also included large numbers of graphics, sculpture, and set design, and who had an enormous impact on the development of 20th-century art. He worked mostly in Barcelona until moving to Paris in 1904, though spending much time in Paris from 1900. Picasso began to produce some of his greatest work very early, in his "Blue" period (1901–4), so described because of the predominant pale, somewhat saddened blue in such works as *The Tragedy* (1903) and *Woman Ironing* (1904). The predominant colors changed after his move to Paris, in the even shorter "Rose" period (1905–6). In 1906–7 he began the process that would quickly result in the revolutionary development of CUBISM, with the unfinished LES DEMOISELLES D'AVIGNON; he then moved into cubism side by side with Georges

BRAQUE, in the next few years working with the collages, often rough new materials, and new techniques of including objects in paintings that were to characterize much of the avant-garde work of the next several decades. This early work would inform all that followed, although his work continued to develop, as in *The Dancers* (1921) and *Three Musicians* (1921). Picasso leaned toward, though never fully joined, the surrealists (see SURREALISM) from the mid-1920s and also toward mythological themes, ultimately producing his *Minotaur* (1935). In 1937, for the Spanish Pavilion at the Paris Exposition, he painted the huge, landmark GUERNICA, commemorating the destruction of the Basque Spanish town by Nazi bombers on April 28, 1937. During World War I and the interwar period, he also produced a large body of graphics, and created several set and costume designs for the ballet, beginning with Leonid MASSINE's PARADE (1917) and including THE THREE-CORNERED HAT (1919) and *Pulcinella* (1920). He joined the Communist Party after World War II, and his dove became the emblem of the 1949 Paris Peace Congress. In the next decades, he continued his enormous volume of production, in pottery, sculpture, prints, and paintings.

Pickford, Mary (Gladys Marie Smith, 1893–1979), U.S. actress, on stage as a child, on Broadway in 1907, and on screen from 1909, there soon becoming "America's Sweetheart," by far the most popular woman movie star of the silent era. She became a worldwide celebrity in such films as *Tess of the Storm Country* (1914 and again in 1922), *Rebecca of Sunnybrook Farm* (1917), *Pollyanna* (1920), *Little Lord Fauntleroy* (1921), and *Little Annie Rooney* (1925). In 1919 she, her husband, Douglas FAIRBANKS, Charlie CHAPLIN, and D.W. GRIFFITH formed United Artists. Tiring of little-girl roles, she attempted to move into the modern period with *Coquette* (1929), for which she won a best actress OSCAR, and several other adult roles, but found her audiences unresponsive, and retired in 1933.

Picnic (1953), the William INGE play, set in small-town Kansas, about the impact of a life-affirming drifter on the constricted lives of the women in a single family group. Ralph Meeker created the Harold Carter role; Janice Rule, Kim Stanley, Eileen Heckart, and Peggy Conklin were the women. Daniel Taradash adapted the play into the 1955 Joshua LOGAN film; William HOLDEN was Harold, opposite Kim NOVAK, in a cast that included Rosalind RUSSELL, Betty Field, Verna Felton, Cliff ROBERTSON, Susan Strasberg, Arthur O'Connell, and Phyllis Newman. Charles Nelson and William A. Lyon won an OSCAR for their editing, as did William Flannery and Jo MIELZINER for art and Robert Priestly for sets.

Pidgeon, Walter (1897–1984), Canadian actor, on stage from 1924 and on screen from 1926. He moved into substantial film leads and strong supporting roles in the late 1930s, in such films as *Dark Command* (1940), *Blossoms in the Dust* (1941), HOW GREEN WAS MY VALLEY (1941), MRS. MINIVER (1942), *Madame Curie* (1943), *Mrs. Parkington* (1944), *That Forsyte Woman* (1949), *Deep in My Heart* (1954), ADVISE AND CONSENT (1962), and FUNNY GIRL (1968), and he later also appeared in several television roles.

Piercy, Marge (1936–), U.S. writer, a poet and novelist of social protest whose major themes have been the Vietnam War, feminism, and social injustice, in such poetry collections as *Breaking Camp* (1968), *Circles in the Water* (1982), and *My Mother's Body* (1985) and such novels as *Going Down Fast* (1969), *Small Changes* (1973), *Woman on the Edge of Time* (1976), and *Fly Away Home* (1984).

Pilnyak, Boris (Boris Andreyevich Vogau, 1894–1938), Soviet writer, whose first novel, *The Naked Year* (1922), glorifying the role of the Russian peasantry in the Russian Revolution, made him a very popular early Soviet writer. But the developing Soviet bureaucracy soon came to dislike his views, as expressed in such works as *The Tale of the Unextinguished Moon* (1926) and several short stories. Although he tried to conform, most notably in the novel *The Volga Falls to the Caspian Sea* (1931), he became a victim of the Stalinist purges of the mid-1930s; he was arrested in 1937, and his death was announced in 1938.

Pink Floyd, British ROCK group, formed in 1965 by Syd Barrett (1946–), Nick Mason (1945–), Roger Waters (1944–), and Richard Wright (1945–); David Gilmour replaced Barrett in 1978. The band was a moderately well-received acid-rock group until the sudden success of its deeply alienated *The Dark Side of the Moon* (1973), an album followed by such further doom-laden and very popular works as *Wish You Were Here* (1975), *Animals* (1977), and *The Wall* (1979).

Pins and Needles (1937), the Harold Rome labor musical, a series of brief, crisp, satirical pieces. Produced in New York by the International Ladies' Garment Workers' Union, and with a nonprofessional cast, it was a quite notable Depression-era artifact.

Pinter, Harold (1930–), British writer, actor, and director, who emerged as a major playwright with THE CARETAKER (1960), which explored his dominant theme of pervasive alienation within the framework of seemingly ordinary everyday life, much akin to the themes developed by Eugène IONESCO and Samuel BECKETT in what later was called the THEATRE OF THE ABSURD, though with much more attention to the development of his ultimately ambiguous protagonists. He adapted the play into the 1964 film. Pinter's influence on the development of the modern English-speaking theater was considerable, in such other plays as *The Birthday Party* (1958), which he adapted for the 1968 film; the TONY-winning *The Homecoming* (1965), which he adapted for the 1973 film; and *No Man's Land* (1975), its two central characters memorably played by John GIELGUD and Ralph RICHARDSON. He also wrote screenplays for such films as *The Servant* (1962), *Accident* (1966), THE GO-BETWEEN (1969), and *The Handmaid's Tale* (1990), and directed several plays by others, including BUTLEY (1971, and the 1973 film) and *Otherwise Engaged* (1975), both by Simon GRAY. **Vivien Merchant**, to whom he was married from 1956 to 1980, played leads in many of his plays.

Pinza, Ezio (1892–1957), Italian bass, who made his debut in 1914, became a leading singer in the early 1920s, and from 1926 to 1948 sang at the Metropolitan Opera, as well as at San Francisco, Chicago, London, and many other opera houses. He retired from opera in 1948 and is best known for his postoperatic career. In 1949, he created and won a TONY for the Émil de Becque lead in SOUTH PACIFIC, opposite Mary MARTIN, and introduced SOME ENCHANTED EVENING; in 1957, he created the César role in FANNY.

Pirandello, Luigi (1867–1936), Italian writer, a leading 20th-century playwright whose best-known work, *Six Characters in Search of an Author* (1921), develops a "play within a play" to suggest that art can shape life. The thesis is further developed in *Each in His Own Way* (1924) and *Tonight We Improvise* (1929). His over 50 plays also include *Right You Are if You Think You Are* (1917), *The Rules of the Game* (1918), *Henry IV* (1922), *Lazarus* (1929), and *As You Desire Me* (1930). He also wrote a large number of short stories and seven novels; the best-known of the novels is *The Late Mattia Pascal* (1904). Pirandello was also a director and actor, who toured with his own company from 1925. He was awarded the NOBEL PRIZE for literature in 1934.

Piscator, Erwin (1893–1966), German director, who preceded Bertolt BRECHT as a major figure in the development of the epic theater of left commitment. His work, much of it physically very large scale for the stage, and some of it using animation and film along with live stage action, included such notable 1920s Berlin productions as *Rasputin* (1927) and THE GOOD SOLDIER SCHWEIK (1928), the latter in collaboration with Brecht. Piscator fled the Nazis in 1933 and taught theater in New York from 1939, developing several large student productions. He worked in West Germany from 1951.

Piston, Walter (1894–1976), U.S. composer and teacher; his work includes seven symphonies and a considerable body of other instrumental and orchestral work, as well as a ballet, *The Incredible Flutist* (1938). His *Third Symphony* (1947) won a PULITZER PRIZE, as did his *Seventh* (1960). He was an influential teacher and theoretician, who taught music at Harvard for several decades (1919–24; 1926–60); he also wrote several textbooks, including *Harmony* (1941).

Place in the Sun, A (1951), the George STE-VENS film, based on the 1925 Theodore DREI-SER novel AN AMERICAN TRAGEDY, about the Gillette-Brown murder case; the novel had previously become the 1931 Josef von STERNBERG film *An American Tragedy*. The Stevens version featured Montgomery CLIFT, Elizabeth TAYLOR, and Shelley Winters. Stevens, screenwriters Michael Wilson and Harry Brown, cinematographer William Mellor, editing, costume design, and music all won OSCARS.

Plath, Sylvia (1932–63), U.S. writer, who emerged as a major literary figure with her first and only novel, the autobiographical *The Bell Jar* (1963). Her poetry collections, most of them published posthumously, include *The Colossus* (1962); *Ariel* (1966); *Crossing the Water* (1971); *Winter Dreams* (1972); and *Collected Poems* (1981), which won a PULITZER PRIZE. Her nightmarish, obsessive work was widely perceived as a feminist scream of anguish against an oppressive world and did indeed indicate intense emotional problems; she suffered a breakdown while still in college and ultimately was a suicide. Plath was married to British poet Ted HUGHES.

Platoon (1986), the Oliver STONE Vietnam War film, a bitterly probing, semi-autobiographical portrayal of the lives of front-line American soldiers, with Charlie Sheen, Tom Berenger, and Willem Dafoe in key roles. The film, Stone, editing, and sound all won OSCARS.

Playboy of the Western World, The (1907), the John Millington SYNGE play, set in the west of Ireland; it was first produced by the Irish National Dramatic Society at the ABBEY THEATRE. The play, one of the classic works of the Irish theater, was in part an unsparing look at some of the superstitions and shibboleths of the time and was greeted by riots on opening in Dublin and while on tour in the United States. A quite notable 1962 film version of the play was directed by Brian Desmond Hurst and starred Síobhán McKENNA.

"**Playhouse 90**" (1956–61), the pioneering U.S. television dramatic anthology, which presented a considerable range of original and classic works. Such original teleplays as JUDGMENT AT NUREMBERG, DAYS OF WINE AND ROSES, and THE MIRACLE WORKER were later adapted into notable plays and films.

Playing for Time (1980), the Fania Fenelon book, recalling her experiences as a prisoner of the Germans at Auschwitz; she was a musician in the band that played for the Nazi officers and as the Nazis marched masses of prisoners to their gas chambers. The book was adapted by Arthur MILLER into the television film, with Vanessa REDGRAVE as Fenelon leading a cast that included Jane ALEXANDER, Shirley Knight, Marisa Berenson, Verna Bloom, Viveca Lindfors, Max Wright, Maud Adams, and Christina Baranski. Daniel MANN directed.

"**Play it, Sam,**" Ingrid BERGMAN to pianist Dooley Wilson in CASABLANCA, as she implored him to play AS TIME GOES BY. Woody ALLEN amended it to *Play It Again, Sam*, and made it the title of his 1969 Broadway comedy hit and 1972 film, playing the lead in both opposite Diane KEATON.

Plisetskaya, Maya Michaelovna (1925–　　), Soviet dancer and actress, a soloist with the BOLSHOI BALLET from 1943, who became one of the leading Soviet ballerinas of the post-World War II period, playing in all the classic roles, perhaps most notably as Odette–Odile in *Swan Lake* and as Raymonda in *The Dying Swan*. She also played leads in such new works as *The Stone Flower* (1954), *Spartacus* (1958), and *Carmen Suite* (1967). On screen, she was *Anna Karenina* (1974).

Plough and the Stars, The (1926), the Sean O'CASEY play, a wry, compassionate, antiheroic view of the Irish Easter Rising of 1916, and by implication of the revolutionary process itself. The play, viewed by many as O'Casey's masterpiece, was misinterpreted by some Irish nationalists as an attack on their revolution; it generated riots when produced by the ABBEY THEATRE in Dublin in 1926, contributed to O'Casey's decision to leave Ireland in 1927, and led to the Abbey's decision not to produce his next play, *The Silver Tassie*.

Plummer, Christopher (Arthur Christopher Orme Plummer, 1927–　　), Canadian actor,

on stage from 1950; a leading classical actor in North America and Britain, who played most of the major roles in Shakespeare, many of them at the Stratford (Ontario) Shakespeare Theatre and in Britain's NATIONAL THEATRE (1971–72). He also appeared in such modern plays as J.B. (1958) and BECKET (1961) and as Atahualpa in *The Royal Hunt of the Sun* (1965), a role he re-created in the 1969 film. He has appeared in such films as THE SOUND OF MUSIC (1965), *The Night of the Generals* (1967), *Oedipus the King* (1968), and *Dreamscape* (1984). He is the father of actress **Amanda Plummer**.

Pogo, the Okeefenokee Swamp-dwelling political possum created by cartoonist Walt KELLY in the mid-1940s. After "Pogo"'s 1948 appearance as a daily comic strip in the *New York Star*, it quickly became a very popular, widely syndicated character, used by Kelly to satirize many of the leading political figures of the time.

Poirot, Hercule, the fastidious, mustachioed fictional Belgian detective created by Agatha CHRISTIE in *The Mysterious Affair at Styles* (1920), who was subsequently the center of many of her works, on paper, stage, and screen, as in MURDER ON THE ORIENT EXPRESS.

Poitier, Sidney (1924–), U.S. actor and director, on stage from 1946; his first appearance was in the American Negro Theatre's *Lysistrata*. He was on screen from 1949, made a considerable impact in such films as *Cry, the Beloved Country* (1952) and *Edge of the City* (1957), and became Hollywood's trailblazing first major Black film star with such films as THE DEFIANT ONES (1958); PORGY AND BESS (1959); A RAISIN IN THE SUN (1961); *Lilies of the Field* (1963), for which he won a best actor Oscar; IN THE HEAT OF THE NIGHT (1967); and GUESS WHO'S COMING TO DINNER (1967). His directorial work was on screen from 1972, with such films as *Buck and the Preacher* (1972), *Uptown Saturday Night* (1974), and *Hanky Panky* (1984).

Polanski, Roman (1933–), Polish director, on stage in Poland from the age of 14, whose shorts were on screen from 1958 and who

became a major international film figure with his first feature, *Knife in the Water* (1962). His work, some of it highly controversial in its time for its inclusion of sexual violence, included such films as *Repulsion* (1964), ROSEMARY'S BABY (1968), *Macbeth* (1971), and CHINATOWN (1974). In 1969 Charles Manson and his followers murdered Polanski's wife, actress Sharon Tate, their unborn child, and some of their friends, in the most celebrated mass murder of the period. In 1977 Polanski was accused of the rape of a 13-year-old, ultimately pleaded guilty, and then jumped bail, fleeing the United States and greatly damaging his film career. His later work includes *Tess* (1979), *Pirates* (1986), and *Frantic* (1988).

Pollack, Sidney (1934–), U.S. director and actor, who worked in theater and television before focusing on film direction in the mid-1960s. Among his most notable films are THEY SHOOT HORSES, DON'T THEY? (1969); *Jeremiah Johnson* (1972); THE WAY WE WERE (1973); *Three Days of the Condor* (1975); *Absence of Malice* (1981); TOOTSIE (1982); OUT OF AFRICA (1985), which he produced and directed, winning OSCARS for the film and as best director; and *Havana* (1990).

Pollock, Jackson (1912–56), U.S. painter. He became a seminal Abstract Expressionist (see ABSTRACT EXPRESSIONISM) in the late 1940s, when he moved to "drip-and-splash" painting, with paint and other material in his mixtures dripped and poured on his canvases and spread by tools other than brushes, such as trowels, a technique called ACTION PAINTING.

Pons, Lily (Alice Josephine Pons, 1898–1976), French soprano; she made her French debut in 1928, and in 1931 made an extraordinarily successful Metropolitan Opera debut in the title role in *Lucia de Lammermoor*, which launched her international career. She sang at the Met for 28 years, and for long periods at San Francisco and Chicago, as well as in many other houses. Pons was a very popular figure, also appearing in several films.

Ponti, Carlo (1913–), Italian-French producer, who practiced law in Italy from 1935 to 1938 before turning to films. Some of his most notable films are LA STRADA (1954), *Two*

Women (1960), YESTERDAY, TODAY, AND TOMORROW (1963), *Marriage Italian Style* (1964), and DOCTOR ZHIVAGO (1965). He is the husband of actress Sophia LOREN.

pop art, a kind of representational art that enjoyed considerable popularity in the United States and Britain from the mid-1950s through the early 1970s, through its depictions of repetitive symbols used in advertising and of mass-produced products, such as the emblematic Coca-Cola bottles and Campbell Soup cans created by Andy WARHOL in the early 1960s. Such artists as David HOCKNEY, Jim DINE, Robert INDIANA, and Roy LICHTENSTEIN were also leading pop-art figures.

Popeye the Sailor, the popular comic-strip character created by Elzie SEGAR in 1929, then joining and soon becoming the main character in *Thimble Theatre*. The spinach-gulping Popeye soon became the central character of the strip, which in 1933 was the basis of the long-running series of Max Fleischer animated film shorts and also of the 1980 Robert ALTMAN film *Popeye*, starring Robin WILLIAMS.

Porgy and Bess (1935), the folk opera on Black American themes by George and Ira GERSHWIN, based on Dubose Heyward's *Porgy* (1927), with Todd Duncan as Porgy, Anne Brown as Bess, and John W. BUBBLES as Sportin' Life. Its music includes such enduring classics as SUMMERTIME, IT AIN'T NECESSARILY SO, and BESS, YOU IS MY WOMAN NOW. In 1959 it became the Otto PREMINGER film, with Sidney POITIER, Dorothy DANDRIDGE, and Sammy DAVIS, Jr. in the key roles. A major work of the American musical theater, it has been revived often, usually as an operetta, and latterly as the opera it was intended to be.

Porter, Cole (1893–1964), U.S. composer and lyricist, a prolific songwriter who wrote scores of enduring standards while creating such hit Broadway musicals as *Paris* (1928), *Fifty Million Frenchmen* (1929), *The Gay Divorcé* (1932; the Hays Office insisted on changing the title to the *The Gay Divorcée* for the 1934 Fred ASTAIRE–Ginger ROGERS film), ANYTHING GOES (1934), *Jubilee* (1935), *Red, Hot, and Blue!* (1936), *Panama Hattie* (1940), *Kiss Me,*

Kate (1948), and *Silk Stockings* (1955, a musical version of NINOTCHKA). He wrote such songs as "Begin the Beguine" (1935); "You Do Something to Me" (1929); MY HEART BELONGS TO DADDY (1938); and NIGHT AND DAY (1932), which became the title of the 1946 film biography, with Cary GRANT playing Porter.

Porter, Edwin Stanton (1869–1941), pioneer, innovative U.S. cinematographer and director, who began working in films in the late 1890s; directed many short films for the Edison company from 1900; and is chiefly remembered as the director of THE GREAT TRAIN ROBBERY, a milestone in the history of the cinema.

Porter, Katherine Anne (1890–1980), U.S. writer, whose first collection of short stories, *Flowering Judas* (1930), established her as a leading author. She is best known for her only full-scale novel, SHIP OF FOOLS (1962), a highly allegorical story set on a German ship sailing from Mexico back to Germany in 1931, as Hitler is coming to power. Porter's other major works include *Pale Horse, Pale Rider* (1939), which contained three short novels, and several other volumes of poetry; her *Collected Stories* (1965) won a PULITZER PRIZE and a National Book Award.

Portrait of the Artist as a Young Man, A (1916), the James JOYCE novel, focusing on the seminal experiences of young Stephen Dedalus, as filtered through his "stream of consciousness." Dedalus, who later appears in ULYSSES, closely resembles Joyce; the work is substantially autobiographical.

Postman Always Rings Twice, The (1934), the James M. CAIN novel, a hard, rough look at contemporary American society as he found it in the mid-1930s, about a drifter and the dissatisfied wife of a roadside innkeeper, who ultimately murder the innkeeper for gain. The novel, adapted into several visual forms in the decades that followed, was the basis of Luchino VISCONTI's first film, the powerful *Obsession* (1942), the most seminal work of the Italian neorealist cinema (see NEOREALISM). In 1945, it was adapted by Harry Ruskin and Niven Busch under its own name into the equally powerful Tay Garnett film; John GAR-

FIELD was Frank and Lana TURNER was Cora, in a cast that included Cecil Kellaway and Hume CRONYN. David MAMET adapted the 1981 Bob Rafelson remake, starring Jack NICHOLSON and Jessica LANGE.

Potemkin (1925), the Sergei EISENSTEIN film, based on one of the key events of the Russian Revolution of 1905, the sailors' revolt on the battleship *Potemkin*, foreshadowing the sailors' and soldiers' revolts of 1917, which ultimately toppled the czar. Eisenstein wrote the screenplay for, directed, and edited this most classic of Soviet films, which had a tremendous effect on the development of world cinema. The central roles were played by Alexander Antonov and Vladimir Barsky. The film was shot by Eduard Tisse. The massacre on the Odessa Steps became, in Eisenstein's hands, one of the most striking and best-known scenes in film history.

Potter, Beatrix (1866–1943), British writer and illustrator, the creator of Peter Rabbit and many other popular animal figures in what became a series of extraordinarily popular children's books. Her first published work, *The Tale of Peter Rabbit*, was privately printed in 1900, after having been created in 1893 as a series of stories sent to a sick child. It was followed by such books as *The Tailor of Gloucester* (1903), *The Tale of Benjamin Bunny* (1904), and 20 more after that.

Potter, Dennis (1935–), British writer, who emerged as a major figure with such television screenplays as *Pennies from Heaven* (1978), *Blade on the Feather* (1980), *Tender Is the Night* (1985), *The Singing Detective* (1986), *Christabel* (1988), and *Lipstick on Your Collar* (1989). He adapted *Pennies from Heaven* into the 1981 Herbert Ross film and also wrote the screenplay for *Gorky Park* (1983).

Poulenc, Francis (1899–1963), French composer; he created such works as the ballet *Les Biches* (1924), first produced by the BALLET RUSSES company of Sergei DIAGHILEV. He also composed well over 100 art songs, many of them based on poems by ÉLUARD and APOLLINAIRE; the operas *The Breasts of Tiresias* (1947) and *Dialogues of the Carmelites* (1956); and a considerable body of other vocal and instrumental music, including several film scores.

Pound, Ezra (1885–1972), U.S. writer, critic, and translator, who exerted considerable influence on the development of modern English-language literature, early in his career through his enthusiastic sponsorship of such writers as T.S. ELIOT and James JOYCE, and from 1925 through the development of his own work, as expressed in his major work, *The Cantos*, a long, diverse, often opaque poetic work published in sections for several decades and still unfinished at his death. Pound, who lived in Italy from 1924 and through World War II, was also a fascist and anti-Semite, who quite openly supported the government of Benito Mussolini, and broadcast on behalf of that government during World War II. He was charged with treason by the American government after the war but was never tried, instead being placed in an asylum for the criminally insane from 1946 to 1958. After his friends secured his release, he returned to Italy.

Powell, Anthony Dymoke (1905–), British writer, who wrote several light satirical novels during the 1930s, beginning with *Afternoon Men* (1931). His major work was a satiric commentary on British life from the end of World War I through the 1960s, in the form of the 12-novel series *Dance to the Music of Time*, beginning with *A Question of Upbringing* (1951) and ending with *Secret Harmonies* (1976).

Powell, Bud (Earl Powell, 1924–66), U.S. JAZZ pianist; he became a leading BOP pianist in the mid-1940s, playing and recording with such figures as Charlie PARKER, Dizzy GILLESPIE, and Thelonius MONK. His career was considerably damaged by continuing psychiatric and substance-abuse problems.

Powell, Dick (Richard E. Powell, 1904–1963), U.S. actor, singer, director, and producer, on screen in juvenile and musical roles from 1932, in such films as 42ND STREET (1933), GOLD DIGGERS OF 1935 (1935), and *Christmas in July* (1940). He made a sharp transition to dramatic roles in the early 1940s, in such films as MURDER, MY SWEET (1945) and *Johnny O'Clock* (1957). From 1952 he also directed and produced films and television dramas, from 1952

to 1956 as one of the host-stars of "Four-Star Playhouse" and from 1961 to 1963 as host and sometimes star of "The Dick Powell Show." Powell died of cancer, probably contracted or enhanced by his three-month-long radiation exposure while filming THE CONQUEROR on location at the Nevada Test Site in 1954.

Powell, Michael (1905–90), British director, producer, and writer, whose directorial work was on screen from 1931; in 1938, he and **Emeric Pressburger** (1902–88) began their long collaboration, formalizing their partnership in The Archers from 1942 to 1956. They wrote, directed, and produced such notable films as *One of Our Aircraft Is Missing* (1942), THE LIFE AND DEATH OF COLONEL BLIMP (1943), I KNOW WHERE I'M GOING (1945), *Stairway to Heaven* (1946), BLACK NARCISSUS (1947), THE RED SHOES (1948), *Tales of Hoffman* (1951), and *The Pursuit of the Graf Spee* (1956).

Powell, William (1892–1984), U.S. actor, on screen from 1922, who made the transition to sound extremely well, playing Philo Vance in a series of films, beginning with *The Canary Murder Case* (1929). He became a major Hollywood star in 1934 as Nick CHARLES, opposite Myrna LOY's Nora Charles in the first of their six very popular THIN MAN films. He played Lorenz Ziegfeld twice, in *The Great Ziegfeld* (1936) and again in *The Ziegfeld Follies* (1945). He was also Godfrey in *My Man Godfrey* (1937) and Father in LIFE WITH FATHER (1947).

Power, Tyrone (Tyrone Edmund Power, Jr., 1913–58), U.S. actor, son of American actor Tyrone Frederick Power (1869–1931) and great-grandson of Irish actor Tyrone Power (1797–1841). He was on stage from 1931 and on screen from 1932, becoming a major Hollywood star in the 1930s, with such films as *Lloyds of London* (1937), ALEXANDER'S RAGTIME BAND (1938), *Suez* (1938), *Jesse James* (1939), BLOOD AND SAND (1940), and *A Yank in the RAF* (1941). He continued to do action films during the postwar period, but also moved strongly into full-scale dramatic roles, in such films as *The Razor's Edge* (1946), *Nightmare Alley* (1947), THE SUN ALSO RISES (1957), and WITNESS FOR THE PROSECUTION

(1958), also returning to the theater, most notably opposite Katharine CORNELL in *The Dark Is Light Enough* (1955).

Preminger, Otto (1906–86), Austrian-American director, producer, and actor, on stage from 1922, whose directorial work was on stage in Vienna from the early 1920s and on screen in Germany from 1931. In the United States from 1935, his theater work included the direction of *Libel* (1935); *Margin for Error* (1939), in which he also appeared; and *The Moon Is Blue* (1951), which he also directed on film in 1953. On screen, he directed and in many instances also produced such films as LAURA (1944), THE MAN WITH THE GOLDEN ARM (1956), ANATOMY OF A MURDER (1959), ADVISE AND CONSENT (1961), and *In Harm's Way* (1965).

Prendergast, Maurice (1859–1924), U.S. painter, who emerged as a leading American Impressionist with such colorful, lively turn-of-the-century watercolors as *Revere Beach* (1896), *Square of San Marco, Venice* (1899), *Carnival* (1900), and *Stony Beach, Ogunquit* (1901). He exhibited with THE EIGHT in 1908 and at the 1913 ARMORY SHOW, painting more in oils, and later producing such highly textured, decorative work as *Neponset Bay* (1914) and *Along the Shore* (1916).

President's Analyst, The (1967), the Theodore Flicker film, a notably effective satire of the Cold War and of the rash of espionage films characteristic of the time. James COBURN played the psychiatrist who becomes the U.S. President's personal analyst, breaks under the strain, and spends the rest of the film on the run, pursued by the secret agents of many countries and of The Phone Company, eager to learn or suppress the secrets he presumably possesses. The cast included Godfrey Cambridge, Severn Darden, Joan Delaney, Jill Banner, William Daniels, and Will Geer.

Presley, Elvis ("Elvis the Pelvis," 1935–77), U.S. singer and actor, the archetypal hip-swinging ROCK star, who became enormously popular—and in his time greatly controversial—in the mid-1950s. He began singing professionally in 1954, became a Memphis celebrity in 1955, and in 1956 emerged as a

In midcareer, Elvis Presley brought his hip-swiveling style to his own 1968 television special.

national phenomenon, with such hit songs as "I Got a Woman," "Heartbreak Hotel," "I Was the One," "Hound Dog," "I Want You, I Need You, I Love You," and "Love Me Tender," followed by such equally popular songs as "Loving You" (1957), "Big Hunk o' Love" (1959), and "It's Now or Never" (1960). He made a considerable number of films, none of them distinguished, including *Love Me Tender* (1956), *Loving You* (1957), *Jailhouse Rock* (1957), *Flaming Star* (1960), *Wild in the Country* (1961), and *Viva Las Vegas* (1964). His early death was probably hastened by substance abuse.

Pressburger, Emeric (1902–88), longtime moviemaking partner of Michael POWELL.

Preston, Robert (Robert Preston Meservey, 1918–86), U.S. actor, on stage from 1936 and on screen from 1938. His occasional theater work included his notable, TONY-winning Harold Hill role in THE MUSIC MAN (1957), which he re-created on screen in the 1962 film, and his Henry II on stage in THE LION IN WINTER (1966). On screen, he played second leads in action films for a generation, emerging

as a major player late in his career, in such films as *The Music Man* (1962), ALL THE WAY HOME (1963), S.O.B. (1981), and VICTOR/VICTORIA (1982), also playing in several substantial television roles in the later period.

Price, Leontyne (1927–), U.S. soprano; her first notable role was as Bess in the 1952–54 revival of PORGY AND BESS. She went on to become one of the first Black singers to become a major figure in grand opera and was one of the leading singers of her time, in concert from 1954; on television from 1955, beginning with her title role in TOSCA for NBC; and at Chicago, San Francisco, Covent Garden, La Scala, and many other houses during the late 1950s. She made her debut at the Metropolitan Opera in 1961 and opened the new Lincoln Center home of the company as Samuel BARBER's *Cleopatra* in 1966. Price also worked as a leading recording artist in a very wide range of roles and solo recitals.

Pride, Charley (1938–), U.S. country singer, who began recording in the mid-1960s and emerged as one of the leading country-music stars of the 1970s; a few of his best-known songs are "All I Have to Offer Is Me, I'm So Afraid of Losing You" (1969), "I'd Rather Love You" (1970), "Amazing Love" (1973), "A Shoulder to Cry On" (1973), "Someone Loves You, Honey" (1978), and "Night Games" (1983). It is also very often noted that he is one of the few leading Black performers in country music.

Pride and Prejudice (1940), the Hollywood adaptation of the classic Jane Austen novel, based on the 1935 Helen Jerome play and written for the screen by Aldous HUXLEY and Jane Murfin. Robert Z. Leonard directed; the cast included Greer GARSON, Laurence OLIVIER, Edmund Gwenn, Maureen O'Sullivan, Ann Rutherford, Edna May Oliver, Mary Boland, Karen Morley, Heather Angel, and Marsha Hunt.

Priestley, J.B. (John Boynton Priestley, 1894–1984), British writer and critic, who emerged in the 1930s as a popular novelist and playwright, with such novels as *The Good Companions* (1929), *Angel Pavement* (1930), and *They*

Walk in the City (1936), and with such plays as *Dangerous Corner* (1932), *Laburnum Grove* (1933), *Time and the Conways* (1937), and *When We Are Married* (1938). His later works include such novels as *Festival at Farbridge* (1951) and *Lost Empires* (1965) and such plays as *An Inspector Calls* (1946), which became the 1954 Guy Hamilton film, with Alastair SIM in the lead, and *The Linden Tree* (1947), as well as a wide range of novels, essays, and historical works. Priestley became an extremely popular radio personality during World War II and continued to appear frequently on radio and television through the early 1980s.

Prime of Miss Jean Brodie, The (1961), the Muriel SPARK novel, about a highly individual Edinburgh teacher and her students. It was adapted for the stage by Jay Presson Allen in 1966 and again in 1969, for the Ronald Neame film version. On stage, Vanessa REDGRAVE created the title role and Zoe Caldwell won a TONY in the Broadway production. On screen, Maggie SMITH won an OSCAR as Jean Brodie, with Robert Stephens, Pamela Franklin, Gordon JACKSON, and Celia JOHNSON in strong supporting roles.

Prince (Prince Roger Nelson, 1958–), U.S. singer and composer, whose very popular work is notable for its sexual content and his own sexually oriented variety-act presentation; it is often seen by some as a sort of latter-day burlesque act that invites parody. A few of his most popular albums are *Prince* (1979), *Dirty Mind* (1980), *Controversy* (1981), *1999* (1982), *Purple Rain* (1984), and *Sign of the Times* (1987). He also appeared in the film *Purple Rain* (1984).

Pritchett, V.S. (Victor Sawdon Pritchett, 1900–), British writer, whose works include several collections of short stories and such novels as *Clare Drummer* (1929) and *Mr. Beluncle* (1951); his biographies include *Balzac* (1973) and *Turgenev* (1977). He was also a prolific and highly regarded essayist and critic.

Private Life of Henry VIII, The (1933), the Alexander KORDA film, with Charles LAUGHTON in a memorable, OSCAR-winning performance in the title role. Five of his wives were played by Elsa Lanchester (his wife in real life), Binnie Barnes, Merle Oberon, Wendy Barrie, and Everley Gregg. Robert DONAT also played a substantial supporting role.

Private Lives (1930), the often-revived comedy by Noël COWARD, which starred Coward and Gertrude LAWRENCE in London and New York, with Robert MONTGOMERY and Norma SHEARER starring in the 1931 film. Tammy Grimes won a best actress TONY in a 1969 Broadway revival.

Prizzi's Honor (1985), John HUSTON's family comedy about a murderous Brooklyn Mafia family, the Prizzis, with Jack NICHOLSON leading a cast that included Kathleen TURNER as his hitwoman wife and Anjelica HUSTON as Maerose Prizzi, in a performance that won a best supporting actress OSCAR. Richard Condon's 1982 novel was the basis of the screenplay, written by Condon and Janet Roach.

Prodigal Son, The, a ballet on biblical themes, choreographed by George BALANCHINE, with music by Sergei PROKOFIEV, book by Boris Kochno, and decor by Georges ROUALT. It was first produced at Paris in May 1929, with Serge LIFAR in the title role, by the BALLET RUSSES company of Sergei DIAGHILEV.

Producers, The (1967), the Mel BROOKS film comedy, so highly regarded by some as to have become a cult classic. Zero MOSTEL was the larcenous Broadway producer of *Springtime for Hitler*, in a cast that included Gene Wilder, Estelle Winwood, Kenneth Mars, Dick Shawn, and Renee Taylor. Brooks won a best screenplay OSCAR.

Prokofiev, Sergei Sergeyevich (1891–1953), Soviet composer and pianist, a major figure in 20th-century music. He studied and worked in Russia until just after the Bolshevik Revolution, lived abroad from 1918, and returned to the Soviet Union in 1933. His early years in Russia produced such experimental modern works as the first and second *Piano Concertos* (1911 and 1913), the *Scythian Suite* (1915), and the one-act opera *The Gambler* (1917), as well as the far more formal *Classical Symphony* (*Symphony No. 1*, 1917) and first *Violin Concerto* (1917). Abroad, he composed such works as the opera *The Love for Three Oranges* (1921),

which he conducted at its Chicago premiere; the ballet THE PRODIGAL SON (1929), choreographed by George BALANCHINE for the BALLET RUSSES of Sergei DIAGHILEV; and many orchestral and instrumental works, including four more symphonies and several piano sonatas. On his return to the Soviet Union—and to Stalinism—his work became considerably less experimental and international, now often (though not always) stressing Russian nationalist themes, as well as noncontroversial classical themes. From this later period came his most popular work, PETER AND THE WOLF (1936); the opera WAR AND PEACE (1943); the ballets *Romeo and Juliet* (1938), *Cinderella* (1945), and *The Stone Flower* (1954); and the scores for the films ALEXANDER NEVSKY (1938) and IVAN THE TERRIBLE (1945).

Proust, Marcel (1871–1922), French writer, whose seven-part REMEMBRANCE OF THINGS PAST (1913–27) is a central work in the history of 20th-century literature. Four parts were published during his lifetime: *Swann's Way* (1913), *Within a Budding Grove* (1918), *The Guermantes Way* (1920), and *Cities of the Plain* (1921–22). The rest were published posthumously: *The Captive* (1924), *The Sweet Cheat Gone* (1925), and *Time Regained* (1927). The work had an enormous impact on many of the artists and intellectuals of his time. Proust also wrote an early unfinished novel, *Jean Santeuil*, published in 1952, and a miscellany of shorter pieces and translations.

Provincetown Players (1916–29), U.S. experimental theater group, founded in 1915 at Provincetown, Massachusetts by Susan Glaspell and others, which in 1916 presented a program of new works that included the first staged Eugene O'NEILL play, *Bound East for Cardiff* (1916), and from 1918 operated out of the Provincetown Playhouse. From 1916 the group also worked out of the Players' Theatre in New York City's Greenwich Village. It mounted first productions of such O'Neill plays as THE LONG VOYAGE HOME (1917), THE EMPEROR JONES (1920), *The Hairy Ape* (1922), ALL GOD'S CHILLUN GOT WINGS (1922), and DESIRE UNDER THE ELMS (1924), as well as new plays by John Reed, Edna St.

Vincent MILLAY, Edmund WILSON, Maxwell Bodenheim, Paul GREEN, and many others.

psychedelic art, a variant on OP ART that was briefly popular in the late 1960s and early 1970s; it attempted to create forms portraying the sensory distortions produced by such drugs as LSD.

Psycho (1960), the Alfred HITCHCOCK movie, a cult film in the horror genre, starring Anthony PERKINS in the title role, in a cast that included Janet LEIGH, Vera Miles, John Gavin, and Martin Balsam. The blood-soaked shower-scene murder became archetypal of its kind. The Joseph Stefano screenplay was adapted from the Robert Bloch novel. Much later, three sequels followed: *Psycho 2* (1983), *Psycho 3* (1986) and *Psycho IV* (1990).

Public Enemy, The (1931), the William WELLMAN early Depression-era gangster film, with James CAGNEY in his first starring role. The cast included Jean HARLOW in a highly sexual role; Edward Woods; Joan BLONDELL; and Mae Clarke, here chiefly remembered for the scene in which Cagney pushes a grapefruit into her face, part of the realism that made the film powerful and attractive in its time but that would soon be prohibited by the film industry's self-censorship.

Puccini, Giacomo (1858–1924), Italian composer, whose operas brought him international recognition. His six best-known works are his first great success, *Manon Lescaut* (1893); *La Bohème* (1896); TOSCA (1900); MADAME BUTTERFLY (1904); THE GIRL OF THE GOLDEN WEST (1910); and the unfinished TURANDOT (1926), completed by one of his students.

Pudovkin, Vsevolod I. (1893–1953), Soviet director, writer, and actor, who very early in his career made three silent films that established him as one of the leading figures in the development of Soviet and world film: MOTHER (1926), *The End of St. Petersburg* (1927), and STORM OVER ASIA (1928). He made the transitions to sound and Stalinism only with difficulty, though later in his career making such well-received films as *Deserter* (1933), *Suvorov* (1941), and *Admiral Nakhimov* (1946).

Pulitzer Prizes, from 1917 a series of annual prizes in journalism, literature, and music, endowed by the terms of the will of newspaper publisher Joseph Pulitzer. There are eight journalism prizes, as well as prizes for musical composition, history, drama, poetry, biography, fiction, and general nonfiction.

Purlie Victorious (1961), the Ossie DAVIS play, a satirical comedy set in contemporary small-town Georgia. Davis was Purlie Victorious Judson, a Black southerner who has returned home to create his part of a new South, in the form of an integrated church. He was strongly supported by Ruby DEE, Godfrey Cambridge, Sorrell Brooke, and Alan ALDA, all of whom re-created their roles in the 1963 Nicholas Webster film, retitled *Gone Are the Days.* The play was also the basis of the 1970 Broadway musical *Purlie.*

Pygmalion (1914), the George Bernard SHAW play, a modern reworking of the Pygmalion-and-Galatea legend. Mrs. Patrick CAMPBELL created the Eliza DOOLITTLE role on the English-speaking stage, opposite Herbert Beerbohm TREE, as Henry HIGGINS. In 1938 the play was adapted by Shaw into the Anthony ASQUITH film, with Wendy HILLER and Leslie HOWARD in the leads, in a cast that included Scott Sunderland, Wilfred Lawson, Everley Gregg, Marie Lohr, David Tree, and Esmé Percy, with several leading British stage players in minor roles. The play was the basis of the musical MY FAIR LADY (1956).

Pynchon, Thomas (1937–), U.S. writer, a purposefully obscure black humorist, who emerged as a major figure with his first novel, *V* (1963), followed by *The Crying of Lot 49* (1966) and seven years later by his National Book Award-winning *Gravity's Rainbow* (1973). It was again many years before the publication of his next novel, the very highly regarded *Vineland* (1989).

Q

Quasimodo, Salvatore (1901–68), Italian writer and translator, a leader of the Hermeticist movement in Italian poetry. Much of his major work reflects the attempt of that movement to create wholly personal poetry, with no regard for formal restrictions; the resulting work is often obscure to all but the poet. In such later poetry as *The Incomparable Earth* (1958) and *To Give and to Have, and Other Poems* (1969), Quasimodo became considerably more accessible. In 1959 he was awarded the NOBEL PRIZE for literature.

Quayle, Anthony (1913–89), British actor, director, and producer, on stage from 1931, who joined the Old Vic company in 1932, playing mainly in repertory through the 1930s. He became a leading player during the postwar period, in a wide range of roles, while also in 1946 beginning his career as a theater director. He directed and acted at Stratford's Shakespeare Memorial Theatre from 1948 and was director of the theater from 1948 to 1956, playing in such roles as Falstaff and Othello. From the mid-1950s he appeared in many modern classics as well, notably as *Galileo* (1967) and in *Sleuth* (1970), both in London and New York. On screen, he played in a long series of strong supporting roles, in such films as LAWRENCE OF ARABIA (1962) and *Anne of the Thousand Days* (1970); he later also appeared in television.

Queen, Ellery, the fictional detective created by and pen name of two American mystery writers, Frederic Dannay (1905–82) and Manfred Lee (1905–71), used in writing the extraordinarily popular Ellery Queen detective series, beginning with *The Roman Hat Mystery* (1929). From 1941 they also jointly edited *Ellery Queen's Mystery Magazine*. Several films have been developed from the Ellery Queen novels, most notably a series of four 1940–41 films starring Ralph BELLAMY, but none were particularly successful.

Quiet Man, The (1952), the John FORD film; John WAYNE was the American returning to his ethnic roots, in a cast that included Maureen O'Hara, Victor MCLAGLEN, Barry FITZGERALD, Mildred Natwick, and Ward Bond. Ford won a best director OSCAR, as did Winton C. Hoch and Archie Stout for cinematography. The Frank Nugent screenplay was based on a Maurice Walsh story.

Quinn, Anthony (1915–), U.S. actor, on screen from 1936, who played in a long series of Hollywood action-film supporting roles, emerging as a major dramatic actor in the early 1950s, in such films as *Viva Zapata* (1952), for which he won a best supporting actor OSCAR; Frederico FELLINI's classic LA STRADA (1954), as Zampanò opposite Giulietta MASSINA's Gelsomina; *Lust for Life* (1956), which won him another best supporting actor Oscar; and LAWRENCE OF ARABIA (1962). He later starred in such films as *Zorba the Greek* (1964), *The Shoes of the Fisherman* (1968), *Mohammed* (1976), and *The Lion of the Desert* (1980).

Quo Vadis (1912), the most notable of the several films derived from the 1895 Henryk Sinkiewicz novel, set in Rome during Nero's reign, as Christianity rose. Enrico Guazzoni's epic 1912 film version was until then the longest film ever shown and was an enormous popular success. The 1951 Mervyn LEROY epic starred Robert TAYLOR and Deborah KERR.

R

Rabe, David (1940–), U.S. writer, whose wartime experiences in Vietnam provided the basis for his three most notable plays: *The Basic Training of Pavlo Hummel* (1971), The TONY AWARD-winning *Sticks and Bones* (1971), and *Streamers* (1976). He adapted *Streamers* into the 1983 Robert ALTMAN film and also wrote the screenplay for *I'm Dancing As Fast As I Can* (1982). His plays also include *In the Boom Boom Room* (1973) and *Hurlyburly* (1984). He is the husband of actress Jill CLAYBURGH.

Rachel, Rachel (1968), the Paul NEWMAN film, his first directorial outing, starring his wife, Joanne WOODWARD; her full, deep portrayal of the sane, complex, highly imaginative, terribly constricted small-town schoolteacher who ultimately breaks free is the heart of the work. The cast included Kate Harrington, James Olson, Estelle Parsons, Geraldine FITZGERALD, and Donald Moffat. The Stewart Stern screenplay was based on the Margaret Laurence novel *The Jest of God.*

Rachmaninoff, Sergei Vasilyevich (1873–1943), Russian composer, conductor, and pianist, a major 20th-century figure in the Romantic tradition. He became a very popular composer with his early *Prelude in C Sharp Minor* (1892) and the *Second Piano Concerto* (1901), then went on in the period before the Russian Revolution to create such further major works as his *Second Symphony* (1907), the *Third Piano Concerto* (1909), and the choral symphony *The Bells* (1913), as well as a large body of other instrumental and vocal music, including the opera *Francesca da Rimini* (1904). He was one of the leading pianists of the era and a notable guest conductor. Rachmaninoff lived abroad after the Revolu-

tion, in his later years composing less but still creating such works as the *Fourth Piano Concerto* (1926), *Corelli Variations* (1931), *Rhapsody on a Theme of Paganini* (1934), and the *Third Symphony* (1936), while pursuing a worldwide career as a pianist and conductor.

Raging Bull (1980), the Martin SCORSESE film biography of fighter Jake LaMotta. The Paul Schrader–Mardik Martin screenplay was based on the LaMotta autobiography. Robert DE NIRO won an OSCAR for his powerful performance in the title role, as did editor Thelma Schoonmaker.

ragtime, an American musical form, from Black African and American roots, that flourished from the mid-1890s through the mid-1920s. "Rags," such as those composed by preeminent ragtime composer Scott JOPLIN, were largely syncopated marches written for the piano, though many rags were also written for the violin and other instruments. Ragtime was succeeded by JAZZ; indeed, many ragtime musicians became jazz musicians by a simple change of self-description.

Ragtime (1975), the E.L. DOCTOROW novel, a densely textured exploration of the turn-of-the-century United States, based on several actual events of its period. It was adapted by Michael Weller into the 1981 Milos FORMAN film, with Howard E. Rollins, Jr., James CAGNEY, Elizabeth McGovern, and Mary Steenburgen in key roles.

Raiders of the Lost Ark (1981), the Steven SPIELBERG thriller, with Harrison FORD as Indiana Jones, who embarks on a series of dangerous adventures; it was a very popular throwback to the serials of the early days of silent film and, like them, was followed by sev-

eral sequels. Michael Kahn won an editing OSCAR.

Rain (1921), the Somerset MAUGHAM short story, set on a South Seas island, about prostitute Sadie Thompson and evangelist Alfred Davidson, interested in saving her soul—and as it turns out, equally and fatally interested in her sexual being. Sadie Thompson proved irresistible to two generations of leading actresses; of the several adaptations, these are the most notable: In the 1922 John Colton–Clemence Randolph play, Jeanne EAGELS played the role, opposite Robert Kelly as the preacher. Gloria SWANSON starred in the 1928 Raoul WALSH *Sadie Thompson*, opposite Lionel BARRYMORE. Joan CRAWFORD starred in RAIN (1932), opposite Walter HUSTON; the film was adapted by Maxwell ANDERSON from the 1922 play and was produced and directed by Lewis MILESTONE. And Rita HAYWORTH sang the role in the 1953 musical remake, opposite Jose FERRER; Curtis BERNHARDT directed.

Rainey, Ma (Gertrude Pridgett, 1886–1939), U.S. BLUES singer, a major figure in the history of the blues. She was in Black vaudeville with her husband, William "Pa" Rainey, during the early part of the century, and Bessie SMITH was one of her protégées. Yet they both recorded in the same period; the classic Ma Rainey recordings of the 1923–29 period stand beside those of Smith in capturing a substantial portion of the American blues heritage.

Rain Man (1988), the Barry Levinson film, written by Ronald Bass and Barry Morrow; the story of two brothers, one autistic, who are at first unknown to each other but develop a deep, warm relationship after an unpromising start. Dustin HOFFMAN was the autistic brother, opposite Tom CRUISE. The film, Hoffman, and the screenwriters won OSCARS.

Rains, Claude (1889–1967), British actor, on stage at the age of 10, who became a leading character actor in Britain and the United States in the three decades before his first appearance on screen, as THE INVISIBLE MAN (1933). He then went on to a very substantial film career during Hollywood's Golden Age, in such films as MR. SMITH GOES TO WASHINGTON (1939), CASABLANCA (1943), *Mr. Skeffington* (1944),

and *Notorious* (1946), receiving OSCAR nominations for all four of the latter films. He was also a very notable Caesar opposite Vivien LEIGH in CAESAR AND CLEOPATRA (1945). Rains returned to the stage in the early 1950s, winning a TONY for his Rubashov in DARKNESS AT NOON (1951). He also appeared frequently in radio plays during the 1930s and later on television.

Raisin in the Sun, A (1959), the Lorraine HANSBERRY play, about the life of a poor Black urban family in Chicago. Hansberry adapted the play into the 1961 Daniel Petrie film, with a cast that included Sidney POITIER, Claudia McNeil, Ruby DEE, Diana Sands, and Steven Perry. The play was the basis for the 1973 stage musical *Raisin*.

Raitt, Bonnie (1949–), U.S. folk and BLUES singer, composer, and guitarist. She began to sing in cabaret in 1969 and to record in 1971, with *Bonnie Raitt*, an album including "Woman Be Wise." Other notable early albums were *Give It Up* (1972), with the song "Love Has No Pride"; *Taking My Time* (1973); *Streetlights* (1974); *Home Plate* (1975); and *Sweet Forgiveness* (1977). Her career then sagged, until the appearance of the extraordinarily well-received album *Nick of Time* (1989), which won several awards and more than reestablished her career, making her one of the leading singers of the early 1990s. She is the daughter of singer **John Raitt** (1917–), whose long career included the leads in CAROUSEL (1945) and THE PAJAMA GAME (1954).

Rambo, the violent action-film hero-caricature created by Sylvester STALLONE in the film *First Blood* (1982) and its sequels: *Rambo: First Blood, Part II* (1985), and *Rambo III* (1988).

Rampal, Jean-Pierre (1922–), French flautist, who emerged as a leading exponent of the instrument and its music during the post-World War II period, touring worldwide as a soloist and in concert from 1945.

Ran (1985), Akira KUROSAWA's epic, loose adaptation of Shakespeare's *King Lear*, set in the warring Japanese Middle Ages, with Lear's three daughters now three sons and with Tatsuya Nakadai, Satoshi Terao, Jinpachi Nezu,

Daisuke Ryu, and Mieko Harada in leading roles.

Rand, Ayn (1905–82), Russian-American writer and philosopher, whose novels passionately argue the merits of her theory of objectivism, which espouses the pursuit of individual goals, opposes the pursuit of liberal social goals, and posits rational self-interest as the only permissible basis for human society. Her most notable novels are *We, the Living* (1936), *The Fountainhead* (1943), and *Atlas Shrugged* (1957). *The Fountainhead* became the 1949 King VIDOR film, with Gary COOPER in the lead.

Random Harvest (1941), the James HILTON novel, about an amnesiac World War I casualty and the woman he marries in both his lives. In the 1942 Mervyn LEROY film, popular in a world once more at war, Ronald COLMAN played the Charles Rainier–John Smith role, opposite Greer GARSON, in a cast that included Susan Peters, Margaret Wycherly, and Philip Dorn.

Ransom, John Crowe (1888–1974), U.S. writer and critic, much of whose work extols the virtues of the preindustrial American South. His poetry was collected in such volumes as *Chills and Fever* (1924), *Two Gentlemen in Bonds* (1927), and *Selected Poems* (1945), and his critical work in such volumes as *God Without Thunder: An Unorthodox Defense of Orthodoxy* (1931) and *The New Criticism* (1941). The latter established him as a leader of that critical tendency, which attempted to analyze each literary work as a discrete entity, entirely disconnected from its history.

Raphael, Frederic (1931–), British writer, who won a best screenplay OSCAR for DARLING (1966) and went on to write such works as the television miniseries "The Glittering Prizes" (1976); the short story *Oxbridge Blues* (1980), which he adapted into the 1984 film; and the novel *After the War* (1988), which he adapted into the 1988 television miniseries. He has also written several other films, teleplays, and novels. His work includes biographies of Somerset MAUGHAM and Byron, as well as essays and classical translations.

Rashomon (1951), the Akira KUROSAWA film, a story of rape and murder set in medieval Japan, told from several very differing points of view. It was Kurosawa's first major international film and the first Japanese film to achieve worldwide impact. The cast included Toshiro MIFUNE, Machiko Kyo, Masiyuki Mori, Takashi Shimura, Minoru Chiaki, and Kichijiro Ueda.

Rathbone, Basil (1892–1967), British actor, on stage from 1911, who emerged as a strong character player in the 1920s, moved gradually into leads, and in the mid-1930s played Romeo to Katharine CORNELL's Juliet on tour and then on Broadway, also playing Robert to her Elizabeth Barrett Browning in THE BARRETTS OF WIMPOLE STREET. He was on screen from 1921, in the sound era becoming one of the greatest villains of the 1930s, in such films as *Captain Blood* (1935) and *The Adventures of Robin Hood* 1938). He became the definitive screen Sherlock HOLMES in *The Hound of the Baskervilles* (1939) and made in all 14 Sherlock Holmes films from 1939 to 1946, also becoming radio's very popular Sherlock Holmes during those same years and taking on the role once more late in his career, on Broadway in 1953. He returned to the theater often, winning a best actor TONY in *The Heiress* and, later in his career, most notably in J.B. (1958–60).

Rattigan, Terrence Mervyn (1911–77), British writer, who began with such successful light comedies as *French Without Tears* (1936); *After the Dance* (1939); and *Love in Idleness* (1944), which in America was *O Mistress Mine*, starring Alfred LUNT and Lynn FONTANNE. During the postwar period he emerged as a major dramatist, with such plays as *The Winslow Boy* (1946), THE BROWNING VERSION (1948), *The Deep Blue Sea* (1952), *The Sleeping Prince* (1953), and SEPARATE TABLES (1954), all of which he adapted into films. Robert DONAT starred in Anthony ASQUITH's 1950 *The Winslow Boy*, and Michael REDGRAVE played the schoolmaster in Asquith's 1951 *The Browning Version*. *The Deep Blue Sea* became the 1955 Anatole LITVAK film, starring Vivien LEIGH. *The Sleeping Prince*, starring Laurence OLIVIER and Vivien Leigh on stage, became on

screen Olivier's 1957 *The Prince and the Showgirl*, in which he and Marilyn MONROE starred. And *Separate Tables* became the 1958 Delbert MANN film, with the key roles played by Burt LANCASTER, Rita HAYWORTH, Wendy HILLER, David NIVEN, Deborah KERR, and Gladys Cooper. Rattigan also wrote several original screenplays.

Rauschenberg, Robert (1925–), U.S. artist, whose work of the early 1950s moved from all-white paintings with numbers and other figures to all-white, all-black, and all-silver paintings, and then in the mid-1950s to collage, to collage-on-paint (which he called "combines"), to silk-screen works; in the early 1960s he added sculpture, in the form of constructions. In aggregate, his work was seminal for the POP ART movement. He also did sets, costumes, and some lighting for the Merce CUNNINGHAM dance company from 1955 to 1965 and sets and costumes for the Paul Taylor company from 1967 to 1969.

Ravel, Maurice-Joseph (1875–1937), French composer, a major figure in 20th-century French music. He created such well-known early works as the *Scheherazade Overture* (1898), *Pavane for a Dead Princess* (1903), and the *String Quartet* (1903) while still in his twenties, then going on to such works as the *Spanish Rhapsody* (1908); the ballet DAPHNIS AND CHLOÉ, choreographed by Michel FOKINE and first produced by the BALLET RUSSES of Sergei DIAGHILEV in 1912; the opera *The Child and the Enchantments* (1925); and his best-known work, BOLERO (1928), originally choreographed by Bronislava NIJINSKA as a ballet and later often played as a piano piece.

Rawlings, Marjorie Kinnan (1896–1953), U.S. writer, whose work is set in the Florida countryside to which she migrated in the late 1920s and includes the novels *South Moon Under* (1933); *Golden Apples* (1935); and *The Yearling* (1938), which won a PULITZER PRIZE and was adapted into the classic 1946 Clarence BROWN children's film, with Gregory PECK, Jane WYMAN, and Claude Jarman in the key roles. *Cross Creek* (1942) was the story of her settlement in Florida; it became the basis for the 1983 Martin RITT film, with Mary Steenburgen in the Rawlings role.

Ray, Johnny (1927–90), U.S. singer, a leading pop figure of the 1950s, for his very emotional renditions of "Cry" and "The Little White Cloud That Cried," the sides of his 1951 breakthrough record. He later sang such songs as "Please Mr. Sun" (1952) and "Here Am I—Brokenhearted" (1952). His popularity waned considerably after the mid-1950s.

Ray, Man (1890–1976), U.S. photographer, filmmaker, and painter; he was a painter in New York before World War I, embraced DADA in 1915, and was a founder of the first New York Dadaist group. He moved to Paris in 1921, then becoming a surrealist (see SURREALISM) and simultaneously moving into highly experimental photography, developing several major technical advances during the interwar period. He also became a highly regarded portrait photographer, though often altering the portrait photos to create somewhat surreal and abstract work.

Ray, Satyajit (1921–), Indian director, whose first work, PATHER PANCHALI (1955), introduced modern Indian film to a greatly impressed world audience. He followed it with APARAJITO (1956) and THE WORLD OF APU (1959). The three films together formed the APU TRILOGY and consolidated his position as one of the foremost figures in the history of cinema and as India's leading director. His later films include such classics as *Distant Thunder* (1973) and *The Home and the World* (1984).

Raymond, Alex (Alexander Gillespie Raymond, 1909–56), U.S. cartoonist, who created several comic strips, most notably FLASH GORDON, in 1934. He also created "Jungle Jim" and "Secret Agent X-9" in the same period.

Rear Window (1954), the Alfred HITCHCOCK film, a thriller adapted by John Michael Hayes from the Cornell Woolrich story. James STEWART starred as the Peeping Tom photographer, opposite Grace KELLY, in a cast that included Raymond BURR as the murderer, Thelma Ritter, and Wendell Corey.

Rebecca (1938), the Daphne DU MAURIER Gothic novel, set in Cornwall. It was adapted by Robert E. SHERWOOD and Joan Harrison

Fated to die young, James Dean made his early mark in *Rebel Without a Cause* (1955), here with Natalie Wood.

into the OSCAR-winning 1940 Alfred HITCH-COCK film, with Joan FONTAINE and Laurence OLIVIER in the leads and Judith ANDERSON and George Sanders in key supporting roles. Cinematographer George Barnes won an Oscar.

Rebel Without a Cause (1955), the Nicholas Ray film, the title role being played by James DEAN, who became emblematic of the rebellious youth of his generation. The cast included Natalie WOOD, Sal Mineo, Jim Backus, Nick Adams, Rochelle Hudson, Dennis Hopper, and Corey Allen.

rebop, alternative term for BOP.

Redford, Robert (Charles Robert Redford, Jr., 1937–), U.S. actor, director, and producer, on stage from 1959, who emerged as a star on Broadway in *Barefoot in the Park* (1963), a role he re-created on film in 1967. He became a major international film star in 1969, playing opposite Paul NEWMAN in BUTCH CASSIDY AND THE SUNDANCE KID, and then a "superstar" in the 1970s with such films as *Downhill Racer* (1969), *Jeremiah Johnson* (1972), THE WAY WE WERE (1973), THE

STING (1973), and ALL THE PRESIDENT'S MEN (1976). Moving into directing, he won a best director OSCAR for his ORDINARY PEOPLE (1980), directed and played the lead in *The Natural* (1984), and directed and produced *The Milagro Beanfield War* (1988).

Redgrave, Michael (1908–85), British actor, on stage in repertory from 1934, who emerged as a leading player in the 1940s and as a notable Shakespearean actor with his *Macbeth* (1947, in New York 1948) and *Hamlet* (1950). During the next three decades he was one of the great players of the British stage, with John GIELGUD, Laurence OLIVIER, and Ralph RICHARDSON, in a wide range of classic and modern leading roles. His film career began in 1938, with THE LADY VANISHES, and includes such films as THE STARS LOOK DOWN (1939), *Kipps* (1941), *Dead of Night* (1945), *Fame Is the Spur* and MOURNING BECOMES ELECTRA (both 1947), and THE BROWNING VERSION (1950). He also played many strong supporting roles later in his career. He was married to actress Rachel Kempson and was the father of actresses

Vanessa REDGRAVE and **Lynn Redgrave** and of actor **Corin Redgrave**.

Redgrave, Vanessa (1937–), British actress, on stage from 1957, who emerged as a major player in classic roles during the early 1960s, starred in THE PRIME OF MISS JEAN BRODIE (1966), and continued to play on stage in a wide variety of classic and modern roles, most notably in *Orpheus Descending* (London and New York, 1988–89). She was on screen from 1958, often in strong dramatic roles, as Isadora DUNCAN in ISADORA (1968); as *Mary, Queen of Scots* (1971); in JULIA (1977), winning a best supporting actress OSCAR; as Agatha CHRISTIE in *Agatha* (1978); in television's PLAYING FOR TIME (1979); and in such later films as *The Bostonians* (1984), *Steaming* (1985), *Wetherby* (1986), *Comrades* (1986), and *Prick Up Your Ears* (1987). Active with her brother Corin Redgrave in British left political causes, she also sharply expressed her political views in some of her work, as in the documentary film *The Palestinians* (1977), which she narrated and produced.

Red River (1948), the Howard HAWKS Western, largely set during a cattle drive on the Chisholm Trail. John WAYNE was the Texas rancher who sets out for Missouri with his herd, opposite Montgomery CLIFT as the orphan boy he has raised as a son, in a cast that included Walter Brennan, Joanne Dru, John Ireland, Coleen Gray, Noah Beery, Jr., Harry Carey, and Harry Carey, Jr.

Reds (1981), the Warren BEATTY film, about early-20th-century American radicals and the Russian Revolution. Beatty starred as journalist and revolutionary John Reed, in a cast that included Diane KEATON as journalist Louise Bryant, Edward Herrmann as Max Eastman, Maureen STAPLETON as Emma Goldman, Jack NICHOLSON as Eugene O'NEILL, and Paul Sorvino, Jerzy KOSINSKI, Nicholas Coster, and Gene HACKMAN. Beatty won an OSCAR for best director, as did Vittoria Storaro for cinematography and Stapleton as best supporting actress.

Red Shoes, The (1948), the ballet film-fantasy, written and directed by Michael POWELL and Emeric Pressburger, based on a Hans Christian Andersen fairy tale. Moira Shearer, Anton Walbrook, and Marius Goring played the leads in a story set in the world of ballet theater. Brian Easdale won an OSCAR for the music, as did Hein Heckroth for the art and Arthur Lawson for the set.

Reed, Carol (1906–76), British director, on stage as an actor from 1924, who moved into film direction in the early 1930s, his work appearing on screen from 1935. He directed such films as THE STARS LOOK DOWN (1939) and *The Young Mr. Pitt* (1942); made two highly regarded wartime documentaries, *The Way Ahead* (1944) and *The True Glory* (1945); and emerged as a major director during the early postwar period, with such films as ODD MAN OUT (1947), THE FALLEN IDOL (1948), the classic THE THIRD MAN (1949), and AN OUTCAST OF THE ISLANDS (1952). His later work, much of it done in Hollywood, was much less notable, although he won a best director OSCAR for *Oliver!* (1968).

Reed, Donna (Donna Belle Mullenger, 1921–86), U.S. actress, on screen from 1943. She played wholesome leading roles from the mid-1940s, in such films as IT'S A WONDERFUL LIFE (1946), *Trouble Along the Way* (1953), and *The Far Horizons* (1955), though her best film role by far was as Alma, the prostitute in FROM HERE TO ETERNITY (1953), for which she won a best supporting actress OSCAR. Moving into television, she played the title role in the long-running family situation comedy "The Donna Reed Show" (1958–66).

reggae, Jamaican popular music, fusing Afro-Caribbean forms with American JAZZ and ROCK forms. It became popular in North America and Europe from the mid-1960s, especially as played by Bob MARLEY.

Reinhardt, Ad (Adolf Frederick Reinhardt, 1912–67), U.S. painter, who worked as a cartoonist before emerging as a leading Abstract Expressionist (see ABSTRACT EXPRESSIONISM) in the late 1940s. His main aim, as stated in a considerable number of articles, was to define and create art that was entirely separate from every aspect of life. Ultimately, that led him to the preminimalist

monochromatic and then all-black paintings that were his mature work.

Reinhardt, Django (1910–53), Belgian Gypsy JAZZ musician, a guitarist, composer, and bandleader who played his guitar with three fingers, his left hand having been injured in a 1928 caravan fire. He became a leading figure in European jazz, as a member of the Paris-based Quintet of the Hot Club of France (1934–39), most notably opposite violinist Stéphane Grappelly, and with his brother Joseph Reinhardt, Rogert Chaput, and Louis Vola.

Reinhardt, Max (Maximilian Goldman, 1873–1943), Austrian actor, director, and producer, who focused on stage directing and producing from 1903 and became by far the most influential single force in the German-speaking theater, first at Berlin's Deutsches Theatre and from 1924 also at Vienna's Josephstadt Theatre. He presented old and new classics, experimented with mass and space, and trained most of the directors who would in the 1920s develop the classic period in German film, such as F.W. MURNAU and Ernst LUBITSCH. He also trained many of those who would become stars on stage and screen, such as Emil JANNINGS and Marlene DIETRICH. He was forced to flee the Nazis in the 1930s, ultimately going to Hollywood, where he developed a theater school, co-directing only one film, *A Midsummer Night's Dream* (1935).

Remarque, Erich Maria (1898–1970), German writer, whose experience as a soldier during World War I informed his first novel, ALL QUIET ON THE WESTERN FRONT (1929). The book, which established him as an internationally popular novelist, was made into the classic, OSCAR-winning 1930 Lewis MILESTONE film, with Lew AYRES in the lead. Remarque's sequel was *The Road Back* (1931). An antifascist, Remarque fled Germany in 1933; much of his further work reflects the experience of fascism and World War II. His best-known later novels include THREE COMRADES (1937), set in a Germany turning fascist; *Flotsam* (1941); ARCH OF TRIUMPH (1946), about refugees in Paris in the late 1930s; *Spark of Life* (1952), a concentration-camp novel; and *A Time to Live and a Time to Die*, set in a Germany about to

collapse in World War II. F. Scott FITZGERALD adapted *Three Comrades* into the 1938 Frank BORZAGE film, with Margaret SULLAVAN, Robert TAYLOR, Franchot TONE, and Robert YOUNG in the leads. *Arch of Triumph* became the 1948 Lewis MILESTONE film, starring Ingrid BERGMAN and Charles BOYER. *A Time to Live and a Time to Die* became the 1958 Douglas Sirk film, with John Gavin and Lilo Pulver in leading roles.

Rembrandt (1936), the Alexander KORDA film biography of the painter, with Charles LAUGHTON in the title role and Elsa Lanchester, Gertrude LAWRENCE, Roger LIVESEY, and Edward Chapman in key supporting roles.

Remembrance of Things Past (*À la recherche du temps perdu*, 1913–27), the seven-part, centrally important work by Marcel PROUST, consisting of *Swann's Way* (1913), *Within a Budding Grove* (1918), *The Guermantes Way* (1920), and *Cities of the Plain* (1921–22), all published during his lifetime, and *The Captive* (1924), *The Sweet Cheat Gone* (1925), and *Time Regained* (1927), all published posthumously. The work is in form a set of highly detailed recollections, largely in the form of sense impressions, as related by the narrator; in content, it is a recountal of Proust's lifelong, despairing journey through the culture of the French upper bourgeoisie, as he found it during his lifetime.

Remick, Lee (1935–), U.S. actress, on stage from 1952 and on screen from 1957. A few of her most notable films are A FACE IN THE CROWD (1957), THE LONG HOT SUMMER (1958), ANATOMY OF A MURDER (1959), DAYS OF WINE AND ROSES (1962), *A Severed Head* (1971), and *The Europeans* (1979). She also appeared in several notable television films, including *The Blue Knight* (1974), *Jennie* (1974), IKE (1979), and as Margaret SULLAVAN in *Haywire* (1980).

Renaud, Madeleine (1900–), French actress, on stage with the Comédie Française 1923–47, for much of that time a leading player in the French theater. She left the company in 1947, with her husband, Jean-Louis BARRAULT, to become the star and co-director of the Compagnie Renaud-Barrault, then

becoming a leading French interpreter of a wide range of classic and modern works. She was on screen infrequently, from 1922, in such films as *Maria Chapdelaine* (1934) and *Stormy Waters* (1941).

Renault, Mary (Mary Challans, 1905–83), British writer, best known for her meticulously researched and crafted historical novels, set in the ancient world. These include *The Charioteer* (1953); *The Last of the Wine* (1956); *The King Must Die* (1958); *The Bull from the Sea* (1962), based on the story of Theseus; *The Lion in the Gateway* (1964); *The Mask of Apollo* (1966); and the Alexander the Great trilogy, consisting of *Fire from Heaven* (1970), *The Persian Boy* (1977), and *Funeral Games* (1981). She also wrote *The Nature of Alexander* (1975).

Renoir, Jean (1894–1979), French director, whose work was on screen from 1925. He made several highly regarded but commercially unsuccessful sound films in the 1930s, including *La Chienne* (1931) and THE LOWER DEPTHS (1936), and in 1937 directed the classic THE GRAND ILLUSION. In 1939 he created another classic, THE RULES OF THE GAME. He spent most of the 1940s in Hollywood, making such films as *The Southerner* (1945) and *Woman on the Beach* (1947). In 1951 he created a third classic, THE RIVER, made in India, and then returned to France, where he completed his career. He was the son of painter Auguste Renoir; the brother of actor Pierre Renoir; and the uncle of cinematographer **Claude Renoir**, whose first film, *Toni* (1934), he directed.

Resnais, Alain (1922–), French director, whose work was on screen from 1948, and who became a key figure in the French NEW WAVE movement, with such films as his antiwar HIROSHIMA, MON AMOUR (1959) and *Last Year at Marienbad* (1961). His later works include LA GUERRE EST FINIS (*The War Is Over*) (1966), *Stavisky* (1974), *Providence* (1977), *My American Uncle* (1980), and *Mélo* (1986).

Respighi, Ottorino (1879–1936), Italian composer, best known for two orchestral works: *The Fountains of Rome* (1916) and *The Pines of Rome* (1924). He wrote such other orchestral works as *The Birds* (1927) and *Roman Festival*

(1929), as well as a considerable body of other instrumental and vocal music. His also wrote several operas, including *Re Enzo* (1905) and *Belfagor* (1923).

Revelations, the ballet choreographed by Alvin AILEY, primarily using Black folk and gospel themes; it became a dance classic and the signature piece of Ailey's dance company. It was first produced at New York, in January 1960, by the Alvin Ailey American Dance Theater.

Rexroth, Kenneth (1905–82), U.S. writer, critic, and translator, from 1927 a San Francisco-based literary, social, and political radical, as expressed in such poetry collections as *In What Hour* (1940), *The Signature of All Things* (1949), *In Defense of the Earth* (1956), and *The Morning Star* (1979) and by such collections of essays as *Bird in the Bush* (1959) and *The Alternative Society* (1971). He also did several volumes of translations of Chinese and Japanese poetry.

Reymont, Wladyslaw Stanislaw (1867–1925), Polish writer, whose best-known works include the novels *The Comedienne* (1896); *The Promised Land* (1899); a multivolume epic of Polish life, *The Peasants* (1904–9); and the trilogy *Rok 1794* (1914–19), about the late-18th-century Polish revolt against Russian rule. He won the 1924 NOBEL PRIZE for literature for *The Peasants*.

Reynolds, Burt (1936–), U.S. actor, on stage from the mid-1950s, on television from the late 1950s, and in films from 1961. He became a popular movie star in the late 1960s, in such films as *100 Rifles* (1969), *Deliverance* (1972), *The Man Who Loved Cat Dancing* (1973), *The Longest Yard* (1974), *Gator* (1976; he also directed), *Smokey and the Bandit* (1977), *The End* (1978; he also directed), *Hooper* (1978), *Starting Over* (1979), *Sharkey's Machine* (1981; he also directed), the two *Cannonball Run* films (1981 and 1984), *Breaking In* (1988), *Rent-a-Cop* (1988), and *Physical Evidence* (1989). He has also appeared in several television films and series.

Reynolds, Debbie (Mary Frances Reynolds, 1932–), U.S. actress, on screen from 1948, who became a Hollywood star in the early 1950s, most notably in the classic musical

SINGIN' IN THE RAIN (1952), and in such light films of the day as *The Tender Trap* (1955), *Tammy and the Bachelor* (1957), *The Mating Game* (1959), *The Unsinkable Molly Brown* (1964), and *The Singing Nun* (1966).

Rhys, Jean (1894–1979), British writer, who took as her theme the financial plight of abused women in a male-dominated world, in such works as *The Left Bank and Other Stories* (1927) and the novels *Quartet* (1929); *After Leaving Mr. Mackenzie* (1930); *Voyage in the Dark* (1934); and *Good Morning, Midnight* (1939). She fell into obscurity after the 1930s but found new audiences in the next feminist wave. With *The Sargasso Sea* (1966) she reemerged as a major figure.

Rice, Elmer (Elmer Reizenstein, 1892–1967), U.S. writer, whose first play, the mystery *On Trial* (1914), rested to some extent on his experience as a young lawyer. A fantasy, *The Adding Machine* (1923), and his PULITZER PRIZE-winning naturalistic drama, *Street Scene* (1929), established him as a major playwright. He adapted the latter into the 1931 King VIDOR film, with Sylvia SIDNEY and William Collier, Jr. in the leads. He also adapted his 1931 play *Counsellor-at-Law* into the 1933 William WYLER film, with John BARRYMORE in the title role. During the 1930s he turned far less successfully toward plays of social protest, such as *We, the People* (1933), *Judgment Day* (1934), and *American Landscape* (1938). His later work includes *Dream Girl* (1945), which on Broadway starred his wife, Betty Field; the 1948 Mitchell Leisen film version starred Betty Hutton.

Rich, Adrienne Cecile (1929–), U.S. writer and radical feminist, best known for such poetry collections as *A Change of World* (1951), *Diamond Cutters* (1955), *Necessities of Life and Other Poems* (1969), *The Dream of a Common Language* (1978), and *Time's Power* (1989).

Rich and Famous (1981), the George CUKOR remake of OLD ACQUAINTANCE, with Jacqueline BISSET and Candice BERGEN in the leads.

Richardson, Ralph (1902–83), British actor, on stage from 1921 and on screen from 1933, who became a leading player with the Old Vic company during the 1930s. He was for five decades one of the great players of the British stage, with John GIELGUD, Laurence OLIVIER, and Michael REDGRAVE, in an extraordinarily wide range of roles, from Falstaff, Toby Belch, and Dr. Clitterhouse to Peer Gynt, Volpone, Othello, and Cyrano and including leads in such modern plays as HOME (1970), *Lloyd George Knew My Father* (1972), and *No Man's Land* (1975). He played in an equally wide range of roles on screen, from THE FOUR FEATHERS (1939) and *The Fallen Idol* (1946) to DOCTOR ZHIVAGO (1962) and television's WITNESS FOR THE PROSECUTION (1984).

Richardson, Tony (Cecil Antonio Richardson, 1928–), British director and producer, whose work was on stage from 1955 at London's Royal Court Theatre and included the first productions of LOOK BACK IN ANGER (1956), which he directed on film in 1959, and THE ENTERTAINER (1957), which he directed on film in 1960. Although continuing to work in the theater, his main further work was on screen, in such films as THE LONELINESS OF THE LONG DISTANCE RUNNER (1962); TOM JONES (1963), for which he won a best director OSCAR; and *The Hotel New Hampshire* (1984).

Richler, Mordecai (1931–), Canadian writer, whose Montreal Jewish roots inform his best-known early work, the partially autobiographical *The Apprenticeship of Duddy Kravitz* (1959), which he adapted into the 1974 Ted Kotcheff film, with Richard DREYFUSS in the title role. His later work includes the novels *Cocksure* (1968), *St. Urbain's Horsemen* (1971), and *Joshua Then and Now* (1980). He has also written short stories, several other film scripts, and many teleplays.

Richter, Conrad Michael (1890–1968), U.S. writer, much of whose work focuses on early American themes, beginning with his Southwest-based *The Sea of Grass* (1937), which became the 1947 Elia KAZAN film, starring Katharine HEPBURN and Spencer TRACY. His midwestern family-history trilogy consists of *The Trees* (1940), *The Fields* (1946), and *The Town* (1950); the latter won a PULITZER PRIZE. A very popular later work was *The Light in the Forest* (1953).

Richter, Sviatoslav Teofilovich (1915–), Soviet pianist; he made his debut in 1934 and from the early 1940s introduced several of the later works of Sergei PROKOFIEV. He emerged as a world figure in 1960 with his first Western tour, as quite recognizably one of the leading pianists of the century.

Riefenstahl, Leni (Helene Bertha Amalie Riefenstahl, 1902–), German director and actress, on screen from 1926, who became a Nazi propagandist after Hitler's accession to power and made two very effective German propaganda films in documentary style: THE TRIUMPH OF THE WILL (1935) and *Olympiad* (1938). Her career ended with Nazi defeat in World War II.

Rigg, Diana (Enid Diana Elizabeth Rigg, 1938–), British actress, on stage from 1957, whose career included many of the key classical roles, with the ROYAL SHAKESPEARE COMPANY (1959–64); with Britain's National Theatre (1972–75); and in such single productions as *Macbeth* (1972), *The Misanthrope* (1973), PYGMALION (1974), *Night and Day* (1978), and *Heartbreak House* (1973). She is probably best known for her Emma Peel in the television series "The Avengers" (1965–67). She has also appeared in several strong teleplays, including *In This House of Brede* (1975), *King Lear* (1983), and *Bleak House* (1984). Her films include *On Her Majesty's Secret Service* (1969), *The Hospital* (1971), and *A Little Night Music* (1977).

Rilke, Rainer Maria (1875–1926), German writer, one of the leading German-language poets of the 20th century, whose focus on matters of belief and mortality, coupled with the quality of his work, considerably influenced the course of modern German poetry. His key works include the poetry collections *The Picture Book* (1902), *Poems from the Book of Hours* (1905), *New Poems* (1907–8), *Duinese Elegies* (1923), and *Sonnets to Orpheus* (1923) and the novel *The Journal of Malte Laurids Brigge* (1910).

Rinehart, Mary Roberts (1876–1958), U.S. writer, a prolific and very popular author of mystery novels, beginning with *The Circular Staircase* (1908) and *The Man in Lower Ten* (1909). Her plays include *The Bat* (1920), co-written with Avery Hopwood. She also wrote the *Tish* comic novels and many short stories.

Rin Tin Tin (1916–32), the German shepherd (and his successors) who became the very popular star of over a dozen Hollywood films and serials from 1922 to 1931.

Rio Grande (1950), the third film in John FORD's CAVALRY TRILOGY.

Ripley, Robert Leroy (1893–1949), U.S. cartoonist; in 1918, then a sports cartoonist for the *New York Globe*, he originated his *Believe It or Not* feature, which ultimately grew into a widely syndicated feature, a series of short films, and a considerable enterprise that drew many imitators.

Rite of Spring, The (*Le Sacre du printemps*), a ballet by Igor STRAVINSKY, on a fertility rite theme. It was choreographed by Vaslav NIJINSKY and presented in Paris in May 1913, by the BALLET RUSSES company of Sergei DIAGHILEV, with Marie Piltz as The Chosen One. The work caused a considerable scandal, as it included a ritual sacrifice.

Ritt, Martin (1919–90), U.S. actor and director, on stage from 1937 and on screen from 1944. Although a theater director whose works include A VIEW FROM THE BRIDGE (1955), he is best known as a film director, for such works as *Edge of the City* (1957), THE LONG HOT SUMMER (1958), THE SOUND AND THE FURY (1959), HUD (1963), THE SPY WHO CAME IN FROM THE COLD (1965), THE GREAT WHITE HOPE (1970), SOUNDER (1972), NORMA RAE (1979), *Cross Creek* (1983), *Nuts* (1987), and *Stanley and Iris* (1990).

River, The (1951), the Jean RENOIR film, set in a British community on the banks of the Ganges and focusing on a sequence of events involving a teenage girl, played by Patricia Walters. The cast included Nora Swinburne, Esmond Knight, Thomas E. Breen, Radha, Suprova Mukerjee, and Adrienne Corri. The film was adapted by Renoir and Rumer Godden from a Godden novel and was shot by Claude Renoir.

Rivera, Diego Maria (1886–1957), Mexican painter, a leading 20th-century muralist, who

studied in Spain from 1908 to 1909, then lived in Paris until his return to Mexico as a Marxist in 1921, intending to develop an indigenous Mexican revolutionary movement in the arts. He joined the Mexican Communist Party in 1922, was later expelled, and was an intimate of Trotsky in Mexico, later still returning to the Communist Party. Rivera created several large murals during the 1920s, most notably at the Ministry of Education (1927) and the Palace of Cortez at Cuernavaca. He did several murals in the United States during the early 1930s, including those at the Detroit Museum (1933) and the disputed RCA Building mural at Rockefeller Center, *Man at the Crossroads*, which was destroyed because he had included a portrait of Lenin; he later re-created the work at the Palace of Belles Artes in Mexico City. His later, often highly political works include *Dream of a Sunday Afternoon in the Central Alameda* (1949), at the Del Prado Hotel in Mexico City, which caused a great scandal because it included the words "God does not exist," a phrase he painted out in 1955 as a gesture of reconciliation after a lifetime of dissent.

Rivers, Larry (1923–), U.S. painter and sculptor, who moved in the early 1950s from ABSTRACT EXPRESSIONISM to more figurative work, which in many instances, as in *Washington Crossing the Delaware* (1953) and his large painting-and-sculpture mural *The History of the Russian Revolution* (1965), reintroduced history to an antihistorical section of the American art world. He also did portraiture, most notably of his mother-in-law, as in *Portrait of Birdie* (1955). His continuing use of Abstract Expressionist painting techniques, coupled with the inclusion of many kinds of materials and artifacts in his collages and other constructions, also associate him with POP ART.

Roach, Hal (1892–), U.S. director, producer, and writer, whose work was on screen from 1915. In 1916, he began his long association with comedian Harold LLOYD, and from the 1920s he developed many comedy series, first as shorts and later as feature films, including the LAUREL AND HARDY and OUR GANG films. During the sound-film era he focused on producing, developing such films as OF MICE

AND MEN (1939) and the three *Topper* films (1937, 1939, and 1941).

Roach, Maxwell (1924–), U.S. JAZZ drummer, bandleader, and composer, who was the leading drummer of the mid-1940s BOP movement and went on to become a very influential figure in modern jazz, recording with such luminaries as Miles DAVIS, Charlie PARKER, and Dizzy GILLESPIE and becoming a highly respected teacher.

"Roamin' in the Gloamin' " (1911), Harry LAUDER's signature song, which he sang in variety throughout the world for decades and also recorded; both words and music were by Lauder.

Robards, Jason (Jason Nelson Robards, Jr., 1922–), U.S. actor, on stage from 1951 and on screen from 1959, who emerged as a leading stage player as Hickey in THE ICEMAN COMETH (1956) and went on to become a leading Eugene O'NEILL interpreter. In 1959 he won a best actor TONY for *The Disenchanted*. He also created the leads in *A Thousand Clowns* (1962), which he re-created on screen in 1965, and in *After the Fall* (1964). Other major screen roles include Ben Bradlee in ALL THE PRESIDENT'S MEN (1976), for which he won a best supporting actor OSCAR; Dashiell HAMMETT in JULIA (1978), for which he won a second best supporting actor Oscar; Howard Hughes in *Melvin and Howard* (1980); and the lead in television's "Sakharov" (1984). He is the son of U.S. actor Jason Robards (1892–1963).

Robbe-Grillet, Alain (1922–), French writer, a leading figure in the French NEW WAVE, with such novels as *The Erasers* (1953), *The Voyeur* (1955), and *Jealousy* (1957). He also wrote several screenplays, most notably for the 1961 Alain RESNAIS film *Last Year at Marienbad* (1961) and for *The Immortal* (1963), which he also directed.

Robbins, Jerome (Jerome Rabinowitz, 1918–), U.S. dancer, choreographer, and director, who became a choreographer while dancing with the American Ballet Theater, his *Fancy Free* ballet providing the basis for his choreography of ON THE TOWN (1944). He went on to choreograph *High Button Shoes* (1947) and THE KING AND I (1951); co-

directed THE PAJAMA GAME (1954); and then directed and choreographed such musicals as *Bells Are Ringing* (1956), WEST SIDE STORY (1957), and FIDDLER ON THE ROOF (1964). He won an OSCAR as co-director of the 1961 filmed version of *West Side Story*. He also choreographed scores of ballets, including such works as *Fanfare* (1953), *The Dybbuk Variations* (1974), and *Quiet City* (1986).

Roberta (1933), the Broadway musical, based on the Alice Duer Miller novel *Gowns by Roberta*, with music by Jerome KERN and book and lyrics by Otto Harbach. The play was most notable for its introduction of SMOKE GETS IN YOUR EYES and such songs as "Yesterdays" and "The Touch of Your Hand." In 1935 it was adapted into the classic Fred ASTAIRE–Ginger ROGERS film musical, with Irene DUNNE receiving top billing, Randolph SCOTT in a fourth lead, and the songs "Lovely to Look At" and "I Won't Dance" added. William A. Seitzer directed the film, adapted from the play by Jane Murfin, Sam Mintz, and Allan Scott.

Roberts, Kenneth Lewis (1885–1957), U.S. writer, whose popular historical novels include *Arundel* (1930), *The Lively Lady* (1931), *Rabble in Arms* (1933), *Captain Caution* (1934), *Northwest Passage* (1937), *Oliver Wiswell* (1940), and *Lydia Bailey* (1947). Several of his novels were adapted into action films, most notably *Northwest Passage*, which became the 1940 King VIDOR movie, with Spencer TRACY in the leading role.

Robertson, Cliff (Clifford Parker Robertson, 1925–), U.S. actor, on stage from the mid-1950s and on screen from 1955. He played John F. Kennedy in *PT-109* (1963) and won a best actor OSCAR in the title role in CHARLY (1968), also appearing in such films as THE BEST MAN (1964), *The Honey Pot* (1967), *J.W. Coop* (1972; he also directed and produced), and *Three Days of the Condor*. But his career was greatly damaged by what amounted to informal film-industry BLACKLISTING following his valid 1979 accusation that a high film-industry executive had signed Robertson's name to a check. His later career included several television appearances.

Paul Robeson in his "Ol' Man River" role of Jim in the film *Show Boat* (1936).

Robeson, Paul Bustill (1898–1976), U.S. actor and singer, on stage from 1924. His debut was in Eugene O'NEILL's ALL GOD'S CHILLUN GOT WINGS (1924), followed by his Brutus Jones in THE EMPEROR JONES (1925), which he re-created in 1933, in his first film. He sang OL' MAN RIVER as Joe in SHOW BOAT in London in 1928, playing the role again in the 1932 New York revival and in the 1936 film, which established him as one of the most popular actors, singers, and then recording artists of his day. Earlier, from 1925, he had emerged as a leading concert singer, especially of Black spirituals. He played *Othello* for the first time in London in 1930, opposite Peggy ASHCROFT's Ophelia, and again in Margaret WEBSTER's long-running and highly regarded 1940 New York production. On screen he also appeared in such films as *Sanders of the River* (1935) and *Proud Valley* (1940). Politically active on the left, his career was very seriously damaged during the McCarthy period; accused of Communist affiliation, harassed, and BLACKLISTED, he found himself unable to pursue his career in the United States, while

for eight years (1950–58) also being denied a passport by his government. He resumed his career in 1958, moved to Great Britain, and played Othello again, at Stratford-on-Avon in 1959. He also resumed his concert career, touring in Britain and throughout Europe, and made several new records. Seriously ill, he returned to the United States in 1963, concluding his career.

Robinson, Bill "Bojangles" (Luther Robinson, 1878–1949), U.S. dancer, in vaudeville as a child and one of the leading tap dancers of the century, as well as a major Black variety entertainer. He was a cabaret headliner in the 1920s, also appearing in such stage musicals as *Blackbirds of 1928*, *Brown Buddies* (1930), *Blackbirds of 1933*, and *The Hot Mikado* (1939). On screen, he reached worldwide audiences in three Shirley TEMPLE films—*The Little Colonel* (1935), *The Littlest Rebel* (1935), and *Rebecca of Sunnybrook Farm* (1938)—and played the lead, opposite Lena HORNE, in *Stormy Weather* (1943).

Robinson, Boardman (1876–1952), U.S. artist and teacher, who greatly influenced the development of American editorial cartooning. He drew for the *New York Morning Telegraph* from 1907 to 1910 and was the very influential editorial cartoonist for the *New York Tribune* from 1910 to 1914. He opposed World War I, also turning toward socialism during and after the war, and left the *Tribune*, then drawing for many publications, including *The Masses*, *Puck*, *The Liberator*, and *Harper's Weekly*. In the early 1920s he turned to book illustration, painting, and teaching.

Robinson, Edward G. (Emmanuel Goldenberg, 1893–1973), U.S. actor, on stage from 1913, a member of the Theater Guild company in the late 1920s and on screen from 1923. He became a star of Hollywood's Golden Age with his archetypal gangster in LITTLE CAESAR (1931) and was typecast as a gangster for some years, then moving on to play major dramatic roles in such films as *Dr. Ehrlich's Magic Bullet* (1940), *The Sea Wolf* (1941), DOUBLE INDEMNITY (1944), *The Stranger* (1946), ALL MY SONS (1948), KEY LARGO (1948), *House of Strangers* (1949), *The Cincinnati Kid* (1965), and SOYLENT GREEN (1973). In 1956 he

returned to Broadway in *The Middle of the Night*.

Robinson, Edwin Arlington (1869–1935), U.S. writer; his first poetry collection, the self-published *The Torrent and the Night Before* (1896), was rooted in his native Gardiner, Maine, which became his Tilbury Town. For the next four decades, most of them spent in New York City, he explored the themes developed in his New England youth, winning PULITZER PRIZES for his *Collected Poems* (1921), *The Man Who Died Twice* (1924), and *Tristam* (1927). Such poems of his as "The Man Against the Sky" (1916) and "Miniver Cheevy" (1910) are often anthologized.

Robson, Flora (1902–84), British actress, on stage from 1921 and on screen from 1931. She was for four decades one of the leading players of the British stage, while at the same time playing strong roles in such films as FIRE OVER ENGLAND (1937), WUTHERING HEIGHTS (1939), CAESAR AND CLEOPATRA (1945), *Saratoga Trunk* (1946), and BLACK NARCISSUS (1946).

Rocco and His Brothers (1960), the Luchino VISCONTI film, which focuses on the underside of Italian life, as it follows five brothers who move from impoverished southern Italy to live, work, and find despair in Milan. Alain DELON played Rocco, in a cast that included Katina PAXINOU, Renato Salvatori, Claudia Cardinale, and Annie Girardot.

rock or **rock and roll**, an American popular music style that quickly developed into a major international style. It originated in the early 1950s, as a "White," or popular music mainstream, adaptation of the Black rhythm-and-blues style. The emblematic rock-and-roll singer was Elvis PRESLEY, singing to electronically enhanced acccompaniment. In the early 1960s rock became a massive international form, with the advent of THE BEATLES and THE ROLLING STONES and the development of a much wider set of musical forms, all called rock, that included many country, folk, and JAZZ elements. Later, rock became almost synonymous with mainstream popular music and also developed various subforms, such as

the sometimes aggressively iconoclastic or abrasive "punk" and "heavy metal."

"Rockford Files, The" (1974–80), the long-running television detective series, starring James GARNER as private investigator Jim Rockford, in a cast that included Noah Beery, Jr., Gretchen Corbett, Joe Santos, and Stuart Margolin.

Rockwell, Norman (1894–1978), U.S. artist, best known for his hundreds of rather optimistic—though in painting terms realistic—magazine covers, most notably those done for the *Saturday Evening Post* from 1916 until the magazine ceased publication in 1969. He also did covers for many other magazines of his time and some book illustration, as well.

Rocky (1976), the John G. Avildsen film, written by Sylvester STALLONE, with Stallone in the title role as a fighter who wins fame and fortune in the ring against all odds. The film, Avildsen, and editors Richard Halsey and Scott Conrad all won OSCARS. The picture was a massive commercial success and spawned four sequels, all of them directed by Stallone.

Rodeo, the ballet choreographed by Agnes DE MILLE, with music by Aaron COPLAND. It was first produced in New York, in October 1942, by the Ballet Russes de Monte Carlo, with De Mille, Frederic Franklin, and Casimir Kokitch in leading roles.

Rodgers, Jimmy (1897–1933), U.S. country-music singer, songwriter, and guitarist. One of the earliest country-music stars, he began recording in 1927, having worked in vaudeville and as a yodeler in the early 1920s. He became identified with such early country-music standards as "Blue Yodel," the first of many yodelling records; "Brakeman's Blues"; and "My Old Pal."

Rodgers, Richard Charles (1902–79), U.S. composer, whose long collaborations with lyricists Lorenz HART and Oscar HAMMERSTEIN II produced some of the most memorable works of the American musical theater. With Hart, he wrote such shows as *A Connecticut Yankee* (1927), *Jumbo* (1935), *Babes in Arms* (1937), and *Pal Joey* (1940). His extraordinary collaboration with Hammerstein resulted in nine musicals, including such classics as

OKLAHOMA! (1943), CAROUSEL (1945), SOUTH PACIFIC (1949), and THE SOUND OF MUSIC (1959). Many of his musicals were made into films; he also wrote the music for such films as *Love Me Tonight* (1932), *State Fair* (1945), and the wartime documentary *Victory at Sea* (1954). His hundreds of songs include such enduring standards as OKLAHOMA! (1943), PEOPLE WILL SAY WE'RE IN LOVE, SOME ENCHANTED EVENING (1949), OH, WHAT A BEAUTIFUL MORNIN' (1943), and YOU'LL NEVER WALK ALONE (1945).

Roethke, Theodore (1908–63), U.S. writer, whose poetry often seeks analogies between the life of plants and that of the human unconscious, in such collections as *Open House* (1941), *The Lost Son* (1948), *Praise to the End!* (1951), his PULITZER-PRIZE-winning *The Waking* (1953), *Words for the Wind* (1958), and *The Far Field* (1964). Some of his essays, letters, and notebooks have also been published.

Rogers, Buck, the prototypical science-fiction comic-strip hero, created by Philip Nowlan and Richard Calkins in 1929. Buck, Wilma, Dr. Huer, and Killer Kane later appeared in comic books; long-running radio, film, and television serials; and feature films.

Rogers, Ginger (Virginia Katherine McMath, 1911–), U.S. actress, on stage in vaudeville and cabaret from the mid-1920s, on Broadway in *Girl Crazy* (1930), and also on screen from 1930, in such films as 42ND STREET (1933) and GOLD DIGGERS OF 1933. She then became a major star of Hollywood's Golden Age, as Fred ASTAIRE's partner in 10 classic film musicals: *Flying Down to Rio* (1933), *The Gay Divorcée* (1934), ROBERTA (1935), TOP HAT (1935), *Follow the Fleet* (1937), *Swing Time* (1937), *Shall We Dance* (1937), *Carefree* (1938), *The Story of Vernon and Irene Castle* (1939), and *The Barkleys of Broadway* (1949). She also played in scores of other films, including *Kitty Foyle* (1940), for which she won a best actress OSCAR, *Roxie Hart* (1942); and *Lady in the Dark* (1944).

Rogers, Roy (Leonard Slye, 1912–), U.S. actor and singer, on stage as a singer in variety from the early 1930s. On screen from 1935, he emerged as a singing cowboy star with *Under*

Western Stars (1936) and was a leading cowboy star for the next two decades, along with his wife, Dale Evans, and his horse, Trigger. All of them also played on television, on "The Roy Rogers Show" (1951–56).

Rogers, Will (William Penn Adair Rogers, 1879–1935), U.S. entertainer, on stage as a rider and rope twirler in Wild West shows from the early 1900s and in vaudeville as a folk humorist and political satirist from 1904, who starred in several *Ziegfeld Follies* from 1916 to 1924. He was on screen from 1918 and became a star with the advent of sound, in such films as *State Fair* (1933), *David Harum* (1934), and *Steamboat 'Round the Bend* (1935). He was a popular radio personality as well, and enjoyed unique celebrity in United States in the early 1930s. He and pioneer aviator Wiley Post died in an Alaskan plane crash during a flight to Siberia.

Rohmer, Eric (Jean-Marie Maurice Scherer, 1920–), French NEW WAVE director and writer, whose work was on screen from 1950. He was editor of CAHIERS DU CINÉMA (1957–1963), and then moved seriously into filmmaking, becoming established as a leading international filmmaker with such films as *My Night at Maud's* (1969), *Claire's Knee* (1970), *Chloé in the Afternoon* (1972), *The Marquise of O* (1976), and *Pauline at the Beach* (1983).

Rolland, Romain (1866–1944), French writer, best known for his massive 10-part novel, the fictional biography *Jean Christophe* (1904–12), which reflected his view of a European civilization in disintegration, and his lifelong attempt to reconcile the conflicts that twice were to destroy his world. A second massive fictional biography was the seven-part *The Soul Enchanted* (1922–33). He also wrote several highly regarded biographies, including *Beethoven* (1903), *Michelangelo* (1905), *Handel* (1910), *Tolstoy* (1911), and *Mahatma Gandhi* (1923). As a playwright he is best known for such patriotic works as *Danton* (1900), *The Fourteenth of July* (1902), and *Robespierre* (1938), as well as for his early play *The Wolves* (1898), which took the side of the unjustly prosecuted Alfred Dreyfus. As a pacifist, self-exiled in Switzerland during World War I, he wrote antiwar essays in *Above the Battlefield*

(1915). Rolland was awarded the NOBEL PRIZE for literature in 1915.

Rolling Stones, The, British ROCK band, organized in 1962; the original members were Mick JAGGER (Michael Phillip Jagger, 1941–), Keith Richards (1943–), Bill Wyman (1936–), Charlie Watts (1941–), and Brian Jones (Lewis Brian Hopkins-Jones, 1942–69). The band, rather carefully cultivating its bitterly abrasive, anticultural, highly sexual image, with Jagger promoted as a devil figure, became popular in Britain and United States in the mid-1960s, touring widely, with such songs as "The Little Red Rooster" (as sung by them in 1964), "The Last Time" (1965), "Mother's Little Helper" (1966), "Lady Jane" (1966), and "Let's Spend the Night Together" (1967) and such albums as the three *Rolling Stones* (1964; two in 1965), *Aftermath* (1966), *Their Satanic Majesties Request* (1967), and *Exile on Main Street* (1972). Their concert appearances became massive and often uncontrollably violent; at Altamont, California, in 1969, their security force, composed of Hell's Angels, killed a member of the audience immediately in front of the stage, an incident captured on film in GIMME SHELTER. The group has continued to tour and record through the following two decades.

Rolvaag, Ole Edvart (1876–1931), Norwegian-American writer, who wrote in Norwegian and translated his work into English. He is best known for his novel of pioneer life in the Dakotas, *Giants in the Earth* (1925), which was the first work in the trilogy that also included *Peter Victorious* (1928) and *Their Fathers' God* (1931).

Romains, Jules (Louis Farigoule, 1885–1972), French writer, best known for the massive 27-novel series *Men of Good Will* (1932–46), in which he created a huge mosaic of French society from before World War I through the early 1930s. His earlier work includes the novel *The Death of a Nobody* (1911); several early poems reflecting his lifelong belief in the kind of quasi-historical determinism described as "unanism"; and many plays, most of them light comedies, most notably *Dr. Knock* (1923) and his adaptation of *Volpone* (1928).

Romberg, Sigmund (1887–1951), Hungarian-American composer, a prolific creator of operettas and film scores, who became a leading American musical-theater figure with such operettas as *Maytime* (1917); *Blossom Time* (1921); *The Student Prince* (1924); *The Desert Song* (1926); *The New Moon* (1928); and, late in his career, *Up in Central Park* (1945).

Ronde, La (1950), the Max OPHÜLS film, which he and Jacques Natanson adapted from the 1903 Arthur SCHNITZLER play *The Round Dance;* a series of vignettes illuminating several aspects of love, its cast included Anton Walbrook, Simone SIGNORET, Serge Reggiani, Simone Simon, Daniel Gélin, Danielle Darrieux, Jean-Louis BARRAULT, and Gerard PHILIPE. Roger VADIM remade the film as *Circle of Love* in 1964.

Ronstadt, Linda Marie (1946–), U.S. singer, who emerged in the mid-1970s as a very well-received popular and country singer with the album *Heart Like a Wheel* (1974), containing such songs as "You're No Good" and "I Can't Help It if I'm Still in Love with You." It was followed by such albums as *Prisoner in Disguise* (1975), *Hasten Down the Wind* (1976), *Simple Dreams* (1977), *Living in the U.S.A.* (1978), and *Mad Love* (1980). She also appeared on stage in Central Park in the *The Pirates of Penzance* and in the 1983 film. Her recording career sagged somewhat during the 1980s, although she, Dolly PARTON, and Emmylou HARRIS did the extraordinary album *Trio* in 1987, and in 1988 she did *Canciones de Mi Padre* (Songs of My Father).

Room at the Top (1957), the John BRAINE novel, adapted by Neil Paterson into the 1958 Jack Clayton film, starring Laurence HARVEY and Simone SIGNORET; she won a best actress OSCAR, as did Paterson for the screenplay. Harvey also starred in the Ted Kotcheff sequel *Life at the Top* (1965).

Room with a View, A (1908), the E.M. FORSTER novel, set in Italy and England; a sensitive exploration of class strictures and the triumph of love. Ruth Prawer JHABVALA won an OSCAR for her adaptation of the novel into the 1985 James IVORY film, with a cast that included Maggie SMITH, Helena Bonham Carter, Denholm Elli-ott, Daniel Day LEWIS, Judi DENCH, Julian Sands, and Rosemary Leach.

Rooney, Mickey (Joe Yule, Jr., 1920–), U.S. actor, on stage in vaudeville with his family as a baby and on screen from the age of six, from 1927 to 1932 as the star of the *Mickey McGuire* series and from 1932 as Mickey Rooney. He was Puck in *A Midsummer Night's Dream* (1935), became the star of the long Andy HARDY series beginning with *A Family Affair* (1937), starred in *Boys Town* (1938), and was Huck in *The Adventures of Huckleberry Finn* (1939). In 1940 he was *Young Tom Edison*, then played opposite Judy GARLAND in several films, and starred in such films as *The Human Comedy* (1943) and *National Velvet* (1944); he also played in scores of other films, as one of the most popular and durable juvenile stars of Hollywood's Golden Age. After World War II his career sagged, though he continued on in character roles and in variety. Late in his career he became a star again, playing opposite Ann Miller on Broadway in the long-running *Sugar Babies* (1979).

Roots (1976), the Alex HALEY novel, the story of his own family, from their African origins, through slavery, to freedom after the Civil War. The PULITZER PRIZE-winning book was adapted by William E. Blinn, Ernest Kinoy, James Lee, and M. Charles Cohen into the powerful, enormously popular 12-hour 1977 television miniseries. The large cast included Louis GOSSETT, Jr., Edward ASNER, Olivia Cole, John Amos, LeVar Burton, Ben Vereen, Leslie Uggams, Madge Sinclair, Moses Gunn, Robert Reed, Ralph Waite, Sandy Duncan, Cicely TYSON, Lorne GREENE, O.J. Simpson, Raymond St. Jacques, Chuck Connors, Macdonald Carey, Scatman Crothers, George Hamilton, Richard Roundtree, Lloyd BRIDGES, and Burl IVES. The miniseries generated an equally powerful 14-hour sequel, "Roots: The Next Generations" (1979), developed by Ernest Kinoy. Its equally large cast included James Earl JONES as Alex Haley, Marlon BRANDO, Ruby DEE, Paul Winfield, Ossie DAVIS, Al Freeman, Jr., Claudia McNeil, Howard Rollins, Jr., Henry FONDA, Olivia DE HAVILLAND, Richard Thomas, Stan Shaw, John

Rubinstein, Dina Merrill, Brock Peters, Andy Griffith, and Diahann Carroll.

Rorem, Ned (1923–), U.S. composer, who created a considerable body of work, and is highly regarded for his art-song cycles. He is better known as a writer than as a composer, for his five very candid autobiographical volumes.

Rosemary's Baby (1967), the Ira Levin novel, about a young woman who becomes dominated by a group of modern Devil-worshipers and ultimately gives birth to a child of the Devil. Roman POLANSKI adapted and directed the 1968 film, with Mia FARROW and John CASSAVETES as the young couple, Ruth Gordon in an OSCAR-winning supporting role, and Sidney Blackmer, Maurice EVANS and Ralph BELLAMY in the other key roles. The trendsetting film was the first major film in what became a wave of very popular American horror movies on occult themes.

Rosenkavalier, Der, the opera by Richard STRAUSS, with libretto by Hugo von HOFMANNSTAL; a story set in Vienna court life and featuring two young lovers and a sophisticated princesss, the Marschallin, which became one of the great soprano roles. It was first produced in Dresden, in 1911.

Rosenquist, James (1933–), U.S. artist, a billboard painter in the 1950s, who in the 1960s transferred his skills to POP ART. He worked very large in poster and mural style, and included random artifacts and images in his work, becoming one of the leading pop artists of the day.

"Roses of Picardy" (1916), a World War I song that became part of the standard repertory of the time; it was long identified with John MCCORMACK. Music was by Haydn Wood, with words by F. E. Weatherly.

Rose Tattoo, The (1951), the TONY-winning Tennessee WILLIAMS play, set in the Deep South, about a highly sexual widow who opts for life when confronted with an elemental truck driver. Maureen STAPLETON and Eli Wallach played the leads on stage; Anna MAGNANI and Burt LANCASTER were the leads in the 1955 Daniel MANN film, in a cast that included Marisa Pavan, Jo Van Fleet, and

Ben Cooper. Magnani and cinematographer James Wong HOWE won OSCARS.

Ross, Diana (1944–), U.S. singer and actress; she was the lead singer of THE SUPREMES and then of Diana Ross and the Supremes in the 1960s, then became one of the leading concert and recording stars of the 1970s, with such songs as "Ain't No Mountain High Enough" (1970), "Touch Me in the Morning" (1973), "Do You Know Where You're Going To?" (1976), and her duet with Lionel Ritchie "Endless Love" (1981). She starred as Billie HOLIDAY in the film biography *Lady Sings the Blues* (1972), and also appeared in *Mahogany* (1976) and the film version of *The Wiz* (1978). A few of her many albums are *I'm Still Waiting* (1971), *Touch Me in the Morning* (1973), *The Boss* (1979), *Diana* (1980), *Why Do Fools Fall in Love?* (1981), *Chain Reaction* (1986), and *Workin' Overtime* (1989).

Ross, Harold (1892–1951), U.S. editor, in 1925 the founder of *The New Yorker* and from then until 1951 the magazine's chief editor. He developed a staff and group of affiliated writers who included several of the key literary figures and illustrators of the period, such as James THURBER, Dorothy PARKER, E.B. WHITE, S.J. PERELMAN, Edmund WILSON, and Ogden NASH.

Ross, Katharine (1942–), U.S. actress, on screen from 1965, who became a leading player in the late 1960s, in such films as THE GRADUATE (1967), BUTCH CASSIDY AND THE SUNDANCE KID (1969), TELL THEM WILLIE BOY IS HERE (1970), and *They Only Kill Their Masters* (1972). Her later work includes *The Betsy* (1978), *The Legacy* (1979), and several television films.

Rossellini, Roberto (1906–77), Italian director, whose work was on screen from 1936 and who quite suddenly became a major international director with the appearance of his postwar neorealist classic (see NEOREALISM), OPEN CITY (1945), which he followed with the equally classic PAISAN (1946), his other notable film of the period being *Germany Year Zero* (1947). His highly publicized liaison with and then 1950 marriage to Ingrid BERGMAN produced little artistically: only such films as

Stromboli (1949) and *Strangers* (1953). His last notable film was *General Della Rovere* (1959). His daughter **Isabella Rossellini** has appeared in such films as *Blue Velvet* and *Wild at Heart*.

Rossen, Robert (Robert Rosen, 1908–66), U.S. director and writer, whose directorial work was on screen from 1947 and includes such films as *Body and Soul* (1947) and ALL THE KING'S MEN (1949). A former Communist, he was blacklisted in 1951 (see BLACKLISTING); after naming many others as Communists, he was allowed to work again in 1953, but then left Hollywood. His later work includes *The Hustler* (1964).

Rostropovich, Mstislav Leopoldovich (1927–), Soviet cellist, pianist, and conductor; he made his debut as a cellist in 1940 and became a leading Soviet soloist in the early postwar period, also playing in trio with Emil GILELS and Leonid Kogan. He was described by many as the world's leading cellist, from his 1955 debuts in New York and London. He and his wife, singer Galina Vishnevskaya, for whom he was often piano accompanist, were very notable defectors from the Soviet Union in 1974, and lost their Soviet citizenships in 1978. Rostropovich made his debut as a conductor in 1975 and in 1977 became director of Washington's National Symphony Orchestra. In 1989 he and the orchestra accepted an invitation to play in the Soviet Union.

Roth, Philip (1933–), U.S. author, much of whose work comments on Jewish-American life. His novella *Good-bye, Columbus* (1959) won an American Book Award and became the 1969 Larry Peerce film, with Richard Benjamin in the central role. His further work includes such novels as *Letting Go* (1962); the comic *Portnoy's Complaint* (1969), mildly scandalous in its time for its masturbatory sequences; *The Ghost Writer* (1979); *Zuckerman Unbound* (1981); *The Anatomy Lesson* (1983); and *Zuckerman Bound* (1985).

Rothko, Mark (Marcus Rothkovich, 1903–70), U.S. painter; a social critic and realist in the 1930s, he moved into surreal styles (see SURREALISM) and then in the late 1940s into ABSTRACT EXPRESSIONISM, often working on very large canvases and with bodies of color on

a field of color. In his later work the color was muted, as in the many large, reddish, monochromatic works done for Houston's St. Thomas Chapel. His death was by suicide.

Rothstein, Arthur (1913–85), U.S. photographer, whose *Dust Storm, Cimarron County* (1937) was one of the most celebrated of the Farm Security Administration photos of the late 1930s. Although he worked for *Look* and *Parade* after World War II, he is best known by far for the large body of Depression-era country pictures he created while with the Farm Security Administration from 1935 to 1940.

Rouault, Georges (1871–1958), French artist, whose earliest work was as an apprentice to a glass painter and stained-glass restorer. On his own, he painted religious works in the 1890s, after 1898 turning for his subjects to the circus and the underside of Parisian life and to the judiciary, producing the long series of powerful, realistic, deep-toned paintings that established him as a major figure. He began his long career as a book illustrator in 1914; moved into set design in 1929, with George BALANCHINE's *The Prodigal Son;* and produced a body of major religious works from the early 1930s. After his agent, Ambroise Vollard, died in 1939, Rouault spent nine years recovering works held by Vollard's heirs; he ultimately did so, and burned over 300 unfinished works in 1948.

Round Midnight (1986), the Bernard Tavernier film, with Dexter GORDON as the alcoholic, still-great Black American JAZZ musician living in Paris in the 1950s, in a cast that included Gabrielle Haker; John Berry; Françoise Cluzet; Lonette McKee; Philip Noiret; and Herbie Hancock, who won an OSCAR for his music direction. Tavernier and David Rayfiel wrote the screenplay. The film is Tavernier's homage to jazz, and especially to jazz luminaries Bud POWELL and Lester YOUNG.

Roussel, Albert (1869–1937), French composer; much of his work was colored by his early travels to India and Southeast Asia, most notably including the ballet-opera *Padmâvatî* (1923). His work also includes the ballets *The Kiss of the Spider* (1913), *Bacchus and Ariadne* (1931), and *Aeneas* (1935). He wrote a large body of instrumental and choral work, includ-

Artur Rubinstein playing his beloved Chopin in concert in New York City at age 89, in 1976.

ing four symphonies, chamber music, and many songs.

"Rowan and Martin's Laugh-In" (1968–73), the antic, wholly irreverent television comedy series, largely a series of quick blackout sketches; the large, shifting cast was led by Dan Rowan and Dick Martin, included regulars Gary Owens and Ruth Buzzi, and at various times included such players as Lily TOMLIN, Judy Carne, Goldie HAWN, Arte Johnson, and Henry Gibson.

Roy, Gabrielle (1909–83), French-Canadian writer, best known for her first novel, *The Tin Flute* (1945), about the life of a poor Montreal family; another early novel, *The Cashier* (1954); and for several of her semiautobiographical stories of farm life in Manitoba.

Royal Ballet, The (1956–), the leading British ballet company; its predecessors were the Academy of Choreographic Art, founded by Ninette DE VALOIS in 1926, which successively became the Vic-Wells (1935) and Sadler-Wells (1948), in the process becoming one of the world's leading ballet companies. Such artists as Frederick ASHTON, Margot FONTEYN,

and Robert HELPMANN were long associated with the company; so later were such leading choreographers as Leonid MASSINE, George BALANCHINE, and Robert CRANKO.

Royal Shakespeare Company (1961–), British theater company, which was developed at the Stratford-on-Avon Shakespeare Memorial Theatre in 1961, the theater then being renamed the Royal Shakespeare Theatre. It was directed by Peter HALL from 1961 to 1968, Trevor NUNN from 1968 to 1987, and from 1987 by Peter Hands. During the expansive 1960s and to a lesser extent in the 1970s, the company also operated from several successive London theater bases, producing many modern plays and classics other than Shakespeare. Some RSC companies toured abroad, and small Stratford-based troupes brought Shakespeare to many British communities from 1965 until financing failed in 1971. In 1982 the company moved into its new London home at the Barbicon cultural center.

Rubinstein, Artur (1887–1982), Polish pianist. A child prodigy, he made his concert debut at Berlin in 1900; made his first American tour in

1906; and became one of the leading pianists of the 20th century, playing the entire repertory, most notably Brahms, Chopin, Beethoven, and several of the modern Spanish composers, including Manuel de FALLA, Enrique GRANADOS, and Isaac ALBÉNIZ. He emigrated to the United States during World War II, thereafter also appearing in several films. His son **John Rubinstein** is an American actor and composer.

Rukeyser, Muriel (1913–80), U.S. writer, much of whose work reflects her commitment to social justice, expressed in a highly individual, personal style, in such books as *Theory of Flight* (1935), *U.S. 1* (1938), *A Turning Wind* (1939), *Beast in View* (1944), *The Green Wave* (1948), and several other collections of her poetry, much of which appears in her *Collected Poems* (1979).

Rules of the Game, The (1939), the Jean RENOIR film; a high drama in comedy form set in a country house, in which the decadence and intrigues of both society people and servants are seen as equally destructive. The situation is Renoir's metaphor for France, then facing a disastrous new world war. He and Carl Koch wrote the screenplay; Renoir also appeared in the film, in a cast that included Marcel Dalio, Nora Gregor, Mila Parely, Roland Toutain, Gaston Modot, Julian Carette, and Paulette Dubost.

Runyon, Damon (Alfred Damon Runyon, 1884–1946), U.S. writer, a widely read sportswriter but best known by far for his short stories and the semi-underworld Broadway people who inhabited them. His best-known collection is GUYS AND DOLLS (1932), which became the basis of the 1950 Broadway musical and the 1955 film.

R.U.R. (1921), the Karel CAPEK science-fiction play, an antimachine satire. R.U.R. are the initials of Rossum's Universal Robots, the new word *robot* then entering the language.

Rushdie, Salman (1947–), British writer, much of whose work is set in India and Pakistan and informed by his Indian descent. His best-known novels include *Midnight's Children* (1981); *Shame* (1983); and THE SATANIC VERSES (1988), a fantasy that generated worldwide Islamic fundamentalist protests (including threats to Rushdie's life) and an even more powerful counterreaction that made it a worldwide best-seller.

Russell, Rosalind (1908–76), U.S. actress, on stage from the late 1920s and on screen from 1934. Her breakthrough role was the lead in *Craig's Wife* (1936), which was followed by such films as *Night Must Fall* (1937); THE CITADEL (1938); *His Girl Friday* (1940; a version of THE FRONT PAGE); *My Sister Eileen* (1942); *Sister Kenny* (1946); AUNTIE MAME (1958), in which she re-created her 1956 stage title role; and GYPSY (1962). On stage, she won a TONY as the lead in WONDERFUL TOWN (1953).

Ryan, Robert (1909–73), U.S. actor, stage-trained by Max REINHARDT in the latter's Hollywood years, on stage from 1939 and on screen from 1940. He emerged as a powerful character player on film from the the mid-1940s, in such films as *The Woman on the Beach* (1947), *Crossfire* (1947), *The Setup* (1949), *Clash by Night* (1952), and THE ICEMAN COMETH (1973). He returned to the theater periodically, notably on Broadway in THE FRONT PAGE (1968) and LONG DAY'S JOURNEY INTO NIGHT (1971).

S

Saarinen, Eliel (1873–1950) and **Eero Saarinen** (1910–61), Finnish and American architects, father and son. Eliel Saarinen was one of the leading Finnish architects of the early 20th century, best known before World War I for his Helsinki railroad terminal (1914). After the American reception of his celebrated runner-up design in the 1922 Chicago Tribune Building contest, he emigrated to the United States in 1923. He was associated with the Cranbrook Foundation at Bloomfield Hills, near Detroit, from the late 1920s, becoming director of the Cranbrook Academy of Art from 1932 to 1948, and designing several Cranbrook structures from 1930 to 1941. His major American works, from 1938 in partnership with Eero, include the Tabernacle Church of Christ (Columbus, Indiana, 1940), the Berkshire Music Center Pavilion (1940), and the Christ Lutheran Church (Minneapolis, 1950). Eero Saarinen emerged as a major American architect after his father's death, with several innovative, highly personal structures, including the General Motors Technical Center (Warren, Michigan, 1956), the Kresge auditorium and chapel at the Massachusetts Institute of Technlogy (1955), and the Trans World Airlines terminal at New York's Idlewild (now Kennedy) International Airport (1962). He also designed Dulles International Airport (1962) and the Jefferson National Expansion Memorial Arch at St. Louis (1964).

Sachs, Nelly (1891–1970), German writer, a Jew who escaped to Sweden with her mother in 1940 through the intervention of a friend, the writer Selma LAGERLOF. She took as her theme the murder of millions of European Jews by the Germans during the Holocaust, in such poetry collections as *In the Dwellings of Death* (1946), *And No One Knows Where to Go* (1957), and *Flight and Metamorphosis* (1959). She was also a playwright, whose best-known work, *Eli* (1951), helped win her a large postwar audience. She shared the 1966 NOBEL PRIZE for literature with Israeli writer Shmuel Yoseph AGNON.

Sacre du Printemps, Le, French name for THE RITE OF SPRING.

Safdie, Moshe (1938–), Canadian architect and urban planner, who emerged as a major figure with his design of Habitat, the prefabricated concrete dwelling units that became a highly visible feature of the 1967 Montreal Exposition. He later designed a Habitat complex at San Juan, Puerto Rico (1972), and several substantial projects in Israel, the United States, and Canada.

Sagan, Françoise (Françoise Quoirez, 1935–), French writer, whose first novel was the extraordinarily popular story of a teenage girl, *Bonjour Tristesse* (1954), which became the 1954 Otto PREMINGER film, starring Deborah KERR; David NIVEN; and Jean Seberg, in the teenager's role. Sagan's later work includes such novels as *A Certain Smile* (1956) and *Scars on the Soul* (1972), as well as several plays and screenplays.

Sagrada Familia, the Barcelona church designed by Antonio GAUDÍ. He began it in 1884, made it his full-time and sole project from 1910, and died in 1926, with the church still unfinished. The church, with its extraordinarily profuse and intricate structure and ornamentation, seen by many as quite surreal, is a magnet for the world's artists and architects.

Saint, Eva Marie (1924–), U.S. actress, on stage from 1948, most notably in *The Trip to*

Bountiful (1953). She won a best supporting actress OSCAR in her first screen role, in ON THE WATERFRONT (1954), and then appeared in such films as A HATFUL OF RAIN (1957), NORTH BY NORTHWEST (1959), and *The Stalking Moon* (1968). Late in her career she has also appeared in several television films.

Saint, The, nickname of Simon Templar, the debonair British fictional detective created in the series of Leslie Charteris novels, which also generated several late 1930s and early 1940s films, four of them starring George SANDERS; a radio show; and later television series, notably the one starring Roger Moore (1967–69).

St. Denis, Ruth (Ruth Dennis, 1878–1968), U.S. dancer, choreographer, and teacher; one of the founders of the American MODERN DANCE movement. She was on stage as a dancer in variety until becoming interested in Egyptian and Indian dance forms and religious beliefs; her first works were *Radha, The Incense,* and *The Cobras* (all first produced in 1906), which she then took on tour. She and her husband, Ted SHAWN, founded the Denishawn School and Dance Company in 1915; until they parted and the company ended in 1931, it was a centrally important training ground for the emerging American modern dance movement. Her later work even more strongly emphasized what she perceived to be Eastern religious forms and content.

"St. Elsewhere" (1982–88), the long-running television medical drama, set in St. Eligius, a Boston hospital. The cast included Ed Flanders, Barbara Whinnery, Ed Begley, Jr., Denzel WASHINGTON, William Daniels, Cynthia Sikes, David Birney, David Morse, Howard Mandel, Christina Pickles, Norman Lloyd, and Ellen Bry.

Saint-Exupéry, Antoine de (1900–44), French writer and flier, whose novels include the autobiographical *Southern Mail* (1929), *Night Flight* (1931); the classic *Wind, Sand, and Stars* (1939), *Flight to Arras* (1942), and *Wisdom of the Sands* (1948). He also wrote and illustrated a classic in quite another vein: the fantasy *The Little Prince* (1943). He died on active service as a pilot with Free French forces in North Africa during World War II.

Saint Joan (1924), the George Bernard SHAW play, about conscience, faith, and the exercise of power. Winifred Lenihan created the role in New York in 1923 and Sybil THORNDIKE in London in 1924. The play, which then entered the world English-language theater repertory, was adapted by Graham GREENE into the 1957 Otto PREMINGER film, with Jean Seberg in the title role, in a cast that included Richard WIDMARK, John GIELGUD, Harry ANDREWS, Richard Todd, and Anton Walbrook.

"St. Louis Blues" (1914), the W.C. HANDY song; perhaps the most classic of its many versions was done in 1925 by Bessie SMITH. The song became the title of the 1958 film biography, with Nat "King" COLE as Handy, in a cast that included Ruby DEE, Cab CALLOWAY, Ella FITZGERALD, Eartha Kitt, Pearl BAILEY, and Mahalia JACKSON.

Saki (Hector Hugh Munro, 1870–1916), British writer, best known for his often-anthologized short stories, collected in *Reginald* (1904), *Reginald in Russia* (1910), *The Chronicles of Clovis* (1911), and *Beasts and Superbeasts* (1914). Saki also wrote several novels and plays. He was killed during World War I.

Salinger, J.D. (Jerome David Salinger, 1919–), U.S. writer, whose novel THE CATCHER IN THE RYE (1951), chronicling Holden Caulfield's search for self-identity, became an extraordinarily popular and emblematic work for young Americans of the post-World War II period. His short-story collections include *Nine Stories* (1953), which carry stories back to 1948, in which he introduces his Glass Family characters; *Franny and Zooey* (1961); and *Raise High the Roof-Beam, Carpenters* and *Seymour: An Introduction,* both published in one volume in 1963. He went into seclusion and stopped publishing in 1965.

Salome, the opera by Richard STRAUSS, adapted from the Oscar Wilde play; it was first produced in Dresden in 1905. It is the sensual, and in its time utterly shocking, story of Salome, Jochanaan (who is John the Baptist), and Herod.

Salomon, Erich (1886–1944), German photographer; from 1928, he produced "candid"

photos of notables, mainly government officials, often in stressful situations. Some of his work was collected in *Celebrated Contemporaries in Unguarded Moments* (1931). Salomon fled Nazi Germany, but was captured in occupied Holland during World War II; he died at Auschwitz.

Sanctuary (1931), the William FAULKNER novel, a Deep South story about rape, murder, forced prostitution, and the ultimate lynching of an innocent man. It was adapted for film twice, as *The Story of Temple Drake* (1933), with Miriam HOPKINS in the title role; and as *Sanctuary* (1960), with Lee REMICK and Yves MONTAND in the leads.

Sand Pebbles, The (1966), the Robert Wise film; the story involves an American gunboat on the Yangtze in the mid-1920s, a series of incidents escalating to armed encounters between Americans and nationalist Chinese, and the fate of a group of missionaries caught in the violence. The film was widely seen as related to the Vietnam War, although it far more directly and clearly referred to foreign domination of China and the long Chinese civil wars. Steve MCQUEEN starred, in a cast that included Candice BERGEN, Richard ATTENBOROUGH, Mako, and Richard Crenna. Robert Anderson adapted the Richard McKenna novel for the screen.

Sandburg, Carl (1878–1967), U.S. writer, whose early, powerful, often-anthologized poems were collected in *Chicago Poems* (1916); these included such free-verse landmarks as "Chicago," "Fog," "Grass," and "To a Contemporary Bunkshooter." His further collections include *Cornhuskers* (1918); *Smoke and Steel* (1920); *Slabs of the Sunburnt West* (1922); and *Good Morning, America* (1928). *The People, Yes* (1936) is his long narrative celebration of Depression-era America. His *Complete Poems* (1950) won a PULITZER PRIZE; several subsequent volumes collected his late poems. Sandburg's long biography of Abraham Lincoln appeared as the two-volume *Abraham Lincoln: The Prairie Years* (1926) and the four-volume *Abraham Lincoln: the War Years* (1939), which won a Pulitzer Prize. He also wrote three volumes of *Rootabaga Stories* for children (1922–30); the novel *Remembrance*

Rock (1948); and the autobiographical *All the Young Strangers* (1953).

Sanders, George (1906–72), British actor, on stage and screen from the early 1930s. During the next four decades he played in scores of films, often as a "heavy" who was the most interesting character in the work, and sometimes in leads, as in the Falcon and SAINT film series. A few of his most notable films were REBECCA (1940); *The Moon and Sixpence* (1942); *The Picture of Dorian Gray* (1944); *The Private Affairs of Bel Ami* (1947); and ALL ABOUT EVE (1950), for which his work as theater critic Addison DeWitt won him a best supporting actor OSCAR.

Sanders, Jay Olcutt (1953–), U.S. actor, on stage and screen from the late 1970s; he has appeared in such plays as *Loose Ends* (1978), Sam Shepard's PULITZER PRIZE-winning *Buried Child* (1978), *The Incredibly Famous Willy Rivers* (1983), and *King John* at the New York Shakespeare Festival (1988). He has also played in such films as TUCKER: THE MAN AND HIS DREAM (1988) and GLORY (1989) and in such telefilms as *The Day Christ Died* (1980) and *Cold Sassy Tree* (1989), as well as in a wide range of other television roles.

San Francisco (1936), the W.S. VAN DYKE film, set in turn-of-the-century San Francisco and culminating in the 1906 earthquake; it starred Clark GABLE, Spencer TRACY, and Jeanette MACDONALD. MacDonald sang the title song, written by Gus Kahn and Bronislaw Kaper; it has considerably outlasted the film, becoming an anthem for San Franciscans, as demonstrated to worldwide World Series audiences after the 1989 earthquake. Anita Loos wrote the screenplay, based on a Robert Hopkins story.

Sargent, John Singer (1856–1925), U.S. painter, long resident in Britain. He was one of the leading portraitists of the late 19th century but began to move away from portraiture in the 1890s and entirely gave it up in 1910. He worked on the Boston Public Library murals from 1890 to 1910, also doing murals for Harvard University and the Boston Museum of Fine Arts. During the 20th century he also produced a large body of impressionistic

watercolors and oils, and during World War I was in 1918 an official war artist for the British government.

Saroyan, William (1908–81), U.S. writer, much of whose work was rooted in his Armenian-American background. He became a very popular short-story writer in the 1930s, with such collections as *The Daring Young Man on the Flying Trapeze* (1934), *The Trouble with Tigers* (1938), and *My Name Is Aram* (1940). He wrote many plays, the two best received being his first successful short play, *My Heart's in the Highlands* (1939), and his PULITZER PRIZE-winning THE TIME OF YOUR LIFE (1940); although he refused the award, the play established him as a major literary figure. His rather uneven, very large body of work also includes several novels, most notably *The Human Comedy* (1943), which he developed from his ACADEMY AWARD-winning original story for the Clarence BROWN film. He also wrote a considerable body of semiautobiographical memoirs.

Sarraute, Nathalie (1900–), French writer, a primary exponent of the postwar "new novel," whose work focuses on the operation of the subconscious, functioning as a kind of subtext under the language of the novel itself. Her best-known works include *Tropisms* (1938), *The Portrait of a Man Unknown* (1947), *Martereau* (1953), *The Planetarium* (1959), and *The Golden Fruits* (1963).

Sartre, Jean-Paul (1905–80), French writer and philosopher, who during the early post-World War II period popularized a form of EXISTENTIALISM, positing that life has no meaning beyond direct personal engagement and commitment based upon personal experience, free of the limiting influences of society. His best-known works include his first novel, *Nausea* (1938), and three of the projected four novels of the tetralogy *Paths of Glory*, consisting of *The Age of Reason* (1945), *The Reprieve* (1947), and *Troubled Sleep* (1949). His plays most notably include *The Flies* (1943), *No Exit* (1944), and *The Condemned of Altona* (1959). Sartre's most influential philosophical essays were published as *Being and Nothingness* (1943) and *Existentialism and Humanism* (1946). Extremely prolific, he also published three

volumes of a long unfinished work on Flaubert, works on Baudelaire and Genet, short stories, a considerable body of other essays, an autobiography, and several other novels and plays, and collaborated on several screenplays. Sartre was awarded the 1964 NOBEL PRIZE for literature but refused the award. He was the lifetime companion of writer Simone de BEAUVOIR.

Sassoon, Siegfried (1886–1967), British writer, a front-line officer during World War I, whose powerful and bitter war poems were collected in *Counterattack* (1918). He published several other volumes of poems and a semiautobiographical trilogy (1928–36), consisting of *Memoirs of a Fox-Hunting Man*, *Memoirs of an Infantry Officer*, and *Sherston's Progress*.

Satanic Verses, The (1988), the Salman RUSHDIE novel, a fantasy that generated worldwide Islamic fundamentalist protests for its allegedly insulting treatment of Mohammed, Abraham, Mohammed's wives, the Koran, and other aspects of the Islamic faith. The protests included book burnings, riots, bombings, and a death threat from Iranian ayatollah Ruhollah Khomeini, who offered a $1 million reward to anyone who would murder Rushdie. Moslem countries banned the book, but governments, booksellers, and readers in most of the world refused to do so, and *The Satanic Verses* became a worldwide bestseller. Rushdie went into hiding to avoid assassination.

Satchmo, nickname of JAZZ musician Louis ARMSTRONG.

Satie, Erik (1866–1925), French composer; his spare, simple musical style, coupled with an often whimsical programmatic content, produced considerable controversy during and after his lifetime. Many musicians viewed his work as flat and shallow, but he was also hailed as a hard-edged anti-Romantic and anti-Impressionist and as a prototypical surrealist (see SURREALISM) by Jean COCTEAU, Guillaume APOLLINAIRE, and many others. His best-known work came late, and it included several ballets: PARADE (1917), choreographed by Leonid MASSINE for the BALLET RUSSES of Sergei DIAGHILEV; *Mercure* (1924), also cho-

reographed by Massine, with sets by Pablo PICASSO; *Relache* (1924), a surreal multimedia piece containing a short film by René CLAIR; and *Jack-in-the-Box* (1926), choreographed by Georges BALANCHINE for Diaghilev. Satie also wrote *Socrate*, for four sopranos and a chamber orchestra.

Saturday Night and Sunday Morning (1958), the Alan SILLITOE novel, an "angry young man's" look at contemporary working-class life in northern England. Sillitoe adapted the work into the 1960 Karel Reisz film; Albert FINNEY was Arthur Seaton, in a cast that included Rachel Roberts and Shirley Anne Field as his two girlfriends.

"Saturday Night Live" (1975–), the late-night comedy series, very popular in the 1970s as it attempted to stimulate and often to shock its audience. It featured a group of regulars, "The Not Ready for Prime Time Players," and a succession of celebrity guests and musical groups, from show business and the world beyond. Some notable regulars included Chevy Chase, Gilda Radner, Laraine Newman, John Belushi, Dan Aykroyd, Jane Curtin, and Don Novello, and later Eddie MURPHY, Billy Crystal, Martin Short, and Dana Carvey.

Savalas, Telly (Aristotle Savalas, 1926–), U.S. actor, on screen, usually as a "heavy," from 1961. He is best known as the star of the long-running television series "Kojak" (1973–78).

Sayers, Dorothy Leigh (1893–1957), British writer, who created the fictional detectives Lord Peter WIMSEY and Harriet Vane, developing two linked series of such very popular novels as *Whose Body?* (1923); *Unnatural Death* (1927); *Strong Poison* (1930); *Murder Must Advertise* (1933); *The Nine Tailors* (1934); *Gaudy Night* (1935); and *Busman's Honeymoon* (1937), first a play and later the 1940 Arthur B. Woods film, with Robert MONTGOMERY as Wimsey. Her later work includes religious dramas and essays. Ian CARMICHAEL played Wimsey in several 1970s television series, as did Edward Petherbridge in several later series.

Scarface (1931), the quintessential Depression-era gangster film, directed by Howard HAWKS and featuring Paul MUNI as an ugly, powerful 1920s mob leader, modeled on Chicago's Al Capone. Key supporting roles were played by Ann Dvorak, Osgood Perkins, Karen Morley, George RAFT, and Boris KARLOFF. It was remade by Brian De Palma in 1983 and reset in the Latin American and Miami drug trade, with Al PACINO in the title role.

Scenes from a Marriage (1973), the Ingmar BERGMAN film; he wrote and directed the work, editing it down and adapting it from his own six-part Swedish television series. Liv ULLMAN and Erland JOSEPHSON played the couple whose marriage is in the process of collapsing, in a cast that included Bibi ANDERSSON and Anita Wall.

Schaffner, Franklin J. (1920–89), U.S. director; he was a leading director in early television before turning to films with *The Stripper* (1963), followed by such films as THE BEST MAN (1964), *The War Lord* (1965), *Planet of the Apes* (1968), PATTON (1970), *Nicholas and Alexandra* (1971), and *The Boys from Brazil* (1978). He won a best director OSCAR for *Patton*.

Scheherazade, the ballet choreographed by Michel FOKINE, to the music of Nicolai Rimsky-Korsakov, based on a story from the *Thousand and One Nights*. It was first presented in Paris, in June 1910, by the BALLET RUSSES company of Sergei DIAGHILEV, with Ida Rubinstein and Vaslav NIJINSKY in the leading roles.

Scheider, Roy (1934–), U.S. actor, on stage from 1961 and on screen from 1964, in character and then in starring roles, in such films as THE FRENCH CONNECTION (1971), KLUTE (1971), JAWS (1975; and the 1978 sequel), ALL THAT JAZZ (1979), *Night Game* (1989), and *The Russia House* (1990).

Schlesinger, John (1923–), British director, with acting and television-directing experience from the mid-1950s, whose work as a film director was on screen from 1961. He emerged as a major director with such films as *A Kind of Loving* (1962), BILLY LIAR (1963), and DARLING (1964). MIDNIGHT COWBOY (1969) won him a best director OSCAR and was followed by

such films as SUNDAY, BLOODY SUNDAY (1972), *Marathon Man* (1976), *Yanks* (1978), *Madame Sousatzka* (1988), and *Pacific Heights* (1990). His television work includes SEPARATE TABLES (1982) and *An Englishman Abroad* (1983). He also directed for the theater and opera, and was associated with the Britain's National Theatre from 1973 to 1988, doing such plays as *Heartbreak House* (1975) and *Julius Caesar* (1977).

Schnabel, Arthur (1882–1951), Austrian pianist and composer; he was one of the leading pianists and classical recording artists of the 20th century, focusing on Beethoven, Brahms, and Schubert rather than on the entire virtuoso repertory. He also wrote several orchestral and chamber works. Schnabel lived in Berlin until 1933, leaving Germany when the Nazis took power. He lived in the United States from 1939, later becoming an American citizen.

Schnitzler, Arthur (1862–1931), Austrian writer, best known for the plays *Liebelei* (1896); *The Round Dance* (1903), which was adapted by Max OPHÜLS into the film LA RONDE in 1950; *The Lonely Way* (1904); and *The Vast Domain* (1911), which was adapted by Tom STOPPARD into *The Undiscovered Country* in 1977.

Schoenberg, Arnold (1874–1951), Austrian composer and teacher, whose very influential work introduced atonality and the 12-tone chromatic scale, or set, both central concepts in the development of much of 20th-century classical music, beginning with the work of such Schoenberg students as Anton WEBERN and Alban BERG. His early, often highly experimental tonal works include the massive *String Quartet No. 1* (1904) and the even more massive choral cantata *Gurrelieder* (1911); but he moved decisively toward atonality in the works that followed and in the early 1920s fully developed a series of works based on the 12-tone set, such as the *Quintet for Winds* (1924) and the *Orchestral Variations* (1928). Schoenberg fled Nazi Germany in 1933, going to the United States, and later became an American citizen, continuing to compose and teach in his later years.

Schulz, Charles (1922–), U.S. cartoonist, in 1950 the creator of the very popular contemporary comic strip PEANUTS.

Schumann-Heink, Ernestine (1861–1936), Austrian contralto, one of the most celebrated singers of her time. She made her debut at Dresden in 1878 and became a leading singer in Europe and America during the next two decades, making her debut at Bayreuth in 1896 and at the Metropolitan Opera in 1899. Although she continued to appear in opera until the early 1930s, she became a much more widely known popular figure in recital and on records, making many United States concert tours from 1904 and later also singing on radio and in films.

Schwartz, Delmore (1913–66), U.S. writer and critic, who emerged as a major poet with his first collection of work, *In Dreams Begin Responsibilities* (1938), which was followed by his verse play *Shenandoah* (1941) and the autobiographical *Genesis* (1943). He won a Bollingen Prize for his *Summer Knowledge: New and Selected Poems, 1938–58* (1959).

Scofield, Paul (David Paul Scofield, 1922–), British actor, on stage from 1940 and on screen from 1954, who emerged in the late 1940s as a leading interpreter of the classics, playing many of the great roles early in his career, beginning with his notable Bastard in *King John* (1945). His *Hamlet* was a great early role; he played it most notably at the MOSCOW ART THEATRE in 1955. He created the Sir Thomas More role in A MAN FOR ALL SEASONS (1960), brought it to Broadway in 1961, won a best actor TONY, and won a best actor OSCAR for the role in the 1966 film. His 1962 *King Lear* played in London and then all over the world; he also played it on film in 1971. His later work on stage includes the Salieri role in AMADEUS (1979), as well as several works on screen, including the film *Anna Karenina* (1984) and the teleplay *Henry V* (1989).

Scorsese, Martin (1942–), U.S. director, whose work was on screen from 1963 and who became a major modern director in the early 1970s, with such films as MEAN STREETS (1973), ALICE DOESN'T LIVE HERE ANYMORE (1974), TAXI DRIVER (1976), RAGING

BULL (1980), and *Goodfellas* (1990). His THE LAST TEMPTATION OF CHRIST (1988), based on the equally controversial Nikos KAZANTZAKIS' novel, was attacked as sacrilegious by some and ignited a major controversy, but attempts to suppress the film were entirely unsuccessful, in all probability increasing its audience.

Scott, George Campbell (1927–), U.S. actor, director, and producer, on stage from the late 1950s and on screen from 1959. He played substantial roles in such films as ANATOMY OF A MURDER (1959), *The Hustler* (1962), and DR. STRANGELOVE (1963) before his OSCAR-winning title role in PATTON (1969); he had given prior notice that he would refuse the OSCAR if offered, and did so as a matter of principle. He went on to star in such films as *The Hospital* (1972), *The Day of the Dolphin* (1973), and *Islands in the Stream* (1977). He also starred in the television series "East Side, West Side" (1963–64) and in several television films. His stage career has included such plays as *The Andersonville Trial* (1959); *Plaza Suite* (1968); DEATH OF A SALESMAN (1975), giving a notable performance as Willy Loman; *Sly Fox* (1976); and *Present Laughter* (1982).

Scott, Randolph (Randolph Crane, 1903–87), U.S. actor, on screen from 1929, who was for over three decades one of Hollywood's most durable Western stars. He played leads in scores of Westerns and other action films, as in *The Last of the Mohicans* (1936), *Jesse James* (1939), *Western Union* (1941), *Santa Fe* (1951), and later in such far more interesting, highly textured Westerns as *Buchanan Rides Alone* (1958) and *Ride the High Country* (1962). Early in his career he also played major roles in such films as ROBERTA (1935) and *My Favorite Wife* (1940).

Scriabin, Alexander Nicolayevich (1872–1915), Russian composer, whose often-played work for the piano includes 10 sonatas (1892–1913) and scores of shorter works. His larger works, and especially those composed after his conversion to theosophy in 1905, are deeply mystical; they include the *Divine Poem* (*Third Symphony*, 1904), *Poem of Ecstasy* (1908), and *Prometheus* (1910).

Seagram Building (1958), the bronze, boxlike Manhattan office building designed by Ludwig MIES VAN DER ROHE and Philip JOHNSON; it became a key artifact of the INTERNATIONAL STYLE.

"Secondhand Rose" (1921), a song introduced by Fanny BRICE in *Ziegfeld Follies of 1921*, with music by James Hanley and words by Grant Clarke.

Seeger, Pete (1919–), U.S. folk singer, composer, banjoist, and guitarist, one of the most celebrated of all American folk singers, for five decades a major figure in the American folk movement, and simultaneously a leading left protest singer. He began his career as a folk-song collector and left activist in the late 1930s, and over five decades later, in the early 1990s, had become an inspirational figure for generations of folk and popular musicians, by no means all of them politically committed people. Seeger, Woody GUTHRIE, Lee Hays, and Millard Lampell formed the Almanac Singers in 1940; the group broke up with the advent of World War II but was a model for THE WEAVERS, formed in 1948 by Seeger, Hays, Ronnie Gilbert, and Fred Hellerman, which was the leading group in the folk-music revival of the time. Seeger and Hays wrote IF I HAD A HAMMER (1948), and Seeger wrote such songs as "Where Have All the Flowers Gone?" (1958), "Turn! Turn! Turn!" (1962), and WAIST DEEP IN THE BIG MUDDY (1966), an anthem of the anti-Vietnam War movement. He also sang and was associated with such songs as WE SHALL OVERCOME, "Wimoweh," "Union Maid," and scores of other folk and political songs. He was blacklisted during the McCarthy era. In the late 1960s he became a leading green activist, with the sloop *The Clearwater* initiating a campaign to clean up the Hudson River.

Seferis, George (Georgios Seferiades, 1900–71), Greek writer and diplomat, a leading modern poet from the appearance of his first poetry collection, *Turning Point* (1931). His further work is found in such volumes as *The Cistern* (1932), *Mythical Story* (1935), *The Exercise Book* (1940), and *Thrush* (1942). He was awarded the 1963 NOBEL PRIZE for literature.

Segal, George (1924–), U.S. sculptor, a realist often identified with the POP-ART movement, whose work consists largely of plaster casts of living people, presented in groups or singly, their settings also drawn from life, as in *Dinner Table* (1962) and *Gas Station* (1963). Some have seen his work as simply realistic, while others have seen it as wholly alienated.

Segar, Elzie (Elzie Crisler Segar, 1894–1938), U.S. cartoonist; in 1919 he created the comic strip "Thimble Theatre" and in 1929 introduced the character of POPEYE THE SAILOR into the strip, joining Olive Oyl, Castor Oyl, and Ham Gravy, later to be joined by Wimpy.

Segovia, Andrés (1893–1987), Spanish guitarist, whose work did much to restore the role of the classical guitar and to expand its repertory in the 20th century. Segovia made his debut in 1909 and developed worldwide interest in the classical guitar as he toured from the mid-1920s. He also transcribed classical works and lute and harpsichord pieces and encouraged modern composers to write new works for the instrument.

Sellers, Peter (Richard Henry Sellers, 1925– 80), British actor, probably best known for his four *Pink Panther* films (1964, 1975, 1976, and 1978). Yet his most memorable work was in DR. STRANGELOVE (1964), Stanley KUBRICK's classic black comedy about the coming of humanity-destroying nuclear war, in which he played the American President; a British officer; and a mad Nazi scientist, now in American service. Some of his other well-received leads were in *The Mouse That Roared* (1949); *The Waltz of the Toreadors* (1962); *The World of Henry Orient* (1964); and his last film, BEING THERE (1979).

Selznick, David Oliver (1902–65), U.S. producer, son of producer Lewis J. Selznick; he was a key figure during Hollywood's Golden Age, if only for his 1939 GONE WITH THE WIND. Several of his other major films are KING KONG (1933), A TALE OF TWO CITIES (1935), REBECCA (1940), and *Duel in the Sun* (1946). He was the husband of actress Jennifer JONES.

Sendak, Maurice (1928–), U.S. writer and illustrator of many extremely popular and imaginative children's books, including such works as *Kenny's Window* (1956) and *Where Wild Things Are* (1964), and illustrator of many more. He also did work for stage and television.

Senghor, Léopold Sédar (1906–), Senegalese writer and political leader, a leading Black African poet and spokesman for the concept of *négritude*, which affirms a unique and valuable Black African contribution to world culture, with deep historical roots. His poetry collections include *Chants d'ombre* (1945), *Hosties noires* (1948), *Chants por Naëtt* (1949), and *Éthiopiques* (1956). He was the first president of Senegal (1960–80).

Sennett, Mack (Michael Sinnott, 1880–1960), U.S. director, actor, and producer, on stage from the early 1900s, on screen as an actor from 1908 and as a director from 1910, working in the early years for Biograph, with such film pioneers as D.W. GRIFFITH and Billy BITZER. He co-founded Keystone in 1912 and soon became the leading comedy director-producer of his time, working with such comedy stars as Charlie CHAPLIN, Fatty ARBUCKLE, and Mabel Normand, and in the process inventing the KEYSTONE KOPS. His corporate affiliations changed several times after 1915, but he continued to develop new performers, moving into feature films and several series during the 1920s. His career did not long survive the advent of sound.

Separate Tables (1954), the Terence RATTIGAN play, actually two unrelated short plays set in the same Bournemouth hotel in the same period; Margaret Leighton won a TONY AWARD as best actress in the original Broadway production. Rattigan and John Gay wrote the screenplay of the 1958 Delbert MANN film, merging the two plays into one; the key roles were played by David NIVEN, Deborah KERR, Burt LANCASTER, Rita HAYWORTH, Wendy HILLER, and Gladys Cooper. Niven won a best actor OSCAR, and Hiller an Oscar as best supporting actress.

"September Song," a song introduced by Walter HUSTON in *Knickerbocker Holiday* (1938); his recording of it became a popular classic in

1950, after his death. Music was by Kurt WEILL and words by Maxwell ANDERSON.

"Sgt. Pepper's Lonely Hearts Club Band" (1967), the BEATLES song, written by Paul MCCARTNEY and John LENNON. It was the title song of their tremendously popular album and also the centerpiece of the film THE YELLOW SUBMARINE (1968).

serialism, an approach to musical composition stemming from the development of 12-NOTE COMPOSITION by Arnold SCHOENBERG and others in the 1920s. The arrangement of musical elements in series was soon extended beyond pitch, enabling composers to apply serialism to several compositional elements, as in the work of Karlheinz STOCKHAUSEN and Olivier MESSIAEN. Like 12-note music, much serial music is atonal, though later ability to incorporate tonality broadened compositional possibilities.

Serkin, Rudolf (1903–), Austrian-American pianist, a child prodigy who made his formal debut in 1915. From 1920 he was a soloist and also was associated with violinist Adolf Busch, in piano and violin recitals and as part of the Busch chamber orchestra. Serkin made his American debut in 1933; taught at and was later director of the Curtis Institute of Music from 1939 to 1975; and in 1949 was a founder of the Marlboro School of Music. He is the father of pianist **Peter Serkin**.

Servant, The (1963), the Joseph LOSEY film; James Fox was the weak rich man corrupted by his far stronger, sadistically inclined manservant, played by Dirk BOGARDE, in a cast that included Sarah Miles, Patrick Magee, and Wendy Craig. The Harold PINTER screenplay was based on the Robin Maugham novel.

Service, Robert William (1874–1958), Canadian writer, whose early poetry, written while living in the Yukon, established him as the prototypical Canadian northern frontier and gold-rush poet. These were collected in *Songs of a Sourdough* (1907), *Ballads of a Cheechako* (1909), and *Rhymes of a Rolling Stone* (1912). By far his most popular poem is "The Shooting of Dan McGrew." His later work, done while living in France after World War I,

included further poems, several novels, and autobiographical works.

"Sesame Street" (1969–), the landmark children's television variety series, developed by Joan Ganz Cooney; it has become tremendously popular in many countries, while at the same time by example championing humane, nonviolent children's programming. Key performers have included THE MUPPETS, Loretta Long, Bob McGrath, Matt Robinson, Emilio Delgado, and Will Lee.

Sessions, Roger Huntington (1903–85), U.S. composer and teacher. The most accessible of his largely modernist work is the incidental music for the play *The Black Maskers* (1923). His works include the operas *The Trial of Lucullus* (1947) and *Montezuma* (1964), as well as eight symphonies (1927–68) and a considerable body of other orchestral and instrumental works. He was an influential teacher of composition and wrote several books on music.

Seven Days in May (1964), the John FRANKENHEIMER film, a cautionary Cold War story about a group of high-ranking American military officers who plan and come close to executing a military coup against a President who dares to seriously negotiate with the Soviet Union. Burt LANCASTER was General James Scott, the key plotter, and Kirk DOUGLAS his aide, Colonel "Jiggs" Casey, who ultimately frustrates the plot, in a cast that included Fredric MARCH as the President, Ava GARDNER, Edmond O'Brien, Martin Balsam, John HOUSEMAN, and George Macready. Rod Serling adapted the Fletcher Knebel–Charles W. Bailey II novel for the screen.

Seven Samurai, The (1954), the Akira KUROSAWA film, about seven samurai who hire themselves out to defend a village against bandits in 16th-century Japan. The movie won a best foreign film OSCAR. In 1960 it was remade by John Sturges as THE MAGNIFICENT SEVEN, with a cast that included Yul BRYNNER, Steve MCQUEEN, James COBURN, Robert VAUGHN, Charles BRONSON, Horst Buchholz, Brad Dexter, and Eli Wallach. The film generated three sequels.

Seventh Heaven (1922), the Austin Strong play, a story set in France, about young lovers

parted by war who are eventually reunited. It was adapted by Benjamin Glazer into the 1927 Frank BORZAGE film, starring Janet GAYNOR and Charles Farrell. Gaynor, Borzage, and Glazer won OSCARS for this classic silent-film love story. It was remade as a 1937 sound film by Henry KING, with Simone Simon and James STEWART in the leads.

Seventh Seal, The (1956), the classic Ingmar BERGMAN film, an allegory set in medieval Sweden at a time of plague, with Max von SYDOW in the lead as a knight returning from the Crusades who plays chess with Death, saves a young pair of traveling players and their child from Death, and ultimately loses his own game, the film ending in a dance of Death. Gunnar Bjornstrand, Bibi ANDERSSON, Nils Poppe, and Bengt Ekerot, as Death, are in key supporting roles.

Sex Pistols, British punk ROCK band formed in 1975, originally composed of Johnny Rotten (John Lydon, 1956–　　　), Paul Cook (1956–　　　), Steve Jones (1955–　　　), and Glen Matlock (1956–　　　), who was replaced by Sid Vicious (John Simon Ritchie, 1957–79). The group, which carefully cultivated a bitter, violent image, became briefly popular in concert, recorded such songs as "Anarchy in the UK" (1976) and "God Save the Queen" (1977), and issued the album *Never Mind the Bollocks, Here's the Sex Pistols* (1977); it broke up in early 1978. Gary Oldman played Vicious and Chloe Webb played his groupie lover Nancy Spungen in the 1986 semidocumentary Alex Cox film *Sid and Nancy*

Shadow Box, The (1977), the Michael Cristofer play, about three dying hospital patients and their separate attempts to come to terms with their impending deaths and their families. Leading roles were played by Geraldine FITZGERALD, Laurence Luckinbill, and Simon Oakland. The work won a Best Play TONY and a PULITZER PRIZE. Cristofer adapted the play into the 1980 telefilm, with a cast that included Paul NEWMAN, Joanne WOODWARD, Christopher PLUMMER, Sylvia SIDNEY, James Broderick, and Valerie Harper.

Shaffer, Peter Levin (1926–　　　), British writer, who emerged as a major modern play-

wright with *Five-Finger Exercise* (1958), which became the 1962 Daniel MANN film, with Rosalind RUSSELL and Jack HAWKINS in the leads. His best-known plays also include *The Royal Hunt of the Sun* (1964), which became the 1969 Irving Lerner film with Robert Shaw and Christopher PLUMMER in the leads; the TONY-winning *Equus* (1973), which became the 1977 Sidney LUMET film, with Richard BURTON and Peter Firth in the leads; and AMADEUS (1979), also a Tony winner, which Shaffer adapted into the OSCAR-winning Milos FORMAN film, with F. Murray Abraham and Tom Hulce in the leads. Forman, Shaffer, and Abraham all won OSCARS for the film.

Shahn, Ben (1898–1969), U.S. painter, photographer, and graphic artist, who became one of the leading socially critical realists of the 1930s. His early works include the series of *Sacco and Vanzetti* paintings (1931–32) that first established him as a major figure and the *Tom Mooney* series (1933), as well as the New York City photographs of the early 1930s. In 1933 he assisted Diego RIVERA on the ultimately destroyed Rockefeller Center murals. From 1935 to 1938 he took over 6,000 photographs in the South and Southwest, as part of the Farm Security Administration photography project, as well as creating several large murals for the FEDERAL ARTS PROJECT from 1933 to 1943. He also painted such works as *Vacant Lot* (1939), *Handball* (1939), and *Girl Jumping Rope* (1943). During the postwar period he turned more to graphics, becoming a leading book and magazine illustrator.

Shakespeare Wallah (1965), the James IVORY film, written by Ruth Prawer JHABVALA, about a valiantly but tenuously surviving touring British Shakespearean troupe in post-independence India, with a cast that included Felicity Kendal, Shashi Kapoor, Geoffrey Kendal, Laura Liddell, and Madhur Jaffrey.

Shane (1953), the George STEVENS classic Western, with Alan LADD in the title role as a retired gunfighter who takes on one more good fight, in defense of a homesteading family, played by Van HEFLIN, Jean ARTHUR, and Brandon de Wilde, ultimately killing bad man Jack Palance. A.B. GUTHRIE and Jack Sher wrote the screenplay, based on the Jack Schae-

fer novel. Loyal Griggs won a cinematography OSCAR.

Shanghai Express (1932), the Josef von STERNBERG film, set on a railroad journey during the Chinese Civil War. Marlene DIETRICH was Shanghai Lily, opposite Clive Brook, in a cast that included Anna May Wong, Warner Oland, and Eugene Pallette. Jules Furthman wrote the screenplay. Lee Garmes won a cinematography OSCAR.

Shankar, Ravi (1920–), Indian sitar player, composer, and teacher, who played a major role in developing a worldwide role for Indian music. He became a leading musician in India from the late 1940s, as music director for All-India Radio (1949–56) and as a composer and sitarist, and toured the world as a solo sitarist from the mid-1950s. In the mid-1960s he taught and profoundly influenced the music of such disparate artists as composer Philip GLASS and THE BEATLES' George HARRISON, along with a whole generation of Western musicians. His classical compositions included two sitar concertos (1971 and 1981) and several other works, as well as the scores for such films as PATHER PANCHALI (1955) and GANDHI (1982).

Shapiro, Karl Jay (1913–), U.S. writer and editor, who emerged as a major poet during and shortly after World War II, with the poems collected in *Person, Place, and Thing* (1942); *The Place of Love* (1942); *V-Letter and Other Poems* (1944), for which he won a PULITZER PRIZE; and *Trial of a Poet* (1947). His later work, much of it reflecting a move toward free verse, includes such collections as *Poems* (1942–53), *Poems of a Jew* (1958), and *New and Selected Poems, 1940–86*. He also wrote a considerable body of critical work.

Sharif, Omar (Michael Shalhoub, 1932–), Lebanese-Egyptian actor, on screen in Egyptian films from 1953, whose Sherif Ali role in David LEAN's LAWRENCE OF ARABIA (1962) brought him worldwide attention. In 1965 he played the title role in Lean's DOCTOR ZHIVAGO. His later films include the Nicky Arnstein roles in FUNNY GIRL (1968) and *Funny Lady* (1975), as well as leads in several action films.

Shaw, Artie (Arthur Arshawsky, 1910–), U.S. bandleader, clarinetist, and composer. With his 1938 recordings of "Begin the Beguine" and "Indian Love Call" he became a leading figure of the big-band era; he was also identifed with such other works as STARDUST, "Frenesi," "Dancing in the Dark," and his own CLARINET CONCERTO. Never very happy with the world of popular music, he took several long sabbaticals during the years of his popularity and left music entirely in 1952, returning briefly as a bandleader in the early 1980s.

Shaw, George Bernard (1856–1950), British writer and critic, one of the central literary figures of the 20th century, as well as a key contributor to the development of British socialism. Before focusing on his extraordinary career as a playwright, he was the author of five unsuccessful novels, a free-lance journalist, a music reviewer (1888–94), and the avant-garde drama critic of *The Saturday Review* (1895–98). He was also from 1884 an untiring pamphleteer and essayist on behalf of the socialist Fabian Society, through which he and such other early socialists as Beatrice and Sidney Webb provided much of the intellectual basis of British socialism. His then-unusual literary and political views made production of his plays very difficult to achieve in Edwardian London, until 1904; then, in four successive seasons at the Royal Court Theatre, 10 of his plays were produced, establishing him as a leading playwright. Many of his plays are part of the world repertory, being continually revived and in many languages. His first play was *Widower's Houses* (1892); it was followed by over two score more, some of the best known and most often performed being *Mrs. Warren's Profession* (1893), *Arms and the Man* (1894), *The Devil's Disciple* (1894), *Candida* (1895), *You Can Never Tell* (1897), CAESAR AND CLEOPATRA (1899), *Captain Brassbound's Conversion* (1901), *Man and Superman* (1903), MAJOR BARBARA (1905), *The Doctor's Dilemma* (1906), *Misalliance* (1910), *Androcles and the Lion* (1912), PYGMALION (1913), *Heartbreak House* (1917), *Back to Methuselah* (1922), and SAINT JOAN (1923). Shaw long resisted adaptation of his work for film but

ultimately permitted adaptation of three of his plays into notable films: *Pygmalion*, which became the 1938 Anthony ASQUITH film, starring Leslie HOWARD and Wendy HILLER, and the basis for MY FAIR LADY (1956); *Major Barbara*, which became the 1941 Gabriel Pascal film, starring Wendy Hiller and Rex HARRISON; and *Caesar and Cleopatra*, which became the 1946 Gabriel Pascal film, starring Claude RAINS and Vivien LEIGH. *The Devil's Disciple* was adapted into the 1959 Guy Hamilton film, starring Burt LANCASTER, Laurence OLIVIER, and Kirk DOUGLAS.

Shaw, Irwin (1913–84), U.S. writer, best known for his story of soldiers' lives in World War II, *The Young Lions* (1948), which was adapted into the 1958 Edward DMYTRYK film, with Marlon BRANDO, Montgomery CLIFT, and Dean MARTIN in the leads. He had previously written four plays, including his antiwar *Bury the Dead* (1936). His novels also include *Two Weeks in Another Town* (1960), which was adapted into the 1962 Vincente MINNELLI film, with Edward G. ROBINSON and Kirk DOUGLAS in the leads; and *Rich Man, Poor Man* (1970). He also wrote several volumes of short stories and a number of original screenplays, including *The Talk of the Town* (1942), *Act of Love* (1953), and *Fire Down Below* (1957).

Shawn, Ted (1891–1972), U.S. dancer, teacher, and choreographer, on stage as a dancer from 1911. He founded his own MODERN-DANCE company in 1914, and in 1915 cofounded the Denishawn School and Dance Company with his wife, Ruth ST. DENIS; they and the company stayed together until 1931. In 1932 he founded the All-Male Dancers Company; his espousal of the cause of the male dancer considerably influenced the development of modern dance in America. In 1933 he set up a dance studio at his Jacob's Pillow, Massachusetts farm, which later became the site of the major American dance festival.

Shearer, Norma (Edith Norma Shearer, 1900–83), Canadian actress, on screen from 1920. She emerged as a major silent-film star in the late 1920s, made the transition to sound successfully, and was one of Hollywood's leading stars during the 1930s, in such films as *The Divorcée* (1930), for which she won a best actress OSCAR; *A Free Soul* (1931); THE BARRETTS OF WIMPOLE STREET (1934); and *Marie Antoinette* (1938). She was married to producer Irving THALBERG from 1927 until his death in 1936 and retired in 1942, after two successive failed films and her remarriage.

Sheeler, Charles (1883–1965), U.S. painter and photographer, whose work in both media sought essential structural elements, in the paintings often expressed as geometrical abstractions, but with structure still in view. He exhibited at the ARMORY SHOW of 1913 and from the 1920s was a leading photographer, with notable groups of photos of the Ford River Rouge plant (1927) and *Chartres Cathedral* (1929). His long interest in depicting New York was expressed in such works as the film *Manahatta* (1920), done in collaboration with Paul STRAND, and *New York No. 2* (1951).

Sheik, The (1921), the Rudolf VALENTINO film, in which he played a desert chief, opposite Agnes Ayres as the kidnapped Englishwoman who eventually comes to love him. The hackneyed work, directed by George Melford, became enormously popular, as did Valentino, pseudo-Moorish architecture, and 1920s Latin lovers.

"She Loves Me" (1963), the BEATLES song, their first massively successful popular record in Britain, words and music by John LENNON and Paul MCCARTNEY.

Shepard, Sam (Samuel Shephard Rogers, Jr., 1943–), U.S. writer and actor, whose many plays include *Tooth of Crime* (1972), *Curse of the Starving Class* (1978), his PULITZER PRIZE-winning *Buried Child* (1978), and *True West* (1979). As an actor he has appeared in such films as *Frances* (1982), *The Right Stuff* (1983), and *Crimes of the Heart* (1986).

Sherriff, Robert Cedric (1896–1975), British writer, whose World War I experiences at the front provided the basis for his tremendously popular play JOURNEY'S END (1928), which became James WHALE's 1930 film. He also wrote several notable screenplays, including THE INVISIBLE MAN (1933), GOODBYE, MR. CHIPS (1939), *This Above All* (1942), and ODD

MAN OUT (1947). His plays include *Badger's Green* (1930); *Home at Seven* (1950), which became the 1953 Ralph RICHARDSON film, in which Richardson also starred; and *The Long Sunset* (1955). He also wrote several novels.

Sherwood, Robert Emmett (1896–1955), U.S. writer, who emerged as a major playwright and screenwriter during the 1930s. Among his best-known plays are *Waterloo Bridge* (1930), which was adapted for film three times, most notably in the World War II Mervyn LeRoy version, with Vivien LEIGH and Robert TAYLOR in the leads; THE PETRIFIED FOREST (1935), which became the 1936 Archie Mayo film, with Leslie HOWARD, Humphrey BOGART, and Bette DAVIS in the leads; his PULITZER PRIZE-winning *Idiot's Delight* (1936), which he adapted into the 1939 Clarence BROWN film, with Norma SHEARER and Clark GABLE in the leads; and his Pulitzer Prize-winning ABE LINCOLN IN ILLINOIS, which he adapted into the 1940 John CROMWELL film, with Raymond MASSEY as Lincoln. His play *There Shall Be No Night* (1940) won a third Pulitzer Prize. Sherwood won an OSCAR for the screenplay of THE BEST YEARS OF OUR LIVES (1946).

She Wore a Yellow Ribbon (1949), the second film in John FORD's CAVALRY TRILOGY.

Shinn, Everett (1876–1953), U.S. painter, a realist with highly Impressionist leanings, who began his career as an illustrator and was part of the group who coalesced around Robert HENRI to exhibit together in 1908 as THE EIGHT, later to be called the ASHCAN SCHOOL. Many of his themes were drawn from the arts, and especially the theater, as were many of his portraits. He also decorated the Belasco Theatre, and in the 1920s he ran his own theater in Greenwich Village.

Ship of Fools (1962), the Katherine Anne PORTER novel, set on a German ship sailing from Mexico back to Germany in 1931, as Hitler is coming to power. The book was adapted by Abby Mann into the 1965 Stanley KRAMER film, with Vivien LEIGH, Simone SIGNORET, Oskar Werner, José FERRER, and Lee MARVIN leading a strong ensemble effort.

Shoah (1985), the long, powerful Claude Lanzmann documentary on the Holocaust, in which he very effectively builds a picture of the time and experience, through interviews with a considerable range of those who lived through it all, very notably including both concentration camp survivors and some who deny any knowledge of the mass murders taking place not far from their homes.

Shoeshine (1946), the Vittorio DE SICA film, written by Cesare ZAVATTINI and others, about two young shoeshine boys in Nazi-occupied Italy, who fail to survive. Imprisoned for black-market involvement, one escapes; the other informs, and the informer eventually kills his friend. Rinaldo Smordini, Franco Interlenghi, Angelo D'Amico, and Aniello Mele play key roles in this darkly shot neorealist work.

Shōgun (1975), the James CLAVELL novel, set in medieval Japan, about an English pilot shipwrecked off Japan who became the protégé of a powerful samurai. It was adapted into the five-part 1980 television miniseries, with Richard CHAMBERLAIN and Toshiro MIFUNE in the leads and Yoko Shimada, John Rhys-Davies, Nobuo Kaneko, and Damien Thomas in key supporting roles; Orson WELLES narrated.

Sholokov, Mikhail Aleksandrovich (1905–84), Soviet writer, whose work is set in his native Don River region. His early short stories reflect his experience as a Red Army soldier on the Don during the Russian Civil War; they were collected as *The Tales of the Don* (1925) and *The Azure Steppe*. By far his best-known work is the massive tetralogy *The Quiet Don* (1928); the work, set in Don Cossack country during the Civil War, established him as the leading Soviet novelist of his time and brought worldwide recognition. His other major work was the two-volume novel published as *Seeds of Tomorrow* (1932) and *Harvest on the Don* (1960). The Sergei GERASIMOV 1960 film *And Quiet Flows the Don* was based on *The Quiet Don*. Sholokov was awarded the NOBEL PRIZE for literature in 1965.

Shop on Main Street, The (1965), a film set in Nazi-occupied Czechoslovakia, with Ida Kaminska as the old Jewish woman who ulti-

mately dies, opposite Josef Kroner as the Czech who commits suicide after her death. The film, written and directed by Jan Kadar and Elmar Klos, powerfully indicts much of a whole Czech generation for what is perceived as its World War II failure to fight genocidal antisemitism.

Shore, Dinah (Frances Rose Shore, 1917–), U.S. singer, popular on radio and records from the late 1930s for her renditions of such songs as "Yes, My Darling Daughter" (1940), "Blues in the Night" (1942), and "I'll Walk Alone" (1944). She also appeared in such films as *Thank Your Lucky Stars* (1943), *Follow the Boys* (1944), and *Till the Clouds Roll By* (1946). She became best known as a television personality, as host of two long-running variety series, "The Dinah Shore Chevy Show" (1951–57) and "The Dinah Shore Show" (1957–62), and from 1970 to 1980 as host of two successive talk shows.

Shostakovich, Dmitri Dimitrievich (1906–75), Soviet composer, a major figure in 20th-century music, whose work was often impeded but never stopped by the Stalinist cultural bureaucracy with which he had to deal for much of his creative life. His orchestral and instrumental work was primary; it included 15 symphonies, his work developing from the notable freedom of the *First Symphony* (1925), written as a graduation exercise, to the politically thematic *October* (No. 2, 1927) and *First of May* (No. 3, 1929). His *Fourth Symphony* (1936) was withdrawn as politically suspect and was not performed until 1961. But the *Fifth Symphony* (1937), although seemingly conforming, was also a powerful, individual work, celebrated throughout the world. Very notable also were the LENINGRAD SYMPHONY (*Seventh*, 1941), written in besieged Leningrad during World War II; the *Tenth Symphony* (1953), and, after he had survived Stalin, the BABI YAR SYMPHONY (13th, 1962). His very large body of work also includes the *Piano Quintet* (1940), 15 string quartets, the violin concertos (1948 and 1967), the cello concertos (1959 and 1965), and the piano concertos (1933 and 1957). He wrote two early operas, *The Nose* (1930) and *The Lady Macbeth of the Mtsensk District* (1934); and three ballets, *The*

Golden Age (1930), *Bolt* (1931), and *Bright Rivulet* (1935). Shostakovich also wrote the scores for such films as *Golden Hills* (1931), *The Young Guard* (1948), *The Fall of Berlin* (1949), and WAR AND PEACE (1964).

Show Boat (1927), the classic American operetta by Oscar HAMMERSTEIN II, with music by Jerome KERN, based on Edna FERBER's 1926 novel; it introduced such songs as OL' MAN RIVER, BILL, MAKE BELIEVE, and WHY DO I LOVE YOU?. Jules Bledsoe originated the role of Joe on Broadway, but his great song "Ol' Man River" became identified with Paul ROBESON, who played Joe in the 1928 London version, again in 1932, and in the 1936 film. Helen Morgan originated "Bill," and Howard Marsh and Norma Terriss sang the leading roles. Hammerstein adapted the play into the classic 1936 James WHALE film, with a cast that included Robeson, Irene DUNNE, Allan Jones, Helen MORGAN, Charles Winninger, and Hattie McDaniel. The film was remade by George Sidney in 1951, with William Warfield, Kathryn Grayson, Howard Keel, and Ava GARDNER in the key roles.

Shuffle Along (1921), the leading Black American theater musical of the 1920s, composed by Eubie BLAKE and with libretto by Noble SISSLE, which introduced two hit songs: I'M JUST WILD ABOUT HARRY and "Love Will Find a Way."

Shute, Nevil (Nevil Shute Norway, 1899–1960), British writer, a prolific novelist best known for three works that were adapted into films: the wartime *Pied Piper* (1941), which became the 1942 Irving Pichel film, with Monty Woolley in the lead; *A Town Like Alice* (1950), which became the 1956 Jack Lee film, with Peter FINCH and Virginia McKenna in the leads, and later a television miniseries; and ON THE BEACH (1957), which became Stanley KRAMER's quintessential anti-atomic war film in 1959, with Gregory PECK, Ava GARDNER, and Fred ASTAIRE in leading roles.

Sibelius, Jean (1865–1957), Finnish composer, who became his country's leading composer and a major figure in 20th-century music, building his work on Finnish mythology and national themes. His most notable early works

include the choral *Kullervo Symphony* (1892); the four tone poems in the *Karelia Suite* (1893), which include the *Swan of Tuonela*; FINLANDIA (1899); and his *First* and *Second Symphonies* (1899 and 1901). His further work includes the *Third* through *Seventh Symphonies* (1907–24; an eighth was probably destroyed), the *Violin Concerto* (1903), and a large body of other instrumental and vocal music, including several tone poems and many songs.

Sickert, Walter Richard (1860–1942), British painter and teacher, who became a leading Impressionist during the last decade of the 19th century. From 1905 he was a central figure in the development of modern British painting, and was a founder of the Camden Town Group in 1911 and of the London Group in 1913, in that period drawing his main themes from the underside of London life.

Sidney, Sylvia (Sophia Kosow, 1910–), U.S. actress, on stage from 1926 and on screen from 1929, who became typecast as the quintessential Great Depression film heroine, in such films as AN AMERICAN TRAGEDY (1931), *Street Scene* (1931), *The Trail of the Lonesome Pine* (1936), and DEAD END (1937), and who later starred in such films as *Blood on the Sun* (1945) and *The Searching Wind* (1946) before her film career faltered. She continued to work in the theater, in a wide range of roles, largely on tour and in regional theater, returning to films in a strong character role in *Summer Wishes, Winter Dreams* (1973) and thereafter in many character roles in films and television.

Signoret, Simone (Simone Kaminker, 1921–85), French actress, on screen from 1942, who in the early postwar period became a major international dramatic star in such films as LA RONDE (1950); *Diabolique* (1955); ROOM AT THE TOP (1958), for which she won a best actress OSCAR, SHIP OF FOOLS (1965); *Le Chat* (1972); and *Madama Rosa* (1978). She was married to actor Yves MONTAND.

Sillitoe, Alan (1928–), British writer, who became one of Britain's prototypical "angry young men" with his first novel, SATURDAY NIGHT AND SUNDAY MORNING (1958), and the short-story collection led by THE LONELINESS OF THE LONG-DISTANCE RUNNER

(1959). His further work includes such novels as *The General* (1960), *The Widower's Son* (1976), and *Down from the Hill* (1984), several more short-story collections, a substantial body of poetry, and children's books. He adapted *Saturday Night and Sunday Morning* into the 1960 Karel Reisz film, with Albert FINNEY in the lead, strongly supported by Rachel Roberts and Shirley Anne Field, and also adapted *The Loneliness of the Long-Distance Runner* into the 1962 Tony RICHARDSON film, with Tom COURTENAY in the central role.

Sills, Beverly (Belle Silverman, 1929–), U.S. soprano and opera director, one of the leading bel canto singers of her era. She sang on radio as a child, made her opera debut in 1946, joined the New York City Opera in 1955, and ultimately moved into leading roles, from the mid-1960s becoming a major figure, in opera and recital worldwide and as a recording artist. She made a very late debut at the Metropolitan Opera, in 1975. She was director of the New York City Opera from 1979 to 1988 and president of the opera's board of directors from 1989.

Silone, Ignazio (Secondo Tranquilli, 1900–84), Italian writer, who took as his main themes the plight of the poor in southern Italy and the fight against fascism. He was a socialist activist in his youth and a founder and leading member of the Italian Communist Party from 1919 until his 1931 break with communism. Then he focused on his writing, from Swiss exile, emerging as a major novelist with such works as *Fontamara* (1930), *Bread and Wine* (1937), *The Seed Beneath the Snow* (1942), and *The Secret of Luca* (1956), and such plays as the antifascist *The School for Dictators* (1938) and *The Story of a Humble Christian* (1971).

Sim, Alistair (1900–1976), Scottish actor, on stage from 1930, and on screen from 1935. He played in often comic character roles on screen during the 1930s, played leads in his three *Inspector Hornleigh* films (1939–41), and from the late 1940s played a succession of unique character roles, some of them leads, in such films as *Green for Danger* (1946), *Laughter in Paradise* (1951), *Scrooge* (1951), *An Inspector Calls* (1954), and *The Belles of St. Trinian's* (1954).

Simenon, Georges (1903–89), Belgian-French writer, best known as the creator of fictional police inspector MAIGRET, from 1930 the protagonist of over 100 mystery novels. Simenon was extraordinarily prolific and equally popular; his output also includes approximately 150 novels in his own name and at least 100 more novels and many hundreds of short stories written under at least a score of pseudonyms.

Simmons, Jean (1929–), British actress, on screen from 1944, who very early in her career played major roles in such films as CAESAR AND CLEOPATRA (1945), GREAT EXPECTATIONS (1946), and BLACK NARCISSUS (1947), then playing Ophelia to Laurence OLIVIER's HAMLET (1948). She relocated to Hollywood in the early 1950s; there her vehicles were generally less rewarding, although she did play substantial roles in such films as GUYS AND DOLLS (1955), ELMER GANTRY (1960), and ALL THE WAY HOME (1963). She also later worked in television, most notably in THE THORN BIRDS (1982).

Simon, Neil (1927–), U.S. writer, who wrote for radio and television in the 1950s and in the 1960s became an extremely popular playwright and screenwriter, with a long string of hit Broadway comedies and films. His work includes such plays as *Come Blow Your Horn* (1961), *Barefoot in the Park* (1963), *The Odd Couple* (1965), *Plaza Suite* (1968), *The Last of the Red-Hot Lovers* (1969), *The Prisoner of Second Avenue* (1971), *The Sunshine Boys* (1972), *California Suite* (1976), and five semiautobiographical works: *Chapter Two* (1978), *I Ought to Be in Pictures* (1980), *Brighton Beach Memoirs* (1983), *Biloxi Blues* (1984), and *Broadway Bound* (1986). He adapted many of his own plays for film, and also wrote several original filmscripts, including *The Good-bye Girl* (1977), which starred his wife, **Marsha Mason**. Some of his most notable film adaptations were *The Odd Couple* (1968), directed by Gene Saks and starring Jack LEMMON and Walter MATTHAU; *The Prisoner of Second Avenue* (1971), directed by Melvin Frank and starring Jack LEMMON and Anne BANCROFT; and *The Sunshine Boys* (1978), directed by Herbert Ross and starring Walter MATTHAU and George BURNS.

Simon and Garfunkel (Paul Simon, 1942–), and Art Garfunkel, 1942–), U.S. folk-ROCK singing duo, who became international figures in the mid-1960s. Simon's song "Sounds of Silence," in their album *Wednesday Morning, 3 A.M.* (1965), became a huge hit, as "electrified" by producer Tom Wilson. They followed it with the albums *Sounds of Silence* (1967), *Parsley, Sage, Rosemary and Thyme* (1967), and *Bookends* (1968) and the GRAMMY-winning "Mrs. Robinson" single, from their score of the film THE GRADUATE (1967). Their other major work together was the celebrated 1970 album BRIDGE OVER TROUBLED WATER (1970); its title song became a new standard, winning Grammys for record of the year, album of the year, and song of the year. They pursued individual work after 1970, getting together for a celebrated reunion concert in New York's Central Park in 1982. Simon created such albums as *Paul Simon* (1972); *There Goes Rhymin' Simon* (1973); Grammy winner *Still Crazy After All These Years* (1975); *Hearts and Bones* (1983); the very notable *Graceland* (1986), for which he won another record of the year Grammy, and *The Rhythm of the Saints* (1990). He also appeared in several films, including ANNIE HALL (1977), and wrote, scored, and starred in *One Trick Pony* (1980). Garfunkel appeared in several films, most notably in CATCH-22 (1970) and CARNAL KNOWLEDGE (1971), and did such albums as *Angel Clare* (1973) and *Breakaway* (1975).

Simonov, Konstantin Mihailovich (1915–79), Soviet writer, whose work as a journalist during World War II was the basis for his best-known novel, *Days and Nights* (1945), set in besieged Stalingrad, and for his popular war poem "You Remember, Alyosha" (1941). During the post-Stalin thaw, he was from 1954 to 1957 editor of *Novy Mir*, which published the work of many dissidents.

Simple, actually Jesse B. Semple, the fictional Harlem character created by Langston HUGHES in what ultimately became five volumes of stories, beginning with *Simple Speaks His Mind* (1950).

Sinatra, Frank (Francis Albert Sinatra, 1915–), U.S. singer and actor, on stage as a singer in variety from 1935, who became a

major recording star and pop phenomenon in concert appearances from 1940, as the first modern teenage singing idol. He also appeared in musical films from 1941, but encountered voice problems in 1952 and found both his singing and acting careers severely damaged. He then successfully moved into dramatic roles, with his OSCAR-winning supporting role in FROM HERE TO ETERNITY (1953), followed by such films as THE MAN WITH THE GOLDEN ARM (1956), *Pal Joey* (1957), *The Manchurian Candidate* (1962), and *The Detective* (1968). He also made a singing comeback, as a more mature singer who became one of the leading song stylists of his time, and once again became a worldwide entertainment celebrity.

Sinclair, Upton Beall (1878–1968), U.S. writer and social reformer, whose muckraking novel THE JUNGLE (1906), an exposé of the Chicago meat-packing industry, helped spark the early pure food and drug laws. His work, most of it concerned with social issues, appeared in many written forms, including novels, plays, short stories, and essays. His Lanny Budd series, 10 political novels covering the years 1913–46, includes the PULITZER PRIZE-winning *Dragon's Teeth* (1942). Sinclair also ran many times for public office as a socialist, almost winning in the California gubernatorial race in 1934, and helped found the American Civil Liberties Union.

Singer, Isaac Bashevis (1904–), U.S. writer, who wrote in Yiddish about Jewish life in his native Poland; many of his works were originally written for serialization in the *Jewish Daily Forward*. His short stories appear in such collections as *Gimpel the Fool* (1957), *The Spinoza of Market Street* (1961), *Zlatah the Goat* (1966), and *The Image* (1985), while his novels include such works as *Satan in Goray* (1935), *The Family Moscat* (1950), *The Magician of Lublin* (1960), and *Old Love* (1979). He also wrote many stories for children. Singer won a NOBEL PRIZE for literature in 1978.

Singin' in the Rain (1952), the Gene KELLY film, a musical set in Hollywood during the transition from silent films to sound. It was directed and choreographed by Kelly and Stanley Donen, and starred Kelly, Donald O'Connor, and Debbie REYNOLDS, in a cast

that included Jean Hagen, Cyd Charisse, Millard Mitchell, and Rita Moreno. The screenplay was written by Betty COMDEN and Adolph GREEN, the songs by Arthur Freed and Nacio Herb Brown.

Sinyavsky, Andrey Donatevich (1925–), Soviet writer, a leading dissident who wrote as Abram Tertz for much of his career. He was imprisoned from 1966 to 1971 for allowing his works to be published underground and abroad. His best-known works include the novels *The Trial Begins* (1960) and *The Makepeace Experiment* (1964); the short stories collected in *The Icicle and Other Stories* (1961); and the short semifictional pieces in *A Voice from the Chorus* (1974).

Siqueiros, David Alfaro (1896–1974), Mexican painter, a leading muralist and left political activist. He joined the army of revolutionary leader Carranza in 1913, studied in Europe from 1919 to 1922, and went back to Mexico as a Communist, aiming to develop a revolutionary movement. He spent much of the interwar period as a political activist, although he did easel painting, was a Republican officer during the Spanish Civil War, and led an abortive attempt to assassinate Trotsky in 1940, then fleeing Mexico for Chile. His only murals in the period were *Portrait of the Bourgeoisie* (1939) at Mexico City and *Death to the Invader* (1942) at Chillán, Chile. Some of his most notable later murals were at the Hospital de la Raza in Mexico City (1952), at University City (1952–56), and at the Natural History Museum in Mexico City (1964); the huge *The March of Humanity in Latin America* (1963–69) is also in Mexico City.

Sissle, Noble (1899–1975), U.S. singer, composer, and bandleader, best known for his collaborations with Eubie BLAKE. Sissle did the libretto of SHUFFLE ALONG (1921), which introduced I'M JUST WILD ABOUT HARRY (later Harry S Truman's campaign song in 1948) and "Love Will Find a Way." He also worked with Blake on *Chocolate Dandies* (1924) and recorded many songs in the 1920s, accompanied by Blake at the piano. He worked mainly as a bandleader from the 1930s through the 1950s.

Sitwell, Edith (1887–1964), British poet and critic, who emerged as a notable experimental poet of the early 1920s, especially with her 1923 public reading of FAÇADE, set to music by William WALTON. She and her brothers **Sacheverell** (1897–1988) and **Osbert** (1892–1969) edited the magazine *Wheels* (1916–21). Her later work, written in a far more serious time, includes such collections as *Street Songs* (1942), *Green Song* (1944), and *Song of the Cold* (1945), while her very late works, collected in *Gardeners and Astronomer* (1953) and *The Outcasts* (1962), reflect growing religious commitment; she became a Catholic in 1955. Her prose work includes a 1930 study of Alexander Pope and *English Eccentrics* (1933). Her brother Sacheverell was a poet and highly regarded travel writer; Osbert was a poet and essayist whose major work was his five-volume autobiography, focusing on the Sitwell family and its social setting in his youth, and especially on George Sitwell, his very notably eccentric father.

Sjöberg, Alf (1903–80), Swedish director, whose work was on stage and screen from 1929. He was from the 1930s through the early 1960s one of Sweden's leading theater directors, presenting many of the older and modern classics, including the work of Henrik Ibsen, William Shakespeare, Bertolt BRECHT, and Arthur MILLER. His considerable film reputation rested on two works: *Torment* (1944) and *Miss Julie* (1951), two of the best regarded works in Swedish cinema before Ingmar BERGMAN.

Sjöstrom, Victor (1879–1960), Swedish director and actor, on stage from the mid-1890s and on screen from 1911, whose directorial work was on screen from 1913 and who became a leading European silent-film director. He was in Hollywood from 1923 to 1928 and there made such films as *He Who Gets Slapped* (1924) and Greta GARBO's *The Divine Woman* (1928); after returning to Sweden, he worked primarily as a producer and occasional actor.

Skelton, Red (Richard Bernard Skelton, 1913–), U.S. comedian and variety entertainer, child of a circus family. He was on stage in vaudeville at the age of 10 and toured for many years before becoming a radio star in 1937. In 1951 he became the star of television's very-long-running comedy-variety *The Red Skelton Show* (1951–71). He also starred in several film comedies, including *Merton of the Movies* (1947), *The Fuller Brush Man* (1948), and *Three Little Words* (1950). Skelton continued to tour in the early 1990s, moving toward his eighth decade in show business.

Skin of Our Teeth, The (1942), the Thornton WILDER play, on historical themes and initially directed and presented by Elia KAZAN in rather surreal style. Fredric MARCH and Florence Eldridge created the roles of Mr. and Mrs. Antrobus, strongly supported by Tallulah BANKHEAD in the Sabina role, Mongomery CLIFT, and Florence Heflin.

Slaughterhouse-Five, or The Children's Crusade (1969), the Kurt VONNEGUT novel, to a considerable extent generated by his experience as a war prisoner during and after the firestorm generated by the World War II bombing of Dresden. It was adapted into the 1972 George Roy HILL film.

Slaughter on Tenth Avenue, a ballet choreographed by George BALANCHINE, with music by Richard RODGERS. It was first produced as part of the Broadway musical *On Your Toes* (1936), with Ray BOLGER, Tamara Geva, and George Church in the leading ballet roles.

Sloan, John French (1871–1951), U.S. artist, one of the group of young Philadelphia illustrators who coalesced around Robert HENRI, followed him to New York, and exhibited together in 1908 as THE EIGHT, later known as the ASHCAN SCHOOL. Sloan's works include such paintings of New York life as *Wake of the Ferry, No. 2* (1907); *Pigeons* (1910); *Backyards, Greenwich Village* (1914); and *The City from Greenwich Village* (1922).

Sly and the Family Stone, U.S. pop-ROCK dance band, popular in the late 1960s and early 1970s, with such songs as "Dance to the Music" (1968), "Everyday People" (1969), "Stand" (1969), "Don't Call Me Nigger, Whitey" (1969), and "Sex Machine" (1969), the latter three in the album *Stand*. Their last major work was *There's a Riot Going On* (1971). The group originally consisted of Sly Stone (Sylvester Stewart, 1944–), Freddie

Stone (Fred Stewart, 1946–), Cynthia Robinson (1946–), Larry Graham, (1946–), Rosie Stone (1945–), Jerry Martini (1943–), and Greg Errico, (1946–).

Smiles of a Summer Night (1955), the Ingmar BERGMAN film, a comedic satire of modern morals and mores in the form of a farce. The cast included Gunnar Björnstrand, Ulla Jacobsson, Harriet Andersson, Eva Dahlbeck, Marget Carlquist, Jarl Kulle, and Ake Fridell. The film was the basis of the 1973 Stephen SONDHEIM musical A LITTLE NIGHT MUSIC.

Smiley, George, the quintessential secret agent created by John LECARRÉ in his Cold War spy novels and played so notably by Alec GUINNESS in the television miniseries "Tinker Tailor Soldier Spy" (1979) and "Smiley's People" (1982).

Smith, Bessie (1894–1937), U.S. singer, generally recognized as the most celebrated BLUES singer of the century and called "the Empress of the Blues." She began as a child street singer, worked with and became a protégée of Ma RAINEY, and became a soloist after World War I. She created her classic series of blues records from 1923 to 1933, accompanied by such artists as Clarence WILLIAMS, Louis ARMSTRONG, and Fletcher HENDERSON. A few of the songs most identifed with her were "Down Hearted Blues," "Baby, Won't You Please Come Home," ST. LOUIS BLUES, "You've Been a Good Old Wagon," and "Nobody Knows You When You're Down and Out."

Smith, David (1906–65), U.S. sculptor, who began his career as a painter in the late 1920s, moved to sculpture in the early 1930s, and was the first American to work in welded-metal sculpture, much of it even in the early years highly abstract and often incorporating "found" artifacts. He worked as a welder during World War II and in the postwar period produced a wide range of sculptures in several styles, perhaps most notably in his *Hudson River Landscape* (1951). In the late 1950s he moved into the large, fully abstract work for which he is best known, as in the *Albany, Zigs,* and *Cubi* series.

Smith, Kate (1907–86), U.S. singer, in vaudeville and radio from the 1920s and in television during the 1950s. Her theme song was "When the Moon Comes over the Mountain." She is best known by far for her introduction of Irving BERLIN's GOD BLESS AMERICA in 1938 (the song had been written in 1918 but not performed) and was thereafter identified with the song.

Smith, Maggie (Margaret Natalie Smith, 1934–), British actress, on stage from 1952 and on screen from 1962, who emerged as a major player in a series of diverse roles at Britain's National Theatre in the early 1960s, including Desdemona opposite Laurence OLIVIER's *Othello* (1964) and in *Miss Julie* (1965). Her later theater work includes PRIVATE LIVES (1972; and on Broadway, 1975) and four seasons at the Stratford (Ontario) Festival, as well as a TONY-winning appearance on Broadway in *Lettice and Lovage* (1989). She won a best actress OSCAR for her THE PRIME OF MISS JEAN BRODIE (1969) and played in leads and strong character roles in several other films, including *Travels with My Aunt* (1972), A ROOM WITH A VIEW (1984), and *The Lonely Passion of Judith Hearne* (1987).

Smith, Stevie (Florence Margaret Smith, 1902–71), British writer and illustrator, a poet and novelist whose drawings enhance her poetry collections. These include *A Good Time Was Had by All* (1937); *Tender Only to One* (1938); *Mother, What Is Man?* (1942); *Harold's Leap* (1950); *Not Waving but Drowning* (1957); *The Frog Prince and Other Poems* (1966); *The Best Beast* (1969); and *Scorpion and Other Poems* (1972). Her novels include *Novel on Yellow Paper* (1936), *Over the Frontier* (1938), and *The Holiday* (1949). The Robert Enders biofilm STEVIE (1978) starred Glenda JACKSON in the title role.

Smith, W. Eugene (1918–78), U.S. photographer; after being wounded on Okinawa while shooting pictures for *Life* magazine during World War II, he became one of the leading photo-essayists of the postwar period, much of his work dealing with matters of social conscience. His best-known works include *Spanish Village* (1951) and the trailblazing book *Minamota* (1975), about the disastrous impact

of environmental pollution on the people of a Japanese village.

"Smoke Gets in Your Eyes" (1933), a song introduced by Tamara in the Jerome KERN–Otto Harbach Broadway musical ROBERTA. The song was one of the great hits of the 1930s; it was sung by Irene DUNNE in the 1935 film. Music was by Jerome Kern, with words by Otto Harbach.

Snake Pit, The (1948), the Anatole LITVAK film; Olivia DE HAVILLAND won a best actress OSCAR for her portrayal of a mental patient caught in a cruelly inhumane insane asylum and system, in a cast that included Leo Genn, Celeste HOLM, Mark Stevens, Beulah Bondi, and Lee Patrick. The Frank Partos–Millen Brand screenplay was based on the Mary Jane Ward novel. The film, Litvak, the screenwriters, and Alfred Newman's music also won OSCARS. The trailblazing, then-horrific film made a considerable contribution to the mental health reform movement of its time.

Snopes, the vicious, grasping, corrupt YOKNAPATAWPHA COUNTY family created by William FAULKNER and featured in several of his works. They are introduced in *Sartoris* (1929) and appear most notably in the trilogy *The Hamlet* (1940), *The Town* (1957), and *The Mansion* (1960).

Snow, C.P. (Charles Percy Snow, 1905–80), British writer and scientist, a prolific novelist and essayist who was particularly interested in the relationship between science and culture, which he explored in *The Two Cultures and the Scientific Revolution* (1960) and many essays. His novels include the 11-volume series *Strangers and Brothers* (1940–70), which was based in part on his long experience in science, education, and government.

Snow, Hank (Clarence Eugene Snow, 1914–), Canadian country singer and songwriter, a radio and recording star in Canada from the mid-1930s. He became a popular singer in the United States from 1949, regularly appearing at the GRAND OLE OPRY from 1950 and reaching wide audiences with such hits as "Moving On" (1950) and "I Don't Hurt Anymore" (1954). His recording career spanned 45 years.

Snow White and the Seven Dwarfs (1937), the OSCAR-winning, trailblazing first feature-length cartoon film, based on the Grimms' fairy tale. The heroine was joined by Bashful, Doc, Dopey, Sleepy, Happy, Grumpy, and Sneezy, in what became a tremendously popular worldwide success. Some detractors pointed out that much of the horrific material presented quite frightened and in some instances may have damaged the small children who were its intended audience.

S.O.B. (1981), the Blake EDWARDS film, an extraordinarily effective satire of Hollywood. It was William HOLDEN's last film, with Holden, Julie ANDREWS, Robert PRESTON, Richard Mulligan, and Robert Webber in key roles, strongly supported by such players as Robert VAUGHN, Loretta Swit, Larry HAGMAN, and Shelley Winters.

social realism, in general, any largely naturalistic visual artwork that includes social comment, and usually comment aimed at social reform, but more specifically a considerable body of social protest-oriented works produced in the United States from the onset of the Great Depression through the end of World War II, as in Ben SHAHN's emblematic THE PASSION OF SACCO AND VANZETTI (1932) and Reginald MARSH's *Tattoo and Haircut* (1932).

socialist realism, a Soviet control construct in the arts and literature, developed informally from the 1920s and formally from the early 1930s, demanding the production of optimistic work naturalistically portrayed. In practice the slogan sought to bend art and literature to entirely serve Communist Party goals during the Stalin era, resulting in the creation of massive public sculptures of exuberant heroes of socialist labor while millions were dying in Stalin's labor camps. The slogan survived into the post-Stalin period, albeit in much altered form, falling into disuse in the Gorbachev era.

So Ends Our Night (1941), the John CROMWELL film, adapted by Talbot Jennings from the Erich Maria REMARQUE novel *Flotsam* (1941). Fredric MARCH played anti-Nazi German refugee Josef Steiner, with Frances Dee as his wife, Margaret SULLAVAN and Glenn FORD as the young refugees who ultimately win pass-

ports for their flight to America, Anna Sten as a refugee who gives her life for Steiner, and Erich von STROHEIM as the Gestapo officer Steiner ultimately takes to death with him.

Solti, Georg (1912–), Hungarian conductor and pianist; he was conductor of the Budapest Opera from 1930 to 1939, spent World War II in Switzerland, and was then music director of the Munich State Opera (1946–52), at the Frankfurt Opera (1952–61), and at Covent Garden (1961–71). He was a conductor and guest conductor all over the world; from 1969, he was the highly regarded music director of the Chicago Symphony. A prolific recording artist, he won many awards for his records.

Solzhenitsyn, Aleksandr Isayevich (1918–), Soviet novelist and dissenter, imprisoned and internally exiled 1945–56, whose work indicted the Stalin government and the Soviet system from which it developed. His first major work was ONE DAY IN THE LIFE OF IVAN DENISOVICH (1962), which exposed the Soviet prison system. He soon fell into increased disfavor with *The First Circle* (1968) and *Cancer Ward* (1968), both of which were published abroad, as was *August 1914* (1971), his massive work on the early days of World War I. He was awarded the 1970 NOBEL PRIZE for literature. Solzhenitsyn was expelled from the Soviet Union in 1973, after publication abroad of the first volume of yet another powerful novel on the Soviet prison system, THE GULAG ARCHIPELAGO (1973–75), and ultimately settled in the United States.

"Someday I'll Find You" (1930), a song introduced by Noël COWARD and Gertrude LAWRENCE in his play PRIVATE LIVES (1930); both words and music were by Coward.

"Some Enchanted Evening" (1949), the song from SOUTH PACIFIC, introduced by Ezio PINZA on Broadway; music was by Richard RODGERS and words were by Oscar HAMMERSTEIN II.

Some Like It Hot (1959), the Billy WILDER film comedy classic, written by Wilder and I.A.L. Diamond, about two musicians fleeing Chicago gangsters after witnessing the 1920s St. Valentine's Day Massacre; the "all-girl band" that is their refuge; and singer

"Honey," created by Marilyn MONROE. Tony CURTIS and Jack LEMMON played opposite Monroe, with Joe E. Brown, Nehemiah Persoff, George RAFT, and Pat O'Brien in key supporting roles. Orry-Kelly won a costume design OSCAR.

"Some of These Days" (1910), the signature song of U.S. singer and actress Sophie TUCKER; words and music were by Shelton Brooks.

"Someone to Watch Over Me" (1924), a song introduced by Gertrude LAWRENCE on Broadway in the title role in *Oh, Kay!* (1926), with music by George GERSHWIN and words by Ira Gershwin.

Sondheim, Stephen Joshua (1930–), U.S. lyricist and composer, a leading figure in the contemporary American musical theater, whose early work included the lyrics for WEST SIDE STORY (1957) and GYPSY (1959). He wrote the lyrics and music for such works as A FUNNY THING HAPPENED ON THE WAY TO THE FORUM (1962), *Company* (1970), A LITTLE NIGHT MUSIC (1973), SWEENEY TODD (1979), and *Into the Woods* (1988). "Send In the Clowns," the hit song from *A Little Night Music*, won both a GRAMMY and OSCAR.

Sons and Lovers (1913), the D.H. LAWRENCE novel, the story of the early life of a coal miner's son, as he moves into the world of the arts; it is thought to be largely autobiographical. It became the 1960 Jack Cardiff film, with Dean Stockwell, Trevor HOWARD, and Wendy HILLER in the leads.

Sontag, Susan (1933–), U.S. writer, best known for her early essays, collected in *Against Interpretation* (1966), and for such later essays as those published in *Styles of Radical Will* (1969), *On Photography* (1977), *Illness as Metaphor* (1978), and *AIDS and Its Metaphors* (1989). She also directed several films, including *Duet for Cannibals* (1969) and *Unguided Tour* (1983), and wrote several novels and short stories.

Sorrow and the Pity, The (1970), the massive, penetrating, engrossing documentary film by Marcel OPHÜLS, who used scores of interviews and much old footage to reexamine and in some instances to indict French reaction to

Vichy and the German occupation during World War II.

Sound and the Fury, The (1929), the William FAULKNER novel, set in his imaginary YOKNAPATAWPHA COUNTY, Mississippi, about the Compsons, a self-destructive old local family. It was adapted into the 1972 Martin Ritt film, with Yul BRYNNER, Joanne WOODWARD, and Margaret Leighton in key roles.

Sounder (1972), the Martin RITT film, about a southern Black sharecropping family during the 1930s, adapted from the novel *Sounder* by Lonnie Elder III. Kevin Hooks starred as David Lee Morgan, growing up in racist rural Louisiana in 1933; Paul Winfield was his father and Cicely TYSON his mother. The film generated a sequel: *Part Two, Sounder* (1976).

Sound of Music, The (1959), the classic Richard RODGERS and Oscar HAMMERSTEIN II musical, based on Maria Von Trapp's *The Trapp Family Singers*, with a score that included such songs as "The Sound of Music," "My Favorite Things," "Edelweiss," and "Do Re Mi." Mary MARTIN and Theodore Bikel originated the roles of Maria and Georg von Trapp in the TONY-winning Broadway production. In George Wise's enormously popular 1965 film version, which won a best picture OSCAR, Julie ANDREWS and Christopher PLUMMER played the leads.

Sousa, John Philip (1854–1932), U.S. composer and musician, who composed for the theater and concert hall, but is by far best known as the leading bandmaster of his day and the composer of such classic marches as "The Stars and Stripes Forever"; "The Washington Post"; and "Semper Fidelis," the U.S. Marine Corps hymn.

South Pacific (1949), the classic Richard RODGERS and Oscar HAMMERSTEIN II musical, based on James MICHENER's 1947 PULITZER PRIZE-winning book *Tales of the South Pacific*, with a score that included such songs as SOME ENCHANTED EVENING, "Bali Ha'i," I'M GONNA WASH THAT MAN RIGHT OUTTA MY HAIR, and YOUNGER THAN SPRINGTIME. The TONY-winning play's pro-integration theme was pioneering in its time. Mary MARTIN was Nellie

Forbush, and Ezio PINZA was Émile de Becque; both won Tony Awards for their roles. In Joshua LOGAN's 1958 film version, Mitzi Gaynor and Rossano Brazzi played the leads.

Soutine, Chaim (1844–1943), Russian-French artist, whose intensely emotional, strongly colored work is often compared with that of German EXPRESSIONISM. In the early 1920s, he turned from his turbulent post-World War I Provençe landscapes (1919–22) to the highly colored paintings of putrescent carcasses for which he is best known, as in *Side of Beef* (1925), *Flayed Ox* (1926), and *Chicken* (1926), from the early 1920s also producing many notably distorted portraits.

Soyinka, Wole (Akinwande Oluwole Soyinka, 1934–), Black Nigerian writer, a playwright, novelist, poet, and teacher who studied and worked in Great Britain, returned to Nigeria in 1960, and during the next three decades became a world figure in drama. Soyinka's work merged Western and African themes and techniques, from his *A Dance in the Forest* (1960), and included the poetry written while he was imprisoned without charges for three years (1967–69) during the Nigeria–Biafra War. He received the 1986 NOBEL PRIZE for literature.

Soylent Green (1973), the Richard Fleischer science-fiction film, set in New York City in 2022, with a desperately overcrowded humanity reduced to seeing films of an earlier, greener Earth as a great privilege and eating an artificial food that turns out to be made at least in part of recycled humans. Edward G. ROBINSON and Charlton HESTON starred, in a cast that included Brock Peters, Leigh Taylor-Young, Chuck Connors, and Joseph COTTEN. Stanley R. Greenberg based his screenplay on the Harry Harrison novel *Make Room! Make Room!* This was Robinson's final film.

Spacek, Sissy (Mary Elizabeth Spacek, 1949–), U.S. actress, on screen from 1972, who attracted attention in offbeat roles in such films as *Badlands* (1973) and *Carrie* (1976) and won a best actress OSCAR for her lead in the Loretta LYNN film biography COAL MINER'S DAUGHTER (1980). Her later films include MISSING (1982), *The River* (1984), *Crimes of*

the Heart (1986), *'Night Mother* (1986), and *The Long Walk Home* (1990).

Spade, Sam, the tough, cynical private detective created by Dashiell HAMMETT and introduced in his novel THE MALTESE FALCON (1930); he was played in the classic 1941 John HUSTON film by Humphrey BOGART.

Spanish Earth, The (1937), a pro-Spanish Republican film written, directed, and shot by Joris IVENS, set in a village near Madrid during the Spanish Civil War, with music by Marc BLITZSTEIN and Virgil THOMSON and with commentary written and read by Ernest HEMINGWAY.

Spark, Muriel Sarah (1918–), British writer, whose best-known novel is her study of a Scottish schoolteacher, THE PRIME OF MISS JEAN BRODIE (1961), which was adapted into a play and then into the 1969 Ronald Neame film, with Maggie SMITH in the OSCAR-winning title role. Her many novels include *Momento Mori* (1959), *The Mandelbaum Gate* (1965), *The Abbess of Crewe* (1974), and *A Far Cry from Kensington* (1988). She also wrote several volumes of poems, short stories, and essays, as well as studies of John MASEFIELD and Mary Shelley.

Spectre de la Rose, Le, a ballet by Michel FOKINE, with music by Carl Maria von Weber; it was produced in Paris in April 1911 by the BALLET RUSSES company of Sergei DIAGHILEV, with Tamara KARSAVINA and Vaslav NIJINSKY in the leading roles.

Spender, Stephen (1909–), British writer, editor, and critic, who emerged as a leading poet on the left from the publication of his *Poems* (1933), which was followed by a considerable body of poetry and prose. In the 1930s he was closely associated with such writers as W.H. AUDEN and Christopher ISHERWOOD; like them, he later rejected Marxism in favor of a considerably more traditional liberalism. As an editor of *Encounter* (1953–66) and as a lecturer, translator, editor, and essayist, he was for several decades a highly visible "man about letters" in Europe and America.

Spielberg, Steven (1946–), U.S. director, writer, and producer, who emerged as a major film director with JAWS (1975) and who became a leading figure in the move toward spectacle that dominated the Hollywood films of the next two decades. He also directed *1941* (1975); CLOSE ENCOUNTERS OF THE THIRD KIND (1977), which he also wrote; RAIDERS OF THE LOST ARK (1981); E.T. (1982); *Indiana Jones and the Temple of Doom* (1984); *The Color Purple* (1985); EMPIRE OF THE SUN (1987), which he also produced; *Indiana Jones and The Last Crusade* (1989); and *Always* (1989).

Spillane, Mickey (Frank Morrison Spillane, 1918–), U.S. writer of detective stories, featuring fictional detective Mike Hammer. Spillane's works, such as *I, the Jury* (1947), *The Big Kill* (1951), and *Kiss Me, Deadly* (1952), were in their time seen as highly sexual and violent and were extremely popular. Several of his novels became films; Spillane himself played Hammer in *The Girl Hunters* (1953). Darren McGavin played Hammer in the 1957–59 "Mike Hammer" television series, as did Stacy Keach in the 1984–87 series.

Springsteen, Bruce (1949–), U.S. singer, songwriter, guitarist, bandleader, and social activist. After being recognized by John HAMMOND in 1972 and offered his first recording contract, he did two early albums, both in 1973: *Greetings from Asbury Park, N.J.* and *The Wild, the Innocent and the E. Street Shuffle*, both only moderately received. From 1975 he emerged as an enormously popular ROCK figure, in concert and with the albums *Born to Run* (1975), *Darkness on the Edge of Town* (1978), *The River* (1980), *Nebraska* (1982), *Born in the U.S.A.* (1984), *Bruce Springsteen & the E Street Band: Live, 1975–85*, and *Tunnel of Love* (1987). His continuing social activism was expressed in such works as *No Nukes* (1979) and (with many others) *We Are the World* (1985), his antiwar stand balanced by his work on behalf of Vietnam veterans.

Spy Who Came In from the Cold, The (1963), the John LE CARRÉ novel, a spy story out of the heart of the Cold War. Alec Leamas is the burnt-out British secret agent cynically used by his service in a final assignment. Paul Dehn and Guy Trosper adapted the novel into the 1965 Martin RITT film. Richard BURTON was a memorable Leamas, in a cast that included Claire BLOOM; Cyril Cusack; Oskar Werner;

Peter Van Eyck; Sam Wanamaker; Michael HORDERN; George Voskevec; and Rupert Davies as George SMILEY, who would later emerge as the central figure in Le Carré's set of Cold War espionage novels.

Stack, Robert (1919–), U.S. actor, on screen from 1939. He is best known by far for his portrayal of G-man Eliot Ness in the long-running television series "The Untouchables" (1959–63). He has also appeared in many movies, largely in supporting roles, and in several television films.

Stafford, Jean (1915–79), U.S. writer, much of whose work focuses on the emotional lives of young people. Her *Collected Stories* (1969) won a PULITZER PRIZE and includes such works as "Boston Adventure" (1944), "The Mountain Lion" (1947), and "The Catherine Wheel" (1952).

Stagecoach (1939), the John FORD film, about a group of southwestern travelers faced with an imminent Apache attack that finally comes. John WAYNE led a cast that included Claire Trevor, Thomas Mitchell, George Bancroft, Andy Devine, and John CARRADINE. The Dudley Nichols script was based on the Ernest Haycox short story "Stage to Lordsburg." Mitchell won an OSCAR, as did the music. The film was remade in 1966 and again for television in 1986, the latter version notable primarily for the presence of country music stars Willie NELSON, Kris KRISTOFFERSON, Johnny CASH, and Waylon JENNINGS.

Stage Door (1936), the Edna FERBER–George S. KAUFMAN play, about a group of young actresses trying to survive in the Depression-era New York theater. Margaret SULLAVAN created the central Terry Randall role. Morrie Ryskind and Anthony Veiller adapted the play into the 1937 Gregory La Cava film, with Katharine HEPBURN leading a cast that included Ginger ROGERS, Andrea Leeds, Adolphe Menjou, Eve Arden, Lucille BALL, Constance Collier, Gail Patrick, Ann Miller, and Jack Carson.

Stalag 17 (1951), the Donald Bevan–Edmund Trzcinski play, set in a World War II German prisoner-of-war camp. John Ericson created the Sefton role, as the unpopular prisoner unjustly accused of being a German spy in the camp, who succeeds in unmasking the real spy. William HOLDEN won a best actor OSCAR as Sefton in the 1953 Billy WILDER film, in a cast that included Peter GRAVES as the spy Price, Don Taylor, Otto PREMINGER, Harvey Lembeck, Richard Erdman, Neville Brand, Sig Rumann, and Gil Stratton.

Stallone, Sylvester (1946–), U.S. actor, director, and writer, on screen from 1974, who wrote and then starred in ROCKY (1976), immediately becoming a huge worldwide box-office draw, while his film won a best picture OSCAR. He then went to do four more *Rocky* films; three RAMBO films, beginning in 1982; and several other popular action films.

Stanislavsky, Constantin (Constantin Sergeivich Alexeyev, 1863–1938), Soviet director, actor, and teacher, whose METHOD for training actors had an enormous impact on the 20th-century theater, and whose books *My Life in Art* (1924) and *An Actor Prepares* (1936) became required reading for theater and film students all over the world. His directorial work was on stage from 1891, and in 1898 he and Vladimir Nemirovich-Danchenko founded the MOSCOW ART THEATRE, Stanislavsky becoming artistic director. There he directed, produced, and often acted in the then-new major works of Anton CHEKHOV and Maxim GORKY, including *The Seagull* (1899), *Uncle Vanya* (1899), *Three Sisters* (1901), THE CHERRY ORCHARD (1904), and THE LOWER DEPTHS (1902), and also presented many other classics and new plays destined to become modern classics. He stayed on as director of the theater after the Russian Revolution. In 1923 he visited the United States with some of his actors, introduced his Method to the American theater, and greatly stimulated the later development of the GROUP THEATRE and the ACTORS STUDIO.

Stanwyck, Barbara (Ruby Stevens, 1907–90), U.S. actress, on stage as a dancer at the age of 15, on Broadway in the late 1920s, and on screen from 1927. She became a Hollywood star in the 1930s, in such films as *Annie Oakley* (1935), *Stella Dallas* (1937), and GOLDEN BOY (1939) and then became a major star in the 1940s with *The Lady Eve*, MEET JOHN DOE,

and *Ball of Fire*, all in 1941, and DOUBLE INDEMNITY (1944). Her film career sagged in the 1950s, but she successfully moved into television series, in "The Barbara Stanwyck Show" (1960–61), "The Big Valley" (1965–69), and later "The Colbys" (1985–87).

Stapleton, Maureen (Lois Maureen Stapleton, 1925–), U.S. actress, on stage from 1941; her first starring role was as Sarafina in Tennessee WILLIAMS's THE ROSE TATTOO (1951). She also created the leading roles in his *27 Wagons Full of Cotton* (1955) and *Orpheus Descending* (1957), appearing in a wide range of character roles and some leads on stage, notably her TONY-winning performance in *Gingerbread Lady* (1970). She also appeared in many television dramas, most notably *Queen of the Stardust Ballroom* (1975). She has also appeared in such films as *Lonelyhearts* (1959); *The Fugitive Kind* (1960); A VIEW FROM THE BRIDGE (1962); *Plaza Suite* (1971), in which she re-created her three 1968 stage roles; and REDS (1981), winning a best supporting actress OSCAR in the Emma Goldman role.

"Star Dust" (1929), the Hoagy CARMICHAEL song, one of the most popular standards of the next two decades, through the Great Depression and World War II. It was identified with Bing CROSBY and was also immensely popular as played and sung by Louis ARMSTRONG, Benny GOODMAN, and several other major musicians of the era.

Star Is Born, A (1937), the William WELLMAN film, about a slipping Hollywood leading man, played by Fredric MARCH, and the young actress he grooms for stardom and marries, played by Janet GAYNOR, in a cast that includes Adolphe Menjou, Andy Devine, and Lionel Stander. Wellman and Robert Carson won an OSCAR for the story, as did cinematographer W. Howard Greene. The film was remade twice, first as the 1954 George CUKOR film, with James MASON and Judy GARLAND in the leads; and again as the 1976 Frank Pierson film, with Barbra STREISAND and Kris KRISTOFFERSON in the leads.

Starr, Ringo (Richard Starkey, 1940–), British musician, with George HARRISON, John LENNON, and Paul MCCARTNEY a mem-

ber of the BEATLES. Starr became the group's drummer in 1962, replacing Pete Best, and also sang, sometimes in solo spots. After the dissolution of the group he went on to build a modest career as an actor, in such films as *Stardust* (1975) and *Caveman* (1981), and also continued to record.

Stars Look Down, The (1935), the A.J. CRONIN novel, set in Welsh coal-mining country, which he adapted into the classic 1939 Carol REED film, with Michael REDGRAVE in the leading role of the young Welsh miner. The cast included Margaret Lockwood, Emlyn WILLIAMS, Cecil Parker, Nancy Price, and Edward Rigby.

"Star Trek" (1966–69), the television science-fiction series, created by Gene Roddenberry, set some hundreds of years in the future, as the U.S.S. *Enterprise* explores the galaxy and beyond, carrying a crew led by William Shatner as Capt. James Kirk and including Leonard Nimoy as Spock, DeForest Kelley, James Doohan, Nichelle Nichols, George Takei, Majel Barrett, and Walter Koenig. The series developed a cult following and generated four feature-film sequels and a new, though far less successful, television series over 20 years later.

Star Wars (1977), a film written and directed by George LUCAS; a space-age Western with notable special effects and depictions of alien beings, with a cast led by Mark Hamill, Harrison FORD, Carrie Fisher, and Alec GUINNESS. It won editing, art, set, special effects, sound and sound editing, and music OSCARS. The extraordinarily popular movie generated two sequels: *The Empire Strikes Back* (1980) and *The Return of the Jedi* (1983).

State of the Union (1945), the long-running Broadway political comedy-drama by Howard LINDSAY and Russel Crouse. Ralph BELLAMY created presidential candidate Grant Matthews on stage, opposite Ruth Hussey as his wife and Kay Johnson as her rival. In 1948 it became the Frank CAPRA film, with Spencer TRACY, Katharine HEPBURN, and Angela LANSBURY in the key roles, in a cast that included Van JOHNSON and Adolphe Menjou.

Steamboat Willie (1928), the third of the MICKEY MOUSE cartoons; it was the first to

Photographer Edward Steichen preparing the noted *The Family of Man* exhibit (1955) at New York's Museum of Modern Art.

have a sound track, which contributed greatly to the subsequent enormous worldwide popularity of the series and character.

Steeleye Span, British folk band, formed in 1969 and dedicated to the marriage of modern electronic instruments with traditional folk music. Original members of the group were Ashley Hutchings, Maddy Prior, Gay Woods, Terry Woods, and Tim Hart, although there were many personnel changes in the next several years. A few of their best known albums are *Please to See the King* (1970), *Below the Salt* (1972), *Now We Are Six* (1974, with David BOWIE as a guest), *Sails of Silver* (1980), and *Back in Line* (1986).

Steichen, Edward (Edouard Jean Steichen, 1879–1973), U.S. photographer, who from 1903 was closely associated with Alfred STIEG-LITZ and the other founding members of the PHOTO-SECESSION; his former New York City studio at 291 Fifth Avenue in 1905 became part of 291, THE LITTLE GALLERIES OF THE PHOTO-SECESSION (1905–17). Such early works as J. PIERPONT MORGAN (1903), ELEA-NORA DUSE (1903), and FLATIRON BUILDING

(1905) became landmarks in the history of photography. From 1911 to 1921 he focused on painting, but was an aerial photographer during World War I; he then moved back into photography, with his Isadora DUNCAN photographs at the Acropolis in 1921, and decisively burned all his remaining studio paintings in 1922. From 1922 to 1938, much of that time as chief photographer for Condé Nast's *Vanity Fair*, he produced a memorable series of portraits, which included his Greta GARBO, Paul ROBESON, John BARRYMORE, Noël COWARD, Eugene O'NEILL, and hundreds more, then going into retirement. During World War II, however, then in his sixties, he became chief photographer for the U.S. Navy. From 1947 to 1962 he was director of the Photography Department of the MUSEUM OF MODERN ART, his most notable exhibition in that period being *The Family of Man* (1955).

Steiger, Rod (Rodney Stephen Steiger, 1925–), U.S. actor, on stage, screen, and television from 1951, who played in several strong dramatic roles on film, beginning with his corrupt union official in ON THE WATERFRONT

(1954) and including his leads in *Al Capone* (1959) and THE PAWNBROKER (1965), as well as his powerful supporting roles in DOCTOR ZHIVAGO (1965) and IN THE HEAT OF THE NIGHT (1967), for which he won a best actor OSCAR. His later films include *Waterloo* (1971), *The Last Four Days* (1977), *The Chosen* (1982), and *The January Man* (1989).

Stein, Gertude (1874–1946), U.S. writer, who lived in France from 1902 and there became a leading avant-garde experimentalist, writing such novels as *Three Lives* (1909) and *The Making of Americans* (1925); the poetry collection *Tender Buttons* (1914); and the opera *Four Saints in Three Acts* (1927), with music by Virgil THOMSON. With the help of her secretary and companion, Alice B. Toklas, she also became the leading expatriate literary hostess of the interwar period. Her least opaque, most traditionally written, and best-known work was her autobiography, which she titled *The Autobiography of Alice B. Toklas* (1933).

Steinbeck, John Ernst (1902–68), U.S. writer, whose early work powerfully depicted the underside of American life during the Great Depression. His PULITZER PRIZE-winning novel THE GRAPES OF WRATH (1939), which told the story of the "Okies," the dust-bowl farmers forced to become migrants in the late 1930s, was a moving, extraordinary work of social protest; it was adapted by Nunnally Johnson into the classic 1940 John FORD film, with Henry FONDA, Jane DARWELL, and John CARRADINE in key roles. The novel was also the basis of the TONY-winning 1990 Frank Gelati play. Steinbeck's other novels include TORTILLA FLAT (1935); *In Dubious Battle* (1936); OF MICE AND MEN (1937); CANNERY ROW (1945); *The Wayward Bus* (1947); EAST OF EDEN (1952); *The Winter of Our Discontent* (1961); a very popular travel book, *Travels with Charley in Search of America* (1962); and many shorter works. He also adapted several of his works into plays, and was most successful with OF MICE AND MEN (1937), with Broderick CRAWFORD creating the Lenny role; Lon Chaney, Jr., played Lenny in the 1939 Lewis MILESTONE film. Several other works also became films, including *Tortilla Flat* (1942), directed by Victor FLEMING and

starring Spencer TRACY, John GARFIELD, and Hedy LAMARR; and *East of Eden* (1955), directed by Elia KAZAN and the movie that made James DEAN a star. In 1962 Steinbeck won the NOBEL PRIZE for literature.

Steinberg, Saul (1914–), U.S. artist, a leading contemporary cartoonist and illustrator. He was born in Rumania and worked as a cartoonist and architect in Europe before emigrating to the United States in 1942. From 1942 much of his work appeared in *The New Yorker*. His collections include *All in Line* (1945), *The Art of Living* (1949), *The Passport* (1954), *The Labyrinth* (1960), and *The Inspector* (1973).

Stella, Frank (1936–), U.S. painter, who emerged as a leading minimalist (see MINIMALISM) and painter on variously shaped canvases from the early 1960s. He at first focused on featuring black lines painted on canvases of various sizes and shapes, later turning to flat color-filled canvases, using bands and rectangles to carry some colors.

Stella, Joseph (1877–1947), U.S. painter; he worked as a socially critical magazine illustrator in New York before studying in Italy from 1909 to 1912. There he met many futurists (see FUTURISM) and was drawn to the futurist style of painting, as reflected most notably in such later paintings as *Brooklyn Bridge* (1918) and *New York Interpreted* (1922). Until his landscapes of the 1930s, he took his main themes from New York City life.

Stern, Isaac (1920–), U.S. violinist; a child prodigy, he made his debut with the San Francisco Symphony in 1935, his New York debut in 1937, and after World War II was quickly recognized as one of the leading violinists of the century, touring the world yearly from 1947 and becoming a major recording artist. He was also part of a celebrated trio, with Eugene Istomin and Leonard Rose. In 1959 he spearheaded the drive to save Carnegie Hall from demolition, then becoming its president.

Sternberg, Josef von (Josef Sternberg, 1894–1969), U.S. director, whose work was on screen from 1925 and who directed several Hollywood feature films in the late 1920s. In 1930 he directed the classic THE BLUE ANGEL

in Germany, brought Marlene DIETRICH back with him to Hollywood, and did six more films with her in the next five years: *Morocco,* (1930), *Dishonored* (1931), SHANGHAI EXPRESS (1932), *Blonde Venus* (1932), *The Scarlet Empress* (1934), and *The Devil Is a Woman* (1935). His subsequent career is chiefly notable for *I, Claudius* (1937), which was begun with great promise but never finished.

Stevens, George (1904–75), U.S. director and producer, on stage as a child, whose work was on screen from 1930. He became a journeyman Hollywood director in the mid-1930s, with such films as *Swing Time* (1936) and *Woman of the Year* (1941), gained recognition as a leading director with A PLACE IN THE SUN (1951), for which he won a best director OSCAR, and went on to direct the classic Western SHANE (1953) and GIANT (1956), another best director Oscar-winner.

Stevens, Wallace (1879–1955), U.S. writer, whose early, sporadic work included such much-anthologized shorter poems as "The Emperor of Ice Cream" and "Sunday Morning." An insurance executive for much of his life, his first collection, *Harmonium* (1923), was published when he was 43. Several more collections followed, and major recognition came with his PULITZER PRIZE-winning *Collected Poems* (1954).

Stevie (1978), the Robert Enders biographical film, which Hugh Whitemore adapted from his own play; Glenda JACKSON played British poet Stevie SMITH in a cast that included Mona Washbourne, Trevor HOWARD, and Alec McCOWEN.

Stewart, James (1908–), U.S. actor, on stage from 1932 and on screen from 1935. He became a star in such late 1930s Hollywood Golden Age comedy-dramas as *It's a Wonderful World, Destry Rides Again*, and MR. SMITH GOES TO WASHINGTON, all in 1939. He added three strong dramatic leads in 1940: *The Shop Around the Corner*; THE MORTAL STORM; and THE PHILADELPHIA STORY, for which he won a best actor OSCAR. After World War II he resumed his career with the classic IT'S A WONDERFUL LIFE (1947) and went on to play in a considerable variety of leading roles, in

such films as HARVEY (1950), REAR WINDOW (1954), *The Spirit of St. Louis* (1957), and ANATOMY OF A MURDER (1959), as well as many Westerns and other action films. Later in his career he also played on television, most notably as Billy Jim Hawkins in the series *Hawkins* (1973–74). He also did *Harvey* on Broadway in 1947 and in London in 1975.

Stewart, J.I.M. (John Innes Mackintosh Stewart, 1906–), British writer and critic; his works include his five Oxford novels, *A Staircase in Surrey* (1974–78); the *Eight Modern Writers* (1963); a volume of the *Oxford History of English Literature*; and biographies of Joseph Conrad, Thomas Hardy, and Rudyard Kipling. He is also known throughout the world as mystery writer Michael INNES, creator of Inspector John APPLEBY, who in the course of more than 30 books rises to the post of assistant commissioner of Scotland Yard, retires, and continues to detect. A few of his mysteries are *Death at the President's Lodging* (1937); *Hamlet, Revenge!* (1937); *The Weight of the Evidence* (1943); *From London Far* (1946); *A Night of Errors* (1947); *Hare Sitting Up* (1959); *Going It Alone* (1979); *Appleby and Honeybath* (1983); and *Appleby and the Ospreys* (1986). He also wrote almost a score of other novels as J.I.M. Stewart, as well as a considerable body of other essays.

Stewart, Rod (1945–), British singer and songwriter; he sang with the Jeff Beck Group and then The Faces in the late 1960s and early 1970s, beginning solo recording in 1969 with the album *An Old Raincoat Won't Ever Let You Down*. Stewart became one of the leading ROCK performers and recording artists of the 1970s, with such albums as *Every Picture Tells a Story* (1971); *Never a Dull Moment* (1972); *Smiler* (1974); and *Atlantic Crossing* (1975), which very notably included "Sailing," from then on his signature song. Among his later albums are *A Night on the Town* (1976), which includes the song "Tonight's the Night." Stewart has continued to tour and write new songs through the early 1990s.

Stieglitz, Alfred (1864–1946), U.S. photographer, who made a major contribution to the development of 20th-century photography and also to the introduction of modern art in the

United States. In 1902 he was the prime mover in the founding of the PHOTO-SECESSION movement, and in 1905, with Edward STEICHEN and others, opened 291, THE LITTLE GALLERIES OF THE PHOTO-SECESSION (1905–17), which became the showcase of the movement and played a worldwide role in establishing photography as a fully recognized art form. From 1908, the 291 galleries also introduced the highly innovative and then-shocking work of such contemporary artists as Henri MATISSE; Pablo PICASSO; Constantin BRANCUSI; John MARIN; and Georgia O'KEEFFE, who married Stieglitz. He also published the centrally important magazine *Camera Work* (1903–17) and continued to show modern work in his two succeeding galleries: An Intimate Place (1925–29) and An American Place (1929–46). His most notable pictures are the long series of O'Keeffe portraits done in the early 1920s, the cloud and sky studies he called *Equivalents*, and the New York studies.

Stijl, De (The Style), a group of Dutch artists, led by Piet MONDRIAN and Theo van Doesburg; their magazine, *De Stijl* (1917–32), was edited by van Doesburg. Mondrian was their leading figure; a theosophist from the early 1900s, he worked in the style he named *neoplasticism*, in which areas of white and primary red, yellow, blue were defined by strong black lines that created rectangles. He left the group in 1925, as van Doesburg and others moved toward more varied concerns and focused somewhat on architecture, though the proximate cause of the break was a dispute over the use of diagonal lines by others in the group.

Still, William Grant (1895–1978), U.S. composer, much of whose work reflected Black, JAZZ, and popular themes. He composed such works as *Afro-American Symphony* (1930) and the operas *Troubled Island* (1941), *A Bayou Legend* (1941), and *Minette Fontaine* (1958), as well as five symphonies and a wide range of other classical and popular works. He was also reportedly the first Black conductor of a major symphony orchestra (the Los Angeles Philharmonic), in 1936.

Stiller, Mauritz (Moshe Stille, 1883–1928), Polish-Jewish director, who worked in Swedish films from 1912 and who became one of

Sweden's leading silent-film directors in the 12 years that followed. He discovered Greta GARBO in 1924, featured her in *The Legend of Gösta Bjerling*, and took her to Hollywood with him that year. She caught on in America; he did not, ultimately returning to Sweden, where his life was cut short by illness.

Sting (Gordon Matthew Sumner, 1951–), British singer, actor, songwriter, and bassist. He, Stewart Copeland, and Andy Summers formed the ROCK group *The Police* in 1977; it became a very popular group in the early 1980s, with the albums *Zenyatta Mondatta* (1980), *Ghost in the Machine* (1981), and *Synchronicity* (1983), and such songs as "Every Little Thing She Does Is Magic" (1981) and the GRAMMY-winning "Every Breath You Take" (1983). Sting then went largely solo, becoming a popular star of the late 1980s and early 1990s, with such albums as *The Dream of the Blue Turtle* (1985) and *Nothing Like the Sun* (1987). He also developed an acting career, appearing in such films as *Brimstone and Treacle* (1984), *Plenty* (1985), *Dune* (1985), and *Rosenkrantz and Guildenstern Are Dead* (1989) and on the New York stage in a 1989 revival of THE THREEPENNY OPERA.

Sting, The (1973), the George Roy HILL film, with Paul NEWMAN and Robert REDFORD as confidence men in 1920s Chicago and Robert Shaw as the New York gangster they "sting," in a cast that included Eileen Brennan, Charles Durning, Robert Earl Jones, and Dimitra Arliss. The film; Hill; screenwriter David Ward; editing; art; sets; costumes; and Scott JOPLIN's music, as arranged by Marvin Hamlisch, all won OSCARS.

Stockhausen, Karlheinz (1928–), German composer, a leading 20th-century exponent of electronic music, after an early interest in serial music had been stimulated by his teacher Olivier MESSIAEN. He also developed his own electronic music ensemble, and he toured throughout the world from 1958. Stockhausen produced a massive body of electronic and other experimental work, and he wrote and taught in support of his views. Some modernists have hailed him as the towering genius of late-20th-century music.

Stokowski, Leopold Anthony (1892–1977), British-American conductor, who played a major role in introducing contemporary classical music in the United States; he was also a highly visible popular figure who did much to bring classical music to wide audiences. He made his conducting debut in 1908, was music director of the Cincinnati Orchestra (1909–12), and was then conductor of the Philadelphia Orchestra (1912–38), in that long period bringing to the United States the works of such modern composers as Alban BERG, Igor STRAVINSKY, Gustav MAHLER, and Arnold SCHOENBERG, as well as conducting the classic repertory. After 1938 he conducted several orchestras, including the Houston Symphony (1955–60), and in 1962 founded the American Symphony Orchestra, which he led until 1972.

Stone, Edward Durell (1902–78), U.S. architect; his early work, in the INTERNATIONAL STYLE, is best expressed by The Museum of Modern Art (1937), designed in collaboration with Philip Goodwin. His later work used light and space far more imaginatively and eclectically, as in the U.S. embassy at New Delhi (1954), New York's Gallery of Modern Art (1959), and Washington's John F. Kennedy Center for the Performing Arts (1972).

Stone, Irving (1903–), U.S. writer of many very popular biographical novels, most notably including *Lust for Life* (1934), which became the 1956 Vincente MINNELLI film, with Kirk DOUGLAS as Van Gogh; and *The Agony and the Ecstasy* (1961), which became the 1965 Carol REED film, with Charlton HESTON as Michelangelo. He also wrote such novels as *Sailor on Horseback* (1938), which fictionalized the life of Jack London; *Love Is Eternal* (1954), on Mary Todd Lincoln; and *The Greek Treasure* (1975), on Heinrich Schliemann.

Stone, Oliver (1946–), U.S. director and writer; he won a best screenplay OSCAR for *Midnight Express* (1978) and wrote and directed such films as *The Year of the Dragon* (1985); *Salvador* (1986); the Oscar-winning Vietnam War film PLATOON (1986); WALL STREET (1987); *Talk Radio* (1988); and BORN ON THE FOURTH OF JULY (1989), his second very notable Vietnam War film. He won a best director Oscar for *Platoon*.

Stoppard, Tom (Thomas Straussler, 1937–), British writer, a multifaceted satirist writing in many fictive forms. He achieved instant recognition as a talented satirist with his TONY-winning play *Rosenkrantz and Guildenstern Are Dead* (1967), which was followed by such highly inventive plays as *Jumpers* (1972) and *Travesties* (1974), which also won Tonys. His later work includes such plays as *Every Good Boy Deserves Favor* (1977); *Night and Day* (1978); *The Real Thing* (1982), another Tony-winner; and *Hapgood* (1988). He has also written for radio, television, and films, his screenplays including EMPIRE OF THE SUN (1987) and *The Russia House* (1990).

Storey, David Malcolm (1933–), British writer, whose background as a professional rugby player was the basis of his first published novel, *This Sporting Life* (1960), which he adapted into the 1963 Lindsay ANDERSON film, with Richard Harris in the central role. He wrote several more novels, including *Flight into Camden* (1961) and *Saville* (1976), but his most notable later work was as a playwright, with such major works as *In Celebration* (1969), directed by Lindsay Anderson and starring Alan BATES on stage and in the 1975 film; HOME (1970), a memorable vehicle for John GIELGUD and Ralph RICHARDSON; *The Changing Room* (1971), another rugby-based story; *Life Class* (1974); *Early Days* (1980); and *The March on Russia* (1989).

Storm Over Asia (1928), Vsevolod I. PUDOVKIN's powerful, technically innovative Central Asian film epic, about a Mongol trapper set up as a puppet ruler in Mongolia by White Guard forces during the Russian Civil War, after he is found to be a descendant of Genghis Khan. (The film title translates more directly as *The Heir of Genghis Khan*.) The trapper, played by Valery Inkishinov, then predictably becomes a Soviet partisan. The cast includes I. Inkishinov, V. Tsoppi, L. Dedintsev, P. Ivanov, and L. Biliniskaya. The film, shot by Anatoli Golovnya, was especially notable for its use of montage to convey a sense of the war on the wide Central Asian steppeland.

"Stormy Weather" (1933), a classic Depression-era song. It was identified with Ethel WATERS in the 1930s and with Lena HORNE after she sang it as the title song of the 1943 Andrew Stone film of that name. Music was by Harold ARLEN and words by Ted Koehler.

Stout, Rex Todhunter (1886–1975), U.S. writer, the creator of Nero WOLFE, his fictional master detective, gourmet, orchid-grower, and overweight Renaissance man, in dozens of highly popular mystery novels and novellas written over four decades, beginning with *Fer-de-Lance* (1934) and ending with *A Family Affair* (1975). He also wrote several other novels and a considerable body of short stories.

Strachey, Lytton (Giles Lytton Strachey, 1880–1932), British biographer. His landmark and by far best-known work is *Eminent Victorians* (1918), in which he introduced what became the modern approach to the art of biography; his Victorians became humans rather than icons, with their multiple faces in view, flaws and accomplishments alike revealed. He had previously written *Landmarks in French Literature* (1912). Later works include his notable *Queen Victoria* (1921), *Books and Characters* (1922), *Elizabeth and Essex* (1928), and *Portraits in Miniature* (1931). He was a leading figure in the BLOOMSBURY GROUP.

Strada, La (*The Road*, 1954), the classic Federico FELLINI film, with Giulietta MASINA in the memorable role of Gelsomina, the simple country girl bought by a brutish traveling strongman, Zampano, played by Anthony QUINN. Richard BASEHART was The Fool, who brings hope to Gelsomina but is finally murdered by Zampano, severing her always tenuous touch with reality. *La Strada* won a best foreign film OSCAR.

Stradling, Harry (1902–70), U.S. cinematographer, whose work was on screen from 1920. He worked in France and Great Britain during the 1930s, shooting such films as *Carnival in Flanders* (1935) and PYGMALION (1938), and then returned to the United States in 1940 to commence three decades as one of Hollywood's leading cinematographers. He won

OSCARS for *The Picture of Dorian Gray* (1945) and MY FAIR LADY (1964). He was the father of cinematographer **Harry Stradling, Jr.**

Strand, Paul (1890–1976), U.S. photographer and documentary filmmaker. He studied with Lewis HINE and was deeply influenced by Alfred STIEGLITZ, some of his early work being published in 1917 in *Camera Work*. He continued to create photographs after World War I, in the sharply delineated "objective" style he advocated, while from the early 1920s he also moved into cinematography, collaborating with Charles SHEELER on *Manahatta* (1920). In 1936 he did the celebrated documentary *The Waves*, set in a Mexican fishing village, and that year also shot, with Pare Lorentz, *The Plow That Broke the Plains*. He was cofounder of Frontier Films in 1937 and coproduced and coedited several documentary films for the company, shooting his last film, *Native Land*, in 1941. His further work includes the photo-essay *Time in New England* (1950), with text by Nancy Newhall. After he moved to Europe in 1950, he did such photo-essays as *A Profile of France* (1952), with text by Claude Roy; and *A Village* (1955), with text by Cesare ZAVATTINI.

Strange Interlude (1928), the PULITZER PRIZE-winning Eugene O'NEILL play, an intricate exploration of the inner worlds of its protagonists, often via long soliloquies. The central role of Nina Leeds was created on stage by Lynn FONTANNE and in the 1933 film version by Norma SHEARER.

Stranger, The (1946), the Orson WELLES film; Welles played Fritz Kindler, a German war criminal hiding in a small Connecticut town and teaching in the local college under an assumed name. Edward G. ROBINSON was Wilson, a Nazi-hunter who seeks, finds, and finally identifies him; Loretta YOUNG was the unsuspecting American Kindler marries. John HUSTON apparently had a substantial hand in creating the Anthony Veiller screenplay, as did Welles.

Strasberg, Lee (1901–82), U.S. teacher, director, and actor, on stage from 1925, who worked with the THEATRE GUILD in the late 1920s and was a cofounder of the GROUP

Igor Stravinsky conducting his "Baiser de la Fée" (1928) for a 1947 New York production of the Ballet Russe de Monte Carlo.

THEATRE in 1930. He directed the theater's first production, *The House of Connelly* (1931), and several other plays during the 1930s and 1940s. In 1948 he became artistic director of the ACTORS STUDIO. A leading exponent of Constantin STANISLAVSKY's METHOD in the United States, he then proceeded to develop a substantial body of actors trained in "Method acting," as it came to be called, including some who became stage and screen stars. In 1974 Strasberg played on screen for the first time, in the Hyman Roth role in THE GODFATHER, PART II. He was the father of actress **Susan Strasberg**.

Stratas, Teresa (Anastasia Strataki, 1938–), Canadian soprano, on stage in variety from the age of 12. She made her Canadian opera debut in 1958 and debuted at the Metropolitan Opera in 1959, moving into leading roles at the Met, Covent Garden, and other major houses in the early 1960s. On screen, she was Violetta in the Franco Zeffirelli *La Traviata* (1982). She has also appeared on Broadway, in *Rags* (1986).

Strauss, Richard (1864–1949), German composer and conductor, best known for several early tone poems and several 20th-century operas. He was a key late Romantic composer, although musically and politically a highly controversial figure. His major tone poems include *Don Juan* (1889), *Til Eulenspiegel's Merry Pranks* (1895), *Thus Spake Zarathustra* (1896), and *Don Quixote* (1897). His major operas include SALOME (1905), ELECTRA (1909), and DER ROSENKAVALIER (1911). During the Hitler era Strauss cooperated with the Nazis, conducting at Bayreuth when Arturo TOSCANINI refused to do so, and in Berlin, in place of Bruno WALTER, who as a Jew was blacklisted by the Nazis. He was also president of the Chamber of State Music, which controlled musical life in Nazi Germany, from 1933 to 1935. His relations with the Nazis apparently later somewhat cooled; although he was widely accused of having been a Nazi collaborator, he was "de-Nazified" in 1948.

Stravinsky, Igor Fyodorovich (1882–1971), Russian composer, long resident in France during the interwar period, and then in the

United States; he was for six decades a leading figure in 20th-century music and was by far the most central composer in 20th-century ballet. His first three major works are the ballets THE FIREBIRD (1910), choreographed by Michel FOKINE for Sergei DIAGHILEV's Paris-based BALLET RUSSES company; PETRUSHKA (1911), also choreographed by Fokine for Diaghilev; and THE RITE OF SPRING (1913), choreographed by Vaslav NIJINSKY for Diaghilev. A few of his later major ballets are APOLLO (1928), choreographed definitively by George BALANCHINE; ORPHEUS (1947); and AGON (1957), both of the latter also choreographed by Balanchine, when he and Stravinsky were living in the United States. Stravinsky also wrote several operas, including *The Nightingale* (1914), *Oedipus Rex* (1927), and *The Rake's Progress* (1951); and such choral works as *Symphony of Psalms* (1930), *Threni* (1958), and *Requiem Canticles* (1966), the latter two works in the serial forms he adopted from the mid-1950s. His considerable body of works also includes such instrumental pieces as the *Symphonies of Wind Instruments* (1920), *Violin Concerto* (1931), *Symphony in C Major* (1940), *Symphony in Three Movements* (1945), and *Ebony Concerto* (1945). His writings include the six volumes of autobiographical material written with Robert Craft (1959–69).

Streep, Meryl (Mary Louise Streep, 1949–), U.S. actress, on stage from 1975 and on screen from 1977, who played in the New York theater before becoming one of the leading film stars of the late 1970s and 1980s. She began her film career with a strong supporting role in JULIA (1977) and went on to such films as THE DEER HUNTER (1978); MANHATTAN (1979); KRAMER VS. KRAMER (1980), for which she won a best supporting actress OSCAR; *The French Lieutenant's Woman* (1981); *Sophie's Choice* (1982), for which she won a best actress Oscar; *Silkwood* (1983); *Plenty* (1984); OUT OF AFRICA (1985); IRONWEED (1987); *A Cry in the Dark* (1988); *She-Devil* (1989); and *Postcards from the Edge* (1990). She has also appeared on television, most notably in HOLOCAUST (1978).

Streetcar Named Desire, A (1947), the PULITZER PRIZE-winning Tennessee WILLIAMS play, in which Jessica TANDY created Blanche Du Bois and Marlon BRANDO so memorably created the Stanley KOWALSKI role, in a cast that included Kim Hunter and Karl MALDEN. Brando, Hunter, and Malden re-created their roles in the 1951 Elia KAZAN film version. Brando won a best actor OSCAR; Vivien LEIGH won a best actress Oscar as Blanche Du Bois, and Hunter won a best supporting actress Oscar.

Street Scene (1929), the Elmer RICE play, set in a poor New York neighborhood; it played on Broadway as the United States moved into the heartbreaking early years of the Great Depression. Sylvia SIDNEY, the archetypal Depression heroine, was Rose, who goes on alone to raise her young brother after her father has murdered her mother and her mother's lover. Rice adapted his play into the 1931 King VIDOR film; Sidney re-created Rose, in a cast that included William Collier, Jr., Max Montor, Estelle Taylor, David Landau, Russell Hopton, Beulah Bondi, and Lambert Rogers. The play was also the basis of the 1947 opera, with music by Kurt WEILL and lyrics by Langston HUGHES.

Streisand, Barbra (Barbara Joan Streisand, 1942–), U.S. singer and actress, on stage in variety from 1961, in musical theater from 1962, and on screen from 1968, who became an internationally recognized popular singing star and recording artist during the mid-1960s. On stage she played a strong supporting role in *I Can Get It for You Wholesale* (1962) and starred on Broadway in the Fanny BRICE role in the musical FUNNY GIRL (1964). She won a best actress OSCAR in the role in the 1968 film and also starred in the sequel, *Funny Lady* (1975). She also starred in such films as *Hello, Dolly!* (1969), *The Owl and the Pussycat* (1971), THE WAY WE WERE (1973), and *Nuts* (1987). Streisand won several GRAMMYS, including those for "People" (1964) and "Evergreen" (1977), *The Barbra Streisand Album* (1963), *My Name Is Barbra* (1965), and *The Broadway Album* (1986).

"Strike Up the Band" (1927), the title song of the Broadway musical of the same name. The play failed quickly in its first run, but it was a hit when rewritten and redone in 1930. Music

was by George GERSHWIN, with words by Ira Gershwin.

Stroheim, Erich von (Erich Oswald Stroheim, 1885–1957), German-Austrian actor and director, on screen from 1914, whose directorial work was on screen from 1919 and included such films as *Blind Husbands* (1919), *Foolish Wives* (1922), GREED (1923), *The Wedding March* (1928), and *Queen Kelly* (1928). His very long—and therefore very expensive—films often brought him into conflict with his producers, a conflict that ultimately destroyed his directing career. *Greed* was ultimately taken out of his hands, and the final cut was done by others, reducing the film to less than half its original length; and Gloria SWANSON's *Queen Kelly* was finished by others after von Stroheim had been dropped as its director. He continued to act on screen, usually as a Prussian officer, contributing a memorable supporting role in the classic GRAND ILLUSION (1937) and appearing in such films as SO ENDS OUR NIGHT (1941); *Five Graves to Cairo* (1943); and, in support of Swanson, the classic SUNSET BOULEVARD (1950).

"Studio One" (1948–58), the television drama anthology series, shot live in the early days of television, which featured both established and new works, developed by such young directors as Franklin SCHAFFNER, Paul Nickell, Sidney LUMET, and George Roy HILL, and such then-new-to-television players as Charlton HESTON, Margaret SULLAVAN, E.G. MARSHALL, Jason ROBARDS, Jr., Ralph BELLAMY, James DEAN, and Steve MCQUEEN. Several of its new works were later further developed, most notably the Reginald Rose teleplays 12 ANGRY MEN (1954) and *The Defender* (1957), which became THE DEFENDERS.

Studs Lonigan, the 1920s Chicago-Irish slum character created by James FARRELL in the "Studs Lonigan" trilogy, consisting of *Young Lonigan* (1932), *The Young Manhood of Studs Lonigan* (1934), and *Judgment Day* (1935); the works, sexually explicit for their time, were widely banned in the United States, enormously helping their ultimate circulation.

Sturges, Preston (Edmond P. Biden, 1898–1959), U.S. writer and director, who wrote

several plays during the 1920s, including *Strictly Dishonorable* (1929), before going to Hollywood as a screenwriter in 1930. As director and screenwriter he made several highly regarded films in the early 1940s, including *The Great McGinty* (1940), *The Lady Eve* (1941), *Sullivan's Travels* (1941), and *The Miracle of Morgan's Creek* (1944).

Styne, Jule (Jules Stein, 1905–), U.S. composer, a classically trained musician who began composing songs for films in the late 1930s and in the 1940s composed the music for such films as *Sweater Girl* (1942), *Step Lively* (1944), and *Anchors Aweigh* (1945). He then emerged as a major musical-theater figure, with such long-running Broadway hits as *High Button Shoes* (1947), *Gentlemen Prefer Blondes* (1949), *Bells Are Ringing* (1956), GYPSY (1959), and FUNNY GIRL (1964), also writing the scores of the latter four musicals on film. He won an OSCAR for the song "Three Coins in the Fountain" (1954).

Styron, William Clark (1925–), U.S. writer, whose highly regarded first work, *Lie Down in Darkness* (1951), established him as a major novelist. It was followed by *The Long March* (1953) and *Set This House on Fire* (1960), and then by his PULITZER PRIZE-winning fictionalized reconstruction of the slave rebellion led by Nat Turner, *The Confessions of Nat Turner*. A volume of memoirs, *Darkness Visible*, was published in 1990. Styron's notable *Sophie's Choice* (1979) became the 1982 Alan J. PAKULA film, with Meryl STREEP winning an OSCAR in the central role of the concentration-camp survivor.

Subject Was Roses, The (1964), the Frank D. Gilroy play, a family drama about a son who has come home from the wars; Martin Sheen was the returned soldier, and Jack Albertson and Irene Dailey were his parents. The work won a best play TONY and a PULITZER PRIZE. Gilroy adapted his play into the 1968 Ulu Grosbard film, with a cast that included Sheen and Albertson in their screen roles, joined by Patricia NEAL. Albertson won a best supporting actor OSCAR.

Sublett, John William, "Bubbles," of the variety team of BUCK AND BUBBLES; as John W.

Bubbles he also created the role of Sportin' Life in PORGY AND BESS (1935).

Sullavan, Margaret (Margaret Brooke, 1911–60), U.S. actress, on stage from the late 1920s and on screen from 1933. She became a leading dramatic star in such films as THREE COMRADES (1938), *The Shop Around the Corner* (1939), THE MORTAL STORM (1940), and SO ENDS OUR NIGHT (1940). Her long and varied theater career included leads in STAGE DOOR (1936), *The Voice of the Turtle* (1943), and *The Deep Blue Sea* (1952). She committed suicide in 1960 and was the centerpiece of the book *Haywire* (1977), by her daughter **Brooke Hayward**. Lee REMICK played Sullavan in the 1980 television dramatization of the book.

Summer and Smoke (1948), the Tennessee WILLIAMS play, set in small-town Mississippi in 1916. The central role of Alma was first created by Margaret Phillips, then re-created by Geraldine PAGE in the celebrated 1952 revival. Page was Alma in the 1961 Peter Glenville film, opposite Laurence HARVEY, in a cast that included Rita Moreno, Earl Holliman, Pamela Tiffin, John McIntire, Thomas Gomez, Una Merkel, and Malcolm Atterbury. Williams did another version of the work in 1964, titling it *Eccentricities of a Nightingale*.

"Summertime" (1935), the classic song introduced on Broadway by Abbie Mitchell as Clara in the opera PORGY AND BESS (1935), with music by George GERSHWIN and words by Du Bose Heyward.

Sun Also Rises, The (1926), the Ernest HEMINGWAY novel, set in France and Spain, about some young people of his "lost generation," who stayed on in Europe after World War I. It was adapted by Peter Viertel into the 1957 Henry KING film, with Tyrone POWER in the Jake Barnes role, opposite Ava GARDNER as Lady Brett Ashley, with Mel Ferrer, Errol FLYNN, and Eddie Albert in key supporting roles.

Sunday, Bloody Sunday (1971), the John SCHLESINGER film, screenplay by Penelope Gilliatt, about a late-20th-century kind of sexual triangle, or tangle, consisting of a bisexual man, a woman, and another man, with a cast that included Glenda JACKSON, Peter FINCH,

Murray Head, Peggy ASHCROFT, Vivian Pickles, and Maurice Denham.

Sundays and Cybele (1962), a film written and directed by Frank Bourgignon; a best foreign film OSCAR-winner, about the ultimately tragic relationship between a damaged ex-pilot and a young girl. The cast included Hardy Kruger, Nicole Courcel, Patricia Gozzi, and Daniel Ivernel.

Sunrise (1927), the F.W. MURNAU silent-film classic, with George O'Brien as the man who falls in love with another woman and plans to but ultimately cannot murder his wife, played by Janet GAYNOR. After several plot twists, they fall in love again and live happily ever after. Gaynor won an OSCAR, as did cinematographers Charles Rosher and Karl Struss.

Sunrise at Campobello (1958), the long-running, TONY-winning Broadway play by Dore Schary. Ralph BELLAMY won a Tony for his memorable creation of Franklin D. Roosevelt, as afflicted by polio in the years 1921–24; Mary Fickett created the Eleanor Roosevelt role. Schary adapted the play into the 1960 film, in which Bellamy re-created the Roosevelt role and Greer GARSON was Eleanor, in a cast that included Hume CRONYN, Ann Shoemaker, and Jean Hagen.

Sunset Boulevard (1950), the Billy WILDER film, with Gloria SWANSON as aging silent-film star Norma Desmond; William HOLDEN as the failed young screenwriter who becomes her lover; and Erich von STROHEIM, once her director and husband, now her butler. Wilder, Charles Brackett, and D.M. Marshman, Jr. won an OSCAR for the screenplay, as did art, sets, and Franz Waxman's music.

Superman, the comic-strip hero created in 1938 by Jerry Siegel and Joe Schuster; the strip was quickly developed into a radio series (1940), movie serials (1948–50), a feature film (1951), and the long-running television series (1951–57). The 1978 Frank Donner film version was a worldwide hit, with Christopher Reeve as Superman and Margot Kidder as Lois Lane and with Marlon BRANDO, Ned Beatty, Gene HACKMAN, and Jackie COOPER in key supporting roles; it generated three sequels.

suprematism, the Russian school of abstract painting developed by Kasimir MALEVICH from 1913; it was a forerunner of CONSTRUCTIVISM, building its images from abstract geometrical symbols and especially the square, triangle, and circle, most notably in his *Black Square* (1915) and *Suprematist Composition:* WHITE ON WHITE (1918).

Supremes, The, U.S. vocal trio, formed in 1960; its original members were Diana ROSS (1944–), Florence Ballard (1943–), and Mary Wilson (1944–). The group became very popular in the mid-1960s, with such songs as "Where Did Our Love Go?" (1964), "Back in My Arms Again" (1965), and "You Can't Hurry Love" (1966). Ballard was replaced by Cindy Birdsong in 1967; the group was then renamed *Diana Ross and the Supremes.* Ross left to become a leading soloist late in 1969, effectively ending the group, although it was not formally disbanded until the late 1970s.

surrealism, an antirational, post-World War I movement in the arts and literature, centered in France from the early 1920s and formalized from 1924 with the publication of the first *Surrealist Manifesto* of André BRETON, a cofounder of the movement; he then became the acknowledged and inflexible leader of the movement. Surrealism, like such antirational later movements as ABSTRACT EXPRESSIONISM, accepted the factual existence of the "unconscious" posited by Freud and from that takeoff point developed a theory of creation from the unconscious, which was thought to occur in any of three ways: as wholly unpredictable and unplanned, through the process of "automatic" creation; through the re-creation of dreams and fantasies, whether automatic or remembered; or through the creation of realistically rendered alternative realities. The theoretical constructs were only that; the forms used overlapped, and when such artists as Salvador DALI and René MAGRITTE flowed a clock or added a severed finger or freestanding eye to a painting, their work seldom fit into the neat classifications provided. Jean ARP, Max ERNST, Paul KLEE, Joan MIRÓ, and many other major artists of the interwar period reflected surrealist influences, as did such founding surrealist writers as Louis ARAGON, Paul ÉLUARD, and Philippe Soupalt. The "automatic" aspect of surrealist theory greatly influenced the development of Abstract Expressionism in the United States after World War II, most notably in the development of the "drip-and-splash" method of Jackson POLLOCK.

Sutherland, Donald McNichol (1934–), Canadian actor, on screen from 1964, a versatile player who became a star in the Hawkeye Pierce role in the comedy M*A*S*H (1970). He went on to become one of the leading dramatic actors of the next two decades, in such films as KLUTE (1971), THE DAY OF THE LOCUST (1975), 1900 (1976), *Casanova* (1976), ORDINARY PEOPLE (1980), *Ordeal by Innocence* (1984), *Gauguin* (1986), *Apprentice to Murder* (1988), and *A Dry White Season* (1989).

Sutherland, Graham Vivian (1903–80), British painter, who worked largely as a graphic artist during the 1920s, moving into painting in the early 1930s; his landscapes of the 1930s found surreal themes and shapes in nature. He was an official war artist from 1941 to 1944, his powerful, more realistic wartime paintings finding similarly surreal images in the wreckage of war. After the war, he produced such works as the St. Mathew's Church *Crucifixion,* the best-known painting of his "thorn" period; the Coventry Cathedral tapestry (1957); and several portraits, including those of Winston Churchill and Somerset MAUGHAM.

Sutherland, Joan (1926–), Australian soprano; she made her Australian debut in 1951 and emerged as a major international figure in the late 1950s, making her debut at Covent Garden in 1959 and at the Metropolitan Opera in 1961. Sutherland has appeared all over the world in most of the great roles, and even more on records; she is generally recognized as one of the leading singers of the century.

Suzman, Janet (1939–), South African actress and director, on stage from 1962, who also joined the ROYAL SHAKESPEARE COMPANY in 1962, beginning the long association that would take her into most of the leading women's roles in Shakespeare and several

major modern roles as well. Her later plays include *The Good Woman of Setzuan* (1976), *Hedda Gabler* (1977), and *Boesman and Lena* (1984). She began her directing career in the late 1980s, with *Othello* (1987) and *Andromache* (1988). She was on screen in television from 1968 and in films from 1970, in such movies as *Nicholas and Alexandra* (1972), *The Draughtman's Contract* (1982), and *A Dry White Season* (1989) and in such television plays as *Mountbatten* (1985).

Swanson, Gloria (Gloria Josephine Swenson, 1897–1983), U.S. actress, on screen from 1915, who became a highly publicized leading dramatic star of the 1920s, in such films as *Bluebeard's Eighth Wife* (1923), The *Untamed Lady* (1926), *Sadie Thompson* (1926), and *The Trespasser* (1929). Although she made the transition to sound well, her style did not suit the early 1930s. Late in her career, she made a notable comeback as the faded silent screen star of SUNSET BOULEVARD (1950), which earned her an OSCAR nomination. The film also featured Erich von STROHEIM as her former director, recalling their disastrous association in *Queen Kelly* (1928), which she produced, he lavishly directed, and she finished after firing him, too late to save most of her money. She made yet another comeback in the mid-1970s, playing strong character roles in several films.

Sweeney Todd, the Demon Barber of Fleet Street (1979), Stephen SONDHEIM's black-comedy musical. Len Cariou was Sweeney Todd, the notorious barber who murdered his customers, and Angela LANSBURY was Mrs. Lovett, the piemaker who baked and served up his victims. Sondheim wrote the words and music; book by Hugh Wheeler.

Sweet, Blanche (1895–1986), U.S. actress, on stage as a child and on screen from 1909, who starred for D.W. GRIFFITH in such early films as *The Lonedale Operator* (1911) and *Judith of Bethulia* (1913). She emerged in the 1920s as one of the leading dramatic stars of the silent era, in such films as ANNA CHRISTIE (1923) and *Tess of the D'Urbervilles* (1924).

Sweet Bird of Youth (1959), the Tennessee WILLIAMS play, set in the Deep South, about an aging film star and her young lover, now returning to his hometown. On stage Geraldine PAGE and Paul NEWMAN played the leads, with Sidney Blackmer as the vengeful politician who settles an old score. Richard BROOKS adapted and directed the 1962 film; Page and Newman re-created their stage roles, and Ed Begley won a best supporting actor OSCAR as the politician. Irene Worth won a TONY in the 1975 Broadway revival of the play.

Sweet Charity (1966), the long-running Broadway musical, based on the Federico FELLINI film NIGHTS OF CABIRIA. Giulietta MASINA's thin, pitiful, always victimized Italian prostitute became Gwen Verdon's always victimized—but always ebullient—dime-a-dance hostess, dancing to Bob FOSSE's choreography and singing "If My Friends Could See Me Now" and "Big Spender." Cy Coleman wrote the music, Dorothy Field the lyrics, and Neil SIMON the book. Peter Stone adapted and Fosse directed the 1969 film version, with Shirley MACLAINE as Charity, in a cast that included Ricardo Montalban, Sammy DAVIS, Jr., Chita Rivera, and John McMartin.

Swimmer, The (1968), the Frank Perry film, adapted from a John CHEEVER short story. Burt LANCASTER played Neddy Merrill, the seemingly hale, buoyant suburbanite who is headed home through the woods on a route that takes him through the pools of his neighbors; but all is character study and metaphor here, and it soon becomes clear that he is an unemployed, broken advertising man who is headed for an empty former home. The cast included Janice Rule, Charles Drake, Kim Hunter, Cornelia Otis Skinner, Marge Champion, Bill Fiore, Janet Landgard, and Joan Rivers.

swing, a popular form of JAZZ, which carried jazz fully into the mainstream of American popular music during the 1930s, and in which the music became much less improvisational, rather predictable, and therefore very danceable. At the same time it came in the form of composed popular songs, themselves very easy to sing and follow, and played by large groups, in what came to be called the big-band era.

Sydow, Max von (Carl Adolf von Sydow, 1929–), Swedish actor, on screen from 1949 and on stage from 1951, who from the late 1950s has been recognized as one of the leading dramatic actors of the modern period, on stage playing in many of the older and modern classics and on screen playing major roles in such Ingmar BERGMAN classics as THE SEVENTH SEAL (1957), THE MAGICIAN (1958), THE VIRGIN SPRING (1959), THROUGH A GLASS DARKLY (1961), and *Winter Light* (1962). His later films include *The Emigrants* (1969), *Three Days of the Condor* (1975), *Pelle the Conqueror* (1986), for which he won a best supporting actor OSCAR, and *Awakenings* (1990).

Symphony of a Thousand, The (1907), the massive *Eighth Symphony* of Gustav MAHLER.

Synge, John Millington (Edmund John Millington Synge, 1871–1909), Irish writer of two of the finest plays of the Irish theater: the one-act *Riders to the Sea* (1904) and the tragicomic THE PLAYBOY OF THE WESTERN WORLD (1907). *In the Shadow of the Glen* (1903) was his first produced play; his works also include *In the Well of the Saints* (1905); *The Tinker's Wedding* (1908); the unfinished *Deirdre of the Sorrows* (1910); and an unproduced early play, *When the Moon Has Set* (1901).

Szell, George (1897–1970), Czech-American conductor; he was a pianist child prodigy but made his career as a conductor, holding several positions as an opera conductor in Europe, including five years at the Berlin State Opera (1924–29). He lived in the United States from 1939, conducted at the Metropolitan Opera from 1942 to 1945, and from 1946 to 1970 conducted and greatly developed the Cleveland Orchestra.

T

Taft, Lorado (1860–1936), U.S. sculptor and teacher, a leading figure in American sculpture from the turn of century, for such major historical allegories as Chicago's *The Fountains of Time* (1922) and such portrait sculptures as *Black Hawk* (1911). He also wrote *History of American Sculpture* (1903).

Tagore, Rabindranath (1861–1941), Indian writer, composer, painter, and educator, most celebrated as an extraordinarily prolific poet, who wrote approximately 1,000 poems in Bengali, from such early work as *Morning Songs* (1883). His 1913 NOBEL PRIZE in literature, however, was awarded primarily for his own translation into English of what became his best-known poetry collection, the mystically oriented *Gitanjali* (1909), published as *Song Offerings* in 1912, with an introduction by William Butler YEATS. Tagore then became known in the West as primarily a mystic, though in reality he was one of modern India's best-known lyrical poets, whose work also included a considerable range of plays, novels, essays, and short fiction. He was awarded a British knighthood in 1915, which he resigned in 1919, in protest of the Amritsar Massacre; his novel *The Home and the World* (1916) reflected his commitment to Indian freedom during the early years of the long fight for Indian independence.

Tale of Two Cities, A (1935), the most notable of the several adaptations of the Dickens novel, this one adapted for film by W.P. Lipscomb and S.N. BEHRMAN and directed by Jack Conway in epic style, with Ronald COLMAN as Sidney Carton, leading a cast that included Elizabeth Allan, Edna May Oliver, Reginald Owen, Basil RATHBONE, and Blanche Yurka. The Carton role was played by William Farnum in the 1917 silent version and by Dirk BOGARDE in the 1980 British remake.

Taliesin, the home of architect Frank Lloyd Wright, at Taliesin, Wisconsin. It was built in 1911, rebuilt after a disastrous fire in 1915, and substantially altered in 1925; in 1932 it became Wright's celebrated architecture school and workshop. Taliesin West, his home and school at Scottsdale, Arizona, was begun in 1937; it continued as a school after his death.

Tallchief, Maria (1925–), U.S. dancer; she was a soloist with the Ballet Russe de Monte Carlo (1942–47), and a principal dancer with the NEW YORK CITY BALLET (1947–65), with a hiatus in the early 1960s. Tallchief danced the leads in many George BALANCHINE works throughout the period, very notably in such works as *Orpheus* (1948), FIREBIRD (1948), *Swan Lake* (1952), and *Nutcracker* (1954); she was also married to Balanchine (1946–52).

Talley's Folly (1980), Lanford WILSON's PULITZER PRIZE-winning play, about Matt Friedman's successful assault on the rock-hard bigotry of the fictive Talley family; in the end he and Sally Talley go off to be married, despite the opposition of the family. Judd Hirsch was Matt Friedman; Trish Hawkins was Sally Talley. This is the second of Wilson's Talley family plays, which also include *The Fifth of July* (1978), *A Tale Told* (1981), and *Talley and Son* (1985).

Tamayo, Rufino (1899–), Mexican painter, from a Zapotec family; his work reflects and merges pre-Columbian and modern influences. He directed the Department of Ethnographic Drawing at the National Museum of Archaeology from 1921 to 1925,

and from the mid-1920s emerged as a leading painter whose considerably abstracted, cubist-oriented work pursues Mexican themes in tropical colors and forms, in such paintings as *Women of Tehuantepec* (1939) and *Animals* (1941), and such murals as those at the Palacio de Bellas Artes in Mexico City (1952) and the Paris UNESCO headquarters (1958).

Tamiris, Helen (Helen Becker, 1905–66), U.S. dancer, choreographer, and teacher. She began her career in ballet, moved into MODERN DANCE in the mid-1920s, gave her first modern-dance recital in 1927, and led her own school and dance company from 1930 to 1945. Much of her work was thematic, focusing on the social concerns of the time, as in her several *Negro Spirituals* pieces (1928–42) and the *Walt Whitman Suite* (1934), a focus carried through while she was chief choreographer of the FEDERAL THEATRE PROJECT, 1937–39. Tamiris moved into the theater in 1945, choreographing such musicals as *Up in Central Park* (1945), ANNIE GET YOUR GUN (1946), FANNY (1954), and *Plain and Fancy* (1955).

Tandy, Jessica (1909–), British-American actress, on stage from 1928, who played in a considerable variety of stage roles in London and New York in the 1930s, including Ophelia to John GIELGUD's *Hamlet* in 1934. In 1947 she created the Blanche DU BOIS role in Tennessee WILLIAMS's A STREETCAR NAMED DESIRE, and won a best actress TONY in the role. Her first husband was Jack HAWKINS; her second, from 1942, is Hume CRONYN, with whom she formed a notable theater partnership, which resulted in many joint starring roles, in such plays as *The Fourposter* (1951); *A Delicate Balance* (1966); *The Gin Game* (1977); and *Foxfire* (1982), for which Tandy won a best actress Tony. On screen she played a wide range of supporting roles, until her OSCAR-winning starring role in DRIVING MISS DAISY (1989).

Tange, Kenzo (1913–), Japanese architect and urban planner, who emerged as a world figure with such works as the Hiroshima Peace Park (1956), Tokyo City Hall (1957), Tagawa Town Hall (1958), and the National Gymnasiums for the 1964 Tokyo Olympics, then going on to create a wide range of structures

throughout the world, such as the Union Bank Building in Singapore (1980) and the Saudi Arabian Royal Palace (1982).

Tanguey, Eva (1878–1947), U.S. vaudeville headliner before World War I, best known for her signature song, I DON'T CARE (1905).

Tanguy, Yves (1900–55), French painter, a self-taught artist who joined the SURREALISM movement in Paris in the mid-1920s. He is best known for his dream landscapes, which create an alternate reality with no relation, real or symbolic, to the world of the artist or viewer.

Tanizaki, Junichiro (1886–1965), Japanese writer, whose early work reflects a deep conflict between traditional and modern values, as expressed in his novel *Some Prefer Nettles* (1929). His later work resolves the conflict in favor of the traditional, especially as regards his view of the Japanese woman's role; it includes his reworking of the classic *The Tale of Genji* (1941) and such novels as *The Makioka Sisters* (1948), *The Key* (1956), and *The Diary of a Mad Old Man* (1962).

Tanner, Alain (1933–), Swiss writer and director, who emerged as a leading experimental, left-oriented filmmaker in the late 1960s, with such works as *Charles—Dead or Alive* (1969), *The Salamander* (1971), *The Middle of the World* (1974), *Jonah Who Will Be 25 in the Year 2000* (1976), *Light Years Away* (1981), and *No Man's Land* (1985).

Tanner, Henry Ossawa (1859–1937), U.S. painter and teacher, resident in France from 1891 and one of the few Black American visual artists to gain major recognition in the early part of the century. He is best known for such religious paintings as *The Destruction of Sodom and Gomorrah, Disciples Healing the Sick*, and the *Raising of Lazarus*.

Taos Pueblo (1930), the Ansel ADAMS photo-essay, with text by Mary Austin; his first major published collection, its photographs were in the sharp, clear style for which his work became celebrated. It was his second book; the first was the soft-focus, Impressionistic *Parmelian Prints of the High Sierras* (1928), published by the Sierra Club.

Johnny Weissmuller, best-known of the film Tarzans, letting out his distinctive halloo.

Tàpies, Antoni (1923–), Spanish painter, who moved from an early surreal phase to a form of abstract relief painting that strongly featured bits and pieces of such material as string, paper, and torn fabrics. From the mid-1950s, he greatly influenced the introduction and course of Spanish abstract art.

Tarkington, Booth (Newton Booth Tarkington, 1869–1946), U.S. writer, who became a popular novelist with *Monsieur Beaucaire* (1900) and an equally popular dramatist when he adapted it into the 1901 play. His most notable works include the PULITZER PRIZE-winning THE MAGNIFICENT AMBERSONS (1918); *Alice Adams* (1921), which won a second Pulitzer Prize; the three *Penrod* books (1914, 1916, and 1929); and *Seventeen* (1916). He wrote over a score of plays, including *Mister Antonio* (1916) and *Intimate Strangers* (1921). Many of his works were adapted for stage and screen, including *The Magnificent Ambersons* (1940), which became the classic Orson WELLES film; and the 1935 film version of *Alice Adams*, directed by George STEVENS, with Katharine HEPBURN in the title role.

Tarkovsky, Andrei (1932–86), Soviet director, whose work was on film from 1959 and who won worldwide recognition with his first feature film, *My Name Is Ivan* (1962). Later he encountered problems with the Soviet bureaucracy of the time, as he simultaneously reached for truth and for somewhat abstracted means of expression, in such films as *Andrei Rublev* (1966), *Solaris* (1972), and *The Mirror* (1976).

Tarzan, the character created by novelist Edgar Rice BURROUGHS in *Tarzan of the Apes* (1914), who became the basis for scores of novels, films, cartoons, animations, and assorted auxiliary materials. The first novel became a film in 1918, with Elmo Lincoln as the first screen Tarzan. Subsequently the role was played by many others, most notably in the 1930s–1940s sound-film series starring Johnny Weissmuller and Maureen O'Sullivan. It was done as late as 1984, in GREYSTOKE: THE LEGEND OF TARZAN, LORD OF THE APES, directed by Hugh Hudson, with a stellar British cast led by Christopher Lambert and Ralph RICHARDSON.

Taste of Honey, A (1958), the Shelagh DELANEY play, set in a Lancashire industrial town, about an unwed young woman pregnant with the child of a Black sailor, who is helped most by her homosexual friend. Delaney and Tony RICHARDSON adapted the play and Richardson directed the 1961 film, with a cast that included Rita Tushingham, Paul Danquah, Dora Bryan, Robert Stephens, and Murray Melvin.

Tati, Jacques (Jacques Tatischeff, 1908–82), French actor and director, who was on stage as a mime in variety during the 1930s and in several short films based on his act. He became an international star in his own screen comedies during the postwar period, beginning with *Jour de Fête* (1949), and then going on to create the four MR. HULOT films, beginning with *Mr. Hulot's Holiday* (1953).

Tatlin, Vladimir Egrafovich (1885–1953), Russian artist and architect, who from 1915 was a major figure in the main, or productionist, faction of the constructivist movement (see CONSTRUCTIVISM); an attempt to create artworks on industrial-engineering principles. By far his

most notable work was the *Monument to the Third International* proposal (1920), which was not adopted.

Tatum, Art (Arthur Tatum, 1910–56), U.S. JAZZ pianist, seen by many of his contemporaries to be one of the finest pianists in the history of jazz, and by some to be the best of all jazz pianists. All agreed as to his touch, the texture of his work, and the richness of his improvisation. He was a soloist from 1932, and from 1938 worked as part of a trio that originally included Everett Grimes and Slam Stewart.

Tauber, Richard (1891–1948), Austrian tenor; he made his debut in 1913 and became a very popular singer in Germany and Austria during the interwar period. He sang with the Dresden Opera (1913–26) and the Vienna Opera (1926–38) as well as in such operettas as *The Land of Smiles* (1931), in a role he re-created on Broadway in 1946. He also appeared in several films, including *Blossom Time* (1934) and *Pagliacci* (1937). After the Nazi takeover of Austria in 1938 he went to Britain, sang at Covent Garden from 1938, and became a British citizen in 1940, continuing to sing in Britain and America.

Taxi Driver (1976), the Martin SCORSESE film, screenplay by Paul Schrader, set on the underside of New York City life, with Robert DE NIRO as Travis Bickle, the pathologically violent protagonist, opposite Cybill Shepherd as Betsy and Jodie FOSTER as Iris, a young-old teenage prostitute; Harvey Keitel was Sport, the pimp who runs Iris.

Taylor, Deems (1885–1966), U.S. composer and critic; his best known works are his first two operas: *The King's Henchmen* (1927) and *Peter Ibbetson* (1931). He was also a well-known music critic and did broadcast commentary for New York Philharmonic radio broadcasts from 1936 to 1943.

Taylor, Elizabeth (1932–), British-American actress, on screen from 1942, who became a leading Hollywood child star playing opposite Mickey ROONEY in *National Velvet* (1944) and an international star during the postwar period, in such films as GIANT (1946); *Raintree County* (1947); CAT ON A HOT TIN ROOF

(1958); *Suddenly, Last Summer* (1959); and BUTTERFIELD 8, for which she won a best actress OSCAR. She won a second Oscar for WHO'S AFRAID OF VIRGINIA WOOLF? (1966), opposite her fifth husband, Richard BURTON. On stage she played leads in THE LITTLE FOXES (1979) and PRIVATE LIVES (1983).

Taylor, James (1948–), U.S. singer, songwriter, and guitarist; his song "Fire and Rain," in the album *Sweet Baby James* (1970), brought him national attention. He became one of the most popular figures of the 1970s, with such albums as *Mud Slide Slim and the Blue Horizon* (1971), *Gorilla* (1975), and *J.T.* (1977), in the mid-1980s also doing the album *That's Why I'm Here* (1986).

Taylor, Laurette (Helen Laurette Cooney Taylor, 1884–1946), U.S. actress, on stage in vaudeville as a child from 1896 and in the theater from 1900. She became a great star on the Broadway stage as Peg in the long-running *Peg o' My Heart*, written by her second husband, J. Hartley Manners; in 1922 she re-created the role on screen, in one of her few film appearances. In 1938, after a difficult decade, she was well received in *Outward Bound*, and in 1946 created the Amanda Wingfield role in Tennessee WILLIAMS's THE GLASS MENAGERIE, scoring an enormous personal triumph.

Taylor, Robert (Spangler Arlington Brugh, 1911–69), U.S. actor, on screen from 1934, who became a substantial Hollywood star in the mid-1930s, in such films as *Magnificent Obsession* (1935) and CAMILLE (1938), and went on to three decades of very durable stardom in such films as *Waterloo Bridge* (1940), *Ivanhoe* (1952), and *Savage Pampas* (1966).

Tchelitchew, Pavel (1898–1957), Russian artist and set designer, resident in France from 1923 and in the United States from 1934. His work ran contra the prevailing abstractionist trends and was "post-Romantic," with surreal aspects, as in *Phenomena* (1938) and *Hide and Seek* (1942). He also did several portraits of Edith SITWELL. He designed the sets for such works as Leonard MASSINE's *Ode* (1928) and George BALANCHINE's *Errant* (1933).

Tea and Sympathy (1953), the Robert Anderson play; John Kerr was the sensitive boy at a

boy's school, concerned about possible impotence and perhaps homosexuality, opposite Deborah KERR as the headmaster's wife, who ultimately takes him through the rite of passage by sleeping with him. Leif Erickson played her husband. They all re-created their roles in the 1956 Vincente MINNELLI film, in a cast that included Darryl Hickman, Norma Crane, Dean Jones, and Tom Laughlin.

Teagarden, Jack (Weldon Leo Teagarden, 1905–64), U.S. JAZZ trombonist, singer, and bandleader, a highly regarded jazz figure from the late 1920s. After playing with Ben Pollack and then Paul WHITEMAN, he led his own big band from 1938 to 1947, later playing with Louis ARMSTRONG and then forming a small band, with which he toured until the early 1960s. He also appeared in several films.

Tebaldi, Renata (1922–), Italian soprano; she made her Italian debut in 1944 and became a substantial figure in Italian opera before becoming an international star in the mid-1950s. She appeared at the Metropolitan Opera from 1955 and until her retirement in 1976 was one of the world's leading singers, in opera, in recital, and on many records.

Te Kanawa, Kiri (1944–), New Zealand soprano; she made her British debut in 1968, and in the early 1970s became a leading international singer, appearing at the Metropolitan Opera from 1973 and in many of the world's major houses, as well as on a considerable body of records, and in opera, recitals, and popular songs.

Tell Them Willie Boy Is Here (1969), a film written and directed by Abraham Polonsky. Robert Blake played Willie Boy, the bitterly independent young southwestern Indian who has killed his lover's father in self-defense and flees with her into the desert, pursued by a posse; she is ultimately a suicide, hoping that he can escape once unencumbered by her, but he is soon a suicide, too, by forcing the posse to kill him. Robert REDFORD was the sheriff who pursues Willie Boy, in a cast that included Katharine ROSS, Susan Clark, Charles McGraw, and Barry Sullivan. This was Polonsky's first directorial outing since *Force of Evil*, in 1948; he had been blacklisted in 1951

after defying the House Un-American Activities Committee during the McCarthy period.

Temple, Shirley (Shirley Temple Black, 1928–), U.S. actress, on screen at the age of three and by age six the leading child star in film history and a worldwide celebrity, winning a special OSCAR in 1934, the year she became a star. Her films include such 1930s classics as *Little Miss Marker* (1934), *Curly Top* (1935), *Poor Little Rich Girl* (1936), *Wee Willie Winkie* (1937), *Rebecca of Sunnybrook Farm* (1938), and *Susannah of the Mounties* (1939).

Temptations, The, U.S. vocal group, formed in 1962; its original members were Eddie Kendricks (1939–), Otis Williams (Otis Miles, 1941–), Paul Williams (1939–73), Melvin Franklin (David English, 1942–), and Eldridge Bryant. The group became very popular in the mid-1960s with such songs as "My Girl" (1965), "Beauty's Only Skin Deep" (1966), "I Wish It Could Rain" (1967), and "Just My Imagination" (1971). They continued to tour and record for the next two decades, though with several personnel changes and somewhat less popular impact.

Ten Days That Shook the World (1919), the John Reed book, a wholly sympathetic report on the Bolshevik Revolution of October 1917. The book was the basis for the technically innovative 1928 Sergei EISENSTEIN film, written by Eisenstein and G. Alexandrov and shot by Eduard Tisse, with a nonprofessional cast. Eisenstein's original film was censored by Joseph Stalin, who forced removal of references to his defeated rival, Leon Trotsky; it was further damaged by removal of a good deal of montage footage. A fully reconstituted version was shown in 1967, on the 50th anniversary of the October Revolution. The alternate name of the film is *October*.

Terms of Endearment (1975), the Larry McMurtry novel, adapted by James L. Brooks into the 1983 film, which he directed, with a cast led by Shirley MACLAINE, Debra Winger, and Jack NICHOLSON. The film, MacLaine as best actress, Nicholson as best actor, and Brooks for direction and screenplay all won OSCARS.

Terry, Ellen (1847–1928), British actress, on stage at the age of nine who was one of the great players of the English-speaking theater during the latter half of the 19th century and a leading player in Henry Irving's company from 1878. The turn of the 20th century found her late in her career, yet still playing leads on the London stage, until her semiretirement in 1907; she then toured, lecturing and giving readings. She was the daughter of actor **Benjamin Terry**, the mother of designer Gordon CRAIG, and the aunt of actor John GIELGUD.

Terry, Sonny (Saunders Terrell, 1911–86) and **Brownie McGhee** (Walter Brown McGhee, 1915–), a leading folk and BLUES duo for several decades, from 1939. Both were blues singers, while Terry was a very notable harmonica player and McGhee a guitarist who also played several other instruments.

Terry and the Pirates (1934), the popular comic strip created by cartoonist Milt CANIFF.

Tertz, Abram, the pseudonym of Soviet writer and dissident Andrey Donatevich SINYAVSKY.

Thalberg, Irving G. (1899–1936), U.S. producer and film executive, the protégé of Carl LAEMMLE. He became production head at Universal at the age of 20 and of Metro-Goldwyn-Mayer at 25, there soon becoming responsible for the severing of Erich von STROHEIM from his masterwork, GREED, and the severe cutting of the work. At MGM Thalberg produced, sometimes without credit, such films as BEN-HUR (1926), ANNA CHRISTIE (1930), MUTINY ON THE BOUNTY (1936), and THE GOOD EARTH (1937), although ill and less powerful in studio affairs after the early 1930s. His life in Hollywood was memorialized in the F. Scott FITZGERALD novel *The Last Tycoon*. Thalberg was married to actress Norma SHEARER.

"Thanks for the Memory" (1937), the Bob HOPE song, from the film *The Big Broadcast of 1938*, his first film. It became Hope's signature song. Words and music were by Leo Robin and Ralph Rainger.

Tharp, Twyla (1941–), U.S. dancer and choreographer; she was with the Paul Taylor company, 1963–65, and then developed her own company, working mainly with modern themes, though with both modern and classical forms. Some of her best-known works are *Re-Moves* (1966), *Forevermore* (1967), *The Bix Pieces* (1972), *As Time Goes By* (1974), and the films HAIR (1979), AMADEUS (1984), and *White Nights* (1985).

That Championship Season (1972), the Jason Miller play, a bitter examination of White, middle-class American values, set at the reunion of four high-school basketball players and their coach. On stage, the key roles were played by Richard Dysart, Paul Sorvino, Charles Durning, Walter McGinn, and Michael McGuire. The work won a best play TONY and a PULITZER PRIZE. Miller adapted his play into the 1982 film, which he directed, with a cast that included Sorvino, Robert MITCHUM, Bruce Dern, Stacy Keach, Martin Sheen, and Arthur Franz.

"That Old Black Magic" (1942), the classic song introduced by Johnny Johnston in the film *Star-Spangled Rhythm* (1942), with music by Harold ARLEN and words by Johnny MERCER.

Theatre Guild (1919–), a pioneering noncommercial U.S. repertory company that had great influence on the development of the American theater from the early 1920s through the mid-1930s, introducing to American audiences the work of such playwrights as George Bernard SHAW and Ferenc MOLNAR, and presenting the original works of such major American playwrights as Eugene O'NEILL, Robert SHERWOOD, and Sidney HOWARD. Its work diminished after the late 1930s breakaway of some of its members to form the GROUP THEATRE and the Playwrights Company, but it still did some notable productions, including THE PHILADELPHIA STORY (1939), OKLAHOMA! (1943), the Paul ROBESON *Othello* (1943), THE ICEMAN COMETH (1946), and SUNRISE AT CAMPOBELLO (1958).

"There'll Always Be an England" (1939), the British World War II song, with words and music by Ross Parker and Hughie Charles.

"There's No Business Like Show Business" (1946), a song introduced by Ethel MERMAN in the Broadway musical ANNIE GET YOUR

GUN (1946), with words and music by Irving BERLIN.

Theroux, Paul Edward (1941–), U.S. writer, several of whose novels reflect his crosscultural interests and often highly critical satirical stance. His works include the novels *Fong and the Indians* (1968), *Girls at Play* (1969), *Jungle Lovers* (1971), *Saint Jack* (1973), *The Black House* (1974), *Picture Palace* (1975), *The Mosquito Coast* (1981), *Dr. Slaughter* (1984), *O-Zone* (1986), and *The White Man's Burden* (1987), as well as the play *The Black House* (1986), short stories, and essays. He has also written several travel books, including *The Great Railway Bazaar* (1975), *The Old Patagonian Express* (1979), *Sailing Through China* (1983), and *Riding the Iron Rooster: By Train Through China* (1988).

These Three (1936), the Billy WILDER film, adapted by Lillian HELLMAN from her first play, THE CHILDREN'S HOUR (1934), with Miriam HOPKINS, Merle Oberon, and Joel MCCREA in the leads and Bonita Granville as the malicious young girl whose false accusations ruin all three lives. The 1962 William Wyler film of that name was also based on the Hellman play, its cast included Audrey HEPBURN, Shirley MACLAINE, James GARNER, and Miriam HOPKINS.

"They Didn't Believe Me" (1914), the landmark Jerome KERN song, his first hit and a new style-setter in the American musical theater. It was introduced on Broadway by Julia Sanderson and Donald Brian in *The Girl from Utah* (1914). Music was by Kern, with words by Herbert Reynolds.

They Shoot Horses, Don't They? (1969), the Sidney POLLACK film, set at a dance marathon in the mid-1930s; the struggles and defeats of the contestants are meant to mirror the realities of life in Depression-era America. Jane FONDA led a cast that included Michael Sarrazin as her partner, Gig Young, Susannah YORK, Red Buttons, Bruce Dern, Bonnie Bedelia, and Michael Conrad. Young won a best supporting actor OSCAR. The James Poe–Robert E. Thompson screenplay was adapted from the 1935 Horace McCoy novel of that name.

Things to Come (1936), the H.G. WELLS adaptation of his own science-fiction novel *The Shape of Things to Come* (1933) into the William Cameron Menzies film, with a cast that included Raymond MASSEY, Ralph RICHARDSON, Cedric Hardwicke, Ann Todd, Edward Chapman, Margaretta Scott, and John CLEMENTS.

Thin Man, The (1932), the detective novel by Dashiell Hammett; it became the 1934 W.S. VAN DYKE film, starring William POWELL and Myrna LOY in the Nick and Nora CHARLES roles; it was the first of the six films in the *Thin Man* series. Peter Lawford and Phyllis Kirk starred in the 1957–59 television series based on the books.

Third Man, The (1949), the Carol REED film, with screenplay by Graham GREENE; a thriller set in post-World War II Vienna, with Joseph COTTEN, Orson WELLES, and Trevor HOWARD leading a cast that included Alida Valli, Bernard Lee, and Wilfrid Hyde-White. Welles played Harry LIME, an amoral profiteer for an emerging Cold War world, who is at the center of the story; the Anton Karas "The Third Man Theme" permeates the film. Cinematographer Robert Krasker won an OSCAR.

Thirty-nine Steps, The (1915), the John Buchan spy thriller, turning on a projected German invasion of Britain. In 1935, with a new war ahead, it was the basis of the Alfred HITCHCOCK classic film thriller, with Madeleine CARROLL and Robert DONAT leading a cast that included Lucie Mannheim, Godfrey Tearle, Peggy ASHCROFT, and John Laurie. It was remade twice, in 1959 and 1978.

"Thirtysomething" (1987–), the television situation soap-opera drama about a group of privileged people in their thirties and their search for personal fulfillment. The cast includes Ken Olin, Patricia Wettig, Mel Harris, Melanie Mayron, Peter Horton, Polly Draper, and Timothy Busfield.

This Is the American Earth (1960), the photograph collection by Ansel ADAMS, with text by Nancy Newhall, based on an earlier exhibition; the work was a powerful, explicit call for preservation of the American natural heritage, a cause Adams had espoused since his youth.

Thomas, Dylan Marlais (1914–53), Welsh writer, a powerful lyric poet, whose collections include *Eighteen Poems* (1934), *Twenty-five Poems* (1936), *The Map of Love* (1939), *Deaths and Entrances* (1946), and his *Collected Poems* (1952). His also wrote the autobiographical *Artist as a Young Dog* (1940), the play *Under Milk Wood* (1954), and the novel *Adventures in the Skin Trade* (1955) and worked on several radio scripts and filmscripts. His career was greatly damaged and his life cut short by alcoholism. *Under Milk Wood* was adapted into the 1973 Anthony Sinclair film, with a cast that included Richard BURTON, Elizabeth TAYLOR, and Peter O'TOOLE.

Thomson, Tom (Thomas John Thompson, 1877–1917), Canadian painter; encouraged by his friend James MACDONALD, he began to sketch in 1908 and to paint in 1912 and in 1913 did his first large canvas, *A Northern Lake*. During the next four years, working sometimes as a guide and ranger at Algonquin Park, he created the entire body of landscapes that were to establish him as the leading Canadian artist of the 20th century, including such large paintings as *Red Leaves* (1914), *Northern River* (1915), *The West Wind* (1917), and *The Jack Pine* (1917) and the long series of 8½″ x 10½″ oil-on-panel sketches, actually finished paintings, that he did in the field. His life and career were abruptly cut short by his death while canoeing.

Thomson, Virgil (1896–1989), U.S. composer and critic; as a composer he is best known for two operas written in collaboration with Gertrude STEIN: *Four Saints in Three Acts* (1934) and *The Mother of Us All* (1947), and for the scores to the films *The Plow That Broke the Plains* (1936), THE RIVER (1937), and *Louisiana Story* (1948). He also wrote the opera *Lord Byron* (1972), as well as ballet, orchestral, and choral music. He was at least as well known as the music critic of the *New York Herald Tribune* (1940–54).

Thorn Birds, The (1977), the Colleen McCULLOUGH novel, set in Australia from the early 1920s through the early 1960s, about a Catholic priest facing the questions of faith and celibacy, and the family whose life is intertwined with his. It was adapted by Carmen Culver into the 10-hour 1983 miniseries, with a cast that included Richard CHAMBERLAIN, Rachel Ward, Barbara STANWYCK, Jean SIMMONS, Richard Kiley, Christopher PLUMMER, Bryan Brown, Piper Laurie, Philip Anglim, and Earl Holliman.

Thorndike, Sybil (Agnes Sybil Thorndike, 1882–1976), British actress, on stage in repertory from 1904, who became a leading young Shakespearean actress at the Old Vic during World War I, and one of the leading players of the English-speaking stage after the war, most notably in her *Trojan Women* (1910), in George Bernard SHAW's SAINT JOAN (1924) and MAJOR BARBARA (1929), and opposite Emlyn WILLIAMS in his THE CORN IS GREEN (1938). During World War II she toured Britain in the classics and then resumed her long career, last appearing in 1969. She did relatively few films, though playing strong supporting roles in such films as *Major Barbara* (1941), *Nicholas Nickleby* (1947), and *The Prince and the Showgirl* (1957). She married actor and director Lewis Casson (1876–1969) in 1909, their careers then intertwining for the next six decades. They last appeared together in ARSENIC AND OLD LACE (1966).

Three Comrades (1937), the Erich Maria REMARQUE novel, set in Germany during the interwar period, as the country moved from democracy to fascism; it is a sequel, with the earlier *The Road Back* (1931), to ALL QUIET ON THE WESTERN FRONT (1929). It was adapted by F. Scott FITZGERALD and Edward Patmore into the 1938 Frank BORZAGE film, with Robert TAYLOR, Margaret SULLAVAN, Franchot TONE, and Robert YOUNG in the leads.

Three-Cornered Hat, The the ballet by Manuel DE FALLA, choreographed by Leonid MASSINE. It was first presented, with sets by Pablo PICASSO, in Paris, in July 1919, by the BALLET RUSSES company of Sergei DIAGHILEV, with Massine and Tamara KARSAVINA in the leading roles.

Three Faces of Eve, The (1957), a film written, directed, and produced by Nunnally Johnson and starring Joanne WOODWARD in an OSCAR-winning role as a psychiatric patient with three

emergent personalities, in a cast that included Lee J. COBB, David Wayne, Vince Edwards, and Alistair Cooke. The screenplay was based on the Corbett Thigpen–Hervey M. Cleckley book.

Threepenny Opera, The (1928), the play by Bertolt BRECHT, with music by Kurt WEILL, based on John Gay's *The Beggar's Opera* (1728). It played in Germany as *Die Dreigroschenoper* and became the 1931 G.W. PABST film, with Rudolph Forster as Mack the Knife and Lotte LENYA as Pirate Jenny. Of several adaptations into English, the 1954 Marc BLITZSTEIN version was by far the most popular, with Lenya re-creating her Pirate Jenny role on the New York stage.

Three Sisters, The (1901), the Anton CHEKHOV play, about the unsatisfied lives of three well-educated women, Olga, Masha, and Irina Prozonov, and their brother, Andrei, trapped by circumstance in a provincial Russian town, their entrapment becoming even more onerous when the officers of the Russian garrison leave. The play was written by Chekhov for presentation by Constantin STANISLAVSKY at the MOSCOW ART THEATRE in 1901, and became a major work in the international repertory as Chekhov became known abroad in translation during the 1920s.

Throne of Blood, The (1957), the powerful Akira KUROSAWA film adaptation of *Macbeth*, told as a samurai story set in medieval Japan, with Toshiro MIFUNE in the lead and Izuzu Yamada in the Lady Macbeth role.

Through a Glass, Darkly (1962), the film written and directed by Ingmar BERGMAN and shot by Sven NYKVIST, exploring the inner worlds and search for belief of a schizophrenic and her family; the cast includes Harriet Andersson, Gunnar Björnstrand, Max von SYDOW, and Lars Passgard.

Thurber, James Grover (1894–1961), U.S. writer and artist, whose view of the human condition was expressed from 1927 largely in the pages of *The New Yorker*, in the form of a wide variety of prose pieces accompanied by his drawings of men, women, and dogs making their way through a tragicomic world. His many collections include *Is Sex Necessary?*

(1929), coauthored with E.B. WHITE; *The Middle-Aged Man on the Flying Trapeze* (1935); *Fables for Our Time* (1940); *My World and Welcome to It* (1942), which includes "The Secret Life of Walter Mitty," the basis of the 1947 film starring Danny KAYE; *The Thurber Carnival* (1945); and *Lanterns and Lances* (1961). Thurber coauthored the play *The Male Animal* (1940) with Elliott Nugent and also wrote several children's books. The biographical *The Years With Ross* (1959) chronicled his relationship with editor Harold ROSS and *The New Yorker*.

Tibbett, Lawrence (1896–1960), U.S. baritone; he made his opera debut at Los Angeles in 1923 and the same year with the Metropolitan Opera, soon emerging as one of the leading singers of his time. He sang at the Met until 1950 and in many of the world's major houses in the same period. In the early 1930s he appeared in several film musicals, and sang in the theater and on television in the 1950s.

Tierney, Gene (1920–), U.S. actress, on stage from 1939 and on screen from 1940. She became a leading Hollywood star of the 1940s, with such films as TOBACCO ROAD (1940), *Belle Starr* (1940), *Heaven Can Wait* (1943), LAURA (1944), *A Bell for Adano* (1945), *Leave Her to Heaven* (1945), *The Razor's Edge* (1946), *The Ghost and Mrs. Muir* (1947), *Never Let Me Go* (1953), and *The Left Hand of God* (1955). Her later work was in supporting roles and on television.

Tiffany, Louis Comfort (1848–1933), U.S. artist and entrepreneur. During the last quarter of the 19th century, he originated and became a leading producer of several kinds of stained glass, most notably of the Favrile glass of the 1890s, often called "Tiffany glass"; he also created several stained-glass projects. During the early 20th century he produced several kinds of now highly prized decorative works, including lamps, pottery, and jewelry.

Tight Little Island (1949), the Alexander McKendrick film comedy, set during World War II, about the people of Tolday, a fictional island in the Outer Hebrides, whose lives are greatly enhanced by their illicit salvage of whiskey from a sunken ship. The cast included

Joan GREENWOOD, James Robertson Justice, Basil Radford, Gordon JACKSON, John Gregson, Jean Cadel, Wylie Watson, and Finlay CURRIE. The Compton Mackenzie novel was adapted by Mackenzie and Angus McPhail. The British title of the film was *Whiskey Galore!*

Tijuana Brass, The, the group led by Herb ALPERT from 1962; with "Lonely Bull" (1962), they introduced what became the very popular "Ameriachi" style.

Time of Your Life, The (1940), the William SAROYAN play, set in a San Francisco waterfront saloon peopled by highly original characters, all nurtured by Eddie Dowling as Joe, the bartender. Saroyan refused the PULITZER PRIZE he won for the play. The 1948 film starred James CAGNEY.

"Times They Are A-Changin', The" (1964), the classic Bob DYLAN song; it became one of the "anthems" of the COUNTERCULTURE of the 1960s, especially of the radical Weathermen group; words and music were by Dylan.

Tin Drum, The (1959), the Günter GRASS novel, a powerful, bitter satire of Nazi Germany before and during World War II, which drew upon the author's early years in Danzig and wartime experience as a German soldier. The dwarf at the center of the novel is the most notable of the many grotesques that people his work; he was played by David Bennent in the OSCAR-winning 1979 Volker Schlondorff film.

Tippett, Michael Kemp (1905–), British composer, who emerged as a major 20th-century figure with the oratorio *A Child of Our Time* (1941), his exploration of the meaning of morality in a time of anguish. His use of Black, JAZZ, and other popular and international cultural themes and forms extended to such equally searching works as the operas *The Midsummer Marriage* (1955), *King Priam* (1962), *The Knot Garden* (1970), and *The Ice Break* (1977) and to the massive oratorio *The Mask of Time* (1982). His large body of work includes four symphonies, concertos, piano sonatas, and other instrumental music, as well as much choral music.

Tobacco Road (1932), the novel by Erskine CALDWELL, which compassionately and realistically explores the lives of a ravaged Depression-era sharecropping family in Georgia. In 1933, it was adapted by Jack Kirkland into the long-running Broadway play and in 1941, by Nunnally Johnson into the John FORD film.

To Begin Again (1982), the José Luis Garci film. Garci and Angel Llorente wrote the screenplay, about a dying literary figure who revisits his Spanish homeland, with a cast that included Antonio Ferrandis, Encarna Paso, Agustin Gonzalez, Pablo Hoyo, and José Bodalo. The movie won a best foreign film OSCAR.

Tobey, Mark (1890–1976), U.S. artist; in the mid-1930s he originated the painting technique of "white writing," essentially the application of East Asian calligraphic techniques to create abstract works, to some extent prefiguring ABSTRACT EXPRESSIONISM.

To Have and Have Not (1944), the Howard HAWKS film, set in the Caribbean and based on the 1937 Ernest HEMINGWAY novel. In the screen adaptation, by William FAULKNER and Jules Furthman, it was updated to become a World War II French Resistance story. Humphrey BOGART starred, opposite Lauren BACALL in her film debut, with a cast that included Walter Brennan, Hoagy CARMICHAEL, Marcel Dalio, Sheldon Leonard, and Dolores Moran.

To Kill a Mockingbird (1960), the PULITZER PRIZE-winning Harper Lee novel, the story of Atticus Finch, a White lawyer in a small southern town who defends Tom Robinson, a Black man unjustly accused of raping a White woman; and of the Finch children, growing up in that time and place. Horton Foote won an OSCAR for his adaptation of the novel into the 1962 Robert Mulligan film. Gregory PECK was Atticus Finch, in a cast that included Brock Peters as Robinson, Robert DUVALL as Boo Radley, and Mary Badham and Philip Alford as the Finch children. The film, Peck as best actor, art, and sets all won Oscars.

Toland, Gregg (1904–48), U.S. cinematographer, one of the most skilled and innovative cameramen of Hollywood's Golden Age, who

shot several film classics before his early death of a heart attack. His works include WUTHERING HEIGHTS (1940), for which he won an OSCAR; THE GRAPES OF WRATH (1940); CITIZEN KANE (1941); and THE BEST YEARS OF OUR LIVES (1946).

Tolkien, J.R.R. (John Radford Reuel Tolkien, 1892–1973), British writer and scholar, creator of the mythic world of Middle Earth and of the race of hobbits in his best-known works: *The Hobbit* (1937), and the trilogy *The Fellowship of the Ring*, consisting of *The Lord of the Rings* (1954), *The Two Towers* (1954), and *The Return of the King* (1955).

Toller, Ernst (1893–1939), German writer, whose first play, the pacifist *Transfiguration* (1919), reflects his experience as a German soldier during World War I. A left socialist, he was one of the leaders of the unsuccessful postwar Bavarian revolution, and spent 1919–24 in prison. His best-known work includes *Man and the Masses* (1921), *The Machine Wreckers* (1923), and *Hoopla! That's Life* (1927). Toller fled Germany for the United States in 1933; his later works included the concentration-camp play *Pastor Hall* and many essays devoted to the antifascist struggle of the time. He was a suicide.

Tom Jones (1963), the Tony RICHARDSON version of the classic Henry Fielding novel (1749), as adapted into an equally classic film comedy by John OSBORNE. Albert FINNEY played Tom Jones in a cast that included Susannah YORK, Hugh Griffith, Edith EVANS, Joan GREENWOOD, Diane Cilento, David Warner, Rachel Kempson, Wilfred Lawson, George Devine, and Joyce Redman. The Redman–Finney eating scene has since often been emulated in life and art. Richardson and Osborne won OSCARS; as did John Addison's music.

Tomlin, Lily (1939–), U.S. actress, singer, and variety entertainer, who emerged as a notable comedian during her three years with television's "Laugh-In" (1969–72) and went on to appear in a wide range of stage, screen, and television roles. Her films include NASHVILLE (1975), *Nine to Five* (1980), *All of Me* (1984), and *Big Business* (1988). She won a special TONY for her one-woman show *Appearing Nightly* (1977) and a best actress TONY for *The Search for Intelligent Life in the Universe* (1986).

Tommy, the Peter Townshend ROCK opera, first performed in 1969 as a concert piece by THE WHO and then a popular album, with its hit song "Pinball Wizard." It became the 1975 Ken Russell film, with a cast that included Roger Daltrey, Elton JOHN, Tina TURNER, Eric CLAPTON, Keith Moon, Ann-Margret, Jack NICHOLSON, and Oliver Reed.

Tone, Franchot (1905–68), U.S. actor, on stage from 1927 in such plays as *Green Grow the Lilacs* (1931) and *The House of Connelly* (1931). He was on screen from 1932, played strong supporting roles in such films as MUTINY ON THE BOUNTY (1935) and THREE COMRADES (1939), and later played leads in such films as *Five Graves to Cairo* (1943) and *The Phantom Lady* (1944). Later in his career, he was on Broadway in A MOON FOR THE MISBEGOTTEN (1957) and played a strong supporting role as the President in ADVISE AND CONSENT (1962).

Tony Awards, from 1947, the annual Antoinette Perry Awards of the American Theatre Wing, the most prestigious of the American theater awards; Perry (1888–1946) had been director of the American Theatre Wing. Awards are given in several categories, including best play, musical, actress, actor, actress and actor in a musical, supporting actress and actor, director, composer, choreographer, as well as in many other technical areas.

"Toonerville Trolley," the long-running comic strip created by Fontaine FOX in 1908; it ran until his retirement in 1955.

Tootsie (1982), the Sidney POLLACK film, starring Dustin HOFFMAN in a highly regarded performance as a man who pretends to be a woman to land an acting job, leading a cast that includes Jessica LANGE, Charles Durning, Teri Garr, Bill Murray, and Pollack himself. The Larry Gelbart–Murray Schisgal screenplay was based on a Don McGuire story. Lange won a best supporting actress OSCAR.

Top Hat (1935), the Irving BERLIN film musical comedy classic, starring Fred ASTAIRE and Ginger ROGERS and directed by Mark Sandrich, with Edward Everett Horton, Helen

Broderick, Eric Blore, and Eric Rhodes in strong supporting roles. Berlin's score features such songs as CHEEK TO CHEEK and TOP HAT, WHITE TIE, AND TAILS.

"Top Hat, White Tie, and Tails" (1935), the Fred ASTAIRE song and dance, which he introduced in the film TOP HAT (1935), with words and music by Irving BERLIN.

Torch Song Trilogy (1988), three linked one-act plays by Harvey Fierstein, all on homosexual themes: *The International Stud, Fugue in a Nursery,* and *Widows and Children First.* Fierstein starred on stage, in a cast that included Joel Crothers, Diane Tarleton, and Matthew BRODERICK. The work won a best play TONY; Fierstein won a best actor Tony. He adapted the play and starred in the 1988 Paul Bogart film, in a cast that included Anne BANCROFT, Broderick, Brian Kerwin, Karen Young, and Charles Pierce.

Tortilla Flat (1935), the John STEINBECK novel, set in a Depression-era California fishing town. It became the basis of the 1942 Victor FLEMING film, with a cast that included Spencer TRACY, John GARFIELD, Hedy LAMARR, Frank Morgan, Allan Jenkins, Sheldon Leonard, and Akim Tamiroff.

Tosca (1900), the opera by Giacomo PUCCINI, based on the 1887 Victorien Sardou play *La Tosca*; a melodrama in which Tosca, her lover, and the villainous chief of police all ultimately die.

Toscanini, Arturo (1867–1957), Italian conductor, generally recognized as one of the leading conductors of the 20th century, who throughout his career insisted on adherence to what he believed to be the intentions of the composers whose works he conducted; he focused most notably on Verdi, Beethoven, Wagner, and Brahms. At the age of 19 he made his debut as an emergency replacement at Rio de Janeiro, conducting *Aïda* from memory. He was musical director of La Scala from 1908 and principal conductor of the Metropolitan Opera from 1908 to 1915, again directing at La Scala from 1921 to 1929. Toscanini was a democrat and an antifascist; he ultimately refused to conduct in fascist Italy and refused to conduct at Bayreuth for the Nazis, then

being replaced by Herbert von KARAJAN. He conducted the combined New York Philharmonic-Symphony Orchestra from 1928 to 1936, and the NBC Symphony Orchestra from 1937 to 1954, in that period becoming one of the most celebrated and highly respected artists of his day.

Tracy, Spencer (1900–67), U.S. actor, on stage from 1922 and on screen from 1930, who played supporting roles on stage until his successful Broadway lead in *The Last Mile* (1929), which resulted in a film contract and his first Hollywood lead, in *Up the River* (1930). He emerged as a major dramatic star in the mid-1930s, in such films as FURY (1936), *Captains Courageous* (1937), and *Boys Town* (1938), winning unprecedented back-to-back best actor OSCARS for the latter two films. During the next three decades he became one of the best-appreciated actors of his time, in such films as *Stanley and Livingstone* (1939), DR. JEKYLL AND MR. HYDE (1941), *A Guy Named Joe* (1943), STATE OF THE UNION (1948), *Pat and Mike* (1952), *The Old Man and the Sea* (1958), THE LAST HURRAH (1958), and JUDGMENT AT NUREMBERG (1961). He costarred in nine films with Katharine HEPBURN; they were constant companions from 1942. She left her work for some years during the early 1960s to be with him during his long final illness, returning with him to do one last film, GUESS WHO'S COMING TO DINNER (1967).

Tramp, The, the film character created by Charlie CHAPLIN in his classic 1915 silent film. The Tramp was the quintessential underdog, the totally sympathetic Everyman who was at the heart of Chaplin's further work—and the man Chaplin seemed to be, to the hundreds of millions who idolized him all over the world.

Traven, B. (1890?–1969), German or American writer, who kept his identity secret during his lifetime; he was probably either a German, Ret Marut, who fled to Mexico after participating in the failed left socialist Bavarian Revolution of 1918–19, or an American, Hal Croves. Whoever he was, some of his early work is set in Germany and most of his subsequent work in Mexico, where he lived and wrote from the middle or late 1920s, taking as his main theme the plight of the Mexican poor. His earliest

Drawn by the love of gold—Walter Huston (left) and Humphrey Bogart in John Huston's 1948 film *The Treasure of the Sierra Madre*.

known novel is *The Death Ship* (1926), set in Germany. His major work is the six-book *Jungle Novels* sequence, set in the Mexican Revolution; these were written in the 1940s and consist of *Government, The Carreta, March to the Monteria, The Troza, The Rebellion of the Hanged*, and *The General from the Jungle*. By far his best-known work is THE TREASURE OF THE SIERRA MADRE (1945), which became the classic 1948 John HUSTON film.

Travesties (1974), the TONY-winning Tom STOPPARD play, set in Zurich in 1917, with a cast of characters that includes James JOYCE; Lenin; and Krupskaya, Lenin's wife. After a brief run in repertory with the ROYAL SHAKESPEARE COMPANY in 1974, the company brought the work to Broadway in 1975, with a cast that included James Woods, Tim Curry, Meg Wynn Owen, James Booth, Harry Towb, and Frances Cuka.

Travolta, John (1954–), U.S. actor and singer, on stage and on television from the early 1970s, who emerged as a film star with his leading roles in *Saturday Night Fever* (1977) and GREASE (1978). He also appeared in such

films as *Urban Cowboy* (1980), *Staying Alive* (1983), *Perfect* (1985), *Daddy Wanted* (1989), and *Look Who's Talking* (1989). On television he starred in "Welcome Back Kotter" (1975–78). He has also made several records.

Treasure of the Sierra Madre, The (1945), the novel by B. TRAVEN, set in Mexico during the 1920s, which John HUSTON adapted into his classic 1948 film, with Humphrey BOGART in the memorable Charlie Dobbs role; his father, Walter HUSTON, in the role of Howard, the old prospector; and Tim Holt as the third partner. Both Hustons won OSCARS for the film, John for screenplay and direction and Walter as best supporting actor.

Tree, Herbert Draper Beerbohm (1853–1917), British actor-manager, who became a major figure on the London stage in the 1880s and 1890s, and was a leading London stage producer early in the 20th century. In 1914 he presented George Bernard SHAW's PYGMALION in London, and he was the first English-language Henry HIGGINS, opposite Mrs. Patrick CAMPBELL's Eliza DOOLITTLE. He was the half-brother of Max BEERBOHM.

Tree Grows in Brooklyn, A (1945), the Elia KAZAN film, set in a poor neighborhood in turn-of-the-century Brooklyn; it was adapted for the screen by Tess Slesinger and Frank Davis, from the 1943 Betty Smith novel. The cast included Dorothy McGuire, Joan BLON-DELL, Peggy Ann Garner, James Dunn, Ted Donaldson, James Gleason, Lloyd Nolan, and Ruth Nelson; Dunn won a best supporting actor OSCAR.

Trilling, Lionel (1905–75), U.S. writer and critic, whose work includes studies of *Matthew Arnold* (1939) and *E.M. Forster* (1945). He is chiefly known for his critical essays, collected in such works as *The Liberal Imagination* (1950); *Freud and the Crisis of Our Culture* (1956), the first of several books on Freud and culture; and *The Mind of the Modern World* (1973).

Triumph of the Will, The (1936), the Leni RIEFENSTAHL propaganda film, shot at the Nuremberg Nazi Party Congress of 1934; it is a massive glorification of the Nazis and deification of Adolf Hitler that is often described as an extraordinary success. But only with the fascist faithful; from the first, the film aroused only hate and fear throughout the rest of the world, helping to alert humanity to the danger of German fascism, and afterward served to show future generations the face of the beast.

Trudeau, Garry (Garretson Beekman Trudeau, 1948–), U.S. cartoonist, who in 1970 created the very popular DOONESBURY comic strip for the Universal Press Syndicate. His topical commentary on American life soon became widely syndicated, generating many collections of Doonesbury cartoons. Trudeau won a 1975 PULITZER PRIZE. He is married to television news figure **Jane Pauley.**

Truffaut, François (1932–1984), French director and critic, who in the early 1950s became one of the young film critics gathered around André BAZIN at CAHIERS DU CINÉMA, there helping develop the AUTEUR theory. He then moved into filmmaking, becoming a key director in the NEW WAVE movement. His work was on screen from 1954, and he gained worldwide recognition with his first feature film, THE 400 BLOWS (1959), which was followed

by such films as *Shoot the Piano Player* (1960), JULES AND JIM (1961), *The Soft Skin* (1964), DAY FOR NIGHT (1973), and *Love on the Run* (1979).

Trumbo, Dalton (James Dalton Trumbo, 1905–1976), U.S. writer, a screenwriter from 1935, whose work was on screen from 1936. As Dalton Trumbo he wrote screenplays for such 1930s and 1940s films as *Kitty Foyle* (1940), *A Guy Named Joe* (1943), and *Thirty Seconds over Tokyo* (1944). In 1947 he was imprisoned and blacklisted as one of the HOLLYWOOD TEN. He then continued to write movies, but from Mexico and at cut rates, for over a decade, writing scores of scripts for the industry that had blacklisted him. As Robert Rich he won a 1957 OSCAR for his *The Brave Ones* (1956), then finally coming back as Dalton Trumbo to openly write the scripts for such films as *Spartacus* (1960), *Exodus* (1960), *Hawaii* (1966), and *Papillon* (1973); he also wrote and directed the script of *Johnny Got His Gun* (1971), based on his 1939 novel.

Tucker, Richard (Rubin Tucker, 1913–), U.S. tenor; he made his debut in 1943, at the Metropolitan Opera in 1945, and at Verona in 1947, opposite Maria CALLAS in her Italian debut. He was a leading singer at the Met for 30 years, in a wide range of roles, and was also a major recording artist.

Tucker, Sophie (Sonia Kalish, 1884–1966), U.S. singer and actress, on stage in vaudeville from 1906, a recording artist from 1910, and a headliner in variety from then through the mid-1950s. Her theme song from 1911 was her greatest hit, SOME OF THESE DAYS. She was on screen infrequently, from *Honky Tonk* (1929), but did get her "Red-Hot Mama" self-description from one of the songs in that film and used it for the rest of her life. She also appeared in such films as *Broadway Melody of 1938* and most notably on Broadway in *Leave It To Me* (1938). She appeared on radio during the 1930s and 1940s, and very late in her career also often appeared on television.

Tucker: The Man and His Dream (1988), the Francis Ford COPPOLA film, about Preston Tucker, his innovative automobile, and the forces he was unable to surmount. JEFF

BRIDGES played Tucker, leading a cast that included Martin Landau, Joan Allen, Frederic Forrest, Christian Slater, Dean Stockwell, Jay O. Sanders, Marshall Bell, Elias Koteas, Patti Austin, and LLOYD BRIDGES.

Tudor, Antony (1909–86), British dancer, choreographer, and teacher; he is best known for his dramatic, greatly internalized ballets, in the psychological mode, such as *Pillars of Fire* (1942), *Romeo and Juliet* (1943), *Dim Lustre* (1943), and *Undertow* (1945), done while he was a choreographer of the Ballet Theatre in New York. Tudor began his career with London's Ballet Rambert 1930–38, in that period choreographing such works as *Lilac Garden* (1936) and *Dark Elegies* (1937). He was later artistic director of the Royal Swedish Ballet (1963–64) and associate director of the American Ballet Theater (1974–80).

Tunes of Glory (1960), the Ronald Neame film, adapted by James Kennaway from his own novel. Alec GUINNESS played the colonel of a peacetime Scottish regiment, and John MILLS was the lieutenant colonel who is to replace him in command, the conflict between the two men becoming the focus of the film. Dennis Price, Kay Walsh, John Fraser, Susannah YORK, and Gordon JACKSON played key supporting roles.

Tune, Tommy (Thomas James Tune, 1939–), U.S. actor, director, dancer, and choreographer, who became a leading figure in the American musical theater in the 1980s. He has won such major awards as the best featured actor in a musical TONY in *Seesaw* (1974), a best choreographer Tony for *A Day in Hollywood/A Night in the Ukraine* (1980), a best director of a musical Tony for *Nine* (1982), acting and choreography Tonys for *My One and Only* (1983), and another best director of a musical Tony for *Grand Hotel* (1990).

Turandot (1926), the opera by Giacomo PUCCINI, based upon the 1765 Carlo Gozzi play, itself probably based on a traditional Chinese story; a melodrama in which a slave, in love with the suitor of her princess, ultimately commits suicide to save him, while the princess and suitor live happily ever after. An earlier *Turandot*, by Federico BUSONI, and also based

on the Gozzi play, was first performed at Hartford, in 1917.

Turner, Ike (1931–) and **Tina** (Annie Mae Bullock, 1938–), U.S. ROCK performers; they were married from 1958 to 1976. Ike Turner was a guitarist, bandleader, and producer from the late 1940s, and Tina Turner emerged as a singer with his band in the late 1950s; her first hit song was "A Fool in Love" (1960). They led a popular soul group through the mid-1970s. Going on alone, Tina Turner became a major popular singer from the mid-1980s, very notably with the album *Private Dancer* (1984), which includes her "What's Love Got to Do with It?" She also appeared in such films as *Tommy* (1975) and *Mad Max Beyond the Thunderdome* (1985).

Turner, Kathleen (1954–), U.S. actress, on screen from 1981, who quickly emerged as a star in the 1980s, with such films as *Body Heat* (1981), *Crimes of Passion* (1984), *Romancing the Stone* (1984), *Prizzi's Honor* (1985), *Peggy Sue Got Married* (1986), *Julia and Julia* (1988), *Switching Channels* (1988), and *The War of the Roses* (1989). She has also appeared on stage, television, most notably in the 1990 Broadway revival of CAT ON A HOT TIN ROOF.

Turner, Lana (Julia Jean Turner, 1920–), U.S. actress, on screen from 1937, who became a leading sex symbol Hollywood star in the 1940s. She appeared in such films as *Somewhere I'll Find You* (1942), THE POSTMAN ALWAYS RINGS TWICE (1946), *Cass Timberlane* (1947), *The Three Musketeers* (1948), *The Bad and the Beautiful* (1952), *Peyton Place* (1957), and *By Love Possessed* (1961).

12 Angry Men (1957), the Sidney LUMET film, adapted by Reginald Rose from his own 1954 television play for STUDIO ONE; about the shifting web of motives and relationships within a jury, as a single juror, played by Henry FONDA, demurs and ultimately turns a jury originally bent on conviction. The cast, playing strongly in ensemble, included Martin Balsam, Ed Begley, Edward Binns, Lee J. COBB, John Fielder, Jack Klugman, E.G. MARSHALL, Joseph Sweeney, Joseph Voscovec, Jack Warden, and Robert Webber.

12-note composition, from the mid-1920s, the development by Arnold SCHOENBERG and others of a mode of musical composition that uses a 12-note scale, arranged or rearranged in a specified order, or series, that serves as the basis of the composition. As originally developed by Schoenberg, 12-note music was by definition also atonal; later he and others were able to incorporate tonality, greatly broadening the range of composition available. Twelve-note music, the use of atonality, and then the further development of SERIALISM on the basis of 12-note musical theory were major departures in 20th-century music, ultimately transforming much of modern composition and performance.

"Twilight Zone, The" (1959–65), the long-running television science-fiction series created and largely written by Rod Serling, who also narrated the show. Two decades later, the series generated the John Landis film *Twilight Zone—the Movie* (1983), which in turn led to a second "Twilight Zone" television series (1985–87). This series was narrated by Charles Aidman and was without Serling, who died in 1975.

291, The Little Galleries of the Photo-Secession (1905–17), three small rooms on the top floor of 291 Fifth Avenue, in New York City, one of them from 1902 to 1905 the studio of Edward STEICHEN. In November 1905 these rooms became the showcase of the PHOTO-SECESSION, a movement led by Alfred STIEGLITZ, Steichen, and others, which helped make photography a major, fully recognized art form. By 1908, the 291 galleries were also showing the then-startling work of such European and American artists as Constantin BRANCUSI, Pablo PICASSO, and John MARIN; later Steichen introduced Georgia O'KEEFFE. The galleries played a major role in the introduction of MODERNISM to the United States.

2001: A Space Odyssey (1968), the space-traveling science-fiction film produced and directed by Stanley KUBRICK, who also handled the special effects and cowrote the screenplay with Arthur C. CLARKE, based on a Clarke short story. Keir Dullea, Gary Lockwood, William Sylvester, and Daniel Richter played key roles; Douglas Rain was the voice of HAL, the computer. The film generated a sequel: *2010* (1984), directed by Peter Hyams.

Tyson, Cicely (1932–), U.S. actress, on stage and in television from the early 1960s, who emerged as a major figure with her starring role in SOUNDER (1972) as Rebecca Morgan, the mother of a southern Black sharecropping family in the 1930s; she re-created the role in *Part Two, Sounder* (1976). Other major roles include the title role in the television film THE AUTOBIOGRAPHY OF MISS JANE PITTMAN (1974) and the Binta role in television's ROOTS (1977).

U

Ulanova, Galina Sergeyevna (1910–), Soviet dancer, a soloist of the Maryinsky Theatre, then the KIROV BALLET, 1928–44, and then of the BOLSHOI BALLET. From the mid-1940s she was generally regarded as the prima ballerina of the company and of the Soviet Union, occupying a role analogous to that of Anna PAVLOVA earlier in the century. She was acclaimed in all the major classical roles and created leading roles in such works as *Lost Illusions* (1935) and *Romeo and Juliet* (1940).

Ullmann, Liv (1938–), Norwegian actress, on stage from 1956 and on screen from 1957, who became a leading stage and screen player in Norway during the early 1960s. Her roles in such Ingmar BERGMAN films of the late 1960s as *Persona* (1966) and *The Passion of Anna* brought her international recognition as a leading European dramatic actress, as did subsequent leads in such films as *The Emigrants* (1971), *Cries and Whispers* (1972), SCENES FROM A MARRIAGE (1973), *Face to Face* (1976), and *Autumn Sonata* (1978), and her Broadway lead in *A Doll's House* (1975).

Ulysses (1922), the seminal novel by James JOYCE, which explores the inner worlds of its protagonists, Leopold BLOOM and Stephen Dedalus, as they lived a single day, June 16, 1904. The author's innovative, allusive use of language, resonation with Greek myth, and adoption of a stream-of-consciousness approach to the work combined to produce a powerful impact on the development of the 20th-century novel. *Ulysses* was widely perceived as obscene in its time and was banned in the United States until 1933.

Umberto D (1952), the Vittorio DE SICA film, a social commentary exploring the plight of a desperate old-age pensioner in postwar Italy. Unable to pay his rent, he and his beloved dog have nowhere to go, but he is unable to carry through his decision to commit suicide. De Sica and Cesare ZAVATTINI wrote the film; the key players were Carlo Battisti in the title role, Maria Pia Casilio, and Lina Gennari.

Unamuno y Jugo, Miguel de (1864–1936), Spanish writer and philosopher, whose essays, most notably in *The Tragic Sense of Life* (1913), considerably influenced the course of modern Spanish culture. His works included such novels as *Mist* (1914), *Abel Sanchez* (1917), and *Saint Manuel Bueno, Martyr* (1931). He also wrote a considerable body of short stories, plays, and several poetry collections.

Unbearable Lightness of Being, The (1984), the Milan KUNDERA novel, set in the late 1960s, which intertwines the busy yet uncommitted and therefore unfulfilled sexual life of its protagonist, a doctor, with his equally unfulfilled life as a man of his time in post-Soviet-invasion Communist Czechoslovakia. The novel became the 1988 Philip Kaufman film, which he and Jean-Claude Carriere adapted, with cinematography by Sven NYKVIST, and with a cast that included Daniel DAY LEWIS, Juliette Binoche, Lena Olin, Derek de Lint, and Erland JOSEPHSON.

Uncle Sam Wants You!, the World War I recruiting poster, by James Montgomery FLAGG. Four million copies were printed for that war, and it was used again in World War II.

Under the Volcano (1947), the Malcolm LOWRY novel, set in 1930s Mexico, exploring the inner world and self-destruction of an alcoholic British diplomat. It was adapted by Guy Gallo into the 1984 John HUSTON film, with

Albert FINNEY as the diplomat, opposite Jacqueline BISSET and Anthony Andrews.

Undset, Sigrid (1882–1949), Norwegian writer, best known for the historical trilogy *Kristin Lavransdatter* (1920–22), set in then-Catholic Norway during the Middle Ages. Her two-volume *The Master of Hestvikken* (1925–27) was set in medieval Norway during the Black Death. She also wrote many novels set in modern Norway, including *Jenny* (1911), the book that established her as a major literary figure. She fled Norway during World War II; exiled in the United States, she wrote two books in English: *Return to the Future* (1942) and *Happy Days in Norway* (1943). Undset was awarded the NOBEL PRIZE for literature in 1928.

Unité d'Habitation (1952), the high-rise concrete dwelling complex designed in Marseilles by LE CORBUSIER; a landmark expression of his planning and architectural theories, its massive concrete was a forerunner of the later "brutalist" approach.

Untermeyer, Louis (1885–1977), U.S. writer and editor, best known as a widely read poetry anthologist; his best-known work, the often-revised *Modern American Poetry* (1919), informed many student generations. He also was a poet, parodist, biographer, and writer of children's books.

Updike, John Hoyer (1932–), U.S. writer, whose second novel, *Rabbit, Run* (1960), established him as a major midcentury novelist. He took as his main theme middle-class morality and personal emptiness in American suburbia. *Rabbit Redux* (1971), and the PULITZER PRIZE-winning *Rabbit Is Rich* (1981), and *Rabbit at Rest* (1990) completed the series. His work also includes such novels as *The Centaur* (1963); *Couples* (1968); *Bech: A Book* (1970) and its sequel, *Bech Is Back* (1972); and *The Witches of Eastwick* (1984). Updike has also written several volumes of short stories, several poetry collections, a play, and a considerable variety of essays. Several of his works have been adapted for film, most notably *The Witches of Eastwick*, which became the 1987 George Miller film, with Jack NICHOLSON,

CHER, Susan Sarandon, and Michelle Pfeiffer in the key roles.

Up Front (1945), the celebrated collection of World War II cartoons by Bill MAULDIN, featuring WILLIE AND JOE, the two resigned, unyielding GIs who had become so popular in the pages of *Stars and Stripes* during the war.

"Upstairs, Downstairs" (1970–75), the extraordinarily popular television series about the life of a moneyed British family and its servants from the Edwardian period through the late 1920s. Gordon JACKSON played a central role as the butler Hudson, with Jean Marsh, Rachel Gurney, Jenny Tomasin, Gareth Hunt, and Hannah Gordon in key roles.

Uris, Leon Marcus (1924–), U.S. writer, whose wartime experiences informed his first novel, *Battle Cry* (1953). His main focus was on modern history, and especially on the Holocaust and the state of Israel, in such novels as *Exodus* (1958), *Mila 18* (1961), and *QB VII* (1976); he also wrote *Trinity* (1976), a novel on northern Ireland. Several of his works have been adapted for film, most notably *Battle Cry*, the 1955 Raoul WALSH film with Van HEFLIN, Tab Hunter, and Dorothy Malone in key roles, and the birth-of-Israel epic *Exodus*, the 1960 Otto PREMINGER film, with a huge cast led by Paul NEWMAN and Eva-Marie SAINT.

U.S.A, the trilogy of novels by John DOS PASSOS, consisting of *The 42nd Parallel* (1930), *1919* (1932), and *The Big Money* (1936); a seminal group of socially critical and realistic works, focusing on the underside of American life and on radical dissent from the end of World War I through the worst years of the Great Depression.

Ustinov, Peter Alexander (1921–), British actor, writer, and director, on stage from 1939 and on screen from 1940. He became a substantial theater and film figure from the early 1950s, most notably with his popular light plays *The Love of Four Colonels* (1951) and *Romanoff and Juliet* (1956); he also appeared in both plays and produced, directed, wrote, and acted in the 1961 film version of the latter. In addition, he appeared in increasingly strong supporting roles on screen, in such films as *Lola Montès* (1955), *Spartacus* (1960), and

Topkapi (1964), winning best supporting actor OSCARS for the latter two films. A notable later film was *Death on the Nile* (1978), in which he played Hercule POIROT. His extraordinarily varied career has also included the writing of several other plays, novels, and pieces of shorter fiction; the direction of plays, films, and operas; and a good deal of work in television.

Utrillo, Maurice (1883–1955), French painter, entirely self-taught, who emerged from a disturbed, sometimes criminal, and alcoholic early life to create a large body of highly regarded Parisian scenes, especially of his home district of Montmartre. His most notable work was done in his "white" period, from 1909 to 1914, although recognition came during the interwar period.

V

Vadim, Roger (Roger Vadim Plemiannikov, 1928–), French director, in films from 1947, who became a celebrity filmmaker with the box-office success of his then-daring first feature, *And God Created Woman* (1956), which presented his first wife, Brigitte BARDOT, in the nude. Sometimes mislabeled a NEW WAVE director, he continued to focus on erotic and sexual matters, in such films as *Les Liaisons Dangereuses* (1959); *Barbarella* (1968), which featured his third wife, Jane FONDA; and *Night Games* (1980).

Valentino, Rudolph (Rodolfo Alfonzo Guglielmi, 1895–1926), Italian-American dancer and actor, who in Hollywood became "The Sheik," by far the greatest matinee idol in film history. He emigrated from Italy in 1913 and was on stage in variety as a dancer in New York before going to Hollywood in 1917. He became an instant and massive international star and celebrity in 1921, with his lead in THE FOUR HORSEMEN OF THE APOCALYPSE, which he followed with great popular successes in such films as THE SHEIK (1921), BLOOD AND SAND (1922), *Monsieur Beaucaire* (1924), and *The Son of the Sheik* (1926). His death, due to a perforated ulcer, was the occasion of a tumultuous public funeral, and he remained a cult figure for decades afterward.

Valéry, Paul (1871–1945), French writer, a leading 20th-century poet and theorist of creativity, whose basic thinking was put forward in *The Evening with Mr. Teste* (1896) and then further developed for half a century in his massive notebooks, published in the 29 volumes of *Cahiers* (1957–61), long after his death. But it was his modest body of poetry that established him as a major literary figure; this includes his most celebrated work, *The Young Fate* (1917);

The Album of Early Verse (1920); *The Graveyard by the Sea* (1920); and *Charms* (1922).

Vallee, Rudy (Hubert Prior Vallee, 1901–86), U.S. singer and actor, who became the archetypal "crooner" of the 1920s and whose "The Rudy Vallee Show" (1929–43), with its "My Time Is Your Time" theme, was one of the leading programs in radio history. His first lead on Broadway was in *George White's Scandals* (1931), which he did on film in 1934; his last, three decades later, was in *How to Succeed in Business Without Really Trying* (1961), which he did on film in 1967. He was also on film in a considerable variety of other roles, from *The Vagabond Lover* (1929) and his other musicals of the 1930s and 1940s to his character roles of the postwar period.

Vamp, The, Theda BARA, as created by studio publicity after 1915.

Van Doren, Mark (1894–1972), U.S. writer and critic, whose first volume of *Collected Poems* (1939) won a PULITZER PRIZE; his later *Collected and New Poems* were published in 1963. His work also includes novels; short stories; a play; studies of Thoreau, Dryden, Shakespeare, and Hawthorne; and several volumes of essays, collected in such volumes as *Private Reader* (1941), *Liberal Education* (1942), and *The Happy Critic* (1961). His brother **Carl Van Doren** (1885–1950) was a writer, editor, and critic who won a PULITZER PRIZE for his biography *Benjamin Franklin* (1938), wrote several other historical works, and also did studies of James Branch Cabell, Jonathan Swift, and Sinclair LEWIS.

Van Druten, John William (1901–57), British-American writer, whose best-known plays, all written in the United States, are *The Voice of the Turtle* (1943); I REMEMBER MAMA (1944);

Bell, Book, and Candle (1950); and I AM A CAMERA (1951), based on Christopher ISHERWOOD's *Berlin Stories*. All four were further adapted: *The Voice of the Turtle* became the 1947 Irving Rapper film, with Ronald Reagan and Eleanor Parker in the roles created on stage by Margaret SULLAVAN and Elliott Nugent; *I Remember Mama* became the 1948 George STEVENS film, with Irene DUNNE in the title role, and was later the basis for a television series and a musical; *Bell, Book, and Candle* became the 1958 Bill Quine film, with James STEWART and Kim NOVAK in the leads; and *I Am a Camera* became the play (1951) and film (1955) of the same name, with Julie HARRIS in the Sally Bowles role, and the musical, CABARET (1966), with Jill Haworth as Sally Bowles. Liza MINNELLI won an OSCAR for the role in the 1972 film version of *Cabaret*.

Van Dyke, William S. (1889–1943), U.S. director, whose work was on film from 1917, usually in Westerns and other action films. Of his scores of competently made films, a few were notable, including *White Shadows in the South Seas* (1928), THE THIN MAN (1935) and three of its sequels, and SAN FRANCISCO (1936).

Varèse, Edgard (1883–1965), French-American composer, a leading exponent of MODERNISM from the early 1920s, who in the 1950s moved into electronic music. His most notable works include *Ameriques* (1921), *Hyperprism* (1923), *Arcana* (1927), *Ionisation* (1931), *Density 21.5* (1936), *Déserts* (1954), and *Poeme électronique* (1958).

Vargas Llosa, Mario (1936–), Peruvian writer, whose powerful, satirical novels focus on the despair engendered by corruption and hypocrisy in his native Peru and other Latin American countries. Although a social critic on the left, he emerged as a seminal modern Latin American novelist, as his enormously complex novels were seen to transcend contemporary issues. His major works include *The City and the Dogs* (1962, also translated as *The Time of the Hero*), *The Green House* (1965), *Conversation in a Cathedral* (1969), *The War of the End of the World* (1984), and *The Storyteller* (1989).

Vasarely, Victor (1908–), Hungarian artist, resident in France from 1930, a key figure in the development of OP ART. In the mid-1940s, he moved from graphics to paintings that combined geometric abstracts and the kinetic uses of color, and by the mid-1950s was producing and writing about works that used color to create the illusion of movement in an almost cinematic way, a process he therefore called *cinétisme*.

Vaughan, Sarah (Sarah Lois Vaughan, 1924–90), U.S. singer, a very well-received JAZZ and popular vocalist from the mid-1940s, who became a major figure with her recording of such songs as "It's Magic" (1947). She was a leading BOP singer in the late 1940s and went on to record and tour worldwide for the next four decades.

Vaughan Williams, Ralph (1872–1958), British composer; his work, deeply reflecting English folk and 15th-to-16th-century church music, was central in the development of 20th-century English music, beginning with such works as *A Sea Symphony* (No. 1, 1909), the songs set to the A.E. Housman poems in *On Wenlock Edge* (1909), *Fantasia on a Theme by Thomas Tallis* (1910), *A London Symphony* (No. 2, 1913), and *A Lark Ascending* (1914). His large body of work includes six more symphonies; the *Fifth* (1943) was later reflected in the music of his opera *The Pilgrim's Progress* (1951), while the *Seventh* (1953) was developed from his film score for *Scott of the Antarctic* (1949). He wrote several earlier operas and a large body of often-performed songs and other choral and orchestral works. Some of the most notable of his other works are the *English Folk Song Suite* (1921), the ballet *Job* (1931), *Grant Us Peace* (1936), and *An Oxford Elegy* (1949).

Vaughn, Robert (1932–), U.S. actor, on screen from 1957. He is best known for his role as Napoleon Solo in television's "The Man from U.N.C.L.E" (1964–68). He has also appeared in many films, including *The Young Philadelphians* (1959), *Bullitt* (1968), and *S.O.B.* (1981).

Veidt, Conrad (1893–1943), German actor, on stage from 1913 and on screen from 1917, who became a leading figure in the German cinema

in the classic THE CABINET OF DOCTOR CALI-
GARI (1919), which was followed by a long
series of major roles, most notably including
the title role in *The Student of Prague* (1926).
He made several films in Hollywood from 1926
to 1929, went back to Germany in 1929 as the
sound-film era began, and fled to Britain in
1933, then making films in Britain and France
until 1940, including *Under the Red Robe*
(1936); *Dark Victory* (1937); and *The Thief of
Baghdad*, which he began in Britain and fin-
ished in the United States in 1940. There he
played notable villains, in such films as *All
Through the Night* (1942) and *Casablanca*
(1943), before dying of a heart attack.

Vereen, Ben (1946–), U.S. actor, singer,
and dancer, who emerged as a leading player in
musical theater as Judas in JESUS CHRIST
SUPERSTAR (1971) and in his TONY-winning
lead in *Pippin* (1972). He created the Chicken
George role in ROOTS (1977) and appeared in
several other television miniseries and tele-
films, as well as in the series "J.J. Starbuck"
(1988–). He has also appeared in such
films as *Funny Lady* (1975) and ALL THAT
JAZZ (1979).

"Very British Coup, A" (1988), the British
television miniseries, the story of a conspiracy
to discredit and destroy Harry Perkins, the left
Socialist Labor Party prime minister of a near-
future Britain, who seriously threatens the rule
of established conservative elites. Ray
MCANALLY memorably created Harry Per-
kins, opposite Alan MacNaughton, as head of
the security service, in a cast that included
Tim McInnery, Jim Carter, Shane Rimmer,
and Kika Markham. The work was based on
the Chris Mullin novel, as adapted by Alan
Plater and directed by Mick Jackson.

Victor/Victoria (1982), a film musical comedy
written and directed by Blake EDWARDS,
based on the 1933 German film, *Victor and Vic-
toria;* Julie ANDREWS was in the title role, as a
failing singer in 1930s Paris who becomes a
huge hit masquerading as a female impersona-
tor. James GARNER and Robert PRESTON also
played leads, in a cast that included Lesley
Ann Warren, Alex Karras, and John Rhys-
Davies. Henry MANCINI and Leslie Bricusse
won an OSCAR for their score.

Vidal, Gore (1925–), U.S. writer, an
often-bitter satirist of modern American life,
manners, and politics, and a prolific writer in
many forms. His best known novels include a
continuing historical series: *Burr* (1972), *Lin-
coln* (1984), *Empire* (1987), and *Hollywood*
(1989); *Myra Breckenridge* (1968) and its
sequel, *Myron* (1972); and several works set in
the classic world, including *Julian* (1964) and
Creation (1980). His plays include *Visit to a
Small Planet* (1957), adapted from his own
television script, which became the 1960 Jerry
LEWIS film, directed by Norman Taurog; and
a powerful political drama, THE BEST MAN
(1960), which he adapted into the 1964 Frank-
lin SCHAFFNER film, with Henry FONDA and
Cliff ROBERTSON in the key roles. He wrote
several other screenplays as well, including
Suddenly, Last Summer (1959) and *Is Paris
Burning?* (1966). Early in his career he wrote
mysteries, as Edgar Box. He is also a very
active essayist and critic.

Vidor, King (1894–1982), U.S. director, whose
work was on screen from 1919. He did several
strong, often technically innovative films from
the mid-1920s into the mid-1930s, including
The Big Parade (1925), *The Crowd* (1928),
STREET SCENE (1931), and *Our Daily Bread*
(1934), then turning to such films as *Stella
Dallas* (1937), *Northwest Passage* (1940), *Duel
in the Sun* (1947), and *The Fountainhead*
(1949).

View from the Bridge, A (1955), the Arthur
MILLER one-act play, set on the Brooklyn
waterfront; Van HEFLIN created the Eddie
Carbone role, with Gloria Marlowe and Rich-
ard Davalos in key roles. In the 1962 Sidney
LUMET film Raf Vallone was Carbone, with
Maureen STAPLETON, Carol Lawrence, and
Jean Sorel in key roles.

Villa-Lobos, Heitor (1887–1959), Brazilian
composer; one of the key Latin American com-
posers of the 20th century, much of whose
very large body of work integrated Brazilian
folk and popular forms with European classical
music, as in the 12 works comprising *Chôros*
(1920–28) and the nine works comprising
Bachianas Brasilieras (1930–45). An extraordi-
narily prolific composer, his work includes 12

symphonies, 17 string quartets, concertos, operas, and symphonic poems.

Villon, Jacques (Gaston Duchamp, 1875–1963), French painter and printmaker, a pioneer Cubist who exhibited at the 1913 ARMORY SHOW in New York. From the 1920s he developed further modes of abstraction, at first developing a new mathematically oriented painting mode, and then moving toward abstraction without underlying meaning. He was also from the 1920s a leading French etcher and printmaker. Villon was brother of Marcel DUCHAMP and Raymond DUCHAMP-VILLON.

Virgin Spring, The (1960), the Ingmar BERGMAN film, set in medieval Sweden; it is based on a grim fable, in which a virgin is raped and murdered, her father takes vengeance on the murderers, and a spring rises at the site of her murder. The film was written by Ulla Isaksson and shot by Sven NYKVIST, with a cast that included Max von SYDOW, Birgitta Pettersson, Birgitta Valberg, and Gunnel Lindblom. It won a best foreign film OSCAR.

Visconti, Luchino (1906–76), Italian director, a child of the nobility, who worked with Jean RENOIR and others in France during the 1930s, there becoming a Communist, and made his first film, *Obsession* (1942), in Fascist Italy. He became a world figure in cinema during the postwar period, with such films as *Senso* (1954), *White Nights* (1957), and four classic works: ROCCO AND HIS BROTHERS (1960), THE LEOPARD (1963), THE DAMNED (1969), and CONVERSATION PIECE (1975). He was also active as a theater and opera director and costume designer in Italy.

Vishniac, Roman (1897–90), Russian photographer, resident in Berlin during the interwar period. He a made a unique photographic record of several European Jewish ghettos in the years immediately prior to World War II and the Holocaust; many of his most arresting photos were published in his *Vanished Worlds* (1983). He emigrated to the United States in 1940, then turning to photomicrography, and became a leading science photographer.

Vlaminck, Maurice de (1876–1958), French painter, entirely self-taught. Much impressed by Van Gogh, he emerged from 1901 as a powerful, violently expressive colorist, who exhibited with the Fauves in 1905. From 1906, much influenced by Cézanne, he moved toward the more fully composed, often somewhat darker-toned paintings that characterize much of his later work.

Voight, Jon (1938–), U.S. actor, on stage in the early 1960s and on screen from 1967, who became a leading player as male prostitute Joe Buck in MIDNIGHT COWBOY (1969), played a major role in DELIVERANCE (1972), and starred in an OSCAR-winning role as the paraplegic veteran in COMING HOME (1978), opposite Jane FONDA.

Vonnegut, Kurt, Jr. (1922–), U.S. writer, whose best-known novel, SLAUGHTERHOUSE-FIVE, OR THE CHILDREN'S CRUSADE (1969), was informed by his experience as a war prisoner during and after the firestorm generated by the World War II bombing of Dresden; it was adapted into the 1972 George Roy HILL film. Vonnegut is a black humorist whose work is often partly in the science-fiction style of his early work, but who always transcends the genre, in such other novels as *Player Piano* (1952), *The Sirens of Titan* (1959), *Cat's Cradle* (1963), *God Bless You, Mr. Rosewater* (1965), and *Deadeye Dick* (1972). He also wrote the play *Happy Birthday, Wanda June* (1970), which became the 1971 Mark Robson film, starring Rod STEIGER and Susannah YORK.

Voznesensky, Andrei Andreyevich (1933–), Soviet writer, who through his poetry became a leading spokesperson for the forces of reform in the Soviet society of the 1960s. His work, in direct line with that of his older friend and predecessor, Boris PASTERNAK, focused on common human themes, rather than on glorification of state and party; its wide acceptance and his public readings became affronts to the authorities, though the content of his work was far from revolutionary. Some of his best-known collections are *Parabola* (1960), *Mosaic* (1960), *Anti-Worlds* (1964), *Story Under Full Sail* (1970), and *The Master of Stained Glass* (1976).

Vuillard, Edouard (1868–1940), French artist, whose flat, muted, highly decorative style,

coupled with his early choice of primarily small-scale domestic interiors, caused him to be described as an "intimist." His work includes a considerable body of graphics, several stage sets, decorative panels, and murals, most notably those for the League of Nations at Geneva (1938). During the interwar period much of his work was in portraiture.

W

"Waist Deep in the Big Muddy" (1966), the Pete SEEGER song, with words and music by Seeger, that became an anti-Vietnam War anthem; the phrase became widely used to describe America's Vietnam position at the time.

Waiting for Godot (1953), the play by Samuel BECKETT, which became the first major work of what was later called the THEATER OF THE ABSURD, with its two derelicts, unable to take action or communicate, presenting Beckett's wholly alienated view of humanity ultimately failing to survive in a completely inimical world. It was first produced in French, then on the London stage in Beckett's own 1955 English translation, and in New York in 1956.

Waits, Tom (1949–), U.S. singer, songwriter, and actor, who became popular in the mid-1970s with such albums as *Closing Time* (1973), *Heart of Saturday Night* (1974), and *Nighthawks at the Diner* (1975); his later work includes *Foreign Affairs* (1977) and the soundtrack album from the film *One from the Heart* (1982). He has appeared in several other films as well, including *Down by Law* (1986) and IRONWEED (1987).

Wajda, Andrzej (1926–), Polish director, whose work was on screen from 1950. He gained international recognition with his anti-war trilogy *A Generation* (1954), *Kanal* (1957), and ASHES AND DIAMONDS (1958), then becoming Poland's leading modern film director. His later work includes *Man of Marble* (1977) and *Man of Iron* (1980). He is also active as a theater director.

Walker, Alice (1944–), U.S. writer, who takes as her theme the experience of Black women in the United States, and whose work is informed by her own share in that experi-

ence. Her novels include *The Third Life of Grange Copeland* (1970); *Meridian* (1976); and her PULITZER PRIZE-winning *The Color Purple* (1982), a southern Black woman's story that was adapted into Steven SPIELBERG's 1985 film, with Whoopi Goldberg in the central role. She has also written several volumes of poetry, beginning with *Once* (1968). Walker has published short stories, essays, and a biography of Langston HUGHES, and is largely responsible for the contemporary rediscovery of Zora Neale HURSTON, as editor of a selection of her works.

Walker, Robert (1918–51), U.S. actor, on screen from 1939. He became a star in the title role of *See Here, Private Hargrove* (1944); co-starred with his wife, Jennifer JONES, in *Since You Went Away* (1944); and went on to such films as *The Clock* (1945), *Till the Clouds Roll By* (1946), *Song of Love* (1947), and *Strangers on a Train* (1951).

Waller, Fats (1904–43), U.S. JAZZ musician, a composer, organist, pianist, singer, and bandleader. He began recording in the early 1920s; wrote the music for several shows, including *Keep Shufflin'* (1928) and *Hot Chocolates* (1929); and wrote many songs, including "Ain't Misbehaving" and "Honeysuckle Rose" (both 1929, with lyrics by Andy Razaf). He became a popular figure in the mid-1930s, with a long series of small group recordings that includes such standards as "Two Sleepy People" and "It's a Sin to Tell a Lie."

Wall Street (1987), the Oliver STONE film, about double-dealing and assorted other immoralities on Wall Street in the free-swinging mid-1980s. When made, it resonated with recent major securities-industry scandals, which were soon followed by even greater

scandals, providing the film with a sense of great immediacy. The cast included Michael DOUGLAS, Charlie Sheen, Hal Holbrook, Martin Sheen, Daryl Hannah, and Sylvia Miles. Douglas won a best actor OSCAR for his portrayal of fictive financier Gordon Gekko.

Walsh, Raoul (1887–1980), U.S. director and actor, whose work was on screen from 1914, often in action films. Some of his better-known works are WHAT PRICE GLORY? (1926), *The Roaring Twenties* (1939), HIGH SIERRA (1941), *Northern Pursuit* (1943), *White Heat* (1949), and THE NAKED AND THE DEAD (1958). Very early in his career he played John Wilkes Booth in BIRTH OF A NATION.

Walter, Bruno (Bruno Walter Schlesinger, 1876–1962), German conductor, a leading 20th-century interpreter of Gustav MAHLER, Wolfgang Amadeus Mozart, Johannes Brahms, and Richard STRAUSS. He conducted under Mahler at the Vienna Opera (1901–13), was musical director of the Munich Opera (1913–22), conducted at the Salzburg festival from 1925, and was conductor of the Leipzig Gewanhus (1929–33). Walter, a Jew, was forced by the Nazis to flee Germany in 1933 and Austria in 1938, then settling in the United States, where he conducted at the Metropolitan Opera (1941–57) and was conductor of the New York Philharmonic-Symphony Orchestra (1947–49).

Walton, William Turner (1902–83), British composer; his earliest notable work was the setting for FAÇADE (1922), the celebrated Edith SITWELL poetry recitation, which later became the 1931 ballet, choreographed by Frederick ASHTON. His best-known works include *Portsmouth Point* (1925), the *Viola Concerto* (1929), two symphonies (1935 and 1960), the *Violin Concerto* (1939), and the opera *Troilus and Cressida* (1954). He also wrote several film scores, including *As You Like It* (1936), HENRY V (1945), HAMLET (1948), and *Richard III* (1956).

"Waltons, The" (1972–81), the long-running television drama series, set in the Depression-era American South. The cast included Richard Thomas, Ralph Waite, Will Geer, Michael Learned, Ellen Corby, Robert Wightman,

Judy Norton-Taylor, Dami Cotler, David W. Harper, and Tom Bower. Earl Hamner, Jr. created and narrated the series.

"Waltzing Matilda" (1903), a song that has permeated Australian history throughout the 20th century, with music by Marie Cowan and words by A.B. Patterson. For the rest of the world it became emblematic of Australian courage and coolness under fire in two world wars, from Gallipoli on. It is now the Australian national anthem.

Wanamaker, Sam (1919–), U.S. actor and director, on stage from 1936 and on screen from 1948. He was blacklisted during the McCarthy period, and from 1952 lived and developed most of his work in Britain, there becoming artistic director of Liverpool's New Shakespeare Theatre in 1957 and also appearing in such films THE SPY WHO CAME IN FROM THE COLD (1965), *The Day the Fish Came Out* (1967), and *Voyage of the Damned* (1976), while directing several films, including *Catlow* (1971) and *Charlie Muffin* (1979). With the effective end of the blacklist he fully resumed his career, working on both sides of the Atlantic in a wide range of plays, films, and telefilms. A main focus from the early 1970s was the rebuilding of Shakespeare's Globe Theatre.

War and Peace, the Tolstoy novel (1864–69); it has been re-created in several forms and in many countries during the 20th century, perhaps most notably in the Oscar-winning 1968 Sergei BONDARCHUK film and in the Sergei PROKOFIEV opera, which premiered in Leningrad in 1946; it was also filmed by King VIDOR in 1956.

"War and Remembrance" (1989), the sequel to the notable 1983 THE WINDS OF WAR television miniseries; John GIELGUD replaced John HOUSEMAN in the Aaron Jastrow role.

Warhol, Andy (Andrew Warhola, 1930?–87), U.S. artist and filmmaker, who emerged in the early 1960s as a leading POP figure and celebrity, with silk-screened works featuring repetitive pictures of advertisements for such consumer goods as Coca-Cola bottles and Campbell Soup cans and celebrities, as well as such subjects as electric chairs and automobile

accidents. From 1963 he was also a filmmaker, producing and directing a considerable number of experimental films, such as *Kiss, Haircut, Bitch, The Velvet Underground and Nico, The Chelsea Girls*, and *Blue Movie* (1963–69), none of which made any perceptible impact on the development of cinema. After Warhol was shot and nearly killed in 1968, Paul Morrissey made several rather more conventional films in the Warhol series, including versions of FRANKENSTEIN and DRACULA.

Warner, Jack L. (1892–1978), U.S. film producer and operating head of Warner Brothers from the mid-1920s. His company became a major force in the film industry after its 1927 release of THE JAZZ SINGER. His involvement in films was for much of his career confined to business matters, although very late in his career he produced a few films, including MY FAIR LADY (1964) and CAMELOT (1967).

Warner, Sylvia Townsend (1893–1978), British writer, whose early novel *Lolly Willowes* (1926) was the first main selection of the Book-of-the-Month Club. Her subsequent novels include *The Corner That Held Them* (1948) and *The Flint Anchor* (1954). She was a prolific short-story writer, many of whose stories appeared in *The New Yorker* from the mid-1930s, and she also wrote several volumes of poetry.

"War of the Worlds" broadcast, the radio broadcast of October 30, 1938, describing Martian landings at Grovers Mills, New Jersey, which frightened millions of listeners so badly as to cause a national panic. It was generated by Orson WELLES's Mercury Theater of the Air, an offshoot of the MERCURY THEATER, and had been broadcast as fiction, which no one was expected to take seriously, being a dramatization of the supposedly well-known H.G. WELLS novel *The War of the Worlds*.

Warren, Harry (Salvatore Guaragna, 1893–1981), U.S. songwriter, who from the early 1930s created many of the most popular songs of the next three decades. A few of these are "I Found a Million-Dollar Baby in a Five-and-Ten-Cent Store" (1930, words by Billy Rose and Mort Dixon); "Shuffle Off to Buffalo" and the title song of 42ND STREET (1933, words to both by Al Dubin); "We're in the

Money" from GOLD DIGGERS OF 1933 (words by Al Dubin); "Boulevard of Broken Dreams," from *Moulin Rouge* (1933; words by Al Dubin); the OSCAR-winning "Lullaby of Broadway," from *Gold Diggers of 1935* (words by Al Dubin); the Oscar-winning "You'll Never Know," from *Hello Frisco Hello* (1943); "Chattanooga Choo-Choo," from *Sun Valley Serenade* (1941; words by Mack Gordon); and the Oscar-winning "On the Atchison, Topeka and the Santa Fe," from *The Harvey Girls* (1946; words by Johnny MERCER).

Warren, Leonard (1911–60), U.S. baritone; he made his debut at the Metropolitan Opera in 1939 and became a fixture at the Met, especially in Verdi, while also singing with several other major companies. He died on stage, during a performance of Verdi's *La Forza del Destino*.

Warren, Robert Penn (1905–89), U.S. writer and critic, whose many collections of poetry include *Eleven Poems on the Same Theme* (1942), *Selected Poems 1923–43* (1944), his PULITZER PRIZE-winning *Promises* (1957), *Incarnations* (1968), and *Now and Then* (1978); he was named first U.S. poet laureate, in 1985. He is best known for his Pulitzer Prize-winning 1946 novel, ALL THE KING'S MEN, a powerful study of corruption, taking as its subject the career of Louisiana governor Huey Long; as adapted and directed by Robert ROSSEN, it became the OSCAR-winning 1949 film, with Broderick CRAWFORD winning an Oscar in the leading role. Warren's many other novels include *Night Rider* (1939), *World Enough and Time* (1950), *Band of Angels* (1955), *The Cave* (1959), *Wilderness* (1961), and *A Place to Come To* (1977). He was also a prolific essayist and editor, especially of reviews and anthologies of southern writing; literary critic; and author of influential texts on southern writing.

Warwick, Dionne (1940–), U.S. singer, who emerged as a leading popular singer in 1962, when Burt BACHARACH and Hal David began their series of almost forty songs for her, beginning with such hits as "Don't Make Me Over" (1963) and "Walk On By" (1964). Her later songs were written by others, including the team of Bacharach and Carole Bayer Sager;

included in this later work were such albums as *A Man and a Woman* (1974) and *Friends in Love* (1982) and such songs as "There Came You" (1974) and the Bacharach–Bayer AIDS-benefit song "That's What Friends Are For" (1988), recorded by Warwick, Elton JOHN, Gladys KNIGHT, and Stevie WONDER. Warwick won several GRAMMYs including awards for "Do you know the way to San Jose" (1968), "I'll Never Fall in Love Again" (1970), and "I'll Never Love This Way Again" (1979).

Washington, Dinah (Ruth Lee Jones, 1924–63), U.S. BLUES singer, who began as a gospel singer, then appeared with Lionel HAMPTON's band from 1943 to 1946, and was best known for such songs as "Baby, Get Lost" (1949), "What a Difference a Day Makes" (1959), and "This Bitter Earth" (1960). Her untimely death was substance-abuse connected.

Washington, Ford Lee, "Buck" of the variety team of BUCK AND BUBBLES.

Waste Land, The (1922), T.S. ELIOT's highly influential long poem, technically and thematically a landmark in the development of English poetry, although its burden of negativism and despair was later in the decade jettisoned by Eliot himself, who embraced the Anglican branch of Christianity.

Watch on the Rhine (1941), the Lillian HELLMAN play. On Broadway, Mady Christians was Sarah, the American wife of German anti-fascist Kurt Mueller, played by Paul LUKAS. Lukas re-created the role, opposite Bette DAVIS, in the 1943 Herman Shumlin film. Dashiell HAMMETT wrote the screenplay; Lukas won a best actor OSCAR.

Waters, Ethel (1896–1977), U.S. singer and actress; she became a popular singer in the early 1920s and was on stage from 1927 in such musicals as *Africana* (1927), *As Thousands Cheer* (1933), and CABIN IN THE SKY (1940; and the 1943 film) and in dramatic roles in *Mamba's Daughters* (1939) and *The Member of the Wedding* (1950), in the latter creating the Berenice Sadie Brown role on Broadway and re-creating it in the 1952 film. She also played in such films as *Stage Door Canteen* (1943), *Pinky* (1949), and THE SOUND AND THE FURY (1959). She also starred in the television series "Beulah" (1950–52). Harold ARLEN's STORMY WEATHER (1933) was her song, which she popularized at the COTTON CLUB. She also introduced such songs as "Heat Wave," from *As Thousands Cheer*, and the title song of *Cabin in the Sky*, in that film also introducing "Taking a Chance on Love."

Waters, Muddy (McKinley Morganfield, 1915–83), U.S. BLUES singer, guitarist, and bandleader, who became a leading blues figure in the 1950s with such songs as "Rolling Stone" (1950), "Honey Bee" (1951), and "I'm Ready" (1954). He reached much wider ROCK audiences in later decades, with such albums as *Sail On* (1968), *They Call Me Muddy Waters* (1970), and *I'm Ready* (1978).

Waterston, Sam (Samuel Atkinson Waterston, 1940–), U.S. actor, whose wide and varied stage, screen, and television experience has included appearances in such plays as *Much Ado About Nothing* (1972) and *A Walk in the Woods* (1988), his very notable television title role in "Oppenheimer" (1982), and such films as THE GREAT GATSBY (1975) and THE KILLING FIELDS (1984).

Waugh, Evelyn Arthur St. John (1903–66), British writer, an often bitterly satirical critic of contemporary culture; after his 1930 conversion to Catholicism, his comments often reflected a conservative Anglo-Catholic point of view. His best known novels include *Decline and Fall* (1928); *Vile Bodies* (1930); *Black Mischief* (1932); *A Handful of Dust* (1934); *Scoop* (1930); BRIDESHEAD REVISITED (1945); *The Loved One* (1948); *Love Among the Ruins* (1953); the semiautobiographical *The Ordeal of Gilbert Pinfold* (1957); and the trilogy based on his wartime experiences: *Men at Arms* (1952), *Officers and Gentlemen* (1955), and *Unconditional Surrender* (1961). *Love Among the Ruins* was adapted into the 1975 George CUKOR television film, starring Katharine HEPBURN and Laurence OLIVIER. *Brideshead Revisited* was adapted by John Mortimer into the 11-part 1982 television series, with a cast that included Jeremy Irons, Anthony Andrews, Laurence OLIVIER, Claire BLOOM, and Diana Quick.

Wayne, John (Marion Michael Morrison, 1907–79), U.S. actor, on screen from 1927,

who began playing B-film Western leads in the early 1930s and scored a major breakthrough in STAGECOACH (1939). He ultimately became Hollywood's quintessential action-film lead, in such movies as *Reap the Wild Wind* (1942); *They Were Expendable* (1945); FORT APACHE (1948); RED RIVER (1948); SHE WORE A YELLOW RIBBON (1949); RIO GRANDE (1950); *The Quiet Man* (1952); *The Searchers* (1956); *Rio Bravo* (1959); *The Alamo* (1960); *In Harm's Way* (1965); *True Grit* (1969), for which he won an best actor OSCAR; *Rooster Cogburn* (1975); and *The Shootist* (1976). He also produced and directed several films, including *The Green Berets* (1969), which expressed his support for the war in Vietnam. Wayne died of cancer, probably contracted or worsened by his three-month-long radiation exposure near the Nevada Test Site in 1954, while filming THE CONQUEROR.

Way We Were, The (1973), the Sydney POLLACK film, adapted by Arthur LAURENTS from his own 1972 novel. Barbra STREISAND and Robert REDFORD starred, she as a campus radical who would not compromise her views, he as the college celebrity who had few views to compromise. The story follows them from the late 1930s and through the end of their marriage, in Hollywood in the early 1950s, as they split during the McCarthy period. The cast included Bradford Dillman, Lois Chiles, Viveca Lindfors, Murray Hamilton, Patrick O'Neal, Sally Kirkland, and James Woods. Marvin Hamlisch won an OSCAR for his score and for the title song, with lyrics by Alan Bergman and Marilyn Bergman.

"We Are the World" (1985), a song introduced at the very notable U.S.A. for Africa benefit, where it was sung to a worldwide audience from several locations simultaneously, via television; words and music were by Michael JACKSON.

Weary Willie, the enormously popular circus-clown character created by Emmett KELLY.

Weavers, The, U.S. folksinging group, formed in 1948 by Pete SEEGER (1919–), Lee Hays (1914–81), Ronnie Gilbert, and Fred Hellerman (1927–). The protest-oriented group was extremely popular for a few years

but was BLACKLISTED during the McCarthy period; before that happened the group had such hits as "Tzena, Tzena, Tzena," GOODNIGHT IRENE, "Kisses Sweeter Than Wine," "On Top of Old Smoky," "Wimoweh," and "The Midnight Special." The group was effectively destroyed by its blacklisting, although it did not formally disband until 1963.

Weber, Max (1881–1961), U.S. artist; while an art student in Paris from 1905 to 1908, he became an early participant in the seminal period of the modernist movement, and then played a role in introducing FAUVISM and CUBISM to the United States. He exhibited at 291, THE LITTLE GALLERIES OF THE PHOTO-SESSION, in 1910 and at the ARMORY SHOW of 1913, and produced such well-known cubist works as *Interior with Still Life* (1911) and *Chinese Restaurant* (1915), as well as several cubist sculptures.

Webern, Anton (1883–1945), Austrian composer, with Alban BERG a student of Arnold SCHOENBERG and an early exponent of atonality; he adopted the system of 12-NOTE COMPOSITION in 1924. His work includes many songs, a symphony (1928), and several other choral and instrumental works.

Webster, Margaret (1905–72), British actress and director, on stage from 1917, who became a leading player in London during the 1920s and early 1930s, largely in the classics. From 1936 she worked in the United States, from the late 1930s becoming the American theater's leading director of Shakespeare, most notably presenting and directing the long-running Paul ROBESON *Othello* (1943). She later cofounded the American Repertory Company and directed a wide variety of classic and modern plays. She was the daughter of actress May WHITTY and actor **Ben Webster**.

Weill, Kurt (1900–50), German composer, who collaborated with Bertolt BRECHT in *The Rise and Fall of the City of Mahagonny* (1927) and THE THREEPENNY OPERA (1928), their astringent, extraordinarily innovative modern adaptation of John Gay's *The Beggar's Opera*. Weill and his wife, Lotte LENYA, fled German fascism in the early 1930s, settling in the United States in 1935. There he composed the music

for such works as *Knickerbocker Holiday* (1938), *Lady in the Dark* (1941), *One Touch of Venus* (1943, a musical version of Elmer RICE's 1947 STREET SCENE), and *Lost in the Stars* (1949).

Weir, Peter (Peter Lindsay Weir, 1944–), Australian director. His best-known films include *Picnic at Hanging Rock* (1975), *The Last Wave* (1977), *Gallipoli* (1980), THE YEAR OF LIVING DANGEROUSLY (1982), *Witness* (1985), *The Mosquito Coast* (1986), and *The Dead Poets Society* (1989).

Weiss, Peter (1916–82), German writer, who left Germany in 1934 and settled in Sweden in 1939. His best-known play is MARAT/SADE (1964; the complete title is *The Persecution and Assassination of Marat as Performed by the Inmates of the Charenton Asylum Under the Direction of the Marquis de Sade*). His most notable plays also include *The Tower* (1967); *The Insurance* (1969); and several docudramas, including *The Investigation* (1965), based on the 1964 Frankfurt war-crimes prosecutions; *The Song of the Lusitanian Bogey* (1967), based on the Angolan insurrection; *Vietnam Discourse* (1968); and *Trotsky in Exile* (1970). He also wrote several novels and shorter pieces, including the autobiographical novels *Leavetaking* (1961) and *Vanishing Point* (1962).

Welk, Lawrence (1903–), U.S. band-leader, who led dance bands from the 1920s and whose straightforward, by then rather old-fashioned music (which he called "champagne music") appealed to large American audiences on television from 1955 through the early 1980s.

Welles, Orson (George Orson Welles, 1915–85), U.S. director, actor, writer, and producer, on stage in Dublin from 1931 and on Broadway in Katharine CORNELL's company from 1933 to 1934. He directed several plays for the FEDERAL THEATRE PROJECT, including the all-Black *Macbeth* (1936), and then with John HOUSEMAN cofounded the MERCURY THEATRE, there directing several plays, including *Julius Caesar* and *The Cradle Will Rock*. On radio their Mercury Theatre of the Air in 1938 did the extraordinary WAR OF THE WORLDS BROADCAST, which so frightened the American nation. Welles went to Hollywood in 1940,

where he produced, cowrote, and created the role on screen of CITIZEN KANE (1941), a character based on the life of William Randolph Hearst and one of the landmark films in the history of the medium. He followed it in 1942 with another classic, THE MAGNIFICENT AMBERSONS, and then ran into the Hollywood studio system and a succession of poorly realized films, coupled with his own inability to work within the Hollywood framework and to raise money for his projects. His Hollywood work includes such films as *Journey into Fear* (1942), *The Stranger* (1946), *The Lady from Shanghai* (1948), and *Macbeth* (1948); abroad, he generated many uncompleted projects, managing to do such films as *Othello* (1952), *Chimes at Midnight* (1966), and *F for Fake* (1975). Welles acted in all of the above, and indeed in all but a few of his films, also creating a memorable Rochester in JANE EYRE (1940) and Harry LIME in THE THIRD MAN (1948), as well as a long series of other powerfully realized character roles. Although his main work after 1939 was in film, he directed such plays as NATIVE SON (1941) and directed, produced, and played the leads in *Moby Dick* (1955) and *King Lear* (1956). He received a special ACADEMY AWARD in 1970.

Wellman, William Augustus (1896–1975), U.S. director, a former World War I fighter pilot and stunt flier whose work was on screen from 1923, and whose *Wings* (1927) established him as a first-rank Hollywood director. He went on to direct such films as *The Public Enemy* (1931), A STAR IS BORN (1937), *Beau Geste* (1939), *The Ox-Bow Incident* (1943), and *Lafayette Escadrille* (1958).

"We'll Meet Again" (1939), the British World War II song, perhaps the most resonant of them all; Vera LYNN, "The Forces' Sweetheart," became identified with the song; Ross Parker and Hughie Charles wrote the words and music. It was used to powerful ironic effect at the end of DR. STRANGELOVE.

Wells, H.G. (Herbert George Wells, 1866–1946), British writer, best known for such classic, often extraordinarily farsighted science-fiction novels as *The Time Machine* (1895), THE INVISIBLE MAN (1897), THE WAR OF THE WORLDS (1898), *When the Sleeper Awakes*

(1899), *The First Men in the Moon* (1901), *The War in the Air* (1908), and *The Shape of Things To Come* (1933). His other, more contemporary novels include *Love and Mr. Lewisham* (1900), *Kipps* (1905), *Tono-Bungay* (1909), *The New Machiavelli* (1908), and *Mr. Britling Sees It Through* (1918). He also wrote *The Outline of History* (1920); with Julian Huxley and George Philip Wells coauthored *The Science of Life* (1931); and wrote *Work, Wealth, and Happiness* (1932), as well as many essays and several works of social commentary, stemming from his socialist views. Wells's science-fiction novels were very often adapted into other forms, and never with more impact than on the night of October 30, 1938, when Orson WELLES's radio WAR OF THE WORLDS BROADCAST frightened the American nation with its tale of a Martian invasion. Other notable adaptations were the 1933 James WHALE film *The Invisible Man*, with Claude RAINS in the title role; and Wells's adaptation of *The Shape of Things to Come* into the 1936 William Cameron Menzies film THINGS TO COME, with Raymond MASSEY and Ralph RICHARDSON in the leads.

Welty, Eudora (1909–), U.S. writer, most of whose work is set in her native Mississippi. Her novels include *Delta Wedding* (1946), *The Ponder Heart* (1954), *Losing Battles* (1970), and her PULITZER PRIZE-winning *The Optimist's Daughter* (1972). She is as well known for her short stories, in such collections as *A Circle of Green* (1941), *The Wide Net* (1943), *The Golden Apples* (1949), *The Bride of Innisfallen* (1955), and *Moon Lake* (1980).

Werfel, Franz (1890–1945), Austrian writer, a prolific lyric poet, playwright, and novelist. While first recognized for his poetry, he is best known for such novels as *The Pure in Heart* (1929); *The Forty Days of Musa Dagh* (1933), set during the Armenian Holocaust; and *The Song of Bernadette* (1941), written in the United States, after Werfel, who was Jewish, had fled the Nazi occupiers of Austria in 1938. The latter novel became the 1943 Henry KING film, with Jennifer JONES in the title role. His best-known plays include *Goat Song* (1926), *Maximilian and Juarez* (1924), and *Jacobowsky and the Colonel* (1944).

Wertmuller, Lina (1928–), Italian director, who made several highly regarded films during the 1970s, including *The Seduction of Mimi* (1972), *Love and Anarchy* (1973), *All Screwed Up* (1974), *Swept Away . . .* (1974), and *Seven Beauties* (1976), but whose career foundered after an aborted long-term Hollywood contract.

Wesker, Arnold (1932–), British author, much of whose work is autobiographical. His earliest plays are the trilogy *Chicken Soup with Barley* (1958), *Roots* (1959), and *I'm Talking About Jerusalem* (1960), all set in London. His further work includes such plays as *The Kitchen* (1961); *Chips With Everything* (1962); *The Friends* (1970); *The Old Ones* (1972); *The Merchant* (1975), derived from *The Merchant of Venice*; and *Love Letters on Blue Paper* (1981), as well as a considerable variety of one-acters, film and teleplay scripts, short stories, children's books, and essays.

West, Mae (1892–1980), U.S. actress and writer, on stage in variety as a child, and a featured performer and then star in vaudeville, burlesque, and musical theater while still in her teens. She wrote much of her own material, focusing on sex and self-parody, and from the 1920s wrote, produced, and starred in several of her own plays, including *Sex* (1926), *Drag* (1927), the well-received *Diamond Lil* (1928), and *Catherine Was Great* (1944). She was on screen from 1932, in such films as *Night After Night* (1932), *I'm No Angel* (1933), *Klondike Annie* (1936), and *My Little Chickadee* (1940); three decades later she appeared in *Myra Breckenridge* (1970) and *Sextette* (1978).

West, Nathanael (Nathan Weinstein, 1903–40), U.S. writer, a bitter satirist who is best known for two novels: *Miss Lonelyhearts* (1933), adapted twice into film, in 1933 and in Vincent J. Donohue's 1958 *Lonelyhearts*, with Montgomery CLIFT, Robert RYAN, and Myrna LOY in key roles; and THE DAY OF THE LOCUST (1939), adapted by Waldo Salt into the 1975 John SCHLESINGER film, with Donald SUTHERLAND, William Atherton, and Karen Black in key roles.

West, Rebecca (Cicely Isabel Fairfield, 1892–1983), British writer, best known as a journalist

and political writer for her post-World II report-
ing on the trials of Nazi war criminals and for
such books as *Black Lamb and Grey Falcon*
(1942), on Yugoslavia; *The Meaning of Treason*
(1949); and *The New Meaning of Treason* (1964).
Her novels include *The Return of the Soldier*
(1918), *The Judge* (1922), *The Thinking Reed*
(1936), *The Fountain Overflows* (1957), and *The
Birds Fall Down* (1966). Her literary criticism
includes *The Court and the Castle* (1958). H.G.
WELLS was her common-law husband; their son
is writer Anthony West, a novelist, short-story
writer, essayist and author of *H.G. Wells:
Aspects of a Life* (1984).

"West End Blues" (1928), a classic Louis
ARMSTRONG JAZZ recording made with THE
HOT FIVE.

Weston, Edward (1886–1958), U.S. photogra-
pher. From the early 1920s, he sought a
sharply delineated realism, each image fully
defined and sized at the moment of taking the
picture, and not thereafter altered, in an
approach he called "previsualization." He
worked in Mexico during the mid-1920s and at
Carmel, California from 1927, there turning to
objects found in nature, his celebrated nude
studies, and landscapes and seascapes. His col-
lections include *California and the West* (1940)
and *My Camera on Point Lobos* (1950).

West Side Story (1957), the long-running
dance musical by Leonard BERNSTEIN, with
lyrics by Stephen SONDHEIM; book by Arthur
LAURENTS; and choreography by Jerome ROB-
BINS, who also directed the play. The work
was a highly innovative, strikingly staged
adaptation of *Romeo and Juliet*, placed in a
New York street-gang setting. Robbins and
Robert Wise directed the 1961 film version,
with a cast that included Natalie WOOD, Rich-
ard Beymer, Rita Moreno, Russ Tamblyn,
George Chakiris, and Tucker Smith. The film,
Robbins and Wise, cinematographer Daniel L.
Fapp, choreography, editing, art, costumes,
sound, and music all won OSCARS, as did Rita
Moreno as best supporting actress and George
Chakiris as best supporting actor.

Whale, James (1896–1957), British director,
who in 1928 directed the enormously popular
R.C. SHERRIFF play JOURNEY'S END and in

1930 went to Hollywood to direct it on screen.
He stayed, in the 1930s directing several clas-
sic films, including the horror films FRANKEN-
STEIN (1931), *The Old Dark House* (1932),
THE INVISIBLE MAN (1933), and *The Bride of
Frankenstein* (1935), as well as the musical
SHOW BOAT (1936).

Wharton, Edith (1862–1937), U.S. writer,
much of whose work is set in New York soci-
ety and in New England. Her best-known
works include the early novels *The Valley of
Decision* (1902) and *The House of Mirth* (1905),
which established her as a substantial literary
figure; a tragedy, the novelette *Ethan Frome*
(1911); her PULITZER PRIZE-winning novel
The Age of Innocence (1920); and the four nov-
elettes comprising *Old New York* (1928). She
was also a prolific, highly regarded, and much-
anthologized short story writer from the 1890s
through the mid-1930s and wrote two volumes
of poems. *Ethan Frome* was dramatized by
Owen and Robert Davis in 1936, with Ray-
mond MASSEY in the title role.

What Price Glory? (1924), the war play by
Maxwell ANDERSON and Lawrence Stallings,
acclaimed in its time for its pioneering realism.
It was the basis of the 1926 Raoul WALSH
film, with a cast that included Victor
McLAGLEN in the Captain Flagg role,
Edmund Lowe, and Dolores DEL RIO; and
again into the 1952 John FORD film, with a
cast that included James CAGNEY, Dan Dailey,
Robert Wagner, and Corinne Calvet.

"When It's Sleepy Time Down South" (1931),
Louis ARMSTRONG's signature song, with
words and music by Otis Rene, Leon Rene,
and Clarence Muse.

"Where Have All the Flowers Gone?" (1961),
an archetypal American protest song of the
1960s, with words and music by Pete SEEGER.

**"Where the Blue of the Night Meets the Gold
of the Day"** (1931), Bing CROSBY's signature
song, with words and music by Crosby, Roy
Turk, and Fred Ahlert.

White, E.B. (Elwyn Brooks White, 1899–
1985), U.S. writer, long associated with *The
New Yorker*, and the author of two very nota-
ble classic children's books: *Stuart Little* (1945)
and *Charlotte's Web* (1952). His essays, humor,

and verse were collected in such works as *The Lady Is Cold* (1929), *Every Day Is Saturday* (1934), *One Man's Meat* (1942), and *The Points of My Compass* (1962). With James THURBER, he co-authored *Is Sex Necessary?* (1929), a book of humorous essays. He also revised William Strunk's *The Elements of Style* (1959), which was thereafter known as "Strunk and White."

White, Josh (Joshua Daniel White, 1908–69), U.S. folk, BLUES, and protest singer and guitarist. He was a popular cabaret artist, recorded from the early 1940s, and was best known for his renditions of such songs as "The Midnight Special," "One Meat Ball," and "The House I Live In."

White, Patrick Victor Martindale (1912–90), Australian writer, one of his country's leading novelists, whose powerful, varied body of work includes novels, plays, screenplays, and short stories. He is best known for such novels as *Happy Valley* (1939), *The Living and the Dead* (1941), *The Tree of Man* (1955), *Voss* (1951), *The Eye of the Storm* (1973), and *The Twyborn Affair* (1979). In 1973 he was awarded the NOBEL PRIZE for literature.

White, Pearl (1889–1938), U.S. actress, on stage as a child and on screen from 1910, who became the star of scores of short films and several serials, most notably the serial THE PERILS OF PAULINE (1914), which became the most popular silent film series in movie history, making her one of the leading stars of her time.

"White Christmas" (1942), the Bing CROSBY standard, which he introduced in the film *Holiday Inn* (1942); words and music were by Irving BERLIN.

White Hunter, Black Heart (1990), the Clint EASTWOOD film; the Peter Viertel screenplay was an adaptation of his own 1953 novel, based on his observation of John HUSTON while working with Huston on the screenplay of THE AFRICAN QUEEN, on location in Africa. Eastwood, who produced and directed the film, starred as John Wilson, who is clearly Huston, in a cast that included Jeff Fahey as Pete Verrill, in the Viertel role; Charlotte Cornwell; George Dzundza; and Marisa Berenson.

Whitelaw, Billie (1932–), British actress, on stage from 1954 and on screen from 1959, who became a leading player in the 1960s, most notably at Britain's National Theatre (1963–65). Her later plays include *The Greeks* (1980), *Rockaby* (1982), and WHO'S AFRAID OF VIRGINIA WOOLF? (1987). She appeared in such films as CHARLIE BUBBLES (1968) and THE OMEN (1976) and has worked extensively on television and radio.

Whiteman, Paul (1890–1967), U.S. bandleader, very popular during the 1920s and through the late 1930s, beginning with such early 1920s records as "Whispering," "Wang Wang Blues," and "Japanese Sandman," all in 1920, and including scores of other popular hits. He commissioned and premiered George GERSHWIN's *Rhapsody in Blue* (1924). His band also appeared on radio and in several theater musicals and films, and he played the lead in the film *The King of Jazz* (1930).

White on White, (1918), the painting by Russian suprematist Kasimir MALEVICH, one of the emblematic paintings of the modern art movement; its full title is *Suprematist Composition: White on White.*

Who, The, British ROCK band, formed in 1964 by Roger Daltry (1944–), Pete Townshend (1945–), Keith Moon (1947–78), and John Entwhistle (1944–), which for the next two decades was one of the leading bands in rock music, on tour and with such songs as "My Generation" (1965) and "Happy Jack" (1966), the title song of one of their albums, and such other albums as *The Who Sell Out* (1967) and *Magic Bus* (1968). They broke entirely new ground with Townshend's rock opera TOMMY (1969); their concert version became a hit album, and the work became the 1975 Ken Russell film. *Quadrophenia* (1973) was Townshend's second rock opera; it, too, became a hit album and then became the 1975 Franc Roddam film. A later notable album was *Who Are You?* (1978).

Who's Afraid of Virginia Woolf? (1962), the TONY-winning Edward ALBEE play, which focused on the corrosive battle between its two thoroughly alienated protagonists, played on stage by Uta Hagen and Arthur Hill, who also

won Tony's for their roles. The play was adapted by Edward Lehman into the 1966 film, with Richard BURTON and Elizabeth TAYLOR playing the leads and with Mike NICHOLS directing his first film. Taylor won a best actress OSCAR; Sandy Dennis won a best supporting actress OSCAR.

"Why Do I Love You?" (1927), a duet from SHOW BOAT, with music by Jerome KERN and words by Oscar HAMMERSTEIN II, introduced on Broadway by Norma Terris and Howard Marsh in 1927 and sung most notably on screen by Irene DUNNE and Allan Jones in the classic 1936 film version.

Widmark, Richard (1914–), U.S. actor, on radio from 1938; on stage from 1943; and on screen from his film debut in *Kiss of Death* (1947), for which he won a best supporting actor OSCAR nomination. He made scores of films in the following four decades, emerging as a substantial dramatic star in such movies as JUDGMENT AT NUREMBERG (1961); CHEYENNE AUTUMN (1964); and *Madigan* (1968), which was also the basis for his 1972 "Madigan" television series. His television work has also included "Cold Sassy Tree" (1989).

Wiegel, Helene (1901–81), Austrian actress, who became a leading player in Germany during the Weimar period in such roles as *Maria Magdalene* (1925) and MOTHER (1932), adapted by Bertolt BRECHT from the Maxim GORKY novel. She was Brecht's wife from 1928; they left Germany together in 1933. She resumed her career when cofounding the Berliner Ensemble with Brecht in 1949. Then she became a leading interpreter of Brecht, very notably in *Mother Courage*. She managed the company after his death in 1956.

Wiesel, Elie (1928–), U.S. novelist, born in Rumania and a survivor of Auschwitz and Buchenwald, who writes mainly in French and has taken the Holocaust for his chosen subject. His novels, which have achieved worldwide impact, are largely autobiographical; some of the best known are *Night* (1960), *Dawn* (1961), *The Accident* (1962), *The Gates of the Forest* (1966), *A Beggar in Jerusalem* (1970), *The Testament* (1981), and *The Fifth Son* (1985). In

1985 he was awarded the NOBEL PEACE PRIZE.

Wigman, Mary (1886–1973), German dancer, who became the leading modern dancer and MODERN DANCE teacher of the Weimar period. She created hundreds of works, and her Dresden-based school, opened in 1920, became a center for modern dance in Europe and America. The Nazis ultimately closed her school, which she reopened after the war, at Leipzig and then West Berlin. Hanya HOLM worked with Wigman in Germany from 1921, and began her American career by founding Wigman's American School in 1931.

Wilbur, Richard (1921–), U.S. writer and translator, a prolific poet who has published many collections of poetry, from *The Beautiful Changes* (1947) through *New and Collected Poems* (1988). His *Poems* (1957) won a PULITZER PRIZE. His translations from the French include *The Misanthrope* (1955), *Tartuffe* (1963), *School for Wives* (1971), *Andromache* (1982), and *Phaedra* (1976).

Wilder, Billy (Samuel Wilder, 1906–), Austrian-American writer, director, and producer, who wrote or cowrote 11 films in Germany from 1929 to 1933; a Jew, he fled the Nazis in 1933 and was in Hollywood from 1934. In 1938, he began the 12-year-long collaboration with Charles Brackett that generated the screenplays of such films as NINOTCHKA (1939); THE LOST WEEKEND (1945), for which he and Brackett won a best screenplay OSCAR; and SUNSET BOULEVARD (1950). Wilder directed the latter two films, winning a best director OSCAR for *The Lost Weekend*, and also directed such films as WITNESS FOR THE PROSECUTION (1958); SOME LIKE IT HOT (1959), and THE APARTMENT (1960), for which he won another best director Oscar and shared another best screenplay Oscar, this time with I.A.L. Diamond. His later works include *Fedora* (1978).

Wilder, Thornton (1897–1975), U.S. writer, who emerged as a popular novelist and substantial literary figure with his PULITZER PRIZE-winning second novel, *The Bridge of San Luis Rey* (1927). Other novels were *The Cabala* (1926), *The Woman of Andros* (1930),

Heaven's My Destination (1935), *The Ides of March* (1948), *The Eighth Day* (1967), and *Theophilus North* (1973). His innovative play OUR TOWN (1938), celebrating small-town, democratic New England values, won a second Pulitzer and established him as a major playwright; he coadapted it into the 1940 Sam Wood film. His play THE SKIN OF OUR TEETH (1942) won yet a third Pulitzer. Wilder's long-running *The Matchmaker* (1955) was later adapted into the musical HELLO, DOLLY!

Wild Strawberries (1955), a film written and directed by Ingmar BERGMAN and shot by Gunnar Fischer, with Victor Sjöstrom as the old professor who reviews his life in a series of flashbacks. The cast included Ingrid Thulin, Bibi ANDERSSON, Gunnar Bjorstrand, Gunnar Sjöberg, Gunnal Brostrom, and Max von SYDOW.

Williams, Andy (1930–), U.S. singer, popular on television, with regular appearances on the "Tonight" show (1952–54) and then as host of several shows of his own from 1957 to 1971. Among his many hit songs are "Butterfly," "Days of Wine and Roses," and "Moon River."

Williams, Clarence (1898–1965), U.S. JAZZ musician, a pianist, composer, and bandleader. He was a key figure in the history of jazz for his organization of many classic jazz recording sessions in the mid-1920s, especially those of Bessie SMITH; he was her leading accompanist. His songs include "Baby, Won't You Please Come Home" and "Cake Walking Babies from Home."

Williams, Emlyn (George Emlyn Williams, 1905–87), Welsh actor and writer, on stage from 1927 and on screen from 1932. His many plays most notably include *Night Must Fall* (1935), in which he played Danny, a role played by Robert Montgomery opposite Rosalind RUSSELL in the 1937 film version; and the autobiographical THE CORN IS GREEN (1938). In the latter he played the Morgan Evans role on stage in London and New York opposite Sybil THORNDIKE. Williams also played leads in several of his other plays, appeared in several other roles on stage, and was in many sup-

porting roles on screen. He also toured very successfully in three solo sets of readings: of Dickens, in 1951; of Dylan THOMAS, in 1955, and of SAKI, in 1977.

Williams, Hank (Hiram Williams, 1929–53), U.S. country singer, who became a recording star in the late 1940s, with such songs as "Lovesick Blues" (1949) and "Cold, Cold Heart" (1951). He became an even more popular figure after his untimely, probably substance-abuse-related death. The Gene Nelson biographical film *Your Cheatin' Heart* (1964) starred George Hamilton as Williams. His son **Hank Williams, Jr.** (Randell Hank Williams, 1949–), also became a country singer.

Williams, John Towner (1932–), U.S. composer and conductor, who became a leading film music composer in the early 1970s. He won OSCARS for FIDDLER ON THE ROOF (1971), JAWS (1975), STAR WARS (1977), and E.T. (1982) and composed scores for such other films as CLOSE ENCOUNTERS OF THE THIRD KIND (1977), JAWS II (1978), SUPERMAN (1978), RAIDERS OF THE LOST ARK (1981), *Indiana Jones and the Temple of Doom* (1984), and EMPIRE OF THE SUN (1988). He was conductor of the Boston Pops Orchestra from 1980 to 1984, and is also a prolific recording artist.

Williams, Robin (1952–), U.S. actor and comedian, in cabaret from the 1970s and the star of television's "Mork and Mindy" series (1978–82). He became a movie star in the 1980s, with such films as THE WORLD ACCORDING TO GARP (1982); *Moscow on the Hudson* (1984); *Club Paradise* (1986); *Good Morning, Vietnam* (1987); *The Dead Poets Society* (1989); *The Adventures of Baron Munchausen* (1989); and *Awakenings* (1990).

Williams, Tennessee (Thomas Lanier Williams, 1911–83), U.S. writer, one of the leading playwrights of the American theater. He was a prolific writer who created a very substantial body of major works, some of them emerging as classics long after their introduction; indeed, his very early *Battle of Angels* (1940) failed in tryouts, was revised in 1957 to become *Orpheus Descending*, and fully emerged as a classic American play in its 1989 revival,

with Vanessa REDGRAVE in the lead. Some of his most notable plays are THE GLASS MENAGERIE (1945), with Eddie Dowling, Laurette TAYLOR, and Julie Haydon in the leads, which established him as a major playwright; the PULITZER PRIZE-winning A STREETCAR NAMED DESIRE (1947), in which Marlon BRANDO so memorably created the Stanley KOWALSKI role and Jessica TANDY created Blanche DU BOIS; SUMMER AND SMOKE (1948); the TONY-winning THE ROSE TATTOO (1950); *Camino Real* (1953); the Pulitzer Prize-winning CAT ON A HOT TIN ROOF (1955); *Suddenly, Last Summer* (1958); SWEET BIRD OF YOUTH (1959); *Period of Adjustment* (1960); *The Night of the Iguana* (1962); and *The Milk Train Doesn't Stop Here Anymore* (1963). He also wrote a considerable volume of short stories; essays; poetry; and two novels, one of them *The Roman Spring of Mrs. Stone* (1950), which became the 1961 film starring Vivien LEIGH. Many of his plays became films, several of them more than once. *The Glass Menagerie* was filmed three times, in 1950, 1973, and 1987, with Amanda Wingfield played successively by Gertrude LAWRENCE, Katharine HEPBURN, and Joanne WOODWARD. Vivien LEIGH won an OSCAR for her Blanche Du Bois, while Marlon BRANDO re-created Stanley Kowalski in Elia KAZAN's 1951 *A Streetcar Named Desire*. Anna MAGNANI won an OSCAR in Delbert MANN's 1955 *The Rose Tattoo*, opposite Burt LANCASTER. Richard BROOKS's 1958 *Cat on a Hot Tin Roof* starred Elizabeth TAYLOR and Paul NEWMAN. Gore VIDAL adapted *Suddenly, Last Summer* into the 1959 Joseph L. MANKIEWICZ film, starring Katharine HEPBURN, Elizabeth TAYLOR, and Montgomery CLIFT. *Summer and Smoke* became the 1961 Peter Glenville film, with Laurence HARVEY and Geraldine PAGE in the leads. The 1962 George Roy HILL *Period of Adjustment* featured Jane FONDA, Tony Franciosa, Jim Hutton, and Lois Nettleton. The 1962 Richard BROOKS *Sweet Bird of Youth* starred Paul Newman and Geraldine Page, with Ed Begley in an Oscar-winning supporting role, and also featured Shirley Knight and Rip Torn. *The Night of the Iguana* became the 1964 John HUSTON film, with Richard BURTON, Deborah

KERR, Ava GARDNER, and Sue Lyon in central roles.

Williams, William Carlos (1883–1963), U.S. writer, a poet who took as his theme and source the everyday life around him, often being described as "nativist," in contrast with such expatriates as Ezra POUND and T.S. ELIOT. His first collection was *Poems* (1909); much of his early work is found in *Complete Collected Poems 1906–38* (1938), which was followed by *The Collected Later Poems* (1950) and such collections as *Journey to Love* (1955) and the PULITZER PRIZE-winning *Pictures from Breughel* (1963). His *Paterson* (1946–58) is a five-volume poetry and prose work set in his own Paterson, New Jersey, where he worked as a family doctor. A prolific writer, his work also includes a considerable body of essays, several plays, and four novels; perhaps best known are his essays in *In the American Grain* (1925).

Willie and Joe, the disheveled, steadfast, enormously popular GIs created by cartoonist Bill MAULDIN while he was attached to *Stars and Stripes* in the Mediterranean theater during World War II. He took them through the war, and then Willie, Joe, and Bill all went home, most notably in the collections UP FRONT (1945) and COMING HOME (1947).

Wilson, Angus (1913–), British writer and critic, who emerged as a major satirist and moralist with his first published work, the short stories collected in *The Wrong Set* (1949). His best-known novels include *Hemlock and After* (1952), *Anglo-Saxon Attitudes* (1956), *The Old Men at the Zoo* (1961), *No Laughing Matter* (1967), and *Setting the World on Fire* (1980). His critical works include studies of Zola, Dickens, and Kipling; several volumes of essays; and a play, *The Mulberry Bush* (1955).

Wilson, August (1945–), U.S. writer, a poet and playwright who has taken his chosen themes from Black American life. He began to publish poetry in the early 1970s and during the 1980s emerged as a powerful new voice in the American theater, with such plays as *Jitney* (1982); *Ma Rainey's Black Bottom* (1984); his TONY-winning FENCES (1987); and THE

PIANO LESSON (1989), which won a Tony and a PULITZER PRIZE.

Wilson, Edmund (1895–1972), U.S. writer, critic, and editor, whose prolific work include such diverse works as his early literary analysis of symbolism, *Axel's Castle* (1931); *To the Finland Station* (1940), about the Bolshevik and other European revolutions; the collected essays in such works as *The Shores of Light* (1952) and *The Bit Between My Teeth* (1965); and his most widely circulated work, the novel *Memoirs of Hecate County* (1946), which achieved the distinction of being banned for alleged obscenity in several jurisdictions and was (at least partly due to this) an enormously popular novel. He also wrote several plays, journals, and reviews, and the autobiographical *Upstate* (1961).

Wilson, Lanford (1937–), U.S. writer, whose early plays include *Balm in Gilead* (1964), a slice of New York life; *The Gingham Dog* (1968); *Lemon Sky* (1970); and *The Hot L Baltimore* (1973), set in a New York hotel. He is probably best known for his plays about the Talley family: *The Fifth of July* (1978), the PULITZER PRIZE-winning TALLEY's FOLLY (1980); *A Tale Told* (1981), and *Talley and Son* (1985).

Wimsey, Lord Peter, the fictional detective created by Dorothy SAYERS, played memorably by Ian CARMICHAEL and then Edward Petherbridge in several 1970s and 1980s television series, and somewhat less memorably by Robert MONTGOMERY in the film *Busman's Honeymoon* (1940).

Winds of War, The (1971), the Herman WOUK novel, set in the early years of World War II, up to the Pearl Harbor attack and the entry of the United States into the war; its sequel, *War and Remembrance* (1978), covered the rest of the war years, focusing on the Holocaust. Wouk adapted THE WINDS OF WAR into the massive 1983 television miniseries, with Robert MITCHUM in the central Pug Henry role, playing in ensemble with Polly Bergen, John HOUSEMAN, Jan-Michael Vincent, Victoria Tennant, Ali McGraw, Ben Murphy, David Dukes, Peter GRAVES, Lisa Eilbacher, Ralph BELLAMY, Jeremy Kemp, and many

other notable players in smaller supporting roles. Wouk also adapted *War and Remembrance* into the equally massive 1989 miniseries, notably with John GIELGUD in the Aaron Jastrow role, originally played by Houseman.

Winnie-the-Pooh, Christopher Robin's celebrated teddy bear, as first created by A.A. MILNE in 1926.

Winterset (1935), the verse play by Maxwell ANDERSON, which was inspired by the Sacco–Vanzetti case. Burgess MEREDITH played the leading role on stage, in a cast that included Richard BENNETT and Margo; Meredith recreated the role in the 1936 Alfred Santell film, in a cast that included Eduardo Ciannelli, Margo, and John CARRADINE.

Witness for the Prosecution (1957), the Billy WILDER film, based on the 1953 Agatha CHRISTIE play, with screenplay by Wilder and Harry Kurnitz. The movie focused on a London murder prosecution, with Charles LAUGHTON as attorney for the defense, Tyrone POWER as the acccused murderer, Marlene DIETRICH as his wife, and Elsa Lanchester as the nurse, in a cast that included John Williams and Henry Daniell in key supporting roles. It was remade in 1982, with a cast that included Ralph RICHARDSON, Diana RIGG, and Beau BRIDGES in the leads and Deborah KERR as the nurse.

Wizard of Oz, The (1939), the film musical classic. Judy GARLAND played Dorothy, with her dog Toto whisked from her Kansas home by a tornado and deposited in the fairyland of Oz, in a cast that included Ray BOLGER as the Scarecrow, Bert Lahr as the Cowardly Lion, Jack Haley as the Tin Woodman, Frank Morgan as the Wizard, Billie Burke as the Good Witch, and Margaret Hamilton as the Wicked Witch. Victor FLEMING directed. Yip HARBURG and Harold ARLEN won an OSCAR for the song OVER THE RAINBOW and Herbert Stothart for the music. Garland won a special Academy Award. The film was based on L. Frank BAUM's children's novel *The Wonderful Wizard of Oz* (1900), which generated 13 sequels and Baum's 1903 Broadway musical. Baum's story was also the basis of the 1975 all-

Judy Garland (right) as Dorothy with Billie Burke as the Good Witch in Hollywood's classic *The Wizard of Oz* (1939).

Black Broadway musical *The Wiz* and its 1978 sequel, starring Diana ROSS.

Wodehouse, P.G. (Pelham Grenville Wodehouse, 1881–1975), British writer, a humorist who is chiefly known for his fictional butler Jeeves, first seen in *The Inimitable Jeeves* (1924), with his employer, Bertie Wooster. Wodehouse also collaborated on several Broadway musicals, including *Miss Springtime* (1916), *Oh, Kay!* (1926), and ANYTHING GOES (1934).

Wolfe, Nero, the fictional, highly cerebral, overly corpulent, orchid-loving, woman-hating master detective created by Rex STOUT in a long series of detective stories narrated by his assistant, Archie Goodwin.

Wolfe, Thomas (1900–38), U.S. writer, who emerged as a major literary figure with his powerful, massive first novel, the autobiographical *Look Homeward, Angel* (1929), set in his native Asheville, North Carolina. He wrote three more novels: *Of Time and the River* (1935), and the posthumously published *The Web and the Rock* (1939) and *You Can't Go Home Again* (1940). His short stories were col-

lected in *From Death to Morning* (1935) and *The Hills Beyond* (1941).

Wolfe, Tom (Thomas Kennerly Wolfe, Jr., 1931–), U.S. writer and artist, a journalist whose social commentary became popular in the 1960s. His first collection was *The Kandy-Kolored Tangerine-Flake Streamline Baby* (1965). His later work includes several other collections of essays and drawings and a National Book Award-winning nonfiction work on the beginning of American space flight, *The Right Stuff* (1980), which was the basis of the 1983 Philip Shepard film, with Sam SHEPARD, Scott Glenn, Randy Quaid, and Ed Harris in key roles. His later work includes the novel *The Bonfire of the Vanities* (1987), which became the 1990 Brian DePalma film.

Women in Love (1920), the D.H. LAWRENCE novel, which focuses on the sexual lives and philosophies of the two couples that are its protagonists, and through them rather directly propounds his own views. It is thought to be largely autobiographical, dealing with the lives of Lawrence; his wife, Frieda; Katherine

MANSFIELD; and John Middleton Murry. The cast of the 1970 Ken Russell film included Glenda JACKSON, Alan BATES, Oliver Reed, and Eleanor Bron; Jackson won a Best Actress OSCAR.

Wonder, Stevie (Steveland Judkins Morris, 1950–), U.S. musician, a singer, composer, and multitalented instrumentalist, who began as a child prodigy on the harmonica and several other instruments, and in later years adopted the synthesizer as his major vehicle. He became one of the leading American popular musicians of the modern period, with scores of hit songs and albums, and also became a leading figure in many movements for social betterment and justice. His albums have developed from *Little Stevie Wonder, the 12-Year-Old Genius* (1963) through such more mature works as *Music of My Mind* (1972), the GRAMMY-winning *Songs in the Key of Life* (1976), *Journey Through the Secret Life of Plants* (1979), and *Characters* (1987). A few of his most memorable songs are "Cherie Amour" (1969), "You Are the Sunshine of My Life" (1972), and his OSCAR-winning "I Just Called to Say I Love You" from the film *The Woman in Red* (1984). Wonder was blind from birth, making his career and set of accomplishments even more extraordinary.

Wonderful Town (1953), the long-running TONY-winning Broadway musical, adapted by Joseph Fields and Jerome Chodorov from their 1940 play *My Sister Eileen*. Rosalind RUSSELL, who had starred in the 1942 film version of the play, did a Tony-winning re-creation of the role in the musical, with Edith Adams as Eileen. The original play had starred Shirley BOOTH, with Jo Ann Sayers as Eileen. Leonard BERNSTEIN wrote the music, with lyrics by Betty COMDEN AND ADOLPH GREEN.

"Wonder Years, The" (1988–), the television situation comedy, a nostalgic story of late-1960s America. At its center is Fred Savage, as 12-year-old Kevin Arnold, in a cast including Daniel Stern as the offstage narrating voice of the adult Kevin Arnold and Olivia d'Abo, Jason Hervey, Alley Mills, and Dan Lauria as the rest of the family.

Wood, Grant (1892–1942), U.S. painter, the preeminent midwestern realist of the early 1930s. His best-known work is his hard-edged, bitterly realistic AMERICAN GOTHIC (1930). His notable *Daughters of Revolution* (1932), which posed three grim-visaged women against *Washington Crossing the Delaware*, quite explicitly attacked the Daughters of the American Revolution, who had in the late 1920s attacked him for daring to have a stained-glass window for a Cedar Rapids veterans' memorial done in Germany. Much of his work of the 1930s celebrated rural life in his native Iowa, as in *Fall Plowing* (1931) and *The Breaking of Iowa's Virgin Soil* (1936).

Wood, Natalie (Natasha Gurdin, 1938–81), U.S. actress, on screen from 1943. She was a leading child actress of the 1940s, from her appearance in *Tomorrow Is Forever* (1946), and can still be seen every Christmas in MIRACLE ON 34TH STREET (1947). She then made a notably effective transition to adult roles; her films include REBEL WITHOUT A CAUSE (1955), *Marjorie Morningstar* (1958), *Splendor in the Grass* (1961), WEST SIDE STORY (1961), GYPSY (1962), *Love with the Proper Stranger* (1963), *Inside Daisy Clover* (1966), and BOB AND CAROL AND TED AND ALICE (1972). She also appeared in several television roles.

Woodruff, Hale Aspacio (1900–79), U.S. artist and teacher, one of the leading Black American visual artists of the century. His best-known works are the *Amistad Slave Mutiny* murals at Talladega College, Alabama. He also did murals for the Works Progress Administration in the 1930s and worked in a considerable range of visual media.

Woodstock (1969), the peaceful, massive folk–rock music festival and COUNTERCULTURE event held at Woodstock, New York. An estimated 400,000 attended, most of them young, to see scores of the most prominent folk and ROCK musicians of the day, including among others SLY AND THE FAMILY STONE; CROSBY, STILLS, AND NASH; Joan BAEZ; THE WHO; Arlo Guthrie; and JEFFERSON AIRPLANE. The 1970 Michael Wadleigh film of the event won a best documentary OSCAR. Joni MITCHELL, who did not attend, wrote the

song "Woodstock" (1970) to commemorate the event.

Woodward, Joanne (1930–), U.S. actress, on screen from 1955, who won recognition as a major dramatic star with THE THREE FACES OF EVE (1957), for which she won a best actress OSCAR. She went on to play leads in such films as THE LONG HOT SUMMER (1958); A FINE MADNESS (1966); RACHEL RACHEL (1968), directed by her husband, Paul NEWMAN; *Summer Wishes, Winter Dreams* (1973); *The Shadow Box* (1980), also directed by Newman; THE GLASS MENAGERIE (1987); and *Mr. and Mrs. Bridges* (1990). She has also worked on stage and in television.

Woolf, Virginia (Adeline Virginia Stephen, 1882–1941), British writer, a leading member of the BLOOMSBURY GROUP and a leading feminist literary figure. Her first novel, the semiautobiographical *The Voyage Out* (1915), was followed by a group of experimental works relying largely on then-current "stream-of-consciousness" techniques rather than on plot and character development. These include *Night and Day* (1919), *Mrs. Dalloway* (1925), *To the Lighthouse* (1927), *Orlando* (1928), *The Waves,* (1931), *The Years* (1937), and *Between the Acts* (1941). She also wrote a substantial body of essays, those in *A Room of One's Own* (1929) and *Three Guineas* (1938) most strongly expressing her feminist views. Her work also includes two volumes of short stories, letters, and diaries, many of these published posthumously. She was a suicide. Her husband was writer, editor, and publisher Leonard Woolf, with whom she cofounded the Hogarth Press and who was also a leading member of the Bloomsbury Group.

World According to Garp, The (1978), the John Irving novel, about the life of a wholly independent and original young man who becomes a writer and the lives of those around him. Steve Tesich adapted the novel into the 1982 George Roy HILL film, with Robin WILLIAMS in the title role and a cast that included Glenn CLOSE, John Lithgow, Mary Beth Hurt, Swoosie Kurtz, Jessica TANDY, and Hume CRONYN.

World of Apu, The (1959), the Satyajit RAY film, the third in the APU TRILOGY, with a cast that included Soumitra Chatterjee, Sharmila Tagore, and Shapan Mukerjee. Ray wrote and directed the film, based on the Bibhutti Bhusan Banerji novel; the music was by Ravi SHANKAR.

Wouk, Herman (1915–), U.S. writer, whose PULITZER PRIZE-winning novel THE CAINE MUTINY (1951) established him as a popular novelist. His best-known novels also include *Marjorie Morningstar* (1955); *Youngblood Hawke* (1962); and THE WINDS OF WAR (1971) and its sequel, WAR AND REMEMBRANCE (1978). He also wrote several plays, the most notable being his adaptation of his own novel into *The Caine Mutiny Court-martial* (1953), which was adapted into the 1954 Edward DMYTRYK film, with Humphrey BOGART in the role of Captain Queeg. Wouk also wrote the screenplays for the massive television miniseries adaptations of *The Winds of War* (1983) and *War and Remembrance* (1989).

Wozzeck (1925), the Alban BERG opera, based on the unfinished mid-1830s Georg Buchner play *Woyzeck* (first published in 1875), about a poor soldier—an army private—who is ultimately driven to madness, murder, and suicide. The play was also the basis of *Woyzeck* (1978), the Werner HERZOG film, with Klaus Kinski in the title role.

Wright, Frank Lloyd (1867–1959), the leading American architect of the 20th century. His thinking and practice were aimed at creating modern structures to meet human needs, as those needs were molded by the total environment and history within which people and structures function and intertwine. He exerted an enormous influence on the development of modern architecture, throughout and long beyond his 72-year career. Some of his most notable works are his own home at TALIESIN, Wisconsin (1911, 1915, and 1925), which in 1932 became a celebrated architecture school and workshop; the Imperial Hotel, Tokyo (1922), which was built to withstand earthquakes, and soon after completion did so; FALLINGWATER (1937), the celebrated home near Bear Run, Pennsylvania, the best-known of his works; the Usonian homes of the 1930s; and

New York's Guggenheim Museum, designed in 1943 and built in the late 1950s. His many books and articles most notably include his autobiography, written in 1932 and revised and reissued in 1943 and 1962. Taliesin West, at Scottsdale, Arizona, continued on as a school after his death.

Wright, Richard Nathaniel (1908–60), U.S writer, who took as his theme the Black experience in America, most notably in his novel NATIVE SON (1940), set in Chicago's South Side Black ghetto, which was later adapted for stage and screen. Wright's first published work was the four-novella *Uncle Tom's Children* (1938); his later fiction includes the novels *The Outsider* (1953) and *The Long Dream* (1958), and the short-story collection *Eight Men* (1961). He wrote two autobiographical works: *Black Boy* (1945) and *American Hunger* (1977). He also wrote several works of social commentary and reportage, including *The God That Failed* (1950), an account of his disillusionment with the American Communist Party, which he had joined in the 1930s and left in the 1940s.

Wuthering Heights (1939), the William WYLER film, adapted by Ben HECHT and Charles MACARTHUR from the Emily Brontë novel, with Laurence OLIVIER as Heathcliff and Merle Oberon as Kathy, in a cast that included Flora ROBSON, David NIVEN, Geraldine FITZGERALD, Donald Crisp, Miles Mander, and Leo G. Carroll. Gregg TOLAND won a cinematography OSCAR. The film established Olivier as a popular movie star.

Wyeth, Andrew Newell (1917–), U.S. painter, one of the leading realists of the century. His work portrays the land and people of Chadd's Ford, Pennsylvania and Cushing, Maine, and by extension much of American rural and small-town life, as in his best-known work, CHRISTINA'S WORLD (1948), and in such works as *Snow Flurries* (1958), *Tenant Farmer* (1961), *Adam* (1963), *The Drifter* (1964), *Thin Ice* (1969), and *Evening at Kuerner's* (1970), and the long series of *Helga* paintings. He is the son of illustrator and

painter **N.C. Wyeth** and the father of artist **James Browning Wyeth.**

Wyler, William (1902–81), German-American director, in Hollywood from the early 1920s, whose work was on screen from 1925 and who emerged in the mid-1930s as one of the leading directors of Hollywood's Golden Age, a meticulous craftsman whose long takes showed his players to their best possible advantage in the dramas he directed. A few of his classic films are THESE THREE (1936); DODSWORTH (1936); DEAD END (1937); WUTHERING HEIGHTS (1939); THE LITTLE FOXES (1941); MRS. MINIVER (1942), for which he won his first best director OSCAR; his celebrated THE BEST YEARS OF OUR LIVES (1946), for which he won a second best director Oscar; THE HEIRESS (1949); BEN-HUR (1959), yielding his third best director Oscar; and FUNNY GIRL (1968).

Wyman, Jane (Sarah Jane Fulks, 1914–), U.S. actress, on screen from 1936, who after a decade of minor roles emerged as a strong dramatic actress in THE LOST WEEKEND (1945), and then as one of the leading dramatic stars of the postwar period in her deaf-mute role in *Johnny Belinda* (1948), for which she won a best actress OSCAR. Most of the film roles that followed were less rewarding, though she did play strong dramatic roles in such films as THE GLASS MENAGERIE (1950) and *The Magnificent Obsession* (1954). She later moved into television, in "The Jane Wyman Show" (1956–1960), and during the 1980s as Angela Channing in "Falcon Crest" (1981–). She was married to Ronald Reagan from 1940 to 1948.

Wynette, Tammy (Virginia Wynette Pugh, 1942–), U.S. country singer and songwriter, who became a very popular figure in the late 1960s, notably with her own song "Stand By Your Man" (1968) and such songs by other composers as "Your Good Girl's Gonna Go Bad" (1967), "The Ways to Love a Man" (1969), "Good Lovin'" (1971), "Womanhood" (1979), and "Cryin' in the Rain" (1981).

Y

Year of Living Dangerously, The (1982), the Peter WEIR film, set in Indonesia in the mid-1960s, during a period of political upheaval. Mel GIBSON played the Australian journalist on assignment, in a cast that included Linda Hunt, Sigourney Weaver, Michael Murphy, Bill Kerr, and Noel Ferrier. Hunt, here playing in a male role, won a best supporting actress OSCAR.

Yeats, William Butler (1865–1939), Irish writer, one of the leading poets of the 20th century, a dramatist and a founder of the ABBEY THEATRE. The first of his many collections of poems was *The Wanderings of Oisin and Other Poems* (1889); these and many of the other poems of his early, most romantic period were considerably affected by his unrequited love for Irish revolutionary Maud Gonne. Much of his most highly regarded later work, thought by some to be deeper and stronger, appeared in such collections as *The Green Helmet* (1910), *The Wild Swans at Coole* (1917), *The Tower* (1928), and *The Winding Stair* (1929). Some of his best-known and often-anthologized poems are "The Lake Island of Innisfree"; "Sailing to Byzantium"; and "Easter 1916," with its final "A terrible beauty is born," which struck an emotional chord that helped kindle the Irish Revolution. His dramatic works, many of them on Irish historic and mythic themes, include such plays as *The Countess Cathleen* (1892), *Cathleen ni Houlihan* (1902), *Deirdre* (1907), *The Unicorn from the Stars* (1908), *The Hour-Glass* (1914), *Calvary* (1920), and *The Death of Cuchulain* (1939). He was awarded the 1923 Nobel Prize for literature.

Yellow Submarine (1968), the celebrated BEATLES animated film, directed by George Dunning and featuring a considerable collection of their songs wrapped in an innovative, highly textured mass of visual images.

"Yesterday" (1965), the BEATLES song, an early work that became an enduring standard; words and music were by John LENNON and Paul MCCARTNEY.

Yesterday, Today, and Tomorrow (1964), the Vittorio DE SICA film, a sex comedy in three episodes starring Sophia LOREN and Marcello MASTROIANNI; the work won a best foreign film OSCAR.

Yevtushenko, Yevgeny Alexandrovich (1933–), Soviet writer, one of the key leaders of the movements toward social criticism and artistic freedom that developed after the death of Stalin. The collection *The Third Snow* and the autobiographical *Zima Junction* (1956) became immensely popular works, and he became a national and international literary and political figure. In his celebrated poem, BABI YAR (1961) he opened the question of Stalinist anti-Semitism; until then the Soviet government had not even marked the site where Germans massacred tens of thousands of Soviet Jews near Kiev. Yevtushenko was officially attacked after publication of *A Precocious Autobiography* (1963), which was published abroad, and moderated the tone of his criticism, while continuing to publish a considerable body of poetry.

Yoknapatawpha County, the imaginary, quite fully developed Mississippi county that is the setting for much of William FAULKNER's works.

York, Michael (1942–), British actor, on stage and screen in the mid-1960s. He appeared in THE FORSYTE SAGA (1967) on television and in the film *Accident* (1967), and

went on to appear in such films as *Zeppelin* (1971), CABARET (1972), *The Three Musketeers* (1973), *The Four Musketeers* (1974), *Conduct Unbecoming* (1974), *The Riddle of the Sands* (1978), and *Fedora* (1978). His television films include *Jesus of Nazareth* (1977), *A Man Called Intrepid* (1979), and *Space* (1985).

York, Susannah (Susannah Yolande Fletcher, 1941–), British actress, on stage from the late 1950s and on screen from 1960. She quickly emerged as a leading player, in such films as TUNES OF GLORY (1960), *Freud* (1962), TOM JONES (1963), A MAN FOR ALL SEASONS (1966), *The Killing of Sister George* (1968), THEY SHOOT HORSES, DON'T THEY? (1969), and JANE EYRE (1970). Her later career includes a substantial body of work in theater and on television, as well as roles in such films as SUPERMAN (1978) and *Superman II* (1980).

You Can't Take It With You (1936), the Moss HART–George S. KAUFMAN play, a comedy about a family of attractive eccentrics. It was adapted by Robert Riskin into the OSCAR-winning 1938 Frank CAPRA film, with a cast that included Jean ARTHUR, Lionel BARRYMORE, James STEWART, Edward ARNOLD, Ann Miller, Spring Byington, Eddie Anderson, Harry Davenport, and Donald Meek. Capra won a best director Oscar.

You Have Seen Their Faces (1937), the Margaret BOURKE-WHITE book, with text by her husband, Erskine CALDWELL. The stark, powerful photo-essay on the Depression-era American South was one of the most celebrated works of the period; like THE GRAPES OF WRATH and LET US NOW PRAISE FAMOUS MEN, it caught the conscience of the nation.

"You'll Never Walk Alone" (1945), a song introduced by Christine Johnson on Broadway in CAROUSEL (1945); with music by Richard RODGERS and words by Oscar HAMMERSTEIN II.

Youmans, Vincent (1898–1946), U.S. composer and producer, best known for his music for such songs as "Tea for Two" from *No, No, Nanette* (1925); "Hallelujah" and "Sometimes I'm Happy" from *Hit the Deck* (1927); and

"More Than You Know" and "Without a Song" from *Great Day* (1929).

Young, Chic (Murat Bernard Young, 1901–73), U.S. cartoonist, who in 1930 created the extraordinarily popular, widely syndicated comic strip BLONDIE, which was later the basis for 28 feature films and two television series.

Young, Lester Willis (1909–59), U.S. JAZZ saxophonist, clarinetist, and composer. In the late 1930s, playing and recording with Count BASIE's band, he became a leading tenor saxophonist and key figure in the further development of jazz. Although he continued to work as a very influential soloist after World War II, his career and later years were seriously damaged by alcoholism and other health problems.

Young, Loretta (Gretchen Michaela Young, 1913–), U.S. actress, on screen as a child and again from 1927, who played romantic leads from the mid-1930s in such films as *Ramona* (1936) and *The Doctor Takes a Wife* (1939), then moved into strong dramatic roles during the early postwar period, notably in *The Farmer's Daughter* (1947), for which she won a best actress OSCAR, *Rachel and the Stranger* (1948), and *Come to the Stable* (1949). Her "The Loretta Young Show" ran for eight years on television (1953–61).

Young, Robert (1907–), U.S. actor, on screen from 1931. He is best known for his two long-running television series: FATHER KNOWS BEST (1954–63) and "Marcus Welby, M.D." (1969-76). His film career includes substantial supporting roles, in scores of films as well as some leads, as in THREE COMRADES (1938).

"Younger than Springtime" (1949), a song from SOUTH PACIFIC, introduced by William Tabbert on Broadway, with music by Richard RODGERS and words by Oscar HAMMERSTEIN II.

Young Frankenstein (1974), the Mel BROOKS film, written by Brooks and Gene Wilder, a parody of the several FRANKENSTEIN films, with a cast that included Wilder, Madeline Kahn, Marty Feldman, Cloris Leachman, Gene HACKMAN, Peter Boyle, and Kenneth Mars.

Yourcenar, Marguerite (Marguerite de Crayencour, 1903–), French writer, best known for her historical novel *Memoirs of Hadrian* (1951), a notably careful reconstruction of the portion of Roman history described and its physical and cultural setting. Her earlier works include *A Coin in Nine Hands* (1934) and *Coup de Grâce* (1939). In 1981 she became the first woman member of the French Academy.

"You're a Grand Old Flag" (1906), the George M. COHAN song, introduced by Cohan in his Broadway musical *George Washington, Jr.* (1906), with words and music by Cohan.

Z

Z (1968), the Constantin COSTA-GAVRAS film, a political thriller set in Greece; the screenplay, by Costa-Gavras and Jorge Semprun, was based on the Vassili Vassilikos novel. Yves MONTAND was the leading democrat and member of Parliament assassinated by secret police agents masquerading as ordinary citizens, leading a cast that included Irene Papas, Jean-Louis Trintignant, Charles Denner, and Jacques Pérrin. The work won a best foreign film OSCAR.

Zadkine, Ossip (1890–1967), Russian-French sculptor; resident in France from 1909, he became an early cubist sculptor. During the interwar period he continued to work in abstract forms, but in his own personal style, as in *Musicians* (1924) and *Orpheus* (1948). His best-known work is the monumental bronze *The Destroyed City* (1951), at Rotterdam, his tribute to those who died when the Germans destroyed the city during World War II and to those who rebuilt the city after the war.

Zanuck, Darryl F. (1902–79), U.S. producer, who began as a screenwriter in the 1920s, moved into production in 1929, and in 1933 became head of production at 20th Century-Fox and a major figure in the film industry. He became an independent producer in 1956 and was president of 20th Century-Fox from 1961 to 1971. Though most of career was spent as a studio executive, he is also credited with the production of such films as *Jesse James* (1939), THE GRAPES OF WRATH (1940), GENTLEMEN'S AGREEMENT (1947), HOW GREEN WAS MY VALLEY (1941), ALL ABOUT EVE (1950), and THE LONGEST DAY (1962).

Zappa, Frank (Francis Vincent Zappa, Jr., 1940–), U.S. composer, guitarist, and bandleader, a satirist and innovator, much of whose work attempts to join JAZZ and modern classical music. He led the group *The Mothers of Invention* from 1965 until it formally disbanded in 1977. His long series of albums began with *Freak Out* (1966); his later works reflect development in the jazz-classical fusion direction, as in the albums *The Perfect Stranger and Other Works* (1985) and the two *Boulez Conducts Zappa* albums (1982 and 1987).

Zavattini, Cesare (1902–89), Italian writer, who focused on screenwriting from the mid-1930s and became one of the key neorealist figures of the postwar period (see NEOREALISM), most notably for his work with Vittorio DE SICA. He wrote scores of screenplays, including those for SHOESHINE (1946), THE BICYCLE THIEF (1948), *Miracle in Milan* (1951), UMBERTO D (1952), and *The Gold of Naples* (1954).

Zetterling, Mai (1925–), Swedish actress, director, and writer, on stage and screen from 1941, whose first starring role on film was in *Torment* (1944), which was followed by such films as *Frieda* (1947), *Quartet* (1948), and *Only Two Can Play* (1962). Her directorial work was on screen from 1963 and included such films as *Loving Couples* (1964); *Night Games* (1966), adapted from her own novel; and *The Girls* (1969). She also appeared on stage in Sweden and Britain.

Ziegfeld, Florenz (1867–1932), U.S. producer, the leading manager-producer of the American musical theater during the first third of the 20th century, who had an enormous impact on the development of the musical-theater form. He did 24 consecutive *Follies* from 1907 to 1931, calling them the *Ziegfeld Follies* from 1911, and also presented such landmark musicals as *Sally* (1920), SHOWBOAT (1927), *Rosa-*

lie (1928), and *Smiles* (1930), in the process featuring and often discovering such stars as Fannie BRICE, Marilyn MILLER, Will ROGERS, W.C. FIELDS, and Eddie CANTOR, and also quite lavishly "glorifying the American girl." From 1914 he was married to actress Billie Burke.

Zimbalist, Efrem (1889–1985), Russian-American violinist; a child prodigy who studied at St. Petersburg, he made his debut at Berlin and London in 1907 and at New York in 1911, then becoming one of the leading violinists of his time. He taught at the Curtis Institute from 1928 to 1968 and was its director from 1941 to 1968. His son is actor **Efrem Zimbalist, Jr.**

Zinnemann, Fred (1907–), Austrian-American director, in Hollywood from 1930, whose work was on film from 1935 and who emerged as a major director in the 1950s, with such films as HIGH NOON (1952), for which he won a best director OSCAR; FROM HERE TO ETERNITY (1953), winning another Oscar; *A Hatful of Rain* (1957); A MAN FOR ALL SEASONS (1966), for which he won a third Oscar; *The Day of the Jackal* (1973); and JULIA (1977).

Zorach, William (1887–1968), U.S. sculptor, a painter in the FAUVIST style early in the century who in the early 1920s turned to sculpture, then emerging as a major figure in American sculpture. He was a realist who worked in semiabstract forms and whose work

and direct carving approach considerably influenced further generations of American sculptors. Two of his many major works are *Spirit of the Dance* (1932), at New York's Radio City Music Hall, and *Man and Work* (1954), at the Mayo Clinic in Rochester, Minnesota.

Zukerman, Pinchas (1948–), Israeli violinist and conductor, who emerged as a major figure in concert and as a recording artist in the 1970s, touring widely in Europe and the United States, often with the English Chamber Orchestra. He has made several records with Itzhak PERLMAN and Daniel Barenboim.

Zweig, Arnold (1887–1968), German writer, whose best-known novel is *The Case of Sergeant Grischa* (1927), the first of a group of powerful antiwar novels that include *Young Woman of 1914* (1931) and *Education Before Verdun* (1935), the latter written after Zweig's 1933 flight from Nazi Germany to Palestine. Zweig was a pacifist and Zionist, who later returned to East Germany.

Zweig, Stefan (1881–1942), Austrian writer, best known for his many biographies, such as *Romain Rolland* (1920), *Three Masters* (1920; on Balzac, Dickens, and Dostoyevsky), *Marie Antoinette* (1932), and *Erasmus of Rotterdam* (1934). His also wrote several plays, most notably the pacifist *Jeremias* (1917), and several novellas. He and his wife fled the German occupation of Austria in 1938, and in 1942 both committed suicide in Brazil.

INDEX